RUDOLF WITTKOWER was born in Berlin and received his PhD. from the University of Berlin in 1923. He was a research fellow at the Bibliotheca Hertziana in Rome until 1933, in 1934 joined the staff of the Warburg Institute in London, and was appointed Reader and later Durning-Lawrence Professor of the History of Art at the University of London. From 1956 until his retirement in 1968 he was Chairman of the Department of Art History and Archaeology at Columbia University. His books include *Architectural Principles in the Age of Humanism, The Drawings of the Carracci at Windsor, Gian Lorenzo Bernini,* and *Art and Architecture in Italy: 1600 to 1750.*

Norton Library titles in
Art, Architecture and the Philosophy of Art

Born Under Saturn

Saturn

The Character and Conduct of Artists:
A Documented History from Antiquity
to the French Revolution

RUDOLF AND MARGOT WITTKOWER

The Norton Library
W · W · NORTON & COMPANY · INC ·
NEW YORK

Books That Live
The Norton imprint on a book means that in the publisher's
estimation it is a book not for a single season but for the years.
W. W. Norton & Company, Inc.

SBN 393 00474 0

PRINTED IN THE UNITED STATES OF AMERICA

2 3 4 5 6 7 8 9 0

CONTENTS

ILLUSTRATIONS

PHOTOGRAPHIC SOURCES

A.C.L., Brussels: 23
Alinari, Florence: 12, 13, 15, 16, 17, 24, 25, 27, 28, 37, 43, 44, 48, 50, 51, 55, 57, 58, 61, 67, 72, 80, 81, 82, 83, 85, 89
Amsterdam, Rijksmuseum: Frontispiece, 1, 3, 68
Anderson, Rome: 9, 11, 21, 38, 45, 49, 54, 56, 63, 77
Basel, Offentliche Kunstsammlung: 64, 65
B. T. Batsford Ltd, London: 7
Bratislava, City Gallery: 31
Braunschweig, Herzog-Anton-Ulrich-Museum: 2
Brogi, Florence: 52, 59, 75, 88
Chatsworth, Devonshire Collections: 18
Copenhagen, Statens Museum for Kunst: 8
A. Dingjan, The Hague: 26
Florence, Soprintendenza alle Gallerie: 10, 22
Frankfurt, Städelsches Kunstinstitut: 73, 76
Gabinetto Fotografico Nazionale, Rome: 14
Genoa, Soprintendenza alle Gallerie: 69
Giraudon, Paris: 35
Graz, Joanneum: 86
Hamburg, Kunsthalle: 39
London, British Museum: 20, 42, 60, 62, 70
 Courtauld Institute: 87
 National Gallery: 66, 79
 Royal Academy: 84
 Warburg Institute: 4, 6, 19
Mantua, Soprintendenza alle Gallerie: 74
Marburg, Bildarchiv: 53
New York, Columbia University: 41
Oxford, University Press: 46
Rome, Bibliotheca Hertziana: 40, 71, 78
 Gabinetto del Disegno, Farnesina: 36
Vatican, Archivio Fotografico: 5, 29
Vienna, Osterreichische Galerie: 30, 32, 34
Windsor, Royal Library: 47

ACKNOWLEDGMENTS

Many friends and colleagues helped to clarify our thoughts by stimulating discussion while the work was in progress. They share an anonymous responsibility in the final text. Among those who supplied valuable information we mention gratefully Colin Eisler, S. J. Gudlaugson, Otto Kurz, Ulrich Middeldorf, Seymour Slive and J. B. Trapp. Our friend Paul Ganz gave us the benefit of his discerning criticism when most of the book was in the draft stage. We also want to put it on record that this book would never have been written in its present form without Henry W. Simon's stimulating comments on some chapters which he was kind enough to read as far back as 1954. Finally we owe a great debt of gratitude to Margaret Ševčenko in New York who, miraculously, not only produced a clean typescript, but also made an infinite number of pertinent suggestions as to style and content. Nancy Dunn in London undertook to read the galley proofs and sincere thanks are due to her for many improvements at this final stage.

We have been greatly assisted in procuring photographs by Horst Gerson, Michael Kitson, Gregory Martin, J. J. Poelhekke, and particularly by Hildegard Giess of the Bibliotheca Hertziana, Rome. In addition, we are indebted to the following publishers and authors for allowing us to quote passages from works for which they hold the copyright:

Basic Books Inc., New York, and Hogarth Press Ltd, London, for quotations from Ernest Jones, *Sigmund Freud, Life and Work*, 1955; B. T. Batsford Ltd, London, for the reproduction of a map from John Harvey, *The Gothic World*, 1950; the University Press, Cambridge, for quotations from C. G. Coulton, *Art and the Reformation*, 1928, and from N. Pevsner, *Academies of Art Past and Present*, 1940; Jonathan Cape Ltd, London, for quotations from Edward MacCurdy, *The Notebooks of Leonardo da Vinci*, 1945, and *The Mind of Leonardo da Vinci*, 1952; Jonathan Cape Ltd, London, and Alfred A. Knopf Inc., New York, for a quotation from Iris Origo, *The Merchant of Prato Francesco di Marco Datini*, 1957; J. M. Dent & Sons Ltd, London, for quotations from

ACKNOWLEDGMENTS

A Florentine Diary from 1450 to 1516. English by Alice de Rosen Jervis, 1927; the Harvard University Press for quotations from Ruth Saunders Magurn, *The Letters of Peter Paul Rubens,* 1955; the Harvard University Press and William Heinemann Ltd, London, for a quotation from Lucian's *Works,* Vol III, ed. by Harmon (Loeb Classical Library); Macmillan & Co. Ltd, London, for quotations from *The Elder Pliny's Chapters on the History of Art.* Transl. by K. Jex-Blake. Commentary and Introduction by E. Sellers, 1896; John Murray Ltd, London, for a quotation from Julia Cartwright, *Isabella d'Este Marchioness of Mantua,* 1932; Princeton University Press and Oxford University Press for quotations from Elizabeth G. Holt, *Literary Sources of Art History,* 1947; Routledge & Kegan Paul, Ltd, for a quotation from Petronius, *The Satyricon.* Transl. by J. M. Mitchell, 1923.

PREFACE

If a man could say nothing against a character but what he can prove, history could not be written.

Dr Johnson

IT IS SCARCELY AN exaggeration to say that in recent years more work has been devoted to the problems of the artist's personality and the mysterious springs of his creative power than ever before in history. Broadly speaking, we may add that, however much the approach may differ, the results are fairly uniform. More often than not psychologists, sociologists and, to a certain extent, art critics agree that certain marked characteristics distinguish the artist from 'normal' people.

The 'otherness' of artists is also widely accepted by the general public. Though comparatively few laymen are really in a position to judge from historical knowledge or personal experience, there is an almost unanimous belief among them that artists are, and always have been, egocentric, temperamental, neurotic, rebellious, unreliable, licentious, extravagant, obsessed by their work, and altogether difficult to live with.

Art historians have contributed relatively little to this discussion. With a few notable exceptions they do not regard psycho-analysis and 'depth psychology' as helpful in historical research, and it has been suggested that this attitude has deprived them of a deeper insight into the behaviour and the work of artists past and present. They claim that non-historians tend to apply too easily the same criteria to different periods and circumstances and they doubt, moreover, whether conclusions drawn from the analyses of individual cases can be generalized, especially if based on insufficient historical data.

In the present book we propose to deal with the problem of the alienated artist from an angle that has been rather neglected. We have attempted to trace the cause and effect of his alienation and to follow the opinions on character and conduct of artists down to the beginning of the romantic era. We have asked ourselves what are the roots of the scholarly and popular belief that artists, rather than some other professional group, form a race apart from the rest of mankind. In other words, our main concern was to investigate when, where, and why an image of the typical artist arose in people's minds, and what its distinguishing traits and varying fortunes have been. The answers to these questions

we have sought in the *mare magnum* of art historical sources—biographies, letters, and documents.

Our enquiry is therefore strictly focused on historical documentation. Since we are concerned with thoughts about artists formed at different historical periods we have tried, as far as possible, to avoid interpreting the past in terms of theories of the present. Our conclusions, we would like to claim, are derived from documents and not from preconceived ideas, although we are, of course, aware of the fact that our selection from among the infinite number of character sketches and from contemporary records of the artists' foibles, idiosyncrasies, and oddities is of necessity discriminative. No one can escape being biased in what he deems important or negligible, revealing or of little interest, and we readily endorse Sir Kenneth Clark's verdict that 'in the history of art, as in all history, we accept or reject documentary evidence exactly as it suits us'.

Not unnaturally we had to impose limitations on our enterprise, dictated partly by our own interests and our familiarity with the material. We have concentrated our quest on the European masters of the visual arts, on painters, sculptors, and architects. The special character of the fine arts as well as the distinctive nature of the source material legitimizes such a restriction. Some readers may object to our exclusion of the nineteenth and twentieth centuries. Regretfully we took this decision, since a satisfactory discussion of the abundant documentation and the many new aspects of our problem after the French Revolution would have required a whole volume. The era of Romanticism constitutes a distinct caesura; in view of the many decisive changes during that period we felt justified in bringing our story to a close at the end of the eighteenth century.

In attempting to reconstruct what people thought about the artists in their midst and how artists assessed their own position we thought it best to let the sources speak for themselves, for we regard their wording and flavour as extraordinarily revealing. A large portion of this book consists therefore of original texts, in English translation, chosen from the relevant literature of all European countries. We were faced with three different categories of documentation, each of distinct value in our context: (i) 'neutral' documents such as contracts, court minutes and tax declarations; (ii) artists' diaries and autobiographies as well as letters by and to artists; (iii) theoretical and biographical writings. On the whole we have discarded *topoi* and legendary material, though both were occasionally used if they seemed to throw light on a characteristic situation or a prevailing pattern of thought. As regards biographies, perhaps the most important category for us, we have tried to confine ourselves to the observations of authors who drew either on their own knowledge of the artists they wrote about or relied on the information of

people who had been in close contact with them. Wherever possible we sought to substantiate one writer's report by further evidence. Even so, personal acquaintanceship and sound tradition cannot simply be accepted as proof of reliability. Only recently did Signorina Modigliani inform us that the stories told by fellow-revellers about her father's dissipated life were romantic inventions or, at least, 'improvements' upon the truth. Moreover, the white-washing or 'black-washing' of an artist's personality often depends on the standpoint of the writer who may introduce or suppress character traits for the sake of some ulterior motive.

A critical analysis of our sources, necessary though it may seem, would go beyond the scope of this book. Also, the existence of J. von Schlosser's *Kunstliteratur* (1924; Italian edition: *La Letteratura Artistica*, 1956) and other more recent studies allow us to dispense with this task. But a few remarks may be in place, particularly for the reader unfamiliar with art historical sources.

Writings on artists as well as by artists began to appear in Italy about the middle of the fifteenth century, but all the early efforts were completely overshadowed by Vasari's *Lives*, first published in 1550. Although Vasari's work became the accepted model of art historical writing for more than two hundred years, it was mainly in Italy that he found successors and imitators: Baglione, Passeri, Bellori and Pascoli in Rome, Baldinucci in Florence, Ridolfi in Venice, Soprani in Genoa, to mention some of the most important names. By comparison non-Italians came later and were few and far between and none of them equalled the Italianized German, Joachim von Sandrart. During the centuries under consideration Italy was not only the most important art centre but Italian artists were by and large more learned and more literate than their fellow artists abroad. It is for these reasons that the major part of our quotations is gleaned from Italian sources.

The procedure of most seventeenth and eighteenth-century biographers follows more or less the same pattern. Apart from some philosophical speculations, they give as a rule, first, an account of the parentage and early years of an artist, then a list of his works, and finally a description of his personality. This narrow framework is further stereotyped, for the origin of the artist is usually described either as so humble that it makes his rise to fame all the more wondrous, or as so elevated that it sheds an ennobling light on the whole profession. All these biographers show a remarkable lack of regard for dates and chronology. Modern critics have often found it difficult to reconcile such vagueness with trustworthiness in other matters. But the guardians of historical accuracy seem to us as time-bound as their less rigid forerunners: what is considered an inexcusable shortcoming today was

meaningless at times when people were often uncertain about their own age.

If we are prepared to condone the biographers' lack of interest in dates, we should also make allowances for their patently subjective views: it is always the art of their country, their city, and their friends that they extol. Vasari, born at Arezzo, praises Tuscan art and artists at the expense of all others; the Bolognese Malvasia defends his countrymen; Houbraken lauds the masters of the Netherlands. Moreover, most of the biographers were themselves artists who had made their way into the upper strata of society and hence they often expressed and reflected opinions conforming to their elevated status. Nor should it be left unmentioned that they copied each other without hesitation whenever it suited their ends.

Taking all this into consideration, it would indeed appear that their character sketches of artists are highly debatable. Sometimes modern research and new finds in archives allow us to control and correct a biographer's report, but it must be admitted that all too often we have no objective way of checking whether a story is true or false. This, of course, opens the door to many and diverse interpretations, and we shall see later how the same early writer may be acknowledged as an unquestioned authority or dismissed as an arch-liar according to whether he confirms or contradicts the modern critic's own views.

The course we have followed has already been indicated. In spite of the methodological impasse, we have found it justifiable to give the old biographers the benefit of the doubt. From our point of view it does not matter very much whether one artist was quite so dissipated as he was reported to be, another so great a wastrel, a third so much of a drunkard —they surely cannot have been paragons of asceticism, parsimony or temperance to earn their reputation. Traditions have a tenacious life, and though the truth may become blurred and embroidered on its way from mouth to mouth and from ear to pen, it is rarely completely perverted. But, above all, we submit these reports and stories not because we believe in their unquestionable accuracy but because they show what the writers believed to be worth communicating and the readers accepted as characteristic of the artists of their time.

As our collection of material grew we noticed, not without surprise, that under its own volition it began to fall into several fairly distinct though not rigidly separable categories. Many documents and tales might have found a place in more than one chapter. In some cases the evidence regarding an artist should logically have appeared under several headings, but for the sake of coherence we preferred leaving it together in the chapter which seemed the most appropriate. Once the framework of the book began to take shape, we found ourselves faced

CHAPTER I

INTRODUCTION: FROM
CRAFTSMAN TO ARTIST

TWICE in the history of the western world can we observe the pheno-
menon that practitioners of the visual arts were elevated from the rank
of mere craftsmen to the level of inspired artists: first in fourth century
Greece and again in fifteenth century Italy.

There is no connection between the two events, although writers and
artists of the Renaissance recalled the glorious days of antiquity when,
in their view, artists were the favourites of kings and enjoyed the
veneration of the people. The archetypal case stimulated imitation. Not
a few artists of the Renaissance saw themselves in the rôle of Apelles,
while their patrons wanted to rival Alexander the Great. Imitation,
however, resulted from the change; it was not its cause.

Sociologists may be able to trace structural similarities between
Greece and Italy at the critical periods, but there is no denying that in
Greece the development took place against the background of a social
organization based on the contrast between slave and freeman, whereas
in Renaissance Italy it arose out of the feudal integration of the body
politic. In spite of their different social and cultural roots and the
interval of nearly two millennia, the emancipated artists were credited
with similar traits of character and, indeed, may have behaved in a
similar manner. We here want to state, rather than to explain, this
peculiar fact.

But we may at least indicate that the artist's special position in
society cannot be dissociated from the fact that unlike the rank and
file of people he has always had the power to enchant and bewitch an
audience, whether it be primitive or sophisticated. The maker of idols
endows his artifacts with magic life, while the creator of works of art
casts a magic spell over the public. Even if it is true that in high civiliza-
tions such as the Hellenistic and the Renaissance some of the primitive's
awe of the magic object is transferred to the artist-magician, it still
remains a mystery why in widely separate periods artists seem to have
had so much in common.

Yet we must beware of generalizations. In many respects the Greek
and the Renaissance approach to artists differ. As an introduction to

our main theme we shall take a fleeting glance at the situation in the ancient world and also consider the long period between antiquity and the fifteenth century.

1 *The Artist in the Ancient World*

There was in Greece a strange dichotomy between a fairly rapid process of individualization among artists and their almost complete neglect by the public. Even as early as the sixth century BC, during the Archaic period, signatures of artists appear on statues and vases. However one may want to interpret the presence of such inscriptions —as pride in a successful achievement or as a wish to record the artist's name for his contemporaries and for posterity—we cannot doubt that these masters regarded a work of art as being distinct from other crafts. This conviction of the uniqueness of artistic creation led them to sign their works, just as medieval artists did seventeen hundred years later. It is also reliably recorded that the mid-sixth century architect and sculptor Theodoros of Samos cast a bronze self-portrait, 'famed as a wondrous likeness',[1] a sure sign of self-respect. The same Theodoros wrote a treatise on the Juno temple at Samos[2] and this was only one of similar contemporary works on architecture.[3] The fifth century BC, the classical period of Greek art, saw the rise of a diversified literature by artists on art. It opened with Polycletus' famous work, entitled *Canon*, on the proportions of the human body, which was followed by the painter Timanthes' compendium and the treatises written by fourth century painters: Pamphilos on arithmetic and geometry, Euphranor on symmetry and colour, Apelles on his theory of art, Melanthios on painting, Nikias on subject-matter, to name only some of the more important writings.[4] Unfortunately none of these treatises has come down to us and although some of them may have been in the nature of technical manuals, not unlike those written in the Middle Ages, there is reason to believe that most of them showed the artists' attempt to grapple with their problems on a theoretical level, to discuss matters of principle, to regard art as an intellectual profession divorced from the old tradition according to which art was just one craft among many others.[5] We cannot doubt that this literature, originating in the second half of the fifth century and gathering momentum in the fourth, reflects a *volte-face* among artists similar to that in the fifteenth and sixteenth centuries.

There are other indications pointing in the same direction. Pliny (AD 23–79), whose *Historia naturalis* contains most of the information we have about Greek artists, tells us that Pamphilos (*c.* 390–340 BC), Apelles' teacher, 'was the first painter who was thoroughly trained in every branch of learning, more particularly in arithmetic and geometry,

without which, so he held, art could not be perfected'.[6] As in the Renaissance we are here faced with a new ideal of the learned painter, a man with an all-round education, participating in the intellectual pursuits of his time. Moreover, as in the Renaissance, it could be claimed that by allying art to mathematics and science it was raised to a 'liberal' profession. Owing to Pamphilos' influence, Pliny informs us, painting 'was the earliest subject taught to freeborn boys, and this art was accepted as a preliminary step towards a liberal education'.[7] And as in the Renaissance, artists now changed their style of living. They wanted to appear as gentlemen in dress and mien and denied that the manual side of their work was laborious. At the turn of the fourth century, Zeuxis' rival, Parrhasios, is said to have signed his paintings: 'One who lived in luxury . . .' Athenaios from Naukratis, who, at the beginning of the third century AD, wrote an antiquarian work on 'The Mysteries of the Kitchen', had it on good authority that

As signs of his luxurious living, he [Parrhasios] wore a purple cloak and had a white fillet upon his head, and leaned on a staff with golden coils about it, and fastened the strings of his shoes with golden latchets.

Nor was the practice of his art toilsome to him, but light, so that he would sing at his work, as Theophrastus in his treatise on Happiness tells us.[8]

If Pliny is right, Zeuxis indulged in a similar taste: 'He amassed great wealth, and in order to make a parade of it at Olympia he showed his name woven in golden letters into the embroideries of his garments.'[9]

How successful were these artists in attaining general recognition of the distinction between art and craft, and of the nobility of the profession? How successful were they in arousing public response to their highly developed self-esteem and in attracting interest to their persons, as the makers of images? Neither the artists of the classical period nor their works are mentioned in contemporary literature. Herodotus and Thucydides describe precious materials but not the works they enrich. Pindar praises victorious athletes but not the monuments erected to perpetuate their fame. Aristophanes mentions citizens of all walks of life—musicians, poets, wrestlers, politicians—but never artists. And none of the great Attic orators down to Demosthenes (384–322 BC) and Aeschines (389–314 BC) reveal the slightest interest in art and artists.[10] It was not until the end of the fourth century that the historian Duris of Samos (b. c. 340 BC), the pupil of Theophrastus, wrote his books on the *Lives of Painters and Sculptors*, of which only a few fragments have survived. Careful philological reconstruction has shown that Duris was attracted by anecdotes which he embroidered with his lively imagination.[11] Nonetheless his works inaugurated the biographical literature on artists and showed, for the first time, some curiosity regarding their personality

and behaviour. *Faut de mieux* later writers had to lean heavily on him. But an art critical and art historical literature on a broad foundation never developed in antiquity.

The opposite was true in the Renaissance and this emphasizes the difference between the Greek and the Renaissance position. Apart from the fact that the entire literary production of the Renaissance on art and artists survives, the emancipation of the Renaissance artist was accompanied by lively public interest. Where so much communication was involved, many intricacies and complexities came into the open which were virtually never discussed in antiquity. In historical perspective, therefore, the problems of the personality of artists in classical Greece and Renaissance Italy have less in common than one is at first inclined to believe.

The reason for the silence of their contemporaries in respect of the great Greek masters is twofold: social and philosophical.[12] Manual work in Greece was mainly executed by slaves; and painters and sculptors hardly ranked higher than slaves, since, like other craftsmen, they had to toil for money. Painters had a social advantage over sculptors because their work required less physical effort. The technical rather than the creative achievements were valued in a work of art. As with other products of manual labour, it was the accomplishment of the execution in accordance with the norms and standards of the craft that counted.[13] Artists are mentioned in the company of barbers, cooks and blacksmiths. In the pseudo-Platonic dialogue *Alcibiades*, architects, sculptors and shoemakers are lumped together as manual workers. Occasionally artists seem to have tried to overcome this social prejudice by working without a fee. Thus the painter Polygnotus is said to have decorated the painted colonnade at Athens free of charge[14] and Zeuxis, who could afford it at the end of his career, reputedly gave pictures away, declaring—so the tradition goes—that they were priceless.[15]

Philosophical arguments supported the traditional standpoint. Socrates (b. 469 BC), himself the son of a sculptor, may have learned in his youth his father's craft and yet he held a low opinion of artists. In his *Recollections of Socrates* Xenophon tells us that Socrates explained to two artists, the obscure sculptor Kleiton and the painter Parrhasios, that the soul can be represented although it is invisible. Artists, he implied by the character of the discourse, do not and cannot understand the first thing about the more subtle issues of their craft.[16] Both Plato and Aristotle assigned to the visual arts a place much below music and poetry. To the Greeks from Homer and Hesiod onward, inspiration was reserved for poets and musicians. Plato's doctrine of divine enthusiasm had room for them but not for artists. The latter represent mere imitations of the physical world which, in turn, is but an image of the divine and intang-

ible spiritual universe. This is the essence of Plato's thought about art. While his theory of the Beautiful forms an important part of his philosophy, the visual arts are excluded from it. Nor did Aristotle develop an art theory, although he gave us a theory of poetry which became of immense consequence.

It is, therefore, hardly to be expected that the personality of artists would have aroused any great interest or stimulated speculation. Nevertheless, in Aristotle's time a change did come about; Duris' books indicate that there was a public interested in the lives of artists. In the period of Hellenism an interest in art and criticism became a status symbol of the educated. Aristotle himself agreed to the teaching of art in the schools, and drawing and even modelling were regarded as a suitable pastime for dilettanti. Private collections were formed; a flourishing art market developed and very high prices were paid for masterpieces. (This new attitude was to become even more prominent when the centre of the old world shifted from Greece to Rome.) Some of the social prejudice against artists also seems to have disappeared. Alexander the Great showed his partiality for Apelles by appointing him a kind of court painter. There is reason to assume that king and painter lived on amicable terms.[17] Tradition has it that the painter did not hesitate to put the king in his place when he showed his ignorance in matters of art, while the generous king presented the painter with his favourite mistress Pankapse with whom Apelles had fallen in love.[18] Such moralizing anecdotes were of course interchangeable and were also told of other artists.[19]

The turn to subjectivity in ancient, particularly Stoic, philosophy permitted society to regard works of art as achievements of individual creators. Artists were now considered capable of inspiration and ecstasy. Late classical authors had no doubts about it: for Philostratus (c. AD 170–245), the sensitive author of the *Imagines*, poets and painters were subject to the same experience and even the pedestrian Pausanias (late second century AD) acknowledged that great works of art were accomplished by the grace of God.[20]

Although it would appear that at a comparatively late date artists acquired stature as creative individuals in the eyes of the public, two differing points have to be taken into consideration. First, alongside the process of emancipation, the tendency survived of judging artists in terms of the Platonic tradition and therefore the stigma attached to the visual arts was never fully overcome in the ancient world. Secondly, the more we advance in time, the more deliberately the interest of the public, of collectors and writers fastened upon artists of the classical Greek period. We have to discuss these points in turn.

Even as late as three hundred years after Plato, Seneca reflected on people who venerate the images of the gods but decry the sculptors who

made them, and in another passage he explicitly refused to count painting and sculpture among the cycle of the liberal arts.[21] About half a century later Plutarch (*c.* AD 40–120) wrote: 'We enjoy the work and despise the maker'; perfumes and dyes, for instance, give us delight, but perfumers and dyers we regard as illiberal and vulgar folk. Similarly no well-born youth would want to be Phidias or Polycletus however much he may admire their art.[22] The satirist Lucian (*c.* AD 125–*c.* 190), who began his career as a sculptor, echoed Plutarch's opinion when he made Education (παιδεία) warn him in a dream that by becoming a sculptor

you will be nothing but a labourer, toiling with your body . . . getting meagre and illiberal returns, humble-witted, an insignificant figure in public . . . one of the swarming rabble.

Even if you should become a Phidias or a Polycletus and should create many wonderful works, everyone would praise your craftsmanship, to be sure, but none of those who saw you—if he were sensible—would wish to be like you; for whatever your achievement, you would be considered an artisan, a craftsman, one who lives by the work of his hands.[23]

Such remarks coming from a philosopher, a historian and a writer—all of the first rank—speak a clear language and indicate that the interest in the personality and the behaviour of artists remained rather limited.

Our second point had a further restricting influence. Since the past was increasingly viewed with nostalgic eyes, we hear little about the writers' contemporaries. Pliny and others lamented the artistic degeneration of their time.

It is extraordinary [Pliny wrote] that when the price given for works of art has risen so enormously, art itself should have lost its claim to our respect. The truth is that the aim of the artist, as of everyone else in our times, is to gain money, not fame as in the old days, when the noblest of their nation thought art one of the paths to glory, and ascribed it even to the gods.[24]

Similarly Petronius, in his cynical appraisal of the Rome of Nero, commented:

It is the greed of gain that has caused the arts to become *démodés*. In the good old days when men still loved the unvarnished truth, the real arts flourished. . .

Don't you be astonished if painting has gone out of fashion, now that gods and men alike conspire to glorify a lump of gold above any production of those silly little Greeks, Apelles and Phidias.[25]

The last words are, of course, satirical. The 'silly little Greeks' were surrounded by an aura hardly matched in the age of the Renaissance, and Pliny and Petronius show how mistaken their generation was

6

concerning the extent of appreciation of art in the good old days. In contrast to the Renaissance when artists invited contemporary comment on their behaviour, biographical details of the great artists of the fifth and fourth centuries BC were circulated centuries later. For this reason it is much more difficult to separate fact from fiction than it is in the case of Renaissance artists.

Nonetheless the ancient reports give cause for reflection, particularly where they refer to such ever-recurring character traits of artists as pride, ardour and ambition. The sculptor Kallimachos (second half of the fifth century BC), for instance, had earned his nickname 'the niggler' by his overzealous application to detail,[26] and the sculptor Apollodoros (fifth to fourth century BC) was called the madman because he was a 'severe critic of his own work and often broke up a finished statue, being unable to reach the ideal he aimed at'.[27] One can well believe that Apollodorus' faculties lagged behind his aspirations. According to Xenophon[28] he was a little slow-witted—the high ideas he had been taught by his teacher Socrates and the presence of such a brilliant contemporary as Praxiteles must have weighed heavily on his dull but ambitious mind. Of the painter Protogenes (late fourth century BC) Pliny says with some caution: 'the story runs' that, while he was engaged in his main work, 'he lived on lupins steeped in water that he might satisfy at once his hunger and his thirst without blunting his faculties by over-indulgence'.[29] Whether Protogenes sustained himself on lupins or not is, of course, impossible to ascertain, but frugally he may haved lived. He seems to have been an extremely poor, self-taught man, to whom fame came late in life.

Such stories, probably garnishing facts, represent artists as rather eccentric, and eccentricity became one of the most marked character traits of western artists. Other traits too we shall meet again, such as the excessive boasting and self-esteem told about the painters Zeuxis, Parrhasius and Apollodorus; the liberty of intercourse with the great (Apelles), and the pride in the elevated status of their profession. As to the last point, not only van Dyck and Guido Reni followed the example of Zeuxis and Parrhasius but also artists in Roman times. Pliny reports about his contemporary, the painter Famulus, who had adorned Nero's Golden House, that he painted only a few hours a day and 'was always wearing the toga, even when he mounted a scaffolding'.[30]

2 Medieval Regression and the Struggle for Freedom

Despite the conquests made by artists in the course of many centuries, despite the fact that even Roman emperors such as Nero, Hadrian and Marcus Aurelius painted and sculpted,[31] Rome never admitted the visual arts into the cycle of the liberal arts, the *artes liberales*, or, in

other words, into the body of theoretical knowledge which a freeman was expected to master. The liberal arts remained the corner-stone of Christian education and this implied the exclusion of the visual arts from the higher sphere of life throughout the Middle Ages. But the debonair atmosphere of imperial Roman society, the cultivated life unthinkable without art, the private collectors, the connoisseurs, the art snobbery— all this was swept away with the decline and fall of Rome. There was no longer an educated public to which the names of Greek artists conveyed any meaning, the 'break-through' of the artist was soon forgotten and once again he was reduced to the modest status of artisan and craftsman.

No longer were characteristics of behaviour associated with artists, not only because there was no medieval Pliny who would have recorded and transmitted them, but because under the changed conditions the personality of the craftmen-artists held little interest. This was still the general reaction in Dante's time. Benvenuto da Imola, professor at Bologna and commentator on Dante, informs us that people wonder why Dante immortalized 'men of unknown name and low-class occupation'. But this, according to Benvenuto, showed Dante's genius, 'for thereby he gives silently to be understood how the love of glory does so indifferently fasten upon all men, that even petty artisans [*parvi artifices*] are anxious to earn it, just as we see that painters append their names to their works'.[32] In fact, from the eleventh century onwards we know the names of a great many artists and, judging from some of their self-laudatory inscriptions (such as Rainaldus', one of the architects of Pisa Cathedral [after 1063] or Lanfrancus', at Modena Cathedral [1099]), we may safely assume that they had no uncertain opinion about their own merits.[33] The medieval craftsman, content to be an anonymous member of his lodge and devoted to his work for the glory of God alone, is as much a myth as was Pliny's dream of a golden age of artists in the distant past. It is now well known that some exceptional masters did rise to positions of trust and distinction, especially in France and Italy, but, in the words of Bishop Otto von Freising (d. 1158), the majority were not admitted into higher positions and were kept away 'like the plague . . . from more honourable and liberal studies'.[34]

With the growth of the northern cities and the Italian communes a hierarchical social and professional organization became necessary: the urban working population had to join the guilds, called '*Arti*' in Italy. In Florence, for instance, after 1293 nobody had civic rights who was not a member of the corporation which represented his professional interests.[35] In the first half of the fourteenth century many of the guilds were given elaborate constitutions or charters which remained unchallenged for the next hundred years and often even much longer. But the

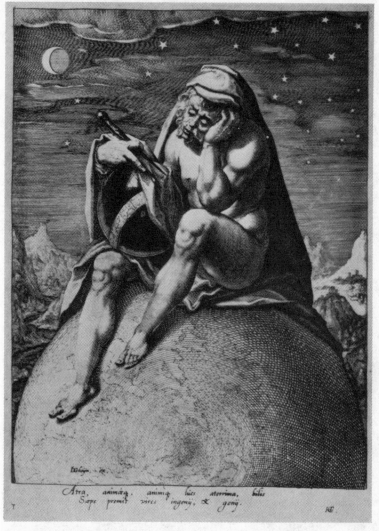

Atra, animæq, animiq lues aterrima, bilis
Sæpe premit vires ingenij, & genij.

1. Jacob de Gheyn (1569–1629), 'Melancholy'. Engraving.
One of Four Allegories representing the Temperaments and their Elements.
The element of Melancholy is the earth, and here, under a sombre night
sky, a melancholic man sits brooding on the terrestrial globe. The Latin
distich written by Hugo Grotius says:
'Melancholy, the most calamitous affliction of soul and mind,
often oppresses men of talent and genius.'

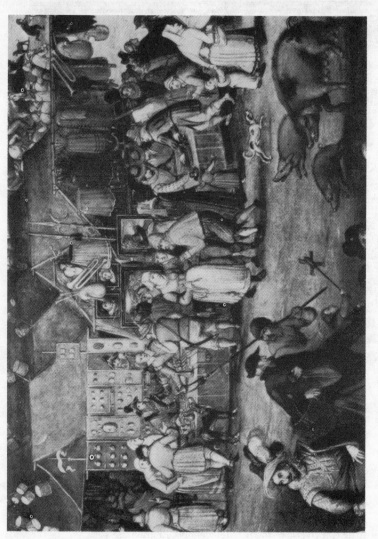

2. David Vinckbooms (1576–1629), A Fair, 1608. Detail. Herzog-Anton-Ulrich-Museum, Braunschweig. In these market stalls pictures are offered for sale just like other wares. This custom was not restricted to Holland alone.

fourteenth and first half of the fifteenth century saw the main strength of the guilds.

The earliest painters' guilds were founded in Italy: at Perugia in 1286, Venice in 1290, Verona in 1303, Florence in 1339, and Siena in 1355, and many more followed in the course of the fourteenth century. In the countries north of the Alps such guilds were, as a rule, established slightly later, although Magdeburg seems to have had a painter's guild as early as 1206,[36] Ghent had a guild in 1338, Prague in 1348, Frankfurt in 1377 and Vienna in 1410. These guilds usually comprised related crafts such as glass makers, gilders, carvers, cabinet makers and even saddlers and paper makers. Sculptors and architects were organized together with stonemasons and bricklayers. Only masters who, by birth or special grant, were citizens of their town could be members of the local guilds and had the right to open workshops and train apprentices.

The guilds concerned themselves with the whole man: they watched over the religious obligations of their members, controlled the education of apprentices, supervised contracts, regulated the relationship to the patrons and even exercised jurisdiction. In addition, they looked after the physical and moral well-being of their members. Needless to say, not all the members of the guilds were paragons of virtue, otherwise it would have been unnecessary to check them by a tight control system from which there was no easy escape. The London Masons' Ordinances of 1481 forbade the use of any 'unmannerly language or unfitting or unhonest words of lying';[37] most guilds prohibited swearing, cursing, the use of obscene language and the carrying of weapons in the workshops. The German masons' statute of 1459 ordered that 'the mason shall in no wise blame his masters' work, neither openly nor in secret';[38] and the Painters' Guild of Cremona assumed the right to destroy indecent pictures and to punish their makers.[39] Frankfurt, Munich, Prague, and Bruges imposed a probation period on itinerant journeymen who had first to prove their respectability before they were allowed to settle and become members of the local guild.[40] These examples give an idea of the nature of the surveillance exercised by the guilds. It was not easy for an artist to assert his individuality or to be unruly.

It would seem that the guilds had an equalizing influence, for artists were *de jure* and *de facto* craftsmen with a well-regulated training and a well-regulated daily routine. Scholars have come to contradictory conclusions: Coulton believes that the guild system had a levelling effect on originality,[41] while Doren, the historian of the Florentine guilds, does not believe that the system interfered with the free development and manifestation of individuality.[42] It is certainly true that the city breeds individualism, but it is against the very background of the

9

guild-controlled craftsman that the personality problems of Renaissance artists appear revolutionary and emphatically real.[43] Jacob Burckhardt's famous thesis of the liberation of the individual in the age of the Renaissance remains valid, especially in the field of the visual arts, although Burckhardt excluded them from his *Civilization of the Renaissance*. Many pages of this book will be devoted to problems engendered by the liberation of artists from the guild monopoly.

An early recorded case of disobedience to the guild laws is that of Brunelleschi, who refused to pay his dues. The *Arte de Maestri di Pietra e Legnami*—the guild to which all building workers belonged—had him thrown into prison on August 20, 1434.[44] In this case, the cathedral authorities immediately took energetic counter-measures: eleven days later Brunelleschi was freed and was able to continue his great work on the Florentine dome without any further interference from the slighted guild.

Brunelleschi's challenge of the guild laws takes on a supra-personal importance: he emerged victorious and established the right of a free man to look after himself and act as his conscience dictated. His was surely not the first such case, but the greatness of the man and of his task gives his action symbolic significance. Moreover, the intellectual climate in Florence was ripe for the emancipation of artists to proceed more rapidly and more effectively than anywhere else.

Brunelleschi's challenge was repeated many a time in a struggle which dragged on over the centuries. The most notorious clash between the upholders of tradition and a representative of the new order took place in Genoa at the end of the sixteenth century. It is worth while recording the events in some detail. The main protagonist was Giovanni Battista Paggi (1554–1627), scion of a noble family. Because he killed a man during a quarrel, he was banned from Genoa and fled to Florence where he embarked on a successful career as a painter.[45] When Paggi declared his intention of returning to his native city, the Genoese painters rose up in arms, even before the ban had been lifted—Paggi's fame and social standing made him a dangerous competitor. Invoking the old guild laws the painters demanded that Paggi should be forbidden to practise his art because he lacked the required apprenticeship of seven years. Paggi put up a great fight. His brother, an eminent physician, together with some learned patricians and friends, gave him their full support. The matter was brought before a committee of the Genoese Senate for final decision.

Paggi's own views are preserved in letters to his brother, written from Florence, and later in a rare leaflet (*'la tavola del Paggi'*) entitled *On the Definition or Division of Painting* and published in 1607.[46] The fire and

conviction of his letters are impressive; he argued, *inter alia*, that 'art can very well be learned without a master because the foremost requirement for its study is a knowledge of theory, based on mathematics, geometry, arithmetic, philosophy and other noble sciences which can be gleaned from books'.[47] The rest, according to him, is observation and practice. He passionately stressed the necessity for an all-round education and wanted to have only well-born and well-mannered men admitted to the study of art. This, he claimed, would be the best way to deter low-class people from debasing the glorious profession and would make high-born citizens proud to count their sons among the artists. Paggi's line of attack and defence agreed, of course, with views by then firmly established among educated Italian artists and accepted by many art lovers. It is therefore not astonishing that the *démarche* of the Genoese painters was defeated: on October 10, 1590, the Senate Committee declared the guild laws applicable only to those painters who kept open shops.

If in retrospect Paggi's victory in the fight against outworn tradition appears a foregone conclusion, we should not forget that entrenched social and professional organizations die slowly, almost as slowly as prejudices. Paggi's biographer, Soprani, reports, no doubt correctly, that in Antwerp Rubens had to face difficulties similar to those of his Genoese colleague and friend. In a letter of 1613, no longer extant, he asked Paggi for a copy of the court decision which might serve as a precedent in his own case.[48]

Even Florentine artists who were used to living their own lives without interference from professional organizations had to wait until 1571 for a legalization of their position. It was in that year that by a grand-ducal decree academicians were exempted from membership of the guilds. In Rome the struggle flared up again and again during the seventeenth century and only towards the mid-eighteenth century was the authority of the guilds fully broken.[49] In France also the guilds defended their rights stubbornly until the firm establishment of the Royal Academy spelled an end to their power. In England 'face-painters', coach-painters, and house-painters were, on an equal footing, members of the Painter-Stainers' Company throughout the seventeenth century, and painters remained low-class tradesmen even longer than in France.

Perpetuating medieval concepts, a great many people kept the social prejudices against the profession alive for generations. Michelangelo's servant and biographer Condivi reports that his master's family regarded it as shameful that one of them should choose to become an artist and that the father beat the boy hard in a vain attempt to break his spirit. Even more *déclassé* than the profession of painting was that of sculpture and, although the painter Granacci, Michelangelo's first teacher, tried

to explain to the father the difference between a sculptor and a stone-cutter ('*tra scultore e scarpellino*'), the old man refused to give in. Only the entreaties of Lorenzo the Magnificent himself made him change his mind.[50] The enlightened attitude of the great Medici was not always shared, it seems, by the humanist pope Pius II, for the 'Sculptor of the Apostolic Palace', Giovanni d'Andrea di Varese, had to take his meals with tailors, cooks, porters, grooms, sweepers, muleteers and water-carriers.[51] On their part, from the sixteenth century onwards all great artists insisted upon a clear distinction between art and craft, but many of their patrons, especially in the north, were reluctant to acknowledge this distinction—perhaps not so much in theory as in practice. Painters who in the Middle Ages were ranked only slightly higher than grooms and kitchen hands at the French court, had, by the sixteenth century advanced no further than to '*varlets de chambre*', a title which they shared with poets, musicians and jesters and which classed them below the military, ecclesiastical and clerical staff of the royal household.[52] The French bourgeois families of the seventeenth century still reacted as the Buonarroti had done a hundred and fifty years earlier. Charles Alfonse Dufresnoy's parents did not want their son to become a painter, because 'they regarded painting as a base craft rather than the most noble of all the arts'.[53]

As late as the mid-eighteenth century Diderot claimed that only children of poor families were allowed to become artists—'*nos plus grands artistes sont sortis des plus basses conditions*'. In German collective biographies of the eighteenth century, artists are still treated together with craftsmen and mechanics, although a distinction is made between the 'fine' and the 'mechanical' arts and the German writer Friedrich Nicolai counted milliners and pyrotechnists among the 'notable artists' in eighteenth century Vienna.[54]

In nineteenth century memoirs, one often encounters a tendency to regard art as a disreputable profession. Thus the German painter Walter Firle recalled: 'In 1879 my resolution to devote myself to the art of painting was still looked upon as a most extraordinary, almost preposterous idea';[55] and Sir Francis Oppenheimer writes that his father closed his house to him when he decided, in 1897, to exchange the English Bar for an artist's life in Paris.[56] But the nineteenth century bias towards artists was probably dictated by bourgeois opposition to bohemianism rather than by the older conviction of the social inferiority of the profession.

It is certainly true that in the Middle Ages lay artists, like other crafts-men, were recruited from the lower strata of society. This situation changed only very slowly. In spite of the new ideological course mapped out by artists from the early fifteenth century on, few self-respecting

citizens would then have chosen an artist's career. With some exceptions, such as Alberti, Brunelleschi and Leonardo, the latter two sons of highly esteemed notaries, it would not be easy to list fifteenth-century artists who came from upper-middle-class or noble families: the aristocracy, finance, commerce, and the Church equally disapproved of the profession. Even the artists in the most progressive centre, Florence, are no exception to the rule.[57] Uccello was the son of a barber, Castagno of a farmer; Fra Filippo Lippi's father was a butcher, Botticelli's a tanner, Fra Bartolomeo's a muleteer, Andrea del Sarto's a tailor, and the Pollaiuolo came from a family of poulterers. Moreover, as in the Middle Ages, boys frequently entered their parent's workshop, carrying on a family tradition of painting or sculpting which frequently extended over several generations. Five generations of the Ghiberti family were goldsmiths and sculptors; three generations of the Robbia family spanned a period of almost a hundred and fifty years.

As long as the profession was held in low esteem, writers were reluctant to concern themselves seriously with artists. Florence again led the way, beginning, before 1400, with Filippo Villani's *Lives of Famous Florentines*, and continuing with the mid-fifteenth century anonymous monographs on Alberti and Brunelleschi, the first of their kind; the collective biographies of artists by Antonio Billi, the Anonimo Magliabechiano and Giovanni Battista Gelli,[58] and, finally, the great work, which epitomises all these earlier efforts, Vasari's *Lives* of 1550, the corner-stone of art historical literature. Nevertheless, E. Zilsel[59] has calculated that the collective biographies of famous Italians, written in the fifteenth and the first half of the sixteenth century, included only 4·5 per cent artists as compared with 49 per cent writers, 30 per cent political and military heroes, 10 per cent dignitaries of the Church and 6·5 per cent physicians. These statistics can, of course, only be regarded as a pointer to the relative unimportance of artists within the cultural setting. It is also characteristic that artists usually appear in these works at the bottom of the social hierarchy. But the general Italian picture perhaps does not do justice to the public esteem artists gained in Florence after the mid-fifteenth century. In 1458 the diarist Landucci enumerated fourteen famous men then living, of whom no less than seven were artists.[60]

After the long interlude of the Middle Ages the fifteenth century biographical writings on artists revived a branch of literature which, as we have seen, had flourished in classical antiquity in a modest way. Even before the rise of the new biographical literature the fourteenth century had shown an anecdotal interest in the behaviour of artists. In Boccaccio's *Decamerone* and the Tuscan *novelle* artists appear mainly as the perpetrators of entertaining and burlesque practical jokes. For Boccaccio

a painter was a man full of fun, high-spirited, quite shrewd, of somewhat lax morals, and not burdened with too much learning. And in one of Franco Sacchetti's *novelle*, written in the late fourteenth century, one finds a painter's wife exclaiming: 'You painters are all whimsical and of ever-changing mood; you are constantly drunk and are not even ashamed of yourselves!'[61] This remarkable statement sounds like a prophetic definition of the bohemian, but it should not tempt us to arrive at too weighty a conclusion. It only shows that even the stringent organization of the guilds could not suppress certain frivolous character traits in artists, for these anecdotes would have been neither invented nor read if they had not echoed a popular reaction to artists. The majority of the stories told in the Tuscan *novelle* are in a class similar to the anecdotal *topoi* in ancient literature on artists. Although the *novelle* had some influence on later art historical literature—even Vasari still incorporated a number of them in his *Lives*—there is no basic link between the earlier entertaining writings and the later instructive historical studies; nor is there any basic link between the two *genres* in their conception of the typical artist. In the fifteenth and sixteenth centuries the image of the artist loses its jolly and light-hearted connotations.

For all we know the artists of the Middle Ages were silent about themselves, except for the self-laudatory inscriptions to which we have referred. No document has come down to us indicating that they were dissatisfied with being ranked on a level with embroiderers, locksmiths and watchmakers. Medieval artists' manuals and medieval aesthetics both suggest that, like tailors, weavers and other craftsmen, artists found fulfilment in the technical perfection of their work.[62]

3 The New Ideal of the Artist

But the day came when artists began to revolt against the hierarchical order of which they were an integral part—a day when they regarded the organization meant to protect their interests as prison rather than shelter. It was in Florence that the new ideology, irreconcilable with the established order, first arose. The artists themselves began to propagate it at the precise moment when Brunelleschi asserted his freedom in the face of the guild laws. Some time before 1437 the painter Cennino Cennini wrote his *Book on Art* which in many ways still has the practical and technical character of the medieval manuals. Yet he also visualized the new type of artist about whose behaviour he talks as follows:

Your life should always be regulated as if you were studying theology, philosophy or other sciences, that is: eat and drink temperately at least twice a day, consuming light yet sustaining food and light wines.

There is one more rule which, if followed, can render your hand so light that it will float, even fly like a leaf in the wind, and that is: not to enjoy too much the company of women.[63]

To our knowledge, this is the first exhortation in writing by an artist to his fellow-painters to emulate a scholar's dignity and temperance. Only slightly later Lorenzo Ghiberti (d. 1455), painter, sculptor and architect, composed his monumental treatise on art and artists which includes the first autobiography known to have been written by an artist. This fact in itself is of the utmost importance, for an autobiography means looking at one's own life as an observer, seeing it in history and as a part of history; it needs the distance of self-reflection, and introspection became an important character trait of the new race of artists. Towards the end of his autobiography Ghiberti states with obvious pride: 'Few are the things of importance created in our country that have not been designed and carried out by my own hand.'[64] If it is permissible to interpret this sentence to mean that Ghiberti laid stress on the fact that he not merely carried out directives but 'designed', that is, invented 'things of importance' himself, then his words, together with Cennini's ideal of a scholarly mode of life, express succinctly what was happening: a new type of artist was arising, an artist essentially different from the artisan of old in that he was conscious of his intellectual and creative powers.

But the *locus classicus* for this new ideal is Leon Battista Alberti's short treatise *On Painting*, written in 1436.[65] When the young scholar and writer visited Florence in 1434 he was delighted to find there 'unheard of and never before seen arts'. Brunelleschi, Donatello, Luca della Robbia and Ghiberti were at the height of their careers, while Masaccio had died a few years before in the prime of life. Inspired by responsive artists and understanding patrons Alberti wrote and circulated his treatise. To him painting, the highest among the arts, 'contains a divine force'. It is 'the best and most ancient ornament of things, worthy of free men, pleasing to the learned and unlearned'. He considers 'a great appreciation of painting to be the best indication of a most perfect mind', and advises that 'the first great care of one who seeks to obtain eminence in painting is to acquire the fame and renown of the ancients', a goal which can only be reached by devoting all one's time and thought to study. Besides acquiring the necessary technical skill the 'modern artist' should master geometry, optics and perspective and know the rules of composition; he must be conversant with the mechanism of the human body for 'the movements of the soul' are shown by 'the movements of the body'. But the highest achievement, good *inventio*, will be his only if he makes himself 'familiar with poets, rhetoricians and others equally well learned in letters'. Alberti also points out that polite manners and easy bearing will do more to earn goodwill and hard cash than mere skill and industry.

It is clear that it no longer sufficed to be an excellent craftsman. The new artist had to be an '*huomo buono et docto in buone lettere*'—a man of good character and great learning. The Renaissance artist had entered the European scene. The time had come for painting, sculpture and architecture to be admitted to the cycle of the liberal arts. In order to raise the visual arts from the level of the mechanical to that of the liberal arts they had to be given a firm theoretical foundation and the first and most important step in this direction was taken by Alberti. By the admission of the visual arts into the circle of the liberal arts, for which artists of the fifteenth and sixteenth centuries pleaded in word and picture, the artist rose from a manual to an intellectual worker.[66] His profession now ranked equal with poetry and the theoretical sciences. To the emancipated artist the old guilds of craftsmen were an anachronistic survival.

The process of liberation was fostered by a complete misinterpretation of the position of artists in antiquity.[67] Alberti adduced the high social standing of ancient painters to lend prestige to their modern successors; towards the end of the fifteenth century, Filarete recorded that painting, in his day still regarded as a disgrace, was practised even by the Roman emperors, and Giovanni Santi, Raphael's father, was not the first to maintain that the Greeks did not allow slaves to study painting. Michelangelo too laboured under the misapprehension, if his biographer Condivi is correct, that the ancients did not admit plebeians to the practice of art.[68]

In *On Painting* Alberti propounded his ideal of the well-adjusted and socially integrated artists which was upheld in academic circles through the ages.[69] But the liberation from the protective bond of the guild also led to the emergence of a different type of artist—one who refused to accept conventions, who belonged, in the eyes of the public, to a class of his own and eventually developed into what is now generally called the Bohemian. These two types of artists, the conforming and the non-conforming, will demand our attention in the following chapters.

CHAPTER II

ARTISTS AND PATRONS: REMARKS ON A
CHANGING RELATIONSHIP

LIKE other wares, art is dependent on producers and consumers. The fate of the artist, and not only his physical existence, is closely inter-woven with the response of the patron. No easy formula can resolve this complex relationship. But an historical assertion can be made with reasonable certainty: as long as the guilds served as the intermediary between artist and patron the problems which could arise were of a nature essentially different from those after the artist's emancipation. The position of the controlled craftsman-artist in medieval society was perhaps not unlike that assigned by Plato to artists and craftsmen in his ideal state. When the medieval system broke down the way was opened to conflicts which Plato regarded as harmful to the moral well-being and discipline of an integrated society. Whether or not one is inclined to accept Plato's negative conclusions, the artist was thereafter able to negotiate with the patron from a position of strength. Some aspects of this changing relationship, particularly at the critical period of tran-sition, will be surveyed in the following pages. As an introduction, it may be helpful to recall how artists made their living in the four or five centuries before the French Revolution.

1 *Financial Resources and Professional Practices*

A master who wished to work on his own had two ways open to him: he could become the head of a workshop, often inherited from a parent, or he could enter the service of a patron. The latter practice grew in importance as the number of small courts and the love of splendour increased first and foremost in Italy and later also in Germany, Austria, France and England. In Spain this form of patronage remained mostly restricted to the Madrid court, while the Netherlands with their society of burghers hardly knew it at all. A court painter usually became a member of the household. Apart from receiving a fixed salary he was provided with living quarters, a certain measure of food, wine, and other necessities and could reckon with substantial presents in the form of money or valuables after having finished a major work. He had to paint or sculpt whatever his patron wished and was expected to

design theatre and festival decorations as well as any occasional work that was desired. He was not allowed to accept work for other clients without the express permission of his employer. Court artists enjoyed not only economic security but also special privileges such as exemption from membership in the guilds. As late as 1646 the envious masters of the guild requested the French *Parlement* to limit the number of '*Brevetaires*' to four for the King and an equal number for the Queen.[1] In England the office of court painter was held for a hundred years by eminent foreigners. Van Dyck, King Charles I's court-painter, was succeeded by Peter Lely and Godfrey Kneller. The knighthoods bestowed on these gentlemen-painters show that they were separated by a social gulf from their less fortunate colleagues organized in the Painter-Stainers' Company. But court artists remained the servants of their masters, however elevated their position at court may have been.

Like the office of court artist, the keeping of a workshop was rooted in the medieval tradition and lived on for many centuries. Such establishments varied from small organizations with one or two apprentices to very large ones employing ten times that number and more. After 1407 Ghiberti had twenty-one assistants[2] for his first bronze door of the Florentine Baptistery and a similarly large number may have been used by Donatello in Padua.[3] Riemenschneider's workshop with several journeymen and thirteen apprentices seems to have been exceptional for Germany in about 1500.[4] The largest workshop ever run by a sculptor was Bernini's; its size grew with the increasing scope of the works executed by him for the Church.[5] At times he needed dozens of artists and craftsmen to carry out his designs. Since normally the head of a workshop was the employer of his assistants, such organizations smacked of trade; in the case of Bernini, however, the papal chancery paid the salaries of his studio hands and the artist remained untouched by the odium of commercialism.

Famous masters did not have to rely solely upon commissioned work for their income. They were frequently honoured, and their earnings considerably supplemented, by salaried public and clerical offices or by regular grants. To name a few from among many: Giovanni Bellini, Titian, and others after them received a yearly stipend paid out of the income from the *Fondaco de' Tedeschi* in Venice, with the one obligation to paint a portrait of the reigning Doge; Fra Sebastiano del Piombo and Guglielmo della Porta were appointed to the office of Keeper of the Papal Seal which carried a good salary; and Dürer was granted a *privilegium* by the Emperor Maximilian which entitled him to a yearly rent drawn from the Nuremberg Tax Office. Particularly in vogue in sixteenth century Italy, this kind of patronage, which made public

funds available to artists, was also extended to poets and scholars whose sinecure was often their only stable income.

Heads of workshops who operated like 'free-lance' artists used slack periods to build up their stock. Such tradesmen's practices were, of course, very far from the minds of the great. A Raphael, a Titian or a Rubens may have indulged in all sorts of financial speculation, but, as artists, they only executed commissioned work. It was the tradesmen-artists who injured the reputation of the whole profession. In the four-teenth century it was customary for painters to keep half-finished pictures in their shops, often prepared by apprentices, and give them the final touches according to the client's wishes.[6] Franco Sacchetti (c. 1335–c. 1400) described in his eighty-fourth *novella* the workshop of a Sienese artist 'who was mainly a painter of Crucifixes of which he always had several in the house, finished and unfinished ones, sometimes four or even six'.[7] The turning out of almost identical products was the craftsman's practice.

German artists of the time offered their 'wares' not only in their shops but also in the streets and at church doors,[8] and the sale of pictures at fairs remained customary for a long time in many countries (Fig. 2). The seventeenth century Northern painters of popular subjects in Rome, the *bamboccianti*, used every possible device to sell their works.[9] Even in the eighteenth century we still find studios, like that of the Guardi family in Venice, well-stocked with paintings and run on much the same lines as a jeweller's or any other craftsman's shop of today. Sculptors, too, worked on speculation. The custom takes us far back in time. At York, a master-mason, who died as early as 1322, dealt in tombstones.[10] The English sculptor Nicholas Hill is known to have sued his agent in 1491 for the proceeds from a sale of fifty-nine heads of St John the Baptist; in all likelihood these heads were made for sale to a standard pattern.[11] There is little difference between such an 'artist' and a stone-mason who laid in a supply of the most popular types of mouldings.[12]

Nicholas Hill used a middleman for the sale of his works, but the specialized art dealer was hardly known before the sixteenth century. He became necessary as a consequence of the increased demand for movable objects such as easel paintings and bronzes; in the last analysis, however, his emergence was the result of radical changes in the profession. Throughout most of the fifteenth century money-lenders and general merchants, who would occasionally serve as agents, still treated art like other commodities.[13] An early example was Francesco di Marco Datini, a native of Prato, whose business kept him for several years at Avignon. Among a rich choice of merchandise, Datini also traded in religious pictures. An order sent on July 10, 1373 to Niccolò

and Lodovico del Bono, merchants in Florence, gives a good idea of what he required. Datini asked for 'a panel of Our Lady ... with many figures. Let there be in the centre Our Lord on the Cross, or Our Lady, whomsoever you find—I care not. Also a panel of Our Lady ... a little smaller. These two panels must contain good figures: I need them for men who would have them fine.'[14] The firm catered mostly for customers who wanted cheap paintings. One of Datini's partners wrote to Florence in 1387: 'If you find no good things at a fair cost, leave them, for there is no great demand ... they should be bought when the master who makes them is in need.'[15]

In the Florentine nobleman Giovanni Battista della Palla we encounter what is perhaps the first international art dealer.[16] From the late fifteen-twenties on, he exported first-rate Italian works to France and thus initiated a trade which took on ever-growing proportions in the following centuries. This development was only possible at a time when works of art were valued as the individual creations of great masters, when names were bought and high prices were involved. Without an awareness that artists were in a category of their own, wholly divorced from the traditional crafts, the new type of art dealer could not have arisen. On the other hand, once firmly established, the dealer became a 'third force' between artist and patron. A direct relationship exists between the increase of his, and the neutralization of the patron's, influence, and he thus played a part in driving the artist into isolation. With the sole exception of seventeenth century Holland, however, the full weight of this development was not felt until more recent times. Nonetheless, the situation there remained somewhat contradictory, for in Holland the artists were neither as free nor the dealers as discriminating as their Italian colleagues.

Unlike their counterparts in the South, Dutch artists rarely had a chance of large-scale, public commissions and hardly any possibility of salaried employment. Consequently the art market was flooded with small easel paintings, prices were mostly ridiculously low, competition was fierce, and artists therefore resorted to all kinds of devices to sell their works or supplement their earnings.[17] They offered their products in fairs and street markets or had them paddled around by hawkers; they raffled them in lotteries or put them up for auction. Above all, they entered into contracts with picture dealers, often on disastrous terms. To mention only one such case: according to Roger de Piles, the distinguished portrait painter Gaspar Netscher 'worked for a long time for dealers who, exploiting his ease in producing, paid him very little for his pictures and sold them at very high prices'.[18] The guilds, which were still operating, did what they could to alleviate the situation by organizing and legalizing art sales and auctions and by severely restricting

foreign competition, but to little avail. They were utterly unable to establish a sound balance between supply and demand.

Many artists sought salvation in a second job, not only in picture dealing, like Rembrandt and Vermeer, but in occupations entirely at variance with their calling. Jan van Goyen dealt in real estate and tulips; Aert van der Neer owned an inn in Amsterdam, Jan Steen a brewery in Delft and an inn in Leyden; Jan van de Cappelle carried on his father's dyeing business; Jacob Ruisdael was a barber-surgeon and Joost van Craebeeck a baker; Philips Koninck owned a canal-shipping company and Hobbema held an appointment as a gauger of imported wine.[19]

It was not at all peculiar to Dutch artists to have a money-making job apart from their true profession. Growing competition forced late medieval German artists into a similar division of loyalty.[20] On occasion the guilds even thought it necessary to take measures to prevent painters from having a second occupation.

Italian and French gentlemen-artists of the seventeenth century would have regarded it as degrading to supplement their earnings by getting mixed up with trade. Nonetheless, dealing in works of art, ancient and modern, was a common practice particularly in Rome, where so many artists had to scrape together a living and where ancient works, thrown up by the soil in a steady stream, promised easy rewards. Often they eked out an existence by working hand in glove with dealers such as the notorious Englishman Jenkins about whose shady transactions more will be said in another place.[21] Sometimes even great artists could not resist the temptation to try their luck in occasional art deals. When he was a young man in Rome, Reynolds purchased Bernini's *Neptune and Triton* on speculation; but he was never able to sell it in London. The group—now one of the treasures of the Victoria and Albert Museum—remained a part of his estate.[22]

Double professions are forced upon artists whenever the supply greatly exceeds the demand. This may happen either when the market is saturated with works of art or where it has not yet been sufficiently opened up. Thus early American artists often combined several professions.[23] James Claypoole had a bookshop in Philadelphia and Benjamin West's first teacher, William Williams, who settled down in Pennsylvania about 1750, earned his living with any kind of work that came his way; he was in turn music teacher, stucco worker, architect and landscape gardener. Others, just like Dutch artists of the seventeenth and eighteenth centuries (Fig. 3), had to revert to 'low-class' jobs such as painting fire buckets, signs, clock-faces, and chests—jobs which Italian artists in the course of their struggle for recognition had scorned three hundred years earlier.

It is certainly correct to say that the importance of the art dealer

in seventeenth century Holland presaged the modern development. Direct communication between the artist and his patron was to a large extent interrupted and for the first time in history many artists continually produced in a vacuum. Although there lies a whole world between the guild-controlled and the dealer-controlled artist, the majority of artists had by no means climbed as high on the social ladder as optimistic theorists of the fifteenth century had expected they would. It was owing to the discrepancy between the actual and the hoped-for conditions that large numbers of the public continued to hold the profession in low esteem.

2 Old and New Ways of Evaluating Works of Art

This assessment of artists cannot be dissociated from the mode of financial compensation. The fact that artists earned money by manual labour put them at the bottom of the social hierarchy in antiquity.[24] It might be argued that something of a similar stigma marked artists in later periods as long as they, like craftsmen or journeymen, received daily or weekly wages or as long as their earnings depended on extraneous matters such as the amount of gold and azure used, the number of figures represented, the size of the work, and the time spent on it. By and large, the medieval artist was a wage-earner. In thirteenth century England a skilled mason was paid about threepence a day[25] and, like this simple craftsman, a great architect such as Henry de Yevele (c. 1320–1400) received a daily wage.[26] An extraordinarily thorough investigation of the church of St Victor at Xanten has shown that the daily wages of the architects did not change very considerably between 1374 and 1519.[27]

When people began to take cognizance of the difference between craftsmen and artists the old terms of regulating payments slowly broke down. There are clear indications to this effect in fifteenth century Florence.[28] Yet even there much of the older system of fixing and regulating prices lived on. Filippo Lippi, for instance, received six times as much money for the Crowning of the Virgin (1441–47, Uffizi) than for his Barbadori altarpiece in S. Spirito (now in the Louvre), painted some years earlier, no doubt because the later picture, although not much larger, contains about five times as many figures. Not even in the succeeding centuries was the traditional policy entirely abandoned of paying artists according to the rules governing trades and crafts. Strangely enough, it was still customary in seventeenth century Holland to fix the price of a picture by calculating the number of working days it took to paint it; the daily wage fluctuated between five and ten escalins.[29]

Instead of receiving cash, artists would often exchange their own

products for other goods. There was nothing degrading in this method of barter, as Dr Antal seems to imply when he says in his book on *Florentine Painting and its Social Background* that 'the fees paid to the artists were in general low; often, especially in the case of monastic commissions, the payment was even made in kind'.[30] In actual fact payments in kind do not reveal the exploitation of poor craftsmen by shrewd clerics; such payments were an integral part of the wage system until the early eighteenth century. The account book kept by the once famous Bolognese painter Marcantonio Franceschini (1648–1729) from 1684 until shortly before his death allows us to see the practice in operation at a late date.[31] On one occasion, for instance, he received for a small painting two silver candlesticks, three bronze *putti* and other goods, the whole valued at 200 lire. In 1704 he 'presented' a painting on copper to a Genoese who returned the courtesy with a box of chocolates which Franceschini immediately sold for 75 lire. These and other payments in kind, such as linen, silverware, furniture, jewels, silk stockings and candied fruit, he entered into his book exactly as he did his cash earnings. Franceschini was reputed to have earned some 250,000 lire in his working life and was considered a very rich man.

Barter was not only a method of payment entirely acceptable to the gentleman-artist—it was even profitable on occasion as Franceschini's case shows—but, in the form of 'presents', it became the customary reward for artistic genius. In other words, by the seventeenth century such partial payments in kind were a sign of special appreciation accorded by grateful or rival patrons to artists of distinction.

Even before the end of the fifteenth century emancipated Italian artists contested the traditional wage pattern. Art, they maintained, cannot be paid by the standards of ordinary wares. This conviction is now so firmly established that no disagreement is possible. But it needed time and patience to carry the point with patrons and public. When the subject was first raised, the argumentation was somewhat ambiguous. At the beginning of the fifteenth century Cennini said in his manual for artists: 'There are some who follow the arts from poverty and necessity . . .; but those who pursue them from love of the art and noble-mindedness are to be commended above all others.'[32] Cennini may here have referred to the ethics of medieval workshop practice;[33] yet by differentiating between those who work to live and the others who live to work as devotees of their noble profession, he only repeated an idea that had become a well-established *topos*. Before Cennini, Filippo Villani in his *Lives of Famous Florentines* described Giotto, incorrectly, as a man who was interested in fame rather than wealth.[34] 'This ideology of self-illusion, initiated by Petrarch and derived from antiquity'[35] was taken up

by Ghiberti as well as Alberti. 'Greed', the latter informs his readers, 'is the enemy of artistic eminence.'[36] Again one surmises that he had in mind mainly those who regarded art as a trade rather than a calling. Alberti further asserts that the artist's primary concern should be to acquire the renown and fame of the ancients. Similarly Leonardo affirms that 'much greater glory results from the virtue of mortals than from their treasures'.[37]

But during the *Quattrocento* one rarely hears suggestions as to how the established wage pattern could be changed; yet the question was being discussed among artists. A reflection of such discussions is to be found as early as the middle of the fifteenth century in the following passage from the pen of Archbishop St Antonino of Florence (1389–1459): 'Painters claim, more or less reasonably, to be paid for their art not only according to the amount of work involved, but rather according to the degree of their application and experience.'[38] The Archbishop seemed not too convinced of the justice of the artists' demand and it is clear that he still looked upon art as a trade.[39] It was not until well into the sixteenth century that artists stated with vigour that the compensation for a work of art depended on the ingenuity and not on the length of time that had gone into its making.[40] This 'discovery' could never again be lost and, willingly or unwillingly, patrons had to take note of it. Once the traditional standards for fixing the price of a work of art had been rejected, the door was open to a somewhat irrational price policy. Michelangelo's *Leda*, painted for Duke Alfonso I d'Este of Ferrara, is a revealing example not only of the uncertainty which the patron faced, but also of the financial possibilities which opened up for artists. On October 22, 1530, the Duke wrote to the master that, as regards payment, he would not make any suggestion of his own, but would bow entirely to Michelangelo's assessment of the value of the work.[41]

The medieval concept of the 'just price' made the artist economically dependent on the patron (be it the Church, the commune or the guild), since the patron had the power to fix wages. As far as great artists of the sixteenth and seventeenth centuries were concerned, the *volte-face* was complete, for the patron had now no choice but to accept the price quoted by the artist. The experience of the collector Sir Dudley Carleton is typical. In a letter of November 25, 1620, addressed to him by his agent Toby Matthew, the latter says about his negotiations with Rubens: 'I did with all the discretion I had, deal with him [Rubens] about the price, but his demands are like the laws of Medes and Persians which may not be altered . . . the cruel courteous painter would not set a less price upon it than before.'[42]

The time had come when great artists could ask and would receive star fees and were capable of amassing wealth undreamed of by four-

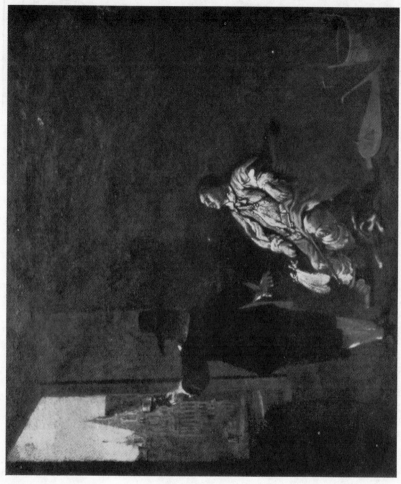

3. Aelbert Cuyp (1620–91),
Shop-Sign for a Wine
Merchant. Rijksmuseum,
Amsterdam. Artists often had
to do hack work in order to
supplement their earnings.
Little of this survives. The fine
quality of Cuyp's shop-sign
shows how seriously such
commissions were taken.

4. This Broadsheet of 1525 gives a remarkable list of castles and monasteries plundered and burnt in the Black Forest and in Franconia by the rebellious peasants before April 1525. Yet many artists sided with the iconoclasts.

5. Albrecht Dürer, Monument glorifying the Victory over the Peasants. Woodcut from *Unterweisung der Messung*, 1525. The monument, constructed of peasants' implements, is crowned by the figure of a peasant, pierced by a sword. The last minute addition of this book and the accompanying text indicate that Dürer rejoiced in the defeat of the peasants.

teenth and fifteenth century masters—the most tangible sign that the image of the artist had undergone a radical change, at least in the eyes of an élite.

3 Religious Convictions and Vicissitudes of Patronage

As long as the guilds were powerful and looked after the rights and obligations of artist and patron alike, both sides submitted to a corporate body. Although the patron as the socially and economically stronger party was favoured, one can talk of an integrated relationship. When this broke down, it was individuals who had to come to terms with each other. Artists as well as patrons had to manoeuvre for new positions. But other factors outside the control of either also appeared on the historical scene. The primary patron of the medieval artist had been the Church and, after the Church, royalty and the nobility. From the twelfth century on, the municipalities, communes, and guilds gathered strength, and communal tasks such as town- and council-houses, assembly rooms and guildhalls absorbed architects, sculptors and painters in large numbers. In addition, a characteristic civic culture arose with the growth of the towns; in time, the wealthy city-dweller became a potential, and eventually a powerful, patron of the arts.

While from the early fifteenth century onwards, these new patrons assumed ever-increasing importance, the problems which began to beset the Church and finally led to the break in its unity deprived many artists north of the Alps of their greatest and steadiest employer. Moreover, the artists themselves were faced with personal decisions on which their work, their future, and even their lives sometimes depended. If not in theory, in practice the gulf dividing artists from craftsmen suddenly opened with unexpected forcefulness, for a saddler or a shoemaker might be as passionately involved in the religious controversy of the day as a painter or a sculptor, but neither saddles nor shoes would conflict with the faith of their maker, while religious imagery could, and in fact often did. Where artists might be deprived of their *raison d'être* by their own conscience, craftsmen would be threatened in their economic existence by the zealotry of others. Their dilemma is illustrated by the following letter of a painter of playing cards.

In 1452 the sermons of the monk Capistranus had made such an impression on the burghers of Nuremberg that they threw all the 'devilish trifles' on to huge bonfires: sledges and gaming boards, modish clothes and dice. But the greatest abomination was playing cards and one Michel Winterperg, whose trade it was to colour them, saw himself put out of his job. Since nobody was allowed to move from his place of residence without permission, Winterperg addressed the following petition to the town councillors:

When the pious Father and other priests preached here in this town that I could not save my soul before God with my trade, which is the painting of playing cards, I gave it up entirely. But I know no other trade by which I can bring up my children here, and I beg your Honours most humbly that you will graciously grant me leave to go to Feucht [a place near Nuremberg] and there to live, and at the same time allow me to retain my civil rights here; I shall gladly continue to pay my taxes here as if I were still a resident and, I trust, your Honours will not refuse my request . . .[43]

Winterperg's logic was admirable; what was sinful in Nuremberg was permissible before God in Feucht.

Such a happy solution did not offer itself to the great artists of the Reformation period. Of the reformers only Calvin expressed strictly iconoclastic views. Neither Luther nor Zwingli were opposed to works of art as long as they were not worshipped. Thus the old question flared up again whether a religious work is a symbol or an idol.[44] Dürer took a firm stand in this matter. He wrote in the dedication of his *Unterweisung der Messung mit dem Zirkel und Richtscheit*, published in 1525, that young painters

. . . should not only be fired with love for art, but should also arrive at a truer and better understanding of it, undisturbed by the fact that with us and in our time the art of painting is much maligned and is said to serve idolatry. For a Christian will not be led to superstition by means of a picture or a portrait any more than an honest man will commit murder because he carries a weapon on him. That would indeed be an unreasonable man who would worship paintings, wood or stone! A picture causes more good than annoyance if it is made decently, competently, and well.[45]

Dürer attacked here the opinions and actions of such 'left-wing' reformatory dissenters as Luther's erstwhile supporter Carlstadt and with a clean conscience reserved for himself the right to paint religious pictures just as Lucas Cranach and other stout Lutherans did. That Dürer was in sympathy with most of Luther's teachings can no longer be doubted.[46] It speaks from his letters, from his diary entries during his Netherlandish journey and from many other documents. His friend Pirckheimer, who was soon disillusioned, remarked in a letter written after the painter's death:

I confess that I too was at first a good Lutheran like our late Albrecht Dürer, because we hoped that Roman villainy and the knavish tricks of monks and priests would be improved, but it appears that things have gone from bad to worse, so much so that the Protestant rogues make the others look pious.[47]

Like Luther, Dürer was repulsed by radical trends and felt moved to express his convictions in the monumental *Four Apostles* (Munich)—a

picture donated by him to the city council of Nuremberg as a solemn warning against the leftist heretics as much as against the Papists.[48]

The conservative Dürer had nothing to fear. But many other artists who sided with the radical reformers had to pay dearly for their convictions. When the long-smouldering discontent of the German peasantry exploded into the revolt of 1524, sweeping all before it, large sections of the town population sympathized with the rebels who, it has been said, anticipated most of the ideas of the French Revolution. But their aims were not only social and political; they were also obsessed by evangelical utopias of Christian love and divine justice—ideals which were kindled by the contrast between their own abject poverty and the wealth of the clerics, merchants, and princes. Luther, at first not disinclined to support the peasants, later lent his immense prestige to the cause of the traditional powers of the princes, and in his pamphlet *Against the Present Brigands and Murderers* (1525) demanded a bloody suppression of the rebellion. After the failure of the movement Dürer gave vent to his feelings in his scathing design for a monument to the defeated peasants which he published in 1525 in the third book of his *Unterweisung der Messung* (Fig. 5).

The leaders of the ill-fated revolt were puritanical in the extreme; as early as 1521 Carlstadt wanted to have all pictures removed from the churches. At this stage Luther agreed if such actions were sanctioned by the authorities.[49] But later he protested when, in 1522, the destruction of works of art was seriously undertaken, although he never pleaded for their preservation on the grounds of their edifying or educational value. Considering such tendencies it is the more remarkable that many artists sided not only with Luther, but with the rebellion, for they must have known that its victory would deprive them forever of their most important patron, the Church (Fig. 4).

The utter incongruity of their position may be gathered from the diary of Georg Breu the Elder (1480–1537): in spite of his large workshop at Augsburg in which he had produced many religious pictures, he still described the wholesale destruction of works of art in his native city with a great deal of satisfaction.

January 18. On that afternoon the magistrate, together with others of the council and also carpenters, bricklayers, and smiths who were needed for the work, went to the Church of Our Lady, closed the doors, and on that day smashed and broke altars, statues, paintings, and all images which had served idolatry. In the evening they started at St Ulrich to tear down, smash, and break everything in the rectory as well as the church.
January 22. The magistrate, together with his followers, broke the idols and paintings in the church of the Holy Cross.
January 24. The paintings and altars at St Maurice were broken and

smashed, and likewise at St George. [The clerics] raised great lamentation against the people of Augsburg [saying] they had suffered violence. Oh, that they were not driven out many years ago—those blessed fathers![50]

Terrible indeed was the fate of some artists who took an active part in the uprising. Among those who were involved in the cause of the peasants was the great Tilman Riemenschneider, an honoured citizen of Würzburg, who had held municipal offices since 1504 and was elected mayor for the year 1520–21.[51] After the revolt had been stamped out he was thrown into prison and tortured. He had another six years to live (d. 1531), but the experience had broken his spirit. No great work came from his workshop after his release.

Jerg Ratgeb, a painter of the same generation, was even more unfortunate.[52] Though descended from serfs and married to a serf, he was a respected citizen; but his past predetermined his support of those who intended to abolish serfdom. When the rebels took Stuttgart he was elected a member of the town council and served as a councillor of war to the peasants. Ratgeb was taken prisoner in battle and was publicly quartered in the market-place of Pforzheim.

Rebellious artists fared better in the city of Nuremberg. There the writings of Carlstadt and Thomas Münzer, the most vigorous peasant leader, had found a large public in spite of the vigilance of the city fathers. When, early in 1525, Dürer's young painter colleagues, Georg Pencz and the brothers Bartel and Sebald Beham, were summoned before a court, they left no doubt that they were steeped in illegal, revolutionary literature and that they stood by their convictions.[53] In their sentence it was declared that they were 'godless unbelievers' and that the city must be protected from having this malignant poison spread. In addition they were to be punished for having refused to acknowledge the established civic authority. They were condemned to a term in prison, but soon released and exiled from Nuremberg. It was not long, however, before they were pardoned and allowed to return.

Not all cases are equally well documented. But whatever their exact position, the careers of two painters, Hans Herbst (1468–1550) and Matthias Grünewald, were ruined by the Reformation. Herbst, now hardly known except to specialists, was an artist of good standing in his time.[54] A member of a well-to-do family from Strasbourg, he was admitted in 1492 to the painters' guild of Basel, the town in which he spent the rest of his life. In February 1529 the Reformation carried the town, though not without opposition. Erasmus left Basel. Herbst, one of the superiors of his guild, railed against the new order, was thrown into prison and released only after a public recantation. His grandson, the learned Theodor Zwinger, later reported that Herbst's conversion to Protestantism was entirely sincere—so much so that he no longer

'cherished his idolatrous art and decided wholly to abstain from painting'.[55] It is likely that Herbst really underwent a change of heart and never painted again. No picture by his hand seems to have come down to us, not even from his Catholic period.

The attitude of one of Germany's greatest artists, Matthias Grünewald, is also open to conjecture. In contrast with the communicative Dürer, not a word from his pen has come down to us. Painstaking scholarship has established[56] that he was born at Würzburg between 1465 and 1480, that his real name was Mathis Neithardt, that he lived at Seligenstadt, a small town near Aschaffenburg, from 1510 to 1525 and that he was court painter to two consecutive Archbishops of Mainz, who had their residence in Aschaffenburg. The first was Ulrich von Gemmingen, the second, from 1514 on, Albrecht von Brandenburg, a generous Maecenas of the arts and a powerful prince of the Church who, at the age of twenty-four, united the bishoprics of Magdeburg, Halberstadt and Mainz. Albrecht sympathized with Luther's ideas and, indeed, around 1520 the whole diocese of Mainz came close to joining the Reformation. On May 7, 1525, during Albrecht's absence in Magdeburg, the chapter of Mainz Cathedral capitulated to the rebels,[57] but the triumph of the victorious peasants was brief. The revenge of the returning Catholics took a most violent form. Albrecht changed from a friend into an implacable foe of the Reformation. All sympathizers lost their positions at court, among them Grünewald. In 1526, he went or possibly fled to the free imperial city of Frankfurt which had become a haven for the persecuted.

A year later Albrecht sent a threatening letter to Frankfurt requesting the surrender of the participants in the rebellion of 1525. Grünewald moved on, first, perhaps, to Magdeburg and then to Halle. All property that was not easily movable he had left behind at Seligenstadt. In Frankfurt he tried to manufacture and sell medicinal soap and in Halle he took employment as a water-works engineer. He died there at the end of August 1528. An inventory of his belongings stored in Frankfurt shows that he had a good deal of Lutheran literature in his baggage, but also two rosaries, and this has moved some scholars to believe that he never broke with the old Faith. Grünewald's Protestant attachment, however, can no longer be doubted. Yet we are faced with a perplexing question: did Grünewald fail to find patrons in Frankfurt and Halle or had he, like Herbst, become an iconoclast? We do not know. He and his work had soon 'sunk so much into oblivion' that Sandrart, a great admirer of his drawings and paintings, could find 'no living man who was able to provide an oral or written account of his activities'.[58]

Whether self-imposed or forced upon him, Grünewald's dilemma was that of German art as a whole. Jacob Burckhardt's assessment is still

valid: 'with the fall of Catholicism painters and sculptors had lost nine-tenths of their occupation', and, moreover, a feeling of depression and constraint changed patron and artist alike.[59] It is an irony that the self-liberation, self-determination and self-sacrifice of artists resulting from the religious strife was rewarded by an inexorable decline. Where the Reformation was victorious, church patronage all but ceased to exist.

During the formative years of the Reformation the situation was often fluid. Artists with Protestant leanings would work for clients of all religious shades and patrons were equally broad-minded in their choice of artists. Holbein is a case in point. Though inclined early towards the Lutheran cause, he continued to work for Catholic patrons. Even after he had embraced Protestantism openly in 1530, he returned to London in 1531 as court painter to King Henry VIII, Luther's avowed enemy. But later the religious issue became crucial even in the handing out of civic and private commissions. Catholic artists found it difficult to obtain work from Protestant patrons and vice versa. Bigotry destroyed many an artist's life. It was not often that an artist put down his reactions on paper, but one such case can here be reported.

The Protestant architect Elias Holl (1573–1646), whose father, grand-father and great-grandfather had been builders and master masons in Augsburg before him, began a diary in 1620, after he had finished his masterpiece, the town hall in his native city. He eloquently describes how he was tossed about by changing religious conditions at home and finally almost reduced to mental breakdown. In 1629 an edict of the Emperor Ferdinand II threatened all civil servants with dismissal unless they reverted to the Catholic faith. Holl refused to comply. Shortly after, the blow fell. He confided to his diary:

In this year 1630, I, Elias Holl, who has with the help of God been appointed master-builder of Augsburg these thirty years, have been relieved of my position by my superiors, and that only because I was not willing to go to the popish churches, to deny my true religion, and to 'accomodate' myself as they call it.[60]

Elias wanted to leave Augsburg and try his luck elsewhere. But he was not allowed to withdraw more than one-sixth of his life's savings. Since he had to feed eight of his surviving twelve children, he was forced to stay and to accept work as a bricklayer. When Gustavus Adolphus of Sweden conquered Bavaria in the beginning of 1632, all Protestants were reinstated in their former jobs. Holl, then fifty-nine years old and weighed down by cares, rejoiced in this change of fortune, though it brought him little relief. He wrote in his diary: 'Apart from building work, the Swedish engineer drove me so hard to do all sorts of difficult fortifications that I almost had no rest either day or night.'[61]

The summer had scarcely passed when Gustavus Adolphus lost Bavaria again. Augsburg, which had suffered a siege by imperial troops, was ravaged as much by famine and an outbreak of the plague as by the effects of military occupation. In 1635 Holl noted that Augsburg was once again Catholic and complained that the burden of

... billeted soldiers and taxes was such that a stone would be moved to feel pity. I have lost all my food and other reserves—may God yet give happiness to me and my people and also to all my other dear friends in Christ who have equally suffered much wordly damage and loss; if it be not here in this life, may He grant it in that other world of eternal joy and yearned-for bliss. Amen.[62]

To side with neither religious party could be equally dangerous. Inigo Jones, apparently a convinced free-thinker, was, it is true, such a favourite at the court of Charles I that his position was never actually threatened so long as the King kept his throne. But there is no saying what would have happened to him if the Catholic party had been more powerful. In a letter of September 17, 1636, addressed to the *Propaganda Fide* in Rome, Jean-Marie Trélon, the Superior of Queen Henrietta Maria's Capuchins, maintained that the Queen's Chapel at Somerset House 'was finished not without great difficulties; the architect [Inigo Jones], who is one of those Puritans, or rather people without religion, worked unwillingly . . .'[63] The Father Superior, in his suspicion against the 'Puritan' Jones, went so far as to impute to him the deliberate protraction of the work out of anti-Catholic motives.

A libertine in Calvinist Holland, the painter Johannes Symoonis van der Beeck called Torrentius, was caught in the net of religious hypocrisy. An extraordinarily colourful personality, he was accused of belonging to the atheistic sect of the Rosicrucians, of being a corrupter of youth, a sexual profligate, a practitioner of black magic and a companion of the Devil. In 1627 he was tortured and condemned to twenty years' imprisonment, but freed on the intervention of Charles I of England. After a stay of several years in London he returned to Amsterdam where he died soon afterwards. His paintings were publicly burned and, in spite of the great stir they had originally made, few of them survive.[64]

4 Merchant Class Patronage and the Emancipation of Artists

In the fourteenth century the rising middle classes in cities like Florence and Ghent superseded the old aristocracy in political power and wealth and vied with it in social prestige. They soon began to aspire to a cultured style of living and required artists in growing numbers. But even throughout the first half of the fifteenth century their patronage was still directed chiefly towards communal and religious tasks and much

less to the embellishment of their personal surroundings. In a recent paper Professor Gombrich reminded us that Cosimo de' Medici commissioned most of his buildings and works of art for reasons of moral principle and political expediency as well as to enhance his prestige.[65] A similar attitude was typical of many less illustrious patrons of the same period. The building and adorning of churches and chapels, so common among merchant patrons, was not only a pious duty but also an act of personal and family pride and a sure way to impress rivals. Such works, conspicuously before the public eye, also meant adding 'great lustre to the state'.[66]

These patrons respected the men who worked for them and showed it by their preference for the educated and progressive masters, such as Masaccio, Donatello, Brunelleschi, Uccello—but they hardly esteemed them as 'artists' in the new sense advocated by Alberti. It did not occur to them to mention their artists' names or discuss their personalities. The old Cosimo de' Medici's extensive patronage never stimulated him or his friends to praise the genius of Brunelleschi, Michelozzo or Donatello. It is indicative of this lack of interest in artists' personalities that no contemporary has left us the name of the architect of the grandest Florentine palace, the Palazzo Pitti, and his identity has caused interminable controversies among art historians.[67]

A change of attitude becomes noticeable from about the middle of the fifteenth century on. It is apparent in the following diary entry of the rich Florentine merchant Giovanni Rucellai:

Memoria that we have in our house more sculptures and paintings, more inlaid works in wood and mosaic from the hands of the best masters who have been with us for a long time, not just in Florence but in all Italy, and their names are the following: master Domenico of Venice [Domenico Veneziano], painter; Fra Filippo of the order [of the Carmelites], painter; Giuliano da Maiano, woodworker, master of inlaid work and mosaics; Antonio di Jacopo del Pollaiuolo, engraver; Maso Finiguerra, goldsmith, engraver; Andrea del Verrocchio, sculptor and painter; Vettorio di Lorenzo Bartolucci [Vittorio Ghiberti], carver; Andrea del Castagno, called Andrea degli impiccati,[68] painter; Paolo Uccello, painter; Desiderio da Settignano and Giovanni Bertini, sculptors.[69]

Rucellai had his full share in pious enterprises, but this note reveals pride in the artists who served him and an interest in their individuality; he appears here as a man who seemed less concerned with assembling anonymous decorations for his palace, than in collecting works by famous masters.

At about the same time some artists began to be accepted in society and extant letters show that they could also be on terms of intimacy with their patrons. Cosimo de' Medici's son, Giovanni, was addressed by Fra

Filippo Lippi as *'charissimo'*—'my very dear'(July 20, 1457)[70]—and by Benozzo Gozzoli as *'amico mio singhularissimo'* (September 11, 1459).[71] Although the humanists kept strangely silent in their correspondence and their writings, they too befriended artists,[72] for the latter shared their own implicit belief in the nobility of learning. These were modest beginnings. Yet by the end of the *Quattrocento* and in the early *Cinquecento* some artists had qualified as belonging to the *élite*.

We know that in the second half of the fifteenth century more and more Florentine citizens indulged in projects of extravagance and splendour. A sober observer noted in his diary for the year 1489–90: 'Men were crazy about building at this time, so that there was a scarcity of master-builders and of materials.'[73] He gives a list of the enterprises in process of construction, among them the Palazzo Gondi and Lorenzo de' Medici's villa at Poggio a Caiano, but, above all, he had the Palazzo Strozzi in mind, begun in 1489 for the banker Filippo Strozzi. One of the great monuments to civic pride, the palace and its owner (who never saw it finished) are telling examples of the new style of living.

Although scholars have recently exploded the 'golden age' of Lorenzo the Magnificent as a legend,[74] he yet epitomizes the change in patronage that came about in the late fifteenth century. His leading position and the traits most noticeable in his character—his craving for luxury, his pleasure in *objets d'art* for their own sake, his appreciation of quality and of authorship, his expert judgment, and his egotism, typical of the avid collector—all these seem to have cast him for the historic rôle which tradition has perhaps not so unjustly assigned to him. It has been said that he was possibly more interested in men than in their works.[75] His interest extended even to the memory of deceased masters. He had a tomb erected for Fra Filippo in the Cathedral of Spoleto twenty years after the artist's death, and his 'court poet' Politian wrote the laudatory inscription for it. He was also instrumental in having a memorial tablet for Giotto placed in the Florentine Cathedral.[76] Lorenzo had a complete understanding of the artist's claim to recognition. A letter addressed to him by Bertoldo, his favourite sculptor, testifies to the ease and intimacy of their relationship. Merry and mischievous in tune, the letter culminates in Bertoldo's assertion that he had decided to abandon the pursuit of the arts to devote himself to cooking.[77]

The new class of patron—wealthy burghers or nobles who had a bourgeois past—with its highly-developed individualism, sense of liberty and enterprise, its progressive and competitive spirit, had an approach to artists which differed from that of the established powers. These patrons found in their artists an attitude towards life which they themselves cherished, and they were sufficiently tolerant to accept outstanding masters as equals. It now became quite usual for artists, not

only in Florence but also north of the Alps,[78] to be admitted to public office, an outward sign of status and dignity. Although all this may have hastened the process of the artists' emancipation, the profession as such was not necessarily judged with similar liberality. In the early sixteenth century Raphael's friend, Baldassare Castiglione, made the point that 'praising the artist does not imply praising the arts',[79] meaning that the attitude towards a great artist and towards his profession was not one and the same thing. How different from Plutarch's 'we enjoy the work and despise the maker'!

Perhaps some artists took the ready support they received in their struggle for freedom too much for granted. We shall see that they insisted upon their rights as free individuals in a somewhat unpredictable and not always inoffensive manner.

5 The Volte-Face in the Relation between Artist and Patron

On April 1, 1438, Domenico Veneziano (d. 1461), who is justly counted among the first great figures of the Florentine Renaissance, wrote the following letter to Piero de' Medici, Cosimo's son, then a young man of twenty-two:

I have just heard that Cosimo has resolved to commission, that is, to have painted, an altarpiece, and that he desires a magnificent work. This pleases me much, and it would please me even more if it would, with your help, be possible for me to paint it. If this should come about I trust in God I can let you see a marvellous work, notwithstanding that there are such good masters as Fra Filippo and Fra Giovanni who have much work to do.

The great and true desire I have to be of use to you makes me presumptuous enough to offer my services. If my work should be less good than whosoever else's, I would subject myself to whatever penalty I deserve, and I am prepared to submit any required proof [of my ability].

But if the work should be so great that Cosimo is thinking of entrusting it to several masters, or if he has made up his mind to give it to somebody in particular rather than to anyone else, then, I beg you to use your kind offices so that I may be permitted to execute at least some small part of it. If you only knew how I desire to create something glorious and for you especially, you would not withhold your favours from me.[80]

This language was well understood in Florence. The artist took his cue from the morals of a commercial clientèle and left no stone unturned to beat his colleagues at the competitive game. But the time was close at hand when the roles were to be exchanged and the patron then approached the artist as petitioner.

The small Italian courts of the fifteenth and sixteenth centuries, with their cultural and artistic aspirations, are a reliable sounding-board for the approaching *volte-face*. Few princely courts could vie with that of

Mantua, where, at the turn of the century, the Marchioness Isabella d'Este displayed an unceasing, ambitious activity. She was one of the keenest collectors of ancient and modern art in her time and tried to rally eminent artists to contribute works for her famous *studiolo*. Some incidents recorded in her extensive correspondence are worth noting.

On January 19, 1503, Perugino, at that time in Florence, signed a contract,[81] the terms of which were in the medieval tradition. He was to paint an allegorical picture and the most minute particulars were stipulated regarding the content, the number of figures, their size, expressions, dress and gestures, together with a full description of the attributes they were to carry, and of the landscape that was to surround them. At the end there was an explicit directive: 'You are at liberty to omit figures but not to add anything of your own.' The painting was to be delivered by June of the same year, but even after endless correspondence and continuous pressure exerted by Isabella's agents, the work (now in the Louvre, Paris) was still not finished until two years later.

Isabella was well aware of the fact that not every artist would be prepared to sign such an old-fashioned contract. Eager to get a work by Leonardo for her collection, she made use of diplomatic channels in order to further her endeavour. In 1501, she wrote to the Carmelite Vicar-General of Florence as follows:

Your Reverence might find out if he [Leonardo] would undertake to paint a picture for our studio. If he consents, we would leave the subject and the time to him; but if he declines, you might at least induce him to paint a little picture of the Madonna, as sweet and holy as his own nature.[82]

Needless to say, Isabella was unsuccessful. Nor could she easily move Giovanni Bellini into action. Her protracted negotiations with the aged master show that she could not quite resign herself to the irksome new ways of artists. She had sent Bellini a payment on account for a picture for her *studiolo*. When it never arrived, she lost patience and asked to be refunded. In 1504, after eight years, Bellini pacified her by sending a Nativity which she greatly cherished. But there was still no sign of the painting for the *studiolo*. New negotiations followed in which Pietro Bembo, the humanist and poet, friend of many artists and Isabella's confident and adviser, acted as intermediary. In January 1506 Bembo was staying in Venice and on this occasion wrote to her affably but firmly:

Bellini, whom I have seen lately, is most willing to serve your Excellency as soon as he has received the measurements for the canvas. The *invenzione* for the composition which, as your Excellency writes, should be suggested by me, will have to be left to his own imagination. He dislikes having precise terms

imposed on him, preferring, as he says, to let his thoughts wander in his pictures at pleasure; according to him, they will then satisfy the beholder.[83]

In the year this letter was written, Albrecht Dürer spent some time in Venice; he met all the important artists and was particularly well received by Giovanni Bellini. Impressed by the high regard in which artists were held, in contrast to conditions in his own country, he exclaimed in a letter to his friend Pirckheimer: 'Here I am a gentleman and at home a mere parasite.'[84] Bellini's passive resistance to Isabella's threats shows how the wind was blowing: the patriarch among Venetian artists could not be intimidated. Bembo, of course, mastered the new vocabulary: invention, imagination, freedom of action. By preaching the new gospel the humanist helped to convert the patron.

The artists did not suddenly or deliberately change their behaviour. They resorted rather to using evasive tactics such as disregard of the guild rules or refusal to comply with requests made by patrons. Naturally, before they understood better, patrons took offence. We know it from Isabella's brother, Duke Alfonso of Ferrara, who wanted to rival his sister's *studiolo* and kept his agents busy trying to extort pictures from elusive painters. Raphael himself had promised a *Triumph of Bacchus* for which the Duke had advanced fifty ducats. In April 1519 he wrote to his agent in Rome:

We are awaiting with great impatience a painting which is being executed for us by Raphael of Urbino. He has said many a time that he was going to finish it soon, but it is now a long while since he began to serve us, and yet he is not ready. That is why we want you to solicit him dexterously and to beg him on our behalf to give it the finishing touches as soon as he can, reminding him that the quicker we get the picture the more we shall be pleased with it, as it is the only one we lack to complete our small room.[85]

For five months the agent tried half-heartedly to achieve the desired result. The idea of soliciting the great Raphael with dexterity obviously made him nervous and he hoped to hand the invidious task back to his employer. On September 3, he wrote to the Duke: 'I should now tell your Excellency, but I do not know whether I do well, that when your Excellency feels so inclined you might write him in your own hand, which may possibly carry more weight than my talking to him in order to induce him to put his hand to the work.'[86] But the Duke knew better than to expose himself and risk offending the Pope's favourite artist. By return of post he answered:

We do not wish to write personally to Raphael of Urbino as you advised, but we want you to go to him and tell him that you have letters from us in which we write that it is now three years since he gave us his word, and that this is not the way to treat people like us. If he does not keep his promise towards

us we shall act in such a way that he will learn how ill he did in deceiving us. And further, you can tell him, as from yourself, that he should avoid provoking our displeasure, since up till now he has enjoyed our affection; that just as he may hope to make use of us by keeping his word, so, on the contrary, if he does not hold to it, he can one day expect to regret it. All this, of course, is between him and you.[87]

Alfonso still vacillated between prods and threats, but, when the winter of 1519–20 passed and nothing had happened, he decided to use stronger language. On January 20 of the new year he requested his agent to

Go and see Raphael of Urbino and ask him what he has done with the work he should have executed for us; and if you do not get more out of him than in the past, tell him, as if it came from you that he should consider well what it may mean to pledge his word to one of our rank, and then to show no more esteem for us than for a vile plebeian; that, since he has lied so often, you yourself believe that in the end we shall grow offended. Let us know what answer he gives you.[88]

The answer came on March 21, 1520: 'I talked to Raphael of Urbino and found him as usual eloquent and very much disposed to be at your Highness' service.'[89]

Duke Alfonso never got his picture. On April 6, 1520, Raphael died. An energetic new agent looked after the Duke's affairs in Rome and with great difficulty extracted from Raphael's unwilling heirs the fifty ducats which the artist had received on account.[90]

A similar exasperating situation confronted Alfonso in his negotiations with Titian. The artist had agreed to paint three Bacchanals for the ducal studio and the execution of one, probably the *Bacchus and Ariadne* (now in the National Gallery, London), dragged on for years. 'Make it your business', the Duke instructed his Venetian agent in November 1520,

to speak with Titian and remind him that he made promises when leaving Ferrara which he has not thought fit as yet to keep. Among other things he said he would paint a canvas which we expect to receive without delay, and as we do not deserve that he should fail in his duty, exhort him to proceed so that we shall not have cause to be angry with him, and let means be found to obtain our canvas immediately.[91]

Alfonso was a true art enthusiast and a new type of connoisseur for whom only the best was good enough. If his negotiations with Raphael and Titian still show some of the old attitude, his virtues as a patron are revealed in his dealings with Michelangelo. They first met in Rome in 1512 when the Duke managed to get permission to inspect the ceiling of the Sistine Chapel from the scaffolding. His admiration for Michelangelo was boundless. In 1529, when the latter visited Ferrara for a short while, 'the Duke received him with great demonstrations of joy', as

Condivi tells us. He probably had it straight from his master that on this occasion Alfonso himself 'opened his treasure-room, displaying all its contents with his own hands'. This is a characteristic connoisseur attitude and, may it be noted, by doing the honours of the house in person the Duke treated Michelangelo like one of his own class. When the hour of departure approached 'the Duke jestingly said to him: "You are my prisoner now. If you want me to let you go free, I require that you shall promise to make me something with your own hand, according to your will and fancy (*come bene vi viene*), be it sculpture or painting." '[92]

Even if Condivi embellished the facts we have no reason to doubt that some such conversation took place and that the Duke allowed Michelangelo complete freedom in every respect. After his return to Florence the master painted the *Leda and the Swan* for Alfonso to which we have already referred.

There followed the well-known incident which exemplifies the revolutionary changes in the profession. When the picture was finished the Duke sent one of his courtiers to Florence to convey the painting safely back to Ferrara. In the accompanying letter the overjoyed patron addressed Michelangelo as 'Dearest friend'. But Alfonso's choice of envoy was a mistake. The latter called the picture 'a mere trifle' (*una poca cosa*) and apparently treated the artist condescendingly. After some spirited exchanges of views, Michelangelo showed him the door.[93] Alfonso had lost his prize. To add insult to injury Michelangelo presented the painting to his servant Antonio Mini who was about to emigrate to France.

6 *Julius II and Michelangelo*

Even the Church, the guardian of tradition, had to come to terms with the new type of artist. Shortly after 1500 the constellation in Rome was auspicious for the change. A strong-willed warrior pope, Julius II, was giving Rome the imprint of his mighty personality. By assembling at his court the great trio, Bramante, Raphael and Michelangelo, and entrusting them with tasks of unrivalled grandeur, he became the most memorable patron the western world has known. No wonder that such a man knew his artists' idiosyncrasies and was prepared to put up with them *ad maiorem dei gloriam*. Moreover, it has often been claimed that there was a deep bond of understanding between him and Michelangelo; if anything can prove it, it is the equanimity with which the irascible pontiff bore more than once the unprecedented behaviour of the great artist.

A crisis in their relationship nearly caused a diplomatic incident between Rome and Florence in 1505. The year before, Julius had

commissioned Michelangelo to design his magnificent marble tomb, but the Pope's interest was soon absorbed by the plans for the rebuilding of St Peter's. Financial difficulties also arose, and the artist, embittered and discouraged, lost his temper and left Rome in a fury to hurry back to his native Florence. His own account is preserved in a letter, dated May 2, 1506, written from Florence to the architect Giuliano da Sangallo:

Before I left his presence, I asked for part of the money needed to carry on the work [on the Pope's tomb]. His Holiness told me to return on Monday. I did so, and on Tuesday, and on Wednesday, and on Thursday, as the Pope saw. At last, on Friday morning I was sent away, or plainly turned out of doors. The man who did this said he knew me, but that such were his orders. I was utterly cast down.[94]

Rather than lose the artist he truly liked and admired, Julius moved heaven and earth to bring about a reconciliation. On July 8, 1506, he addressed the following letter to the Florentine authorities:

Michelangelo the sculptor, who left us without reason and out of mere caprice, is, we understand, afraid of returning though we, knowing the humours of men like him, have nothing against him. Still, in order that he may dismiss any suspicion, we rely on your loyalty towards us that you will promise him in our name that if he returns he shall be neither hurt nor injured and that we will restore him to the same apostolic favour which he enjoyed before he left us.[95]

Michelangelo did return to Rome, but his brooding nature was not blessed with the capacity to forget. He fretted for decades over old injuries. In a letter dated January 1524 his old anger wells up again unabated:

Pope Julius changed his mind about the tomb and would not have it made. Not knowing this, I applied to him for money and was expelled from the chamber. Enraged at such insult, I left Rome on the moment. The things with which my house was stocked went to the dogs.[96]

And even after thirty-six years he still remembered every detail:

I urged the Pope with all my power to go foward with the business [of the tomb], and he had me turned away by a groom one morning when I came to speak upon the matter. I went home and wrote as follows to the Pope: 'Most blessed Father, I have been turned out of the palace today by your orders; wherefore I give you notice that from this time on, if you want me, you must look for me elsewhere than in Rome.'

I went and took the post and travelled towards Florence. The Pope, when he had read my letter, sent five horsemen after me, who reached me at Poggibonsi about three hours after nightfall, and gave me a letter from the Pope to this effect: 'When you have read this, come back at once to Rome, under penalty of our displeasure.' I replied then to the Pope that as soon as

he would discharge his obligations towards me I would return; otherwise he need not hope ever to see me again. Later on, while I was in Florence, Julius sent three briefs to the Signoria. After the last the Signoria sent for me and said: 'We do not want to go to war with Pope Julius because of you. You must return; and if you do so, we will write you letters of such authority that, should he do you harm, he will be doing it to this Signoria.' And so they did and I went back to the Pope.[97]

These letters reveal more than the clashing of two headstrong personalities. Never before had an artist dared to turn his back on a Pope and never had a patron shown so much understanding for the 'humours of such men.' For all his violent and autocratic ways, Pope Julius was broadminded enough to forego his claims to reverential submission from an artist whose genius he fully appreciated. In the realm of the spirit Julius met Michelangelo as an equal.

7 Dilatoriness of Artists

We have seen how the slowness of their artists taxed the patience of Alfonso and Isabella d'Este to the limit; but their experience was not exceptional—tardiness was a pandemic evil. Thus Isabella's son Federico Gonzaga, first Duke of Mantua, eager to take up residence in his newly-erected Palazzo del Te, had to prod his court architect and painter Giulio Romano, in a letter of 1528 which strikes a familiar note:

Giulio. Because we have been given to understand that no painter is working on our rooms in the Palazzo del Te, we believe that they will be finished neither in August, as you promised us, nor yet in September or October. The numerous postponements of the dates for finishing the work may have amused us so far, but as we see that this latest date will also pass without our being satisfied, we are telling you that if you want to have them finished by the promised term, you must speed on the work diligently; if you do not we shall provide for other painters who will finish it.[98]

Both patron and painter knew of course that these were empty threats, for the unconcern of artists about promised delivery dates had become legendary. Their dilatoriness was considered a trait common to all. Isabella d'Este explained it as due to the *bizarria* (extravagance) of their character.[99] In the correspondence about Michelangelo's (lost) bronze David for Pierre de Rohan, Maréchal de Gié, the Signoria of Florence informed the latter in April 1503 that the artist had promised the work in the very near future, but 'in view of the character of such men', it appeared impossible to predict when the work would be finished. That 'such men' may be taken as referring to the profession in general is confirmed by a previous letter (December 1502) in which the unreliability of painters and sculptors is pointed out.[100] Michelangelo's behaviour fostered such ideas. Asked by Pope Julius when he would

6. Page from Villard de Honnecourt's Sketchbook, *c.* 1250. Bibl. National, Paris. 'I have been in many countries as you can see from this book' are the first words on this page. The sketchbook is a unique document for the interests and working methods of an itinerant medieval artist.

7. Map showing the Wanderings of three South German Architects of the Fifteenth Century.
Master masons and craftsmen of the Middle Ages often moved from place to place in search of promising opportunities. In Germany the habit prevailed until well into the fifteenth century.

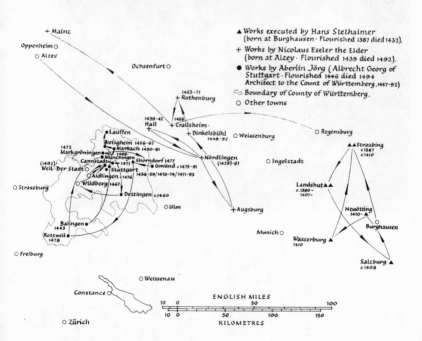

▲ Works executed by Hans Stethaimer (born at Burghausen · Flourished 1387 died 1432).

+ Works by Nicolaus Eseler the Elder (born at Alzey · Flourished 1439 died 1492).

● Works by Aberlin Jörg (Albrecht Georg of Stuttgart · Flourished 1446 died 1494 Architect to the Count of Württemberg. 1447-92)

⌒⊃ Boundary of County of Württemberg.

○ Other towns

+ Mainz
Oppenheim ○
Alzey ○
Ochsenfurt ○
1453-71 + Rothenburg
1439-41 Hall
1456 + Crailsheim
▲ Lauffen + Dinkelsbühl 1448-92
○ Weissenburg
1472 Markgröningen
Bietigheim 1456-67
● Marbach 1450-81
1468 ● Münchingen ● Nördlingen (1429)-61
Cannstadt ● ○ 1471 Schorndorf 1477
(1492) ○ Weil-Der-Stadt ● Stuttgart ● Gmünd c1475-91
1436-59/1470-74/1471-93
● Aidlingen c1476
● Wildberg 1467
○ Strassburg ● Dettingen c1460
○ Ulm
+ Augsburg
○ Regensburg
○ Weissenburg
○ Ingolstadt
▲▲ Straubing c1387 c1410
Landshut c1390-1407- ▲▲
Neuötting 1410- ▲
Balingen 1443
Rottweil 1478
Munich ○
Wasserburg 1410 ▲
Burghausen ○
○ Freiburg
Salzburg ▲ c1403
○ Weissenau
Constance ○

ENGLISH MILES
10 0 50 100
10 0 50 100 150
KILOMETRES

○ Zürich

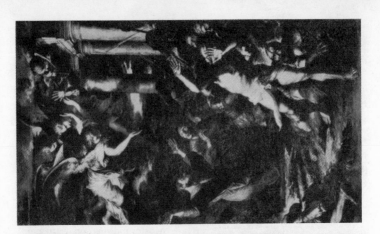

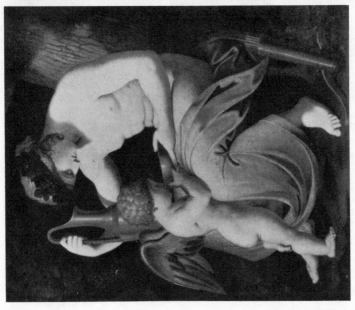

8. J. A. Carstens (1754–98), Bacchus and Cupid, 1796. Museum, Copenhagen.
Carstens' thoroughly academic style shows little of that rebellious spirit which made him defy the requests of the Prussian Minister in Berlin.

9. Salvator Rosa (1615–73), SS. Cosmo and Damian, 1669. S. Giovanni dei Fiorentini, Rome.
Famous for his romantic landscapes, Rosa himself preferred this altarpiece in the grand manner to his other works. After its completion he was entirely exhausted, but he was convinced of having surpassed even Michelangelo.

finish the ceiling of the Sistine Chapel, he is supposed to have answered: '*quando potrò*'—'whenever I can'![101]

But it would be erroneous to believe that dilatoriness was a character trait which developed in the wake of the artist's newly won freedom. Similar complaints were levelled against craftsmen-artists of the Middle Ages and are common in the early *Quattrocento* at a time when artists were still fenced in by guild regulations. In the late fourteenth century the merchant Francesco di Marco Datini, whom we have met before as a picture dealer, was so fed up that he swore he would never again have anything to do with painters since 'they are all of the same mould'.[102] As a rule patrons tried to assure punctual delivery by stipulating a time-limit in the legally binding contract, and a penalty in case of failure to keep to the promised date.[103]

Yet transgressions were the rule rather than the exception. To mention Jacopo della Quercia as just one example: the Commune of Siena allowed him twenty months to carry out the Fonte Gaia, starting April 1409; after many interruptions the fountain was completed ten years late. For his reliefs around the doors of S. Petronio at Bologna the contract of March 26, 1425, stipulated two years, but when Quercia died more than thirteen years later the work was still unfinished.[104]

Tardiness is not—and never was—peculiar to artists only. In fact, we all know from bitter experience that delivery dates are promised by all trades and professions only to be broken. But in two respects the procrastination of artists differs from such everyday occurrences. The emancipated artist often regarded a time-limit imposed upon him as incompatible with the process of creation and the public, by singling out dilatoriness as a character trait of artists, contributed to the image of the alienated artist, although in this particular respect he surely acted like the majority of his fellow men.

CHAPTER III

ARTISTS' ATTITUDES
TO THEIR WORK

1 *Artists' Personalities and the Beginning of the Renaissance*

FOR more than two generations the question of the beginnings of the Renaissance has been debated by historians of all schools.[1] It is not our intention to enter the arena of the combatants or to contribute a theory of our own. Our concern is with the personality of artists and it is only in this context that we wish to touch upon the problem of historical 'periodization'. Well-defined personalities of artists are known to us at least from the middle of the twelfth century onwards. Does this prove, as has sometimes been claimed, that we are here at the threshold of a new historical phase? Art has always been produced by individuals and a lack of literary information about them does not mean that they had no individuality. It has also been said that in Italy, if nowhere else, a new type of artist emerged as early as the beginning of the fourteenth century: the artist with a solid education, with broad cultural interests, and of high social standing, in a word, the *'uomo universale'*, the universally endowed and trained man—a type we normally associate with such later artists as Leonardo da Vinci, Michelangelo, and Raphael.

Early documents and inscriptions contain epithets such as *'doctus'*, *'expertus'*, *'probus'*, *'sapiens'*, *'prudens'*, *'praestans'* and *'artificiosus'*, but they should not delude us. They refer to the expert handling of the work and to nothing else. When in a document of 1200[2] the architect of the castle of Ardres near Saint-Omer is called *'doctum geometricalis operis'* he is praised as a skilful geometrician rather than as a learned mathematician. And when the inscription on the tomb of Pierre de Montreuil, the great architect who died in 1266, says: 'Weep, for here lies buried Pierre, born at Montreuil, a sterling character and in his life a *doctor latomorum*', he is not eulogised—in the words of an English translation—as 'a learned doctor', but as 'the teacher of masons'.

There is no reason to confine our search for the 'universal artist' to the later Middle Ages. S. Eligius, who died as Bishop of Noyon in 658, seems to have possessed many of the characteristic traits.[3] He began his career as an apprentice to a goldsmith; in due course he became an artist of remarkable accomplishments and a favourite of kings. We are told that

he had beautiful hands and slim fingers (a pointer to his social standing), that he was a passionate reader and a lover of precious jewellery and gorgeous silken gowns, that he kept servants and was surrounded by a circle of devoted pupils. His career was crowned by his distinguished advancement after he had taken the vows. Here as well as in other cases it is no longer possible to separate facts from fiction. But even if we are on much firmer historical ground it is not easy to evaluate the documents correctly. When Giotto is referred to as '*doctus*', '*expertus*', and '*famosus*', is this not the well-known terminology sanctioned by tradition? And when Dante in the celebrated verses of Purgatory XI extols Giotto—

> In painting Cimabue thought to hold
> The field; now Giotto is acclaimed by all
> So that he has obscured the former's fame

—or when the Dante commentator, Ser Andrea Lancia, writing in 1333-4, still during Giotto's lifetime, says of him that he 'was and is among known painters the greatest',[4] are these the voices of homage paid to individual greatness, first-fruits of the modern conception of Fame, which for Burckhardt was one of the most telling symptoms of the Renaissance? Once again, we have heard this language at a much earlier time. At the end of the eleventh century the St Albans Chronicle of the Abbots gives praise to Robert, the mason of the abbey church, as the one 'who excelled all the masons of his time',[5] and in the second quarter of the twelfth century it is said of Lanfred, the architect of the Castle of Ivry, that 'his talent transcended that of all the craftsmen of Gaul'.

Nor does it seem permissible to draw conclusions regarding the social position of artists from the high rank attained by some long before the fifteenth century. It was not rare for masters of the Middle Ages to belong to the royal household or to be given positions of trust and importance within the community. From the thirteenth century onwards, architects in particular were highly paid and amassed considerable fortunes. The fact that Simone Martini was possibly knighted[6] and that Giotto was wealthy, and that, in a document of 1330, King Robert of Naples called him 'our dear and faithful court painter' and counted him among his *familiares*, does not indicate a general change in the status of artists.

Neither appreciation of artistic quality and individual style by some members of the public nor the social and economic success of some artists can be taken as signs of a new era. Patient search will lead to the discovery of one or all of these features at ever earlier periods as the seventh century case of S. Eligius has shown. We will therefore have to look for additional criteria in seeking a cogent 'periodization'.

In the previous chapters we had occasion to observe a new self-

awareness of fifteenth century artists, a new ideal of learning arising among them, a new conception of the creative process, and a significant change in the relation of artist to patron. The fifteenth century witnessed far-reaching changes in what might be called the collective personality of artists. A study of the various aspects of an artist's approach to his work will confirm the view that, during this period, his conduct shows compelling signs of a change of epochal importance. It is for this period that we would reserve the term 'Renaissance'.

2 *Wandering Craftsmen and Artisans*

As long as the social and intellectual aspirations of artists were those of craftsmen, they lived and worked like all other artisans. Most medieval skilled craftsmen were freemen, as opposed to bonded labourers. Their progress from apprentice to journeyman to master was prescribed; their obligations and rights towards their patrons set down; their working hours and free days regulated by law. This routine was only broken when, as he frequently did, the artisan took to the road, wandering from place to place and even from country to country.

In the thirteenth century English masons are known to have worked on the papal palace in Avignon; the master mason of St Louis, King of France, accompanied his sovereign on his journeys and worked in Cyprus and the Holy Land; English embroiderers and alabaster carvers travelled to France, Germany, and Norway. Work on the great cathedrals attracted large numbers of craftsmen. From Abbot Suger's remarks, written before the middle of the twelfth century, that he 'convoked the most experienced artists from divers parts' and that 'the barbarian artists were even more lavish'[7] than his own countrymen, we may conclude that some of the goldsmiths and jewellers, the carvers and stained glass makers who adorned the abbey church of St Denis, came from far afield. This list could easily be continued for many pages.

The most interesting and most famous of these itinerant artists, Villard de Honnecourt, was born near Cambrai and worked and studied in France, Switzerland, and Hungary before the middle of the thirteenth century. The sketchbook which he kept on his wanderings gives us a rare insight into the manifold interests and accomplishments of a medieval architect. On one of the pages he proudly wrote: 'I have been in many countries as you can see from this book'[8] (Fig. 6).

Although the reasons for these migrations were numerous, two stand out as decisive: training and economic pressure. It was traditional for journeymen to round off their years of training by broadening their experience in different towns or countries. On the other hand it was necessary for some, such as masons and craftsmen connected with the building trade, to take to the road either because of seasonal conditions

—during the northern winter they naturally sought employment in milder climates—or simply because more promising opportunities were being offered elsewhere (Fig. 7).

In contrast to these self-imposed or enforced movements of large numbers of craftsmen, well-known masters travelled when summoned to places far from their native lands. Many instances are documented but only two of the more famous ones will be noted here: the appointment of Master William of Sens, sometime after 1174, as architect to Canterbury Cathedral, and, at the end of the fourteenth century, the summoning of Heinrich Parler of Gmünd to Milan to give advice on the continuation of the Duomo. It hardly needs emphasizing that the travels of such masters had an important bearing on the transmission and diffusion of artistic conventions, of forms and styles. They also provide evidence for the excellence of communications during the Middle Ages. But since these journeys were undertaken upon invitations such as had been extended to artists and architects throughout the centuries, they do not pertain to the problem under review.

In the fourteenth and fifteenth centuries the migrations of artisans and craftsmen took on a somewhat different character. One might say that emigration replaced migration. The economic problems and political conflicts which plagued Central Europe drove large numbers from their native lands. Many wandered across the Alps and settled in Italy. At the end of the fourteenth century weavers from Flanders, Brabant, and Lower Germany outnumbered the native weavers in Florence. Northern tapestry weavers and embroiderers, and even saddlers, furriers, tanners, barbers and other foreign artisans were to be found in all major Italian cities.[9] Between 1420 and 1450 eight hundred names are mentioned as members of the confraternity of foreign shoe-makers, established in Rome in the late fourteenth century; in the thirty-one years between 1500 and 1531 we find over two thousand names listed. They had come from the Low Countries, from Germany and Austria. Other trades, too, were in the hands of foreigners. Thus during the later fifteenth and sixteenth century the majority of inn-keepers south of the Alps were of German or Flemish origin. Painters, sculptors, and builders represented but a small part of this mass migration. In their adopted country foreign craftsmen and artisans, no less than foreign tradesmen, became rooted city dwellers. Those who stayed at home also showed a growing tendency to settle down. Only journey-men would still continue their traditional wanderings as part of their training.

The behaviour of artists from the fifteenth century onwards has to be seen in relation to the way of life characteristic of the *petit bourgeois* class to which they still belonged in the eyes of most of their contemporaries.

Artists persistently showed itinerant habits. Did they perpetuate an outmoded, medieval custom? Evidently economic distress remained a driving power. But it is more important to note that now, probably for the first time in history, the compelling force behind their *Wanderlust* often conflicted with their economic interests, a fact which throws a clear light on the widening gulf between their class and their new professional aspirations: they were driven by a strange combination of a thirst for knowledge and a yearning for freedom far beyond anything that had ever moved their fellow-craftsmen.

3 *The Lure of Rome*

> *Neither painters and sculptors nor architects can produce*
> *works of significance unless they make the journey to Rome.*
> Francisco de Hollanda, *Tractato de Pintura antigua*, 1548

Brunelleschi's and Donatello's controversial journey to Rome early in the fifteenth century sets the theme: Vasari tells us that the two close friends decided to turn their backs on Florence and spend some time studying in Rome.

Brunelleschi sold a smallholding which he owned at Settignano and they set off from Florence to Rome. There, seeing the magnificence of the buildings and the perfection of the temples, Brunelleschi was so entranced that he seemed to be beside himself. And thus, having given orders to measure the cornices and to draw the plans of those buildings, he and Donatello carried on continually, heedless of time or cost, nor were there places in or near Rome which they did not study and there was nothing good of which they did not, if possible, take measurements. And since Filippo was free of family worries, he could give himself up entirely to his studies. He cared nothing about eating or sleeping: his sole interest was the architecture of the past.[10]

Later, Vasari continues:

If they found by chance some buried pieces of capitals, columns, cornices or the foundations of buildings, they put workmen on the job and made them dig down to the bottom. Because of this a rumour spread in Rome and people who saw them passing through the streets, carelessly dressed, called them 'those treasure hunters', for it was believed that they devoted themselves to geomancy in order to find treasure.[11]

The friends returned to Florence by different routes. Donatello stopped at Cortona where he admired a beautiful ancient sarcophagus. Back in Florence he described

. . . the excellence of its workmanship. Filippo Brunelleschi became fired with an ardent desire to see it and went off on foot just as he was, in his mantle,

cap, and wooden shoes, without saying where he was going, and allowed himself to be drawn to Cortona by the devotion and love that he bore to art.[12]

Where this 'devotion and love' reigned, where learning beckoned, no other consideration was allowed to interfere. Learning now meant the study of antiquity, and antiquity meant Rome, and so to Rome artists were drawn irresistibly. Written almost a century and a half after the event, Vasari's tale of Brunelleschi's and Donatello's journey to Rome and its sequel at Cortona may be to a certain extent fictitious. Art historians are often unjustly critical of Vasari's veracity; in this case, however, he relied largely on the anonymous *Life* of Brunelleschi, written not long after the master's death and nowadays still our principal source for his life.[13] Also, the sarcophagus, supposedly so much admired by Donatello, is still in the Cathedral at Cortona. This does not prove, but at least it supports Vasari's story.

Even if legends have been woven around the two pioneering addicts of Roman antiquity, we have no reason to doubt that these artists took to the road with a new purpose and a goal clearly in mind. They initiated a pilgrimage which was to bring thousands of artists to Rome in the centuries to come, all of them seeking mastery in their art through the study of Rome's past.

Yet it may be argued that the artists were late-comers in this quest. Before them, Dante, in his *On Monarchy*, had hopefully looked to Rome to foster a revival of the one Universal Empire. His disciple Cola di Rienzo, who was elected Tribune of the Roman people during the revolution of 1347, believed he could help to reinstate Rome's political greatness by an act of sympathetic magic: the collection and interpretation of Roman inscriptions. Petrarch, Rienzo's enthusiastic supporter, went beyond the political and national aims of the Tribune: he was captivated by Rome as a city. With him historical recollections and visual impressions merge into an overwhelming image of the Eternal City. His whole being responded with tremendous excitement to what his eye perceived. In a letter of March 1337 he reported to his friend, the Cardinal Giovanni Colonna:

At present I can hardly even begin to write, I am too overwhelmed by the miracle of so much grandeur and so many surprises. One thing, however, I want to say: the contrary of what you expected has happened. As I recall it, you were against my visiting Rome, warning me that the sight of the ruined city would contrast too sadly with all that I had heard and read about her, so that my fervent enthusiasm would dwindle. And I myself was not disinclined to postpone my visit in spite of my great longing, because I feared that the sight before my eyes would belittle the image formed in my mind. Reality is always the foe of famous names. But this time, oh wonder, reality has dimin-

ished nothing but exceeded everything. Truly, Rome was grander than I had thought, grander too are her ruins! I am no longer astonished that this town has conquered the world. I am only surprised at its happening so late.[14]

Five years later he tried to persuade Pope Clement VI to return from Avignon to Rome. In his petition he makes the personified *Roma* implore the Pope to come and end her misery. But, she says,

. . . if fate denies my wish, console me from afar and think of me. . . My vast temples sway under the weight of their age, my castles tremble on their crumbling walls. Soon they will crash to the ground if no-one comes to restore them . . . Yet my majesty survives, triumphant, among the fallen masonry of all those ruins.[15]

It took more than two generations before artists could see Rome as Petrarch had done before them. But then an avalanche was set in motion. Rome gave their itinerant habits direction and Rome changed many an artist's approach to his work. Drawing from the ancient monuments, measuring, digging, reconstructing, collecting—all these became vital activities in the process of rejuvenation which swept through Italy and finally through the whole western world. The spirit which animated fifteenth century artists finds expression in many passages from Leon Battista Alberti's *Ten Books on Architecture*, written about 1450. In Rome there remained, he writes,

. . . many examples of the ancient works, temples and theatres, from which, as from the most perfect masters, a great deal was to be learned; but these I saw, and with tears I saw it, mouldering away daily.

There were no remains anywhere of ancient works of any merit which I did not examine in order to see if anything was to be learned from them. Thus I was continually searching, considering, measuring, and making drawings of everything I could hear of, till such time as I had made myself master of every contrivance or invention that had been used in those ancient structures.[16]

The story of the lure of Rome is full of dramatic incidents of which only a few can be reported here. To get to Rome often became a veritable obsession and sometimes seems to have brought on psychological complications which were surely spared the wandering craftsmen of the Middle Ages. We may venture a guess that such a crisis overtook the young Ferrarese painter Benvenuto Garofalo (1481–1559) who suddenly threw up the work his teacher Boccaccino had found for him:

Without saying so much as 'donkey' to me [complained Boccaccino to Garofalo's father] he has gone away, though I do not know where. I had provided him with work, but he went, leaving everything unfinished. This is by way of warning that you may take steps toward finding him. If one can

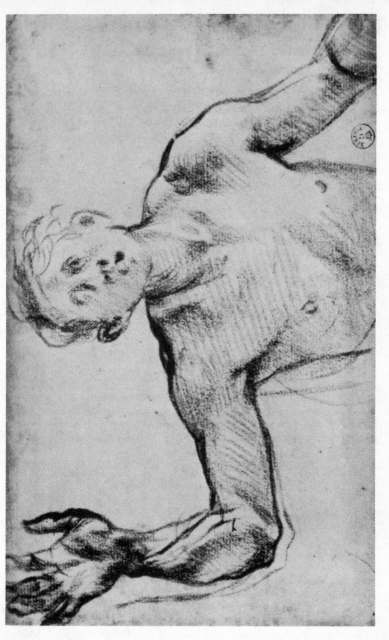

10. Jacopo Pontormo (1494–1556), Study of a young Man. Drawing. Uffizi, Florence. The haunted quality of Pontormo's works would seem to reflect the artist's introspective nature and anguished mind.

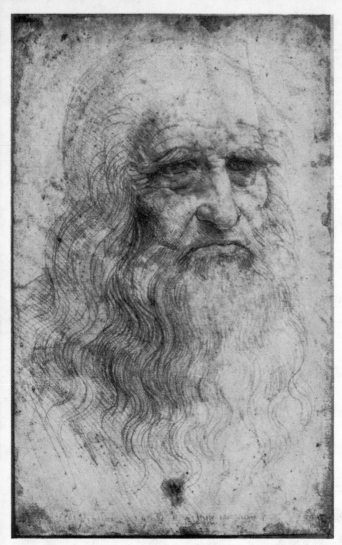

11. Leonardo da Vinci (1452–1519), Self-Portrait. Drawing. Bibl. Reale, Turin.
Leonardo, then about sixty years old, represented himself as a deeply-lined thinker
of venerable age, with a mouth expressive of bitterness and disappointment.

12. Portrait Bust of Michelangelo. Louvre, Paris.
One of several bronze casts after Daniele da Volterra's wax model executed within
four months of Michelangelo's death. The model was based on drawings and possibly
a death mask. In the casts Michelangelo's ugliness, aggravated by his broken nose,
was idealized so as to enhance the expression of sensitivity, drama and nobility
which contemporaries saw in his face.

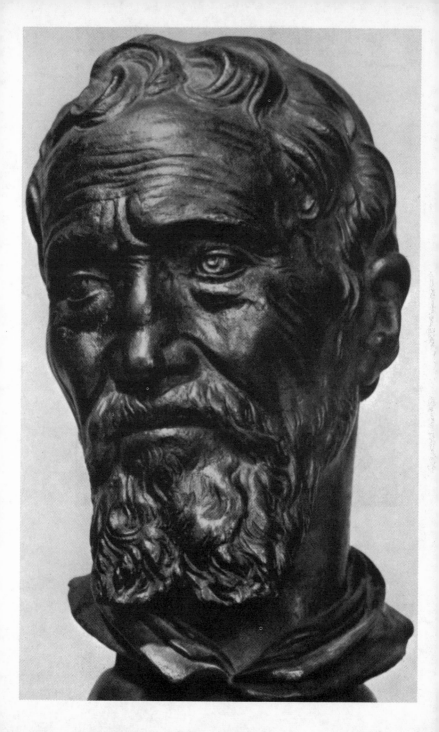

13. F. Barocci (1528/35–1612), Rest on the Flight into Egypt, 1573. Pinacoteca Vaticana. The artist described his agonies while creating this peaceful scene. His pictures scarcely reveal that they were painted by a deeply disturbed hypochondriac.

14. J. Cornelisz. Cobaert (Copé), St Matthew and the Angel. Marble. SS. Trinità de' Pellegrini, Rome.
Copé, a 'suspicious melancholic', left this ungainly figure unfinished when he died in 1615. For over thirty years he had worked at it in great secrecy.

believe him, he said he wanted to see Rome. Maybe he has gone to that city.[17]

More convincing than this equivocal case are others which really allow us to fathom the artist's mind. The young Poussin's long wavering between going to Rome and staying in Paris is well documented. His biographer Passeri describes Poussin's suspense and distress before he arrived at a final decision. Born in 1594, he had left his birthplace Les Andelys at the age of eighteen and had settled in Paris.

But within him the desire to see Rome and live there grew ever more ardent. At last his impatience was such that he decided to set out on the road, but though he hurried along on the journey, once he had crossed the Alps and reached Tuscany he felt, as he himself said, without knowing why, the urge to return to Paris. So, whatever the reason, back to Paris he went. From there he transferred himself to Lyons and stayed a few years in that town working on this and that. Yet once more he felt the powerful stimulus to see Rome, and this desire grew steadily stronger. But he had contracted a small debt with a merchant which served him as a pretext for staying—it seemed to him like a chain binding his liberty. In the end, unable to stand that town any longer, he begged the merchant to be patient, for he would pass part of the debt on to his father, from whom he would receive early satisfaction. The merchant courteously agreed and accepted Nicolas' offer.

Having got rid of this difficulty, he set out on the journey to Rome, even though he had little money—having spent, as if in despair, all he owned in one evening with his friends.[18]

However, instead of turning south he went north, explaining that he had to go back to Paris to earn some money. There he was soon drawn into the circle of the Italian poet, Giovan Battista Marino, for whom he worked for a short while. Marino was determined to settle in Rome and urged Poussin to accompany him. This was not to be; yet Marino's presence in Rome was, no doubt, an added attraction for Poussin when he finally took the fateful resolution: 'At last, in 1624 he decided for the third time to travel to Rome and arrived there quickly in a happy state of mind at the end of April.'[19]

Poussin had come to stay. Perhaps he had hesitated so long because he felt deep in his mind that the journey to Rome would be an irrevocable step. As it turned out, Rome claimed him entirely. Only in Rome could he fulfil his destiny and develop his classical style, with immeasurable consequences for the history of painting in his time as well as in the following centuries. Once only did he leave Rome again. In 1640 he accepted a call to Paris to carry out the decorations for the *Grande Galerie* of the Louvre. It was the most frustrating experience of his mature years. From Paris he wrote to his Roman patron and friend, Cassiano del Pozzo: 'Were I to remain in this country for a long time, I should be

forced to become a hack like all the others who are here. Studies and valuable observations from the antique or other sources are here completely unknown.'[20]

The lure of Rome had made him an exile for life.

Of another great Frenchman, Poussin's exact contemporary, the engraver Jacques Callot, born in Nancy in 1592 of wealthy parents, it is reported that he ran away from home at the age of twelve and reached Florence in the company of begging and marauding gypsies. Florence, however, was not his goal; he went on to Rome, where he was found and taken back to Nancy. But the easy life of a young gentleman had no attraction for him. He sneaked away a second time but only got as far as Turin; there his brother discovered him and brought the adventure to an abrupt end.[21] This whole story may be fictitious. Yet Baldinucci reports that 'one of Callot's compatriots who knew him well' had told him that the young artist had left 'the comfort of the paternal home, had made a long and dismal journey to Rome . . . and in order to realize his dreams had subjected himself to the pangs of a poor and hard life'.[22] We know that Callot was in Nancy in 1607 and that a year later, at the age of sixteen, he travelled to Rome in style, chaperoned by the Count Tornielle de Géberviller who went as Lorrainean ambassador to the papal court.

Whether or not there is any truth in Callot's earlier escapades, the almost contemporary reports of usually reliable biographers indicate that ordeals suffered in order to get to Rome and study there, raised an artist's stature in the eyes of the public.

In 1666, the year after Poussin's death, the French Academy in Rome was founded—an offspring of the Royal Academy in Paris. Henceforth the journey to Rome became an officially sanctioned institution, and the *Prix de Rome* was regarded as the most distinguished prize an aspiring French artist could win. Like the mother institution, the Roman Academy was state-supported and state-directed. It, too, could boast a proper hierarchy of officers who nursed and guided the students, and assessed their work. In addition, they indulged in the time-consuming routine of sending to Paris long and often dreary reports which have all been preserved and published.[23] Nevertheless, the deadly hand of officialdom could not quell the excitement which the study of Rome's monuments provided. The promise of intellectual and artistic fulfilment still worked like a magnet, and even more so after Raphael, Michelangelo and other great Renaissance masters had added lustre to the glory of ancient Rome. As time went by, many nations followed the French example, even after Rome had yielded her primacy in matters of art to Paris.

Academic artists had existed long before the foundation of the French

Academy. Vasari, with his intellectual curiosity, his tireless enthusiasm and dogmatic views, was the prototype of the new species. In his autobiography he recalls how, in his youth, he had decided 'never to shrink from any fatigue, discomfort, vigil, and toil,' in order 'to attain by assiduous labour and study some of that grandeur and rank that so many others have acquired'. Characteristically, the emphasis is on social success and this seems to be at variance with a disinterested pursuit of serious studies, but Vasari gives a rather impressive account of his arduous working day:

There remained nothing notable at that time in Rome, or afterwards in Florence, or in any other place where I stayed, that I did not draw in my youth; and not pictures only, but also sculptures and architectural works, ancient and modern. And besides the benefit that I gained by drawing the vault and chapel of Michelangelo, I likewise drew all the works by Raphael, Polidoro [da Caravaggio], and Baldassare da Siena [Peruzzi] in company with Francesco Salviati. In order that each of us might have drawings of everything, we would draw different objects during the day and then we would copy each other's drawings at night so as to save time and extend our studies; more often than not we ate our morning meal standing up, and it was little at that.[24]

He also explains that he regarded a study period of many months in Rome, made possible by Cardinal Ippolito de' Medici, as 'his true and principal master in the arts'.

Because Rembrandt never had this experience and the intellectual discipline resulting from it, his academically-minded contemporaries, and there were many, looked upon him as a failure rather than a success. The thoroughly Italianized Sandrart granted Rembrandt that he was 'not lacking in observation of nature nor sparing in industry and constant application', but deplored the fact that

. . . he had never visited Italy or other places where he might have studied antiquities and art theory; and since he could only read Dutch—and even that badly—he could find little help in books. Thus he never changed his ways and did not hesitate to contradict our theories on anatomy and the proportions of the human body; on perspective and the usefulness of classical statues; or on Raphael's art of design and on rational art education; and he also argued against the academies which are so very necessary to our profession, reasoning that one should only, and exclusively, follow nature and no other rules.[25]

While the future of European painting lay with Rembrandt who resisted the alluring call of the south, the academicians, everywhere in command of official art policy, went on fostering the Italian journey as obligatory. Indeed, in the course of the eighteenth century the general public

joined the artists in ever greater numbers: the Grand Tour to Italy with Rome as the goal became an imperative requirement for a man of good breeding. Such a man, the Earl of Shaftesbury assures us, must form

... his Judgment of Arts ... upon right Models of *Perfection*. If he travels to Rome, he inquires which are the truest Pieces of Architecture, the best Remains of Statues, the best Paintings of Raphael, or a Carache. However antiquated, rough, or dismal they may appear to him, at first sight; he resolves to view 'em over and over, till he has brought himself to relish 'em, and finds their hidden *Graces* and *Perfections*.[26]

At the end of the century Rome became the occasion for a monumental clash between the divergent claims of academic propriety and personal freedom. The quarrelling parties were the mediocre German painter, Jacob Asmus Carstens (1754–98), and the Prussian Minister von Heinitz. After a difficult youth Carstens went to study at the Copenhagen Academy. In 1783 he set out for Rome together with his brother, also a painter, and a friend, the sculptor Busch. Like wandering craftsmen of old they went on foot, but never got beyond Mantua. In 1788 Carstens appeared in Berlin where he was eventually appointed Professor at the Academy. The thought of Rome seems never to have left him and soon he approached the Minister, who sanctioned a leave of absence. In October 1792 he arrived in Rome, fortified by his full professor's salary and a handsome expense account. At first his correspondence with Berlin was polite enough, but in his third year in Rome he decided to resign his academic position without any qualms about his financial obligations. Understandably, the Minister fumed. 'What useful services have you rendered the Academy for all this money?' he asked the painter in a letter of December 19, 1795, and requested him to refund the entire sum. In his long-winded answer of February 20, 1796, Carstens complained of being unjustly treated; for, he argued, 'I have used to proper purpose and conscientiously the pension given me by His Majesty for my further education ... I deny that I have any obligations towards the Academy.' The letter ends with a climax which should be quoted in full:

I wish to tell your Excellency that I do not belong to the Berlin Academy but to mankind. It never entered my mind nor have I ever pledged myself to become the slave of an academy for the rest of my life in return for a pension which was a present given to me for a few years in order to further my talent. It is only here, among the finest works of art in the world, that I can study, and I shall continue to the best of my capacity to justify myself before the world through my works. Renouncing all advantages of my position, I prefer to face poverty, an uncertain future and, in view of my already weak constitution, possibly a frail and helpless old age, in order to fulfil my duty and my calling. My faculties have been entrusted to me by God; I must be a conscientious steward so that, when the day comes and I am told: render an account

of your stewardship, I need not say: Lord, the talent that Thou hadst entrusted me I buried in Berlin.[27]

Carstens' absurd heroic sacrifice offered to the *manes* of Rome was in vain. Apart from a few specialists the world no longer takes much note of his work. His dry classicism was the fruit of academic training (Fig. 8), but his thirst for freedom seems to presage a new age. On the other hand, his behaviour was perhaps not so different from that of the young Garofalo, in a pre-academic period. Both refused to accept responsibility and authority, though under completely different conditions. There is a thin dividing line between ardour and obsession, and if Rome became an obsession with many artists, they showed a frame of mind characteristic of the profession since the Renaissance.

4 Obsession with Work

It may be objected that our last statement is not particularly revealing. If 'obsession' can be defined as a 'persistent and inescapable preoccupation with an idea or emotion',[28] most sane persons, or in any case those temperamentally inclined to strong attachments, are 'obsessed'. We, by writing this book, are in the company of passionate rugby fans, card-players, stamp collectors, the inventor of the first cartwheel, and the pedant who counts the nouns in Homer. Leaving aside psychotic obsessions, 'normal' obsessions, whatever their ultimate psychological cause, belong to the most characteristic behaviourist attitudes of *homo sapiens*; to find them among artists is therefore only to be expected. But obsessions also have an impersonal, collective history, dependent on periods, regions, social strata, professions, and many other factors: from the fifteenth century on, Rome became a collective obsession of artists.

It was not the only one. At the same period the guild controls began to slacken and concurrently changes in the artist's attitude to his work, real as well as imaginary, were noticed. Instead of being subjected to the regulated routine of a workshop, the artist now was often on his own and developed habits compatible with his freedom. Among other idiosyncrasies for which there was little scope in earlier times he developed an excessive zeal for study and work. Because of Vasari's bias we are comparatively well informed only about Tuscan artists during the fifteenth and sixteenth centuries, but it is well to remember that Florentines were, in fact, the most progressive artists in Europe during the critical period, and if Vasari conveys the impression that his countrymen showed a greater obsession with their work than others he may not have been entirely wrong, for it was in Florence that the new type of artist first took tangible shape.

We have more than once had occasion to discuss Vasari's reliability.

Regarding fifteenth century artists, he had at his disposal a miscellaneous tradition, but though some of the following material may be anecdotal, we side with Plutarch in accepting anecdotes as valuable material for the characterization of men of distinction. In Vasari's time it was still remembered that the great Masaccio (1401–28)

... was a very absent-minded and careless person; having fixed his mind and will wholly on matters of art, he cared little about himself and still less about others. And since he would never under any circumstances give a thought to the cares and concerns of the world, nor even to his clothes, and was not in the habit of recovering his money from his debtors, except when he was in greatest need, Tommaso was called Masaccio (Silly Tom) by everybody.[29]

The corollary to obsession with one's work is indifference to dress, cleanliness, food, family, public affairs; in short, to everything outside the object of the fixation. Vasari's *Lives* abound with this theme and it is worth noting the many different angles from which he approached it.

Luca della Robbia (1400–82) founded a workshop which was later carried on by his nephew and great-nephews and which supplied churches and public buildings as well as private houses with a truly stupendous number of majolica works. He was first placed by his father with a goldsmith, but decided to become a sculptor.

Having abandoned the craft of a goldsmith he applied himself so much to sculpture that he did nothing but ply his chisel all day and draw all night; and this he did with so much zeal that often, feeling his feet frozen at night and wanting to warm them without getting up from his drawing, he would put them into a basket full of wood-shavings.[30]

Of Paolo Uccello (1397–1475), pupil of Ghiberti and friend of Donatello, a great experimenter apart from being a great painter, the story went that

... without ever pausing for one moment, he pursued his studies of the most difficult problems in the art of [perspective].

Because of these investigations he remained secluded in his house, almost like a hermit, for weeks and months, without knowing much of what went on in the world and without showing himself. Spending his time on those caprices, he knew, while he was alive, more poverty than fame.

He left a wife who used to relate that Paolo would spend the whole night at his drawing-board trying to find the rules of perspective, and when she called him to come to bed, he would answer: 'Oh, how sweet is this perspective!'[31]

A fellow-citizen of Vasari's was driven to truly alarming lengths by his devotion to the study of the human body. Bartolomeo Torri, whose birth-date is unknown, but who died as a young man in 1554, had left his native Arezzo in order to study in Rome under Giulio Clovio. A mutual

acquaintance of Clovio's and Vasari's related that Clovio had to turn Torri out of his house

. . . for no other reason than this filthy Anatomy, for he kept so many limbs and pieces of corpses under his bed and all over his rooms, that they poisoned the whole house. Besides, by neglecting himself, and by thinking that to live like a foolish philosopher, dirty and wayward, and to avoid the society of other men was the best way to become great and immortal, he ruined himself completely.[32]

Even minor painters were carried away, it seems, by the wave of general enthusiasm. Without Vasari's partiality to all Tuscan artists, the name of Cristofano Gherardi (1508–66) might easily have sunk into oblivion. Born in San Sepolcro near Arezzo, Gherardi served a brief apprenticeship with Rosso Fiorentino, then entered Vasari's studio and remained in his countryman's employment until his death. His passion for decorative work such as grotesques, fruit garlands and the like was so great that

. . . the morning had scarcely broken into day when Cristofano would appear at his work, at which he took such care and which delighted him so much that very often he would not dress properly before setting out; frequently it even happened that in his haste he put on a pair of shoes—which he kept under his bed—that did not match, but were of two kinds; and quite often he wore his cloak wrong side out, with the hood on the inside.[33]

Following Vasari's lead, later biographers, too, liked to spice their reports with similar reminiscences; the dedicated spirit of the Renaissance pioneers seemed to animate succeeding generations also. Again, *prima facie* we have little cause to reject the gist of their stories: they would hardly praise an artist's diligence if, in fact, he had been a notorious loafer. We do not want to tax the reader's patience with too many of these tales, but one or two examples chosen from each of the most renowned biographers may be given.

The painter and architect Lodovico Cigoli (1559–1613) emerges ever more clearly as one of the great masters of the end of the sixteenth century. He was born near Empoli and, at the age of thirteen, went to Florence where he entered the studio of Alessandro Allori, a late-Mannerist painter who enjoyed a considerable reputation. Art historians who discuss Cigoli hardly mention the artist's precarious state of health in his youth and his serious breakdown. Baldinucci's report is circumstantial:

Alessandro Allori had a few rooms in the cloister of the venerable basilica of San Lorenzo; being a student of anatomy, he continuously brought there human bodies which he skinned and cut up according to his needs. I do not know whether the young Cigoli [who, it should be remembered, was at that

time little more than a boy] wanted to keep his master company or whether he wished to satisfy his inclination for studies so necessary to his art, but the fact is that he spent days and sometimes whole nights amidst these melancholy operations. In the end his youth could no longer resist the violent disgust which his senses suffered from the frightful sight of the dead and the odour of corruption. At last he broke down under the weight of an illness which, among other torments, not only deprived him of his memory but from time to time gave him epileptic fits; so much so that in order to save his life the doctors forced him to leave Florence.[34]

In their endeavour to learn to understand the structure and the movements of the human body, fifteenth and sixteenth century artists went to inconceivable lengths. The church, of course, objected on principle to the desecration of the dead, but some friendly clerics proved helpful. Michelangelo's biographer Condivi gives us to understand that the Prior of S. Spirito conspired with the young master to make it possible for him to study corpses in a special room of the monastery. The indefatigable Leonardo dissected no less than thirty bodies, and 779 drawings for the book on anatomy which he planned to publish are still extant. Such enthusiasm subsided in the seventeenth century when it was no longer necessary for artists to delve in this field: they found their academies amply stocked with skeletons and *écorchés* (flayed figures) which can still be seen in many art schools, now redundant relics of an activity which was once of absorbing interest. In any case, for a fairly long time it seems to have remained a point of professional honour to prove one's devotion to art by suppressing all instinctive reactions to such grisly work as dissecting under the most unhygienic conditions. Cigoli's contemporary, the Dutch painter and engraver Hendrick Goltzius (1558–1617), appears to have surpassed even his colleagues' stamina in facing putrefaction. In October 1590 he left Haarlem for Rome where he arrived early in 1591.

At that time poor Italy was oppressed by a great famine with a high mortality. The streets were, so to speak, covered with corpses, some dead from hunger, others from disease. Goltzius found himself drawing in places where the stench of the dead bodies brought him near to fainting, such was the fervour with which he had thrown himself into his studies.[35]

Giacomo Palma (1544–1628), called Palma Giovane to distinguish him from his uncle Palma Vecchio, began his career when the aged Titian and Michelangelo were still vigorously active. His long working life extended from the late flowering of the Renaissance through the Mannerist period and into the Baroque. Before he died such artists as Rubens and Bernini had created many of their masterpieces. But, unperturbed by the great changes he witnessed, Palma continued the Mannerist

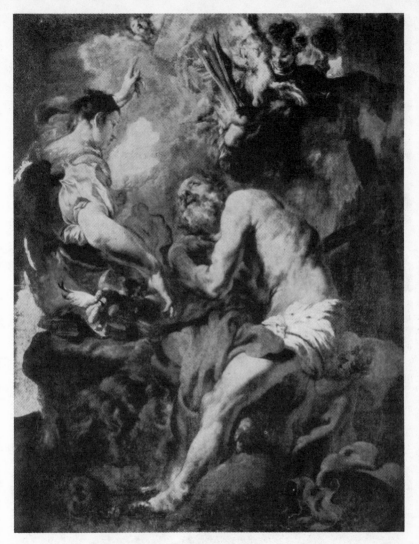

15. Jan Lys (1597–1629), The Vision of S. Jerome. Pinacoteca, Vicenza. An earlier
and smaller version of the large painting of *c.* 1628 in S. Nicolò dei Tolentini, Venice.
Lys painted many works in a fury of creativity revealed in the verve of his brush
stroke. Such bursts of energy were often followed by periods of inaction.

16. Franciabigio (1482–1525), Marriage of the Virgin, before 1515. Fresco. Detail. SS. Annunziata, Florence. Offended because his work had been unveiled before it was finished, the irascible painter damaged some of his figures with a bricklayer's hammer. The result can be seen to this day.

tradition of his youth and, being an entirely devoted painter, he remained equally unruffled by personal attachments.

He was of a very healthy constitution and, having no thought other than to work, he always lived far removed from those worries and passions which in a short time reduce a man to the grave. Thus, when his wife was being buried, he began to paint, and when the women returned from the funeral, he asked them whether they had accommodated her well.[36]

Carlo Maratti (1625–1713), the leading Roman painter of the late seventeenth century, built his accomplished style on the passionate study of his youth. At that time he had always remained 'far removed from every form of juvenile levity'. Not a day had passed

. . . without his studying the ever commendable works of Raphael. He was the first to enter those rooms [in the Vatican] and the last to leave them, taking no heed of heat or frost and the excesses of the season. He endured the winter without heating and in summer lost no daylight with sleep. For his nourishment and sustenance, he took nothing but some bread and a small flask of wine together with some other light refreshment against hunger. Then, having drawn the whole day, he left St Peter's and the Stanze to go in the evening to the Academy of his master [Andrea Sacchi], who lived far away in strada Rosella, near the Quattro Fontane. After the closing of the Academy he would travel as far again, or even further, in the shadow of the night to the Trastevere and S. Pietro in Montorio, where his brother lodged, fearing neither wind nor rain and never stopping for any reason that might have detained him. At home, after having refreshed himself and rested a little, he would begin his night's vigil by exercising his ingenuity with subjects of his own invention, giving them shape in fantasies and drawings.[37]

The rather endearing figure of a minor painter, the Venetian Niccolò Cassana, called Niccoletto (1659–1713), the son of the Genoese Giovan Francesco Cassana, may also be mentioned. He enjoyed a certain reputation for his portraits and mythological scenes. After having worked for the Florentine court, he spent the last years of his life in England where his fierce southern temperament—'all fire and flame'—must have caused quite stir.

When painting, Niccoletto would get so absorbed in his work that he did not even hear when somebody asked him a question. And when his colours did not come out as lively and warm as he would have wished, he almost became frantic, throwing himself on the floor and shouting: 'I want some spirit in this figure, I want it to talk, to move, and I want blood to circulate in its veins.' In short, he said he wanted all that he found missing. Then, taking his brushes again, he repainted it, correcting here, adding there, as he thought necessary, carrying on either contentedly or giving vent to even greater fury: such was his desire to be better than merely good.[38]

Anton Raphael Mengs (1728–79), whose Neoclassical paintings are the jejune products of his passionate belief in academic principles, was a ceaseless worker. Born in Bohemia, he settled in Rome and died in Madrid. His biographer and friend, the Cavaliere d'Azara, Spanish Minister in Rome, tells us about his habits:

At the dawn of day he began his labour, and without interruption except to dine, he continued till night; then, taking very little food, he shut himself up in his house, at some other work, either drawing or preparing materials for the following day.

His whole pleasure during his life was painting and study, from which nothing could ever divert his mind.[39]

A passage from a letter by Salvator Rosa may conclude this survey. Known for his sparkling wit, celebrated as a poet and composer of music, painter of enormously popular large battle-pieces as well as of small seascapes and landscapes, Rosa always scorned the easy success of these works, because to him—a champion of the classical tradition—nothing but religious or historical subjects constituted High Art. When at last 'after thirty years spent in Rome, thirty years of shattered hopes and constant disappointments', he was given a commission for an altarpiece, his joy was boundless and his application to the task extreme. 'Ring the bell,' he wrote on October 11, 1669, to his friend Giovan Battista Ricciardi when he had finished the large panel with the martyrdom of the Saints Cosmo and Damian for S. Giovanni de' Fiorentini in Rome. 'This work has not only kept me away from the pen, but also from everything else in the world and I can tell you that sometimes I even forgot to eat. My effort has been so great that towards the end I was forced to spend two days in bed.'[40]

Passeri, a friend of Rosa's, met the painter one evening on the Pincio shortly after the unveiling of the work. Rosa's self-satisfaction was embarrassing and irritating, for he boasted that he had surpassed Michelangelo, and Passeri quickly changed the subject.[41] The painting itself (Fig. 9) proves that effort and results are not always on a par.

In 1547, three years before Vasari's *Lives*, Johann Neudörfer of Nuremberg wrote one of the earliest German collections of biographical notes on artists. A comparison of the titles alone reveals the difference between the Italian's advanced and the German's traditional approach to art. Vasari called his work *Lives of the most excellent Painters, Sculptors and Architects*; Neudörfer entitled his *Information about Artists and Craftsmen in Nuremberg*, and his brief texts confirm that he did not at all differentiate between painters, sculptors, and artisans. Moreover, while Vasari, as well as all the Italian biographers who followed him, stressed obsession

asses, need leisure for thought and creative activity,
equently prevented by circumstance from attaining
artists, often masters of their own time, can follow
tion. Thus many Renaissance artists, determined to
g for introspection, conspicuously departed from the
p tradition.

know, another type of inertia, one that results from
acy or resignation. We may mention the case of
bo (1485–1547) who 'changed from a zealous and
one most idle and negligent'. Vasari, envious of the
nitial success in Rome and of Michelangelo's warm
believed that the fault lay partly with 'the magnifi-
pe Clement VII' who bestowed 'too rich a reward'
aking him Keeper of the Papal Seal in 1531, and
he painter for taking 'so much pleasure in wasting
l talks that he spent whole days idle'.[54] But Vasari
ay well have been Sebastiano's own explanation:

means of subsistence, I will not paint any more, because
world men of genius who do in two months what I used
d I believe that if I live long enough, which will not be
l find that everything has been painted. And since these
uch, it is well that there should also be one who does
have more to do.[55]

ter, Andrea Sacchi (1599–1661), one of the great
an Baroque, argued on similar lines. Passeri reports

an uneasy mind; knowing perfectly well the difference
d the better, he was never content.
ds of his reproached him for his laziness and asked the
so slow in his work, he answered: 'Because Raphael and
ighten me and make me lose heart.' And he added that
rtune of his time not to have friends with whom he could
s inherent in the painter's profession and that this was
asons: men were either unaware of these difficulties or,
t wish to talk about them.[56]

Sebastiano del Piombo, Sacchi persevered. He was
ed with theoretical problems and, in fact, had ample
cuss them. Although 'he spent whole days without
he kept on working until the very end of his life'.[57]
different context that despair born from the feeling
dequacy seems to have been comparatively rare
, in any case, not a predicament to which the new

with work as a characteristic trait of the new race of artists, Neudörfer
referred to it only incidentally and without discriminating. He talks of a
watchmaker who 'was so dedicated to his art that he completely lost his
memory—nay his reason' and of a locksmith 'so over-zealous in his
searchings and ponderings that he forgot his meals'.[42] It was due to the
new Italian conception of art and artists that 'over-zealous' locksmiths
and watchmakers dropped out of scholarly discussions and that only
inspired painters, sculptors, and architects were deemed worthy of
attention. The more artists disengaged themselves from craftsmen the
more they were expected to display—and did display—symptoms of
behaviour not associated with the rank and file citizen.

But Neudörfer's text calls to mind our previous observation that
obsessions were by no means peculiar to the new type of artist. It would
be rash to maintain that Renaissance artists showed a more intense
application to their work than medieval craftsmen. Nevertheless, since
they were no longer tied to a prescribed day in the workshop, they could
indulge in their idiosyncrasies as they pleased and, if they wanted, all the
time. Even this is not so different from other, mainly intellectual,
professional groups, but by insisting on the difference, an image of the
otherness of artists began to evolve. Additional traits of character,
partly contradictory to what we have heard so far, gave this image more,
and rather ambiguous, substance. It appeared that the new type of
artist was not only much addicted to work, but that he could also be
exceptionally lazy—to such an extent that in time his laziness became
proverbial.

5 Creative Idleness

Jacques était paresseux comme tous les vrais artistes
Henry Murger, *Scènes de la vie de Bohème*

Our concern here is, of course, not congenital laziness, timeless and
international, the scourge or the redress of mankind according to the
viewer's standpoint. The laziness we mean is different in essence and we
suggest, therefore, that it should be termed 'creative idleness'. One of
the hallmarks of the emancipated artist was his need for introspection
and introspection necessitates pauses, often of considerable length. The
skilled hand of the craftsman may be made to work at will, but the 'gift
of inspiration' cannot be forced. From the late fifteenth century onwards,
we find that with some artists periods of most intense and concentrated
work alternate with unpredictable lapses into inactivity. Early reports
about this unaccustomed behaviour in artists are not very frequent, but
some are gratifyingly explicit. A contemporary of Leonardo da Vinci has
left us a vivid description of the latter's procedure when painting the
Last Supper. According to him

Leonardo had the habit—I have seen and observed him many a time—of going early in the morning and mounting the scaffold, since the Last Supper is rather high off the ground, and staying there without putting down his brush from dawn to dusk, forgetting to eat and drink, painting all the time. Then, for two, three, or four days he would not touch it and yet he would stay there, sometimes one hour, sometimes two a day, wrapped in contemplation, considering, examining, and judging his own figures. I have also seen him— according to how he was taken by his caprice or whim—leave the Corte Vecchia, where he was working at that superb horse of his in clay—and go at midday, when the sun is at its highest, straight to the church of S. Maria delle Grazie, where, ascending the scaffolding, he took the brush and gave one or two strokes to those figures, and then at once went away again to some other place.[43]

Leonardo himself 'reasoned that sometimes great minds produce more when working less. For with their intellect they search for conceptions and form those perfect ideas which afterwards they merely express and portray with their hands.'[44]

Like Leonardo, Pontormo is a case in point. We have no reason to doubt Vasari's account: 'Sometimes, setting out to work, he began to think so profoundly about what he was going to do that he came away without having done anything all day but stand lost in thought.'[45]

The sculptor Rustici argued that 'men who toil the whole day, that is, those who work for their living rather than for honour, are actually workmen; works of art cannot be executed without long reflection'.[46]

These passages must be considered in conjunction with another problem: the artist's natural talent. From the beginning of the sixteenth century onwards, statements are common about artists being born not made. Leonardo insisted that painting 'cannot be taught to those not endowed by nature' and he declared painting to be more sublime than the sciences because works of art are inimitable.[47] The Venetian Aretino, one of the most gifted *literati* of the sixteenth century, was a passionate champion of inborn artistic genius;[48] in a letter of 1547 he expressed his conviction epigrammatically: 'Art is the gift of bountiful nature and is given to us in the cradle.'[49] His friend Lodovico Dolce, in his *Dialogue on Painting* of 1557, made this view his own;[50] and later in the century Lomazzo reiterated that 'those who are not born painters can never achieve excellence in this art, that is, if they are not blessed with creative gifts and the concepts of art from the cradle'.[51] The work of the artist who is thus endowed by nature cannot be measured in terms of working hours spent on manual labour.

How artists looked upon this matter shortly before the middle of the sixteenth century may be gathered from Francisco de Hollanda's *Dialogues*. Hollanda puts the following words into Michelangelo's

type of artist easily succumbed. The despair of the solitary soul, however, was only too well known to them. Indeed, solitude and secrecy are among the conspicuous phenomena which separate Renaissance artists from medieval craftsmen.

6 Creation in Solitude

> With men thou canst not live
> Their thoughts, their ways, their wishes are not thine;
> And being lonely thou art miserable.
>
> Matthew Arnold, *Empedocles*

It is not our intention to enlarge upon the fascinating history of the problem of solitude in its general aspect. But in order to see the behaviour of numberless artists in a wider perspective, we have to recall that seclusion belongs to the distinct pattern of intellectual life in East and West alike. Anchorites and men of letters, philosophers and mystics yearned for, and often attained, this way of existence. To be sure, the narcissistic withdrawal from the world has ambiguous motives and ambivalent effects: it may lead to misery as well as to contented release. Petrarch, one of the first Italians to long for the solitary life, gave literary expression both to his elation and to his despair. He often described to his friends his solitary rambles through the woods of Vaucluse 'abjuring the tumult of cities, shunning the thresholds of the proud, laughing at the concern of commonalty, equally far from joyfulness and sadness'.[58] But in *De secreto conflictu* he described the nightmares that beset him: a kind of melancholy ('*acidia*') 'grips me sometimes so tenaciously that I am tormented through long days and nights; for me this is a time without light or life—it is a dark inferno and most bitter death'.[59]

Michelangelo, who suffered all the agonies of seclusion, also experienced its more joyful sensations: 'There is no peace to be found except in the woods,' he wrote to Vasari from a rest at Spoleto.[60] But it is not this arcadian side of the solitary life that we have to consider, for the intellectual recluse of the Renaissance primarily felt the pangs of isolation. Erasmus, the most European of sixteenth century humanists, the centre of a large circle of friends, unceasingly active and seemingly the very opposite of a recluse, was yet of a most retiring disposition. 'I have always wished to be alone, and there is nothing I hate so much as sworn partisans', and he calls himself 'the most miserable of all men, the thrice-wretched Erasmus'.[61] Many artists of the late fifteenth century and the first half of the sixteenth conformed to this type. When they aligned themselves with scholars and poets, they stepped outside the pale and developed symptoms, often even to an excessive degree, of the class they joined.

Since we are concerned with the artists' attitudes to their work, the discussion of one specific aspect of seclusion is here in order, namely creation in solitude. It is well known that Michelangelo never allowed anyone, not even the Pope, to be near him while he worked. Critics have mistakenly regarded this as one of Michelangelo's personal foibles. In actual fact, artists like Piero di Cosimo, Pontormo, and many others behaved similarly. They may often have acted on impulse, but they also knew how to justify their behaviour. Leonardo wrote that 'the painter must live alone, contemplate what his eye perceives and commune with himself'.[62] Even Vasari, himself a painter, explained (vii,270) that 'love for his art' makes an artist 'solitary and meditative' and deemed it necessary 'that he who takes up the study of art should flee the company of men'. He defends the recluse against 'those who charge him with being whimsical and strange' by pointing out that whoever 'wants to work well must keep away from cares and worries since [the attainment of] mastery requires thought, solitude, and a tranquil, not a distracted mind'. The sculptor Giovan Francesco Rustici (1474–1554) who had studied with Leonardo

used to say in his mature age that one must think first, then make sketches, and then the designs. Thereafter one must leave them alone for weeks and months without looking at them; then one chooses the best and begins the execution. This cannot be done by everyone nor by those who only work for profit. And he added that one must not show one's works to anybody before they are finished, so that one can change them without hesitation as often and as thoroughly as one likes.[63]

This passage also supplies an excellent insight into the importance attached to self-criticism as the only valid judgment and the total exclusion of the patron as an active agent during the creation of the work.

Franciabigio (1482–1525), a follower of Andrea del Sarto, took a desperate step when the good fathers of the SS. Annunziata in Florence unveiled, together with del Sarto's frescoes, his own *Marriage of the Virgin*, in the mistaken belief that the work was finished.

Next morning the news was brought to Francia that both his and Andrea's frescoes had been unveiled, whereupon Francia almost died of grief; and filled with anger against the fathers because of their presumption and the lack of respect with which they had treated him—he rushed out, arrived at his work, climbed on to the scaffolding which had not yet been dismantled, and with a bricklayer's hammer which was lying about he smashed some female heads, damaged the head of the Virgin and almost entirely effaced a nude figure which is breaking a staff.[64]

What aroused this outbreak of southern irascibility? Evidently, the

artist did not want the fresco, done in competition with Sarto, to be seen by anyone before he himself considered it as finished. The traces of his hammer, still visible today (Fig. 16), prove the essential correctness of Vasari's report.

Vasari gives us further instances of artists of this generation who enviously guarded their secrets. The Ferrarese painter, Ercole Grandi (c. 1463–1531), we are told, 'was of an eccentric disposition, particularly when he worked, for he made it a rule not to let any man, whether painter or not, see him then'.[65]

More affable men than Michelangelo or Pontormo were given to working in solitude. Tintoretto (1518–94), who was 'of a pleasant and gracious nature', happily married and well-liked by his friends with whom 'he conversed very amicably', was yet of

... such a retiring nature that he lived far removed from any gaiety because of the continuous labours and worries to which he was subjected by the study and practice of his art.

When not occupied with painting, he spent most of his time withdrawn in his studio which was situated in the remotest part of the house, where his occupation required a light to burn all day long. Here, spending the hours which were meant for rest, among infinite numbers of reliefs, he arranged with the help of models made by himself those compositions which were needed for the works he had to carry out. He would rarely admit any but servants there, not even friends, let alone other artists, nor did he ever let other painters see him at work.[66]

At the time of writing, Ridolfi, Tintoretto's biographer, deemed it necessary to defend the artist by explaining somewhat obscurely: 'The art of painting does not render a man eccentric, as some people think, but it makes him careful and prepared for every contingency.'

It seems that even before the seventeenth century the attitude of artists began to change. No longer was creation in solitude regarded as a prerequisite of success. Only in extreme situations would artists impose such a complete blackout as Guido Reni did before agreeing, in 1627, to paint a fresco in St Peter's which was, however, never executed. 'I have requested [he wrote in a letter of August 19, 1627] that not a soul, not even the cardinals, ascend the scaffolding, and the whole Congregation accepted this.'[67]

The great masters of the seventeenth century were far from being recluses. Rubens and Bernini, the most typical exponents of the time, were great gentlemen with urbane manners who never objected to visitors inspecting their studios. They did not even mind working while others looked on. The standards of professional behaviour set in the seventeenth century continued throughout the eighteenth in academic circles. If Michelangelo could have observed Canova in his studio, it

would have caused him some surprise. The German painter, C. L. Fernow, informs us that Canova had 'the praiseworthy habit' of having the ancients read to him while he was working.[68]

In this chapter we have discussed the changing attitudes of artists to their work rather than the changes in working methods. Surrender to the 'Lure of Rome', instead of compliance with medieval migratory habits, is as much a sign of a basic re-orientation as are obsession with work, creative idleness, and creation in solitude. First mentioned in the contemporary literature with reference to a clearly defined Florentine circle, these purely psychological aspects were soon regarded as typical of the profession far beyond the boundaries of Tuscany. But when leading artists embraced a new ideal of professional demeanour, nonconformity lost much of its appeal. For the next two hundred years it lingered on as a mere undercurrent, though sporadically it gained prominence.

CHAPTER IV

ECCENTRIC BEHAVIOUR
AND NOBLE MANNERS

1 *Florentine Eccentrics of the Early Sixteenth Century*

TALES about the strange behaviour of artists are as old as the literature on artists and the adjectives used to describe their foibles are legion. Absurd, peculiar, mad, fantastic, bizarre, eccentric, capricious, whimsical, laughable, and also charming (since the non-conforming conduct has its attractions) are some of the epithets. Such words have sometimes changed their meaning in the course of time; nor can they be translated from one language into another without losing their specific flavour. In settling on 'Eccentric Behaviour' for the chapter heading, we have been aware of the semantic objections the word 'eccentric' may raise; but it seemed to us to have the widest connotations and to be more in keeping with the texts before us than would be the use of a modern term, unknown to writers whose aim was observation rather than interpretation of behaviour. Juan Luis Vives (1492–1540), the great Spanish humanist, expressed this typically sixteenth century approach in his book *De Anima et Vita*, published in 1538. 'What the soul is,' he wrote, 'is no concern for us to know; what it is like, what its manifestations are, is of very great importance.'

It was the visible manifestations as well as the philosophical and moral aspects of psychological problems, not their causes, which interested the artists' biographers and which they recorded. We have presented their stories in groups of similar patterns of behaviour and in roughly chronological order, rather than arranging them according to psychological categories, while bearing in mind that the very term 'psychology' was not known until the last decade of the sixteenth century.

It should be remembered that the theme of the artist's extravagant conduct, known to the ancients, did not enter literature again until the fourteenth century. Many of the stories and anecdotes, however, told and re-told first in the Tuscan *novelle* and later all over Europe, ought to be taken for what they were meant to be: light reading matter designed to entertain with plausible character sketches. The majority of these tales belong to the class of literary *topoi* which Kris and Kurz[1] investigated on a broad basis. But if we read in a late fourteenth century letter written

by the merchant Francesco Datini such remarks as: 'those painters are all full of deceit' or: 'they do exactly what they please' we may take it that the characters in the *novelle* were not freely invented.[2]

In the second half of the fifteenth century the position began to change. With the heightened interest in artists' personalities, we also get the first essentially reliable accounts of their behaviour. It is probably historically correct that the early biographers were facing a particularly 'bizarre' group of artists.

One of the earliest trustworthy reports about an eccentric artist appears in Girolamo Borselli's Bolognese Chronicle and concerns the sculptor Niccolò dell'Arca (c. 1435–94). Perhaps a native of Bari, Niccolò seems to have spent the early years of his active life travelling about. He is believed to have worked in Dalmatia, in Naples, and quite likely also in France. In 1463 he settled in Bologna for good. The chronicler, who died in 1497, three years after Niccolò, had ample occasion to observe the master during the span of three decades. The following characteristics struck him as unusual enough to be recorded:

Niccolò dell'Arca did not want to have pupils nor to teach anybody. He was strange and had barbaric manners; he was so rough that he repulsed one and all. As a rule he lacked even the necessities of life; being pig-headed, he never accepted the council of friends.[3]

Isolated, such a report of strange foibles and manners would be of purely biographical interest. It is only when we can point to similar traits appearing simultaneously or in quick succession in a number of artists that we may be entitled to draw conclusions of a more general nature. Indeed, with his obvious dislike of workshop-companionship, his stubbornness and peculiar behaviour, Niccoló dell'Arca belongs to a well-defined contemporary group of artists. Again it is in Florence and again within the one or two generations active around 1500 that a coterie of eccentric artists can be discerned.

One of the oldest of these is Piero di Cosimo (1461–1521), about whom few dates and facts are known, although Vasari's biography brings him to life most vividly. In his own time Piero was especially praised for his elaborate festival decorations, in particular for his *Triumph of Death* (1511), an enormous black float painted with white bones and crosses, and pulled by oxen. Evidently derived from Petrarch's *Trionfi*, it was crowned by a huge figure of Death wielding his scythe. On the float were many sarcophagi with lids, and every time the float stopped, the lids opened and out stepped figures all clad in black with their skeletons outlined in white paint. Then, sitting down on their tombs, and accompanied by many more 'skeletons' on horseback, they would sing appro-

priate dirges. The spectacle was taken to have political overtones and the songs proved so vastly entertaining that some forty years later Vasari could not refrain from printing a specimen which, roughly translated, ran:

> We are dead as you can see,
> Dead like you will one day be.
> Once, as you, we had life and breath,
> You will follow us in death![4]

Taking up familiar songs from the medieval Dance of Death, the inventor of this successful though peculiar show was, not surprisingly, held by some to be 'rather a madman'. It was known that

. . . he cared nothing for his own comfort and reduced himself to eating only boiled eggs which, in order to save fuel, he cooked when he was heating his glue, and not six or eight at a time but some fifty, and, keeping them in a basket, he would eat them by and by. This life he enjoyed with such gusto that, compared with it, any other seemed to him slavery. He could not bear the crying of children, the coughing of men, the jingling of bells, and the chanting of friars; and when the rain was pouring in torrents from the sky, it pleased him to see it streaming from the roofs and splashing to the ground. He was terrified of lightning and when he heard very loud thunder he wrapped himself up in his mantle and, having closed the windows and locked the door of his room, he crouched in a corner until the storm had passed. He was very varied and original in his discourse and sometimes said such extraordinary things that he made his listeners rock with laughter. But when he was old, he was so strange and eccentric that nothing could be done with him. He would not have assistants standing around, and his foolishness robbed him of all possible aid. When he wanted to work but could not, because of his palsy, he fell into a great rage and tried to force his hands to stop trembling, but, while he muttered to himself, the mahl-stick, or even his brushes, fell from his grasp. It was a pitiful sight. Flies enraged him, and even shadows annoyed him.[5]

Jacopo Pontormo (1494–1556), a generation younger than Piero di Cosimo and for a brief time his pupil, was in his way as eccentric as his master. Orphaned as a small child, he began his apprenticeship probably at the age of eleven and was thought of as a prodigy. He grew up to become one of the outstanding painters of Florentine Mannerism. Pontormo's devoted pupil Bronzino was a friend of Vasari's and very likely told him many details about his master's life. Besides, Vasari, who knew Pontormo slightly, had probably seen with his own eyes the strange house that the painter had built for himself and which

. . . had the appearance of an edifice for an eccentric and solitary man rather than of a well-ordered habitation; to reach the room where he used to sleep

and at times to work, he had to climb a wooden ladder which, after he had arrived, he would draw up with a pulley so that no one could mount the steps without his wish or knowledge. But what most annoyed other men about him was that he would not work save when and for whom he pleased, and after his own fancy, so that often, when he was sought out by noblemen who desired a work by his hand, and once in particular by the excellent Ottaviano de' Medici, he would refuse to serve them—and then he would go and do anything in the world for some low and common fellow at a miserable price.

Jacopo was a temperate and polite man; his manner of dress and way of life were wretched rather than seemly and he lived nearly always by himself, not wishing that anyone should serve him or cook for him.

He was so afraid of death that he could not bear to hear it mentioned, and he fled from the sight of corpses. He never went to festivals, or to any place where people gathered, so as not to be caught in the crowd; and he was solitary beyond belief.[6]

This report conjures up the haunted quality of Pontormo's art (Fig. 10). But no speculation is necessary, for the essential truth of Vasari's Life of Pontormo is borne out by an invaluable document from the painter's own hand. From 1554 to 1556, that is, during the last years of his life, Pontormo kept a diary in which he jotted down day by day, sometimes hour by hour, everything that crossed his mind. It is a moving testimony of a lonely, introspective man, wrapped up in his work and beset by worries about his failing health. During those years he was engaged on the frescoes for S. Lorenzo, begun in 1546 and still incomplete at his death. He dryly records the progress of the work, accompanying the entries with little sketches in the margins. He notes every change in the weather, every irregularity in his physical condition: *when* he was attacked by a toothache; *how long* a spell of dizziness had lasted; *why* he might have been tortured by an obscure pain; what steps he took to alleviate it. He wrote down exactly not only what he ate, but also how much of it: so many figs or eggs; so many ounces of bread, fish or meat, and whether it was boiled, roasted or fried. Here, to give an example, are the entries for the last days of March 1555:

Wednesday I did the rest of the *putto* and had to stoop uncomfortably all day, so that on Thursday I had a pain in my kidneys; and on Friday, apart from the pain, I was ill-disposed and did not feel well and had no supper that night; and on the morning that was the 29th day I did the hand and half the arm of that large figure [the St Lawrence] and the knee and that part of the leg on which rests his hand. That was on the said Friday, and the said evening I did not sup. And had no food until Saturday night when I ate 10 ozs. of bread and two eggs and a salad of borage flowers. Sunday the 31st I had lunch in the house of Daniello, fish and capon; and in the evening I had no meal and on Monday morning I was distracted by pains in my body. I got up and then, owing to wind and cold, I returned to bed and stayed there until 6 o'cl. and

all day long I felt unwell, yet in the evening I supped a little on boiled meat with beets and butter; and I remained thus not knowing what was the matter with me. I think my returning to bed must have harmed me, yet now, at 4 o'cl. in the morning I seem to feel much better.[7]

Lest it be thought that these two great painters, Piero di Cosimo and Pontormo, are typical cases of genius bordering on insanity, we should like to quote the strange habits of Graffione Fiorentino (1455–1527), a slightly older contemporary of Piero's. His dull paintings show no trace of inspiration, yet 'he was a bizarre and fantastic person. In his house he would never eat off a table laid with any other cloth save his own cartoons, and he slept in no other bed than a chest filled with straw, without sheets.'[8]

During this same period there also existed in Florence 'a company or rather a gang of friends', young artists who loved to *épater le bourgeois*. Their leader was Jacone (d. 1553), a pupil of Andrea del Sarto and for a while assistant to Pontormo. They spent their time 'in a round of suppers and feasting', cracking jokes about 'everyone and anything'. Moreover,

. . . under the pretence of living like philosophers, they lived like swine and brute beasts; they never washed their hands, nor their faces or hair or beards; they did not sweep their houses and never made their beds save once every two months; they laid their tables with the cartoons for their pictures, and they drank only from the bottle or the jug; and this miserable existence of theirs, living, as the saying goes, from hand to mouth, was held by them to be the finest life in the world.[9]

We cannot doubt that artists like Piero di Cosimo and Pontormo were deeply disturbed men and probably clinical cases. But neurotics have always existed in every walk of life. We have no idea how many medieval artist-craftsmen were neurotic; and even if there were many (which is unlikely) it would still be uninteresting because nobody would have paid special attention to their troubles. But now artists began to make their entry into the *élite* and their behaviour became a public concern, otherwise it would not have been discussed openly and in print. Moreover, men like Piero and Pontormo were looked upon as eccentric rather than ill, as typical rather than exceptional, and they helped to shape the image of the new artist.

2 Michelangelo's 'Distress of Mind and Temper'

To the names so far mentioned we might have added those of Rustici and Sodoma and many others who have found a place elsewhere in this book. But a discussion of 'eccentric' Renaissance artists cannot omit Leonardo da Vinci (1452–1519) and Michelangelo Buonarroti (1475–1564), whose enigmatic personalities would need more space than we have at our disposal. It is hardly too much to say that no writer engaged

in their study has set pen to paper without attempting to describe and explore their characters. The attraction of such an enquiry is understandable even though the result is doomed to remain inconclusive. Both Leonardo and Michelangelo were Tuscans and both showed the inquisitive mind and the ardent devotion to cogent reasoning that we have come to associate with the Florentine spirit since Dante's time. But in all other respects they had little in common.

Michelangelo's demonic frenzy of creation; his almost unique power to express his ideas with equal force in sculpture, painting, architecture, as well as in poetry; his utter devotion to the few friends he truly loved and his incapacity to be even perfunctorily civil to people he did not care for; his passion for beauty, expressed in many of his poems, and the total neglect of decorum in his personal appearance and daily life—all this puzzled his contemporaries as much as it did posterity. There cannot be many adjectives that have not, at one time or another, been used to characterize his personality. He has been called avaricious and generous; superhuman and puerile; modest and vain; violent, suspicious, jealous, misanthropic, extravagant, tormented, bizarre, and terrible; and this list is far from being complete. Not a single one of the graces, the good looks, the gentleness which fate had reputedly showered on Raphael smoothed the ruggedness of Michelangelo's nature. He was ugly (Fig. 12), rough in manner, over-sensitive, uncompromising. He certainly was an uncomfortable man to live with. Even when young, between the ages of twenty-one and twenty-five, he lived a solitary, squalid life in Rome, removed from social intercourse and from the glamour of the papal court, despite his almost unbelievable success as an artist. His father was alarmed. On December 19, 1500, after his younger son Buonarroto had visited Michelangelo in Rome, he wrote from Florence:

Buonarroto tells me that you live in Rome with great economy, or rather penuriousness. Now economy is good, but penuriousness is evil, for it is a vice displeasing to God and men, and, moreover, injurious both to soul and body. So long as you are young, you will be able for a time to endure these hardships; but when the vigour of youth fails, then disease and infirmities make their appearance, for these are caused by such discomforts, mean living, and penurious habits. As I said, economy is good, but above all things, shun stinginess. Live reasonably well and see you do not suffer privations.[10]

The father's bourgeois ideal of good husbandry and common sense never held any attraction for the son. He stubbornly adhered to his own ways both in his private and his professional life: he suffered no talented assistant near him and refused to collaborate with anyone. None of his studio hands developed into an artist of importance. His obduracy and distrust led to many difficulties with his fellow artists. The projected

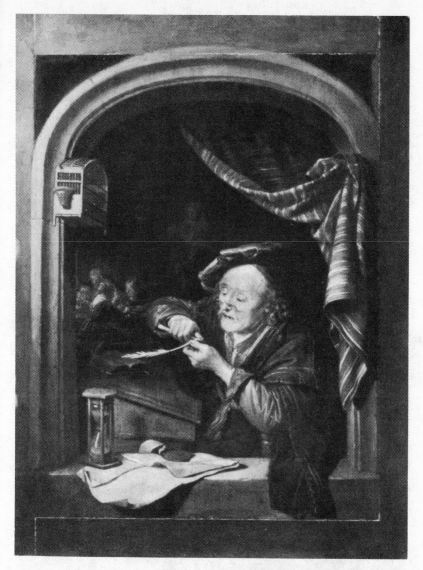

17. Gerard Dou (1613–75), A Schoolmaster sharpening a Pen, 1671. Gemäldegalerie, Dresden. Dou, who was obsessed by a mania for cleanliness, painted his highly-paid cabinet pictures with an exaggerated attention to detail.

18. Parmigianino (1503–40), Self-Portrait. Drawing. Chatsworth.

During the last years of his life the artist sacrificed his career to alchemical experiments and, according to Vasari, walked about almost like a savage. At the time of this portrait he saw himself as a noble thinker with features reminiscent of the traditional representations of the head of Christ.

19. So-called Hausbuchmeister, 'Children of Mercury'. Drawing on parchment, c. 1480. Print Room, Wolfegg.

Those born under Mercury were supposedly industrious, devoted to study, and fond of good living. They included watchmakers, organ-builders, sculptors, and painters. This astrological tradition changed during the Renaissance when men of genius, among them artists, were believed to be melancholic and therefore governed by Saturn.

façade of S. Lorenzo in Florence is a case in point. According to Vasari, Pope Leo X had promised Jacopo Sansovino that he would have a share in the sculptural decoration of the façade, but Michelangelo insisted on doing all the work himself. Vasari's report is correct: a letter of June 30, 1517, in the hand of the enraged sculptor exists, abusing Michelangelo, then at Carrara, in the most violent terms:

The Pope, the Cardinal, and Jacopo Salviati [the Pope's brother-in-law and Michelangelo's friend] are men who, when they say yes, make a contract, inasmuch as they are true to their word; they are not what you make them out to be. You measure them with your own rod; for neither contracts nor plighted troth avail with you, who are always saying nay and yea, according as you think it profitable. I must inform you that the Pope promised me the sculptures and so did Jacopo Salviati . . .

I have done all I could to promote your interests and honour. Not having earlier perceived that you never confer a benefit on anyone and that, beginning with myself, to expect kindness from you would be the same as wanting water not to wet. I have reason for what I say, since we often had arguments, and may the day be cursed on which you ever said any good about anybody on earth.[11]

Thirty years later, in a letter to Duke Cosimo de' Medici, the jealous Baccio Bandinelli recalled the façade of S. Lorenzo and said: 'the reason why Michelangelo has never finished any of his sculptures is simply that he never wanted help from anybody for fear of educating masters.'[12]

Michelangelo was probably unruffled by such accusations. He could, in fact, be helpful and generous, but he was a bad judge of people and all too often extended his kindness to persons of little merit. His two devoted biographers did their best to convince themselves and their readers of his liberality. Condivi explained that he cared more 'to *do* good than to *seem* to do it', and Vasari, after enumerating the many drawings, models, and cartoons which Michelangelo had presented to friends and fellow-artists, exclaimed: 'Who can accuse that man of avarice who gives away for nothing things which might have brought him thousands of crowns?'

All who knew Michelangelo well were acutely conscious of his difficult nature. In 1512, during an audience, the Pope said of him to Sebastiano del Piombo: 'He is terrible, as you can see, and one cannot deal with him.'[13] Michelangelo's *terribilità* became proverbial—to indicate both the tormented impetuosity of his character and the sublimity of his art. Persistent introspection made him a good critic of himself and a few of his meditations throw more light on his personality than the opinions of his friends and enemies.

More than once Michelangelo allows us an insight into the problems that moved him to the core. The essence is perhaps contained in the three lines of a sonnet which remained a fragment:

> Entire understanding none can have
> Before he's not experienced the immensity
> Of art and life.[14]

That experience can only be won in isolation and isolation spells agony.

His suffering is the thread which runs through many of his letters. Already as a young man of twenty-two he wrote to his father: 'Do not wonder if I have sometimes written irritable letters, for I often suffer great distress of mind and temper' ['*gran passione*'].[15] This is the keynote. In 1509 he tells his brother Buonarroto: 'I live here in great distress and the utmost bodily fatigue, have no friends and seek none. I have not even time enough to eat what I require.'[16] And three years later, again to his father: 'I live in a sordid way, regarding neither life nor honours—that is, the world—and suffer the greatest hardships and innumerable anxieties and dreads' ['*mille sospetti*'].[17]

In 1524 he writes to his friend Pietro Gondi:

No-one ever entered into relations with me—I speak of workmen—to whom I did not do good with all my heart. Afterwards, some trick of temper or some madness ['*pazzia*'], which they say is in my nature, which hurts nobody except myself, gives them an excuse for speaking evil of me and calumniating my character.[18]

As a man of fifty he reports to Sebastiano del Piombo about a dinner party: 'This gave me exceeding great pleasure, since it drew me forth a little from my melancholy, or shall we call it my mad mood, not only did I enjoy the supper, which was most agreeable, but far more the conversation.'[19]

In letters of 1542 to his friends Niccolò Martelli and Luigi del Riccio he bemoans his deficiency as an artist. To the former he said: 'I am a poor man and of little merit, who plods along in the art which God gave me, to lengthen out my life as far as possible.'[20] And to the latter: 'Painting and sculpture, labour and good faith, have been my ruin and I go continually from bad to worse. Better would it have been for me if I had set myself to making matches in my youth! I should not be in such distress of mind.'[21] At the age of seventy-four he wrote to his friend Giovan Francesco Fattucci: 'You will say that I am old and mad; but I answer that there is no better way of keeping sane and free from anxiety than being mad.'[22] And at about the same period he put the paradox differently in a famous sonnet:

> *La mia allegrez' è la maniconia*
> *E'l mio riposo son questi disagi*

> Melancholy is my joy
> And discomfort is my rest.[23]

The last quotations seem to leave no doubt that the agonized revelling in self-reflection was a satisfying experience to Michelangelo. But it would be wrong to believe, as is often done, that Michelangelo was an exception. The artists discussed in the first part of this chapter show many similar traits of personality.

3 Leonardo's Aloofness

Michelangelo, the solitary, was nevertheless prolific in supplying posterity with clues to his character, his life, and his work. The vast majority of his letters and sonnets are concerned with his personal reactions, with *his* state of mind, *his* emotions, *his* thoughts about beauty, love, religion, and the ultimate meaning of life and art. Leonardo's writings reveal him as the very antithesis of Michelangelo. The 5300 pages of his extant notebooks are filled with every conceivable kind of observation—observations, however, of an entirely objective nature. Even searching introspection had with him the character of an experiment from which his emotions were strictly excluded. If Vasari is right, Leonardo was beautiful, affable, generous and an excellent conversationalist, well-liked by everybody.[24] Michelangelo, despite his solitary habits, could never escape from passionate entanglements; for better or for worse they were as much a part of him as his heartbeat. Leonardo, despite his urbanity, always remained aloof, shunning involvements of any kind. 'Of his affections, his tastes, his health, his opinions on current events, we know next to nothing', writes Sir Kenneth Clark.[25] And Professor Heydenreich says that 'the inner reserve, the impersonality of his nature, must have been so great as to form an insurmountable barrier between himself and others—a barrier which neither he nor others could cross'.[26] He registered matters of personal or public concern without revealing the slightest reaction: 'On Wednesday, the ninth of July, 1504, my father, Ser Piero da Vinci, notary at the Palazzo del Podestà, died; he was eighty years old; he left ten sons and two daughters.'[27] Can detachment be carried further? A similar note of objectivity is to be found in his observations of disasters:

On the tenth day of December at nine o'clock a.m. the place was set on fire. On the eighteenth day of December 1511 at nine o'clock a.m. this second fire was kindled by the Swiss . . .[28]

A few general meditations, interspersed here and there, seem to be evidence of his desire to avoid, as far as humanly possible, the distractions of the humdrum of daily life and the temptations of personal attachment. The tenor of these notes may be gauged from the following examples:

Intellectual passion drives out sensuality.

Whosoever curbs not lustful desire puts himself on a level with the beasts.

Neither promise yourself things nor do things if you see that when deprived of them they will cause you material suffering. This by experience is proved that he who never puts his trust in any man will never be deceived.

The memory of benefits teaches ingratitude; it is fragile. To the end that well-being of the body may not injure the mind the painter or draughtsman must always remain solitary.

While you are alone, you are entirely your own, and if you have one companion you are half your own, and the less so in proportion to the indiscretion of his behaviour.

Grow in patience when you meet with great wrongs, and they will then be powerless to vex your mind.[29]

Such were the rules according to which Leonardo endeavoured to live. But his self-portrait at Turin (Fig. 11), drawn when he was about sixty, representing himself as a deeply-lined thinker of venerable age, shows a mouth expressive of bitterness and disappointment. Profound scepticism also speaks to us from the extraordinary letter addressed to his half-brother Domenico (?), his junior by more than thirty years:

My beloved brother,

This is sent merely to inform you that a short time ago I received a letter from you from which I learned that you have an heir, which circumstance I understand has afforded you a great deal of pleasure. Now in so far as I had judged you to be possessed of prudence I am now entirely convinced that I am as far removed from having an accurate judgement as you are from prudence, seeing that you have been congratulating yourself on having created a watchful enemy, who will strive with all his energies after liberty, which can only come into being at your death.[30]

One wonders what the brother and his family thought about this congratulatory letter. Freudian analysis *ante festum* and personal detachment have probably never been combined in similar terms. It is this aloofness that determined us to include Leonardo in this chapter. To the eyes of the world his impassibility, his utter control over affections and passions must have seemed as 'eccentric' as Michelangelo's hypersensitive involvements.

But how can we reconcile Vasari's character sketch with this opinion? Vasari owed his information about Leonardo largely to the latter's devoted friend, Francesco de' Melzi, who was, next to Andrea Salai, the only person who lived on terms of intimacy with the much older master and idolized him. This could not fail to colour Vasari's report. Moreover, it seems to us that Vasari resorted in Leonardo's *Life* to the same technique of idealization which he used in Raphael's case and about

which more will be said later. To be sure, certain qualities which he ascribed to Leonardo, such as his liberality, his poise, and his distaste for base motivations, cannot be doubted. One readily accepts Leonardo's own words that he had 'not been hindered either by avarice or negligence, but only by want of time'.[31] Nor can anybody charge him with having ever been driven by mercenary impulses:

As for property and material wealth, these you should ever hold in fear.
Pray, hold me not in scorn! I am not poor. Poor rather is the man who desires many things.[32]

On the other hand, Vasari's account is not without contradictions. Tales about Leonardo's desultory character must have induced him to state that 'he might have drawn great profit from his erudition and knowledge of letters, had he not been so variable and unstable'.[33]

Another contemporary made the same point: 'His life is varied and very irregular, so that he seems to be living day by day.'[34] Vasari is also somewhat critical of his perfection mania and deplores that most of his works remained unfinished. This led him to 'believe that his wilfulness obstructed his outstandingly brilliant mind. Moreover, he was in constant search for excellence above excellence and perfection above perfection.'[35]

In addition, Vasari informs us about the endless number of uncanny, crazy contraptions (*pazzie* is the word he uses) which Leonardo set up in his house in order to frighten his visitors.[36] Finally, his extravagant manner of dressing and his unorthodox ideas about food must be mentioned. At a time when eating habits were far from moderate, Leonardo was a professed vegetarian.[37] The contemporary explorer Andrea Corsali, describing in a letter to Giuliano de' Medici the customs of certain natives, wrote: 'They do not eat anything containing blood; and among them they agree not to harm any living thing just as our Leonardo.'

Evidently, Leonardo's oddity was generally known and talked about. When he described man as 'carnivorous' and said that he was a 'sepulchre for other animals, a resting place for the dead . . . a coffer full of corruption,' he paraphrased, it is true, a passage from Ovid,[38] a passage, however, with which he was in full sympathy as he showed by the following exclamation: 'King of the animals, as thou hast described him [i.e. man] . . . I should say rather—king of the beasts!'

We would venture to conclude that in spite of the reverence for his extraordinary intellectual curiosity and the universality of his genius, in spite of the magic of his unusually fertile and creative mind, Leonardo's personality was no less elusive to his contemporaries than it is to us. Non-conforming habits in a man as conspicuous as he was, must have

greatly added to the impression of strangeness and wrapped in a shroud of mystery this other great solitary of the Renaissance.

The peculiar phenomenon that a number of 'bizarre, strange, eccentric' artists appeared rather suddenly on the historical scene at a specific period and a particular place needs a word of explanation. Some authors have claimed that political, economic, and religious crises lay at the root of Pontormo's and other artists' troubles. It seems hardly necessary to repudiate *expressis verbis* such causal deductions. Upheavals which cast their shadow over the whole community and miseries shared by all rarely produce abnormal reactions in single individuals. There is even less reason to assume that a particular professional group should prove more vulnerable to the effects of general misfortunes than others.

It has also been said that the changing pattern of the social structure and the rise of new ideals and concepts in the Renaissance helped to bring about new types of personality, and this seems to a certain extent correct. The psychological make-up of the Florentine merchant of the Renaissance, for instance, shows distinctive characteristics. Meticulous in financial affairs, carefully calculating, prudent and circumspect, self-assured and hard as nails, these men were at the same time proud citizens, interested in cultural pursuits and champions of a new style of civilized living. The most advanced capitalist state in Europe also generated the near-modern type of capitalist merchant. The artists, on the other hand, though as full of drive and new ideas as their patrons, could not face reality with similar confidence. At this stage of our inquiry we would merely like to suggest that the Florentine artists between roughly 1470 and 1530 had to cope with difficulties for which their intellectual equals, the scholars, philosophers and writers, were better prepared. For the first time since antiquity, artists, too, had to tackle problems which other creative minds had always known. Some of these artists sought refuge from their fellow-citizens in various forms of alienation and this, in turn, helped to foster the idea that artists were by nature a special and an odd kind of people.

4 *Tribulations of Mind and Body*

More tales of eccentric artists made their appearance in the pages of biographical literature soon after Vasari. The following cases will give an impression of the tenor of such reports. We may begin with the pathetic Jacob Cornelisz. Cobaert, or Copé, as he was called in Italy. The year of his birth is unknown. He came to Rome from the Netherlands and found employment with the famous sculptor Guglielmo della Porta who died in 1577. Copé stayed on in Rome, earning his living as a model-maker for goldsmiths, ivory and marble carvers. Not until 1615,

when he was about eighty years old, did he close his eyes on a world in which he had remained a stranger and where the disappearance of his ghost-like figure, 'pale, half-dead, and always with his spectacles on his nose', left no great void. Yet Copé had lived with a dream. For well over thirty years all his secret efforts had gone into the creation of just one original marble work, the statue of St Matthew first destined for the Contarelli chapel in S. Luigi dei Francesi (Fig. 14). It was a nervous, weird, and uninspired work, left unfinished at Copé's death.[39] His biographer, Baglione, who in all likelihood knew him personally, had little sympathy for the old sculptor who

. . . spent his whole life working at this statue, never letting anyone see it and unable to keep his hands off it. Although he had no experience with marble, he refused any advice or help. This man made friends with no-one and lived like an animal, nor did he want either man or woman to enter his house. If by chance he was ill, he let down a string through the window, and calling to some neighbouring housewife, he begged her to buy whatever was needed. The stuff having been put into a basket attached to the string, he pulled it up again. In this manner he spent a long time—an enemy to human intercourse. He was solitary, suspicious and melancholic, trusting nobody.[40]

Next, the painter Federico Barocci (1528/35–1612) may find a place here. Born at Urbino, he belonged to an old family of painters and received careful instruction in architecture, geometry and perspective from his uncle, the architect Bartolommeo Genga. Though highly gifted, and of great importance for the formation of the Baroque style in painting, he was not a genius comparable to the very great. His strongly emotional religious works were much in demand; but his prolific output baffled those who knew the difficulties under which he laboured.

It certainly seems incredible [writes Bellori] to hear of so many public as well as private works having been executed by this master with the utmost diligence and the greatest study combined with the liveliest observation and natural talent, when his incurable illness allowed him only to work for an hour in the morning and another in the evening. Nor could he prolong his effort even in thought, let alone touch a brush or draw a single line; and when he taught young people, as he often did, he took that time out of the only hours which he was permitted to work. All the rest of the day he spent in pain from stomach cramps, caused by continuous vomiting which overcame him as soon as he had eaten.

At night he hardly slept, and even during that short time he was tormented by frightful dreams, and sometimes he moaned and made so much noise that one person would stay by him and wake him on purpose, in order to free him from this oppression. So it went on ever since the day on which he believed he had been poisoned until his death, that is, for fifty-two years, and it seems hardly credible that in such long, uninterrupted and atrocious sufferings he

could stand the fatigue and rigour of painting without ever taking a rest or enjoying some hours of leisure.[41]

Though he published his *Vite* sixty years after Barocci's death, Bellori had, of course, started collecting his material many years before, so that his information may still have come from people who had known the painter. The reliability of Bellori's account is, moreover, supported by letters written by Barocci himself as well as by those who were in close contact with him.

In 1573 Barocci sent a painting together with the following letter to one of his patrons:

I am sending you the picture (Fig. 13), which I know for certain will not satisfy you, because I am not pleased with it myself. And yet it has been born out of so many labours and tribulations which I have suffered and still endure every day that I can swear to you I am beside myself. My mind being so troubled, I was unable to consider well what I have done. But you will excuse me if I have not fulfilled your wishes, for so it is decreed by fate and my ill health which always torments me.[42]

Seventeen years later his health had not improved. In 1590 his patron, Duke Francesco Maria II of Pesaro, wrote to his ambassador, Bernardo Maschi, in Madrid:

It almost seems to us that you are joking when you ask whether count Cincione [the Spanish Secretary of State] may have a painting by the hand of Barocci, for you will have heard more than once that it is not merely a difficult enterprise to extract works from the hands of that man, but quite impossible. You have been informed not only of his natural slowness, which is quite incredible, and the constant indispositions which molest him more and more, rendering him unable to work most of the time, but also of his despair whenever anyone mentions commissioning him for some work. You have also been told how, having accepted commissions some ten years ago for which he has long since been remunerated, he obstinately refuses to accept another until those have been delivered.[43]

In 1597 Duke Francesco Maria had to send an equally negative answer to Prince Andrea Doria. He wrote:

From the letter I had by your Excellency I understand that it is your wish to obtain from here a devotional picture. I would be as ready to be at your service in this as in any other matter, but with regard to works by Barocci I have to tell your Excellency that he works so very little because of his ill health that even I myself can never get a single work out of his hands which was not done expressly to be sent away immediately.[44]

Barocci reached the ripe age of at least seventy-seven years and, considering his intense sufferings during the last fifty of them, one reads with

some admiration that he died 'full of zest for life, with all his senses intact'. One's first reaction, of course, is to think that his complaints betray some form of neurosis or a psychosomatic disease. On the other hand, the disorder may have been caused, as Bellori reports, by an attempt of envious colleagues to poison him. Whether the consequences of this nefarious deed made him physically or psychologically ill for life must remain as conjectural as the story itself. In any case, poisoning was so widely practised for centuries that it might well have been the root of his troubles. Deadly potions and powders were easily available, and difficult to detect before the advent of chemical analysis. Barocci's fears recall those of Lucas van Leyden (1494? –1533) who was said to have been equally plagued by suspicions of poison administered by envious competitors. Like Barocci, Lucas spent much of his time in bed, yet, again like Barocci, he produced an astonishingly large number of works.[45]

The dread of poison was heightened by a widespread belief in witchcraft and black magic and it was by no means only the ignorant or half-educated who took the powers of sorcery for granted. Guido Reni (1575–1624), one of the greatest painters of the seventeeth century, was a victim of such superstitions. While Barocci may have had reason to believe himself poisoned, Reni, so Malvasia informs us, lived in a world of imaginary terrors,

... always fearing poison and witchcraft. He never allowed women around the house. He hated to have anything to do with them, but should this prove necessary, very quickly got rid of them. He was particularly afraid of old women and avoided them, complaining that every time he went shopping or stopped to bargain, there was always one of them about. He wanted servants of the utmost simplicity, even to the verge of stupidity. Should he get presents of food from important people which he could not send back, he would throw them away or let them lie about to be eaten by the worms.

Having conceived a similar suspicion [of witchcraft] when one of his slippers got lost in the house, he went into a rage, and the same happened when he found a woman's shirt among his linen. Everything had to be dipped at once into pure water and dried again. Thereafter he wanted his Marco to do the household washing with his own hands.

One day, whilst I was watching him paint he asked me whether one could bewitch somebody's hands so that he could no longer use the brush or would perforce work badly. It happened to him sometimes that he beheld in his mind's eye, as if in a vision, the most beautiful creations, whilst the awkward and reluctant hand, rebelling against the intellect, absolutely refused to execute them. Aware of his thought, I frankly said no, and tried in the way which my youth allowed to give him some apposite reason. He answered that in Rome a Frenchman had taught him a secret through which one could, by touching someone's hand in a friendly fashion, give him in a short time an

incurable disease from which he would infallibly die. He had, however, an antidote for himself.[46]

Malvasia's reliability is not rated too highly among art historians—we believe unjustly. The intimate traits he reports as an eye-witness have the stamp of trustworthiness. Even the relation between the artist's sublime 'idea' and the incapacity of the hand to render it, was surely much on Reni's mind, because it belonged to the standard themes of Italian art-theory.

Some of the foibles of Gaspare Celio (1571–1640), a Roman contemporary of the great Bolognese Reni, remind us in certain respects of those of the Florentine circle. Celio was a mediocre but inordinately ambitious painter, greedy for titles and honours (see p. 236), who managed to become President of the Accademia di S. Luca in Rome in the face of strong opposition. During his tenure of office he caused trouble and annoyance everywhere because, as Baglione tells us,

. . . he was haughty and did not appreciate anyone of his profession. On the contrary, he not only dared to criticise living artists with the greatest liberty, but also the most eminent among the masters whom we have had in our century. He had his own opinions, and always considered himself superior to others. He was so eccentric that he did not want any living being to enter his house, and not only did he keep the windows closed so that one could not lean out, but he also nailed them down in order that they could not be opened. If by chance anybody knocked at the door, he was answered, though one could not see by whom, and the door was as locked and bolted as the entrance of any secret prison, so that people very rarely entered his house. In this fashion he kept his wife closed in for forty-five years, without her getting any fresh air except for those times when she went out to attend church functions.[47]

It hardly needs special mention that the biographical literature on artists of later periods contains innumerable reports about such 'eccentric' traits as excessive vanity and self-assurance and also of irascibility, vagueness in speech and action, mistrust and unreliability, utmost reserve and unbearable loquacity, and many more vagaries of one kind or another. The great engraver Giovanni Battista Piranesi (1720–1778), for instance, whose etchings of Roman ruins evoke pleasant and nostalgic memories in many a drawing-room, was described by the British architect James Lewis, who knew him well, as 'extremely vain of his works and . . . sensible in the extreme to flattery'.[48] And Piranesi's friend, the architect Robert Adam, gave the following character sketch of him in a letter of October 19, 1755, adressed to his brother James:

[Piranesi is of] such a disposition as barrs all Instruction; His Ideas in locution so ill ranged, His expressions so furious and fantastick. That a Venetian hint is all can be got from him, never anything fixt, or well digested. So that a quarter of an hour makes You sick of his company.[49]

But it would be to no purpose to list more such examples here. At this stage we prefer rather to concentrate on some unusual idiosyncrasies the cumulative affect of which doubtless strengthened the belief in the eccentric behaviour of artists.

5 *Cleanliness Mania*

Of all the various afflictions and obsessions which have beset artists during the centuries under review, cleanliness mania was a remarkably rare one. We have before us Soprani's report on Giovan Domenico Cappellino and Sandrart's account of Gerard Dou. The very care and wonder with which both biographers treat their subject seem to indicate the novelty of their experience.

The Genoese Giovan Domenico Cappellino (1580–1651), an insignificant painter,

. . . was of a serious and retiring nature and therefore alien, even in his youth, to those amusements and distractions which lead young people astray. This helped him to remain fresh, healthy and lively for a long time. He was always moderate and circumspect in his talk, and wanted his pupils to be the same.

His predilection for cleanliness was incredible. He did not want any of his young men to shake his coat, move chairs or walk carelessly in the room in which he was painting, for fear that the rising dust might fall upon his palette. Whenever he asked for the box of brushes or any other thing lying on any small table he would, after he had taken whatever was needed, insist that it be replaced on exactly the same spot and within the area of dust which peradventure might have been raised by even the lightest movement. If, through necessity, a fishmonger or grocer entered the house, he was very careful that they touch nothing, and if by any chance they should touch some object, he immediately had it cleaned in such a fashion as if it had been polluted or infected.

This scrupulous cleanliness of his even went so far that he would not touch coins which he saw to be dirty or earth-stained, and if they were, he made his young man clean them. When he left the house, whoever was in his company had to measure his steps geometrically and walk very lightly, so as not to raise dust or splash mud. One day, as he was walking in a certain street, he noticed that a boy, carrying a flagon of oil in his hands, had passed him. This worried him so much that he returned home post-haste, took off his coat, and fearing it to be stained, never wore it again. His mother once having fallen into the mud, he abstained for a time from going near her, saying that he continuously smelled the odour of mud.

He had already lived in a house for many years when one day he had a slight headache and, suspecting that it might be caused by the rays of the sun being reflected from a wall near his room, he changed houses. But also the new one did not satisfy him, for the charnel house of a church having been emptied in the vicinity, he complained all the time of a bad smell.

Should I tell of all the fastidious scruples of this man, I should never be finished. Yet with such an exaggerated and affected care for cleanliness, this painter ended dirty and neglected. Dirty, because he never allowed anyone to sweep the room in which he slept, nor would he let it be entered so as to make his bed or change his sheets, which he did himself only a very few times in all his life; neglected, because leading so retired a life, he did not even care for assistance when he lay dying.[50]

The Dutch painter Gerard Dou (1613–75) was one of the best-known representatives of the *petite manière*. He had worked as a glass engraver before he started his much-admired *genre* scenes. Dou, who never left his native country, remained unmarried. While travelling in the Netherlands Sandrart visited the artist and was struck by his peculiar ways. This is what he has to say about him:

Once I went with the artist van Laer to see Gerard Dou and his work. When, among other things, we praised the great care which he had lavished on painting a broomstick hardly larger than a finger nail, he replied that he would need three more days to finish it. He surely was a most remarkable painter of still-lifes.

He sold his little works, the largest of which measured about a span, for 600, 800, and even 1,000 and more Dutch guilders. The price of his paintings he figured out according to the hours which he had spent on them, writing them down every day. For each hour he charged a pound in Flemish money, which is $3\frac{1}{2}$ taler. He never worked unless the weather was good, and for everything he needed life models. In later years he always ground his colours on glass and made his own brushes. He was so much upset by dust that he locked up his palette, brushes and paints with the greatest care. When he set down to work he would wait a long time for the dust to settle, then, gingerly, he took his palette out of a little box next to him, and prepared his paints and his brushes meticulously, locking everything up again as soon as he had finished the day's work.[51] (Fig. 17.)

6 *Alchemists and Necromancers*

Ever since the Middle Ages, alchemists have been blamed or praised with equal fervour according to whether they were considered fraudulent, or at least misguided dabblers in secret and occult practices, or whether they were regarded as genuine explorers in the realm of natural sciences. Dante banned them into Hell; Petrarch saw in alchemical studies nothing but 'smoke, ashes, sweat, vain words, deceit and shame'. Rubens, according to Sandrart, declined the offer of the 'far-famed Master Brendel from London' to enter into partnership with him so that they could grow rich together (provided Rubens gave him a house and the necessary funds) with the words: 'Master Brendlin, you arrive twenty years too late, because in the meantime I have found the true philosopher's stone in my brushes and paints.'[52]

On the other side were the countless defenders of alchemy from whom we may single out Salomon Trismosinus, a sixteenth century scholar credited with the once famous work *Splendor Solis*; he called 'noble alchemia—the most beloved art and solace of the poor—a gift from God'. Luther had other reasons to side with the alchemists. He 'liked the good art of alchemy' not only because she was 'truly the philosophy of the ancient sages' and was 'of great use in treating metals but *item* because of her allegorical and secret meanings which are very beautiful, signifying the resurrection of the dead on the Day of Judgment'.

The champions of alchemy remained undaunted in the face of strong opposition. Cupidity and credulity or, if one prefers, untiring *Forschergeist*, never ceased to stir their imagination. Neither strictures nor expostulations, neither papal decrees nor civil laws forbidding the practice could stop the search for the philosopher's stone or the attempts at transmuting base metals into gold. Considering the enormous lure of alchemy it is not surprising to find artists among her devotees—it is only surprising that so few seem to have succumbed to this enticing occupation.

The rational Vasari was, as might be expected, repelled by the devotees of the black arts. His ideal of the well-reasoned, well-balanced artist had little room for those who deserted their vocation for the sake of a whim. He criticized Cosimo Rosselli (1439–1507), the teacher of Piero di Cosimo and one of the Florentine painters called to Rome to decorate the Sistine Chapel, for having been 'so much attracted by alchemy that he spent everything he had [for his passion] as do all who dabble in it. Thus he wasted his life and in the end was reduced from easy circumstances to the greatest poverty.'[53]

Vasari's account of the fatal passion which wrecked the life and work of Parmigianino (1503–40) is flavoured with the same indignation. In 1531 this great and original artist had been commissioned to paint the vaults of the dome of the Steccata, the celebrated Renaissance church in his native Parma. But he became so deeply absorbed in alchemical experiments that he

. . . began to abandon the work, or at least to carry it on so slowly that it was evident that he took little pleasure in it. And this happened because he had begun to study alchemy, and had quite deserted his art, thinking that he would become rich quicker by congealing mercury. Thus, racking his brain, but not with imagining beautiful inventions and executing them with brushes and colours, he wasted whole days, playing about with charcoal, glass bottles, and other such nonsense, which made him spend more in one day than he earned by a week's work at the church of the Steccata. Without other revenues, yet having to live somehow, he was wearing himself out little by little with his furnaces. And what was worse, the men of the Company of the

Steccata, perceiving that he had completely abandoned the work, and having perchance paid him more in advance than was his due, as is often done, brought a suit against him. Thereupon, thinking it better to withdraw, he fled one night with some friends to Casal Maggiore. And then, having cleared his mind a little of alchemy, he painted a panel-picture for the church of St Stephen.

In the end, having his mind still set on his alchemy, Parmigianino, like so many others, grew quite crazy. He changed from a fastidious and gentle person into an almost savage and unrecognizable man with a long beard and unkempt hair. Being so reduced and having grown melancholic and eccentric, he fell a prey to a severe fever and a cruel flux, which in a few days caused him to pass to a better life. And in this way he found relief from the torments of this world, which he never knew but as a place full of troubles and cares. He was buried naked, as he had directed, with a cross of cypress wood upright on his chest.[54]

When it became obvious that Parmigianino's obsession prevented him from finishing his frescoes in the Steccata, the exasperated Commissioners of Work began to cast about for someone to replace him and approached Giulio Romano. Parmigianino, at last realizing the seriousness of his position, tried desperately to cling to his job. Giulio Romano, court-painter at Mantua and a man of the world as well as of principle, knew how to extricate himself from an awkward situation. Although he had at first accepted the Commissioners' offer, he withdrew diplomatically from the affair. In May 1540 he wrote to Parma:

I should be glad for advice as to what I am to do with regard to the work in question for which I promised a design. It is customary among painters not to enter into somebody else's work unless he who began it is agreeable and satisfied, which I had not, in so many words, been told to be the case, but I understood that Master Francesco [Parmigianino] did not want to finish the aforementioned work, nor did your Excellencies care for him to finish it because he kept your Excellencies waiting too long.

Precisely for these reasons the aforesaid Master Francesco has now sent me a beardless, very arrogant young man who told a long story and talked in riddles; he was very devoted and loyal to the said Master Francesco and knew better than a lawyer how to defend his case and confuse yours in such a way that, so far as I could understand him, the outcome could only be a scandal—a thing which I much abhor, the more so as my fortune does not depend on such dubious gains.

I beg you, whom I take to be full of wisdom and discretion, to put your-selves into my position. Since I am by nature desirous to live in peace I think it best for me to return the 25 scudi to you or for the aforesaid Master Francesco to write me a letter, declaring his consent to the enterprise. To prove my case I am enclosing a letter by him from which you will see how much he complains and how offended he is.[55]

Parmigianino's letter to Giulio Romano has survived. It was written on April 4, 1540. Four and a half months later Parmigianino died without having done further work in the Steccata. Whether or not Parmigianino's obsession with alchemy 'may be considered ultimately religious in its intent'[56] is impossible to say. But the impressive self-portrait drawing at Chatsworth (Fig. 18)[57] shows that at the time of the Steccata frescoes he saw himself as a noble thinker with traits reminiscent of the head of Christ, strangely similar to Dürer's self-interpretation a generation before.

A contemporary of Parmigianino's, noted for a similarly reprehensible addiction, was Silvio Cosini (1495–1547). He tried his hand at necromancy. A sculptor and stucco worker from Fiesole, he had found employment in Florence, Genoa and Milan, but he also lived

... for some time with all his family in Pisa; and once, while he was sacristan to the company of the Misericordia, which in that city accompanies those condemned to death to the place of execution, there came into his head the strangest caprice in the world. One night he disinterred the corpse of one who had been hanged the day before and dissected it for art's sake. Being an eccentric, and perhaps even a wizard, and a person who believed in spells and similar follies, he flayed it completely, and from the skin, treated after a method which he had been taught, he made himself a jerkin which he wore for some time over his shirt without telling anybody, believing that it had some great virtue. But having once been scolded by a good Father to whom he had confessed the matter he took off the jerkin and laid it to rest in a grave as the monk had commanded him to do.[58]

The fact that Giovan Franscesco Rustici (1474–1554) was a Florentine of noble family, that he had been admitted to the select group of men who met in the Medici gardens and was a friend of Leonardo da Vinci softened Vasari's pen considerably. He treated Rustici's dabbling in necromancy more as a gentleman's whim than as an artist's straying from his vocation. He thought that

... there never was a man more amusing or fanciful than Giovan Francesco Rustici, nor one who delighted more in animals. He had made a porcupine so tame that it stayed under the table like a dog, and sometimes it rubbed against people's legs so that they drew them in very quickly. He had an eagle, and also a raven which could say a great many things so clearly that it was just like a human being. He also applied himself to the study of necromancy by means of which, I am told, he gave strange frights to his servants and assistants; and thus he lived without a care. Having built himself a room almost like a fish pond, and keeping in it many serpents, or rather grass-snakes, which could not escape, he used to take the greatest pleasure, particularly in summer, in standing and observing the frantic and mad pranks which they played.[59]

A Genoese sculptor of the seventeenth century even paid with his life for his alchemical interests. Domenico Parodi (1653–1703), less distinguished than his father Filippo, Bernini's pupil, yet enjoyed a certain reputation so that

... when Admiral Pekenburgh arrived in Genoa with a squadron of English ships, he wanted to have his portrait done by him in marble and for this purpose he delayed his departure for some time. In the meanwhile Domenico executed the work to the admiral's greatest satisfaction, so much so that, besides paying the agreed price, he made him a present of 40 doubloons and most warmly invited him to come with him to England. But Parodi refused the invitation owing to some fantastic caprices of his. Had he never given in to these, he might have been more proficient in his art; nor would he have met the miserable death which I shall tell of presently.

Domenico was a lover of letters and sciences and had spent all he could earn on costly books. He had formed a rich library of over seven hundred rare volumes, among which he passed the greater part of his time heedless of what he lost by this distraction from his profession. Among those books there were a few which dealt with metallurgy and the fallacious way of making gold. Being too credulous, he gave himself up to lengthy experimentations, and one of these experiments cost him his life. For one day, having closeted himself in his room in order to make an extract of antimony, the venomous vapours were attracted into his vitals. Feeling himself overcome, he rushed out immediately, but he was already half dead, and did not survive this accident for more than three days. It happened in the year 1703, when he was fifty years of age.[60]

7 Weird Hobbies

A less sinister 'craze' than the passion for the occult arts, but one also fraught with disasters, was the devotion to what we would nowadays call hobbies. These extraneous occupations of some artists caused rather mixed feelings in their biographers who half admired and half deplored the energy and ability spent outside their art. Characteristically, the term hobby, which originated in England in the early nineteenth century, does not exist in Italian; the nearest equivalent would be the words *ghiribizzo* and *pazzia*—literally 'whim' and 'folly', an indication that, to the Italians at least, people with hobbies appear somewhat strange and ridiculous. It would seem that artists, wrapped up in their work, rarely needed this outlet for pent-up wishes and emotions. Cherubino Alberti (1542–1615) was rather an exception, at least for his times. A respectable painter and successful engraver, he was raised to the rank of *cavaliere* under Pope Clement VIII and was at one time President of the Accademia di S. Luca. Moreover, he was a member of an ancient family of artists and a man who

... had a wife and children and was comfortably off because all that Giovan

20. Albrecht Dürer (1471–1528), Melancholy, 1514. Engraving. The brooding allegorical figure is a moving self-revelation of Dürer's own state of mind. But he was in good company: melancholy became fashionable in the sixteenth century.

21. Raphael (1483–1520), Detail from the 'School of Athens', 1509–11. Stanze, Vatican. This crouching figure has only recently been recognized as an idealized portrait of Michelangelo. Raphael represented his great rival, then about 35 years old, in the traditional pose of Melancholy, wrapped in solitary thought.

22. Hugo van der Goes
(d. 1482), Detail from the
Portinari Altarpiece, c. 1476.
Uffizi, Florence.
In the Procession of the Magi
Hugo van der Goes shows the
humble and the poor as divinely
illuminated, capable of
directing the proud and
unpleasant looking Kings. The
painter was imbued with the
spirit of Thomas à Kempis's
Imitation of Christ.

23. Hugo van der Goes, Detail from the Death of the Virgin. Musée Communal, Bruges. The picture may date from the last months of Hugo's life, after his recovery from an attack of severe depression. His inner torment, his grief and anguish speak to us from the careworn faces and emaciated hands of the Apostles who keep vigil near the dying Virgin.

24. Francesco Bassano (1549–92), Self-Portrait (usually attributed to Leandro Bassano). Uffizi, Florence.
The gifted son of a famous father and a mentally unbalanced mother, Francesco suffered from anxiety and delusions. He ended his own life in a fit of persecution mania.

25. Annibale Carraci (1560–1609), Self-Portrait. Galleria Nazionale, Parma.
Annibale, aged 33, represented himself as his contemporaries described him: with 'his hat jammed on any old way' and absorbed in thought.

Battista Alberti [d. 1601], his brother had earned was passed on to him as his heir. Enjoying the fruits of Giovanni's labour he lived in his house in happiness and honour. However, he fell into a melancholic humour, or so it was judged by his friends, which consisted in his wanting to construct diverse catapults, such as were used in olden times, before the introduction of artillery. In this caprice he passed all his time, and he had so many of these weapons made that his house was full of them, and now he experimented with one, and now with another, trying out which would throw a greater or lesser weight. It was ridiculous that he should try to work catapults in times when one uses big muskets and formidable cannon. He wanted all his friends to have a try and he himself lost the time which he could have better employed towards improving himself.[61]

Baglione was, of course, right. Catapults were the artillery of classical antiquity. Cannon had been in use as early as the fourteenth century and in Alberti's time they were most effective weapons. His anachronistic experiments, therefore, appear somewhat ludicrous.

While Alberti's biographer, Giovanni Baglione, himself a painter, had obviously no sympathy for a fellow-artist who strayed from the arduous path, the learned *abbate* Baldinucci was more tolerant. His curiosity rather than his wrath was aroused by the versatile Cavaliere Paolo Guidotti (1560–1629) who, in the best Renaissance tradition, was a painter, sculptor and architect; student of mathematics, astronomy, anatomy and law; lover of music, and writer of poems. The painter Matteo Boselli, 'a most trustworthy man who had spent a long time in the school of Paolo Guidotti', told Baldinucci

... that Paolo once got it into his head that he could find a way to fly. With great cunning and much labour he constructed some wings made of whalebone covered with feathers, which he flapped by means of springs arranged under his arms so that they would help him to raise the wings in the act of flying. After very many trials he at last put himself to the test by launching himself from a height and, aided by the wings, he carried himself for about a quarter of a mile, not flying, I think, but falling more slowly than he would have done without them. So Guidotti continued until, tired of the strenuous movement of his arms, he fell on to a roof which collapsed and, crashing through the opening, he found himself in the room below, having suffered a broken thigh through his fall which reduced him to a low state. The same Boselli affirmed that he had seen with his own eyes the fragments of this apparatus.

Guidotti was so inquisitive in matters of anatomy that it was his habit to go by night to those cemeteries where he knew a man had been recently buried, and from the interred corpse he took what part of the body he wanted for his use, and carrying it to a solitary place, as for instance the highest part of the Colosseum, he dissected it and drew such studies of it as he required.[62]

Guidotti's interest in flying should secure him a place, admittedly a none

too distinguished one, in the long history of pioneers, leading back to antiquity and ultimately into the realm of myth. But Leonardo's infinitely more serious experiments had already proven that feathered wings were inadequate and doomed to failure.

One of the foremost German painters of the seventeenth century, Nikolaus Prucker or Brucker (1620–1694), went completely to pieces over his hobbies.

He devoted too much time to his birds, particularly his starlings whom he taught to talk, and also to building little stages on which he performed comedies and plays with puppets moved by wires; these he made jump about gaily and perform some jolly galliard or other dance to the accompaniment of his lute. Furthermore, he invented all kinds of useful tools for painting such as palettes, varnishes, and other similar things, and in particular a marvellous and curious wooden lay figure whose every limb was movable even to the smallest joint of a finger.[63]

Brucker's patron, the Elector Maximilian of Bavaria, liked the artist. He sent him to Italy, appointed him court painter and made him a present of the house in which he had his workshop. The gift included the licence to sell beer on the premises. This time-honoured national drink, 'heavy family cares' and the neglect of his art for the sake of his hobbies reduced Brucker to penury. In the end he had to eke out his living by selling little wooden ladders for chicken coops which he made at home and offered in the street markets.

8 *Sixteenth Century Critics of Eccentric Artists*

The connection between many of the individual cases in this chapter is admittedly a loose one. Men like Piero di Cosimo and Pontormo had deeply troubled natures; Copé was a surly recluse; Gaspare Celio vacillated between braggadocio and morose seclusion. Barocci seems to have been an extreme hypochondriac tormented by pains and frightful dreams; the tenor of his letter of 1573 reflects his agony. Reni and Piranesi, on the other hand, are in different categories altogether. The former shared the superstitions of his age to a marked degree, while the latter combined vanity with an extraordinarily unpredictable mind. Cappellino and Dou were obsessed by the fetish of cleanliness. Others sacrificed their professional standing, their health, their happiness and even their lives to such contemporary crazes as alchemy and necromancy or to some *idée fixe* of their own making.

A kaleidoscopic picture of oddities—but do they belong to the nature of artists? *Mutatis mutandis* these eccentricities, as varied and crazy as life itself, are to be found in other professional groups throughout history and at many periods. Most artists here mentioned were more or less

neurotic individuals among the large mass of entirely 'normal' artists and—although we have no definite way of proving it—hardly represented an unusually high percentage of the profession even if many more names were added. Must we, then, conclude that it was a literary invention of the Renaissance to regard artists as a particularly eccentric group?

This would seem to us a hasty verdict. We already have had occasion to discuss at some length the special position of the group of Florentine artists around and after 1500. The observations thus far made and also those which will follow, inevitably point to the conclusion that in the late fifteenth century a new type of artist emerged with distinct traits of personality. The approach of these artists to their work is characterized by furious activity alternating with creative pauses, their psychological make-up by agonized introspection; their temperament by a tendency to melancholy; and their social behaviour by a craving for solitude and by eccentricities of an endless variety. If this analysis is correct, it would follow that such artists as Barocci and Copé also conformed to type.

But it is unnecessary to indulge in speculations, for the reality of the new type of artist is put into relief by the violence of the reaction against it. As early as the middle of the sixteenth century the non-conforming artist with his foibles and eccentricities was no longer 'fashionable'. It was felt that artists should merge unobtrusively with the social and intellectual *élite*. Vasari himself, to whom any form of extravagance was anathema, reports in the most glowing terms that Raphael

. . . was endowed by nature with all that humility and goodness which one sometimes meets in those who, more than others, add to their humane and gentle nature the most beautiful ornament of felicitous affability. This made him show himself sweet and agreeable to everybody and under any circumstances.

It is true that up to then the majority of artists had by nature something mad and uncouth about them; hence, apart from their detachment from reality and their eccentricity, they displayed the dark shadow of vice rather than the brilliant clarity of those virtues which make men immortal. Raphael, by contrast, was shining most brightly with all the rarest virtues of the soul accompanied by so much grace, learning, beauty, modesty, and excellent demeanour, that all this would have sufficed to cover even the worst vice and the greatest defect.[64]

Even before these words were written, Francisco de Hollanda ascribed the following statement to Michelangelo, surely in order to give it the weight of highest authority:

People spread a thousand pernicious lies about famous painters. They are strange, solitary, and unbearable, it is said, while in fact they are not different

from other human beings. Only silly people believe that they are *fantasticos e fantesiosos*—eccentric and capricious.[65]

The most illuminating proscription of the eccentric artist comes from the pen of Giovan Battista Armenini, who was trained as a painter in Rome between 1550 and 1556. In his *Dei veri precetti della pittura* of 1587 he writes:

An awful habit has developed among common folk and even among the educated, to whom it seems natural that a painter of the highest distinction must show signs of some ugly and nefarious vice allied with a capricious and eccentric temperament, springing from his abstruse mind. And the worst is that many ignorant artists believe themselves to be very exceptional by affecting melancholy and eccentricity.

As a counter-argument Armenini quotes examples of great and learned masters, ancient and modern and, with reference to their immaculate life, continues:

It is certain that this is the way for painters to become great and famous, and not by means of whims and oddities, as we have said. Artists are therefore well advised to keep away from the vices of madness, uncouthness, and extravagance, nor should they aim at originality by acting in a disorderly way and using nauseating language. This is the behaviour of abject and depraved men, nor does it help as a pretext for the ignoramuses to cover themselves with the shield of the difficulties they encounter in becoming proficient. The example of so many excellent artists shows that it is all the other way round.[66]

Similarly, the Milanese, Giovan Paolo Lomazzo (1538–1600), who also had begun as a painter, extolled in his much-read treatises the dignity and rationality of art and artists. In his *Idea del tempio della pittura* of 1590 we read that the artist must be able

. . . to give a reasoned account of everything. This, indeed, constitutes the authority of the painter's art. Moreover, it [i.e. such an approach] will make him moderate, humane, and circumspect in all his actions. This one can also learn from philosophy as is proved by the wise Leonardo, the ascetic Michelangelo, the mathematician Mantegna, the two philosophers Raphael and Gaudenzio [Ferrari] and the great druid Dürer. They acquired praise and fame not so much by the excellence of their art alone as by their humaneness and the gentleness of their manners which made them exceedingly liked and sought after by all with whom they conversed. And this side seems the more necessary in painters and will distinguish them all the more since they are reputed among the vulgar—who usually judge indiscriminately and without consideration—to be capricious and hardly less than mad, because most painters appear to be eccentric and often driven by humours in their discourses. I do not want to inquire now whether this results from their own nature or from the intrinsic difficulties of their art in which they are continually steeped as they investigate her secrets and her most difficult problems.[67]

This body of evidence is extremely revealing and we have to examine it closely. First, we are assured that there had been and still were artists who displayed rather conspicuously a non-conforming behaviour. This had led to the popular conception of the eccentricity of those engaged in the profession and, in turn, encouraged would-be artists to live up to their reputation. But mid- and late-sixteenth century writers disavowed this image of the typical artist and replaced it by a new image: the conforming, well-bred, rational philosopher-artist, who is richly endowed by nature with all the graces and virtues. Vasari himself created the prototype by the literary portait of Raphael's character and demeanour. Henceforth this literary portrait remained the guiding star for generations. Now even Michelangelo was envisaged as having conformed to the new ideal.

9 *The Image of the Noble Artist*

Even before Vasari's first edition appeared, the Venetian painter Paolo Pini had laid down the rules of conduct for the accomplished gentleman artist:

A painter should, above all, abhor all the vices such as cupidity, that vile and despicable part of human nature; improper and dishonest games; intemperance, mother of ignorance and idleness; nor should he live to eat but feed moderately in order to live; unless reason governs him he should shun coition, for it enfeebles virility, humiliates the mind, causes melancholy and shortens life; he should not be familar with vile, ignorant or rash people but converse with those from whom he can learn and derive profit and honour. He should dress fittingly, never be without a servant, and use all the comforts he can and which are made for human beings.[68]

To be sure, the new image of the artist corresponded by and large to Leon Battista Alberti's far-sighted vision, expounded in his *On Painting* more than a hundred years before. But while Alberti visualized his ideal painter as a man of learning, well-versed in all the liberal arts, without laying any particular stress on his behaviour, it was now his morality in the broadest sense on which attention was focused. Such a shift was called for because the non-conforming artist appeared to have an unprincipled and depraved personality. By contrast, the lofty art of a Raphael could only result from a high-minded soul. This concept, moreover, was ultimately derived from the Neoplatonic belief, permeating Renaissance thought, that man's soul is mirrored in his body and, as a corollary, the artist's soul in his work. Marsilio Ficino had clearly expressed this idea in his *Theologia Platonica*, the keystone of Renaissance philosophy:

In paintings and buildings the wisdom and skill of the artist shines forth.

Moreover, we can see in them the attitude and the image, as it were, of his mind; for in these works the mind expresses and reflects itself not otherwise than a mirror reflects the face of a man who looks into it.[69]

According to this theory a depraved character cannot produce works of a high order. The closely allied concept that the painter always paints himself (*ogni dipintore dipigne sè*), noted by Cosimo de' Medici and recorded by Politian,[70] was often repeated in art-theoretical literature far into the eighteenth century and has now come back in modern psychological dress.

We need not give many examples of the continuity of what became a *topos*: that the morality of a man and the quality of his work are inseparable. Suffice it to quote from Jonathan Richardson's *An Essay on the Theory of Painting* of 1715, a pioneering work for England:

The way to be an Excellent Painter, is to be an Excellent Man.

A Painter's Own Mind should have Grace, and Greatness; That should be Beautifully and Nobly form'd.

A Painter ought to have a Sweet, and Happy Turn of Mind, that Great, and Lovely Ideas may have a Reception there.[71]

Even after the modern concept of genius had made its entry, it was first the exalted, lofty, and harmonious qualities that were regarded as characteristic of the very greatest, while the familiar association of genius with madness was not stressed until the nineteenth century. The Abbé Du Bos devoted to this theme many pages of his *Reflexions critiques sur la poésie et sur la peinture* of 1719. He enlarged on such points as the following:

Le génie est presque toujours accompagné de hauteur . . . I speak of the nobility of the heart and of the mind.

Vivacity and delicacy of feeling are inseparable from genius.

Genius is not to be found in a man of cold temperament and indolent humour.

It is the artists of genius who have much more exquisite sensibility than normal people.[72]

Writers influenced by the *topos* of the nobility of the artist were naturally inclined to idealize the lives and characters of their heroes. As an example of this attitude we may refer to Charles Perrault's character sketch of his contemporary, the painter Pierre Mignard (1612–95), published in Perrault's *Hommes illustres* of 1696, and popularized through the abbreviated version appended to the second edition of Roger de Piles' *Abrégé de la vie des peintres*:

His good qualities were not restricted to his professional talent; his *esprit*, his friendliness and the charm of his manners secured him many friends who were

always very devoted to him. His friendship was faithful, loving, and firm. Integrity and uprightness were his by nature. Finally, honourable men found as much delight in his conversation as the connoisseurs in his pictures.[73]

We shall see later[74] that Mignard's character could also appear in an entirely different light.

The question of conformity has, of course, also an important socio-logical aspect, for ever since the emergence of the academies as profes-sional organizations—a development which began in mid-sixteenth century Italy and continued for over two hundred years—the artist saw himself in the rôle of a gentleman and the public complied with this idea. The vicissitudes of this type of artist will be discussed in another chapter. Propriety, it may be said, became the order of the day, and this is one of the reasons for the relative dearth of unfavourable revelations in artists' biographies of the period. Even if certain aspiring artists may in fact have shown more accommodating manners than the eccentrics, they were not necessarily better men.

Looking back from the position of the academic artist, we can now more fully understand the plight of his pre-academic colleague. Not unlike the medieval artist, the academician enjoyed the benefit of a professional organization, a centre towards which his life gravitated. The Renaissance artist, by contrast, partaking no longer in the old and not yet in the new social structure, had to fend for himself. But the development went full circle. The Renaissance artist's fight for libera-tion from the encumbrance of the guilds was re-enacted in the romantic artist's fight for liberation from the ties of the academy. Just as the individualism of the Renaissance artist put an end to the sheltered position of the late medieval craftsman, so the new romantic vocabulary —enthusiasm, naïvety, spontaneity, feeling, autonomy of artistic creation, intuition, totality of vision, and so forth—reversed the principal tenets of the academic artist. The spectre of the artist arose as a kind of being elevated above the rest of mankind, alienated from the world and answerable in thought and deed only to his own genius: the image of the Bohemian took shape, fostered as much by the ideology and conduct of the artists as by the reaction of the society on the fringe of which they lived. Thus we see toward the end of the eighteenth century and at the beginning of the nineteenth problems of personality in the making which, under kindred circumstances, had beset the artists of the Florentine Renaissance circle. With good reason, therefore, we may talk of a proto-Bohemian period around 1500 separated from the Bohemian era proper by the centuries of the conforming artist.

It is always dangerous to fragmentize history in an effort to sort out changing concepts. Naturally, the anti-conventional type had come to stay and one may even discern distinct centres where it flourished.

Moreover, we shall have occasion to see that this type had many facets, particularly in the seventeenth century. But as we have remarked before, compared with the entrenched position of the gentleman artist, the proto-Bohemians were, on the whole, relegated to the wings. In spite of such figures as Caravaggio and Borromini, it may be claimed that Bernini and Rubens, Lebrun and Reynolds embody most fully the seventeenth and eighteenth century ideal of the artist as a versatile, unaffected, well-bred, captivating man of the world.

10 *Rubens—the Perfect Gentleman*

Michelangelo, the great solitary, is as much a representative of the sixteenth century as Rubens, the most accommodating and sanest of all artists, is of the seventeenth. It therefore seems fitting to conclude this chapter with some words about Rubens' personality.

It might be difficult to find another artist who combined so perfectly the genius of a great painter with the skill of a professional politician; who was an accomplished linguist and avid reader, equally at home with artists, scholars, and kings; who was, moreover, blessed with poise, good looks, and two extremely harmonious marriages. His Italian biographer, Bellori, describes his affability and prudence, his erudition and eloquence, his alert mind, broad culture, and all-embracing intellect. He was, of course, an artist to Sandrart's taste. The German writer knew him well and recorded that

... he was generally highly esteemed because of his agreeable conversation, his knowledge of languages, and his polite manners.

Quick and industrious in his work, he was courteous and kind to everybody and since all found him pleasant he was very popular.

I waited upon him with delight since, as an artist, he was able to give me splendid professional advice by way of discourse, counsel, and talks, as well as through his works.

I found him not only an excellent artist but equally perfectly endowed with a great many virtues.[75]

He was a man exceptionally favoured by nature and his character shines brightly in his considerable correspondence, much of which has come down to us. In a letter to his learned friend Peiresc he discussed his recent marriage to sixteen-year-old Hélène Fourment, a merchant's daughter who was thirty-seven years his junior.

I made up my mind to marry again, since I was not yet inclined to live the abstinent life of a celibate, thinking that, if we must give the first place to continence, *fruimur licita voluptate cum gratiarum actione* [we may enjoy licit pleasures with thankfulness]. I have taken a young wife of honest but middle-class family, although everyone tried to persuade me to make a Court

marriage. But I feared *commune illud nobilitatis malum superbiam praesertim in illo sexu* [pride, that inherent vice of the nobility, particularly in that sex. Cf. Sallust, *Jugurtha*, 68], and that is why I chose one who would not blush to see me take my brushes in hand. And to tell the truth, it would have been hard for me to exchange the priceless treasure of liberty for the embraces of an old woman.[76]

Only a well-balanced man, sure of himself and without a trace of the social climber, could so clearly and dispassionately state the motives underlying his actions. Rubens did not smart under the social stigma attached to the artist's profession in certain court circles, nor is there ever any sign in his letters that he felt resentful of his few enemies or critics, one of whom believed him to be 'an ambitious and greedy man, who wants only to be talked about, and is seeking favour'.[77]

His immense success and his great wealth made him self-assured but never vain. Without boasting he could say of himself as an artist:

I confess that I am, by natural instinct, better fitted to execute very large works than small curiosities. Everyone according to his gifts; my talent is such that no undertaking, however vast in size or diversified in subject, has ever surpassed my courage.[78]

And with the same certitude he could write of himself as a politician: 'I assure you that in public affairs I am the most dispassionate man in the world, except where my property and person are concerned. I mean (*ceteris paribus*) that I regard the whole world as my country, and I believe that I should be very welcome everywhere.'[79]

Rubens was one of those rare people whose mind was never idle and whose power of concentration was such that even a dash of showmanship did not make it less impressive. Otto Sperling, a Dane who passed through Antwerp in 1621 and visited him in his studio, left this record of his experience:

We called on the celebrated and very eminent painter Rubens whom we found at work. Though occupied with his painting, he had Tacitus read to him whilst (at the same time) he dictated a letter. We kept silent for fear of disturbing him, but he addressed us without interrupting his work; all the while having the reading continued and still dictating the letter, he answered our questions as though to give us proof of his powerful faculties.[80]

Whether or not the reader will find this account fully convincing, it conjures up a vivid picture of the ease and versatility which belonged to the natural gifts of this great gentleman among artists.

CHAPTER V

GENIUS, MADNESS,
AND MELANCHOLY

1 Genius and Madness

OF ALL the intricate questions concerning the nature and personality of artists few have given rise to more consistant inquiry than that of the connection between genius and madness. First discussed in Greece almost twenty-five hundred years ago, the problem has lost none of its peculiar attraction and urgency. Admittedly, silence prevailed during the Middle Ages, at least so far as artists were concerned, but since post-medieval times the idea has never again been wholly abandoned that artistic talent and genius are dependent on a precariously balanced type of personality.

Plato differentiated between clinical insanity and creative insanity —that inspired madness of which seers and poets are possessed. Later, with the Hellenistic break-through (see p. 5) artists also were admitted to the circle of inspired creators. The Renaissance returned to this Hellenistic interpretation of Plato's theory of the *furores*. But the Renaissance concept of the *divino artista*, the 'divine artist', had a double root. It was not only derived from Plato's theory of poetical enthusiasm but also from the medieval idea of God the Father as artist: as architect of the universe. When, as early as 1436, Alberti suggested in his treatise *On Painting* that the artist may well consider himself, as it were, another god, an *alter deus*,[1] he probably had the medieval *deus artifex* in mind. Whatever Alberti's source, he evidently suggested that the artist should be divorced from the rank and file of 'normal' people.

It was Marsilio Ficino, the great Florentine philosopher and commentator on Plato's *Dialogues*, who paved the way for the diffusion of Plato's thought. Ficino summed up his ideas on inspiration in a letter of 1457 addressed to his friend Pellegrino Agli. A few passages from this long statement may here be paraphrased: The soul, which tries to grasp through the senses as much as possible of divine beauty and harmony, is enraptured by divine frenzy. Plato calls celestial love the unutterable desire, which drives us to recognize divine beauty. To see a beautiful body arouses the burning desire after divine beauty and, therefore, those who are inspired are transported into a state of divine madness.[2]

Thereafter the idea that the true artist created in a state of inspired madness was much discussed and widely accepted. We need not probe further into the pervasive influence of Plato's theory of the *furores*,[3] but shall turn to another tradition according to which genius was not far removed from real madness. Seneca's often quoted dictum: '*nullum magnum ingenium sine mixtura dementiae fuit*'—'there never has been great talent without some touch of madness'[4]—would seem to express this point of view. In actual fact, Seneca's further comment leaves no doubt that he referred to the Platonic fire of divine inspiration rather than to insanity. But when the passage was quoted out of context, as it often was from the seventeenth century onwards, it suggested a different meaning. Dryden's

> Great wits are sure to madness near allied,
> And thin partitions do their bounds divide,

and even Schopenhauer's 'genius is nearer to madness than the average intelligence' echo the misinterpreted line from Seneca.

During the nineteenth century clinical diagnosis confirmed the previous assumption of an alliance between genius and madnesss. Early in the century Lamartine already talked of '*cette maladie qu'on appelle génie*'; by the end of the century the idea of disease was so firmly established that a popular magazine declared 'evidence is not lacking to warrant the assumption that genius is a special morbid condition'.[5] Meanwhile a school of professional psychologists, represented by such men as the Frenchman Moreau (1804–84), the Italian Lombroso (1836–1909) and the German Moebius (1853–1907), had correlated psychosis and artistic activity.[6] Their findings had a considerable influence on twentieth-century psychiatrists. At the beginning of the century Courbon maintained that 'megalomania . . . is usual in artists',[7] while Lange-Eichbaum, whose encyclopedic work *Genius, Insanity and Fame* enjoyed and enjoys undue popularity, concludes that 'most geniuses were psychopathically abnormal . . . very many were also neurotics'.[8] Nor do dogmatic psycho-analysts break away from the basic pattern, although the terminology has changed. Artists, we are told, are subject to Oedipus and guilt complexes, narcissism and 'heightened bisexuality',[9] or are victims of their 'super-ego as well as of frustrations and psychic traumas'.[10]

Psychiatric opinion conquered large sectors of the public. A writer like Proust maintained that 'everything great in the world comes from neurotics. They alone have founded religions and composed our masterpieces.'[11] And Lionel Trilling regards the supposed connection between mental illness and artistic genius as 'one of the characteristic notions of our culture'.[12]

Although without doubt the opinion of the majority sides with the view that artistic talent is granted to man at the expense of emotional balance, we would falsify the picture if dissenting voices were left unrecorded. We have seen in the last chapter that ever since Vasari's literary portrait of Raphael genius was also depicted as the acme of moral and intellectual perfection and equipoise. This image of genius found a spirited nineteenth century advocate in Charles Lamb who, in his essay on *The Sanity of True Genius*, denied the connection between genius and madness:

So far from the position holding true, that great wit [i.e. genius] has a necessary alliance with insanity, the greatest wits, on the contrary, will ever be found to be the sanest writers. It is impossible for the mind to conceive a mad Shakespeare. The greatness of wit, by which the poetic talent is here chiefly understood, manifests itself in the admirable balance of all the faculties. Madness is the disproportionate straining or excess of any of them.[13]

Charles Lamb had some following even among medical men. C. Pelman, an early twentieth-century psychologist, expressed the conviction that

... geniuses who were insane are far outnumbered by those greater ones who show no trace of insanity. It can be stated with complete assurance that not one of the great geniuses was mentally diseased; if madness actually occurred, then the creative powers were diminished (Coleridge, de Quincey, and others).[14]

Evidently, Pelman was here up in arms against Lombroso and his school.

Not a few modern psychiatrists share Pelman's point of view. 'Psychosis is never productive in itself . . . only man's mind can be creative, never a disease of his mind'[15] sums up this position, which has found support in studies combining psychiatric and statistical techniques.[16] Also, the psycho-analyst D. Schneider secedes from the majority of psycho-analytical opinion when he writes:

The lives of talented men and women famously abound in episodes of inhibition, despair, moodiness, irritability, restlessness—alternating with episodes of productivity . . . These disequilibria have been assumed to be intrinsic to genius; of course they are not specific to the artist—they exist in baseball players and truck drivers and pillars of society.[17]

In the two previous chapters we have made similar observations,[18] but by weaving the historical and psychological evidence together, we believe we have taken note of a problem which a purely psychological approach fails to acknowledge: the notion of the 'mad artist' is a historical reality and by brushing it aside as mistaken, one denies the existence of a generic and deeply significant symbol.

A veritable anticlimax, more radical even than Schneider's verdict, is that of two psychologists according to whom

. . . the painter or writer is not unique and no more in need of personality understanding than is the greengrocer or the banker or the man in the street, all of whom have their own peculiar manner of dealing symbolically with psychic forces whether they deal with money (manna), power, painting, or politics.[19]

Objectively unassailable, this truly democratic psychology, which obliterates value judgments, realigns once again (as in medieval times) the artist with the common man and effaces the specific traits of character often associated with creative minds in the last five centuries.

We cannot conclude these remarks about genius and madness without mentioning a semantic problem. Modern psychologists are usually precise in their use of terminology, but before the nineteenth century the word 'mad' had, and in common parlance still has, numerous shades of meaning. We have seen that the Italian equivalent *pazzia* may mean folly, strangeness, and eccentricity. When Armenini implored artists to keep away from 'the vice of madness',[20] he employed the term in this loose sense, for evidently a deranged mind would be incapable of following his advice. Nor did Michelangelo want to suggest that he was clinically insane, when he talked of himself as *pazzo*. We have already pointed out that before the nineteenth century hardly any writer regarded insanity as the concomitant of genius. Finally, the catchword 'mad artist' of the *vox populi* does not refer simply to lack of mental or emotional stability. William Phillips correctly remarked that the notion implied 'a mythical picture of the creative man: inspired, rebellious, dedicated, obsessive, alienated, as well as neurotic'.[21] This image of the 'mad artist' which arose in the Renaissance, when artists had fought for and won a special place in society, and which lingers on in the popular mind, is compounded of many heterogeneous elements rather than restricted to the belief that genius is mentally ill.

To sum up, in historical perspective the problem of the 'mad artist' confronts us with three intrinsically different forms of madness: first, Plato's *mania*, the sacred madness of enthusiasm and inspiration; secondly, insanity or mental disorders of various kinds; and thirdly, a rather vague reference to eccentric behaviour. We are here concerned not with the theoretical problem of genius and madness, but with the concrete problem of how in the past writers and public alike observed and described the character and behaviour of artists. For this purpose our three categories supply an insufficient frame of reference. Before the revolutionary development of the modern medical sciences, charac-

ter was interpreted in terms of the ancient doctrine of humours. A familiarity with this doctrine is necessary in order to understand more fully the image of the 'mad artist' current since the Renaissance.

2 The Saturnine Temperament

The Greeks were the first to classify the infinite variety of the human psyche as derived from four humours. Hippocrates, the great physician of the fifth century BC, seems to have firmly established the theory according to which the human body consists of the four humours or fluid substances: blood, phlegm, yellow bile, and black bile. Health is dependent on the equilibrium of these substances, while an excess of any one produces disease. Through Galen, the second century AD physician whose prolific writings contain the fullest exposition of Greek medical thought, the 'humoral pathology'[22] was handed on to the Middle Ages and the Renaissance. By associating the humours with psychology, they became determinants of man's temperament: predominance of blood, it was believed, engenders sanguine types, of phlegm, phlegmatic types, of yellow bile, choleric types, and of black bile, melancholic types. From here it was a short step to the linking of temperaments not only with physiological characteristics but also with intellectual and professional predispositions. It was Aristotle[23] who first postulated a connection between the melancholic humour and outstanding talent in the arts and sciences. 'All extraordinary men distinguished in philosophy, politics, poetry, and the arts,' he maintained, 'are evidently melancholic.' Thus he gave rise to the belief in the link between genius and melancholy. But the melancholy of such men is a precarious gift, for if the black bile is not properly tempered, it may produce depression, epilepsy, palsy, lethargy and what we would nowadays call anxiety complexes—in a word, although only the *homo melancholicus* can rise to the loftiest heights, he is also prone to conditions bordering on insanity. For a long time the melancholic temperament retained the ambivalent quality of Aristotle's definition. Yet it must be emphasized that for Aristotle and those influenced by him, melancholy does not simply lead to the alternatives of genius or madness, of assiduity or sloth, of achievement or waste; he was well aware of the many intermediary stages between the poles, and this is an aspect of great importance in our context.

Although the Aristotelian concept of melancholy was never forgotten, the Middle Ages regarded melancholy mainly as a physical disorder[24] and the Church condemned it as close to the vice of sloth (*acedia*). Not until the late fifteenth century was Aristotle's position newly and fully endorsed. In his *De vita triplici* (1482–89) Marsilio Ficino showed that melancholy, the ambivalent temperament of those born under the equally ambivalent planet Saturn, was a divine gift, and he, the zealous

Platonist, closed the circle by reconciling Aristotle's and Plato's views, for he maintained that the melancholy of great men was simply a metonymy for Plato's divine *mania*.[25] The Renaissance accepted Ficino's conclusion: only the melancholic temperament was capable of Plato's creative enthusiasm.

In order to understand fully the peculiar power of the classical doctrine of the temperaments, one has to see it in conjunction with the belief in astrology which exerted an ever-growing influence from the twelfth century onwards. Renaissance scholars, trying to buttress the 'scientific' foundation of astrology, turned to the writings of late-antique astronomers and astrologers for confirmation of the causal connection between the stars and all emanations of life on earth. Ficino himself, in the third book of *De vita triplici*, considered the entire field of medicine in its relation to astrology. A man's temperament was determined by his planet: while men born under Jupiter are sanguine and men born under Mars are choleric, Saturn determines the melancholic temperament; depending on Saturn's conjunction at the moment of birth, the *melancholicus* will be either sane and capable of rare accomplishment or sick and condemned to inertia and stupidity. The importance of horoscopy as a method of establishing a person's temperament need hardly be emphasized. The belief in astrological determinism led to a coordinated macrocosmic-microcosmic conception of the world which was swept away with the victory of the empirical sciences; but chaos descended in the wake of enlightenment.

The stars determined not only the humours but also occupational interest and talent. Each planet's field of occupational influence was the result of a long and complicated process of transmission of old beliefs. We cannot delve into this strange chapter of human imagination and circular thinking. Suffice it to say that when the Greeks 'mythologized' the sky between the fifth and the third centuries BC, they endowed the planets and constellations with the qualities attributed to their gods.[26] Later these same qualities were thought to determine man's fate on earth. Thus the copper-red planet was given the name of the warrior-god Mars; war, plunder, rape, and misery was his domain and those born under him were predestined to be soldiers and killers. The swiftly-moving planet was called Mercury, after the light-footed messenger of the gods. His Greek equivalent, Hermes, was venerated as the god of commerce and as the inventor of the sciences, of music and the arts. It is for this reason that his 'children' are industrious and devoted to study; they are watch-makers, organ-builders, sculptors and painters (Fig. 19). According to astrological tradition, therefore, artists were born under Mercury.

How, then, are they related to the sinister, brooding, secluded Saturn?

A shift of 'patronage' from Mercury to Saturn came about in the Renaissance, for very good reasons. We have seen that in Ficino's re-assessment of the Aristotelian position, men endowed with genius have a saturnine rather than a mercurial temperament and Saturn must therefore be claimed as their planet. Ficino in this context considered only scholars and writers. But Renaissance artists who regarded themselves as equal or even superior to the men of letters could not forgo their saturnine birthright, the prerogative of exalted creators (Fig. 1).

Ficino's work rather than anyone else's was the signal for a new approach to the problem of talent. From then on even moderately gifted men were categorized as saturnine and, conversely, no outstanding intellectual or artistic achievement was believed possible unless its author was melancholic. In the sixteenth century a veritable wave of 'melancholic behaviour' swept across Europe.[27] Temperamental qualities associated with melancholy such as sensitivity, moodiness, solitariness, and eccentricity were called for and their display acquired a certain snob value,[28] comparable to the *Weltschmerz* of the Romantics or the bitterness of our own Angry Young Men. It is only to be expected that melancholy is an ever-recurrent *topos* in Vasari's *Lives*. Even minor artists such as Parri Spinelli (d. 1452)—who 'shortened his life since he was by nature melancholic and solitary'[29]—and Lorenzo Vecchietta (1412–80)—'a melancholic and solitary person, always lost in contemplation'[30]—join the saturnine company. As regards the great masters, their melancholy was a foregone conclusion. Melanchthon tells us that Dürer was a *melancholicus*,[31] and the artist himself left us a deeply moving self-revelation in the brooding figure of his Melancholy engraving (Fig. 20).[32] Of Raphael a contemporary reports, still during the artist's lifetime, that 'he is inclined to melancholy like all men of such exceptional talent',[33] and in the School of Athens Raphael gave his own interpretation of Michelangelo: he showed him wrapped in solitary thought in the traditional pose of Melancholy (Fig. 21).[34] One feels bound to infer that Renaissance artists displayed traits of personality which would tally with the then current ideas on creative talent and that consciously or subconsciously biographers and contemporaries read into the character of artists what they expected to find. One has to be careful not to take such information at its face value or use it as historical fact on which to build psychological theories.

We can now also throw more light on Michelangelo's 'madness' and 'melancholy'.[35] It is true that Michelangelo, by using the word *pazzia* to characterize his state of mind, refers to his non-conforming obsessions rather than to the Platonic 'madness'. Yet his almost narcissistic emphasis on *pazzia* would be unthinkable without his familiarity with Plato's concept of *mania*. We have mentioned that Renaissance artists appro-

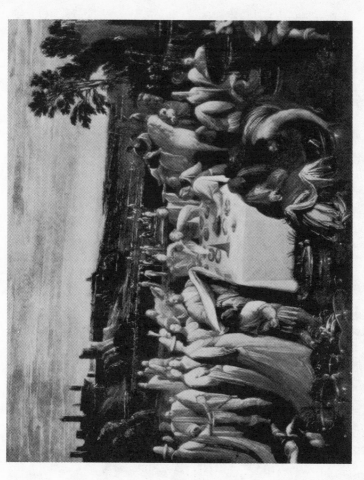

26. Giovan Andrea Donducci, il Mastelletta (1575–1655), A Feast in a Landscape.
Nijstad Antiquairs, Lochem—The Hague.
The painter transformed one of the rustic feasts which he loved into a scene of elegance and mystery.
Mastelletta's immensely attractive cabinet pictures are the work of a depressive recluse.

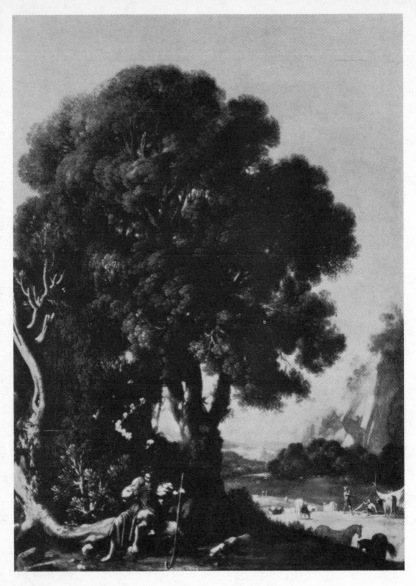

27. Adam Elsheimer (1578–1610),
Landscape with Mercury and Argus, *c.* 1608. Uffizi, Florence.
No one will fail to be enchanted by this vision of a gentle
world, full of mysterious light and romantic charm.
Few would suspect that it is the work of a melancholic,
incapable of coping with reality.

priated to themselves this condition of inspired frenzy, for it gave their art the aura Plato had conceded to poetry. The alliance between Platonic 'madness' and Aristotelian 'melancholy' postulated by Ficino is echoed in Michelangelo's use of these terms, and there is reason to assume that it was this alliance that many a Renaissance artist regarded as essential for his own creativity.

In a treatise written in 1585 Romano Alberti, later secretary to the Accademia di San Luca in Rome, codified the artist's claim of belonging to the melancholic tribe. He ingeniously countered Plato's contempt for the mere imitation of nature by explaining that

. . . painters become melancholic because, wanting to imitate, they must retain visions fixed in their minds so that later they may reproduce them as they have seen them in reality. And this not only once but continuously, such being their task in life. In this way they keep their minds so abstracted and detached from reality, that in consequence they become melancholic which, Aristotle says, signifies cleverness and talent because, as he maintains, almost all gifted and sagacious persons have been melancholic.[36]

At the same time Timothy Bright, in his *On Melancholy*, summarized the generally accepted definition of the *melancholicus*. He is, we are told,

. . . cold and dry; of colour black and swart; of substance inclining to hardness; lean and sparse of flesh . . . of memory reasonably good if fancies deface it not; firm in opinion, and hardly removed where it is resolved; doubtful before, and long in deliberation; suspicious, painful in studies, and circumspect; given to fearful and terrible dreams; in affection sad and full of fear, hardly moved to anger but keeping it long, and not easy to be reconciled; envious and jealous, apt to take occasions in the worst part, and out of measure passionate. From these two dispositions of brain and heart arise solitariness, mourning, weeping . . . sighing, sobbing, lamentation, countenance demisse and hanging down, blushing and bashful; of pace slow, silent, negligent, refusing the light and frequency of men, delighted more in solitariness and obscurity.[37]

As these two quotations show, the classical doctrine of the temperaments offered a satisfactory explanation for the talent of artists as well as for their strange and eccentric behaviour. It is apparent from Bright's text that many of the cases discussed in the foregoing chapter display the traits of melancholic natures.

But now even at the height of the melancholy vogue, doubts were voiced which eventually helped to supplant the Renaissance concept of the *melancholicus*. First there was a growing awareness of the epistemological limitations in the face of psychic problems. As early as 1538 Juan Luis Vives expressed this with these words: 'There is nothing more recondite, obscure, and unknown to all than the human mind, and until

now the things belonging within its range could, least of all, be expressed and demonstrated by appropriate words.'[38]

Scholars debated the vexed melancholic temperament as hotly as they do psycho-analysis in our day. 'The Tower of Babel,' exclaimed Robert Burton (1576/7–1640), 'never yielded such confusion of tongues as the Chaos of Melancholy doth of Symptoms.' Secondly, the Church, which had always looked askance at melancholy, was more critical than ever in the age of the Counter-Reformation. The clear-headed mystic St Teresa decreed that 'there are varieties of this temper . . . I verily believe that Satan lays hold of it in some people as a means whereby to draw them to himself if he can'. Echoing Aristotle's differentiation she distinguishes the 'diseased melancholy' from the 'merely distracted melancholy' which, in her view, is a disorder 'more common in our day than it used to be; the reason is that all self-will and licence are now called melancholy'.[39] Thus the Church took note of the new individualistic way of life of independent minds, but obviously could not concur with the contemporary fashion.

Finally, and this is most important, quite a few writers began to grow rather critical of melancholy. They had always been concerned with the question of how to avoid the negative influence of the melancholic humour. In *De vita triplici* Ficino gives detailed advice on diet and régime[40] and particularly recommends the therapeutic power of music,[41] which had been acknowledged ever since David played the harp for Saul: 'so Saul was refreshed, and was well, and the evil spirit departed from him' (I *Samuel* 16, 23).[42] About the middle of the sixteenth century the Venetian painter Paolo Pini, in his *Dialogue on Painting*,[43] regarded melancholy as an evil rather than a blessing. One of the fictitious interlocutors, the Florentine painter Fabio, introduces himself as an extreme *melancholicus*[44] (and to this extent Pini pays lip service to the fashion); Pini, through the mouth of Fabio, is also convinced that 'the stars implant in us the properties of their nature'.[45] Yet on the other hand he recommends sport, exercise, and conviviality so as to 'put the digestion in order, destroy melancholy and also *purifica la virtù dell'uomo*' —'purify man's virtue', which should be interpreted as referring to the heightened quality of artistic performance.[46] This anti-melancholic attitude of the younger generation is paralleled by the new image of the conforming artist which we have discussed.[47] By and large, together with the 'proto-Bohemian', the melancholic artist had gone out of fashion in the seventeenth century. The great masters of the period, Bernini and Rubens, Rembrandt and Velasquez, were never described as melancholic and showed no trace of the affliction. It was not until the Romantic era, with artists like Caspar David Friedrich,[48] that melancholy appears once again as a condition of mental and emotional catharsis.

It is interesting to note that Timothy Bright, who published his treatise in 1586, was no longer in sympathy with the melancholic humour. 'Of internal Senses,' he wrote, 'I take fantasies to be the greatest waste of these spirits.' The learned Robert Burton, teacher at Christ Church in Oxford, in his *Anatomy of Melancholy* of 1621, was even less sympathetic. He could laugh at, as well as thunder against, those 'supercilious critics, grammatical triflers, notemakers, curious anti-quaries and the rest of our Artists and Philosophers,' whom he deemed 'a kind of mad men as Seneca esteems of them'.[49]

Burton's unwieldy tome does not only consist of an eclectic collection of miscellaneous material. His probing into the causes, symptoms, and cures of melancholy also reflects the growing interest of his age in the study of abnormal psychology.[50] His book was an enormous and instant success and five editions appeared during his lifetime. Nonetheless, a psycho-pathology ultimately still linked to Aristotle and Galen had had its day. Burton was soon forgotten and resuscitated only in the nine-teenth century.[51] Seventeenth century interest shifted on the one hand to empirical enquiry and on the other to a study of the *affetti*, the emotions, which found its classic in Descartes' *Les passions de l'âme* of 1649. In 1697 G. E. Stahl, in his *Lehre von den Temperamenten*, dethroned the humoral pathology, and in 1713 Bernardino Ramazzini, in *De morbis artificum*, the first work on occupational diseases, attributed the 'melancholic fits' of painters to 'the injurious qualities of the colours that they use'.

The older biographers of artists had no choice but to regard the ancient doctrine of the temperaments as a proven fact. They had no other terms of reference and most of them continued to use the established termino-logy well into the seventeenth and even the eighteenth century. By categorizing an artist as melancholic, they implicitly accepted the Aristotelian-Ficinian position of melancholy as the temperament of contemplative creators. But they also remained aware of the tenuous borderline between 'positive' and 'negative' melancholy. They may note various symptoms of departure from a hypothetical norm without, how-ever, clearly expressing an opinion as to the point on the sliding scale which—according to Aristotle—divides a 'positive' melancholic dispo-sition from clinical melancholia. Nonetheless, it is often possible to differentiate between melancholy treated as a *topos* and the report of a true pathological condition. We happen to have fairly full and reliable accounts of a number of cases which would appear to have been con-sidered 'diseased' melancholics.

It seems justified to single out a few accounts for closer inspection, because they show in some detail what observations were made and

what criteria were used in assessing mental disorders and how the relation between illness and productivity was viewed. Only our last example, that of Messerschmidt, who lived almost to the end of the eighteenth century, was neither implicitly nor explicitly described as melancholic.

Before turning to these cases, it should be said that it is impossible to estimate with even a semblance of accuracy how large the number of disturbed artists was in proportion to other professions. Moreover, we have concerned ourselves with artists whose disease did not lead to permanent creative sterility. A great artist like John Robert Cozens, who became hopelessly insane in 1794, stopped producing altogether. Not many similar instances have been recorded. In our context such artists cease to be of interest after the onset of their misfortune.

3 *Hugo van der Goes' Case History*

One of the first reliable records of a mentally ill artist is that of Hugo van der Goes, the great Flemish painter of the second half of the fifteenth century. Few facts are known about Hugo's life, but an attempt to reconstruct the spiritual climate in which he worked may help us understand why this highly successful painter entered a monastery and what caused his breakdown. Probably born around 1435, van der Goes became a free master of the painters' guild at Ghent in 1467. About seven or eight years later, at the height of his career, he joined the Roode Clooster near Brussels as a brother *conversi*—a rank between a lay brother and a monk. In 1438 this monastery was affiliated to the Windesheim Congregation which had been founded some sixty years earlier by the Brothers of the Common Life. The brotherhood grew with extraordinary rapidity and by the end of the fifteenth century the Windesheim Congregation counted more than eighty-six religious communities, most of them situated in Holland and the ecclesiastical province of Cologne, bearing witness to the reformatory zeal within the Catholic Church and the ready response of the population.[52] There is nothing either surprising or morbid in the fact that Hugo shared the religious fervour of his environment. In his time the originally extremely severe monastic rule had been somewhat eased under the moderating influence of Thomas à Kempis, the most famous member of the Windesheim Congregation,[53] and Hugo, when he entered the monastery, was not only allowed to continue painting but was also granted special privileges. Gaspar Ofhuys (1456–1523), the chronicler of the Roode Clooster,[54] enumerates them, not without a note of indignation:

Immediately after his initiation and throughout his noviciate Father Thomas [Vessem or Wyssem], the Prior, allowed him to seek consolation and diversion

in many ways after the manner of the wordly, though with the best of intentions, as Hugo had been an honoured person among them. And so it happened that while he was with us he became more acquainted with the pomp of the world than with the ways of doing penitence and humbling himself. This caused strong disapproval in some. Novices, they said, should be humbled and certainly not exalted. But since he was so eminently knowledgeable in the art of painting pictures he was more than once visited by persons of high rank, and even by His Serene Highness, the Archduke Maximilian [the future German emperor], because they were all fired by the desire to see his pictures.

Some five years after he had entered the monastery Hugo set out on a journey in the company of several monks, among them his half-brother Nicolaas who had also taken vows. This Nicolaas informed the chronicler of what had happened on the journey:

One night on their return brother Hugo was struck by a strange disorder of his imagination. He cried out incessantly that he was doomed and condemned to eternal damnation. He would even have injured himself had he not been forcibly prevented by his companions.

Much delayed, the travellers at last reached Brussels and sent word to the Prior to come to their aid. Father Thomas immediately left his monastery.

Seeing this sick man and learning all that had happened he presumed that brother Hugo was suffering from the same complaint that had once afflicted King Saul, and reflecting that Saul's disorder had yielded when David plied his harp, he immediately gave orders to play music frequently in Hugo's presence. Father Thomas also took care of other entertainments and recreations in order to dispel the phantasmagorias clouding his diseased mind. Yet his condition did not improve; he continued to talk unreasonably, and to consider himself a child of perdition.

The first remedy, then, was the time-honoured one of applying music therapy—a method to which Ficino also attributed a beneficial influence in cases of melancholic afflictions.[55] Brother Ofhuys goes on to report that Hugo returned to the monastery where he was nursed day and night, contrary to rumours of neglect which had been spread 'by very many people, even by those of high rank'. The writer had become the *infirmarius* of the monastery soon after 1482, and his medical knowledge made it possible for him to give a carefully reasoned account of the character and cause of Hugo's disorder. He refrained from making a final diagnosis, but explained that

. . . certain people talked of a peculiar case of *frenesis magna*, the great frenzy of the brain.[56] Others, however, believed him to be possessed of an evil spirit. There were, in fact, symptoms of both unfortunate diseases present in him,

although I have always understood that throughout his illness he never once tried to harm anyone but himself. This, however, is not held to be typical of either the frenzied or the possessed. In truth, what it really was that ailed him only God can tell. We may thus have two diverse opinions on the disease of our brother; on the one hand we might say that his was a case of a natural disease, viz. a special case of brainstorms. There are, of course, several types of the disease depending on its original cause: sometimes the cause is melancholic [that is, black-bile producing] food; at other times it is the consumption of strong wines which heat the body juices and burn them to ashes. Furthermore, frenzies may occur because of certain sufferings of the soul like restlessness, sadness, excessive study and anxiety. Finally, frenzy may be caused by the virulence of noxious juices, if such abound in the body of a man who inclines to that malady.

With relation to the above sufferings, I can say for certain that our brother was much troubled by them. He was deeply worried, for instance, about how to finish the many pictures which he still had to paint—in fact it was said, at least at the time, that nine years would hardly suffice for the task. He also devoted himself too often to the reading of a Flemish book. If we add to this his partaking of wine, though doubtlessly done out of regard for his guests, I for one cannot help fearing that it but helped to worsen his natural [morbid] inclination.

The classical humoral pathology formed the basis for this objective analysis;[57] but at this point the physician yields to the churchman and rigid moralist. Old resentments mingle with metaphysics, when the writer expounds as a further hypothesis

. . . that it was God's all-loving providence which had ordained this malady. This brother had been flattered enough in our Order because of his great art —in fact, his name became more famous this way than if he had remained in the world. But since he was, after all, just as human as the rest of us, he had developed a rather high opinion of himself due to the many honours, visits, and compliments which were paid to him. But God, not wanting his ruin, in His great mercy sent him this chastening affliction which, indeed, humbled him mightily. For brother Hugo repented and, as soon as he had recovered, he exercised the greatest humility. Voluntarily he desisted from eating in our refectory. From then on he took his meals humbly with the lay-brothers of our monastery.

The *infirmarius* concludes this part of his narrative with a pious contemplation:

I have on purpose been so circumstantial because I say to myself that God has suffered all these happenings not only to punish sin, I mean to admonish the sinner and give him occasion to improve, but also to teach us a good lesson.

Ofhuys' report gives us a clear picture of the painter's illness. It ran its

course through a pre-pathological, a pathological and a post-pathological phase. Between about 1475 and 1480 Hugo was sane to all intents and purposes. Early in 1481 he had an attack of severe depression which, however, passed and after his recovery he was presumably able to paint again during the brief span of time before his death in 1482. Nobody, it seems, not even the observant Ofhuys, discovered any sign of an affliction before the breakdown. We have already pointed out that in his time Hugo's retirement behind the protective walls of a monastery was far from strange, particularly considering the liberal conditions offered him. How then can his breakdown be explained? Such explanations as an unsubstantiated tale of an unhappy love affair or his despair of attaining perfection in his art (which have been suggested to date)[58] are too hackneyed to be acceptable. Hugo's companion offered a more convincing explanation. In contrast to the thesis of cause and effect between morbid predisposition and creative power (which at that moment the South fully accepted) Ofhuys argued that it was the success of Hugo's art that had produced his illness. His fame, the many honours bestowed upon him, his free intercourse with the great and wealthy within the walls of the monastery had driven Hugo into a conflict with his religious duties and convictions: Hugo's breakdown, in other words, was his escape from his scruples of conscience. There is no doubt that Hugo's work mirrors his deep piety, but, strangely enough, modern students have not noticed that in his interpretations of the Holy Stories he was profoundly indebted to the teaching of Thomas à Kempis. Like many of the devout, Hugo must have read and re-read *The Imitation of Christ*,[59] a work which was in all probability written by Thomas à Kempis in 1441. Here he found such admonitions as: 'Keep company with the humble and simple, with the devout and virtuous ... Unfailing peace is with the humble ... Better surely is the humble peasant who serves God than the proud philosopher who studies the course of heaven and neglects himself.'

An analysis of the procession of the Magi in the Portinari altarpiece (Fig. 22), painted by Hugo shortly before he joined the Brothers of the Common Life, shows that he was imbued with these ideas. One of the two heralds, dressed as a Burgundian dandy, has dismounted and asks his way in the words of St Matthew: 'Where is He that is born King of the Jews?' He turns to a poor haggard man and it is he who can guide him. Further back are the three kings, depicted as unpleasant characters reminiscent of the philosophers who study the course of heaven and neglect their inner selves. Along the road, between the trees of the woods, are other worn-out paupers, their eyes turned in the direction of the approaching royal train. Hugo was probably the first painter to introduce into religious imagery the ugly faces and gnarled bodies of

the humble and the poor not as repulsive sinners, but as divinely illuminated.

It was precisely the teachings of Thomas à Kempis and the spirit of Windesheim, to which he so obviously tended before taking the vows, that also led him to doubts, conflicts and ultimate disaster. The statutes of Windesheim required that those received into the Brotherhood should be 'constant in religion, withdrawn from the world, not caring for dress, prompt in confessing sins, and in making known their temptations; they should voluntarily practice mortification of the senses and observe silence and quiet'.[60] In *The Imitation of Christ* the theme of the mortification of the senses is approached from many angles:

Convert me, O Lord, unto Thee, and leave me not to run after earthly things . . . Wander not, my soul, after vanities and false extravagances. . . Refuse to be comforted outwardly, if thou would'st be inwardly refreshed . . . Many are the traps laid for souls that willingly wander abroad . . . Do thou then get thee to thy cell and dwell there, and count it grievous to be elsewhere.

In the *Little Alphabet of the Monks*, compiled by Thomas à Kempis, the brethren found rules of conduct which they were told 'constantly to keep in mind and continually endeavour' to comply with:

Shun conversation with worldly men, for thou art not able to be satisfied with both God and men; with things eternal and things transitory.

The devil is continually tempting thee to seek after high things, to go after honours.

Do not begin to wander after the various desires of the world, when the devil tempts thee. Listening to evil things is hurtful to the soul; the beholding of beauty is temptation.[61]

The piety of Thomas à Kempis was austere. His mind was entirely directed to matters of the soul. There is no sign that he ever enjoyed the sublunary manifestations of divine love or praised, like St Francis, God's creatures on earth. There are only exhortations not to succumb to 'affections for fading things'—those 'things' which are a painter's life-blood.

Torn between the commands of his art and those of the monastic life, ever fearful to be found wanting either in his work or in his religious duty, incapable of renouncing the 'consolation and diversion' of the world and its appeal to the senses, living within the community of stern brethren whose animosity he could not fail to notice, Hugo headed straight towards a crisis. The breakdown became inevitable because he remained a captive both of his religious convictions and of his art. We suggest that he fell prey to the scourge of *pusillanimitas* or 'scrupulosity',[62] the religious malady common in the late Middle Ages and again in post-Tridentine Catholicism, whose essence is a morbid doubt in the

adequacy of devotion. Those seized by this affliction are overcome by the burden of their sins and tormented by fears of punishment and retribution; and in men of a melancholic disposition, scrupulosity may lead to a complete breakdown. All the symptoms of Hugo's illness point in this direction: his conviction of being doomed and condemned to eternal damnation, as well as his suicidal tendencies.

Contrary to general opinion,[63] we suggest that Hugo painted at least one work after his recovery, the moving *Death of the Virgin* (Fig. 23). It is in this picture that the painter conformed most fully to Thomas à Kempis' spirit of renunciation. No trace is left of worldly attractions, the very light fails to relieve this scene of ultimate extremity. Ofhuy's dry description of the painter's repentance and humility after his illness shows that Hugo sought a road to redemption, apparently the only one open to him, to regain his peace of mind. But his inner torment, his grief and his anguish speak to us from the careworn, deeply lined faces and emaciated hands of the Apostles who keep vigil near the dying Virgin, the image of utter exhaustion.

4 Seventeenth Century Melancholics

Annibale Carracci

It was neither his temporary insanity that raised Hugo into the ranks of genius nor his mental instability that produced the intensity of feeling in his paintings. Hugo lived in deeply disturbed and fervently religious times. His work expresses the contemporary religious climate as much as his own experience—a statement too obvious to mention were it not for the fact that his illness has been repeatedly used as proof of the connection between genius and madness. Those who find support of this view in the tension and excitement of his canvases conveniently overlook the fact that a painter as deeply disturbed as Annibale Carracci (1560–1609) created classically poised works in spite of his illness.

On July 15, 1609, Monsignor Agucchi, a scholar and friend of many artists, wrote from Rome to Canon Dulcini in Bologna:

I do not know how to begin writing to you. It is now almost two o'clock in the morning and I have just come from seeing Sig. Annibale Carracci—may he rest in Heaven—pass into another life. He recently went, almost as if tired of life, to seek death in Naples and, not finding it there, came back to face it in Rome, in this dreadful season which is the most dangerous for such a change of air.

I had not heard either of his return, nor of his illness until this morning. I do not know what the opinion of people in your part of the world is, but among the best painters of Rome he was held to be the greatest artist alive at that moment. And although these last five years he had hardly been able to

work at all, he nevertheless retained his knowledge and judgment and was beginning again to paint some small things worthy of himself, as could be seen from a most beautiful Madonna, painted secretly some little time before his going to Naples.[64]

Annibale's ceasing to work and the incident believed to have caused it were no secret in Rome. Baglione, who knew him well, talked about it at length in his biography of the painter.

Annibale Carracci, having finished the beautiful work in the Farnese Gallery, grew discouraged and fell into a deep melancholy which nearly carried him into another world. He had expected full recognition for his labours from the magnanimity of Prince Farnese, but he was betrayed in his hopes. This was due to a certain Don Giovanni, a Spaniard, a courtier and favourite of the Cardinal who, in order to prove how carefully he handled the Prince's affairs, had a platter with only five hundred gold *scudi* given to Annibale as his reward for the ten years of continuous work which he had done with so much care and exquisite skill. Because of this, Carracci fell into such a humour that he did not want to paint any more. To escape from the solicitations of the Cardinal, who wanted certain rooms in the palace finished, he decided to try his fortune and in order to avoid further annoyances he went to Naples. There, after a stay of a few days, he felt worse and made up his mind to return to Rome. Having reached this city, he fell ill, and his state being aggravated by his disorders, a malignant fever overcame him.[65]

We know from a letter written by Cardinal Farnese himself that Annibale fell ill in the early months of 1605[66] and other letters written in 1606 and 1607 confirm that the disorder persisted. Annibale's contemporary, the physician Giulio Mancini, described its symptoms in fairly precise terms: 'He was taken ill with a fatuity of mind and memory so that speech and memory failed him and he was in danger of instantaneous death. However, with care he ended by being able to do some work.'[67] Mancini leaves the cause of the illness open, although he too mentions Annibale's dissatisfaction with the reward offered him by Cardinal Odoardo Farnese. The story remained the talk of the Roman studios and was still told, somewhat embellished, in 1665 during Bernini's stay in Paris.[68] Similarly, both Bellori and Sandrart add some details to Baglione's report—whether studio gossip or of their own invention it is now impossible to say. Bellori has it that the acute fever which Annibale contracted on the journey from Naples to Rome 'did not so much accelerate his death as did the amorous disorders of which he had not told the doctors who inadvertently bled him from a vein'.[69]

Sandrart went even further. What Agucchi and Mancini did not mention at all, what Baglione alluded to as Annibale's 'disorders' and

himself, strange, unapproachable; worse, in fact, than a beast. He did not trust whoever cooked for him, and therefore bought his lunch day by day, and dined now in this, now in that tavern. Not assured that the washerwoman might not poison his clothes, he wore the same shirt for months on end. When it was worn out, he would dress in one just bought from the shop, and stretched the worn and filthy one on a frame and put priming over it. These were the least of his unceasing suspicions. He soon retired to a small house in an uninhabited part, so that none would know or observe where he lived. There he stayed hidden for weeks on end without showing himself—so that he lost the commissions which before were very numerous on account of his reasonable prices and expeditious work. He did nothing but small coppers and canvases which he carried under his arm, full of fear, to some barber or other disreputable shop to sell at a low price, moving all those who knew him to deep compassion.

Having reduced himself to such an unhappy state that he no longer knew on what to live, he turned for help to the Fathers of St Francis, for whom he had painted both officially and unofficially, asking to be accepted as a lay brother. He always painted for them gladly, and at a low price, wrapping himself in a little overall and a cloak made from their wool, and partaking of their food. But as he always wanted to eat by himself, he would never let himself be seen in the refectory, not even on the occasion of their main solemnities, although the Guardian Father lovingly begged him to do so. He, however, renounced the key to his room and left the place. A few days later he implored the Reverend Canons of S. Salvatore to grant him the same favour and it was courteously conceded to him by those noble monks. They not only let him eat their self-same food separately and assigned to him two good rooms in the convent, but they also allowed him the free use of a little country house at S. Polo di Ravone, which was all the more delightful and acceptable to him as it was completely ruined and damaged, a nest for mice, frogs, and other hideous animals. But he never wore the usual dress of the Order, and he showed himself little, except at meal-times in the kitchen. He would both astonish and amuse the cook and scullery help because he put soup, meat, entrée, as well as cheese and fruit all on one plate. When they asked him the reason for this, he answered that it was a mistake to make a distinction, as all these victuals would anyhow get all mixed up inside the body. He never allowed his room to be swept, nor his sheets to be changed. Weeks and months passed without the poor old man being seen at the convent, and it was believed that he was at S. Polo in his hermitage when suddenly it was heard that he was dead, having been taken in, they say, by relatives of his, who inherited nothing but the rags that covered him.

Thus at last terminated the wretched life of this good man who had been of honest habits and, what is most praiseworthy, a virgin; never having had any commerce with women.[76]

Evidently, Mastelletta was seriously disturbed for many years of his life. With his growing alienation from the world, he abandoned the monu-

mental scale and grand manner of his early work, but found a perfect medium of expression—and an infinitely more personal one—in his landscapes in cabinet format. Once again, these pictures show no sign of a diseased mind (Fig. 26). We have, however, to admit that lacking a satisfactory monograph on the artist it is at present impossible to date them with any degree of certainty. It seems likely that many of the small landscapes painted with a nervous brush and peopled with ghostlike figures date from before the final breakdown. These paintings share their imaginative and romantic quality with the work of other contemporary artists, foremost among them the German Adam Elsheimer, whose life and background will require our attention next.

Adam Elsheimer

Born in Frankfurt in 1578, Elsheimer left Germany at the age of twenty and travelled slowly via Munich and Venice to Rome where he arrived in 1600, never to leave the papal city again. His intimate, deeply poetic, small landscapes formed the greatest possible contrast to the Roman grand manner, but they immediately found many admirers among the *cognoscenti* and imitators among his fellow artists. Himself a convert to Catholicism, he was welcomed by some learned German and Dutch converts and enjoyed the friendship of such painters as Rubens and Paul Brill. Young, successful, and well-liked, a brilliant career seemed to lie before him. Yet he was far from happy. Sandrart describes him as a man who

. . . brooded much over his work. Lying or sitting for days on end in front of some beautiful trees he would keep them so well in mind that he could paint them at home without a sketch, and his memory and mind were so well trained that he could reproduce them quite true to nature.

In the end, this wearisome method tired him and increased his natural inclination for melancholy. He was a bad manager of his domestic affairs and, as he was married to a Roman woman by whom he had many children, he was often in want although he received good pay for his work.[77]

The Roman woman was in all probability of Scottish descent. She had been widowed for barely two months when Elsheimer married her and she found two further husbands in quick succession after the painter's death. It is very likely that she was an unsatisfactory companion to a highly susceptible young painter and may well have contributed to 'his natural inclination for melancholy' which clouded the last years of his brief life. Baglione and the physician Giulio Mancini, both contemporaries of the painter and both living in Rome, talked of his depression and the growing neglect of his work. The Spanish writer Martinez, who would still have had first-hand information from Elsheimer's contemporaries, says: 'He was solitary and introspective, so much so that he

walked abstractedly through the streets, never talking to anyone unless first spoken to.'[78]

Sandrart himself based his biographical notes on good authority. He interviewed Elsheimer's aged teacher in Frankfurt as well as another old painter who remembered him clearly. He did more. While in Utrecht in 1625 he visited Hendrick Goudt, the man who is supposed to have been the cause of Elsheimer's imprisonment—that indignity from which he never recovered. Goudt, a rich Dutchman of good family, had learned etching and calligraphy. In 1605 he went to Rome, where he first seems to have lived with Elsheimer in a kind of pupil-friend relationship. Later he came to some business arrangement or partnership with the artist, who accepted certain sums of money from him in part payment for future works—a scheme which proved most unfortunate. The painter sank into ever deeper gloom, worked less and less, and retired almost completely into himself. Goudt, who saw the chances of his receiving a return for his money dwindle, had him put into prison for debts. There, to quote Sandrart, Elsheimer 'did nothing to ease his lot by work—as he should and could have done, but was so dejected that he fell ill, and though he was released, he left this world shortly after'.

Hendrick Goudt—or Signor Enrico as he was called in Rome— returned to Holland soon after his partner's death. He was a strange man, vain, covetous of titles and honours, a Catholic convert, as some said, for the sake of a papal office. When Sandrart visited him in Utrecht he had been suffering for years from an 'indisposition of the brain'. In fact, he had become feeble-minded in 1617 and only showed a lively interest when he could talk about his friend Elsheimer and the Roman years. He died insane in 1648.

Rubens talked about Elsheimer, his exact contemporary, in two letters to Dr Faber, his Roman physician. In 1609 he asked Faber to greet 'Signor Adam, Signor Enrico and the other friends whose good conversation makes me often long for Rome'. The second letter, written in January 1611, when Rubens had received the news of Elsheimer's death, is a moving document of the affection and the faith in his talent, which the young German had inspired.

I have received from you two letters of very different tenor and content. The first was thoroughly amusing and gay; but the second, of December 18, was the bearer of the most cruel news—that of the death of our beloved Signor Adam—which was very bitter to me. Surely, after such a loss, our entire profession ought to clothe itself in mourning. It will not easily succeed in replacing him; in my opinion he had no equal in small figures, in landscapes, and in many other subjects. He has died in the flower of his studies, and *adhuc sua messis in herba erat*. One could have expected of him *res nunquam visae nunquan videndae; in summa ostenderunt terris hunc tantum fata.*

For myself, I have never felt my heart more profoundly pierced by grief than at this news, and I shall never regard with a friendly eye those who have brought him to so miserable an end. I pray that God will forgive Signor Adam his sin of sloth, by which he has deprived the world of the most beautiful things, caused himself much misery, and finally, I believe, reduced himself to despair, whereas with his own hands he could have built up a great fortune and made himself respected by all the world.[79]

In the more recent biographies of Elsheimer some scholars have expressed surprise at Rubens' use of the harsh words 'sin of sloth' (*accidia*) for what they take to have been no more than an incapacity for earning money. But Rubens was a most generous and considerate man, broadminded, well-mannered, and a master of letter-writing. He would undoubtedly never have used such strong language unless he meant what he said and had reasons for meaning it. Elsheimer was the son of a provincial tailor. The young painter had left a thoroughly respectable small artisan's milieu for the glamour and the misery of a foreign artists' colony in Rome. He changed his religion, married a dubious woman, became certainly financially and possibly emotionally dependent on a crank—half artist, half man-of-the-world—went through the frightful experience of a Roman prison, and suffered a mental breakdown. Rubens accused some unnamed persons of having brought about this miserable end, and Dr Faber knew whom he had in mind.

Whatever the forces were that ultimately destroyed this great artist, Rubens knew that Elsheimer, irresolute and bewildered, was hopelessly incapable of coping with his problems. But neither Rubens nor any of the biographers realized that Elsheimer had probably been a sick man for a long time, a truly 'diseased' melancholic.[80] Nevertheless, he was capable of painting to the end his visions of a gentler world, full of mysterious light and romantic charm, with a force and conviction rarely equalled (Fig. 27).

Francesco Duquesnoy
It was one thing for northern artists to study for a while in Italy and return home, as Dürer and so many others did, enriched by experiences and impressions. It was a very different thing for those who made the south their home. The difficulties of taking root in alien surroundings are always great. In the case of Francesco Duquesnoy, a Flemish sculptor (1594–1643), who came from Brussels to Rome in 1618, penniless and entirely dependent on the goodwill of strangers, particularly aggravating circumstances have to be taken into consideration: his own unaccommodating personality and the presence of the overpowering figure of the young Bernini reduced considerably his chances of getting important sculptural commissions. Although Duquesnoy's small works in

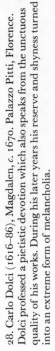

28. Carlo Dolci (1616–86), Magdalen, *c.* 1670. Palazzo Pitti, Florence.
Dolci professed a pietistic devotion which also speaks from the unctuous
quality of his works. During his later years his reserve and shyness turned
into an extreme form of melancholia.

29. Francesco Duquesnoy (1594–1643), S. Susanna, 1629–33. Marble.
S. Maria di Loreto, Rome.
This classically poised and serene statue was the work of a deeply depressed
man. Duquesnoy may have been insane in the last months of his life.

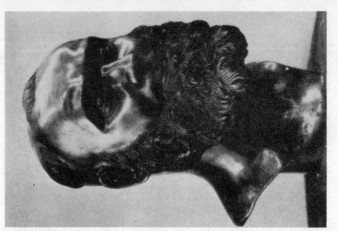

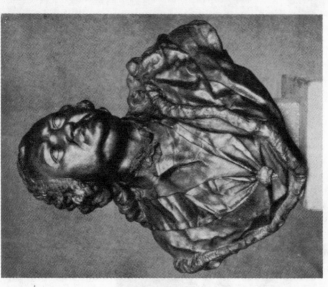

30, 31. Franz Xaver Messer-schmidt (1736–83), Gerard van Swieten (1769, gilt lead, Vienna); Ignaz Aurelius Fessler (c. 1780, lead, Bratislava).

These portrait busts show that Messerschmidt had well-known patrons throughout his career. Moreover, following the general trend of European art, he developed from a Baroque to a Neoclassical style.

bronze, ivory and clay found an appreciative public and although, in the sixteen-twenties, he made friends with the classicist circle of Sacchi and Poussin (whose house he shared), he had to earn his living chiefly by the restoration of antique statues. But after almost ten years in Rome his exceptional talent found recognition. In 1627 Bernini allowed him a share in the sculptural decoration of the *Baldacchino* in St Peter's; and in 1629 he was given the two most important commissions of his career: the monumental statue of St Andrew for St Peter's and the life-size figure of St Susanna for the church of S. Maria di Loreto in Rome. The graceful Susanna (Fig. 29), with its classical simplicity of stance and its serenity of expression, was received with the greatest enthusiasm. No one who admires the charm and poise of this statue would suspect that it was the work of a deeply depressed man, 'so hesitant and careful in every particular that he wore out his life in irresolution. Nor did he ever come to a decision on anything without long and tiresome consideration which went into minutiae of no importance. This incapacity of his caused him to obtain little work and money, because his dilatoriness exasperated those who wanted his works.'[81]

Even his friend and great admirer Bellori had to admit that

... Francesco was slow and laborious over his inventions, nor was he satisfied unless he copied over and over again from the antique or from nature: so much so that he made several studies not only for the principal members like a hand or foot, but also for a finger, or a fold in the material. Nor was he content with his diligence.[82]

Passeri, who was still a child when Duquesnoy died, admired the artist for his 'exquisite taste and profound understanding'. As far as Duquesnoy's personality was concerned, he reported what others had told him, namely that the sculptor

... did not care to be treated with familiarity, avoiding as far as possible the intricacies of friendship. This had the effect of making him little liked or agreeable, and he was to feel the damaging result [of this attitude] in times of need, finding himself lacking in followers and supporters.[83]

Moreover, Duquesnoy was plagued by morbid suspicions that people wanted to spy on his works. He was haunted by fears 'about his poverty, and oppressed by great fatigue' so that, in Bellori's words,

the unhappy state of mind of this excellent man was worthy of much commiseration. Praise of his accomplishment ('*virtù*') cheered him little, finding himself in poor health, bedridden with gout and perturbations of melancholy, so weak that with the slightest exertion his head turned and he fainted.[84]

An invitation from Louis XIV to settle in Paris as court sculptor came as an immense relief. Now

. . . this great man, who up till then had been afflicted and tormented by various sufferings, breathed freely at last, taking courage in the thought that his lot would improve with the change of air, and that he would be restored to perfect health.

In the meantime his indispositions continued, either on account of his hard work, or because of the noxious thought which worried him, his health being so weakened as if he had suffered from continuous vertigo. This complaint of his progressed so much that he began to go out of his mind and to show signs of real madness, not of the impetuous and raging kind, but just wandering.[85]

In 1643, on his way to embark for France, Duquesnoy died in Livorno. Rumours and speculations about the sculptor's malady and death agitated the studios in Rome. When the English traveller John Evelyn stayed in the Eternal City a year later, he noted in his diary: 'For sculptors and architects we found Bernini and Algardi were in the greatest esteem, Fiamingo as a statuary, who made the *Andrea* in St Peter's, and is said to have died mad because it was placed in an ill light.'[86]

Did Duquesnoy's precarious condition worsen towards the end to such an extent that he became insane? Whatever the truth, he had been a borderline case for many years. This was revealed to his contemporaries by his conduct and procrastination. Without their records posterity would have been hard put to form a picture of the man who succeeded better than any sculptor before or since in representing the happy and artless simplicity of children.

Carlo Dolci

Carlo Dolci's frame of mind is in some ways reminiscent of Duquesnoy's. A vivid and circumstantial description of Dolci's growing depression has been preserved in the biography written by his life-long friend Baldinucci. Born in Florence in 1616, Dolci started his training at the age of nine. In 1648 he became a member of the Florentine *Accademia del Disegno* and a few years later he married at the relatively late age of thirty-eight. His often slick and mawkish paintings, greatly acclaimed by the court society, were perhaps not quite as generally and as ardently admired as Baldinucci, the fervent partisan of Tuscan painters, would have us believe. On the other hand, Baldinucci's report helps to explain the unctuous quality of many of Dolci's works (Fig. 28):

Since childhood Dolci had acquired the habit of frequenting the Benedictine order and, his devotion growing every day, he had made the firm vow never in all his life to paint any but sacred pictures or stories, and to represent these in such a fashion that they might move whoever was looking at them to Christian piety. Yet, following the will of his confessor, he sometimes agreed to paint moral or indifferent subjects, that is, he represented the figure of some Virtue

or Art, but so modestly arrayed that it was singular to see. He always used to give an account of his intentions on the back of any work which he set himself to do, noting down all his sentiments, the day on which he began it, and the name of the Saint whose memory was celebrated on that day. During Easter Week he never wanted to paint anything except subjects appertaining to the Passion of Our Lord.

The circumstances being opportune, he was advised to get married in the year 1654. His marriage was arranged, and it was charming to behold our painter play the part of the groom—I say, to see him with over-modest gravity, his person neatly attired, jubilant and gay—yes, but (at the same time) all taken by feelings and words of sentiment and devotion. When the morning came on which he had to give the ring to the bride, nobody was missing but the groom. They look and look for Carlino, till at last he is found in the chapel of the Crucifixion in SS. Annunziata in the act of praying.[87]

In 1672 at Easter, much against his wishes, Dolci was sent by Anna de' Medici to Innsbruck. He was to go as her court painter in connection with the wedding of her daughter and the Emperor Leopold. When he returned to Florence in September

. . . poor Carlo began to have so many misfortunes that one cannot count them. These were caused by a pernicious melancholic humour which, due to his pusillanimous, reserved and shy nature, had conquered him so completely that it was no longer possible to exchange a word with him, let alone hold a conversation. He only expressed himself with sighs, the effect, as far as one could see, of a mortal anguish of the heart. His closest friends laboured to draw him away from those thoughts which made him believe that he had by now lost all his ability and was good for nothing. He was all the more grieved as he felt himself burdened with the maintenance of seven daughters, and no little weight was added to the worries of his tormented mind by the sight of his wife, who, being obliged to look after him day and night, was reduced to a poor state of health by fatigue.[88]

Baldinucci tried everything in his power to help his friend. He offered to take him away to the country, but his efforts were in vain. An amateur pupil of Dolci, Domenico Baldinotti, was more successful. Together with the painter's confessor he thought out a plan. One day the two went together to Dolci's house:

Baldinotti took a palette, arranged the colours on it, prepared stick and brushes, and then fired the big gun—that is, the priest, putting himself into position, ordered Dolci to obey and finish a veil for one of the two images of the ever glorious Virgin Mary which was already well advanced. The painter obeyed, and the work succeeded so well that his strong fears of having lost every artistic ability were at once dispersed, and those dark phantoms vanished.[89]

Thanks to this successful ruse Dolci recovered enough to paint a great

deal, though his working method remained exceedingly laborious. Baldinucci goes on to say:

It may appear strange to hear that he finished so many works, being so very slow or, to be more accurate, taking such a long time over each thing, for sometimes he would take weeks over a single foot.

During the year 1682 Luca Giordano, the famous painter, arrived in the city of Florence from Naples, whence he had been called.

Giordano wished to visit the studios of the most renowned painters and among these that of our Carlo. The latter received him with demonstrations of the sincerest affection, showing him all his works. Giordano praised him highly. Then, in that free and amusing way of his, with his graceful Neapolitan manner of speech, he began talking thus: 'Everything pleases me, Carlo; but if you carry on like this, I mean, if you take so long to finish your works, I believe the time is still very far off before you will have put aside the hundred and fifty thousand *scudi* which my brush has earned me, and I believe that you will surely die of hunger.' These words, spoken in jest, were so many wounding daggers to the heart of poor Carlo, and from then onwards he was assailed by a host of despondent thoughts and began to show signs of what was to happen later. He had already finished the very beautiful picture (which was to be his last) of the Adoration of the Magi, and he had it taken to the palace of the Grand Duchess Vittoria who liked it very much. He was sent for by the *Serenissima* herself, and on his arrival Her Highness had the beautiful picture brought in and, having much praised it in his presence, had it carried back to its place. Then, by order of the same *Serenissima*, another picture was brought which had just been painted by Giordano, and her Highness said: 'What do you think of this picture, Carlo? Would you really believe that it has been done, as indeed it has, in the time of a few short days?' Thereupon Carlino, whose mind was already heavy with turbid thoughts, began to change strangely, and with the wrong opinion of himself characteristic of extreme melancholics, he developed the fixed idea that there was not in all the world a master so worthless as he.

He returned home, not at all his usual self, but in a most confused state of mind, to the greatest grief and wonder of his family. From that moment on his thoughts wandered away from art into strange waverings of obscure fantasies.[90]

Dolci did not recover and died in 1686.

5 *Was Franz Xaver Messerschmidt insane?*

The last artist we intend to discuss in the present context is the German sculptor Franz Xaver Messerschmidt (1736–83). We have devoted more space to him than his importance may warrant, but Messerschmidt has become a test case—one is inclined to say *the* test case— for the problems concerning artists and insanity ever since Dr Ernst Kris, in a detailed and brilliant study thirty years ago,[91] evaluated Messerschmidt's work

in relation to the available literary evidence. Kris's paper has the added distinction that it was written by a scholar who was not only a fully trained art historian, but also a practising psycho-analyst. Although we are concerned with opinions of the past and not with psycho-analytic inquiry for which, in addition, we lack the necessary qualification, Kris's study is of such uncommon interest that we could not resist the temptation of examining his results from a historical rather than a medical point of view. We may add that in doing so we anticipate some of the questions to which we will return in the last chapter.

The son of a large but poor South German artisan family, Messerschmidt served his apprenticeship in Munich and, probably, in Graz. At the age of sixteen he went to Vienna where he studied for two years at the Academy. His obvious talent found favour and from about 1760 on he often received commissions from the Imperial Court and the nobility. In 1765 he travelled to Rome and subsequently quite possibly to Paris and London. Full of new impressions, which are reflected in his works, he returned to Vienna. In 1769 he obtained a teaching post at the Academy. Barely two years later he fell ill and his academic career was cut short. He was not in actual fact dismissed, but when the full professorship for sculpture became vacant in 1774, his hopes for the appointment were dashed because, in the words of the Prime Minister, Count Kaunitz,

. . . this man, either owing to his poverty or to a natural disposition, has for three years suffered from some confusion in his head which, though it has now abated, allowing him to work as before, yet shows itself from time to time in a not quite sane imagination. Although I regret the circumstances of this otherwise skilled man and wish they might be bettered, I could never advise Your Majesty to appoint a man as a teacher to the young academicians whom they might taunt at every opportunity with having once suffered from a disordered mind which is not quite clear yet; towards whom all the other professors and directors are hostile; who still has strange bees in his bonnet; and who therefore can never be entirely composed.[92]

Deeply offended, Messerschmidt refused to accept the pension Kaunitz offered him and left Vienna. He went first to Munich and, in 1777, to Bratislava where the presence of the famous sculptor who had worked for the Imperial Court in Vienna caused a considerable stir.

Messerschmidt's sculptures, especially his portrait busts, had always enjoyed a great reputation, but in the last decade of his life an extraordinary enterprise, a large series of character busts, enhanced his fame. Although he had chosen to live the life of a recluse, many vistors came to see the strange sculptor and his weird creations. Their curiosity was not always satisfied. One caller found him in his 'little room—in a gruff humour', not disposed to talk. 'He had decided not to show anything to

anybody; he wanted to work for himself and for nobody else.' The visitor thought that 'this honest man combined a great deal of pride with some folly the result of which one can see in his appearance which is haggard'.[93]

Another, luckier visitor wrote: 'To have been in Pressburg [Bratislava] and not have seen the famous sculptor would disgrace an art lover' and after having inspected the place where Messerschmidt 'studied his Egyptian heads' he was amazed to find the sculptor 'not only an artist but also a seer of ghosts'.[94]

But the most successful caller was Friedrich Nicolai who went to see the artist in 1781. The erudite and somewhat pedantic writer gained the confidence of the uneducated and enigmatic sculptor and the incongruous pair must have talked for hours. Nicolai published a detailed report of the meeting,[95] the gist of which may be told partly in his own words. He found Messerschmidt

. . . equally remarkable as an artist and as a man. He was a person of unusual strength of mind and body—in his art an extraordinary genius, in daily life a little inclined to oddities which stem chiefly from his love for independence.

In 1765 he went to Rome where he attracted the attention of all artists who studied there and won the friendship of the foremost among them.[96]

The meeting between the two men took place in the artist's 'little house close to the Danube in the suburb called Zuckermandl'. Of this place Nicolai says in a note: 'This suburb is the property of Count Palffy. It is situated within the grounds belonging to the palace and enjoys several privileges'—which sounds rather more congenial than Dr Kris's description of 'a house on the outskirts of the city near the Jewish cemetery, in what was generally considered an uncanny neighbourhood'.[97]

Nicolai continues:

There he lived, mostly on ordinary commissioned work, very thriftily, but independently and very contented. I found him in that lonely little house physically robust and of good cheer. He was quite candid and unaffected in his bearing and we were soon fairly intimate.

His entire furniture consisted of a bed, a flute, a tobacco pipe, a water jug, and an old Italian book on human proportions. This was all he had wanted to keep of his former possessions. Apart from this he had hanging near the window a half sheet [of paper] showing a drawing of an Egyptian statue without arms which he always looked at with great admiration and reverence. This was connected with a specific folly of his which he carried to astonishing lengths.

Messerschmidt was a man of fiery passions, yet he had a great longing for solitude. He was incapable of wronging anyone, but wrongs inflicted on him hurt him deeply. They embittered him but he kept his cheerful courage. He lived entirely for his art; in all things not connected with it he was very

ignorant, though he was capable and very desirous of learning. In Vienna he had fallen in with people who boasted of some secret knowledge, of contacts with invisible spirits and of powers over the forces of nature. This kind of person is very common all over Europe and especially in Germany.

Messerschmidt tried to impress on Nicolai that he really did see ghosts, a faculty which he ascribed to his chastity, because only pure-living people could see the invisible. Nicolai asked him to explain these notions. The answer, given 'somewhat haltingly and not quite clearly', revealed that the sculptor never for one moment doubted the actual existence of spirits which disturbed and frightened him much, especially at night. His worst tormentor was the spirit of proportion. Messerschmidt produced a most involved theory about human proportions; their secret was contained in the Egyptian Hermes. The spirit of proportion, envious of Messerschmidt's staggering discoveries, inflicted pains upon various parts of his body and the sculptor, knowing about the mysterious relations between certain parts of the body and some parts of the face, had to pinch himself here and there and then pull the appropriate kind of face in front of a mirror in order to break the power of the spirit over him. 'Pleased with this system [of subduing the jealous spirit] he resolved to represent these grimacing proportions for the benefit of posterity. According to him there were sixty-four varieties of grimaces.'

Nicolai saw him at work at the sixty-first head: 'Every half minute he looked into the mirror and with the greatest accuracy he pulled the face he needed.'

Messerschmidt greatly preferred these 'distorted grimaces' to his other works. Two so-called Beak Heads especially delighted him, but, though quite communicative about the other busts, he was most unwilling to talk about these. Nicolai understood that they were images of the spirit of proportion. Messerschmidt 'looked at them only briefly with a fixed gaze. He said: the spirit had pinched him and he had pinched the spirit in turn, and those busts were the result. He had thought : "I shall force you yet!", but he nearly died over it.'

Messerschmidt was a gifted artist and has always ranked among the better German sculptors of his time. During his career his portrait busts and statues developed from a florid Baroque style to a calm and sober Neoclassicism, in complete accordance with the general trend of European art (Figs. 30, 31). It is more difficult to observe a development in his character busts, for he had taken the decisive step towards classicism before he started work on them.

The series of busts was begun in about 1770. He finished twelve heads by 1777 and produced the other fifty-seven in the last six years of his life —a considerable achievement in view of the fact that he was, at the same time, engaged on a number of portrait busts and figures and prob-

ably on some small works, now lost. Messerschmidt was never one of the world's outstanding masters, but his late commisssioned work compares well with that of his early period (Figs. 30, 31). Of the sixty-nine character heads which were found in his studio after his death, forty-nine have survived. The majority are executed in lead, a few in stone, and one is carved in wood. Their quality varies. Some of them are truly expressive (Fig. 32), some are decidedly odd (Fig. 33), while others do not rise above the level of empty grimacing (Fig. 34). But it would be difficult to find any other master of his rank who could have sustained a better quality throughout such an extensive series.

Messerschmidt's contemporaries were perhaps more impressed by the curiosity value than the artistic merits of these heads. After his death they were exhibited in one of the booths of the Prater, Vienna's popular amusement grounds. Later critics felt somewhat uneasy. They were at a loss to account for this patently obsessive interest in facial contortion. The busts have been variously described as illustrations of the theory of Mesmer (1734–1815), who thought that the psychological and physiological conditions of man are governed by the magnetic forces of the nervous system;[98] as the products of a 'pedantically naturalistic artist— a sarcastic, scornful eccentric who mocked the weaknesses of his fellow-creatures';[99] or as revealing the 'distress of a solitary, creative soul'.[100] These critics also differed in their opinions about Messerschmidt's personality. Feulner, who did not dismiss Nicolai's observations altogether, 'would have been inclined to regard the character studies as the productions of schizophrenic fancies had this kind of self-portrayal . . . and self-irony not been consciously subjected to artistic discipline'.[101] Tietze-Conrat rejected Nicolai's memoirs as being 'observed through the spectacles of a shallow apostle of enlightenment' and 'prefers to see in the dark words which Nicolai repeats as the master's confessions, the latter's rebuff of a tedious interviewer'. She found 'nothing in those character busts which would reveal spiritualism, superstitions, or a distorted mind'.[102]

As far as the quality of Messerschmidt's commissioned sculptures is concerned, Dr Kris agrees largely with his art historian predecessors. He notes that the early works 'surpass the traditional artistic level [of the Austro-Bavarian Baroque] in many respects', and writes that 'even in the works of his later period his sovereign mastery of depicting likeness, his superior skill as a portraitist, remained unimpaired'.[103] It is in his interpretation of the artist's personality that Dr Kris differs from previous writers. Here the psycho-analyst takes over. Quoting those passages from the documents which support a Freudian analysis, and after a detailed discussion of some of the stranger aspects of the grimacing heads, he arrives at the diagnosis that 'we are indeed dealing with a

psychosis with predominant paranoid trends, which fits the general picture of schizophrenia'.[104]

Much of this disparity of opinion, or so it seems to us, is a question of trust and emphasis—trust, that is, in the reliability of the sources; and emphasis, because it must remain a matter of choice which part of the testimony offered by the literary and visual documents one prefers to stress. Neither the sources nor Messerschmidt's *oeuvre* present a clear-cut case. Both contain proofs for the sanity as well as for the 'paranoid delusion' of the artist's mind. Unlike his predecessors, Dr Kris believed that the key to Messerschmidt's personality and work lay in his insanity.

With such contrasting opinions before us we should like once more to review the facts briefly and add some points hitherto overlooked. Count Kaunitz's letter and some of the observations of Messerschmidt's visitors surely indicate that the artist was not always clear in his mind, but he could also give the impression of robust health and cheerful contentment. There can be no doubt that at least part of his personality had remained intact. Even during the period of his greatest preoccupation with his dubious character studies, i.e. in the last eight or ten years of his life, he carried out a number of perfectly normal works: a memorial bust to the deceased wife of his teacher, at least four portrait busts, two full-size portrait figures and three (very likely more) portrait reliefs—a not inconsiderable number of commissions for an artist leading a retired life. His subjects included dukes and duchesses; the famous personal physician to the Empress Maria Teresa, Dr van Swieten; the well-known librarian and historian Martin George Kovachich and the equally well-known Ignaz Aurelius Fessler[105] (Fig. 31), and it is hard to believe that all or any of them would have entrusted their portraits (and money) to a notoriously insane sculptor. To create side by side 'official' art and works of a 'private' nature is not, in itself, unusual. The practice appeared as early as the sixteenth century, became more and more common and marked, for instance, the work of Goya, Messerschmidt's great contemporary. Nor is it a sign of insanity that Messerschmidt endowed his 'private' works with private meaning. While such works as Michelangelo's drawings dedicated to his friend Tommaso Cavalieri are immediately understood as mythological scenes, their hidden, personal meaning was in their time not intelligible to more than a very few people and can now be reconstructed only on the basis of literary records.[106] To awaken response in the beholder a work of art must transmit at least one meaning directly, and this most, though not all, of Messerschmidt's character busts do. We can recognize spontaneously such expressions as laughter, scorn, anger, stupidity, grief, quietude, boredom, although we may be at a loss as to what private message the artist wanted to convey.[107] It seems to us—as it seemed to other

observers with the exception of Dr Kris[108]—that most of the character heads maintain their organic unity. The artifacts of psychotics, on the other hand, convey little without a verbal key and their structure invariably falls to pieces.

Dr Kris would like us to see the character busts as an attempt on Messerschmidt's part at 'regaining contact, a procedure of self-healing'.[109] From here he proceeds to unravel the subconscious rather than the conscious impulses which led to the artist's strange enterprise. Before following Dr Kris further, we may ask to what extent Messerschmidt's ideas belonged to his time. In many ways this moderately important German sculptor stood between two worlds. He moved from the lower-middle-class of his origin into the upper-class intellectual and academic milieu of Vienna. There he met some of the enlightened minds, but had also contact with devotees of occult practices. Uneducated, he remained ignorant, although he became absorbed by theoretical and esoteric problems. Strange as his preoccupation with proportion, physiognomics and spiritualism may seem to us, they were in themselves not unusual interests in his period. Proportion had been the backbone of art theory since Leon Battista Alberti's days. Artists, philosophers and theologians alike regarded proportion as the mysterious order governing the universe, and it was this order that artists strove to recapture in their works. Physiognomics too was an old prerogative of artists. We have only to think of Leonardo, the Carracci, Lebrun and others. In the seventeenth century the study of emotions and their physiognomical expression had become an integral part of academic teaching.[110] In addition, the theory of a connection between certain parts of the body and the face had a long history.[111] Not even Messerschmidt's struggle with ghosts and demons would, in itself, be a proof of his insanity unless one believes that large numbers of people had been deranged for centuries. Under whatever name one likes to classify it—occultism, black magic, spiritualism, demonology and so forth—the occupation with supernatural powers had an enormous attraction, and not only for the uneducated.[112] Highest authority supported the belief in the existence of diabolical and demoniacal forces as is borne out by the countless victims of the Inquisition. It is well to remember that the last two witches, tried and condemned by presumably quite sane judges, were beheaded in 1775 and 1782, the one in Germany, the other in Switzerland.

It is one of the weird aspects of history that the eighteenth century, the Age of Reason, also saw a revival of magical beliefs and rites and the foundation of a great number of secret societies with centres in England, France and especially in Austria and Germany. Nicolai, the personification of eighteenth century enlightenment, was naturally appalled by any signs of superstition and irrationality. Without knowing which 'old

Italian book on human proportions' Messerschmidt had prized so highly, or to what secret society he had belonged in Vienna, we cannot possibly say how far his demons were products of delusions or how far they were recognized members of the 'diabolic tribe', described and discussed in many publications, depicted in widely sold broadsheets, invoked at countless secret meetings, and thoroughly condemned by rationalists. Only the Egyptian figure which hung near the window in the sculptor's room is immediately familiar. Nicolai was doubtlessly correct in recognizing it as a representation of Hermes Trismegistos, the venerable Graecized Egyptian god of esoteric knowledge, whom Renaissance philosophers had rediscovered and who has haunted innumerable treatises ever since.

Lastly, a word should be said about Messerschmidt's chastity which gave both Nicolai and Dr Kris much food for discussion. His concern about a pure life may appear in a different light if we remember that not only the Church but also occult sects laid great store by the exercise of continence and regarded it as a prerequisite for attaining insight and cognition. The rules for acceptance into the Rosicrucian order, for example, laid down between 1767 and 1777, stipulated that before admission to membership a candidate must learn to walk the path of virtue and refrain from all sensual pleasures.[113] Even the most extravagant beliefs can hardly be quoted as proof of an individual's insanity, if they are shared by many thousands for hundreds of years.

Nevertheless, Messerschmidt may have been, and probably was, as mad as a hatter, but, despite Dr Kris's psycho-analytical interpretation, we still do not know for certain what it was that caused the artist to 'suffer from some confusion in his head'. Kris's analysis is based on assumptions which, on occasion, are purely conjectural. We are told, for example, that the band-like muscle formation around the mouth of some of Messerschmidt's busts is a symbolic rendering of the girdle of chastity,[114] and one wonders whether this association arose in the subconscious of the analyst rather than in that of the artist. How can it be proved that anal fantasies played an important part in Messerschmidt's delusions and that his 'schizophrenic identification with God, the Creator' was at the root of his fear of the demon of proportion?[115]

We have mentioned these few but salient points at the risk of misrepresenting Kris's closely-knit thought. How much or how little of his interpretation will survive, it may be too early to say. But one of his observations, made here and elsewhere, is of great importance for any future discussion of artistic activity and insanity: his recognition that the creative activity of an artist may remain unimpaired, partially or even wholly, by his mental illness. Yet it is precisely this recognition which makes it almost impossible in a case like Messerschmidt's to draw the

line between 'sane' and 'psychotic' production. Kris chose to single out the rigidity, emptiness, uniformity of expression, the stereotyped grimacing and the 'falling apart' of some character busts as typical signs of schizophrenia. Obviously, to perceive all these traits, as Kris does, depends on the individual critic's sensibility. Even those who follow Kris's stylistic observations may prefer to see in Messerschmidt's less convincing efforts the limitations of his talent.

There remain the two Beak Heads (Fig. 33) which, as we have learned, had a particular emotional import for Messerschmidt. They are the only sure indication within the series of character busts of a breakdown of 'normal' communication and of the illusory world in which the sculptor lived. For Kris they are 'the clearest expression of the sexual nucleus of Messerschmidt's delusions'.[116] Kris was interested in illuminating 'the extent and the manner in which psychotic mechanisms may influence creative activity'.[117] This is surely an important undertaking. But the reader may find that the tracing of the monotonous pattern of subconscious urges obscures more than it clarifies historical situations.

CHAPTER VI

SUICIDES OF ARTISTS

It matters not how a man dies, but how he lives
Dr Johnson

1 A Statistical Enquiry

Psychiatrists are of the opinion that many different psychological types are predisposed to suicide. According to Zilboorg 'there is no single clinical entity [such as depressive psychoses, compulsive neuroses, etc] recognized in psychiatry that is immune to the suicidal drive'.[1] This is a significant statement in the context of our enquiry. For if the image of the 'mad artist' as it developed over a long period of time were based on objective facts artists should be particularly prone to suicide. The opposite, however, seems to be the case. Our search, aided by friends and colleagues,[2] led to the discovery of a remarkably small number of self-inflicted deaths among artists.

Even suicidal dispositions are rarely mentioned in the sources. Cases like that of the Florentine artist Andrea Feltrini (1477–1548) are quite exceptional. Feltrini, a minor painter, was mostly engaged in decorative work. Vasari, who knew him well all his life, called him 'the best man that ever touched a brush', but said that

… he was of such a timid nature that he would never undertake any work of his own account, because he was afraid of exacting money for his labours.

Tortured by a melancholic humour, he was often on the point of taking his life, but he was so closely watched and so well guarded by his companion Mariotto that he lived to be an old man.[3]

But our apodictic statement about the rarity of suicides among artists may be challenged. It is, indeed, difficult to see how the question of numbers can ever be raised above the level of plausible guesswork. Throughout long periods of European history there was an ugly stigma attached to self-murder, and it is certain that relatives, friends and biographers of suicides would go to any length to hide a deed so vehemently condemned by Church and society. Also, many suicides, particularly by poisoning, were probably never detected.[4] It was not until the French Revolution that suicide ceased to be a crime in most European countries.

Next, one would have to ascertain the ratio between suicides among

artists and in other professions, but again the data are inconclusive. The science of statistics is a late-comer in the field of research and, with the exception of Sweden, few statistics on suicides were compiled before the second half of the nineteenth century. Even then the method of procedure was not coordinated but varied from place to place. In some countries police records were consulted, in others, doctors' death certificates; nor can we be certain that all or even the majority of cases were registered. Moreover, statistical tables were usually drawn up under headings which are useless to us, such as the relation of male to female, of married to unmarried suicides, or the comparative frequency of incidence among the various religious denominations. Even classifications according to occupation are of little value for our enquiry because these tables differ too widely in the definition of professional groups.[5] As a rule artists are not listed as a unit at all; presumably they are relegated to the section 'other professions'. But in a statistical analysis of the professions for the years 1866–76 in Italy, artists do appear separately[6] and this survey lends support to our thesis that they are little inclined to suicide—less, in fact, than all other professionals with the exception of priests.

It has been said that in medieval times self-destruction was so rare that 'no notable suicides' are on record between AD 400 and 1400.[7] Some scholars believe that from the sixteenth century on the number of suicides rose steeply[8] and so, supposedly, did the public interest in the macabre act. One author, counting only the major theoretical works, has calculated that four treatises on suicide were written between 1551 and 1580, whereas fifteen appeared in the seventeenth century, eighty-four in the eighteenth and five hundred and forty in the nineteenth century.[9] But then, of course, the total number of books published also grew enormously from century to century.

For some unknown reason people in the eighteenth century seem to have been convinced that England had the highest rate of suicides. Roland Bartel, an American scholar who investigated this curious belief, mentions Defoe, who wrote that contemporary reports from London suggested that England had more suicides per year than all of Europe put together.[10] A French visitor remarked that 'the English die by their own hand with as much indifference as by another's' and a German was surprised about the many voluntary deaths 'committed by Persons of good Families as well as by the Dregs of the People'. Needless to say that it was the English weather which was often blamed for these acts of despair, an explanation which reassured Jefferson because he expected that 'America's clear skies would protect her people from any inclination to hang themselves that they might have inherited from their English ancestors'.[11] Those who presumably had no experience of the English

climate or had grown accustomed to it, preferred to blame too much meat-eating or tea-drinking for the self-extinction of Britons.

We mention these absurd statements because they show how helpless people were when confronted with the phenomenon of suicide. But it would be rash to expect that even the essential facts about suicide have been resolved by the research of the last hundred years. Based on statistics, some scholars found the number of voluntary deaths dropping in times of common distress like wars; others thought that, on the contrary, 'periods of disorganization are peculiarly favourable to suicide'.[12] Some believe that the highly sophisticated are most inclined to self-destruction; others put factory workers at the top of the list. Some look for social and economic causes; others for psychological motives. To the layman all these arguments and counter-arguments sound both right and wrong. It seems that suicide is as much a social as a psychological problem and that there are as many individual motives as there are suicides. One reads almost with relief the confirmation of this truism by a psychiatrist who investigated 1817 cases delivered into the General Hospital in Cincinnati. 'Suicidal attempts,' he concludes, 'occur in a great variety of individuals under a variety of circumstances.'[13]

Few books on suicide[14]—and none of the statistics—mention suicide committed for philosophical reasons. Yet the freedom to choose death voluntarily was regarded by the Stoics of Rome and later by those of the Renaissance as the natural and supreme birthright of man. Suicide not only began to find a place in the literature of the period, but suicides all'antica like that of Filippo Strozzi in 1538 actually occurred. Moreover, ancient suicides such as those of Lucretia, Dido, Marcus Curtius, and many others were now celebrated by artists as symbols of Chastity, Virtue, Love, and Courage. But it is doubtful whether any artist ever followed the noble examples of antiquity. The cases that have come to our knowledge are less heroic. They tell us of the trials, the sufferings and frustrations of tormented men. Before turning to them, we must attempt to answer the question of why suicides among artists are apparently fewer than among other professions.

Melancholy and the suicidal disposition are closely connected and one may wonder why the melancholic Renaissance and post-Renaissance artist so rarely succumbed to the death-wish. Men like Piero di Cosimo and Pontormo, unhappy and lonely as they may have been, found an escape from their discontent in the excitement and rapture of creation. By over-emphasizing a satisfaction peculiar to them, they compensated for the lack of pleasures which are dear to others.

This leads to another point: call it what you will—Platonic enthusiasm, Promethean creativity, innate talent, or the exalted qualities of the *divino artista*—their belief in being so endowed brings solace to artists

where other men might give way to despair. In a previous chapter we have remarked that despair born from the feeling of professional inadequacy is rare among artists. 'He is sustained in the misery of the present by the hope of a golden future', to quote from the memoirs of a nineteenth century artist.[15] Moreover, the element of release should not be under-estimated. Wherever the image of the mad artist has validity, neurotic behaviour, not easily tolerated in the average person, is excused and even expected from artists. A sixteenth century writer encouraged Raffaele da Montelupo, Michelangelo's collaborator, with the words: 'Your being a sculptor brings with it a privilege that permits you every extravagance.'[16] This attitude of the public aided the artists' adjustment and reduced their flight into suicide.

2 Rosso Fiorentino

The death of Rosso Fiorentino (1494–1540), the first suicide reported in art historical literature, immediately poses some typical problems. The only contemporary source for Rosso's supposed act of self-extinction is Vasari, who was in Italy when the painter died in France. Had Vasari been correctly informed about his friend's death or had he too easily accepted unfounded, perhaps even malicious, rumours? Why should the artist, who was then only forty-six years old and at the height of his fame, have taken his own life? These questions are relevant because they concern the life and death of a great artist as well as the interpretation of contemporary source-material. The essential facts, mostly communicated by Vasari, are as follows.

Giovan Battista, called il Rosso, was born in Florence. Well-mannered, well-read, and highly gifted, he was one of the leaders of the Florentine group of Mannerist painters. From 1523–24 on, he worked in Rome, was captured by the Germans during the Sack of Rome in 1527 but escaped, and after three years of a rather restless life spent in central and northern Italy, he decided to go to France where he was well received by the French Court and the Florentine colony alike. In Paris, in Vasari's words,

... he painted some pictures which he presented to King Francis I, and which were later hung in the Gallery at Fontainebleau; the King took infinite pleasure in them, but much more in the noble appearance, speech and manner of Rosso, who was tall, with red hair in accordance with his name, and very serious, deliberate and judicious in all his actions.[17]

The king soon commissioned Rosso with the greatest task of his career, the decoration of the *Grande Galerie* at Fontainebleau (Fig. 35). Among many minor works, he produced designs 'for all the vessels of the King's sideboard, for trappings of horses, for masquerades and for *trionfi*'.[18] He

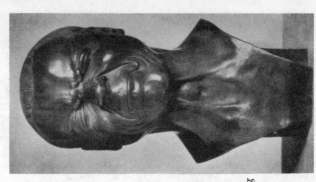

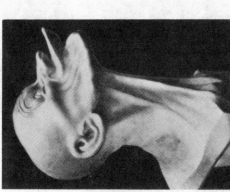

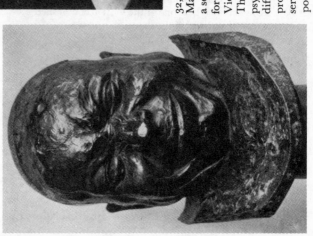

32, 33, 34. F. X. Messerschmidt, 'A happily smiling old Man', 'Beak Head', 'A splenetic Man'. Three busts from a series of Character Heads (begun c. 1770) of which forty-nine have survived. Österreichische Galerie, Vienna.

These heads have been made the subject of a penetrating psycho-analytical study. In Messerschmidt's case it is difficult to draw the line between 'sane' and 'psychotic' production, especially since he created this baffling series simultaneously with perfectly conventional portrait busts.

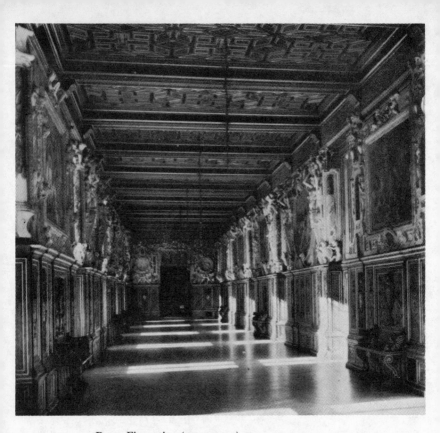

35. Rosso Fiorentino (1494–1541),
The *Grand Galerie*, Fontainebleau, 1534–37.
With the help of a large number of artists
Rosso created here one of the most accomplished
decorative works of the sixteenth century.
Royal patronage carried him to the height
of his profession, yet he probably
committed suicide.

was, moreover, 'appointed superintendent of all buildings, pictures, and other ornaments' at Fontainebleau. His remuneration was generous. Though he lived mostly in rooms at Fontainebleau, a house in Paris was put at his disposal; he had an allowance of four hundred *scudi*, and was given

... a Canonicate in the Sainte Chapelle [under the jurisdiction of Notre Dame] in Paris, with so many other revenues and benefits that Rosso lived like a nobleman. He kept many servants and horses, gave banquets and was extraordinarily kind to all his friends and acquaintances, especially to Italian strangers who arrived in those parts.[19]

But the celebrated painter and accomplished courtier was not always master of his temper. Earlier in his biography Vasari tells at length how, at the time of his wanderings in Italy, Rosso had come to blows with a priest who had objected to his conduct during Mass. Because of this scandalous behaviour he had to flee in the dark of night. A similar lack of self-control probably led to Rosso's undoing. A Florentine painter, a collaborator and intimate friend, Francesco Pellegrini, had come to stay with him. One day Rosso was infuriated to find that he had been robbed of some hundred ducats.

Suspecting that no one but Francesco could have done this, he had him arrested and rigorously examined under torture. But Pellegrini, professing his innocence and declaring nothing but the truth, was finally released; justly moved by anger, he showed his resentment against Rosso for the shameful charge which had wrongly been brought against him.

Pellegrini issued a writ for libel and Rosso,

... unable to clear or defend himself, realized that he was in a sorry plight. He had not only accused his friend falsely, but he had also stained his own honour; and whether he ate his words or adopted other shameful methods, he would always appear as an unfair and wicked man. Resolving therefore to kill himself by his own hand rather than be punished by others, he took the following course: one day, when the King happened to be at Fontainebleau, Rosso sent a peasant to Paris for a certain very poisonous distillation, pretending that he wished to use it for making colours or varnishes, but intending to poison himself, which he did.[20]

As usual, Vasari's story has not been accepted unanimously. One scholar calls Vasari's *Life* of Rosso well-informed and almost without error.[21] Another is strongly inclined to discard the suicide as legendary. He found documents to prove that Rosso stopped attending the meetings of the Chapter of Notre Dame in April 1540 and died on November 20 of the same year—not, as Vasari writes, in 1541. He therefore suggests that the painter may have fallen ill that spring and died a natural death seven months later, a surmise for which he finds support in the fact that

'*un obit triple*' for the soul of the deceased was celebrated a few days after his demise.[22]

M. Roy, the writer of the paper, was himself rather careful in his conclusions. But in spite of his reservations, it has now been generally accepted as an established fact that Vasari erred and that Rosso did not commit suicide. However, none of the points made by Roy militates against Vasari's story. As to the date of Rosso's death, Vasari, not being a modern historian, was never too seriously concerned with dates. In this case an error is all the more understandable as he may have thought in terms of the winter of 1540–41—not having been informed, or not remembering when he wrote the *Life*, that the event took place before the turn of the year. Moreover, neither Rosso's absence from the Chapter meetings nor the celebration of Mass after his death proves the author's point. It is impossible to ascertain what prevented Rosso from doing his duty as a canon. One might equally well argue that the excitement and the worries of the court case reported by Vasari absorbed him completely. Documents also show that at the time of his death Rosso had heavy debts and owed Pellegrini a considerable sum of money.[23] May not such matters have influenced the conduct of a man who was used to living in style?

The celebration of the Requiem Mass for the painter's soul looks at first like a valid argument against his suicide. We have heard that the Church regarded suicide as a criminal offence. The deliberations of the Council of Prague of 563 were still in effect. They stipulated that victims of suicide would be 'honoured with no memorial in the holy sacrifice of the Mass . . .'[24] On the other hand, the Church never abandoned a suicide if the sinner had time to confess and receive Extreme Unction. We suggest that the effect of the poison was sufficiently delayed for the last rites to be administered.

We have reason to assume that this is the correct interpretation. Roy's strongest evidence against suicide—the order of the canons to celebrate Requiem Mass for the painter's soul—may be construed to imply that his manner of death had created a delicate situation. The document says that up to that time canons used to celebrate Masses for a deceased member immediately or as soon as possible after his demise in various cathedral and collegiate churches. Henceforth this custom would be discontinued and replaced by a funeral Mass '*sans autre solennité*' in the Sainte Chappelle only. It appears that the new ruling was laid down with an eye to Rosso's case: no Mass had been celebrated for him on or after the Sunday of his death,[25] which had presumably occurred at Fontainebleau.

In addition, there exists the record of a strange inscription planned for an epitaph in Florence. Vasari published it in his first edition of 1550,

that is, ten years after the artist's death. He omitted it from the second edition of 1568, apparently because it was never used. A free translation from the Latin reads as follows:

Courage and Despair caused Florence to erect this monument to the Florentine Rosso, most famous throughout the whole of Italy and France for invention and composition as well as for the various expressions of character, who, since he wanted to escape the punishment of retaliation, exchanged poison for the gallows and lost his life miserably in France through greatness of spirit as much as through the poisoned cup.

Guglielmo della Valle, the editor of the Vasari edition of 1791–94, called this inscription 'not very religious indeed'. To advertise a suicide thus in a church seems rather extraordinary, and the frankness of the statement probably made its acceptance impossible. On the other hand, it proves that Rosso's suicide was common knowledge in Florence in the decade after his death.

3 *Francesco Bassano*

The death of Francesco Bassano (1549–92) is entered thus in the parochial register of San Canziano: 'On July 3, 1592, died Messer Francesco Bassano, painter, aged 42, from having long had hectic fevers and from finally having thrown himself out of a window, in a fit of frenzy, eight months ago.'[26] This desperate action remained no secret even in Rome. Baglione reported it some fifty years later as a rumour.[27] Bassano's biographers have given us the background to his unfortunate end.

Brought up under the tutelage of his father Jacopo, Francesco married at the age of twenty-nine and, in the following year, he left his birthplace, Bassano, and his father's workshop for the first time and settled in Venice. His parent's fame and his own unquestionable, though lesser, talent secured him many commissions and a good income. But the presence of such masters as Tintoretto, Veronese, and Palma Giovane, and the solicitude of the elder Bassano, who frequently appeared in Venice to keep an eye on the son's work in the Doge's palace, cannot have increased Francesco's self-confidence which was never very strong. His younger contemporary, the writer Ridolfi, talks of his 'simplicity' and says that he had inherited from his mother 'a certain light-headedness which in the course of time increased in such a way that his mind became disordered'.[28]

Verci, the artist's other biographer, was also a native of Bassano; he would have drawn on sound local tradition although he wrote about a century after Ridolfi on whom he also drew extensively. He says that Francesco,

. . . being of a very quiet and sweet disposition, shy and solitary by nature

(Fig. 24), became hostile to every company and diversion, caring for nothing but a continuous application to the study of his art. He led a pure and innocent life. His mind was so unquestioning, simple and credulous that whatever fabulous story he listened to or read about filled him with fear and agitation; with his imagination vividly impressed by those extravagant tales, he followed the misadventures of fictitious persons and was moved by compassion to sobs and tears. Tormented by this weakness, his spirit worn out by indefatigable toil in painting, he fell into a fierce hypochrondria which often drove him out of his senses. At last, in the grip of a furious fixation, he believed that he was going to be arrested, whereupon he fled without peace from room to room, hiding from his friends, even from the servants, and almost losing confidence in his wife, as he suspected that she might deliver him to the police. She, however, who loved him dearly, took care of him, and, at the same time, in order to have him cured by doctors, had him continuously watched by various persons. But every care was in vain, for one day, when by accident he had been left alone, hearing somebody knocking very noisily at the door, he believed that the constable had come for him. Thereupon he fled in terror and, climbing out of a window, precipitously threw himself down hitting his temple on a stone, and lay mortally wounded.[29]

4 Francesco Borromini

Bassano's suicidal attempt could be freely discussed because he lived long enough to redeem his sin. For the same reason Borromini's deed was never kept secret: in fact, his suicide is probably the only one among artists which comes readily to mind even nowadays, perhaps not so much because his illness and death are especially well documented, but because they seem consistent with the tragic life and strange architecture of this most enigmatic figure among the great masters of the Roman Baroque.

Born in a small town on Lake Como, Francesco Borromini (1599–1667) went to Rome in about 1620. For almost a decade he worked as a stonemason and architectural draughtsman, acquiring great technical knowledge under the guidance of his kinsman, the aged Carlo Maderno. It was this professional skill rather than his genius that made Bernini employ him on some of his own architectural enterprises. Not until the age of thirty-five did Borromini receive his first independent commission, the small church of S. Carlo alle Quattro Fontane. Of this his patron wrote that 'in the opinion of everybody nothing similar with regard to artistic merit, fantasy, excellence and singularity can be found anywhere in the world' (Fig. 37).[30] Henceforth, during his lifetime and after, Borromini's work met with a mixed response. There were those who admired his imaginative and noble creations, although they may have felt somewhat uneasy about his 'bizarre and fascinating ideas'.[31] Others, like Bellori, who judged him with a classical bias, expressed their

disgust by calling him a 'Gothic architect'—at that time a most derogatory epithet—'a complete ignoramus, the corrupter of architecture, the shame of our century'.[32] His biographer, Passeri, warned that his 'taste in questions of architecture was singular, and not to be imitated unreservedly', and two years before Borromini's death, in a drawing-room conversation in Paris, Bernini and others agreed that his architecture was strange ('chimerical').[33] His manner of life, too, set him apart.

He made himself everywhere conspicuous because he insisted on appearing constantly in the same set of clothes, not wishing to follow the customs of normal dress.

Borromini was not a man of means, for he never allowed himself to be tyrannized by money matters or the burden of a family, and never having submitted himself to the bonds of matrimony he had no desire to accumulate wealth.[34]

Such a man was not likely to live on easy terms with his patrons and fellow-artists, and in fact he encountered a great many difficult situations specially in his later years. After Innocent X's death he had the humiliating experience of being dismissed by Prince Camillo Pamphili as the architect to the church of S. Agnese in Piazza Navona, and to see as his successor the same Rainaldi whom he himself had ousted only four years before. He seems to have been irascible, and ruthless in his anger. Once, during his work for S. Giovanni in Laterano, a man was surprised there in the act of damaging some marble blocks. Borromini had him arrested and beaten up so severely that he died.[35] His contemporaries talked of his envy. He felt especially frustrated by Bernini whose success and fame eclipsed his own, but of whose inferiority as an architect he was convinced. All this

. . . grieved and upset him so much that in order to throw off the fit of melancholy which oppressed him, he decided to go on a journey, and he went to Lombardy. But when he came back to Rome his melancholy returned, for which reason he spent whole weeks locked inside his house without ever leaving it.[36]

In his sixty-eighth year Borromini fell seriously ill. He was 'afflicted by a fever which gave signs of some violence and malignity'[37] and

. . . was assailed again with even greater violence by hypochrondria which reduced him within a few days to such a state that nobody recognized him any more for Borromini, so haggard had his body become, and so frightening his face. He twisted his mouth in a thousand horrid ways, rolled his eyes from time to time in a fearful manner, and sometimes would roar and tremble like an irate lion. His nephew [Bernardo] consulted doctors, heard the advice of friends, and had him visited several times by priests. All agreed that he should never be left alone, nor be allowed any occasion for working, and that one

should try to make him sleep at all costs, so that his spirit might calm down. This was the precise order which the servants received from his nephew and which they carried out. But instead of improving, his illness grew worse. Finding that he was never obeyed, as all he asked for was refused him, he imagined that this was done in order to annoy him rather than for his good, so that his restlessness increased and as time passed his hypochondria changed into pains in his chest, asthma, and a sort of intermittent frenzy. One evening, during the height of summer, he had at last thrown himself into his bed, but after barely an hour's sleep he woke up again, called the servant on duty, and asked for a light and writing material. Told by the servant that these had been forbidden him by the doctors and his nephew, he went back to bed and tried to sleep. But unable to do so in those hot and sultry hours, he started to toss agitatedly about as usual, until he was heard to exclaim: 'When will you stop afflicting me, O dismal thoughts? When will my mind cease being agitated? When will all these woes leave me? . . . What am I still doing in this cruel and execrable life?' He rose in a fury and ran to a sword which, unhappily for him and through carelessness of those who served him, had been left lying on a table, and letting himself barbarously fall on the point was pierced from front to back. The servant rushed in at the noise and seeing the terrible spectacle called others for help, and so, half-dead and covered in blood, he was put back to bed. Knowing then that he had really reached the end of his life, he called for the confessor and made his will.[38]

Though published only in 1730, this report is irrefutably correct and corresponds in all essentials with Borromini's own statement. The accident occured during the early morning of August 2, 1667. Borromini lived through the day. Mortally wounded, he was yet perfectly conscious and clear in his mind. He gave a precise account of the happenings, signed the protocol with his own hand, and received Extreme Unction.[39] In accordance with his wish he was buried next to his kinsman Carlo Maderno, his beloved teacher and greatest friend.

5 Pietro Testa

There were no extenuating circumstances to ease the minds of Pietro Testa's biographers. The painter died alone. His friends were at pains to explain his sudden end as an unfortunate accident, but it is nowadays, and probably correctly, believed to have been self-inflicted.

Testa (1607[11?]–1650) was born in Lucca. He came to Rome before 1630 and was a pupil first of Domenichino, later of Pietro da Cortona. A prolific worker, especially as an engraver, he was also passionately interested in historical and theoretical studies, but he was plainly not a success. Passeri deplored Testa's 'never [having been] able to obtain for himself the protection of those who might help him rise in the world'.

It has recently been suggested that Testa's failure was caused by his preference for strange subjects (Fig. 36) and his neglect of painting in

favour of the lesser art of etching, and that the lack of sympathetic response aggravated a deep rift in his nature: Testa was torn between his innate romantic leanings and his overt classical theories.[40]

His biographers are at one in describing the difficulties under which he laboured. Passeri says that

> ... he did not know how to be one of those cunning ones who smile with their lips whilst carrying a razor under their coat. His great and noble talent inclined him strongly towards philosophy, and made him prefer retirement and solitude, which was his greatest handicap, since he could never accommodate himself to playing the courtier in antechambers.[41]

The writer goes on to describe how Testa 'abandoned himself to an extreme melancholy', how he used to go 'alone to the most solitary places', and he thinks, or pretends to believe, that the painter was accidentally drowned during one of his solitary wanderings. Rumours of suicide immediately began to circulate. Passeri calls them 'calumnies and malicious inventions'; Baldinucci tried to stifle them by explaining that Testa either slipped or that 'the ground moved under him' while he was observing the reflections of a rainbow on the waters of the Tiber.[42] Sandrart, for whom Testa had worked in Rome in the 1630's, has yet another explanation: 'One day, on the shores of the Tiber, a sudden gust of wind blew his hat into the river, and when he tried to retrieve it, as ill-luck had it, he fell into the water, and as no help was available, he was most miserably drowned.'[43]

Sandrart knew Testa well and liked him. He has left us a fine character sketch of the 'shy *stoicus*' whom he found living in direst poverty and whom he often 'supplied with food, clothing and money'. It would have offended his sense of decency and decorum to admit his friend's sinful deed.

6 *Marco Ricci*

Whereas Testa's biographers cast about for rather flimsy explanations for his probably unnatural death, a contemporary of Marco Ricci (1676–1730) turned the painter's quite possibly natural demise into a very questionable suicide. A notebook of 1738 contains the following remarks on the famous Venetian landscape painter:

> He died in the house of his uncle Sebastiano of a fever and catarrh, having lived with his uncle for thirteen years.
>
> In the ardour of his youth Marco was a vicious fellow and given to a bad life; nor was he ashamed to mingle in taverns with vile plebeians. One night in a tavern he felt offended by certain words uttered by a *gondoliere*, whereupon he took a tankard, smashed it over the head of that unfortunate man and killed him. Thereafter his uncle sent him to Spalato in Dalmatia with recom-

mendations to a gifted landscape painter from whom he learned much. He stayed there for about four years and then returned to Venice where his uncle had in the meantime appeased the law. It was said that Marco was very eccentric. After his return from England, and while he lived in his uncle's house in Venice, it suddenly came to his mind that he wanted to die, but to die like a knight. One morning, therefore, he dressed up most strangely, with a sword at his side, and lay down on his bed.[44]

He locked himself into his room and, although he grew very hungry, he remained on his bed for two days and two nights. His family became alarmed. Not knowing whether he had left or was in his room, they finally broke open the door and found Marco, half-famished, in his peculiar attire waiting for death. However, he was soon restored and did not repeat this particular experiment, but he is reported to have died by the no less singular expedient of changing his doctor's prescription from a harmless medicine into a fatal one. Whether the whole story is an invention, whether the doctor himself circulated it to cover up his own mistake, or whether Marco, denied the privilege of a knightly death, really poisoned himself will probably never be established. Only this much can be said in view of what will be discussed in later chapters: neither his dissipated life nor his uncontrollable temper is necessarily indicative of an unstable mind.

Five suicides of which only two are confirmed seems an extraordinarily small number for the many thousands of Italian artists who died between about 1450 and 1800. That this figure may not be too far off the mark is perhaps borne out in a negative way by the Florentine diary started by Luca Landucci in 1450 and carried on by an anonymous writer until 1542. In those ninety-two years we find eight suicides mentioned altogether, none of them committed by an artist.

7 Suicides of Northern Artists

Holland and England

In the northern countries the situation was not much different. Houbraken seems to have heard of only three suicides, that of the little-known Jacob de Wolf (d. 1685) who 'fixed his dagger in a corner of his room, let himself fall upon it, and thus ended his life', of Pieter van Laer, a doubtful case,[45] and of Emanuel de Witte who was suspected of having drowned himself.

De Witte's life (1617–92) is well-documented. His better works, especially his immaculately composed renderings of church interiors (Fig. 39), rank high among the art of the seventeenth century. In spite of many commissions he had constant financial troubles. He was given

36. Pietro Testa (1607/11–1650), Engraving, 1641. This enigmatic design is usually, but wrongly, called an Allegory of Winter. Testa had a preference for strange subjects, phantasmagorias of an extreme melancholic who probably drowned himself.

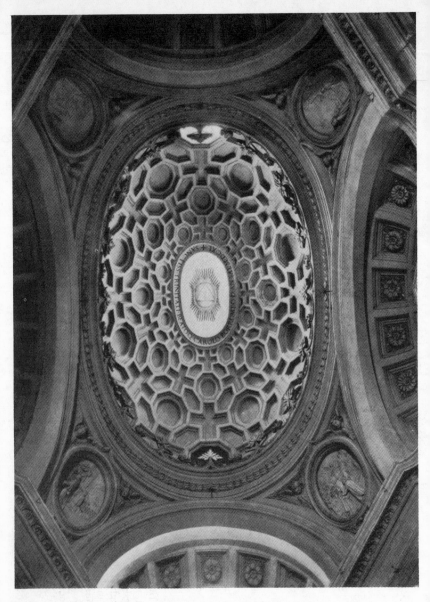

37. Francesco Borromini (1599–1667), Dome of S. Carlo alle Quattro Fontane, 1638–41. Rome.

Borromini's architecture was regarded as strange and 'capricious' even during his life-time. It has been maintained that his work reveals his progressive psychosis.

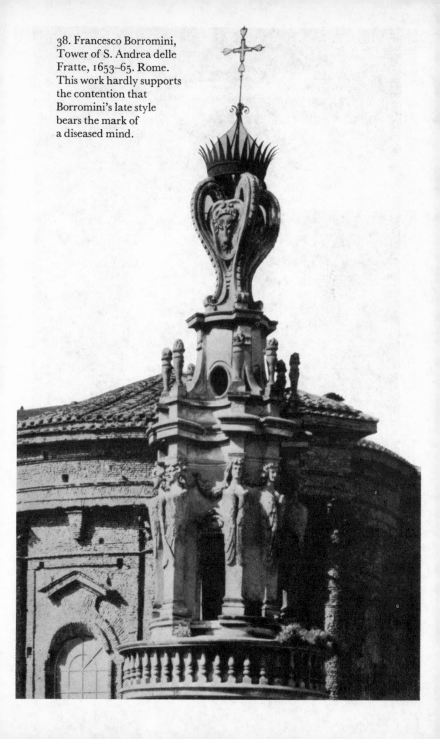

38. Francesco Borromini, Tower of S. Andrea delle Fratte, 1653–65. Rome. This work hardly supports the contention that Borromini's late style bears the mark of a diseased mind.

39. Emanuel de Witte
(1617–92), Interior of a Church,
signed and dated 1656.
Kunsthalle, Hamburg.
One of the most accomplished
and sober painters of church
interiors in seventeenth
century Holland, de Witte led
an eccentric and debauched
life. Old, poor and broken in
spirit, he committed suicide.

to drinking and gambling; he had to pawn his household goods, his furniture and his paintings; he owed his rent for years and took payments on account for pictures which he only delivered after his exasperated patrons had taken the matter to court. At the age of seventy De Witte was one of a party of four who were accused of unruly behaviour and fined for 'great insolence' and 'noise'. Then,

. . . when he saw that Fortuna turned away from him, that everybody avoided him and regarded him like a stranger in his own country, he fell into poverty and lost his self-confidence.

As he differed in his way of life from others, so also did he differ in his death, because it seems that he ended his life by his own hand.[46]

In England none of the better-known artists committed suicide. We hear of Henry Tilson (1659–95), one of the many minor portrait-painters who turned out more or less successful likenesses of the English aristocracy and gentry. Vertue, still under the spell of Burton's notion of the melancholic genius leading a life 'free from bodily exercise', describes him as having been

. . . much more acceptable to the curious in art than he was to a Mistress whom he had courted for a long time till at length, through a Melancholy Habit of body contracted by her unkindness, and a sedentary life he shot himself with a pistol to the Heart.[47]

The death of Edward Dayes (1763–1804), who had won a certain fame for his miniature portraits, mezzotints, and water colours caused, it seems, no great stir.

His temper was neither amicable nor happy: it was probably owing to this cause that his dissolution was accelerated by his own hand. This melancholy event took place during the last week of May 1804 at his house in Francis Street, Bedford Square, where he had resided for several years.[48]

France

The tensions and bitter rancours which agitated the artists of the Royal Academy in France are thrown into sharp relief by the life and death of François Le Moyne (1688–1737). Born in Paris, Le Moyne entered the Royal Academy at the age of thirteen. After five years of study he received his first prize, the Academy medal, third class. In the following year he succeeded in gaining the first class medal and in 1711 he won the *Prix de Rome* but, owing to the wars, he could not go to Italy until 1724 and then was able to stay for only seven months. Thus Le Moyne spent his entire life in the atmosphere of bitter jealousies, incessant intrigues and deadly enmities which poisoned the official art world of Paris at the time. He was consumed by ambition. He complained to his friend, the

writer Dézallier d'Argenville, that his paintings were given 'terrible neighbours in the Salon'. Fearful lest anybody should outshine him, he worked unceasingly and far beyond his strength. He was known for his

. . . irritability caused by craving for recognition and honours which he doubtlessly deserved, but which, according to him, scarcely ever equalled his merits. Never finding anyone who was not, in his own eyes, his inferior, he deemed insufficient whatever was given to him, and for the same reason judged everything he was promised as far beneath his due.[49]

Neither his body nor his mind could stand the strain and his health broke:

Le Moyne had suffered from severe headaches which at times prevented him from working. The death of his wife occurred while he was in the middle of his preparations for the Salon. He was so afflicted by the loss that he left his studio for a time.

In the last six months of his life he was attacked by a hectic fever which gave him little rest. He suspected everyone. He believed himself constantly followed by police officers. His friends tried to distract him; they read Roman history to him, and when some noble-minded Roman had committed suicide he had the passage read out again, exclaiming: There is a beautiful death![50]

This is the only time that we have found an allusion to the Stoic right of self-extinction, but Le Moyne's death had nothing of classical grandeur about it. It had become clear to his friends that something drastic should be done for the artist whose reason was obviously deteriorating, so

. . . on the morning of June 4, 1737, ten months after Le Moyne had been appointed *premier peintre*, monsieur Berger, the friend with whom he had travelled to Italy, came to his house as had been arranged the night before. Pretending to take him for a few days' rest into the country, he really came to have him locked up and try such remedies as are used in similar cases. But whether Le Moyne was suspicious or imagined he would be taken to prison —an idea that had long obsessed him—he locked himself into his room as soon as he heard his friend approaching, and silently he pierced himself nine times with his sword. Unaware of the tragedy his friend begged him insistently to open. When he threatened to force the door, Le Moyne mustered enough strength to obey and he appeared in that state to which his frenzy had reduced him; but that very instant he fell dead.[51]

With the brief life of an obscure young French painter we find ourselves in a different world. Dry and factual as the few preserved records are, they conjure up the atmosphere of the beginning of the Romantic era, the *ambiance* of *La Bohème*.

Jean-Louis Sauce, son of a bootmaker, was born in Paris in 1760 and died there in 1788. At the age of twenty-three he passed the entrance examinations to the Academy and was admitted as a student. Already in

the following year he won the hotly contested 'first medal'. In that year he also fell in love and subsequently

... lived for three years with a little lace-maker called Geneviève-Rosalie Poirier whom he promised to marry. Having met her on the eve of the wedding, he conducted her to his room on the fifth floor of a house in the rue de Vaugirard. After a sumptuous dinner at which the sculptor Spercius of the rue de Pot-de-fer took part, and doubtlessly excited by brandy, Sauce threw himself on the unfortunate girl, fired two pistol shots at her, and pierced her with his sword in spite of her cries and her pleas for mercy. Then he threw himself out of the window and smashed his head on the pavement. The doctor counted no less than six wounds on the body of the victim; but they are not very deep and it is hoped that her life will be saved.

The landlord refuses to take care of the body of the suicide.[52]

Nothing is known of Sauce's work except that five pen and *bistre* drawings were sold at auction in 1814 for eight francs; at least two of them are still extant (Fig. 41).

Denmark

This chapter will be concluded with an account of the suicides of two Danish artists, the painter Eric Pauelson or Poulsen (1749–90) and the sculptor Johannes Wiedewelt (1731–1802). Pauelson's modest talent and apparently uneventful life have not induced his biographers to comment on the motives for his deed. We are told that he travelled for three years through Germany, France, Switzerland, and Italy when he was over thirty years old; that his application for election to the Accademia di S. Luca was rejected, but that he became a member of the Academies of Düsseldorf, Bologna and Florence after his return to Denmark in 1784. Four years later he was sent to Norway by the Danish Crown Prince and the water colours of Norwegian landscapes which he brought back earned him considerable praise. We have not been able to find out why and how he ended his life at the age of forty-one.[53]

Wiedewelt, on the other hand, has aroused more attention. 'Once the pride of his countrymen',[54] he is nowadays remembered for his friendship with Winckelmann rather than for the quality of his work. As a promising youth of nineteen Wiedewelt went to Paris and, after studying for three years with Coustou, he travelled on to Rome where he met Winckelmann. A close relationship ensued and under the influence of the older scholar the young sculptor became one of the earliest and most ardent advocates of Neoclassical doctrines. When Wiedewelt returned to Copenhagen after an absence of seven years, he impressed his countrymen as much by his learning and his proficiency in ancient and modern languages as by his art. The modernity of his style concealed the weak-

ness of his talent.[55] His success was immediate, his rise in offices and honours rapid. One year after his arrival he was nominated court sculptor and a member of the academy. At the age of thirty he became a professor of sculpture, at forty-one director of the Academy, a post which he held for almost twenty years.

But with advancing age Wiedewelt could not sustain his place of eminence against the competition of the rising generation and especially against the growing fame of his pupil Thorvaldsen. His application in 1788 for the post of court sculptor to the King of Prussia was turned down in favour of the young Schadow (1764–1850), his junior by more than thirty years. In the end, burdened with the care of two aged sisters and an incapacitated friend, beset by growing poverty and ill health, he ended his misery by drowning himself.

8 *Conclusion*

To the five Italian suicides, we have been able to add nine committed in Northern Europe. These fourteen incidents (which include four uncertain ones) occurred within the course of about four hundred and fifty years, that is, between roughly 1350 and 1800, the only period for which our records are fairly reliable. If we break this figure down we get the following result: no suicide is recorded before 1500; two cases appear in the sixteenth century, six in the seventeenth, and six during the following 104 years. It seems characteristic that four of the fourteen (or ten certain) suicides were committed within the brief span of sixteen years, towards the end of the eighteenth and the turn of the nineteenth century—at a time when suicide had lost some of its stigma and after it had become, partly through the impact of Goethe's *Werther*, much more common among professionals and intellectuals than ever before.

Although admittedly our statistics are far from reliable, we believe that they indicate the general trend correctly and show, if proof is needed, that artists behave more normally than 'ordinary' people when it comes to suicide.

Where the sources are sufficiently detailed, they provide reasonable explanations for the self-inflicted deaths. Thus Rosso is supposed to have acted from a hurt sense of honour; the Renaissance conception of honour (see Chapter VIII) made this explanation plausible. Francesco Bassano and Le Moyne obviously became insane; both suffered from persecution mania. Three artists—Borromini, Testa, and Tilson—were described by the now familar term of melancholic; Ricci and de Witte conformed to the image of the eccentric and debauched artist; Wiedewelt acted out of despair. Regarding Sauce, we are told that he was probably drunk. These reports are no better or worse than what we read in the press nowadays.

None of the early biographers made any attempt to seek reflections of an artist's suicidal tendencies in the specific character of his work. One would naturally not expect psycho-pathological investigations before the early nineteenth century, but even the Neoplatonic theory, according to which there exists a mirror-image relationship between mind and work, is nowhere in evidence. It is scarcely necessary to point out that this theory had little practical applicability. Good for making a parade of the author's learning it had no place in the 'workaday' writing of biographies. But modern art historical research has not probed into this question either: scarcely a single historian has availed himself of the new scientific methods—with one notable exception.

In his work on Borromini, Hans Sedlmayr,[56] using Kretschmer's psycho-physical terminology, tried to discover in Borromini's architecture features compatible with the latter's unstable mind. He argues that Borromini was a 'schizothymic' type, that is, a type whose schizoid condition remains within the bounds of normality. But, according to Sedlmayr, Borromini's suicide belongs to the picture of an increasing schizophrenia and consequently he finds in the architect's late work typical signs of this pathological process (Fig. 38). Sedlmayr himself was not unaware of the pitfalls of his thesis. Logically, the many artists constitutionally akin to Borromini should also display similar characteristics in their art— and this is impossible to demonstrate. Thus even in this classical case the enigma of the relation between the work and the personality of the suicide remains unresolved.

CHAPTER VII

CELIBACY, LOVE, AND LICENTIOUSNESS

THE SUBJECT to which this chapter is devoted—the love-affairs of artists—has produced singularly conflicting opinions among scholars. There are those who find that artists show a marked leaning toward celibacy, while others maintain that they are predominantly of an amorous or even promiscuous bent. Nineteenth century biographers often described the artists of the past as simple and staunch family men. Tales to the contrary were taken either as exceptions or as malicious inventions. Modern writers, by contrast, are inclined to discover a tendency towards homosexuality in artists, past and present.

The crux of the matter is that each view can be supported, quoting chapter and verse. Any number of celibate artists can easily be matched by an equal number of happily married ones, and it would not be difficult to find a Don Juan for every misogynist. Nor does the common practice of scrutinizing only the lives of 'great' masters allow us to draw general conclusions. We have to state at the outset that we have no axe to grind and can, therefore, admit that we have found no reliable means of computing the preponderance (or absence) of one form of love relationship over another among artists. All we can show is that throughout the centuries artists' sexual habits have tended to change with the changing moral climate.

1 *Celibacy*

The classic examples of celibate artists, quoted over and over again, are of course Michelangelo, Leonardo, and Raphael. But no possible common ground exists for their aversion to or abstention from marrying.

Michelangelo, the great solitary, had a strong family sense. Like a good Italian he fulfilled his filial obligations. He helped his brothers and his nephew Lionardo with advice and money though he constantly complained of their demands on his time and purse. Many of his letters show that friendship and affection were necessary to him and that he responded warmly though erratically when they were offered. Whether he was ever in love with a woman is doubtful; his devotion to handsome

youths is well attested. Letters to and from Gherardo Perini (1522) and Febo di Poggio (1534), both otherwise little-known personalities, and poems dedicated to the memory of Luigi del Riccio's nephew, Cecchino Bracci (1544), clearly express this inclination.[1] But neither in his youth nor in his mature years does he seem to have formed any very strong and lasting attachment. When Tommaso Cavalieri and Vittoria Colonna entered his life he was at the threshold of old age.

Cavalieri, a young Roman nobleman, and Michelangelo first met in 1532 when the artist was in his fifty-eighth year. The ensuing friendship lasted until that day in February 1564 when Tommaso Cavalieri, together with two other friends, two doctors, and an old servant, gathered around the dying master.

Michelangelo's relationship with Vittoria Colonna, Marchioness of Pescara (1490–1547), dates from about 1538, when he was past sixty and she approaching fifty. Betrothed as a child and married to the Marquess of Pescara at the age of nineteen, Vittoria Colonna saw little of her husband, who spent most of his life in military campaigns and died in 1525. The childless, middle-aged widow, not blessed with beauty, knew how to make the most of her intellectual gifts. Although she lived in semi-retirement, dividing her time between Rome, Ischia, and convents in Orvieto and Viterbo, she corresponded extensively with many learned men. When Michelangelo met her she had acquired a certain fame as a poetess and a great reputation for piety, though in some quarters her neo-Catholic views had aroused suspicion. The sculptor and the noble lady exchanged letters, madrigals, and sonnets, and Michelangelo sent her some of his most intensely devout religious drawings as signs of his veneration and friendship. At their meetings in Rome they conversed about lofty ideas, often in the company of a small and select circle of admirers. Francisco de Hollanda has perpetuated in print what he claims to have been the gist of their talks. Reading Vittoria Colonna's few preserved letters addressed to Michelangelo one cannot quite recapture the fascination these slightly affected and rather tortuous effusions had for the recipient. Perhaps she was one of those persons whose originality shone brighter in the spoken than in the written word. That Michelangelo was deeply impressed by her cannot be doubted. Years after her death he treasured every word from her pen in his possession. He had kept her letters and had one hundred and forty-three of her sonnets bound into a book which he 'used to lend to many persons, and they have all of them now been printed',[2] as he informed his nephew.

Michelangelo never showed any reticence in making his feelings and passions known not only to the recipients of his letters and poems but also to many of his other acquaintances. His love-poems were circulated

among his friends. He asked his friend, the banker Luigi del Riccio, more than once to correct sonnets addressed to Tommaso Cavalieri. Sebastiano del Piombo, among others, carried messages of devotion from the artist to Cavalieri and vice versa. Both Michelangelo and Ricci adored the beauty of Cecchino Bracci and they shared their grief over the boy's death at the age of fifteen. The 'private' meaning with which Michelangelo endowed the drawings dedicated to Tommaso Cavalieri appears veiled only to us—their message was surely less obscure to those who spoke the same language. It seems unlikely that Michelangelo should have suffered from feelings of guilt because of these friendships, less probable still that his Platonic love should have been 'rejected by the self' as has recently been asserted.[3] He and those near him considered Platonic love as the highest attainable form of spiritual union between men, not to be thought of in the same breath with the objectionable practices of the uninitiated. We fully subscribe to Professor Panofsky's view that 'among all his contemporaries Michelangelo was the only one who adopted Neoplatonism not in certain aspects but in its entirety' and that he 'might be called the only genuine Platonic among artists influenced by Neoplatonism'.[4]

The true character of Michelangelo's love-poems was soon misunderstood and a prudish age feared that the poems might expose him as a homosexual. His great-nephew, the first editor of these poems (1623), felt it expedient to expurgate the collection.[5] Later critics invented absurd excuses in order to cleanse the name of the venerated master from the odium of perversion.[6] Guasti, Symonds, Frey and others recognized that much of the exalted language in the poems and letters was literary cliché, widely used to prove learning and familiarity with the great models of the past.

Leonardo's celibacy seems to have sprung from a rejection of all ties. Though in his youth he undoubtedly had strong homosexual inclinations (p. 170), he neither needed nor offered friendship of any kind. In his later years he looked upon the satisfying of animal instincts with derision and with advancing age he developed almost misanthropic habits.

Raphael, in contrast, was not at all averse to marrying. For him it was a question of the right choice at the right time. Meanwhile he enjoyed the company of women exceedingly and we shall later give some evidence of his far from celibate disposition.

Then, as now, confirmed bachelors were the target of much banter. The following anecdote about Botticelli's aversion to matrimony was first incorporated into a manuscript written by an anonymous author between 1537 and 1542, that is, not long after the painter's death in 1510. Later, in 1622, it was published with other burlesque stories; it is

40. Agostino Tassi (*c.* 1580–1644), Frieze with maritime Scenes from the
Fresco Decorations in the Palazzo Pamfili, Piazza Navona, Rome.
Although publicly denounced as 'a rogue and a wretch' by his own sister, Tassi
received many commissions from eminent Roman families. The frieze here illustrated
was painted for Cardinal Pamfili, later Pope Innocent X.

41. Jean-Louis Sauce (1760–88), A Bacchanal. Drawing, signed: Sauce.
Private Coll., New York.
The drawing reveals an artist educated in the French academic tradition, but
Sauce must have been an early Romantic. His suicide on the eve of his wedding
conjures up the ambience of *La Bohème*.

42. Raphael (1483–1520),
Studies for Figures of the
Disputà in the Vatican Stanze,
1509–11. Print Room,
British Museum.
While engaged on designing
the most sublime representation
of Christian dogma, Raphael's
mind wandered off to the lady
of his heart: on this and other
drawings he jotted down
fervent love poems.

quite likely that it contains a grain of truth, even if it has been embellished in the process of writing.

Once when Tommaso Soderini pressed Sandro Botticelli to get himself a wife, the latter answered him: I will tell you what happened to me one recent night. I dreamt that I had taken a wife and this grieved me so much that I woke up. And in order not to fall asleep and dream again I got up and walked like mad all over Florence throughout the night. By this Messer Tommaso understood that he had better not touch the subject again.[7]

Other artists remained unwedded for much the same reasons that motivate bachelors at all times, irrespective of their profession. The list is long and distinguished. It includes such men as Alberti, Pontormo, Rosso, van Dyck, Claude Lorrain, Reni, Watteau and Reynolds. We doubt whether a common denominator can be found in these cases, or whether typical traits can be detected in the works of celibate artists. Yet such attempts have been made, even by scholars to whom the word 'psychology' was anathema. The great Wilhelm von Bode observed:

May not the peculiar phenomenon that the most charming Madonnas have always been painted and modelled by unmarried artists such as Botticelli, Luca della Robbia, Donatello, Leonardo and Raphael be due to this: that the yearning for THE woman stimulated the imagination and creativity of artists more than the fulfilment of their desires?[8]

In actual fact, Bode voiced in his way what we would call 'repression' and 'sublimation' in modern parlance. Such observations never entered the minds of writers before the nineteenth century. They looked upon the unmarried state of artists from a purely pragmatic point of view. To give just two examples: we are informed that Brunelleschi and Donatello, young in Rome, enjoyed their independence because 'family cares did not worry them, as neither had wife or children, here or elsewhere'.[9] Guido Reni, according to Malvasia, 'was generally believed to be a virgin, and he never gave cause for the slightest scandal'.[10]

2 Raphael—the Lover

When Raphael was twenty-one he had been near to concluding a most desirable union with a niece of Cardinal Bibiena, his great patron, but her death intervened and robbed him of his promised bride. Raphael remained unmarried, not because of some vague yearning for an unobtainable ideal, but for very practical reasons which he explained in a letter to his uncle, Simone Ciarla, on July 1, 1514:

With regard to marrying [*torre donna*][11] I reply that I am very glad indeed and forever grateful to God that I neither accepted the one you first wanted to give me nor any other, and in this respect I was wiser than you who suggested

them. I am sure that you will now agree that I would never have got where I am, having 3,000 gold ducats put aside in Rome.[12]

Raphael goes on to list the works he had in hand for Pope Leo X in the Vatican and in St Peter's and the very considerable income he derived from them. But all this immense burden of work did not prevent him from being head over heels in love. A few years later, he was engaged on the Cupid and Psyche frescoes in Agostino Chigi's Villa Farnesina. Of that time Vasari recalls that Raphael

. . . was a very amorous person, fond of women and always ready to serve them; because of this inclination his friends were more complacent and indulgent towards his pursuit of carnal pleasures than was probably right. Thus, when his dear friend Agostino Chigi commissioned him to paint the first loggia in his palace, Raphael was not able to give much attention to his work owing to his great love for his mistress. Agostino felt such despair that, in spite of difficulties, he arranged with the help of others and by his own and various means that this lady should come and live all the while with Raphael in that part of the house where he was working; and in this manner the work was brought to conclusion.[13]

Raphael's first modern biographer, J-D. Passavant, indignantly rejected this story as a 'miserable and absurd invention'.[14] Following him, it has usually been dismissed as one of Vasari's less excusable aberrations. To be sure, from the standpoint of Victorian ethics any such avowal had to be regarded as an insult to Raphael's 'noble character'. But sixteenth century morality differed from that of modern times. To Vasari the incident in the Farnesina did not appear vicious or degrading, otherwise he would not have reported it, since he had written about Raphael's character in terms of the highest admiration (see Chapter IV).

We do not deny that Vasari may too credulously have accepted studio gossip circulated after Raphael's death. It is now generally agreed that Vasari can hardly have been correct in attributing Raphael's untimely death to his amorous excesses.[15] The painter fell ill with a violent fever at the end of March 1520 and died on April 6. Many letters flashed the news across Italy, but none makes as much as a hint at the cause reported by Vasari.

Nevertheless, it was Raphael himself who was to blame for the rumours concerning his love affairs. At the time of the preparation of the Disputa in the Camera della Segnatura his emotions were roused by less lofty thoughts than the Eucharist Sacrifice shown in the fresco. He was so thoroughly infatuated by the lady of his heart that he jotted down love-poems on a number of preparatory drawings for this work (Fig. 42).[16] If they are not good poetry, there is no denying that they are sensual. One at least may here be given:

Love thou hast bound me with a beauteous face
Blooming like roses and as snow pure white,
With sparkling eyes that pierce me with their light
And words that fill my soul with their sweet grace.

Not sea nor river can put out the fire
Burning within me. Yet I'll not complain.
The more I am consumed the more I'm fain
To relish my torment and my desire.

How dear the chain, how light the welcome yoke
of those enchanting arms that held me fast!
I'd die a thousand deaths were this bond broke—

Enough. In silence will I think of our past.
A great joy kills. If ne'er again I spoke
Yet will I treasure thee unto the last.

It will remain forever unknown whether this charmer was the woman whom, according to Vasari, he loved 'until death'[17] and whom, when he was dying, 'like a good Christian he sent away before making his will, but bestowed enough on her to secure her an honest life'.[18] Posterity has woven legends round this woman and others who had entered into Raphael's life. Who is the mysterious *Donna Velata* of the Pitti Palace (Fig. 43)? Was she a woman called Caterina, because the painting in its original condition may have shown wheel, palm and halo? And is she the same as the legendary baker's daughter from Trastevere whom Raphael portrayed in the so-called *Fornarina*, now in the Galleria Nazionale in Rome?—a painting so famous in its time that contemporary copies of it are still in Rome and elsewhere. Nor do we know whether Raphael eternalized the features of his beloved in the *Sistine Madonna* or in any of his tender paintings of the Virgin. True to the current Neoplatonic ideology, he explained in a letter to Baldassare Castiglione that for the rendering of beautiful women in pictures 'I am making use of a certain idea, which I have formed in my mind'.[19]

3 Licentiousness and Religious Art

Filippo Lippi's Elopement with Lucrezia Buti

We have seen in a previous chapter that Renaissance and Baroque writers and patrons had theories about the fitting behaviour of artists.[20] Before these ideas had been consolidated, the question hardly arose whether the makers of sacred images should also be men of exemplary conduct.

The scandal of Fra Filippo Lippi's elopement with a nun may have set tongues wagging, but it did not lessen the impact of his religious

imagery. Filippo Lippi (1406–69), himself a monk, was, in Vasari's words,

... commissioned by the nuns of S. Margherita [in Prato] to paint the panel of their high altar; he was working at this when one day he noticed a daughter of Francesco Buti, a citizen of Florence, who was living there as a ward or a novice. Having set eyes on Lucrezia (for this was the name of the girl), who was very beautiful and graceful, Fra Filippo talked the nuns into allowing him to portray her in the figure of Our Lady in the work he was doing for them. Given this opportunity and becoming ever more enamoured of her, he found ways and means to steal her away from the nuns and to run off with her on the day that she went to see the Girdle of Our Lady, an honoured relic of that town, then on view. This brought much disgrace upon the nuns and upon her father Francesco, who was never seen cheerful again [see note 25]. He made every effort to recover her but she, either through fear or for some other reason, refused to come back and insisted on staying with Filippo, to whom she bore a male child who was also called Filippo [Filippino Lippi] and who became, like his father, a very excellent and famous painter.[21]

Vasari clearly relished the story. Almost a hundred years after the event, he made the most of this sensational contribution to the *chronique scandaleuse*. On the other hand, he did not bother to mention that in 1450 the good *frate* forged a signature, was tortured, and confessed.[22] Nowadays an artist would not exactly enhance his career by counterfeiting a document. But in 1450 the incident was of minor interest, for Fra Filippo was neither imprisoned nor suspended from his clerical offices. It therefore seems unlikely that Vasari attempted to save the painter's reputation when he remarked in his final appraisal: 'Fra Filippo lived honourably by his labours, spending extraordinary sums on the pleasures of love, in which he continued to take delight to the very end of his life.'[23] Obviously, even in Vasari's eyes Fra Filippo's reckless pursuit of 'the pleasures of love' did not lower his honourable standing as an artist.

Vasari's account of the abduction is correct in all essentials. In details it was even surpassed by reality. According to documents[24] Lucrezia Buti was not a ward or a novice but a fully pledged nun when she eloped in 1456 with Fra Filippo, the then chaplain of S. Margherita in Prato. The annual exhibition of the Sacred Girdle, during which the nuns were permitted to leave the convent and participate in the celebrations, attracted throngs of people, and in the general confusion chaplain and nun escaped to Fra Filippo's nearby house. The Mother Superior and the Church authorities tried to avoid a public scandal, but when first Lucrezia's sister Spinetta Buti, and soon after three more nuns, slipped away, action was called for; it took two years to bring the five fugitives back to the fold. All of them, even Lucrezia who in the meantime had

borne Filippo's son, again served the year required of novices before, kneeling at the high altar, candle in hand, they were once more invested with the nun's habit and veil. The ceremony took place in December 1459, in the presence of the vicar of Prato, the bishop of Pistoia, and the abbess of the convent. The penitents solemnly promised 'steadfastness, change of conduct, chastity, and obedience to the rules and regulations of the said convent'. But their change of heart was of brief duration. In less than a year three of the twice-confirmed nuns had renewed their relations with their former *beaux* and Lucrezia and Spinetta managed to escape for a second time. When exactly this happened is not known, but by 1461 they were both installed in Fra Filippo's house. This time Cosimo de' Medici came to the aid of the lovers. Thanks to his intercession the Pope relieved the *frate* from his vows. At the same time, however, Filippo lost all his clerical offices and the revenues that went with them.

Like so many other orphans Filippo and Lucrezia, who had both lost their parents in early youth,[25] had been destined by their relatives for a monastic life at an age when they themselves had no choice in the matter. The practice of handing over to monasteries children who would later find they had no vocation whatever for a religious life inevitably produced a great many cynical monks and nuns. But this can only partly explain the extraordinary moral laxity among members of the clergy, which is confirmed by many documents of the time and which, in later years, was one of the chief complaints of all church reformers. Thundering against straying churchmen, Savonarola exclaimed in a sermon in 1493: 'You can see priests who gamble openly, frequent taverns, keep concubines and commit similar sins' and he denounced nuns 'who stand all day at the screen and chatter with worldly youths'.[26]

Fra Filippo's romantic love affair owes its notoriety not only to Vasari's spirited account, but above all to the fact that here was one of the great Renaissance masters, and a monk at that, a painter of sacred images who stopped at nothing to satisfy his carnal appetite. The irreverent behaviour of this painter-monk added fuel to the old debate about the worldly versus the pious Renaissance artist. How was it possible that a man of his moral fibre could produce pious works and spend a lifetime painting them? (Fig. 44). The obvious explanation is that, except for Savonarola's brief interlude, few people in the fifteenth and the early sixteenth centuries saw a contradiction between the licentious behaviour and the religious works of an artist. Neither popes, cardinals nor princes, nor the biographers thought it in the least incongruous to commission well-known libertines with the most important sacred imagery and nobody was surprised that they fulfilled their tasks with real passion and enthusiasm. This also explains why so many stories about licentious

artists were much more readily circulated and accepted by earlier than by more recent generations.

Unprincipled Renaissance Artists

Judged from the standpoint of modern ethics, our question poses a serious problem. In contrast to art historians, who usually avoid the issue altogether, a neo-Thomist like Jacques Maritain devotes a great deal of thought to it. First he quotes Fra Angelico's alleged dictum 'to paint the things of Christ, the artist must always live with Christ'.[27] This, however, ties up with the familiar Neoplatonic doctrine (see Chapter IV) and may therefore be Vasari's interpretation of Fra Angelico's philosophy of life rather than the painter's own. But Maritain knew very well that by referring to Fra Angelico he begged the question and quite rightly asked 'how could artists, so devoid of piety as many in the fourteenth and fifteenth centuries, have produced works inspired by such intense religious feeling?'[28] He found that these artists were still 'steeped in Faith so far as the mental structure of their being was concerned'. Hegel argued similarly, as Professor Schapiro reminds us,[29] that 'in an age of piety one does not have to be religious in order to create a truly religious work of art'. While this is obviously right the fact remains that moral laxity stamped late medieval and Renaissance artists as children of their own time.

Fra Filippo Lippi was in good and numerous company. It is true, however, that on occasion the law clamped down on these men. At the beginning of the century Jacopo della Quercia had run into trouble. His assistant at Lucca, Giovanni da Imola, had an illicit love affair and in order to raise hush-money the couple pawned the lady's valuables— which juridically were her husband's property—to Quercia. In December 1413 the scandal exploded. Giovanni da Imola went to prison. Quercia fled from Lucca to Siena. The Sienese government rallied behind him and publicly declared him to be an honourable man and an enemy of all vices.[30]

In 1457 the Venetian Carlo Crivelli (b. 1430/35, d. after 1493) was condemned to six months in prison and a fine of two hundred lire for abducting the wife of an absent seaman and keeping her hidden in his house for many months, 'knowing her in the flesh in contempt of God and the sanctity of matrimony'.[31] But Crivelli's reputation did not suffer: in 1490 he was knighted by King Ferdinand II of Naples,[32] and for the rest of his life proudly added to his signature the epithets '*eques laureatus*' or '*miles*'. Once again, the unprincipled conduct has no bearing on the magnificent, deeply religious works of this master (Fig. 45).

Among Florentine artists of the next generation one has to account for the inconsistency between the life and the work of a man like Domenico

Puligo (1475–1527), a not very distinguished painter of portraits and religious pictures mainly for domestic use. He was so 'devoted to the pleasures of the world' that he was 'unwilling to endure much fatigue' and rushed through his work in order to make money, and 'associating with gay and light-hearted companions, with musicians and fair ladies, he died in the year 1527, in the pursuit of a love affair, having caught the plague in the house of one of his mistresses'.[33]

The same discrepancy between conduct and work is apparent in Mariotto Albertinelli (1474–1515). He painted scenes only from the Bible, although his life was far from being saintly—despite his friendship and years of collaboration with Fra Bartolomeo, that devout painter who, under the influence of Savonarola, had become a monk in the monastery of S. Marco. Vasari informs us that

Albertinelli was a most restless person, devoted to the pleasures of the flesh and all the good things in life; thus, having begun to hate the subtleties and brain-wrackings of painting and being often stung by the tongues of other painters, he resolved to turn to a more humble, less fatiguing, and more cheerful art.[34]

The artist opened an inn and a tavern, but after a time preferred to return to his old profession. He got a commission in Viterbo which he interrupted because 'he felt the desire to see Rome'. However, he was drawn back to Viterbo

. . . where he had several sweethearts to whom he wanted to show how greatly he had missed them in Rome and prove how good he was at the old game.[35] This he did with supreme effort. But since he was neither young nor valiant enough for such enterprise he was forced to retire to bed—for which he blamed the air of that place and had himself carried to Florence. Neither help nor rest were of any avail, for he died of his complaint within a few days at the age of forty-five.[36]

Later in the sixteenth century the situation changed. Many artists became extremely punctilious in questions of morality. Henceforth—to paraphrase Emile Mâle—'we shall have Christian artists; we shall no longer have a Christian art.' But in spite of the new code of behaviour, in spite of Reformation and Counter-Reformation, the old Adam could not be suppressed. The earlier dissolute creators of religious art found worthy successors.

4 Debauchery among Sixteenth and Seventeenth Century Artists

Debauchery knows no bias. The deadly sin of Lust reigns over the talented and the mediocre, the successful and the luckless, the diligent and the idle alike.

Such a widely famed artist as the Florentine Pierino del Vaga (1501–

47), an avid worker, endowed with an original mind and a fertile imagination, found 'the only happiness . . . and repose from his labours' in taverns, the well informed Vasari tells us,

. . . and thus, having ruined his constitution by the fatigues of his art and by the excesses in eating and in love, he was attacked by asthma which, sapping his strength little by little, finally caused him to sink into consumption; and one evening, while talking with a friend near his house, he fell dead of an apoplectic seizure in his forty-seventh year.[37]

Taddeo Landini (1550–96), sculptor and architect, best remembered for his graceful *Fontana delle Tartarughe* in Rome, 'was loved and respected by Pope Clement VIII' although the 'good time' he enjoyed brought him 'such an acute and terrible pox' that 'his nose dropped off'.[38]

Pieter van Laer (*il Bamboccio*, 1592/95–1642), the friend of Poussin, Claude and Sandrart,

. . . got tired of Rome where, either through fate or mismanagement, he could not accumulate any capital, notwithstanding his having earned a great deal owing to the remunerative opportunities which he had there. It is true that loose women were the main cause of his incessant thirst for money.

He returned to Holland, his native country, where

. . . his works were so much in demand that he could not satisfy everybody. But as in the matter of women all the world is alike, so Bamboccio found himself everywhere in the same predicament. In Haarlem, his home town, he caught a certain disease that brought him little delight although he had acquired it through his pleasures.[39]

The prim Sandrart, who called van Laer one of his closest friends, praised his goodness, modesty, easy temper, and peacefulness[40]—not a word about his insatiable appetite in matters of sex.

Among the lesser artists we find such conspicious rakes as Cristofano Allori (1577–1621). A society man 'who played, danced and rhymed very proficiently' he had joined for a while a religious brotherhood in Florence which saw its task in

. . . converting and leading people of every sort and condition towards an exemplary and holy life.

But at last, tempted perhaps by all the varied entertainments and pleasant pastimes with which his mind had always been filled, he abandoned the prayers and the brotherhood. He returned to his amusements until he fell deeply in love with a very beautiful woman called la Mazzafirra. With her he used to squander all his considerable earnings, and what with jealousy and the thousand other miseries which such relations usually bring with them, he led a thoroughly miserable life. Since we have mentioned la Mazzafirra, we should also tell that he made use of her face, portrayed from the life, to

represent Judith in one of the oddest pictures which ever came from his hand (Fig. 48).[41]

This large painting is one of Allori's best works, and nobody will be so uncharitable as to blame the painter for having been infatuated by the exotic beauty of his mistress. If Baldinucci is right—and he appears well-informed—Judith's attendant represents Mazzafirra's mother, while Allori portrayed himself in the head of Holofernes: a symbol of his suffering 'by the hand' of his beloved.

Or we may quote Francesco Romanelli (c. 1610–42), a facile fresco painter, protégé of the Barberini in Rome and of Mazarin in France. While in Paris he was commissioned to decorate some rooms in the Louvre.

Within a short time he had the cartoons ready and began to paint the first chamber. But he had not yet quite finished it when he began to taste the bitter fruits of the gay and wasteful life to which he had abandoned himself in that city by taking advantage of his liberty. Away from his wife, he enjoyed the continuous company and intimate conversation of women, the fault lying with his fiery temperament which was much inclined towards amorous adventures. Because of this, he was assailed by the tormenting illness which usually accompanies such pastimes.[42]

Mazarin wanted Romanelli's wife to join her husband in Paris. But in a letter to Cardinal Francesco Barberini, the painter pleaded the urgency of his work in Paris as a pretext to decline that offer.[43]

There is Giovan Antonio Paracca (before 1560–1642/6), called *il Valsoldo*, after his birthplace near Lugano. His rather frigid, unattractive statues, mostly for Roman churches, had a certain measure of success, but

. . . he was a good-time man and did not work unless in need of money. In those times in which art works were much in demand he earned large sums, and as long as these lasted he lived as a gentleman, spending freely. He rented a beautiful garden, and what with his gay feasting and goings-on, full of pox and short of cash, he sank into extreme penury and was reduced to the alms-house. And there, in the flower of his activity, this very good artist died.[44]

Clearly the biographers, though not condoning debauchery, were not greatly shocked by it either and, in fact, a rather charitable attitude seems to have prevailed all round. A legal document may serve as an illustration.

In February 1683 there appeared before the episcopal court in Rome two painters, Andrea Maffei (the elder brother of the much better artist Giacomo), and Nicolo Galtieri, Andrea's pupil. They came to register '*un matrimonio di urgenza*' because Andrea Maffei had seduced the young man's sister. The girl was only nineteen years old; Andrea

declared his age to be 'about thirty' (in fact, it was forty). They were married the same day, but both mother and child died in childbed. However, the honour of the Galtieri family had been saved, so the sad outcome of Maffei's conduct was not held against him but was put down to 'bad luck', and the family repaired Andrea's loss by giving him the dead girl's sister as his second wife.[45]

5 *Agostino Tassi—The Seducer of Artemisia Gentileschi*

Early in the seventeenth century a similar case of seduction made a great public stir in Rome—not because of the violation of the moral code, but because the culprit had refused to accept the expected consequences. It was for this reason that the offended father had taken the matter to court. The main figures in what developed into a *cause célèbre* were the painter Orazio Gentileschi, his gifted daughter Artemisia, and Agostino Tassi, Orazio's friend and the girl's teacher. In 1612, when Artemisia was fifteen years old and Tassi over thirty, Orazio Gentileschi addressed the following petition to the Pope:

A daughter of the petitioner has been deflowered by force and known in the flesh many a time by Agostino Tassi, painter, close friend and colleague of the petitioner. Also involved in this obscene affair was Tassi's hanger-on Cosimo Quorli. It is known that, apart from the defloration, the said Cosimo has also, with his lies, wrung from the hands of the said maiden several paintings by her father, and especially a Judith of considerable size. And since, Blessed Father, this is so brutal and depraved a deed, and has caused such serious and grievous detriment and damage to the poor petitioner, particularly since it was committed under the pretence of friendship, he feels as if all this had killed him.[46]

The ensuing court case lasted several months. Artemisia was interrogated for the first time on March 18, 1612. She declared that during the last year in her father's house in via della Croce, when one day she found herself alone with her teacher, the rape had occurred 'notwithstanding her strong resistance and the wounds she inflicted on him'. To calm her, the painter had talked of marriage and consequently she regarded herself as his wife, but when she realized that he was not going to keep his promise she revealed everything to her father who then took legal action. Two months later Artemisia was cross-examined under torture. When the thumbscrews were put on she called out to Tassi: 'This is the ring you give me, and these are your promises.'

All the members of the Gentileschi household as well as some fifteen or sixteen artists were called as witnesses. Among them was one G. B. Stiattesi, an intimate friend of Tassi's, who declared that he had known the painter when the latter was living in Livorno and was

. . . married to a certain Maria who ran away from him with one of her lovers. Tassi, after having searched for her in vain and then learning of her being in the province of Mantua, had her murdered by hirelings. After his wife had left him he came to Rome with his sister-in-law [then fourteen years old], and in the year before the present law case he was prosecuted for incest.[47] I know that he loved Artemisia from whom he had received a picture representing Judith; he had not told her that he could not marry her because he believed that she had also been violated by Cosimo Quorli.

Two days later, on March 26, Tassi was called to testify. He was an old hand at juridical procedure and knew how to answer all charges with skilful evasions or brazen counter-attacks. He opened his defence with the words: 'I have found myself a prisoner for more than eight days now; I was taken in the strada della Lungara and I cannot imagine for what reason.' Questioned about his past he admitted he had been in prison two or three times. He explained that he had 'travelled [from Tuscany] to see the world on the galleys of the Grand Duke, by his orders'—an ambiguous phrase: it was known that he had been condemned to the galleys.[48] Asked about his wife, his answer was: 'She died, I do not know how or when, for I left her in Lucca.' He declared that Gentileschi and Stiattesi had been his best friends but now they were his enemies because they owed him money. His former friendship to Stiattesi was attested before the court by the evidence of several love-poems addressed to the latter and one addressed to Tassi apparently in Stiattesi's hand.

At the next hearing Tassi heaped more abuse on Gentileschi and especially on Stiattesi whom he now openly accused of having perpetrated the rape of Artemisia, and two days later he volunteered the information that 'a certain Gironimo, a Modenese painter, had enjoyed Gentileschi's daughter, and he [Tassi] had helped to beat him up'. But Tassi did not extricate himself as successfully as he had done the year before when he had been accused of unlawful relations with his sister-in-law. On that occasion his own sister Olimpia had appeared as a witness against him and had stated:

This brother of mine is a rogue and a wretch who lives by his wits; he never wanted to behave well, right from boyhood, and therefore he went away from Rome to Livorno, and there are writs and charges against him for rogueries which he had committed whilst he was away from Rome.

He spent over eight months in the Corte Savella prison, but in the end the case was dismissed.

Tassi's law-cases must have been well known all over the country. The Artemisia affair had certainly caused a sensation. But Tassi did not care and his patrons did not mind. In the years after the scandal he

received his greatest commissions for decorations in the palaces of such eminent Roman families as the Peretti, Rospigliosi, Lancelotti, Ludovisi, Pamfili (Fig. 40), and even in the papal palace on the Quirinal. Just to show that he was not a reformed character after his earlier exploits, we may mention that he was involved in court cases again in 1619, 1622, and 1630. In 1622, as a man well past his youth, he was sued by the prostitute Cecilia Durantis, known as Pretty-Feet, for having given her a blow in the eye, bitten her in the right arm, and rifled her house. As usual, Tassi denied the charge.

The list of Tassi's 'escapades' is impressive: it includes rape, incest, sodomy, lechery, and possibly homicide. He served a term on a Tuscan galley, was sued for debts, and imprisoned for unruly behaviour in Livorno and Rome, but never—as he proudly claimed—for banditry. To what extent did all this damage his reputation? An announcement after his death only mentioned his fame as a painter of battle-pieces, perspectives, sea- and landscapes;[49] according to Sandrart he was liked for his good humour and wit;[50] Mancini, writing about 1620 (almost a quarter of a century before Tassi's death), described him as a quick-witted, clever man but one whose free speech antagonized many of his friends; moreover, he had brains and knew how to defend himself.[51] Only Passeri strikes a critical note. Even though he has high praise for Tassi as an artist, he finds his conduct abominable: 'licentious in the extreme', 'a genius at telling lies', impertinent, pompous, false, garrulous, incessantly involved in brawls, with no piety and no fear of God— these epithets are a fair selection from Passeri's character sketch.[52] But the more serious offences, precisely those which would nowadays land a man in prison for many years of his life, are soft-pedalled. How Tassi was judged in the highest circles may be gathered from a jocular remark (reported by Passeri) made by Pope Innocent X, for whom, while he was still a cardinal, the artist had worked in the family palace (Fig. 40). The Pope said that of all the painters with whom he had had dealings only Tassi had not deceived him. His listeners thought this rather paradoxical, and the Pope explained:

We have always had a bad opinion about many belonging to this profession; yet when meeting them often, they succeed in giving the impression of good and honourable men. But having always regarded Agostino as wicked, every experience has proved us right, and so we were not deceived in what we thought about him.[53]

But by modern standards the crowning puzzle is that Orazio Gentileschi and Tassi soon forgave and forgot and renewed their old friendship. Artemisia, a lascivious and precocious girl, later had a distinguished and highly honourable career as an artist.

6 Illicit, Ideal, and Platonic Love

In the foregoing pages we have indicated that debauchery and even crime had not the stigma which is attached to them today. The whole attitude towards sex was entirely different from ours; a few further notes about this might be in place here.

About the middle of the fourteenth century a certain Paolo di Messer Pace da Certaldo jotted down a miscellany of aphorisms, proverbs, and maxims interspersed with a good deal of advice on all kinds of practical questions. Among them we find the following counsel: 'Take good care not to keep company or friendship with men who have the reputation of being traitors, or heretics, or forgers of coins, or homicides, or assassins, or gluttons, nor with slanderers and sodomites.'[54]

Paolo's fragmentary manuscript notes were rightly entitled *The Book of Good Manners* by the modern editor. So far as one can judge, Paolo, the scion of a good Florentine family, intended to write a vademecum for polite society. In this light, his warnings sound odd to modern ears; they conjure up a society which had to be taught points of rudimentary ethics. It may appear equally strange that sex plays a subordinate rôle in Paolo's list. Only sodomites are singled out among the undesirable companions, while libertines seem to have had the author's blessing. This proof *per negationem* is supported by the fact that illicit love was commonly and openly practised by all classes of society. The conduct of some of the Renaissance popes, of the princes of the blood, and the aristocracy is too well-known to need special mention. Dürer's coarse jokes (or hearty banter, according to some biographers) in his letters from Venice illustrate the ribaldry of the educated middle class. '*Item*, you stink so of whores that I can smell it over here' is one of the translatable and printable sentences among the unambiguous allusions to the love-affairs of his patron, the German humanist Willibald Pirckheimer.[55] It is not without interest for the 'moral improvement' to which Dürer was later subjected that this passage reads in Conway's Victorian standard translation: 'It strikes me that there is an odour of gallantry about you; I can scent it out even at this distance.'[56] In another letter Dürer asked his friend to remember him to the Augustine prior Eucharius Carl: 'My reverence to our prior. Tell him to pray for me to God that He may guard me, and especially from the French [pox]. Because I know nothing that I fear more, since almost everyone has it. Many people are quite eaten up by it and die.'[57]

Syphilis was the scourge of the age; it was carried into Italy by Charles VIII's French army (hence the name) and raged in Florence most alarmingly at the time of Savonarola's greatest triumphs.

Obscenity and indecency were not confined to Renaissance society:[58] a long tradition reaches back into antiquity and further into the dim

past of primitive man. The libertine approach to sexual matters in the Renaissance carries on medieval customs: the obscenities of the *Cent Nouvelles Nouvelles* found their sequel in the Florentine *Novelle* of the fourteenth and fifteenth centuries and the *Facetiae* of the sixteenth. In the later Middle Ages remarkable indecencies invaded the churches; everybody knows the many coarse, unmistakably sexual representations to be found on choir stalls, on capitals, and in the margins of religious manuscripts. Professor Huizinga has shown how 'religion and love are mixed up with a sort of ingenuous shamelessness' in certain medieval literary productions. Where this spirit was rampant, piety and blasphemy coalesced. We can now understand better why such a sexual extrovert as Fra Filippo Lippi caused no stir and why no contemporary discovered any dissonance between his behaviour and his work.

Antiquity not only produced Ovid's *Ars amandi* with its pedantic exposition of animal pleasures, but also Plato's philosophical concept of love. This duality of a spiritual and a sensual kind of love was maintained throughout the Middle Ages, when philosophers and theologians discussed the contrast between sacred and profane love—the love of God opening the gates to Paradise and the love of the senses leading to Hell. But with the poetry of the troubadours a new ideal of courtly love, pure, refined, and beautiful, made its entrance, at the farthest remove from the lascivious erotic literature of the Middle Ages as well as from the sexual customs of all strata of society. The dualism in the literature about love continued. It is evident in the contrast between the spiritualized love in Dante and the voluptuous love stories told in Boccaccio's *Decamerone*. It is evident, later, in the antithesis between the new concept of love which spread with the Platonic revival of the Italian Renaissance, and in the elegant obscenities published by erudite humanist writers. At the beginning of the sixteenth century the Platonic conception of love led to a spate of treatises, all expounding the old doctrine of divine beauty mirrored on earth, to the contemplation of which the soul should be dedicated. Michelangelo lived, thought, and felt in terms of this concept of love:

> Those who are blessed with wisdom can perceive
> That all the beauty of this earth is but a mirror
> Of that celestial source whence all life springs.
>
> (Frey, lxiv)

It was, however, a different kind of literature that captivated the educated public. The authors were accomplished humanists. A book like Antonio Beccadelli's *Hermaphroditus*,[59] circulated as a manuscript in 1425 and dedicated to Cosimo de'Medici, was, it is true, violently attacked by members of the clergy and Beccadelli's effigy was publicly

burned in Milan and Bologna. Nevertheless, the book was copied over and over again and read with delight by large numbers of people, including high-ranking dignitaries of the Church. In 1432 the author of these 'shameless sensualities' which depict 'the sins of Sodom and Gomorrha' (Symonds) was crowned with the poet's laurels by Emperor Sigismund in Parma. Later he was raised to the rank of Cavaliere at the court of Naples and died a rich and honoured man.

The *Facetiae* of Beccadelli's contemporary Francesco Poggio (1380–1459) ran into several editions and were read as much in the rest of Europe as they were in Italy, and Filelfo's *Satires* (written between 1448–53), which nineteenth century critics regarded as 'the most nauseous compositions that coarse spite and filthy fancies ever spawned' (Symonds), were rewarded with five hundred gold ducats by the admiring Pope Nicholas V.

These are only three examples from a very large number of books, few of which have been translated into modern languages. Historians and literary critics have mostly confined themselves to quoting carefully selected extracts, and even those they usually leave safely in the original Latin. Much of this literature is so unrestrained that a great Italian scholar felt 'it would not be right to give even the faintest indication' of its contents.[60]

Of course it would be as wrong to presume that every reader of obscenities was himself depraved as it would be to suggest that every fan of detective stories has homicidal inclinations, and it must be remembered that the authors were as much praised and rewarded for the elegance of their Latin style as for their unbridled imagination. But even though aesthetic considerations entered into the discussion, there is no doubt that a degree of bawdiness which has rarely been matched either before or since was tolerated and enjoyed.

While this type of literature, so obviously at variance with the teachings of the Church and the fundamental tenets of morality, helped to propagate illicit love and sexual perversion in an acceptable and even delectable form, another approach to love appeared which, in a way, harked back to the tender passion sung by the troubadours. Baldassare Castiglione incorporated into his *Courtier*, written between 1508 and 1516, the ideal of a civil, high-minded love. In this book, which was to become the guide to good manners for the whole of Europe, we hear that 'a kiss is a knitting together of body and soul', that the lover 'shall do no wrong to the husband, father, brethren or kinsfolk of the woman beloved. He shall not bring her in slander . . . he shall evermore carry his precious treasure about with him shut fast within his heart.'[61] We have reason to think that Raphael, who was so close to Castiglione and his circle and seems to have lived up to the standards of conduct pro-

pounded by his friend, conformed also as a lover to the latter's urbane precepts (Fig. 43).

At that time Castiglione's chivalrous ideas percolated down to only a chosen few. In order to realize the attitude of the majority, one has only to study the character of public, private and court entertainments. We can here merely hint at the lack of inhibition that marked so many festivities before the French Revolution. Organizers of popular amusements knew how to play upon the baser instincts of the people. In June 1514 a 'hunt' was arranged in the Piazza de' Signori in Florence to which many beasts were brought such as lions, bears, leopards, bulls, and stags. Wooden stands and platforms were erected for the enormous crowds. Among the strangers were several cardinals who had purposely come from Rome to see the spectacle.

> Everything had been very well arranged, except that someone without the fear of God did an abominable thing in this Piazza; in the presence of forty thousand women and girls he put a mare into an enclosure together with the stallions, so that one could see copulations and this much displeased decent and well behaved people, and I believe that it displeased even the ill-bred.[62]

This is from the virtuous Landucci—but was his judgment correct? Another diarist, Cambi, paid lip service to the general indignation but let it slip out that 'this feast was the most marvellous entertainment for girls to behold'.[63] By introducing this spicy note, the organizers repeated an entertainment which, according to the papal Master of Ceremonies, John Burchard, Pope Alexander VI and his daughter Lucrezia Borgia had watched with relish from the windows of the Vatican palace. That popular opinion was not on the side of the 'decent and well-behaved' citizens can be proved by an infinite number of instances, by obscene theatrical performances and such favourite entertainments as the Roman Carnival, where a race was held between naked old men, hunchbacks and Jews in the streets of the city—a custom that was not abolished until 1668.

The promiscuous festivities which kept the French court and nobility amused in the seventeenth and particularly the eighteenth century have always been notorious. But there is little difference between their taste and that of the fifteenth century patrician ladies of Lübeck who frequented the taverns and places of prostitution of that Hanseatic port, in order to humour their lewd inclinations. Nor is there much to choose from between the fêtes at St Cloud and Versailles or Naples, where in 1669 the Duchess of Medina had devised a masked ball at which she and twenty-three other beauties appeared naked.[64]

These examples also indicate that the Reformation and Counter-Reformation had no lasting effect on public morality. Although it is true

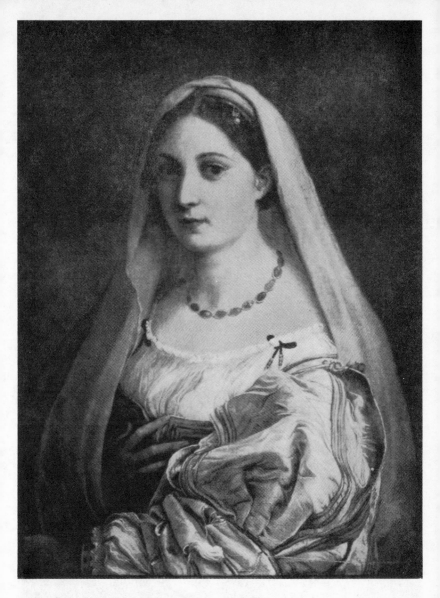

43. Raphael, *Donna Velata*, *c.* 1514. Palazzo Pitti, Florence.
Originally the painting showed the wheel, palm and halo
of St Catherine. The Sitter probably represents one of
Raphael's loves, interpreted in terms of Castiglione's
high-minded ideal of womanhood.

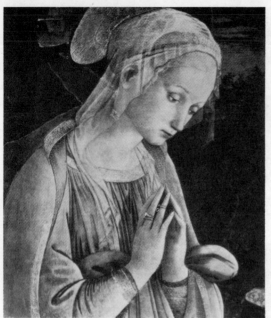

44. Fra Filippo Lippi (1406–69), Virgin adoring the Child, *c.* 1463. Detail. Uffizi, Florence.
According to Vasari this painter-monk spent extra-ordinary sums on amorous pleasures. Like other artists of his time he was still 'steeped in faith' and there is no contradiction between his licentious behaviour and the expression of truly religious feeling in his work.

45. Carlo Crivelli (1430/35– after 1493), Pietà, before 1490. Pinacoteca Vaticana, Rome. What kind of person this great master of religious paintings was, we do not know. Early in life he served a term in prison, but was knighted in 1490. Thereafter he proudly added *miles* to his signature.

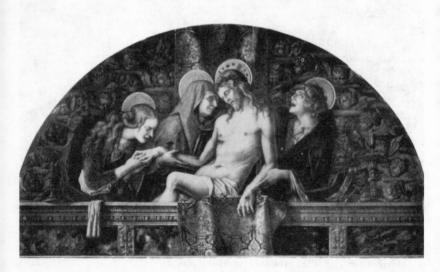

that innumerable treatises were written on correct relationships between the sexes, and although reformed Catholicism endeavoured by every means to curb sensuality and libertinism, in the long run the only result was the rise of hypocrisy. But rather than pursue this matter further we should like to return to Paolo da Certaldo's warning against associating with sodomites and see to what extent his advice was heeded.

7 'The Unspeakable Vice'

Public Opinion and Homosexuality

The wide gulf between desirable and actual behaviour is especially apparent in the relentless but unsuccessful fight against homosexuality. From biblical times it has always been considered a sin and Paolo da Certaldo's list shows that in the fourteenth century it ranked with the worst crimes. In a sermon of December 1305 Fra Giordano exclaimed in Florence: 'Oh, how many sodomites are among the citizens! Or rather: all of them indulge in this vice.'[65] Later documents make it clear that laws were not very effective in combating this particular evil. In his sermon of November 1, 1494, Savonarola publicly admonished the priests of Florence:

Abandon your pomp and your banquets and your sumptuous meals. Abandon, I tell you, your concubines and your beardless youths. Abandon, I say, that unspeakable vice, abandon that abominable vice that has brought God's wrath upon you, or else: woe, woe to you![66]

Savonarola's eloquence, of course, made a deep impression on people. But, apart from his outright antagonists, many were merely cowed into temporary submission. It is with obvious relief that, after the monk's death, 'a certain Benvenuto del Bianco, a member of the Council of Ten, turned to one of his colleagues and said: "And now we can practise sodomy again!"'[67] Though they streamed to hear Savonarola's sermons, people did not noticeably change their mode of life. The great reformer died at the stake in 1498. Only four years later it was found necessary to strengthen the existing morality laws. In 1502 Landucci wrote in his diary: 'Certain godly laws against the unmentionable vice and against swearing were reformed; and other good laws were made.'[68] These reforms do not seem to have produced the desired results, because early in 1506 sterner measures had to be taken. Again according to Landucci,

... the 'Eight' published a proclamation to the effect that those who had been guilty of a certain villainy, and there were several, should lose their heads if they did not show up; they had dared to threaten a father if he did not give them his son. The young men of Sodom were no worse than this when they asked Lot for the angels. And these deserve the same punishment that befell

them. It is unwillingly that I have recorded this because it is the unspeakable sin. May God forgive me.[69]

The penalties inflicted—at least on paper—upon Florentine offenders varied according to circumstance. Grown men were castrated; boys and youths between fourteen and eighteen years of age had to pay the considerable sum of one hundred lire and five times as much if they were over eighteen; the punishment for procurers was a fine or the loss of a hand, and, in case of repetition, of a foot; fathers who allowed their sons to be misused were treated like procurers; the house in which sodomy was committed was destroyed; anyone found day or night in a vineyard or a locked room with a boy who was not a relative was suspect.[70]

Other cities took similar measures. Venice, like Florence, had to revise the penalties and tighten the laws several times in quick succession (1418, 1422, 1431, 1455),[71] because the number of offenders was growing alarmingly. If we consider, for instance, that the Venetian prostitutes found it more profitable to don mannish clothes in order to attract customers, we may safely conclude that the culprits were not only the few popes and princes, artists and scholars who appear in the history books, but came largely from the nameless and forgotten rank and file.

In spite of the unequivocal attitude of the Church, the authorities, and the 'well-behaved' citizens towards the 'unspeakable sin', there was a notable laxity in enforcing the law. This came partly from a general apathy towards transgressions in a world used to crime, violence and excesses of every description, and partly from the tolerance of the humanist-inspired educated classes, for whom homosexual love had the sanction of the Greek philosophers.

Leonardo's Denunciation and his Relation to Salai

These considerations may to some extent explain why one hardly ever hears of artists having been brought to trial, although their way of life or their emotional attachments were as much an open secret as those of other citizens. One of the few exceptions is the law-suit in which the young Leonardo was involved. Because the suit against him was filed anonymously, most Leonardo scholars have dismissed it as an infamous libel and have taken his acquittal as proof of his innocence. But the acts, preserved in the Florentine archives, do not really permit such categorical conclusions. Anonymous denunciations, however despicable they may appear to us, were perfectly legal bases for juridical procedure in Florence at the time. Anyone who believed he had a justifiable case against a transgressor could cast his written accusation into the *tamburo*, a kind of drum-shaped letter box provided for that purpose at the Palazzo Vecchio. The denunciations were then examined and justice would take its course if witnesses were found.

Such a denunciation was posted on April 9, 1476, against Jacopo Saltarelli, an artist's model, and four Florentine citizens. It said:

I notify you, *Signori Officiali*, of a true fact, namely, that Jacopo Saltarelli, brother of Giovanni Saltarelli, lives with the latter at the goldsmith's in Vacchereccia [Via Vacchereccia, leading from via Por S. Maria to Piazza della Signoria] opposite the *tamburo*: he dresses in black and is about seventeen years old. This Jacopo has been a party to many wretched affairs and consents to please those persons who request such wickedness of him. And in this way he has had many dealings, that is to say, he has served several dozen people about whom I know quite a lot and here will name a few:

Bartholomeo di Pasquino, goldsmith, who lives in Vacchereccia;

Lionardo di Ser Piero da Vinci, who lives with Andrea de Verrocchio;

Baccino the tailor, who lives by Or San Michele in that street where there are two large cloth-shearers' shops [via dei Cimatori] and which leads to the loggia de' Cierchi; he has recently opened a tailor's shop.

Lionardo Tornabuoni, called *il teri*, he dresses in black.

These committed sodomy with said Jacopo: and this I testify before you.[72]

The required witnesses do not seem to have come forward since the defendants were released: *absoluti cum condizione ut retamburentur*, absolved on condition that nothing further should be found in the *tamburo*. On June 7, 1476, the same complaint was posted once more but was again conditionally dismissed. No additional evidence has been found in the archives.

It is not surprising that no one seems to have been eager to support the denunciations. Certainly one, and most likely two, of the accused men were sons of influential fathers who were in a position to shield their straying offspring from the scandal of imprisonment or worse. Leonardo Tornabuoni, of whom nothing further is known, was in all likelihood the son of Piero, first cousin of Lorenzo the Magnificent, and Leonardo da Vinci's father was a well-known notary to the Signoria. Who would have dared to make enemies of such men? Moreover, the offence, if it had been committed, would scarcely have roused a storm of indignation. Considering the moral and literary climate to which Leonardo's judges were accustomed, many such charges were possibly dealt with as a routine matter and permitted to lapse.

Whether Leonardo was rightly or wrongly accused will probably never be known, but that he could be attracted by unworthy people is proved by at least one well-documented case.[73] In 1490 he took into his house the ten-year-old Gian Giacomo de' Caprotti, a beautiful, curly-haired boy. The very next day Leonardo ordered new clothes for him. The lad promptly stole the money put aside for his outfit. During the first year he stole two silverpoints from the studio, money from a stranger, and a piece of Turkish leather which was to be made into boots for

Leonardo and which Gian Giacomo sold for twenty *soldi* in order to buy himself sweets. During that year he also acquired twenty-four pairs of shoes, some of which he presumably sold. His greatest pleasure was to hang about in the streets. This angelic-looking boy appears in Leonardo's notebooks as Salaij or Salai, a name which has caused some confusion until it was convincingly shown that it derived from Luigi Pulci's epic *Morgante*, where it is used as a synonym for Satan. Yet over the years Leonardo bought the little devil a ring and a necklace, modish trousers and stuff for shirts, and a silver-brocaded cloak. Though he calls him a 'thief, liar, pig-head, glutton' in his notebook, he took him on all his Italian travels, bought a dowry for his sister, installed his father as a tenant-farmer in his vineyard, and remembered him generously in his will.

Salai stayed with Leonardo until 1516, that is for twenty-six years. He died in 1524 from a gunshot wound, whether accidentally or not is unknown. His likeness has been preserved in a number of drawings and paintings, some by Leonardo's own hand.

Why did Leonardo put up for so long with a youth whose defects he fully knew? Without doubt he was at first strongly attracted by the physical perfection of the boy (Fig. 47) and equally repulsed by his own reaction—not, we believe, because he had particular objections to homosexual relations but because he disapproved, as he himself repeatedly writes, of any 'lascivious pleasures'. An allegory of 'Pleasure and Pain' (or 'Lust and Repentance') of the early 1490's renders his thoughts in pictorial form (Fig. 46). But we do not have to resort to hypotheses in deciphering this cryptic drawing, for Leonardo himself supplied an explanatory inscription. To regard his well-considered words as 'free associations' and 'fantasies [he] had while lying in bed'[74] does an injustice to his acute reasoning power and puts his entire personality into a wrong light. Picture and text do not reveal him indulging in 'sexual daydreams' as has recently been maintained,[75] but show in allegorical form a conscious striving for clarification of his reactions. There is little difference between one man's 'instinctual life' and another's, but a world of difference between an inarticulate day-dreamer and one who can rationalize his urges and formulate them in works of art. It is this difference that sets certain men apart from the majority and not the subconscious desires which they share with the rest of mankind.

Leonardo's conscious endeavours were directed towards subduing sensuality; Michelangelo's towards intensifying it. After years of trial and error Michelangelo found in Cavalieri the perfect answer to his quest for 'perfect' love. After some initial failure, Leonardo succeeded in mastering his 'animal instincts' so completely that he could presumably

detach himself even in daily contact from the little 'Satan' whom he kept on as a useful mixture of model, servant, and studio help. He was no longer either attracted or repelled; he had conquered 'Pleasure' together with 'Tribulation and Repentance'.

Giovanantonio Bazzi—the 'Sodomite'

Leonardo's partiality for his unsatisfactory pupil must have been known to many of his patrons, but it never for one moment troubled them, nor did it lessen their regard for his genius. The same imperturbability, so difficult to understand for many nineteenth century scholars, marked the attitude of Giovanantonio Bazzi's (1477–1549) patrons. His nickname 'Sodoma' has been a source of bewilderment to the admirers of his art. One of the most celebrated of the Sienese painters, he also worked with great success in Milan, Florence, and Rome where he was honoured in 1518 by Pope Leo X with the title of Cavaliere, although by then he had been known everywhere as 'Sodoma' for at least five years. Praised as one of the finest Renaissance artists by earlier art historians, he has lately lost some of his perhaps exaggerated renown and Vasari's strictures do not sound so unjust and spiteful now as they did to a previous generation of critics. Vasari wrote of him: 'If Giovanantonio had been as diligent and virtuous as he has been lucky, and if he had not behaved so wildly towards the end of his always irregular and beastly life, he would not have been in such wretched straits in his old age.'[76]

But even the virtuous Vasari was not overtly disturbed by Sodoma's 'beastliness'. Good-humouredly he reported that the painter was

. . . a merry and licentious man who kept others diverted and amused by leading a life of scant chastity, in consequence of which—and because he always surrounded himself with boys and beardless youths whom he loved beyond measure—he acquired the nickname of Sodoma. This not only failed to trouble or anger him, but he took pride in it, making stanzas and satirical poems on it which he sang very prettily to his lute. Apart from this he delighted in having in his house many kinds of extraordinary animals: badgers, squirrels, monkeys, marmosets, dwarf donkeys, Berber horses for the *Palio* races; ponies from Elba, jays, bantams, Indian turtle-doves and as many other creatures as he could lay his hands on. But above all he had a raven who had learned to talk so well that he could imitate the voice of Gianantonio, especially in answering someone who knocked at the door (Fig. 49).

All these animals 'were so domesticated that they were always with him in the house cutting the strangest capers and making the weirdest noises in the world so that his house seemed a proper Noah's Ark'.[77]

It may seem not a little absurd that Vasari talked in the same breath of Sodoma's licentiousness and his amusing private zoo, but it surely indicates that one 'oddity' was as good—or as bad—as another in the

eyes of his age. Besides, the keeping of unusual animals had a certain snob value. Rich people paid large sums for animals and birds imported from Africa and from as far away as India. The less well-to-do were satisfied with beasts from nearer home. Piero di Cosimo, Leonardo and Rustici are also known to have delighted in collecting weird creatures which, like Sodoma, they used occasionally as models. That Sodoma was indeed a snob appears from his way of dressing. After praising Sodoma's work for Agostino Chigi in the Farnesina, which showed his 'most excellent qualities and natural talent', Vasari continues

. . . but he always made a mock of everything and worked as his fancy took him, caring for nothing so much as for dressing pompously, wearing brocaded coats, capes adorned with gold cloth, the richest caps, necklaces and similar trifles, stuff for buffoons and mountebanks: all of which caused Agostino Chigi, who liked those whims, the greatest amusement in the world.[78]

Vasari's account of Sodoma's behaviour was left unchallenged for a long time. A hundred years after Vasari the Sienese historian Ugurgieri talked of the artist as a 'capricious and facetious' man who 'lived from hand to mouth'. In support of this reputation he recorded that, relying on

the great renown and authority Sodoma enjoyed in his native town because of the excellence of his art, he allowed himself a certain licence which was tolerated by the authorities: when all citizens had to make known their possessions [for income tax purposes] the following ridiculous declaration was submitted by Sodoma in 1531:

I, Gio. Antonio Sodoma di Bucatura declare before you, honourable citizens, appointed to levy taxes:

I have an orchard at the Fonte Nuova which I till for others to harvest;

a house, for which I have a law-suit with Niccolò de' Libri, where I live in [Via] Vallerozzi.

I have eight horses at present, nicknamed nanny goats and I am a gelding to groom them.

I have a monkey and a talking raven which I am keeping in order that it should teach a donkey theologian in a cage how to talk; an owl to scare madmen, a barn-owl, and I won't tell you anything about the tawny owl because of the aforesaid monkey.

I possess two peacocks, two dogs, two cats, a kestrel, a hawk, and six hens with eighteen pullets;

and two turkeys, and many other birds which it would be hard to describe. I also possess three wicked brutes, that is, three women.

I have upward of thirty grown-up children, and as for heavy loads, Your Excellencies will admit that I have enough to carry. Besides, according to the statutes whoever has twelve children is exempt from paying taxes to the town. Therefore I wish you well. Good-bye.

Sodoma Sodoma *derivatum* M. Sodoma.[79]

The reaction of the city fathers has not been recorded. It can hardly have been on the lines taken by a German scholar who is convinced that the painter's nickname was 'entirely unwarranted' since 'the sensitive soul of this artist . . . was incapable of any sexual aberration or offence against the law',[80] and who goes out of his way to make us 'understand psychologically' that Bazzi's 'strong, aching soul carried the name Sodoma defiantly'.

In at least one case an artist had to pay with his life for the 'unspeakable sin', probably not so much for having committed it as for having been caught *in flagrante* under the most damaging circumstances possible: Jerôme Duquesnoy (1602–54), brother of François, committed sodomy in a chapel of the Cathedral at Bruges and was condemned to death by strangulation.[81] The respectable Sandrart says of him: 'Decency forbids us to mention what he did. But he died as he had lived—an example and lesson to one and all, that virtue and vice reap their reward.'[82]

8 *Moral Conduct and Obscene Art*

The attitude of critics who attempt to vindicate the behaviour of Sodoma and other 'amoral' artists is ultimately derived from the Neo-platonic theory, according to which a beautiful work can only be created by a beautiful soul. Conversely, a lascivious artist cannot but produce obscene art. When artists began to be convinced of the causal connection between their conduct and their work, many of them endeavoured to lead an irreproachable life.

There have always been some who regarded their way of life and their art as inseparable, and this was especially true in times of strong religious revivals. Hugo van der Goes, who was influenced by the Augustinian reform movement, and Fra Bartolomeo, who followed Savonarola, are but two notable examples from the late fifteenth and the early sixteenth centuries. We may add the names of Fra Angelico, the saintly friar of S. Marco, and of Domenico Ghirlandaio[83] and Andrea del Sarto,[84] both of whom joined religious brotherhoods. But it was under the impact of the Catholic reform movement that an unprecedented number of artists took orders or, when they remained in the world, made it their concern to live up to the moral standard prescribed by the Church. Many Mannerist and Baroque artists, who have so often been attacked for the erotic character of their art, were, in fact, more respectable and more responsible members of society than their Renaissance precursors.

Only a very few examples can be mentioned here. Of Francesco Furini (*c.*1600–46), famed for his sensuous though rather sentimental rendering of the female body, we hear that at the age of forty he toyed with the idea of becoming a priest 'to remove himself even further from

the temptations of the world, particularly from those to which he was exposed by the habit of keeping life models for the painting of his nudes'.[85]

The brothers Jacques and Guillaume Courtois, renowned members of the mid-seventeenth century colony of French artists in Rome, actually entered the Jesuit Order as lay brothers.[86] The Genoese landscapist Carlo Antonio Tavella (1668–1738) was, by contrast, a family man:

He was so God-fearing that in order to avoid any occasion for social intercourse, vain conversation or worldly frivolity he led an almost solitary life. His house resembled more a religious hermitage than the home of a painter. A sort of monastic rule was kept, for there were hours dedicated to vocal oration, mental meditation, eating and work. From this everyone can see how well he brought up his family.[87]

Bernini's conduct as husband, father, friend, and man of the world was exemplary. He was deeply religious, went to Mass each morning, and for forty years walked every evening to the Gesù, where he spent some time in prayer. On the other side of the religious fence an artist like Philippe de Champaigne (1602–74) may be mentioned. As a mature man he became attracted by the severe doctrines of the Jansenists and fashioned his life in accordance with their stern principles.

Such artists felt that they carried a great responsibility. The bad example of dissolute artists may not have been a greater threat to the virtue of their fellow-citizens than that of other libertines, but in their works artists had a powerful means of corruption that was entirely their own. The awareness of this danger goes as far back as documents take us. Plato's *Republic* immediately comes to mind:

. . . we must also supervise craftsmen of every kind and forbid them to leave the stamp of baseness, licence, meanness, unseemliness, on painting and sculpture, or building, or any other work of their hands; and anyone who cannot obey shall not practise his art in our commonwealth. We would not have our Guardians grow up among representations of moral deformity, as in some foul pastures where, day after day, feeding on every poisonous weed they would, little by little, gather insensibly a mass of corruption in their very souls.[88]

An impressive chapter of the history of civilization could be written about the destruction of works of art regarded as unedifying, sacrilegious and obscene. In 1470 a decree of the painters' guild at Cremona forbade its members under penalty of thirty-two *soldi* and destruction of the offending works to paint indecent pictures and sell them.[89] Savonarola stormed not only against the ostentatious decorations of churches, but also against the brazen indecency of contemporary art. 'I tell you, the Virgin dressed herself like a poor woman . . . and you represent her as a

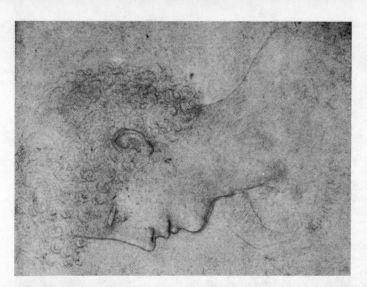

46. Leonardo da Vinci
(1452–1519), Allegory of
Pleasure and Pain, early 1490s.
Drawing. Christ Church,
Oxford.

The idea for this cryptic
drawing may have sprung
from Leonardo's relationship
with Salai. The accompanying
text shows that the artist used
the traditional language of
allegory to clarify and
rationalize his emotions.

47. Leonardo da Vinci,
Portrait of Salai, 1497/8,
Drawing. Royal Library,
Windsor Castle.

At the age of 38 Leonardo
took into his house a beautiful,
curly-haired boy whom he
nicknamed 'Salai', i.e. Satan,
who stayed with him for
twenty-six years. This drawing
shows Salai aged about 18.

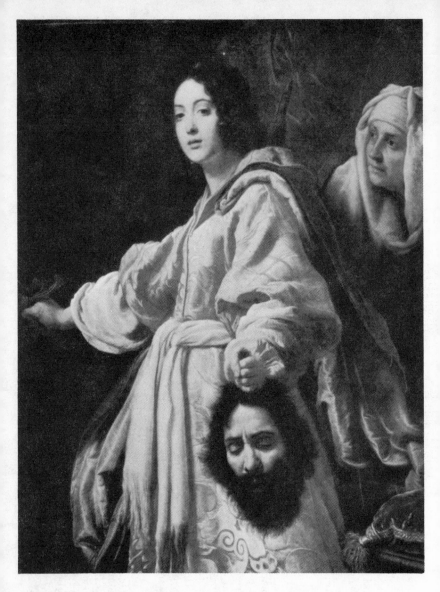

48. Christofano Allori (1577–1621),
Judith with the Head of Holofernes, *c.* 1609. Palazzo Pitti, Florence.
Allori, a notorious rake, fell in love with an exotic beauty
with whom he squandered his considerable earnings. He portrayed her here
as Judith and himself in the head of Holofernes: a symbol of his sufferings
'by the hand' of his beloved.

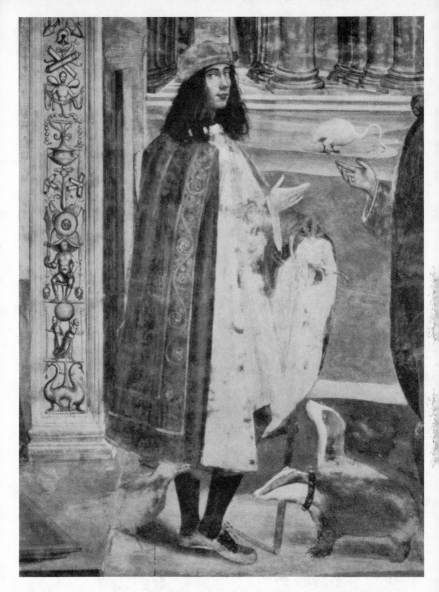

49. Giovanantonio Bazzi, called 'Sodoma' (1477–1549), Self-Portrait, after 1517.
Detail from a Fresco at Monteoliveto near Siena.
Bazzi's nickname is revealing of his reputation. He had a sharp, satirical tongue,
was fond of horse-racing and garish clothes and boasted a sort of private zoo. His
self-portrait shows him in his finery, surrounded by some of the creatures
from his collection.

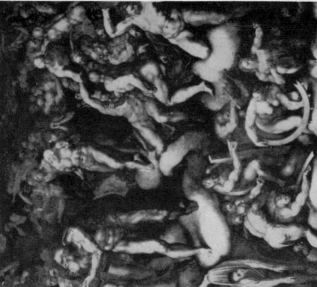

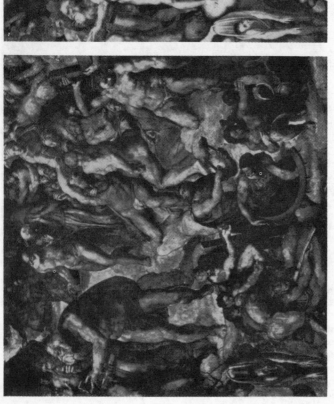

50. Michelangelo (1475–1564), Last Judgment, 1536–41. Detail. Sistine Chapel, Vatican. The counter-reformatory objections to nudity induced Pope Paul IV to have a number of offending figures draped, fourteen years after the completion of the Last Judgment.

51. Marcello Venusti (1515–76). Copy after the Last Judgment, 1549, before Daniele da Volterra's Additions. Detail. Museo di Capodimonte, Naples. Venusti's copy shows the original state of the fresco. Daniele da Volterra, who 'draped' some of the figures, proceeded with the greatest possible respect for his master's work.

whore,' he exclaimed in one of his sermons.[90] But it was during the Counter-Reformation that propriety in art became of paramount importance. The Tridentine Council decreed: 'All lasciviousness must be avoided, so that figures shall not be painted or adorned with a beauty inciting to lust.'[91] Counter-Reformation theologians and writers, such as St Charles Borromeo, Cardinal Gabriele Paleotti, Archbishop of Bologna, and the Fleming Molanus, enlarged on the theme of a new standard of decency in art. What was obscene in their opinion? It was, above all, the nude figure on which the artists of the Renaissance had concentrated their greatest effort—regarding man, created in the image of God, as the measure of universal harmony.

Long before the Council of Trent the objections to nudity were raised with a vengeance against Michelangelo's *Last Judgment*. The work was finished in 1541. Four years later Pietro Aretino of all people, himself one of the most lascivious writers of the sixteenth century, addressed his notorious accusing and abusive letter to Michelangelo. Furious that the master had not sent him some drawings he coveted, Aretino lashed out against Michelangelo for having represented 'things from which one would avert one's eyes even in a brothel' and he deemed the design 'more suitable for a luscious bathing room than for the noblest chapel on earth'.[92] The letter contains the filthiest innuendoes and even hints at Michelangelo's improper relations with young men. With his sure instinct Aretino sensed the changing spirit of the age. He touched off other less personal attacks and finally, in 1555, ten years after Aretino had sounded the charge, Pope Paul IV ordered Michelangelo's pupil, Daniele da Volterra, to drape the offending figures (Figs. 50, 51). Even a hundred years later the subject was still topical. A satire by Salvator Rosa (1615–73) ends with the lines:

> Daniele da Volterra then was told
> Quickly to tailor pants for the Last Judgement
> —So great and dreadful was that error to behold.[93]

Perhaps the most explicit statement by an artist on the question of impropriety comes from the sculptor Bartolommeo Ammanati (1511–92). He formulated his views in the exceedingly long letter of August 1582, addressed to his fellow academicians in the Florentine Accademia del Disegno. In spite of the prudish tenor of the epistle, it must be conceded that Ammannati gives an excellent analysis of the character and influence of obscene art; he is fully aware of the extraordinary power of visual statements and the chain reaction from obscene thought in the creator to obscene effect on the beholder. We can only print a relatively small portion of this strange document, which also reflects the reform of

personal conduct caused by the intensity of the Catholic revival in Italy. Ammanati admonishes his friends

. . . that they take care for the love of God and if their salvation is dear to them not to fall into the error and sin into which I have fallen whilst working, namely that of making many of my figures completely undraped and naked. I have in this followed the use, nay the abuse, of those who did so before me and who have not considered that it is far more honourable to show oneself to be an honest and chaste man rather than a vain and lascivious one, even though working most excellently. In truth, mine is no small error or defect and I have no other way in which to amend and correct it (since it is impossible to change my figures or tell whomever sees or will see them that I regret having made them thus) but to confess and write it publicly, making it known to all that I did ill, and how much I am pained and repentant, and in this way warn all others not to fall into such a harmful vice. For rather than offend society and even more our blessed Lord by giving a bad example to anyone, one should desire the death of both body and fame. It is a very grave and great sin to make naked statues, satyrs, fauns, and similar things, baring those parts which should be covered and which one cannot see but with shame: both reason and art teaching us that they should be covered. For if no other harm comes from it, one thing is certain: that others understand the artist's dishonest mind and greedy desire to please, from which it follows that such works bear witness against the conduct of their creator. I therefore confess (inasmuch as it appertains to me) to having this much offended against God's great majesty, though I was not moved by the desire to offend. But I do not excuse myself for this as I see that the bad effect is the same; and ignorance, custom, and similar things do not mitigate my fault in the least. Man must know what he does, and what effects might and will in the end result from his deeds and works. Therefore, my dearest brothers of the Academy, may this warning be acceptable to you, for I give it with all the affection of my heart: never make figures which in any part might be lascivious or immodest, I speak of completely nude figures, nor do any other thing which might induce any man or woman of any age to wicked thoughts towards which, unfortunately, this corrupt nature of ours is all too ready to be moved without the need of further invitation. Therefore I advise you all to guard yourselves with every care in order that in your mature and prudent years you may not, as I do now, feel ashamed and pained to have acted thus and especially of having offended God, as no one knows whether he will have time to ask forgiveness, nor whether he shall have to render account in all eternity for the bad example he has given and which lives and will, unfortunately, live to shame and taunt him for a long time, and which, with such care and vigilance, he has tried to render immortal.[94]

Ammanati goes on to praise the merits of beautifully draped statues such as Michelangelo's Moses in S. Pietro in Vincoli and to lament the readiness of some artists to make things which 'please only the senses'.

'Disgraceful' as some ancient and modern writings are, he says, it is far worse to make statues and pictures which incite evil thoughts; for profane writings are not accessible to all, but indecent paintings and sculptures, displayed in public places and, worst of all, even in churches, can be seen by everyone, and will, at one single glance, arouse 'improper and obscene' thoughts in the beholder.

Ammanati was seventy-one years old when he wrote this letter which was his spiritual testament. Some eighteen months earlier, on February 16, 1581, he and his wife, the poetess Laura Battaferri, had willed their worldly possessions to the Jesuit College in Florence which was housed in an old presbytery adjoining the little church of S. Giovannino in the via de' Martelli and for the renovation of which Ammanati had started to make plans as far back as 1572.[95] From about that time, he had devoted most of his attention to architectural designs, gradually abandoning sculptural works. This, it seems, was chiefly the result of his growing religious and moral scruples, though the failure of his last great sculptural enterprise, the Neptune Fountain in the piazza della Signoria, may have been a contributing factor. The huge marble Neptune is not a success by any standards, but the graceful bronze figures surrounding the unwieldy giant are masterpieces of invention and execution (Fig. 52). It is by them that Ammanati is best remembered, but their sensuality makes one understand the misgivings of an artist whose life and work was in his later years directed by Jesuit fathers.

Our attention has been focused on the link between personal conduct and obscene art—not on the problem of obscene art as such. But since the subject has been raised, a few more general remarks may be added.

Even the little material assembled in this section will have made evident the difficulty of defining what obscene art really is. It can safely be said that works intended as obscene could be looked upon as inoffensive and virtuous and, more often, that works intended as sincere or light-hearted, cheerful and amusing, may be interpreted as obscene. Such interpretations depend to a large extent on the conceptions of morality prevalent at a given period. Few in fifteenth century Florence saw obscenity in contemporary art, nor were nude figures often objected to until a prudish age judged differently. When Savonarola had opened the eyes of his fellow citizens some women confessed that the beautiful body of Fra Bartolomeo's St Sebastian in S. Marco, the work of a painter beyond moral reproach, awakened lascivious thoughts in them. For that reason the picture was first transferred from the church to the monastery and was later sold.[96] But it must be admitted that nudity has always presented problems in the Christian civilisation of the West.

The question as to what extent moral conduct and artistic integrity are

connected was scarcely raised before the Counter-Reformation. For the Middle Ages and the Early Renaissance the problem hardly existed. Despite the frank sensuality and sexuality of many medieval works (Fig. 53) their creators may well have been God-fearing and pious men, just as Fra Filippo's sterling religious paintings came from an artist with questionable moral standards. Yet once the artists became conscious of the problem, the situation changed. When their works reflected their principled life, sentimentality or even hypocrisy raised its head and stamped the products of many masters, Francesco Furini (Fig. 56) and Carlo Dolci among them. Others, like Rubens and Bernini, knew how to combine the stern demands of moral conduct with a healthy sensuality, and their work shows it. When the debonair Charles de Brosses, *président des parlements* of Dijon, wrote the memoirs of his Italian journey of 1739–40, he observed of Bernini's S. Teresa, considered the epitome of divine rapture, 'If this is divine love, I know it well'.[97] (Fig. 54)

CHAPTER VIII

ARTISTS AND THE LAW

HORACE WALPOLE, writing on the engraver William Wynne Ryland, who was executed in August 1783 'for forging and uttering bills of exchange', says that this 'unhappy act . . . has ruined his reputation as a man: but his name as an artist will ever be held in the highest estimation'.[1] This is a revealing phrase. The contrast between the fame of the artist and the reputation of the man contains philosophical and psychological implications which, so far as we know, were hardly explored in the sixteenth and the seventeenth centuries. It is clear that the division between a man and his work negates the prevailing Neoplatonic concept according to which a great artist cannot be a bad man (see Chapter IV)—a concept implicitly accepted by many art historians who tend to minimize criminal and unruly behaviour by artists. How was the criminality of artists viewed in the Renaissance and after? Three cases may serve as an introduction to the problem with which we are faced.

1 Three Cases of Criminal Artists

The great German-Polish sculptor Veit Stoss (d. 1533) sued a Nuremberg merchant in 1503 for failing to pay a debt of 1265 florins. It turned out that the main piece of evidence, a promissory letter supposedly written, signed, and sealed by the merchant, had been faked by the sculptor. Although Stoss believed he was in the right because he thought that the merchant had deceived him,[2] the fact remained that he had forged a legal document, and this was punishable by death. But, because of the numerous petitions on his behalf, the artist was only branded through both cheeks and released, after having sworn never to leave the town. Within a year he broke his oath and fled, but was allowed to return on condition that he would go to prison for four weeks and never again leave the town without special permission—a restriction which, if enforced, would have hit him hard, since he used to take his woodcarvings to the fairs in south and central Germany. Moreover, it was difficult for a branded man to find apprentices or procure help from other masters. Desperately trying to better his civic and economic position, he succeeded in obtaining a patent of restitution and rehabilitation

from King (later Emperor) Maximilian and, on the King's intervention, was allowed to work at the royal court and to move within a mile of the city gates, provided he did not spend the night away from home without the magistrate's knowledge.

Stoss must have taxed the patience of the city fathers to the limit. In 1506 they again sent him to prison, this time for unjustified and persistent claims for money, and they did not mince their words in decrying his unruly behaviour. They called him '*ein unruhiger heilloser Bürger*'—a restless, wicked citizen—'who caused much concern to the honourable city fathers and the town', and in a lawsuit of 1527 he is mentioned as '*ein irrig und geschreyig Mann*'—a muddled and garrulous man. Faced with the delicate task of discussing the criminal records of their heroes, art historians, so far as they are interested in biographical detail at all, often try to explain away the documented facts. Euphemistic terms such as *Sturmgeist* (impetuous temperament)[3] were used to remove posthumously the stigma of delinquency from Veit Stoss's character.

Jacques van Loo (1614–70), the son of a painter, had acquired a good name for himself in Amsterdam where he settled at the age of twenty-eight. In 1660 he was involved in a brawl with a wine merchant, a brutal and troublesome individual, who loved to provoke people in order to show off his strength. Van Loo killed his dangerous opponent by stabbing him in the belly and fled the country post-haste. He was banned forever *in absentia*.[4] In the following year he settled in Paris where no one seems to have held either the homicide or his flight from justice against him. He was immediately elected an Associate of the Royal Academy and two years later he was honoured with a full membership in that illustrious institution. His sons, grandchildren and great-grandchildren became well-known painters and distinguished academicians.

Neither Veit Stoss nor Jacques van Loo lacked important commissions in spite of their criminal acts. Stoss had the excuse of having tried to redress a wrong he had suffered; van Loo may have killed in self-defence. It is more difficult for us to understand the condoning attitude of Pieter Mulier's Italian patrons. Mulier (*c.* 1637–1701), a Dutch painter, had become a Catholic convert when he was about thirty years old, during a visit to Antwerp. Afterwards he went to Rome, well supplied with recommendations by the discalced Carmelite father who had received him into the fold. It therefore did not take him long to find work. He fell in love with and married the sister of his favourite pupil but soon regretted this step. Though inordinately jealous, Mulier grew heartily tired of his wife and decided to extricate himself from the tedious attachment. He fled and made his way to Genoa where he led an exceed-

ingly gay life and promptly fell in love again, but the girl was not prepared to yield to his entreaties without benefit of clergy. The only solution to this impasse, or so it seemed to him, was to get rid once and for all of the Roman lady in order to be free to marry his Genoese love.

Having come to an agreement with a hireling, Mulier sent him to Rome with an order to fetch his wife and kill her wherever it suited him best on the road back. As soon as he arrived in Rome the ruffian went to see the wife and, handing her letters from her husband, he told her that she should prepare to leave as quickly as possible, for he could stay but briefly and therefore wished to hurry. The miserable woman, seeing that horrid face, grew suspicious, for she was aware of how little her husband cared for her. She deferred the departure as long as she could. But having received also by mail express orders to leave at once, she prepared herself—though unwillingly—for the journey and left with the abominable executioner who barbarously killed her in the vicinity of Sarzana. The horrible news spread to Genoa and, as Mulier imprudently pressed for a speedy marriage, he gave everyone reason to suspect what had happened; even those who sought to defend and excuse him in public admitted among themselves that he was guilty. There was so much murmuring and gossip that at last Justice took its course and Mulier was sent to prison.[5]

The artist was first condemned to death, but his friends succeeded in appealing against the conviction and dragging the proceedings on for years. During all that time Mulier was busily painting in prison. In the end the Genoese Court yielded to the entreaties of two powerful Milanese patrons: Count Borromeo and the Governor of Milan intervened and obtained his release. Mulier left Genoa immediately and went to Milan where he worked so successfully for the Milanese nobility that he was soon able to 'afford a magnificent house, keep a carriage and outriders, and build a handsome zoo which he filled with all kinds of animals to serve him as models'. While he lived thus in splendour he forgot all about his second wife who 'was almost reduced to begging'. Towards the end of his life he seems to have suffered from all kinds of disorders which prevented him from working so that he had to borrow money. He was living in sadly reduced circumstances when an acute fever ended his tempestuous life.

2 Legal and Psychological Aspects of Crime in the Renaissance

> *We Italians are irreligious and corrupt above others*
> Machiavelli

The manifestly indifferent and apparently cynical attitude of high-ranking public figures towards the most flagrant violations of law and decency must, however, be judged against the background of a con-

ception of crime and punishment which had its roots in the Middle Ages, when the interpretation of right and wrong had often been arbitrary and judgment was based on trial by ordeal rather than on strictly legal grounds. Man-made laws were fallible, but the inscrutable will of God was accepted with resigned patience.

In 1494 the Florentine Landucci noted in his diary that his son had been stabbed one night

. . . across the cheek, by no means slightly; and we cannot think by whom. We believe it must have been a mistake, as he has never offended anyone or suspected anybody of having a grudge against him: it happened as punishment for our sins. I freely pardon the aggressor, as I hope that the Lord may pardon me, and I pray God to pardon him and not send him to Hell for this.[6]

The same Landucci relates a story which in 1510 excited the whole of Florence and neighbouring states:

At this time there was a cardinal [Francesco Alidosi, then legate in Bologna] so bereft of the fear of the Lord that he contrived to corrupt by means of bribes a Florentine girl, the daughter of a worthy man, a good citizen, and of an ancient house, who was married to another worthy man, whose names I will not mention so as to spare their honour. The cardinal caused her to be secretly brought to him in Bologna (where he was with the Pope) to the great sorrow of her father and mother and relatives. The thing was hateful to everyone. Finally she was brought back after a few days, amidst much murmuring about the disgrace to the city, because all the people were aware of it. For although it was a private case, it was regarded as one concerning the whole of Florence.

Alidosi, Julius II's favourite, whom the Pope made Bishop of Bologna in October 1510, did not survive his evil deed for long. In May 1511 a French army entered Bologna. Alidosi fled; it was rumoured that he had intrigued with the French. At Ravenna he met the Duke of Urbino, the commander of the papal army and his arch-enemy, who took it upon himself to mete out private justice. With the words ' "Thou traitor. Thou hast disgraced the Holy Church!" he thrust his sword into his breast, piercing him right through.' And Landucci adds: 'See the justice of God! for it was this cardinal who had carried off the Florentine girl . . . According to all accounts, he had done many similar things, and even worse.'[7]

It must be recalled that lawbreakers infested every country and every class of society. Unrestrained passions, violence and felonies of all kinds were not confined to a 'criminal class'. Kings and popes, members of the aristocracy and clergy; burghers, craftsmen and peasants were all capable of crimes which now, as a rule, are the reserve of specialized professionals or maniacs. Jacob Burckhardt[8] quotes the case of a Ferrarese

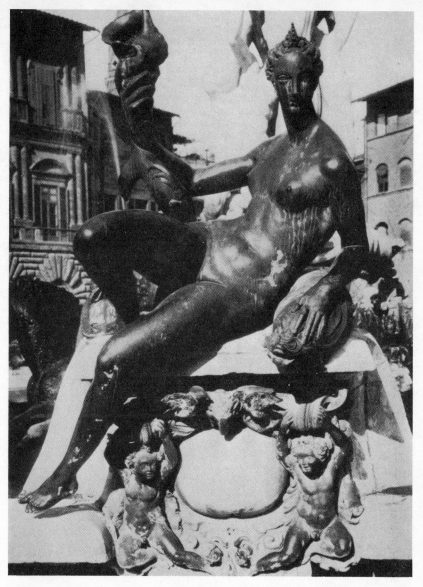

52. Bartolommeo Ammanati (1511–92), Bronze Figure from the Neptune Fountain, 1571–75. Piazza della Signoria, Florence.
Under the influence of the austere ideas of the counter-reformatory Church the aged Ammanati violently rejected his own earlier works such as the sensual bronze figure shown in this illustration.

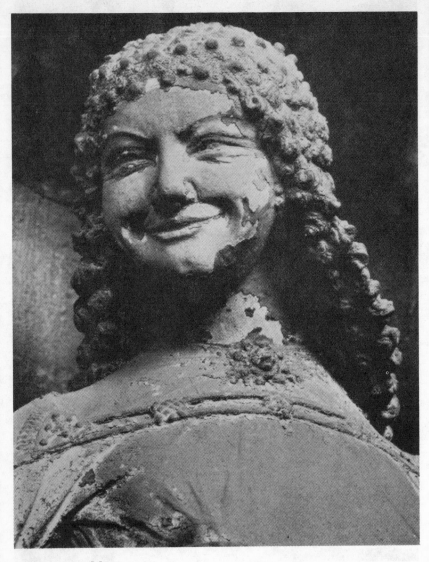

53. Anonymous Master, *c.* 1275.
Head of one of the Wise Virgins from the *Paradiespforte*, Cathedral, Magdeburg.
Medieval churches and monasteries abound with sensual works.
But their makers may well have been pious men of exemplary conduct.

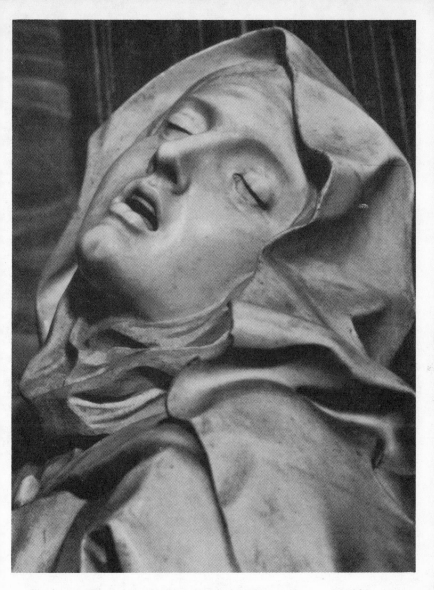

54. Gianlorenzo Bernini (1598–1680), Head of S. Teresa, 1645–52. Marble.
From the Ecstasy of S. Teresa in S. Maria della Vittoria, Rome.
In contrast to many other artists of his period
Bernini knew how to combine the stern moral demands
of the counter-reformatory Church with a healthy sensuality.

55. Giovanni Baglione (c. 1573–
1644), Divine Love, after 1600.
Museum, Berlin-Dahlem.
This picture, painted for
Cardinal Benedetto Giustiniani,
found higher praise than
Gentileschi's counterpart, the
'Archangel Michael', and was
the cause of Gentileschi's
unremitting hatred of Baglione.

56. Francesco Furini
(1604–46), Andromeda.
Galleria Nazionale, Rome.
When artists began to see a
connection between moral
conduct and artistic integrity,
self-consciousness or even
hypocrisy made its entry.
Furini's work is a case in
point. He played with the idea
of entering a monastery.

priest who committed a murder on the very day on which he celebrated his first Mass. Having received absolution in Rome he proceeded to kill four more people and to marry 'two wives with whom he travelled about. He afterwards took part in many assassinations, violated women, carried others away by force, plundered far and wide.' For these and other deeds he was imprisoned in an iron cage in the year 1495.

The atrocities perpetrated in the entourage of the papal court, especially during the Borgia reign, are too well-known to be enumerated here. In our context it matters little whether all the stories about poisoning, rape and murder were true; it is more important to understand the reactions to what was believed to have happened. A diary entry by Landucci for the year 1503 is again helpful:

We heard that Valentino [Cesare Borgia] was dead, and also four cardinals. This was not true; only one cardinal was dead. It was said that Valentino had poisoned a flask of wine and that this cardinal had died in consequence. And it was said besides that the Pope had also drunk of it by mistake. If so, for the sake of poisoning the cardinals, he had poisoned his father. God only knows if this be true or not; anyway, the Pope lay dying for a day or two. See what a situation Valentino is in now, with so many enemies besetting him.[9]

The memoirs of Johannes Butzbach (1478–1526), who rose to be Prior of the Benedictine monastery of Laach, take us into the atmosphere of petty crime and give us an idea of the unbelievably hard life of a fifteenth century apprentice.[10] At the age of about eleven he was entrusted by his parents to an itinerant student who had promised to take the boy on his wanderings in order to show him the world and teach him Latin and grammar. Instead, he taught him thieving and begging. The boy succeeded in running away and found an apprenticeship with a tailor for whom he had to work from three or four o'clock in the morning until nine or ten at night, sometimes even longer. He had to carry water, sweep the house, keep the fires, run errands, collect debts and steal the wax from the candles in the church which was then used in the workshop. In return he was taught the trade. In search of a life away from hunger, theft, and cold, harsh words and beatings, he became attracted by monastic peace and was admitted as a tailor in a monastery. Later he studied at the famous school of Deventer and was ordained. It was then that he wrote his autobiography in Latin to educate his younger brother in the ways of the world, in the love of God, and in the language of the ancients.

The authorities tried to establish peace and order by any conceivable means. They called on public support by having the deeds and, where known, the likenesses of criminals painted on the walls of churches, palaces and public buildings.[11] One of the earliest of such 'posters' is

mentioned in a document of 1272. Later, well-known artists were often employed for this kind of work: Andrea del Castagno painted so many of them that he was called Andrea *degli impiccati* ('Andrea of the hanged men'); Botticelli portrayed the murderers of Giuliano de' Medici after the Pazzi revolt, and in 1529, during the siege of Florence, it was Andrea del Sarto's task to portray the rebels and the disloyal citizens and soldiers who had fled. But what was meant to be a punishment was often treated as a joke. None of these paintings has survived.

A constant need was felt for revising old or decreeing new laws. In view of the murders committed by artists it is of particular interest to note the discrepancy between the often brutal punishment for small offences and the comparative leniency towards capital crimes. Landucci informs us that in 1478 a law was promulgated 'which forbade anyone who had killed a man to return to Florence'. This provision, preserved in the State Archives of Florence, begins with the words:

The high and magnificent *signori*, having in mind how grave is the sin of homicide by which man, a creature made and created in the image of God, is destroyed, and seeking the reasons why it is so very frequent under our jurisdiction, find, among other things, that it is encouraged by the facility of pardon.[12]

By depriving the culprit of all hope of acquittal and by imposing new and severe punishment, the *Signori* expected to deter men from committing such crimes. But in spite of all efforts there remained too many loopholes favouring the law-breaker. The reach of jurisdiction was usually confined to the boundaries of small states or even towns so that it was easy enough to escape judgment by the simple expedient of flight into a neighbouring territory, while confession and rather freely dispensed absolution enabled the culprit to make his peace with the Church and his own conscience. Also banishment, which sounded so severe on paper, held little terror for adaptable men who could soon find work and a new home in a place where their deeds were either unknown or ignored. Skill and knowledge opened more doors than a clean police record. 'He who has learned everything is nowhere a stranger,' said Ghiberti, following Theophrastus; 'robbed of his fortune and without friends he is yet a citizen of every country and can fearlessly despise the changes of Fortuna.'[13]

Equally important are some other considerations. The attitude towards malefactors was often ambivalent. In England, where according to an Italian report of 1496 there were more criminals than in any other country, such a distinguished man as Lord Chief Justice Sir John Fortescue (*c.* 1394– *c.* 1476) expressed admiration for the courage of thieves and robbers.[14] Popular sympathy sided even with murderers;[15]

the desperado who defied the law had an aura of sinister glamour about him. This taste for the lurid is reflected in the literature of all nations whose heroes, stripped of the magic enchantment of poetry, are often little more than glorified criminals. Gangster and murder stories are but the modern version of ancient epics. They show the same adulation of power as do their ancient prototypes and the same indifference towards the subtler distinctions between famous and infamous deeds. It is told that Pausanias, thirsting for everlasting fame, asked the philosopher Hermocrates how he could best attain his goal. The answer was: by killing him who is most famous—whereupon Pausanias murdered Philip, King of Macedonia. Varchi, the sixteenth century writer, ascribed Lorenzino's murder of Duke Alessandro de' Medici to the assassin's thirst for fame.

An important incentive for transgressions of the law derived from a peculiar sense of honour and self-respect. The sword and the knife were ever ready to defend one's honour or revenge wounded pride. The man of action did not rely upon the unpredictable and slow-working juridical machinery to assert his rights. When Cellini (1500–71) lost a law suit in Paris, unjustly to his mind, he instantly took matters into his own hands. Very satisfied with his performance he recalls in his autobiography:

I found that when verdicts were given against me, and there was no redress to be expected from the law, I must have recourse to a long sword, which I had by me, for I was always particularly careful to be provided with good arms. The first that I attacked was the person who commenced that unjust and vexatious suit; and one evening I gave him so many wounds upon the legs and arms, taking care, however, not to kill him, that I deprived him of the use of both his legs . . . For this and every other success, I returned thanks to the Supreme Being, and began to conceive hopes that I should be for some time unmolested.[16]

3 Passion and Crime in Cellini's Life

Because of his extraordinary autobiography Cellini has become one of the most widely-known personalities of the Renaissance, and the book itself one of the most important and most controversial sources for a study of the period. The peculiar tangle of facts and fiction in his reminiscences opens up a number of problems. The interpretation of what is truth and what imagination, what is typical of the Renaissance mind and what significant for Cellini only, is sometimes more revealing of the idiosyncrasies of the interpreter than of the period or the personality of the artist. One writer saw in him the sum of 'the most naïve peculiarities of a foreign nation in bygone days' (Kotzebue). Others thought that he was an abominable exception among the honest and God-fearing artists of the past; and in one psychologist's view

the artist suffered from hallucinations and delusions and anomalies of character which clearly indicate that he was a paranoic.[17] To be sure, Goethe, Cellini's first German translator, had a deeper insight into the artist's psychology. Goethe's knowledge of the historical as well as the national implications led him to see in Cellini the incarnation of the Italian Renaissance spirit. Describing the epoch as one in which everyone had to rely upon himself in order to defend his rights, he says: 'How forceful does the Italian character come out in cases like his. The offended one, unless he takes his revenge instantly, falls into a kind of fever that plagues him like a physical disease until he has healed himself through the blood of his opponent.'[18] Goethe also stressed an element in Cellini's character that was often disregarded by later writers. 'Our hero', he says, 'has the image of ethical perfection as something unattainable but constantly in mind.' This dichotomy between ideal and actual behaviour, between the knowing of what is right in theory and the doing of what is expedient in practice is typical of many men in Cellini's own time.

After what we have said in the preceding section, it hardly needs emphasizing that neither Cellini's life nor his character show particular signs of anomaly; his 'hallucinations' appear perhaps less remarkable when they are compared with the then current superstitions and demonological beliefs. Yet it should be mentioned that Cellini suffered from recurrent bouts of fever, probably malaria, and it is anybody's guess how his brain worked during these attacks. Most certainly, his art, rich in invention, extraordinarily skilful and expert in execution, reveals a man with infinite patience in his attention to the minutest detail and one capable of trenchant and relentless self-criticism (Fig. 58). His lesser-known writings—sonnets and poems—are not literary masterpieces but they spring from a clear and untwisted mind. He is capable of transmuting a bitter prison experience into a sarcastic sonnet which begins:

> There is no place like prison to my mind
> To get to know the difference 'twixt God's Bounty
> And that pertaining to mankind.[19]

A look at the data of the artist's life shows that in all essentials his memory served him well though his vivid imagination often embroidered and enriched the facts. He was born in Florence and there apprenticed to a goldsmith after his father had given up hope of making a musician of him. At the age of eighteen or nineteen he went to Rome and from that time until he reached his forty-fifth year he never spent more than four, or at most five, consecutive years in any one place. Sometimes it was his ambition that drove him on. At other times he tried to avoid wars or an outbreak of the plague, or he returned home to recuperate from one

of his bouts of ill-health. His great gifts and unusual skills secured him work wherever he went—Florence, Rome, Ferrara, Mantua, or abroad at the court of King Francis I in Paris and at Fontainebleau. But his temper was as hot as his tongue was sharp, his vanity was as inordinate as his jealousy and, though not entirely devoid of friends, he had enemies galore.

His criminal record began as early as 1516. He got into serious conflict with the law at least four times—apart from about ten other scrapes, not all of a minor character.[20] The first was in 1523, when he escaped severe punishment by his flight from Florence after he had wounded two men during a brawl; the second, in 1534 in Rome when he murdered his rival, the goldsmith Pompeo de Capitaneis. He went into hiding, but soon obtained a letter of pardon from Pope Paul III, who was more interested in Cellini's work than in his crime and took him back into his service. The third time justice clamped down on him, ironically enough on a charge which was probably unfounded: in 1538 he was accused of having rifled the papal treasure-chest during the Sack of Rome. Within a year he was imprisoned, fled, was retaken and incarcerated but finally released. The last blow fell early in 1557. In that year, and not for the first time, he was accused of sodomy committed about five years earlier. He was condemned to a fine of fifty gold *scudi* and four years in the *stinche*—the dreaded Florentine prison which he had only just left at the end of October 1556. But on the intercession of Duke Cosimo I the sentence was changed to four years' house arrest. It was then that he began to dictate his memoirs, which occupied much of his time between about 1558 and 1562. During this period, worried by intrigues, beset by his enemies and by financial troubles, Cellini prepared himself to take orders but thought better of it and, having obtained release from his vows, married the mother of his illegitimate son and daughters in 1565 and produced two more children.

Cellini's 'escapades' were known through the length and breadth of Italy. Yet in 1563 the Duke confirmed the gift of a house and garden near S. Croce as a token of his 'singular regard'. Eight years later Cellini died and was buried in SS. Annunziata with great ceremony. A monk delivered (in the words of a contemporary document) 'the funeral sermon of Signor Benvenuto in praise both of his life and works, and his excellent moral qualities' to the great satisfaction of all the academicians and the throngs of people who struggled to get into the church 'to hear the commendation of his good qualities'.[21]

Even a perfunctory glance through the available literature and the published criminal records shows that Cellini was not at all the exception he is so often believed to have been. His only claim to novelty lies in his having committed his memoirs to paper: no other artist has left a similar

account of his misdeeds. But the list of culprits is long. In the following pages we will present a few outstanding examples; they invariably show a characteristic disparity between the magnitude of the crime and the leniency of the punishment.

4 Leone Leoni—a Successful Villain

Cellini's slightly younger contemporary Leone Leoni (1509–90), also called Leone Aretino, worked mainly as a sculptor and an engraver of medals, coins and precious stones. His professional activity took him to Milan, Venice, Padua, Ferrara, Genoa and Rome. He also travelled in the retinue of Don Philip (later King Philip II) to Germany and in 1551 he was in Augsburg together with Titian. He moved in the highest circles, held public office, was a friend of such literary men of international reputation as Bembo and Pietro Aretino and earned a handsome income especially with his highly valued portrait medals. Signs of recognition were bestowed on him: the Knighthood of the Order of Santiago, a prior's office in his native Arezzo, and the gift of the magnificent Palazzo Omenoni in Milan, which he remodelled and where he resided in splendour, surrounded by his collections (Fig. 59).

Yet Leoni's criminal proclivity easily matched that of his most felonious contemporaries. In the very town of Milan he had been condemned to the galleys for assault. His own version of the incident was told by his friend Jacopo Giustiniani in a letter of May 16, 1540, addressed to Leoni's fellow-countryman, Pietro Aretino. This is the essence of the story:

Leone d'Arezzo, a man as well-mannered as he is virtuous, has asked me to describe to you in detail the misfortunes which have befallen him a short while ago, since he is unable to do so himself owing to his hasty departure. For you must know that, being as much supported as he is liked and esteemed by the nobles of this Court [of Milan], and because of his success and rare virtues, he was persecuted by the envy and ill-will of certain brother-artists of his and especially of one Pellegrini di Leuti, a German jeweller of the Pope's.[22]

This German had spread word that Leoni had counterfeited money. Considering Leoni's previous opportunities, and later attainments, in this field of activity, the charge was probably not unfounded. From 1538–40 Leoni had worked as an engraver for the papal mint. Later, in 1543, he fell into disgrace with the Duke of Ferrara for counterfeiting money while working for the Ferrarese mint.[23] This did not, however, disqualify him from being appointed Master General of the mint of Parma and Piacenza in 1546. Leoni was greatly offended with the German jeweller and swore 'everlasting vengeance ... And thus, on the

first day of March, at the hour of the *Ave Maria*, he slashed him so hard across the face that he seemed a horrid monster to behold and otherwise slashed him in such a way that only death can deliver him.'

The following day Leoni was hauled before the magistrate 'although he had committed the deed upon mature consideration'. At first he refused to talk, and only after he had been put to torture and threatened that the same treatment would be applied to his mother and his wife did he confess; he was condemned to the loss of his right hand. But at the last moment the penalty was commuted to service on one of the papal galleys 'in consideration of his being innocent of most of the accusations except the sin of face-slashing—if sin it is'. The writer goes on to point out how merciless this sentence was towards Leoni's 'poor mother, wife, children and brothers who all lived by the sweat of his brow'. But already some of Leoni's well-wishers were at work to obtain his release and the writer hopes that

. . . now that your Honour has been informed of everything you will surely help with all possible celerity to liberate your Leoni who not only loves and reveres you like a father but also adores you as a god. And do not spare your almighty pen which, I know, is so feared by the highest ranking people that it could release a homicidal slayer from the galleys, let alone a virtuous and honest youth such as Leoni who finds himself there for a mere slashing—and of whom? Of an infamous and wicked man and for no other reason than to defend his honour. And who would have acted otherwise?

Prince Andrea Doria must have had similar thoughts. Thanks to his intervention Leoni was freed within twelve months. Six years later he attacked and probably killed his assistant, the sculptor Martino Pasqualigo, who refused to follow him to Milan. The brutal act at first shocked Pietro Aretino, but the timely gift of a couple of portrait medals helped him to change his mind: 'Now I revoke the indignation I felt towards you . . . and I extend to you again my usual benevolence.'[24] The assaults on the German jeweller and on his assistant may have been out-bursts of his vicious temper, but Leoni's next homicidal attempt was premeditated and dictated by purely mercenary motives. In 1559 Titian sent his son Orazio to Milan to collect his Spanish pension. Leoni, who was under more than one obligation to Titian for help and useful recommendations, invited Orazio to be his guest in the Palazzo Omenoni. All went well until Orazio had received the two thousand ducats. Then, in the words of Titian, 'that wicked Leoni, unworthy to carry the title of Cavaliere and imperial sculptor . . . was moved by a diabolical impulse. He took it into his head to murder Orazio—to take his life in order to get the money.'[25]

Armed with daggers Leoni and his servants fell upon the unsuspecting

guest. Though badly wounded Orazio struggled and, helped by his own servant, managed to escape. Leoni was arrested but in spite of the gravity of the crime and although Titian sent a long and detailed report to Philip II in Spain (from which we have quoted), the assailant got off lightly. He had to pay a fine and was banned from Milan. He betook himself to Rome where Pope Pius IV honoured him with the commission for a monument to his brother, the Marquess of Marignano, to be erected in Milan Cathedral. Just for the record it may be noted that both Leoni's son Pompeo and his grandson Miguel Angel were accused of homicide in Spain in the year 1597.[26]

With the exception of Cellini's, these and many similar misdeeds are now all but forgotten. The majority of the perpetrators were minor artists. Their names are scarcely known outside a small circle of specialists whose interest in the lives of these artists is usually limited to the data which help to establish the chronology of their work. If, like Veit Stoss, a culprit was among the outstanding masters of his time, his modern biographers, as a rule, minimize or even deny his guilt. To conceive of a great master as a criminal offender runs counter to the ethical code of Victorian and post-Victorian writers. Of all the great sinners among artists only Michelangelo Merisi, known as Caravaggio (1573–1610) has never found an apologist. It is his conduct, and his conduct alone, that has always been singled out for special attention, particularly since the Caravaggio vogue of recent years.

5 *Caravaggio, the 'Bohemian'*

Perhaps it is easier to accept the combination of aggressive brush and ruthless dagger than the dissonance of pleasing works and hideous actions. Caravaggio's revolutionary style of painting (Fig. 57) and his unbridled passions have always been linked together. The effect on the spectator of the one has often influenced his judgment of the other. Stendhal called him infamous. Ruskin saw in his works 'definite signs of evil desire ill repressed'. For Roger Fry he was the first artist 'to defy tradition and authority'. Many of his contemporaries loathed him but had to acknowledge his extraordinary genius. Recent critics have seen the traditional ties in his art rather than the time-bound traits in his character.

Almost two-thirds of Caravaggio's life is shrouded in relative obscurity. He was born in Lombardy in 1573, trained for a few years in Milan, and went to Rome in about 1588 at the age of not much more than fifteen. For several years he had to struggle with abject poverty and ill-health, but by 1597 he is already referred to as a 'most famous painter'. Thereafter his life is fairly well documented. From 1600 on we find him frequently mentioned in the police records,[27] the first time in October of

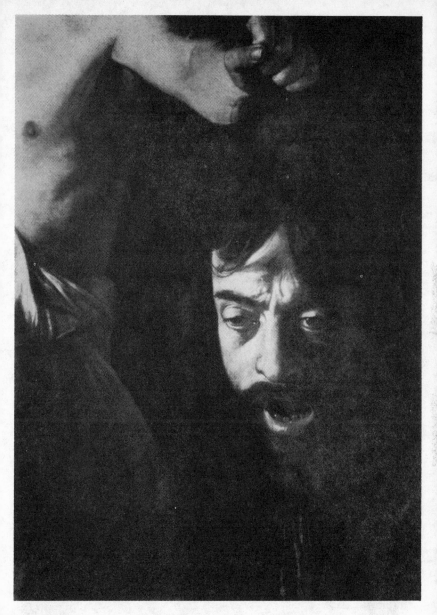

57. Caravaggio (1573–1610), Detail from 'David with the Head of Goliath', *c.* 1605. Galleria Borghese, Rome. Caravaggio's unruly conduct and brutal realism have often been linked together. But it is a fallacy to believe that an unbridled personality and a revolutionary style are complementary.

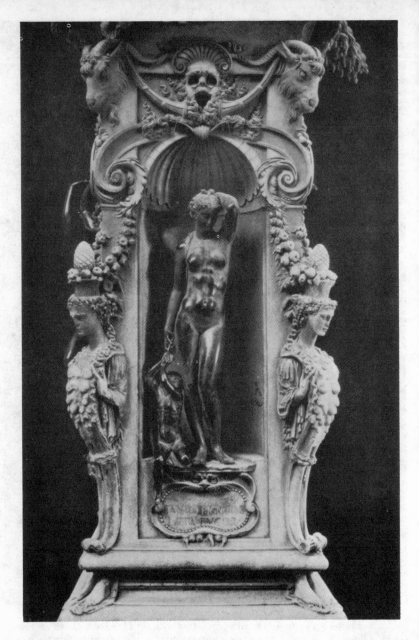

58. Benvenuto Cellini (1500–71), Danae with the Young Perseus. From the Pedestal of the Perseus Statue, 1545–54. Loggia dei Lanzi, Florence. If Cellini was a paranoiac who suffered from hallucinations, as some modern authors maintain, he was yet capable of infinite patience and relentless self-criticism in his artistic production.

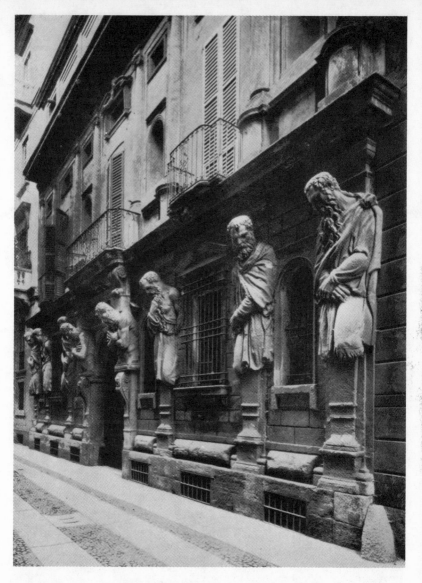

59. Palazzo Omenoni, Milan. Rebuilt and redecorated to Leoni's design after 1565.
In this impressive palace the sculptor Leone Leoni (1509–90), a villain if ever
there was one, resided in splendour: a telling example of the indifference of
Renaissance society to flagrant violators of law and decency.

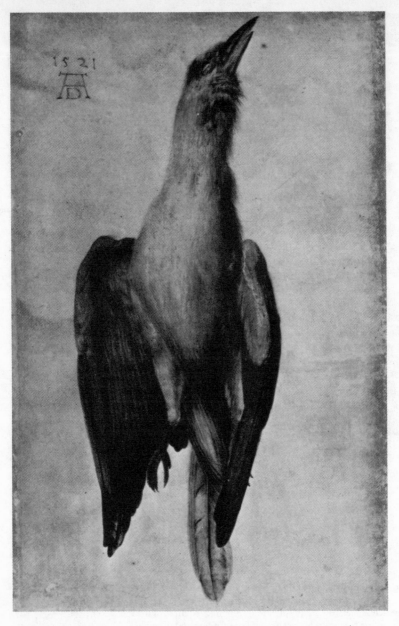

60. Copy after Dürer. Study of a dead Roller. Dürer's monogram and the date 1521 are later additions. Watercolour. British Museum.

Dürer was faked at an early date, but this copy may originally have been made without intent to defraud. Skilful imitations were often as much valued as the originals.

that year when he was present at, but not participating in, a street brawl and again in November when he picked a quarrel after nightfall with a fellow-painter whom he threatened with a cane. He was only prevented from harming him seriously by the intervention of some nearby butchers who hurried to the scene carrying lights and separated the fighters. In February of the next year he was summoned for drawing his sword against a soldier but, although he inflicted a wound which was likely to leave a permanent scar, he was pardoned because his victim forgave him.

Two years later, in August 1603, Baglione brought an action for libel against several artists. The defendants were the following: Onorio Longhi, Orazio Gentileschi (see p. 199), the unimportant painter Filippo Trisegni, and Caravaggio. Caravaggio was interrogated in September; his defence was remarkably insolent, his phrasing both clumsy and confused. The French ambassador interceded on his behalf and stood bail for him; he was dismissed with the provisos that he appear before the court again after one month and that he promise not to offend the plaintiff during the intervening time or to leave his house without the written consent of the Governor of Rome.

In the following year Caravaggio was summoned twice. The first time, in April 1604, he was sued by a waiter of the Osteria del Moro where he had ordered a dish of artichokes. The waiter brought four artichokes cooked in butter and four in oil. Upon being asked which were which, he answered: 'Smell them and you will know.' This was enough to enrage Caravaggio to such a degree that he threw the plate, artichokes and all, into the waiter's face, wounding his cheek. He then seized his sword and frightened the poor wretch out of his wits. Six months later he was arrested, this time for insulting a constable.

The first half of the year 1605 saw him in more trouble than ever. In February it was he, for once, who was the plaintiff in a minor affair involving the return of a rug. But in May we find him jailed for being in possession of both a dagger and a sword without a licence. On his insistence that he had the oral permission of the Governor of Rome to carry weapons he was released without bail. In July he was sued for giving offence to one Laura and her daughter Isabella. Two painters, a shoemaker, and a bookseller stood bail for him. Nine days later he assaulted a notary with whom one night he had had 'words in the Corso on account of a girl called Lena who is to be found at the Piazza Navona' and who was 'his girl'. But the parties were 'exhorted and persuaded by mutual friends . . . to make peace as befits good Christians'. Caravaggio declared his regret and was granted 'forgiveness and peace'. In September he was sued by his landlady: after the assault on the notary he had fled from her house and, since he was six months in arrears with his rent

and had, moreover, damaged a ceiling in the house, the infuriated woman served a writ for possession. The painter was peeved. He returned one night, first alone, then with some of his cronies, and hurled stones at her windows, breaking the Venetian blinds.

During the winter of 1605 he kept relatively quiet. However, from a document of uncertain date it appears that probably either late in 1605 or early in 1606 the artist was one day found in bed with wounds in his throat and on his left ear. This aroused suspicion. A Clerk of the Criminal Court was summoned to interrogate him, but to all questions Caravaggio answered stubbornly that the wounds were due to an accident, that he had fallen on his own sword somewhere in the streets—he did not remember where—and that nobody had been with him. This did not sound very convincing and he was forbidden to leave his rooms under penalty of five hundred *scudi*.

In the spring of 1606 he was once more involved in a violent quarrel. This time Caravaggio's vicious temper was his undoing. He was a passionate player of ball games, and one Sunday at the end of May he, together with three friends (one of whom was Onorio Longhi), apparently decided to measure their skill against another group of four players whose leader, Ranuccio Tommassoni, had won ten *scudi* from him. In the evening the two parties came to blows on the Campo Marzio. Swords were drawn and both Tomassoni and Caravaggio were wounded—Tommassoni so severely that he died soon after. Caravaggio fled and was banished from Rome *in absentia*. He went first into the hills near Rome where he found refuge with one of his patrons. Steps were taken to obtain an amnesty on the grounds that the painter himself was badly wounded and that the homicide was not premeditated but an accident. The authorities, however, were slow in their deliberations and Caravaggio moved on, first to Naples and later, in 1608, to Malta. He worked hard during these two years and with complete success. In Malta he was commissioned to portray the Grand Master of the Maltese Order who, 'wishing to extend to him special grace and favour', decided 'to invest him with the insignia of our Order and the Belt of Knighthood', thus gratifying 'the desire of this excellent painter' whom he called elsewhere 'the Honourable Michael Angelo'. In bestowing on the fugitive homicide this honour for which he had received 'a papal authorization especially granted to us for the purpose', the Grand Master was also thinking of Malta and his Order, pleased that both 'may at last glory in this adopted citizen with no less pride than the island of Kos, also within our jurisdiction, extols her Apelles'.[28]

Caravaggio's joy at being a Cavaliere was short lived. A little less than three months after receiving the knighthood (and many other signs of favour as well) he had, in the words of Baglione, 'some dispute with a

cavaliere di giustitia whom he offended I know not how'. He was imprisoned in October but fled and 'secretly departed from the district, against the form of the statutes'. Two Knights of the Maltese Order were charged with searching for the fugitive and finding out how he had escaped. This information obtained, the Grand Master summoned a General Assembly, deprived the culprit of his habit and solemnly proclaimed his expulsion from the Order. Caravaggio had made his way to Sicily where he soon found work in Syracuse, Messina and Palermo. In the late summer or autumn of 1609 he returned to the mainland. Reports reached Rome that he had had a violent and nearly fatal encounter with unnamed enemies in Naples in October. Eight months later he suddenly disappeared. He bundled up his few possessions and left Naples for Rome: some said he expected to be pardoned soon, others that the ban on him had already been lifted. But the round-about way he chose for his return journey makes one suspect that he was not too sure of his reception at the scene of his crime. We know that he boarded a boat in Naples bound for Port 'Ercole, a harbour under Spanish protection some eighty miles north of Rome. He went ashore at a deserted spot near the town but was mistaken by the Spanish guards for someone else and imprisoned. Freed after a few days he found that the boat had left with all his belongings. Desperate and enraged, he ran along the malaria-infested shore towards Port'Ercole where he succumbed to a violent fever and where he died, according to his epitaph, on July 18, 1610, aged thirty-six years, nine months and twenty days.

In spite of his uninterrupted criminal record, Caravaggio never lacked distinguished and helpful patrons once his genius had been recognized. They were great collectors, aristocrats and churchmen; Cardinal Scipione Borghese, Paul V's nephew and the man nearest the papal throne, was the most enthusiastic purchaser of the artist's paintings.

It has been claimed that Caravaggio was the first Bohemian artist.[29] His disorderly life, his dubious friends, his disregard for propriety would seem to make this an attractive hypothesis. But, surely, he was in direct line of descent from the early sixteenth century 'proto-Bohemians' and, moreover, had plenty of company in his own times. There is as little reason to proclaim Caravaggio as an exceptionally violent and uninhibited artist as there is to declare Cellini a paranoiac. Both are remarkable by virtue of the quality of their works rather than by virtue of their ill deeds. To name only a few kindred spirits, the great German painter Konrad Witz (d. 1445),[30] the Cremonese Boccacio Boccaccino (*c.* 1467–1525),[31] the Sienese Giacomo Pacchiarotti (1474–1540),[32] the Roman Tommaso Luini, called Caravaggino (1600–35),[33] the Neapolitan Angelo Maria Costa (eighteenth century),[34] the Spaniard Alonso Cano (1601–67),[35] as well as scores of minor or totally unimportant artists,

were suspected or found guilty of violence, theft, and murder. They are never quoted as evidence for extraneous theories, psychological or otherwise, not because they were less guilty but because they were less gifted or less conspicuous than the two great masters.

Verbatim reports of Roman court cases in Caravaggio's time are abundant. They help us to see Caravaggio's personality in clearer perspective by giving ample evidence for the violence of tempers, the ease with which offence was given and taken, and the professional suspicions and quarrels which kept artists distracted and lawyers busy. Some excerpts from these papers may here be given.

6 Belligerent Artists

When the papal architect Martino Longhi died in Rome in 1591, his younger sons as well as his fairly large estate were left in charge of a guardian. His eldest son, Onorio (c. 1569–1619), was living in Portugal at the time of his father's death. He returned to Rome in 1591 to look after his affairs and, believing himself swindled out of his rightful inheritance, he tried to take the law into his own hands. As late as 1598 the indignant guardian took the matter to court and stated before the judge:

You must know that I am the guardian of the said Onorio's brothers, and when the said defendant came back from Portugal he asked me for many things which he said belonged to him and addressed me in highly injurious terms. In fact, when I was in the house of Maria the innkeeper, the said Onorio came with others, among whom were Doctor Albasino and Domenico Attavante with his page, and they began to insult me by saying: 'You cuckolded thief, I want you to die by these hands' and such like. They were armed with cudgels and had forced the door of the room wherein I found myself.[36]

A year later, in 1599, Onorio, together with 'Claudio the stone-cutter', was sued by the widow Felicita Silano. She complained:

It is now two nights ago that the said Onorio came to my doors saying: 'Open, you bag and poltroon.' Having left, he came back and wanted to kick down the door, threatening me with further insults. He said that if I spoke he would beat me over the head with his sword. This same Claudio came and did the same thing five or six months ago, inciting others and particularly Onorio, to cause trouble at my door. I am not a woman to put up with such treatment, and therefore I am now bringing the matter before the Court.[37]

In 1600, 1601, and September 1603, Onorio was involved in Caravaggio's law-suits. In November 1603 he was sued by Tommaso or Mao Solini, a Roman history and *genre* painter, pupil of the painter-writer

Baglione. The minutes of the proceedings need little comment. Mao stated:

At about ten o'clock this morning I was in the church of the Minerva, together with my friend Giovanni Baglione, both of us wanting to hear Mass. While we were awaiting the Mass, I saw Onorio Longhi who beckoned to me with a nod to come near. When I was close to him, he began to say: 'I want to make you pass under a bridge of canes, you spy and cuckold.' To which I answered that in church I could be insulted but outside he would not have dared to say such a thing. At this Onorio raised his voice, and always with the same insults, invited me to come outside. We left by the door which gives on to the back of the Minerva. He took a brick, and I told him that he was telling a pack of lies. At that moment Baglione came out and held me back. Seeing that Baglione had a dagger, a certain solicitor, Andrea di Toffia, a companion of Onorio, turned against him and gave him a blow with his fist. Meanwhile Onorio had thrown the brick at Baglione which only touched his hat. He retired into the church. Later we found him at the door of my house with a sword, and he defied me. We entered a shop and he followed us, greatly insulting me. Among those who saw Onorio threaten me there was the sculptor Tommaso della Porta; and this is why I sue Onorio, so that he may be punished as he does not cease to revile me with notes and challenges.[38]

Tommaso della Porta was a reluctant witness, eager only to assert that he had nothing to do with the quarrel, but Baglione enlarged on his own grievance: 'As my coat fell when my hat was hit by that brick, Onorio saw my dagger and said to Andrea di Toffia: "Let's take the dagger from him." Andrea gave me a blow with his fist, and I gave him a push and put my hand on my dagger. Then they retired.'[39]

The proceedings went on for a whole week. No detail was left unmentioned and one can well understand why Onorio Longhi had the reputation for being a 'bizarre' person 'difficult to put up with', and that he 'aroused much hatred among his colleagues'.[40]

Onorio's son, called Martino after his grandfather, had not only inherited the family's artistic talent, but also the unruly spirit of his parent.

As long as his father Onorio was still alive, he always obeyed and followed him. After his death he gave full vent to his wild and licentious spirit and began to let his caprice be the arbiter of his work.

He did not gain many followers, nor did others applaud or strive to imitate him as he had hoped. When in looking at the works of his fellow architects, he perceived how far removed these were from his own conceptions, his wild and turbid mind would give way to fits of fury in which he would revile and insult their work. But he did this so brazenly and publicly that he covered himself with ridicule by unrestrainedly making noisy demonstrations in the *piazza*. All these violent and uncontrolled outbreaks were not enough to soothe and soften the impetuousness of his irate bile, for he did not abstain

from laying hands on lawyers, priests, and every sort and condition of person, so that he was severely dealt with according to the rigours of the law. In the end he was put into prison for having picked a quarrel with an eminent lawyer.[41]

This ruffian, whom Passeri describes as having been 'of an odd appearance, not deformed or spindly, but with a bizarre carriage', was nevertheless an eminent architect, 'a good poet and erudite in the sciences', and he recognized at least one authority: he always showed the greatest 'reverence and respect' for his mother,

... a mean, ill, and feeble woman, somewhat lame and small of stature. And yet, though he was a fully grown man in age, mind, and experience, she beat him incessantly, without regard or respect of any kind, and he took the blows without protest, neither getting cross, nor taking them as a motive for resentment.[42]

The Longhi were by no means exceptional as a family of troublemakers. There were, among others, the two generations of Gentileschi who kept the courts busy. In his younger years Orazio Gentileschi (1563–1639) had ranked among the foremost painters in Rome and his fame was not at first dimmed by his constant feuds with his fellow-artists though it seems that by 1615 his reputation had begun to suffer at least in some quarters. Cosimo II of Tuscany had toyed with the idea of calling Orazio to Florence and had asked Piero Guicciardini, his Roman agent, to make enquiries about the painter. The answer was not favourable. Gentileschi, according to Guicciardini, had done some quite nice little paintings, but on the whole he was 'deficient in draughtsmanship and composition' so that his works could hardly please 'even people of mediocre understanding. . . . On top of that he is a person of such strange manners and way of life and such temper that one can neither get on nor deal with him.'[43]

Still, he was successful enough in Genoa and in France in the early 1620's and he received a generous stipend from Charles I when he answered the King's call to London in 1626.

Some of his Roman colleagues detested him. Caravaggio did not include him in his list of 'valentuomini' (i.e. good artists). Baglione had a special grudge against him. In 1602 Baglione had gone on a pilgrimage to Loreto and had brought back several images of the Madonna 'of the kind which one wears on one's hat'. He had given them away as presents, and Gentileschi too was desirous of having one. But, Baglione explained in court,

... since I had none left in silver, I sent him two lead ones with a letter in which I advised him to consider their devotional rather than their cash value. He sent me the following answer written in pencil:

'To Giovanni, Painter. I do not send you back your Madonnas as you deserve, but keep them for their devotional value. But I do not hold you for a man who has enough spirit to buy them made of anything other than lead; and it is true that in other actions of yours you have given proof of this to all the world. So I laugh at you and your advice. I would like a service from you— that you hang an ox heart from the chain which you wear around your neck, as this would make an ornament equal to your grandeur. For I tell you: had you sent me a silver one, I would have paid for it, as I myself would never have sent a leaden one to a courteous gentleman. And at this I leave you, sneering at your friendship.'[44]

This letter, because of the reference it contained to the chain he was wearing around his neck, was used by Baglione as evidence in the libel suit he filed in the following year against Caravaggio, Gentileschi, and others.[45] Certain grossly defamatory sonnets against Baglione had been circulated among the Roman artists and he was convinced that Orazio was one of the authors. The chain in question was the cause of much grievance, jealousy and derision. It was a necklace given him by Cardinal Benedetto Giustiniani as a reward for a picture of 'Divine Love' painted for S. Giovanni Decollato (Fig. 55). Gentileschi, who had painted an 'Archangel Michael' for the same oratory, was furious about the preferential treatment Baglione had received from the Cardinal. He abused the rival picture because of its 'many imperfections' and after this affair was no longer on speaking terms with Baglione; the two painters did not even greet each other because, Gentileschi explained, 'when going about in Rome he waits for me to doff my hat to him, whilst I wait for him to do the same to me'.[46] No wonder that Baglione in his biography of Gentileschi did not exactly flatter his late adversary:

Had Orazio been of a more amiable temper [he wrote] he would have been a better artist,[47] but his tendencies were more bestial than human, and he had no regard for anyone however eminent. He stuck to his opinions, offending everybody with his satirical tongue, and we must hope that God in His benevolence will forgive him his trespasses.[48]

Orazio's children also needed a good deal of forgiving. His daughter's doubtful innocence has been discussed before. His sons Francesco and Giulio were imprisoned in Portugal in 1641 for fraud. In 1648 Francesco was mentioned in a trial of the Inquisition as having denounced and betrayed a fellow-prisoner—yet in 1660 he was appointed '*peintre ordinaire du roi*' at Angers.

The statement of an otherwise unknown Milanese painter may conclude this survey. It reads like a scene from an operetta, but Francesco Sola was in bitter earnest when he declared in September 1617 before the Roman court:

I shall tell your Lordship the reason why I find myself in prison. This evening I was sitting on the doorstep of my house in my shirt-sleeves, that is, I was not wearing my doublet, for I had just then stopped painting, when a beardless young man, carrying a sword, passed by, going down towards [the Palazzo?] Mattei.

Noticing that the youth was staring oddly at him, Sola stared back. The stranger then asked the painter what he wanted, to which he answered: 'Nothing.'

The young man thereupon said that had I been his equal he would have taught me a lesson. So I answered that I did not consider myself a lesser one than he, and that I was a painter, gentleman, and a young man of honour. He then stepped back and prepared to draw his sword. I wanted to rush upon him, but the crowd separated us, and when the corporal arrived we were led to prison.[49]

In all the cases we have discussed in this and the previous chapter the artists' criminal behaviour was accepted with remarkable equanimity. Must we then conclude that the patrons and the public regarded eccentricity, extravagance, melancholy and 'madness' as specific traits of artists, but acquiesced in their ill deeds because they shared their notions of right and wrong? While we have tried to show that a general laxity of morals led to indifference towards criminal artists, this is surely not the whole story. First, it would not be correct to believe that nobody cared. There are, moreover, distinct signs that the situation was not static. During the fifteenth and the early sixteenth centuries people were probably less concerned about criminality than later. But there was a growing tendency to extenuate the guilt of artists because they were artists. This is even true when artists were still classed as craftsmen: Veit Stoss obtained his royal patent because his woodcarvings were better than anybody else's. The emancipated artist was able to verbalize his claim for special consideration. Cellini said that men like himself, 'unique in their profession, stand above the law',[50] and not a few enlightened patrons agreed.

Still, the criminality among artists hardly contributed to their alienation, for, after all, like most citizens the vast majority of them never saw the inside of a prison. There is, however, no way of estimating the proportion of indicted artists to offenders from other professions or trades in the centuries with which we are concerned. Statistics, such as they are, were compiled much later and are inconclusive. The earliest ones state that between 1881 and 1885 murders were rarely committed by members of the 'liberal professions' but that bankruptcy and counterfeiting occurred rather frequently. The largest number of juvenile

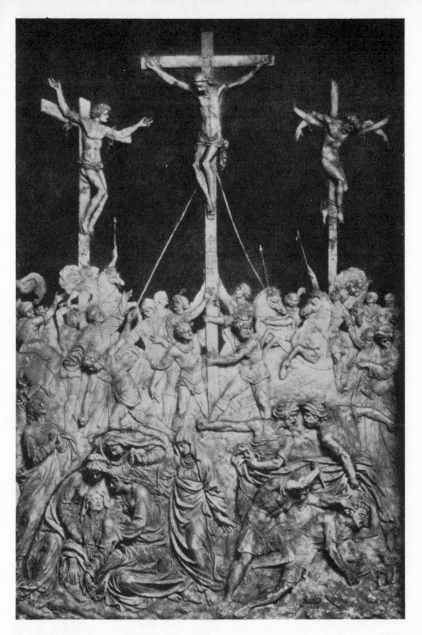

61. Guglielmo della Porta (d. 1577), Crucifixion. Wax Model. Galleria Borghese, Rome. Porta's studio was broken into and rifled after his death. Models, similar to this one, were sold to now forgotten artists who used them for their own purposes. The ensuing law case throws an interesting light on the illicit art market of the period.

62. Claude Lorrain (1600–82), A Page from the *Liber Veritatis*. Print Room, British Museum. Faked pictures by Claude began to be circulated after the artist's first great successes. In order to protect his artistic property Claude made washed drawings of all the works which left his studio and entered them into a book which he called 'Book of Truth'.

63. Michelangelo Cerquozzi (1602–60), The Masaniello Revolt in Naples, 1647. Galleria Spada, Rome. Cerquozzi used the revolt of July 1647 as the subject for one of his highly-paid, popular scenes. The topographically correct Market Place of Naples is probably the work of his collaborator Viviano Codazzi. Cerquozzi himself never left Rome. He was so tight-fisted that his stinginess became proverbial.

64. Hans Holbein the Younger (1497–1543), Venus, before 1526. Öffentliche Kunstsammlung, Basel.

The model for this and other Holbein pictures was Magdalena Offenburg, a beautiful woman of easy virtue. No documents inform us about the character of Holbein's association with her.

65. Holbein, One of Holbein's pen and ink illustrations in a Copy of Erasmus's *Praise of Folly*, Basel, 1515. Öffentliche Kunstsammlung, Basel.

The inscription 'Holbein' above the fat, amorous drinker is by a different hand. It has been claimed that the tradition of Holbein's dissipated life was chiefly based on this jest.

delinquents arrested in 1883 came from the industrial working classes and very few from professional families.[51] Presumably the heading 'liberal professions' also included artists but we do not know how many, and even if we did, we could hardly draw retrospective conclusions from the circumstances prevailing at the end of the nineteenth century. All we can say is that criminal tendencies have never found a place among the traits described as typical of the 'artistic temperament'.

7 The Ethics of Faking

One offence against the code of laws is the special reserve of artists, namely the faking of works of art, and this chapter would be incomplete without a discussion of some aspects of this problem. In contrast to counterfeiting money or documents, works of art are often imitated without intent to deceive, and it is not at all easy to draw the line between legitimate and fraudulent imitation. Even 'the aristocrats among the forgers',[52] Bastianini (1830–68), Dossena (1878–1937), and van Meegeren (1889–1947), did not admit to dishonest intentions—except for van Meegeren and then only under considerable pressure. They claimed rightly or wrongly to be original creators and found enough support for their point of view to make prosecution difficult or impossible.

Moreover, the ethics of forging has changed in the course of time. While manifest fraudulent intent is now punishable by law, this was not always so. On the contrary, in the sixteenth century, when archaeology was a young science, fakes based on erudition did credit to the learning and skill of the artist.[53] Clever forgeries were appreciated and collected. Thus Vasari writes of the Milanese sculptor Tommaso della Porta, a relative of the more famous Giacomo and Guglielmo, that he

. . . excelled in marble works and especially in counterfeiting marble heads which were sold as antiques; and he was so good at sculpting masks that nobody could compete with him. I myself own one in marble by his hand; it stands on the mantelpiece in my house at Arezzo and everybody believes it to be antique.[54]

When Michelangelo, soon after his return to Florence from Bologna in 1495, produced his Sleeping Cupid (now lost), his patron Lorenzo di Pier Francesco de' Medici was so struck by the 'antique' manner of the work that he promised Michelangelo that if he would 'treat it artificially, so as to make it look as though it had been dug up, I would send it to Rome; it would be accepted as an antique, and you would be able to sell it at a far higher price.'[55]

Michelangelo gladly complied. The full and somewhat involved story is told by Condivi in his *Life of Michelangelo* published in 1553 under the master's supervision. Michelangelo was then seventy-eight years old,

but his memory was reliable. He had obviously no compunction about making his youthful exploit known to posterity, nor was he troubled by the moral aspect of an intentional deception; although angry at being the financial loser in the transaction, he was proud that his successful imitation of the classical style had won him the attention of a Roman patron and an invitation to come to Rome.

Not only the emulators of classical antiquity, but the imitators or forgers of contemporary art were also often admired. In Johann Neudörfer's *Nachrichten von Künstlern und Werkleuten*, written in 1547, we find three artists praised for their 'good imitations' of Albrecht Dürer's works. One of them, Hans Hoffmann (d. *c.* 1591), 'was a diligent painter . . . who copied Albrecht Dürer so assiduously that many of his works were sold as Dürer originals'.[56] Such a copy by an anonymous draughtsman is shown in Fig. 60.

On the other hand, from the late fifteenth century onwards appreciation of invention and originality had grown rapidly. Men who regarded artistic talent as ordained by Providence or Nature and admired the works of great artists as unique and inimitable (p. 60), developed a respect for authenticity and, implicity, a weariness of copies or concoctions with fraudulent intent. Since their emancipation, artists too began to look for ways of protecting themselves against counterfeits. But they had no legal means of safeguarding their artistic property. None of the forgers of the sixteenth and seventeenth centuries had to live in fear of going to prison. Moral condemnation and loss of patronage was their only possible punishment. It took more than two hundred years for the law to catch up with a situation which threatened to get increasingly out of hand. Not until Hogarth's claims and representations led to the Engraving Copyright Acts of 1735[57] was a beginning made and at least one area of artistic production legally protected from pilfering. Sculptors and painters had to wait even longer. Prior to the copyright laws artists had to have recourse to their own devices. An obvious way of maintaining their authorship rights was to keep a complete list of all their works. Claude Lorrain's *Liber Veritatis* is the best-known instance of this kind of safeguard.

8 Claude's 'Liber Veritatis'

At the age of thirteen or fourteen Claude (1600–82) had left his native France and gone to Rome. A very rudimentary education, a few years' training as a pastry cook, and some knowledge of ornamental drawing, probably acquired from an older brother, was all the equipment the lad brought to the centre of learning and the arts, the gathering place of the fashionable world, and a hotbed of intrigue. Though never making good his lack of education nor ever learning to master the Italian language

fully, his Roman stay of more than half a century was highly successful. By all accounts Claude was of a particularly peaceful and amiable disposition, of retiring habits, and entirely devoted to his work. He was unstinting in his advice to other artists, kind to many, but close friend to few. This guileless, single-minded man made his way slowly to the top of his profession amidst the most ruthless competition and among the most profligate artists of his time. Though a dreamer and, in W. Friedlaender's phrase, a *homo illiteratus*, he was neither a weakling nor a simpleton and knew how to protect himself. Once it happened while he was working on his pictures that, in the words of Baldinucci,

. . . not only was his composition cribbed by some envious persons desirous of unfair earnings, but, through imitation of his manner, copies were sold in Rome as originals by his brush; by this the master was being discredited, the patron for whom the pictures were painted badly served, and the buyers defrauded since they were given copies instead of the originals. But matters did not end there as the same happened to all the pictures which he painted thereafter. Poor Claude, who was a man of innocent ways, did not know from whom to guard himself among the numerous persons who came to his studio nor what decision to take. Every day similar pictures were brought to him so that he might recognize whether they were by his hand or not. Thereupon he decided to keep a book and began copying the composition of all pictures which left his studio, describing with a really masterly touch every minute detail of the picture itself, for whom it had been painted, and, if I remember rightly, the honorarium which he had received for it (Fig. 62). To this book he gave the name of *Book of Compositions* or *Book of Truth*.[58]

The main offender against Claude was the French painter Sebastien Bourdon (1616–71). As a very young man he had come to Rome and, 'since he had a lively imagination, a good memory, and a great facility with the brush, he easily counterfeited whatever he saw, imitating the mannerisms of anybody'.[59] By faking not only Claude but also such masters as Andrea Sacchi, Michelangelo Cerquozzi and Pieter van Laer ('Bamboccio'), Bourdon successfully kept the wolf from the door 'at a time when the magnificence of our kings and their ardour for the arts had not yet established grants for young students who went out' to Rome, as his French biographer explained,[60] adding, not without pride, that it took Bourdon less time to execute a fake than it took Claude to produce the original. Although, according to Félibien, this versatile painter 'did not have the leisure to study everything regarding the theory and practice of his art during his stay in Rome',[61] he became one of the charter members of the French Academy and was called to Stockholm as court painter to Queen Christina of Sweden.

Claude's *Book of Truth* was by no means unusual. Even lesser artists, such as Elisabetta Sirani, kept lists to prove the authenticity of their

paintings. Whether or not Claude's placidness, his intellectual inertia, the fact that he never married reveal a 'slightly abnormal' nature may be debatable; whether he 'suffered temporarily or even constantly from depression' is open to doubt. But it seems quite unwarranted to see, as has been suggested, in Claude's perfectly natural resentment of being plagiarized a sign that 'he was lacking in initiative and was moved to angry excitement only when his immediate and strongest interest in life was hurt'.[62]

9 Faking of Old Masters and Fraudulent Restoration of Antiques

It was of course much safer for fakers to practice their skill and ingenuity on the works of those who could no longer protest and from the earliest to the most recently departed masters of fame there were few who have not been fraudulently imitated.[63] From the seventeenth century on, the list of perpetrators is endless. One notorious case, that of the painter Terenzio Terenzi (d. *c.* 1621), may speak here for many similar ones. Baglione tells us that he

. . . went about buying old panels and old-fashioned frames blackened by smoke and worm-eaten which showed some figure even though rough and badly worked. He painted on top of these, and by means of some good drawing and much messing about with colours, he almost made them look like something. After having painted them, he hung them up in smoke and by the application of certain varnishes mixed with colours, he made them look like pictures many hundred years old. With his art and ingenuity he took in the most knowledgeable minds of his time, that is, those who make it their profession to understand the manners of the excellent painters of old, and he hoodwinked them with these panels as was later discovered in one notable instance.

Terenzio was in the service of Cardinal Montalto when one day he got hold of an old picture with a beautifully carved gilt frame. He took the opportunity to paint a Madonna and other figures inside it which he traced from a good drawing, and he worked so hard and did so well that in the end a picture resulted which seemed genuine and old to whoever was not of the profession or a good master himself. He dared to present this to Cardinal Montalto, his patron, as coming from the hand of Raphael of Urbino, and by this truly presumptuous and ungrateful act wronged him who gave him food and shelter. The cardinal showed it to connoisseurs who recognized the fraud. This much disgusted the prince who dismissed Terenzio, not wanting to see him again.[64]

Cardinal Montalto had no other defence. No legal prosecution was possible.

A very lucrative business was the 'perfecting' of antique marbles. Usually the counterfeiters kept very quiet about their activities—a sound rule to which the famous British sculptor Joseph Nollekens was a

notable exception. He openly admitted his own and gleefully connived in his friends' deceits. During a ten-year stay in Rome (1760–70) he started on a profitable little sideline:

The patrons of Nollekens, being characters professing taste and possessing wealth, employed him as a very shrewd collector of antique fragments, some of which he bought on his own account and, after he had dexterously restored them with heads and limbs, he stained them with tobacco water and sold them, sometimes by way of favours, for enormous sums.[65]

Reminiscing about his Roman days Nollekens recalled that John Deare, the sculptor (1759–98), was

. . . a very upstart fellow, or he ought to have made money by sending over some antiques from Rome. I told him I'd sell 'em for him, and so might many of 'em; but the sculptors nowadays never care for bringing home anything. They're all so stupid and conceited of their own abilities. Why, do you know, I got all the first and the best of my money by putting antiques together? Hamilton [the painter, 1723–98] and I, and Jenkins [the notorious art dealer], generally used to go shares in what we bought; and as I had to match the pieces as well as I could, and clean 'em, I had the best part of the profits. Gavin Hamilton was a good fellow; but as for Jenkins, he followed the trade of supplying the foreign visitors with *intaglios* and cameos made by his own people, that he kept in a part of the ruins of the Coliseum, fitted up for them to work in slyly by themselves. I saw 'em at work though, and Jenkins gave a whole handful of 'em to me to say nothing about the matter to anybody else but myself. Bless your heart! he sold 'em as fast as they made 'em.[66]

From the same source we learn a little later that John Barnard,

. . . who was very fond of showing his collection of Italian drawings, expressed surprise that Mr Nollekens did not pay sufficient attention to them. 'Yes, I do,' replied he; 'but I saw many of them at Jenkins's at Rome, while the man was making them for my friend Crone the artist, one of your agents.' This so offended Mr Barnard, who piqued himself upon his judgment, that he scratched Nollekens out of his will.[67]

10 *Thefts of Works of Art*

Faking being a lengthy business, which requires a good deal of ability and knowledge, some artists chose a simpler way to profit from the genius of others: they took to burglary. Obscure artists robbed the successful ones; apprentices stole from their masters. Dutch and other foreign painters living in Italy were quite often a prey to their newly-arrived countrymen to whom they gave hospitality and who repaid the kindness of their hosts by making off with their pictures and selling them.[68]

The number of unemployed or under-employed artists in Rome during

the later sixteenth and throughout the seventeenth century was very large. Their life was hard and the temptations were many. Consequently an underworld net of thieves and receivers developed which supplied the art market with stolen goods. Thus in 1562 one Rainaldo Rofferio from Bologna stole from his master Maino Mastorghi's workshop an alabaster bust and sold it to a stone-mason who in turn sold it to a sculptor living in the Piazza del Popolo.[69] Mastorghi himself was, it seems, no paragon—nine years before, his mistress Lucia Travisano had denounced him for violence and neighbours had complained about his habit of disturbing their nights by singing and playing music with his companions.

In 1611 a group of three artists had worked out a big coup. They were a young painter, Bernardino Parasole, son of an *intaglio* worker and his wife, one of the best-known designers of laces and embroideries; Parasole's friend, a painter named Domenico; and the brother of 'Signor Terenzio, painter to Cardinal Montalto', that is, of course, the Terenzio of the faked Raphael. The victim this time was not an artist but an antiquarian. The haul comprised some cartoons by Polidoro da Caravaggio, a number of drawings, and four hundred medals. From the court minutes it is not quite clear whether the three youths were the thieves or the receivers of the stolen goods.[70]

Not all the booty went into the art market. Some of it served to enrich the stock of models and designs kept by craftsmen whose ambition was greater than their inventive powers. When Michelangelo's workshop in Florence was broken into, the burglars carried away some fifty drawings and several wax and clay models. A chisel which was left behind was traced to Baccio Bandinelli's father, a goldsmith, and no Florentine doubted that he was involved in the theft.[71]

A most revealing law-case ensued from the theft of models left at his death by the sculptor Guglielmo della Porta, famous for his bronze works and best known for his tomb of Pope Paul III in St Peter's. Guglielmo's date of birth is unknown. He was born near Lugano, worked for many years in Genoa and went to Rome in 1546. A year later he became Sebastiano del Piombo's successor as Keeper of the Papal Seal. In 1558 he made a will in which he left the bulk of his considerable assets to his two illegitimate sons, Mironio, who died young, and Fidia, who survived him. Some time later, perhaps in 1561 when he enlarged his house, Guglielmo married, though not the mother of his children, and in 1567 his lawful wife bore him a male child, Teodoro. In 1577 Guglielmo changed his will in favour of this legitimate son and soon after he died. His widow married one of the late master's studio hands, Sebastiano Torrigiani, who became Teodoro's guardian.[72]

To cut an illegitimate son out of one's will was an unusual step.

Children born out of wedlock were almost always well provided for. Guglielmo possibly disapproved of Fidia, his first-born, who seems to have been an unsatisfactory character. Constantly in debt, unable to pay the rent for the house in which he lived with a certain 'Angela, a woman of thirty years of age who wears a coat of red cloth', Fidia was bitterly disappointed at not succeeding to part of the estate. He started litigation against his stepmother but seems to have been unsuccessful and finally decided to help himself to part of the inheritance which had been denied him under his father's will. Guglielmo's artistic remains had been stored in two rooms, kept under lock and papal seal until Teodoro's coming-of-age. The contents of these rooms were valuable indeed. Among them were many plaster, terracotta, and wax models (Fig. 61); a number of bronze reliefs with scenes from the life of Christ, others with episodes from Ovid's *Metamorphoses*; several representations of the Crucifixion of Christ as well as drawings and sketches. One night in 1586 Fidia broke into the rooms, carried away most of the treasures and sold them. The breaking of a papal seal was a serious offence, punishable by death. Fidia was jailed and condemned.

When Teodoro came of age and demanded his inheritance from his guardian he was told that most of his father's artistic legacy had disappeared. For the moment Teodoro was powerless. According to the law he could not start legal action without knowing against whom to proceed and he had to bide his time, waiting for the stolen pieces to turn up. Once a certain Andrea Tozzo was found in possession of some of Guglielmo's models and was duly sent to prison. At long last, in 1609, twenty-three years after the theft, Teodoro succeeded in tracing two of the receivers, Antonio Gentile, a goldsmith and former friend of Guglielmo's, and a bronze founder, Sebastiano Marchini. Teodoro could prove that both had made casts from his father's models and had sold them from their workshops. He now claimed the restitution of all the models and forms which were his rightful property.

A lengthy and involved lawsuit followed. Marchini declared that he had only recently acquired the models found with him. Gentile admitted that he had bought a number of objects from Fidia as well as from Torrigiani some twenty-five years earlier but he never knew where they came from. Other witnesses were called and it turned out that many more people had been involved in buying and selling the disputed models or in making cheap casts from them, thus 'dispersing [Guglielmo's] work and debasing its rare quality' to Teodoro's 'great and flagrant detriment'. The length of time that had elapsed since the burglary presented, of course, great difficulties. Fidia and Torrigiani were no longer alive, and it was impossible to determine the guardian's rôle in the sinister affair. Had he been the instigator of the crime or had he only

connived at Fidia's felony? Was the old Antonio Gentile so uninformed and innocent as he pretended? He was in his ninetieth year when he had to explain the acquisition of works which were familiar to him from years long past, when he had seen them take shape under Guglielmo's hands. He knew perfectly well that they had been willed to Teodoro, a fact which he seems to have resented. Asked during the second hearing whether he recalled from whom he acquired certain wax models he answered: 'From Fidia, brother of Teodoro who gave nothing to Fidia.'

Some of the witnesses were advanced in years and pleaded ignorance or lack of memory. Besides Gentile, who died in the same year, there appeared Jacob Coppé, also a very old man, who had been a pupil and factotum of Guglielmo's. His evidence was vague when it came to dates, but he clearly recognized the works which he had helped to create, and he gave a little extemporaneous definition of artists: 'All sculptors are architects, and know about architecture, because it's all one and the same art, so to speak.' Other witnesses were typical of the shady proletariat of artists at the time. There was Jacques d'Armuis, a French sculptor, who bought quantities of models in Rome which he shipped home to France or peddled around among the artisans of the town. He had sold one of the wax models to a Florentine goldsmith living in Rome, and a cast of it had been taken to Naples by a young Fleming. A German goldsmith, found in posssession of another of the stolen models, said that he was holding it in safe keeping for one Gabriel, a countryman of his, who had left it with him before departing from Rome. He did not know from whom his friend had bought it, nor at what price—'and this is the truth'. The same mysterious Gabriel was said to have sold yet another model to one Giovanni Potof who left it with a certain Giovanni Knopf before he, too, disappeared from Rome. And so it went on and on through seven weeks. The outcome of the suit is not known, but as far as it goes it throws a rare light on the illicit art market of the time and on those forgotten craftsmen who came to Rome in search of work and who eked out their meagre earnings by stealthily profiting from the '*invenzioni*' of great masters. This, incidentally, may also explain the high quality of many an anonymous work.

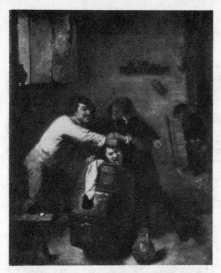

66. Adriaen Brouwer (1605/6–38),
Three Boors drinking.
National Gallery, London.
The authenticity of this picture has
lately been doubted, but whether by
Brouwer himself or a close follower,
it is a good example of those endlessly
repeated renderings of tavern scenes
at which Brouwer and his fellow-
artists were more than mere spectators.

67. David Teniers the Younger
(1610–90), Scene in a Tavern.
Gemäldegalerie, Dresden.
From the late sixteenth century on
the passion for tobacco had become
second only to that for spirits.
Tavern scenes in Dutch seventeenth
century pictures are almost unthinkable
without pipe smokers. The stupor of
the tipplers was intensified by the
admixture of hemp to the tobacco.

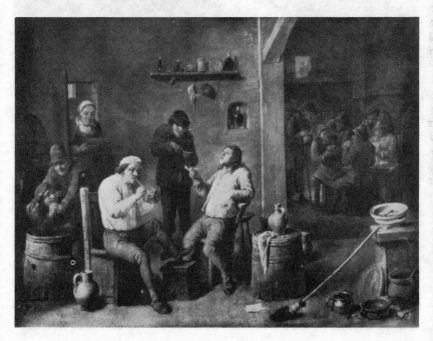

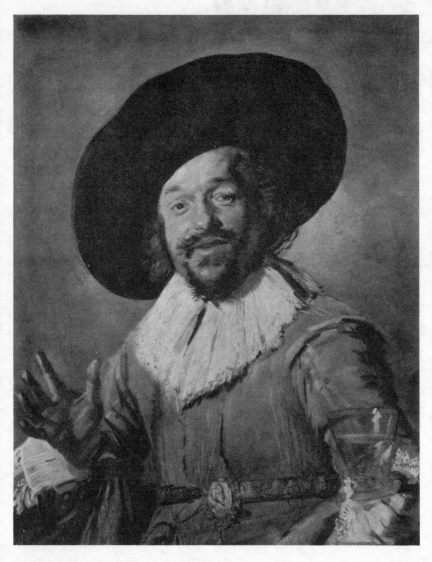

68. Frans Hals (1580/85–1666), The Merry Drinker, c. 1627. Rijksmuseum, Amsterdam. Hals' pictures of inveterate tipplers may have nourished the tradition of his own intemperance. But there are reasons to believe that such paintings were not produced by a teetotaller.

69. Anton Maria Maragliano (1664–1739),
Head of a Wooden Figure.
Chiesa della Visitazione, Genoa.
Although temperate in his
personal needs, Genoa's
most famous wood carver
entertained royally and gave away
vast sums of money.
His work, however, is of
an intense religious character.

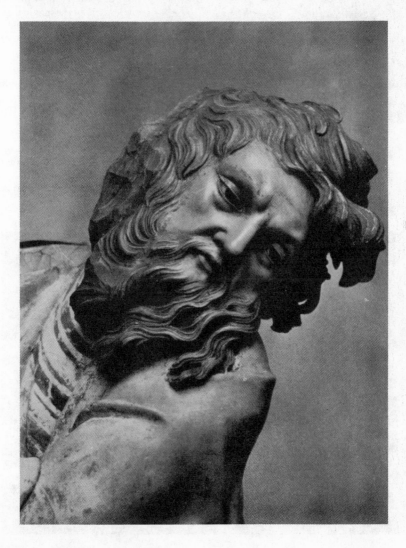

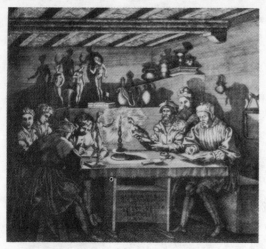

70. Baccio Bandinelli (1488–1560), The 'Academy' in the Artist's House. Engraving by Agostino Veneziano from Bandinelli's design, 1531. Bandinelli's thought was constantly engaged on furthering the prestige of his profession. He gave his modest school the magic name *accademia* and probably used this print for propaganda purposes.

71. Federigo Zuccari (1542/3–1609), Ceiling Fresco: 'Apotheosis of the Artist', 1598. Palazzo Zuccari, Rome. Zuccari, first president of the Accademia di S. Luca, intended to make the Academy heir to his house on the Pincian Hill. He decorated it with esoteric allegories of his credo as an artist.

CHAPTER IX

MISERS AND WASTRELS

MOST early biographers were greatly interested in the way artists spent their money. The reports they left abound with talk of squanderers while niggards are rarely, and misers hardly ever, mentioned—a fact which will probably cause little surprise since artists are usually assumed to be born spendthrifts. This is an old belief; we find it like a *leitmotif* running through many of the Florentine *novelle* of the fourteenth and fifteenth centuries and a little later north of the Alps too. Thus in one of the burlesque stories published in 1555 by the German *Meistersinger* Jörg Wickram, the author talks about a shoemaker and his two sons and relates how the elder, an unassuming lad, followed his father's trade while

. . . the younger was a painter and, as is the way with painters, he was reckless, strange, and extravagant. He squandered his shillings before he earned his pennies, and it often happened that he pawned his tools and mortgaged his workshop in order to have money for his boozing.[1]

1 Misers

Nowhere in the whole literature about artists have we found a similar generalization with regard to parsimony. A thrifty, much less a miserly, artist did not fit the image of the urbane man of genius: Vasari and the seventeenth century biographers favoured conformity, but conformity with the upper-class concept of gentlemanly prodigality rather than with the bourgeois ideal of tight-fisted husbandry. When they discuss miserliness in artists, they usually associate it with some weakness of character, while a squanderer may appear as a man of blameless character. As a rule, misers in these works are depicted as insecure people, frightened of an uncertain future because they lack confidence in their own ability. Antonio Correggio (*c.* 1489/94–1534), one of the great geniuses of the Renaissance, is described by Vasari as

. . . a person who had no self-confidence nor did he believe that he was good at his art when he compared his shortcomings with the perfection to which he aspired. He was contented with little, and he lived like an excellent Christian.

Burdened with family cares Antonio was always anxious to save money and in
in this way he became as miserly as could be.[2]

In the complete absence of any letter by or about Correggio one has to
scan the few known data of his life to check on Vasari; it seems, at least
to us, that the facts do not contradict him. Correggio was about twenty-
five years old when he married a poor girl of sixteen whose dowry
amounted to no more than 257 ducats. She bore him four children and
left him a widower after ten years of married life. In 1523 the painter
moved from his birthplace, Correggio, to Parma where he had also
worked before and where he was to create in the cathedral his most
famous frescoes. What little is known about the payments he received
for his work indicates that his income was modest, and so were the few
investments he was able to make. In 1530 he acquired a smallholding
for 195 *scudi* and ten *soldi*, and three years later he bought some land at
Correggio.

He died when he was about forty. The story went that he had set out
from Parma on foot, intending to carry the heavy weight of sixty *scudi* in
pennies all the way to Correggio. Overcome by heat and fatigue he
drank cold water. This threw him into a violent fever from which he did
not recover. It is easy to discount this story as a legend, but it is unjust to
charge Vasari with deliberately spreading absurd falsehoods. Tales of
Correggio's wretched life and obscure death lived on for generations.
We may quote a letter purportedly written in 1580 by Annibale Carracci
from Parma to his cousin Lodovico in Bologna, but now generally
believed to have been Malvasia's invention.[3] In our context the author-
ship is of less importance than the local tradition echoed in the following
passage: 'It drives me mad and I could weep when I think about the
unhappiness of poor Antonio. So great a man . . . to be lost in this spot
where he was not recognized or lifted to the stars, and there to die so
miserably!'

Other reputedly parsimonious artists husbanded their resources with
better results. Misers like the Dutch painter Marten van Heemskerck,
the Fleming Denys Calvaert, and the Italian *bamboccciante* Michelangelo
Cerquozzi, though impecunious in their youth, lived in easy circum-
stances in their later years.

Heemskerck (1498–1574) was prodigiously industrious and his income
must have been considerable. Yet the well-informed van Mander tells
us that the painter 'suffered from the fear that he might come to
poverty in his old age, and for that reason he always carried gold
crowns hidden in his clothing until his death. He was by nature thrifty
and niggardly.' Heemskerck also had the reputation of having been
'faint-hearted and so easily frightened that, when the militia held a

parade, he climbed into the upper part of the tower—so afraid was he of their shooting'.[4]

Calvaert (1540–1619) left Antwerp for Italy as a very young man. He settled in Bologna, where he enjoyed a good name both as a teacher and a painter. Malvasia's diffuse report of Calvaert's *Life* is largely based on direct information obtained from one of the latter's pupils. It is summarized by Baldinucci, whom we may therefore trust when he talks about Calvaert's extreme shyness, adding the following character sketch:

... Calvaert left a large sum of money which he had earned as much through toiling at his art as from his exaggerated parsimony—if we do not wish to call it sordid miserliness—which he always practised both in his way of dressing and living. All these things, added to a melancholic nature and an inclination to suspicion and anger, though of the kind that quickly flares up and as rapidly dies down, deprived him of a great part of that lustre to which his virtue entitled him.[5]

Cerquozzi (1602–60), a Roman painter who never left his birthplace, began his career as a specialist in still-lifes and particularly in battle-scenes, for which he was nicknamed Michelangelo *delle battaglie*. Under the influence of Pieter van Laer, who came to Rome in 1625, he became one of the foremost representatives of that group of 'realist' painters who were derided as *bamboccianti* by their 'classical' opponents. Salvator Rosa said of them in one of his satirical poems (*Satire* iii) that they could think of no other *concetto* than beggars and paupers, blackguards, rogues, and pickpockets (Fig. 63). But these 'sordid and plebeian' scenes were immensely successful with the dilettanti who seemed 'only to love in painting what they abhorred in life'. Cerquozzi, after having spent much of his youth in poverty and ill-health in quarters which he shared with some Dutch painters, later became a wealthy man and could buy himself a good house on the Pincio.

His biographers, who sided of course with the academicians, were non-plussed by Cerquozzi's success. Passeri, the admirer of the grand manner, pounced eagerly on the manias, true or false, of this recalcitrant artist. 'In the beginning,' Passeri writes,

... Cerquozzi was content with keeping his prices low in order to attract the dilettanti, and so he made a name among art-lovers. By taking small sums from many clients he managed to earn quite a lot, and when he found that he had some money to spare, his mind grew so confused that his behaviour became ridiculous. In the past he had suffered great want; now seeing himself with a few hundred *scudi* in pocket, he did not know how to use them. He was attracted by the sight of these accumulated coins, and seemed to feel the warmth of this cash which was so handy for satisfying his every fancy. But he guarded it jealously, fearing it might be taken from him, and was robbed of sleep for many night by this fear. During the day his work suffered as he

would fret with despair and seek to hide the money in various corners of the house, where nobody might suspect that he kept it. He buried it beneath the floor of his room, and then, dissatisfied, he would dig it up again and stuff it into the cavity of one of those heads, cast in plaster after the antique, which painters usually keep for study, closing the hole with plaster for greater safety. But fearful that, through some accident, it might fall and break, thus disclosing the hidden treasure, he would take it out again, and be reduced once more to the torments of his mania.

This kind of tale may have been pure studio gossip, but

... the meanness of his life became proverbial, and when people wanted to tease someone they would say: 'You are more stingy than Michelangelo' [Cerquozzi] because he spent very little on himself, abstaining from every form of entertainment and pastime in order not to waste money on such ephemera. Although avaricious, he always dressed decently, but with the moderation which befitted a modest estate.[6]

Cerquozzi remained unmarried, because, Passeri explains, 'he preferred to endure an incommodious life than put up with the company of a wife whose continuous expenses frightened him'. The writer also does not fail to mention, doubtlessly because it confirmed his low opinion of the *bamboccianti* in general, that Cerquozzi's 'conversation was verbose and common as he used the most plebeian expressions pronounced in the worst of accents'.

This list of misers could probably be extended, though we doubt that further additions would change the general picture very greatly. But we do not want to end without mentioning one of the arch-niggards of all time, the English sculptor Joseph Nollekens (1737–1823). There is nothing pathetic about him: no fears of the future beset him, no bad experience of the past haunted him. Self-assured, business-like and always successful in his work, he simply could not bear to part with his money. 'He absolutely suffered his own uncle and aunt to sell their beds to support them in water-gruel; and it was not until the kind interference of Mr Saunders-Welch, who had ... seen them in Paris, that he allowed them thirty pounds a year.'[7]

'Old Nollekens was a miserably avaricious man,' said Thomas Banks, a fellow-sculptor,[8] and he might have added that Mrs Nollekens was in every way her husband's equal. They outshone each other in cunning devices to keep the household costs at a minimum. The combined dining-living room, which served also as the 'sitters' parlour', was a place of gloom and chill because of the elaborate ritual they had evolved to save candlelight and coal which to them 'were articles of great consideration', and 'as for soap,' their maid declared, 'the house had never known any for forty years'.[9] Though the walls were adorned with a

number of paintings, drawings, and engravings, and the mantelpiece was graced by 'several small models of Venus', his dwelling lacked the

... refinements which the sculptor could easily have afforded. For many years, two pieces of old green canvas were festooned at the lower parts of the windows for blinds.

The kitchen was paved with odd bits of stone, close to the dust hole, which was infested with rats; the drains had long been choked up; and the windows were glazed with glass of a smoky greenish hue, having all the cracked panes carefully puttied. The shelves contained only a bare change of dishes and plates, knives and forks just enough, and those odd ones.[10]

In his avidity to waste nothing Nollekens was not above filching a nutmeg or two from the punch table at the Royal Academy Club, or taking 'good care to put a French roll into his pocket' after a substantial meal at an inn.[11] At his death at the age of eighty-six Nollekens' ward-robe was found to contain, apart from his hat, sword and bag, and an old court coat which he had worn at his wedding, only 'two shirts, two pairs of stockings, one table cloth, three sheets, and two pillow cases' together with a few 'other rags'.[12] In his will he left the income of no less than twelve leasehold houses and two ground rents as well as some annuities and about eight thousand pounds in cash to be distributed among his friends and studio hands. His valuable collection of works of art was to be put up for auction.

J. T. Smith, the author of Nollekens' *Life*, who had for years lived in the joyful anticipation of a fat legacy, was shattered to find that a mere hundred pounds was all that was willed to him. The many venomous attacks in his book, published five years after the sculptor's death, were his revenge for this disappointment. But he had to concede that Nolle-kens had occasionally been generous in helping a needy fellow-artist; that he had liberally bought, not only antiques, but also the works and engravings of contemporary artists, and that he was not without some endearing traits. He

... had no idea whatever of making himself noticed by singularities. His actions were all of the simplest nature; and he cared not what he said or did before anyone, however high might be their station in life. He so shocked the whole of a large party one night at Lady Beechey's, that several gentlemen complained of his conduct, to which Sir William could only reply, 'Why, it is Nollekens, the Sculptor!'[13]

2 *Hans Holbein—a Squanderer?*
It would be easy to top these heterogeneous examples of misers with a long list of wastrels. Many of the artists who have been discussed in other chapters could find a place here; many whose profligacy is attested

by the older writers, but forgotten or doubted by more recent ones, could be added to the well-known and often quoted spendthrifts.

At least one of the disputed squanderers should be mentioned: Hans Holbein the Younger (1497–1543), the exact coeval of Correggio. There are few reliable contemporary reports about Holbein, and the biographies of him were all written long after his death. The story of Holbein's dissipated life was first told by Charles Patin in the Basel edition of Erasmus's *Praise of Folly* of 1676. It has been claimed, rightly or wrongly, that this story was based solely on the jesting inscription 'Holbein' above one of the latter's famous pen and ink illustrations for Erasmus's work. The illustration in question shows a fat fellow drinking wine and making love to a woman (Fig. 65). But there are some facts which may support Patin's claim. We know for certain that his debts forced the painter repeatedly to ask for advances on payments. Dr Ludwig Iselin, the grandson of Holbein's Swiss benefactor Amerbach, recorded how on his brief return from England in 1538, Holbein arrived in Basel 'dressed in silks and velvets—he who formerly could only afford to buy his wine by the glass'.[14] We also know that, despite his eminent position at Henry VIII's court, he never accumulated any money. He certainly died poor. All he had to dispose of in his will were a horse and his 'goodes' from the sale of which some small debts were to be paid: 'fyrst to Mr Anthony, the Kynges servaunte of Grenwiche, ye sume of ten poundes, thurtene shyllynges and sewyne pence sterlinge' and secondly 'unto Mr John of Anwarpe [Antwerp], goldsmythe, sexe poundes sterling'; for the keep of two illegitimate children he could leave no more than seven shillings and sixpence a month while they were 'at nurse'.[15]

The fact that Holbein fathered two children in London although he had a wife and four children in Basel is usually passed over by his modern biographers with discreet silence. Nor do they like to admit that for a number of years, until he left for England in the autumn of 1526, Holbein had had close connections with Magdalena Offenburg, a beautiful woman of noble family but easy virtue, which brought her into conflict with the law. He used her as a model for one or two of the series of Basel costume drawings, probably for the Virgin in the altarpieces at Solothurn (1522) and Darmstadt (1526) and certainly for the Basel *Venus* (before 1526, Fig. 64) and the Basel *Laïs of Corinth* (1526), the notorius Greek courtesan.[16]

Magdalena's record suggests that her association with Holbein may not have been purely platonic. He had married in 1519, but with Magdalena Offenburg in the background and with his constant absence from Basel we may doubt the strength of the conjugal bond. Nor does it seem to show affection on his wife's side that she sold her portrait with

two of her children (now in the Basel Museum) even before her husband had died.

Woltmann, Holbein's first modern biographer, brushed aside the question of the painter's dissolute life by remarking 'there exists that which refutes such stories more certainly and distinctly than any authentic attestations of morality, namely, the works of the master'.[17] The writer's Victorian naïvety is disarming. If anything the few facts we have been able to assemble favour the old tradition.

3 *The Pattern of Prodigality in the Low Countries*

More interesting than disconnected cases of squanderers, not perhaps from the psychological, but from a historical or sociological, point of view, are certain coherent patterns of profligacy which emerged towards the end of the sixteenth and especially during the seventeenth century. They disclose the habits of whole groups of artists who tossed around their money on an unprecedented scale. One such pattern is particularly noticeable in the Low Countries, another in Italy, though naturally, representatives of both also turned up elsewhere.

Frans Hals (1580[or 85]–1666) is probably the first who comes to mind when one thinks of prodigal Netherlandish artists—not so much, we suspect, because so many people are especially familiar with the circumstances of his life, but because his rendering of inveterate tipplers somehow appears to make the tradition of his own tippling and consequent destitution plausible (Fig. 68). In fact his whole long life was one endless and hopeless struggle with creditors. Despite his numerous and important commissions, he never had money. He was in arrears with the membership fee for his guild—a sum of four guilders. He owed money to his shoemaker, his carpenter, his baker, and his canvas merchant. His family life was chaotic. Twice he failed to pay the agreed allowance for the offspring of his first marriage. Of his ten children by his second wife one daughter caused so much trouble that her mother applied to the mayor of Haarlem for the girl 'to be brought into the workhouse of this city, in the hope of her improvement'.[18] Unable to defray the boarding expenses for an imbecile son who could not be kept at home, Hals had to turn to the municipality for help. During the last four years of his life he had to be supported by public funds. In the winter of 1663 he could not even afford to buy fuel so that the city supplied him with three cartloads of peat. Yet somehow or other Hals always seems to have managed to have enough money for a spree. Houbraken is not a source favoured by art historians, but he probably had the following report on good authority:

Although Frans Hals was usually in his cups every night, his pupils held him in great esteem. The older ones among them kept watch over him in turns and

fetched him from the tavern, particularly when it was dark and late, so that he should not fall into the water or come to harm in any other way. They used to see him home, take off his shoes and socks, and help him into bed.[19]

Of other artists born in the sixteenth but living well into the seventeenth century we may quote the Antwerp master Abraham Janssens (1573/4–1632), a highly successful painter of religious, allegorical, mythological, and historical subjects until the rising fame of Rubens overshadowed his own. He was held up by Sandrart as a 'wretched example of indolence and vice'.

Having thoughtlessly espoused a beautiful maiden, he gave himself up to leisure and, having rashly filled his house with children, he became over-whelmed by melancholic thoughts so that he had little time for poetical inspiration or fruitful meditation. This caused him to give up more and more of his plans and to become desultory in his studies. He almost hurried away from his best work in order to stroll listlessly about the town to see whether any new succulent foreign fish or Italian delicacies had arrived. He prepared these foods himself in an excellent manner, and consumed them with his boon companions over a good drink.[20]

Hercules Seghers (1589/90–1638?), one of the greatest Dutch etchers, was destitute when he was in his early forties. A house he had bought in 1619 for some four thousand guilders had to be sold in 1631 for about half the amount. His dealings in pictures could not restore his ruined finances, caused, it has lately been suggested, by his costly experiments in etching and his expensive printing presses.[21] Earlier writers believed him to have been an embittered drunkard and tradition has it that 'when he returned home one night more drunk than usual, he fell down the stairs and died'.[22]

The most light-hearted of all the incorrigible seventeenth century spendthrifts was Adriaen Brouwer (1605/6–1638). By all accounts he was more than a mere spectator at the riotous scenes which he loved to depict (Fig. 66). Whether true or not, Houbraken's description of the scene after the conclusion of Brouwer's first sale of a picture gives a good idea of the memory he left behind. Much to his surprise, the story goes, Brouwer received the sum of one hundred ducats,

. . . but he was not accustomed to having so much money and did not know what to do with it. Overjoyed, he threw it on his bed and rolled in it, then collected the glittering silver pieces and went off, nobody knew where. After nine days he returned, late in the evening, singing and whistling. When asked whether he still had his money, he replied that he had got rid of the encum-brance. That is how he continued to live, unable to refrain from feasting, drinking and frolicking, whenever he had money.[23]

By and large, the reliable Sandrart confirms the studio tales about Brouwer's riotous life:

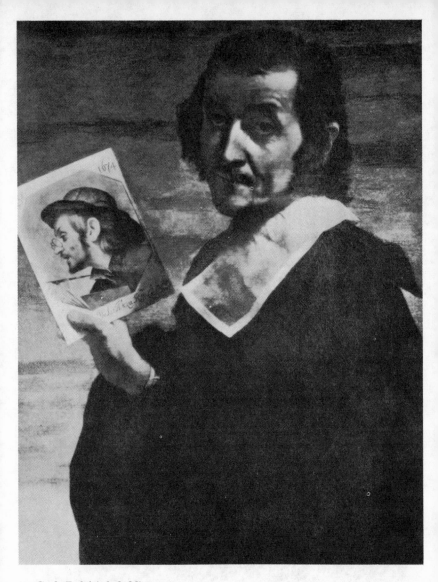

72. Carlo Dolci (1616–86),
Double Self-Portrait, 1674. Uffizi, Florence.
This portrait is a revealing pictorial document
of the dichotomy in the life of a seventeenth-century
gentleman-artist. Dolci represented himself both as
a nobly attired thinker and as a toiling craftsman.

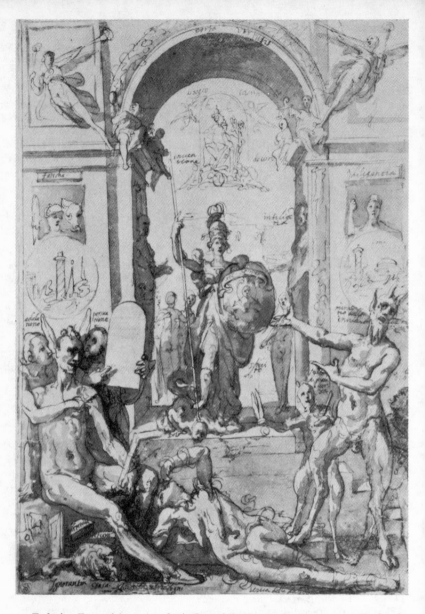

73. Federigo Zuccari (1542/3–1609), *Porta della Virtù*, 1581. Preparatory Design for
a lost Painting. Städelsches Kunstinstitut, Frankfurt.
Zuccari's allegorical painting was his scathing answer to the severe critics of
one of his pictures. He caused a scandal, for the offended party is believed to have
been represented in the guise of Ignorance and Envy.

His works were frequently sold by weight for ready cash, however excellent and valuable they may have been, and though he worked much, it was not he, but mostly others after him who reaped the benefit, because he always carried on in such a way that neither his person, nor his house, nor his purse were furnished with the barest necessities. He jibed and laughed at himself for being able to dispose of all his means so quickly and so neatly. So bad was his estate that after his death he was given a miserable pauper's funeral in a cemetery. But later, on the representation of the best connoisseurs in the profession, his body was carried with great solemnity into the church, accompanied by the most noble gentlemen of Antwerp, both clerics and laymen, and a wonderful epitaph was engraved on his tombstone.[24]

Brouwer's contemporaries Emanuel de Witte (Chapter VI, p. 144), Jan Lievens and Jan Miense Molenaer seem to have led similar lives. Lievens (1607–74), famous as a painter and engraver, the friend of Rembrandt, Rubens and van Dyck, was constantly in trouble over money. Contracts between him and his clients were repeatedly broken and taken to court by one side or the other. A court case involving one of his sons gives an idea of Lievens' disorderly household. The youth was cursing, swearing, drinking all day; he was disobedient to his parents and had made promises of marriage to a minor whom he visited day and night. Lievens appealed to the court for help. The profligate should either be made to mend his ways or be imprisoned until the father was able to send him abroad. In his last years Lievens' finances were such that his children, fearing to inherit nothing but debts after their father's death, appealed for the right to refuse the inheritance.[25]

Molenaer (1610–68), married to the well-known painter Judith Leyster, the daughter of a bankrupt, also appears in a great many court cases for a variety of offences. Among others he was twice convicted for using insulting language in brawls which sprang up when he was raffling his paintings. Although he came into an inheritance, and in spite of his increasing fame and earning-power which enabled him in his later years to buy three houses and some land, he could not pay his butcher's and grocery bills, and when his estate was wound up after his death, Molenaer was found to owe three years' interest on borrowed money.[26]

It is with a good deal of hesitation that we mention Vermeer van Delft in this context. The information about his life and work is scanty. None of the early biographers so much as mention him; his name was forgotten and did not re-emerge until after the middle of the nineteenth century. The few facts that have since been found are quickly told.

He lived from 1632 to 1675. In 1653, at the age of twenty-one, Vermeer married. In the same year he became a member of the St

Lukas guild in Delft, but it took him three years to pay off the entrance fee of five guilders.[27] Four years later the couple acknowledged a debt of two hundred guilders, and in the course of time they ran up a bread bill of no less than six hundred and seventeen guilders which Vermeer paid for with two pictures. Shortly before his death he borrowed one thousand guilders, presumably because his speculations in the art market had miscarried. His widow submitted a statement in which she declared herself unable to meet the demands of her creditors. Owing to the war with France, she said, her husband had earned very little in his last years and the works of art which he had bought had to be sold at a great loss.[28] She also claimed that she had to support eleven children.

Because so far only about forty pictures have been found which are with any degree of certainty by Vermeer's hand, he is supposed to have been a slow and painstaking worker. This, and the probability that he was a Catholic in a militantly Protestant country, has been suggested as the cause of his poverty. But these assumptions seem to be based on admiration of his art rather than on the few known facts. We have no means of judging how many pictures Vermeer really painted or how many of them have been lost. We do know, however, that during his lifetime he must have enjoyed a better than average reputation: for a cabinet piece with one figure he received three hundred guilders, a price equal to that paid for a work by Gerard Dou who was then one of the highest-paid painters. Also, the hardship story of the poor widow left destitute with eleven children is not without flaws. Three of her children were old enough at their father's death to be self-supporting; her mother was a woman of some means; and she herself was given an expensive funeral in 1688.[29] Considering the habits of artists at the time, Vermeer's heavy debts may indicate that he, like so many of his colleagues, preferred to spend his money on more pleasurable things than paying the baker's bill.

In contrast to our limited knowledge of Vermeer, rich documentation about Torrentius (Chapter II, p. 31) allows us to reconstruct his extraordinary life and conduct. Inordinately fond of high living, modish dress, constant revels, fine horses, and the daughters of good families, he was the paragon of a libertine. His miserable end has been reported in another place.

There is not much point in extending this list of drinkers and wastrels, but it should be said that the riotous life of these artists was not very different from that of their patrons. These ranged from farmers and tradesmen to powerful merchants—all of whom had profited from the colonization of the Americas and the Far East and some of whom had amassed large fortunes. Speculation on the wildly fluctuating stock-

market and gambling were rife in every class of the population, and money, so easily won and uncertainly held, was quickly spent on fast living and hard drinking.

Also, Northern Europeans have never been abstemious. Beer and wine had been consumed in great quantities for centuries;[30] now, a new, cheap and potent beverage was added in the form of alcohol distilled from grain and potatoes. Gin, whisky, and *schnapps* made their victorious and devastating entry.[31] 'What were vices are now considered virtues: 'tis now the fashion of our times, an honour: 'tis now come to pass . . . that he is (held) no Gentleman, a very milksop, a clown, of no bringing up, that will not drink, fit for no company . . .' wrote Robert Burton in 1621, and after citing some examples of debauchery and drunkenness from classical antiquity, he talks of the 'myriads in our days' who 'have drinking-schools and rendezvous; these *Centaurs* and *Lapithae* toss pots and bowls as so many balls; invent new tricks, as sausages, Anchovies, Tobacco, Caviare, pickled Oysters, Herrings . . .'[32]

Burton's medley of reprehensible pleasures contains one addiction which had grown alarmingly: the passion for tobacco had become second only to that for spirits. Introduced into Europe at the beginning of the sixteenth century, tobacco had first been used in the form of snuff and was long believed to be an unfailing remedy against all possible ailments and diseases. Tobacco-smoking had been started at the English Court in the 1580's; from there it had spread rapidly to Holland and the rest of Europe.[33] The tobacco trade gained enormously in importance, and, despite high import duties and repeated warnings against its dangers, tobacco smoking became one of the most widespread and most costly pleasures. No seventeenth century Dutch painting of merry-making would be complete without tobacco-pipes (Fig. 67).

Surely, there was nothing unusual in the way Dutch artists partici-pated in the general wave of fast living. There was, however, something exceptional in the way they had to struggle in order to eke out a liveli-hood. For some inexplicable reason the number of practising artists had for a long time been disproportionately large in the Low Countries. In order to enhance their prestige and increase their chances of getting commissions many went south and studied for a few years at the fountainhead of Rome. The following passage, written by a Frenchman in the eighteenth century, could have been printed with equal justifi-cation a hundred years earlier. The journey to Italy, he says,

. . . is more customary among the Dutch or Flemish painters than among Frenchmen. The former are convinced that it is requisite for their advance-ment. If they had painters leaning towards heroic art their assumption would be right; but since there are few among them devoted to history painting, most of them depicting *bambocciate*, merrymaking, flowers, fruits, landscapes,

and animals—a kind of art little practised by the Italians—this journey is, perhaps, not quite so essential for them as they believe.[34]

4 *Artists' Conviviality*

The Dutch Bentbrotherhood in Rome

The Italians looked with mixed feelings upon the *Fiamminghi* who came to live among them. Many of the northerners were Protestants and their religion excluded them from the most respected branch of an artist's activity—large-scale commissions for churches. Their small cabinet pieces, readily bought by collectors, were despised by the protagonists of the grand manner. In daily life those foreigners made themselves conspicuous in many ways. They usually flocked together in one district. In Rome they congregated in the small area between the Piazza del Popolo and the Piazza di Spagna. They were 'much given to merry-making' and often drunk, and kept the Roman courts busy with viola-tions of the law. Worst of all seemed their organized assemblies which struck the Italians as quite barbaric. The most notorious of the foreign artists' associations was the Dutch Bentbrotherhood, founded in 1623 to protect the rights and interests of the Netherlandish artists in Rome. The *Bentvueghels* or Bentbrothers acquired an especially bad name for their initiation rites, which were followed by veritable orgies. A Dutch traveller who was permitted to attend one such ceremony described the arrangements devised by the artists as more 'charming and witty' than the best theatre scene. Then he goes on:

In this show only one, called the *Veldpaap* [Field-pope], does the talking. He sits with great dignity on a high and lofty chair and explains at length to the Greenhorn—that is what the newly initiated is called—certain laws and rules regarding the study of painting and the inviolability of the institution of the Bent. Then the newcomer, after having declared with great humility that he is prepared to accept everything, receives the laurel crown from the Field-pope and immediately all Bentbrothers present raise a great cry: viva, viva, viva our new brother.[35]

By stressing the solemnity of the proceedings the visitor obviously tried to repair the disrepute into which those gatherings had fallen. He was well aware of the objections raised against the initiation rites and 'the very improper misuse of the word baptism'. His description was pub-lished in 1698. Shocked by the mock 'baptism' the clergy had forbidden the use of the term as far back as 1669, but the veto does not seem to have been observed too strictly.

The actual initiation rites were performed with a certain measure of secrecy. The banquet which followed was held in full view of the public.

It usually took place in a famous tavern next to an ancient tomb in the vicinity of S. Agnese fuori le Mura. According to Passeri each participant 'contributed his share, but the greatest expense fell to the new-comer. The celebration lasted fully twenty-four hours, during which they never left the table and had their wine brought there in whole barrels.'[36]

A French traveller, who visited Rome between 1713 and 1715, still talked of the Bent meetings where 'everyone follows the law of Bacchus: they dress up as Bacchantes and Druids, cloaked in sheets, and new members are submitted to somewhat crude rules; one also meets quite indecent behaviour there'.[37]

A typical Bentbrother's life is told by Houbraken in his note on Filip Roos (Rosa da Tivoli, 1655/7–1706). Though of German origin, Roos had grown up in Amsterdam. Aged about twenty he went to Rome and a few years later married a daughter of the Italian painter Giacinto Brandi (see p. 238). The couple lived in a

... ramshackle house at Tivoli near Rome, where he reared diverse large and small animals in order to paint them. For this reason his abode was called 'Noah's Ark' in the Bent. From there he often rode to Rome accompanied by his servant, but without money. Then he would quickly [on the way] paint a picture or two in this or that inn from where his servant had to carry it to Rome, still wet and fresh from the easel, in order to sell it at any price; he needed the money to ransom himself and his horse at the inn, because nobody was prepared to lend him any. Le Blon and others told me that his Bent-brothers knew immediately from far away whether he was in the money or not, because if he was not and saw one of his friends he would avoid him, but if he was, he would proudly approach him and never rest until together they had spent it all in the next tavern.[38]

Scandalized public opinion could do little about the conduct of individual *Fiamminghi*, but at least their organized revels could be stopped. In 1720 the Bentbrotherhood was dissolved by papal decree.

Festivities of Italian Renaissance Artists

The meetings and associations of Italian artists were also not always models of decorum, but the native brand caused, on the whole, less public offence. For one thing, excessive drinking is not a Mediterranean vice and drunkards were hardly known among Italian artists. Further, with few exceptions their gatherings were splendidly arranged affairs, admittance to which was considered a great honour. Thus the 'Company of the Cauldron', founded in Florence in the early sixteenth century, restricted its membership to twelve, each of whom could invite four guests to the gala dinners. One of the rules of these festive meetings

stipulated that everybody had to bring one dish of his own design. It seems that the participants outdid each other in fantastic and costly inventions. Vasari describes at great length Andrea del Sarto's contribution to one of the banquets. The centrepiece was an octagonal temple fashioned after the Baptistery but raised over columns. It stood on a pavement of multi-coloured jelly, simulating mosaics; the columns, which looked like porphyry, were sausages; the capitals and bases were cut from parmesan cheese, the cornice from sugar paste and the apse from marzipan. *Lasagne*, with peppercorns for notes and letters, made the book lying on a lectern carved from a piece of veal. Boiled thrushes with open beaks were the singers around the lectern. These and similar devices caused much admiration.

Even more sumptuous were the dinners given by the 'Company of the Trowel' (founded in 1512) with a membership of twenty-four, recruited from all the Florentine guilds and including the best artists and some of the worthiest citizens. Vasari mentions such aristocratic names as Rucellai, Ginori, and Medici. The chief festivity took place on the feast of St Andrew, the patron saint of the company. The banquets were distinguished by elaborate ceremonies; the guests appeared in whatever fancy dress they chose; exquisite food was served, often in peculiar disguise to set the assembly guessing. The whole abounded in ever new allegorical and symbolic allusions, and, Vasari added, 'what fun and games they had after dinner I shall leave to everyone's imagination rather than tell myself'.[39]

One's imagination is probably led in the right direction by reading Cellini's description of the festivities of a similar association established in 1523 in Rome. On one particular occasion members were asked by the president to bring their sweethearts. Cellini 'felt obliged to resign' the lady of his heart to his friend Bacchiacca who was 'deeply in love' with the same girl. But Cellini 'thought of a frolic to increase the mirth of the company'. He dressed a boy 'of about sixteen . . . who was a very genteel person with a fine complexion' in beautiful female clothes and adorned him with fine jewels. He succeeded in mystifying the assembly completely. The inevitable *dénouement* gave everybody cause for much banter and laughter.[40]

This kind of organized hilarity became unfashionable towards the middle of the century. Vasari himself still saw its decline. It was replaced by the convivial gatherings at the newly founded academies where patrons of the arts and men of the world mingled with artists and writers. These were often occasions for a display of lavish extravagance, but, since they greatly appealed to the Italian taste for a good show, they caused little or no public displeasure; they were a far cry from the riotous and sacrilegious meetings of the Bentbrothers.

5 Extravagance among the Italians

Lavishness Vindicated

A certain measure of prodigality was acceptable and even desirable in the eyes of the biographers because it was regarded as a sign of the high social standing of the profession. Andrea del Castagno (c. 1423–57), who died in debt,[41] was praised by Vasari for having lived decorously and spent generously on dressing well and appointing his house nobly.[42] Or, to give another example, Vasari says of Bramante that 'he always lived in the most splendid fashion doing honour to himself; and the money he earned in the position to which his distinguished life had led him was nothing compared to what he would have liked to spend'.[43]

Vasari looked upon such conduct in terms of his own ideal of academic eminence. Later biographers also had only approval for demonstrations of lavishness. Passeri preferred to see an artist dispose of his money in the ways of a *grand seigneur* rather than to save it and live like a craftsman. Writing of Guercino (1591–1666) he observes that when the painter

. . . left Cento [his birthplace] to establish himself in Bologna he was very coarse, indiscreet and uncivil, more apt to commit blunders than follow the ways of polite society. But becoming accustomed to city life he acquired courteous, easy and likeable manners, thus appearing less rough and uncouth.[44]

As time passed he accumulated a great deal of money with which he lived in splendour and comfort. He never placed it where it would earn him interest, but liked to keep the cash which he had amassed ready at hand for his immediate wants and needs. He said that he did not wish to go to bankers and counting houses begging for his own, and that his continued earnings were a larger capital than any interest which he could have extracted from investments.[45]

The Gambler Guido Reni

Passeri also did not regard the dissipations of Guido Reni (1575–1642) as inconsonant with the professional dignity of a gentleman-artist. According to him, this immensely gifted and successful Bolognese painter

. . . enjoyed a position of the highest reputation. There was no prince or potentate, even of foreign and distant lands, who did not wish for works by his hand. As he became aware of these advantages, for the sake of his reputation and that of the profession he fixed the price for each of his figures at a hundred *scudi* for a whole figure, fifty for a half-figure, and twenty-five for a single head.[46]

But Reni was an inveterate gambler. 'You paint well—but you also gamble well,' Cardinal Bentivoglio is reported to have said, to which Reni replied: 'Money means nothing to me for I have an inexhaustible goldmine in my brushes.' It became painfully clear, however, that even this mine was inadequate to meet Reni's gambling losses.

As his debts grew he raised the price of his works, reducing their size so that he was paid from four to five hundred *scudi* for figures only. He did not do this out of greed for gain, but was spurred by a great desire for glory and fame, for he considered painting to be worthy of honour and recognition above all other professions.[47]

Baldinucci, in his biography of the painter, sounds slightly more sceptical when he says that Guido 'habitually defended with great ability and even perhaps with some arrogance the reputation of art and artists'. But he, too, has no moral objections to Reni's excesses, only regret for the deterioration of his work when—following the well-informed Malvasia[48]—he describes how gambling and inordinate spending have driven the painter to turn his studio into a veritable picture factory:

In order to pay his debts he had to paint half-figures and heads straight on the canvas (*alla prima*) and to finish his most important works with little care. He was also obliged to borrow money at high interest from any kind of person, to beseech his friends for small sums and, in a manner of speaking, to sell himself and his liberty by accepting work which was paid by the hour.

When Guido began to get on in years . . . his spirit was crushed by the worrying thoughts of his debts, whilst his life was made weary by the need of working himself to the bone in order to obtain the necessities of life. Through his gambling he met people of low estate and quality so that he, who for so many years had held himself and his virtue in such esteem, was the first to debase himself. Under the pretext of helping him in his needs, these people advanced him loans which burdened him with further obligations and worries. They wheedled pictures and drawings out of him for the lowest prices and sold them for large sums, thus enriching themselves.

To these misfortunes was added one of no mean consideration, and this was the maltreatment which he suffered from a nephew of his, who sold whatever Reni had in his house, often sending out a thousand copies of his works before he had finished the original.[49]

Genoese Spendthrifts

It is striking, but hardly surprising to find in Genoa in the seventeenth century a number of artists who were anything but close-fisted. After a period of political and financial upheaval, Genoese merchants had grown immensely rich through the new overseas trade and international banking manipulations. From the second half of the sixteenth century on, they became builders on the grand scale and enthusiastic patrons of the arts. Genoese artists had no difficulty in earning money and less in spending it.

The painter Bartolomeo Gagliardo (1555–1620), called *Lo Spagnoletto* because of his long stay in Spain, profited from Genoa's overseas connections. Almost as famed for his skill as a road-builder as he was for his paintings and engravings, he went to the West Indies. The collapse of a

tunnel which he had attempted to dig there made him leave the place in a hurry. He returned secretly to his native Genoa, bringing with him 'a considerable sum of money'.

But he did not know how to moderate his expenditure, so that in a short time, what with parties, gambling, and other pleasures, he squandered all he had. When his friends saw him spending immoderately and throwing his money about, they often warned him to squander less and keep something for his old age when he would no longer be able to earn. But he was in the habit of answering that all he wanted was enough money to buy an earthenware urn in which to put his body and enough lime to burn it.[50]

Giovacchino Assereto (1600–49), long almost forgotten and only recently rediscovered, enjoyed the reputation of being one of the best painters of the town, if not of the time—an opinion which he himself fully shared.

He was of a happy character, robust mind, and a prompt worker. From the expression of his face he seemed of a melancholic and troubled disposition, but from experience one knew him to be totally different. He loved gaiety and company beyond measure, being himself sharp, facetious, and brilliant.[51]

Equally easy-going, though his serious, sometimes ecstatic paintings do not reveal it, was Giovanni Benedetto Castiglione (1610?–65), who 'always treated himself and his family in a splendid manner, and since he neither refrained from spending, nor cared for saving, little remained for his heirs when he died'.[52]

Lastly we may mention Anton Maria Maragliano (1664–1739), Genoa's most famous woodcarver, whose sculptures have an intense and deeply religious quality (Fig. 69).

Many of his works were sent as far as the two Americas, and he earned immense sums of money from them, so much indeed that had he been less prodigal, he could have put aside a large capital. But he used almost all his earnings to entertain his friends, who could do him no greater injury than to refuse his invitations to the splendid banquets which were always held in the most renowned taverns. Thither he would daily conduct a goodly number of his friends, and, besides the heavy expense, he wasted a great deal of time there. But in spite of this he never committed excesses of intemperance, as he was, on the contrary, very frugal in eating and even more in drinking. He lent vast sums of money and often to persons who, abusing his courteous liberality, never gave it back to him.[53]

6 *Spanish, German, and French Wastrels*

It is surely more than a coincidence that some of the non-Italian inveterate wasters had been living in Italy. Naturally, not only their style and their views on art but also their mode of life was influenced by their close contact with Italian artists. When El Greco (1541–1614)

came to Venice as a youth he saw the old Titian, his first teacher, in all his wealth and glory; in his early manhood he witnessed the magnificent ways of some of the famous artists in Rome; after he had settled in Spain he himself led a life as luxurious as any of theirs. Jusepe Martínez wrote in the middle of the seventeenth century that 'he earned many ducats, but wasted them in ostentatious living; he even kept paid musicians in his house so that he might enjoy every pleasure while he ate',[54] and Pacheco observed that 'he was extraordinary in all things, and as extravagant in his paintings as in his ways'.[55]

El Greco had come to Toledo in about 1576. A great reputation had preceded him, and he himself held no mean opinion of his gifts. The prices he felt entitled to ask were high by Spanish standards and several of his patrons litigated against his charges. After one such case which arose over payments for his *Burial of Count Orgaz* and which he lost, El Greco exclaimed: 'As surely as the rate of payment is inferior to the value of my sublime work, so will my name go down to posterity as one of the greatest geniuses of Spanish painting.'[56]

El Greco's fame declined even during his lifetime. Whether, as one source maintains, he was the victim of intrigues; whether it was the wars with the Netherlands and the devastating results of the expulsion of the Jews and *Moriscos* which ruined Toledo; whether it was physical disability which prevented him from work, or simply a change of taste which made patrons recoil from his intensely ecstatic late style, we do not know. But it seems that the painter spent the last years of his life in relative seclusion and obscurity.

When the Spanish writer Francisco Pacheco visited El Greco in Toledo in 1611 the artist, then in his seventieth year, was too ill to take him around, but he amazed his visitor with his mental and conversational powers, even shocked him by his unbroken rebellious spirit. El Greco's son could show Pacheco a great many of his father's paintings, but with the exception of a very few pieces of furniture, a good library, and a fairly comfortable kitchen, the twenty-four rooms of El Greco's house were probably almost empty. An inventory, taken after the master's death, records no more than the barest necessities in that large establishment.[57]

That the influence of Italian life on young foreign artists was known and feared is shown by a remark in the autobiography of the architect Elias Holl (1573–1646), the son of an old, and respected Augsburg family of builders and master-masons. Holl relates that he began his career with working for Jacob Fugger—'a strange man' who

... was in his cups every day even at his midday meal. He kept open house, liked to have guests daily who were all hard drinkers. He wanted to send me to Italy with his son, young master Joerg, but my father was advised against

it for very good reasons. I myself would have gone with great delight, but it was not to be. I might, perchance, have learned little to my advantage and might have become depraved; I was then seventeen years old.[58]

Obviously, in Germany the debaucheries of a patrician were so utterly removed from the sphere of a commoner that they could not conceivably corrupt a young artisan. But the example set by Italian artists was a different matter.

In 1590, the year young Elias Holl had hoped to go to Italy, Hans Rottenhammer (1564–1625), Germany's favourite early Baroque painter, was living in Rome, and the impressions he gained there doubtlessly influenced his future conduct. Rottenhammer, a native of Munich, spent the last twenty years of his life in Augsburg, earning

. . . large sums of money from emperors, kings, and other great patrons with his marvellous works in oil and *al fresco*; yet all his earnings did not help him much, he spent it all quickly and lived forever in great straits. His friends reported as a truth that he had earned close to eighty thousand guilders, but spent nearly eighty-two thousand, always wasting more than gaining; so much so that after his demise his friends clubbed together to pay for his last resting-place. Other regrettable affairs which might be told of this excellent man we shall pass over in silence so as not to darken his brilliant fame in the arts through the irregularities of his life.[59]

Sandrart's tactful silence hides nothing worse than the painter's inordinate fondness for drink, a Teutonic passion which he shared with many compatriots.

Two Frenchmen, Gaspar Dughet and Jean-Nicolas Servandoni, may round off this list of squanderers. Dughet (1613–75), son of a French father and an Italian mother, the brother-in-law of Nicolas Poussin whose name he adopted, was an immensely popular landscape painter.

He was well rewarded for his works, and earned so much that those who had any knowledge of his affairs held the opinion that at his death he could have left at least twenty-five thousand *scudi*. But such was his fondness for having a gay time with his friends, and so great his urge to go hunting, for the delight of which he always kept many dogs, that rarely, if ever, did the earning of one commission stretch to mingle with that of the next.[60]

Dughet was a Roman born and bred and completely accepted the mode of life of Italian artists. Servandoni (1695–1766), by contrast, although born in Florence and educated in the school of the painter Pannini and the architect G. I. Rossi, belonged to a type of eighteenth century master who was at home nowhere and everywhere. Truly cosmopolitan, polished in their manners, usually great extroverts and fond of luxury, these artists aped the demeanour of the aristocracy. Servandoni worked in Paris, London, Dresden, Brussels, Vienna, and Stuttgart. He was a

choleric man and a great fighter—and the embodiment of a monumental waster to boot. 'This Servandoni', wrote Diderot in the *Salon* of 1765,

. . . is a man whom all the gold of Peru would not enrich, he is the Panurge of Rabelais who had fifteen thousand ways of accumulating wealth and thirty thousand of spending it. A great technician, great architect, good painter, wonderful decorator, there isn't one of his talents which doesn't bring him in enormous sums, yet he owns nothing and never will. The King, the Nation, the Public have renounced the hope of saving him from poverty; one prefers the debts he has to those which he will incur.[61]

We have made the point in this chapter that thriftless artists conformed, to a large extent, with the cultural climate in which they lived. The contrast between the pleasures sought by Dutch and Italian artists surely supports this view. If we are correct, can we bury the old legend according to which cheerful disregard of the value of money is one of the characteristics of the artistic temperament?[62] The question is not easily answered since it is difficult to decide whether the 'artistic temperament' is wholly or only partly a projection of the public's imagination.

Though the reader may have no quarrel with our main point, we have to emphasize that, in retrospect, the prodigality of Frans Hals, of Brouwer or of the Bentbrothers ties up with the behaviour of their squandering forerunners and successors: all of these cases helped to consolidate the image of the Bohemian artist. But even the most flagrant offence against the bourgeois approach to money did not diminish the standing of the artists as artists. This was not only the point of view of the biographers who, after all, would not have written about artists without having been deeply committed—it also applied to the average citizen. Frans Hals, for example, was an honoured member of the community, in spite of his drunkenness, his unruly life and his Bohemian household. It cannot be doubted that even in such a bourgeois society as Holland, objections of a moral nature were waived in the face of artistic genius.

CHAPTER X

ACADEMIC AMBITIONS AND
PROFESSIONAL JEALOUSIES

1 *Professional Pride*

The prodigal life of Italian and Italianate artists of the seventeenth century cannot be dissociated from the founding of the academies of art. To become a member of an academy was everybody's ambition, not only for reasons of professional prestige, but also because the glamour of an academic title was considered a passport to the higher spheres of society.

Professional pride, of course, animated artists at many periods. Anecdotes and *bon mots*, transmitted by the sources, are eloquent enough. Apelles is said to have reprimanded a shoemaker with the classic rejoinder: 'Every jack to his trade!'[1] A Florentine collection of stories and diary notes, attributed to Politian, tells us that Donatello refused to obey repeated commands to appear before the Patriarch of Florence with the words: 'Tell him I am as much a patriarch in my work as he is in his',[2] a retort as expressive and cutting as that which Raphael—if his friend Baldassare Castiglione is right—sprang on two cardinals who had criticized the red faces of SS. Peter and Paul in one of the artist's works. '*Signori*', Raphael supposedly answered, 'there is nothing miraculous about this. After long consideration I have painted them thus, because I believe that SS. Peter and Paul must be as red in heaven as you see them here having blushed at seeing their church governed by men like you.'[3] No less pungent was the manner in which 'in the midst of a numerous company' the French academician Robert Le Lorrain (1666–1743) reputedly snubbed a tactless *abbé*: '*Monsieur l'abbé*, one needs only a little collar and a moment's nepotism to make a man like you, but it takes over thirty years to form a man like me—and then one does not always succeed.'[4] Such legends show that the public was well aware of the high opinion artists had of their calling and that they were up in arms if the recognition which they felt their due was not forthcoming.

2 *Baccio Bandinelli's Pretensions*

Quite a few artists believed that the way to professional and social recognition was that of Hogarth's industrious apprentice: the judicious

229

accumulation of property by assiduous work, and a code of behaviour which met the sternest demands of a bourgeois ideology. What Michelangelo achieved by virtue of the greatness of his art, others tried to accomplish by aspiring to the standards of the society in which they lived. Baccio Bandinelli (1488–1560), Michelangelo's unequal competitor, a great but conceited sculptor, illustrates this mentality just before the rise of the academies. Immensely ambitious and heartily detested by most of his colleagues, he prided himself in his memoirs[5] on having gained the public respect for which he was craving: more than one pope as well as Duke Cosimo de'Medici favoured him with their friendship and the Emperor Charles V himself held him in high esteem. His rapaciousness was proverbial, but he never wasted his earnings on high living. His sole interest was 'getting rich and buying property'[6] for the benefit of his descendants and the glory of his house. He boasted of being a 'Florentine noble', having convinced himself by circumstantial though shaky evidence that he was descended from 'the very ancient and very noble blood of the Bandinelli of Siena' and that, therefore, Pope Alexander III was among his ancestors.[7] His claim was publicly acknowledged when Charles V created him a Knight of the Order of St Jago,[8] an honour reserved for those of noble lineage. Naturally, he married a woman of gentle birth 'whose virtue and love were beyond description'.[9]

In his autobiography he explained to his heirs that he would leave them four houses and six holdings and, in addition, 'a fine and comfortable house at Prato in which the estate manager lives'. All deeds, patents, contracts and documents were carefully filed and among his possessions there were

... cattle, loans and other things as well as houses full of furniture, particularly that in Florence which is so well equipped that if you take into account the pictures and statues, the shell made of gold and precious stones given me as a present by Charles V, also the vessels of agate and amethysts, the objects of silver and other furnishings, you will find that the value of the whole would amount to more than five thousand ducats.[10]

The method by which he accumulated these riches is described in a letter sent by Baldassare Turini, head of the papal Chancery, to Cardinal Cibo on May 11, 1540, regarding the work on the papal tombs of Leo X and Clement VII in S. Maria sopra Minerva in Rome:

Cavaliere Bandinelli has succeeded in managing you all so well, *Signori*, that he has pocketed almost the whole of the money which there was for making the sepulchres. It is disgraceful to have promised him six hundred *scudi* for a story [relief] which one could have had made more beautifully than his for three hundred. He has also been promised three hundred *scudi* for a small story which could have been obtained for a hundred and fifty, and more

beautiful than his; and the figures of St Peter, St Paul, St John the Baptist, and St John the Evangelist, for which he gets four hundred *scudi* each, could have been obtained more beautifully than his for two hundred. As for the two Popes, he wants five hundred *scudi* for each, whilst one could have them made for three hundred, and more beautifully than what he will produce. My reverend Monsignor, if only your Eminence could have seen and see the avidity and the desire which he has to grab all this money and the affectation with which he supplies these figures and stories, be they beautiful or ugly, you would not believe it; and it was and will be a great shame if you, reverend Signori, should allow him to treat you in this way.[11]

Bandinelli had begun to dictate his memoirs in 1552; in 1560 he died. During those last eight years the ageing sculptor suffered much distress. His favourite son, Clemente, the offspring of a 'legitimate intemperance',[12] had died in 1554. In the same year, his arch-enemy Vasari had succeeded in ousting him from the work in the Palazzo Vecchio. Bandinelli felt rejected and even ridiculed by his fellow artists. In self-defence he attributed his setbacks not only to the machinations of his enemies and to overwork, infirmity, family worries, the distractions of public offices and constant unavoidable travelling, but chiefly to his passion for reading and writing which had taken too much of his time.[13] He boasted of his familiarity with classical literature, with Dante and Petrarch, and claimed to have composed no less than two hundred sonnets, eighteen lyrical poems, six *sestine* and two *trionfi*, pointing out that of his sonnets 'some dealt with sacred, some with moral subjects' since he found no delight in 'amorous ones'.[14] Significantly he added: 'Rather than to wield my chisel it would have been far more to my taste to immortalize my name by my pen, this being a truly congenial and liberal pursuit.'[15]

Undoubtedly, Bandinelli's reputation as an insufferable braggart was fully earned, but his greed, his pretence at nobility, and his ostentatious pride in his literary prowess, all combine to produce a clear pattern: he construed his world of hard cash and lofty aspirations as a bulwark against medieval ideas which still lingered on. In contrast to Leonardo and other convinced champions of the equality or even superiority of the visual arts to poetry, Bandinelli still smarted under traditional prejudices and at heart believed that sculpture did not equal the distinction of literary pursuits. Like his younger contemporary and compatriot, the painter Francesco Salviati (1510–63), whom it pleased, according to Vasari, 'to mix with men of learning and great persons, and who always hated plebeian craftsmen',[16] Bandinelli had to prove to himself as much as to others that he had broken the traditional bonds of his class. A noble birth, a noble marriage, noble friends, an irreproachable family life, austere comfort backed by considerable means, and intellectual

pretensions: this was his way to draw the demarcation line between plebeian craftsmen and socially acceptable artists.

One other important step remained to be taken; one could embrace the 'academic' life. Academies of art were still unknown, but Bandinelli thought of a remedy. He established a school in his workshop, first in Rome in about 1530 and again in Florence some years later—and gave these enterprises the highbrow title of '*accademia*'.[17] There was an aura of learning, of freedom and breadth of tuition, of philosophical endeavour and gentlemanly pursuit connected with the name. It satisfied Bandinelli's self-esteem and gave his profession the prestige for which he was longing. We can still savour something of the magical enchantment which the name must have conjured up at the time, particularly when we look at the publicity which Bandinelli regarded as opportune. Engravings made after his designs[18] show the academy in action: the stylish youths who draw and copy, the meditating or expostulating elders, are all devotion, concentration and discipline (Fig. 70).

3 Academies of Art in Florence and Rome

It cannot be denied that Bandinelli accurately sensed the spirit of the age. The sixteenth century has been called 'the century of academies', and the time was ripe for a proper Academy of Art. The academic movement had begun in the second half of the fifteenth century with the informal gatherings of Ficino's Platonic Academy in the Medici villa at Careggi near Florence.[19] Here philosophical discussions ranged over a wide field, but art and art theory hardly entered. It is well known that this first modern academy was the breeding-ground for the infinitely rich development of European academies. As early as the first half of the sixteenth century the original universality began to break up[20] and to be replaced by formalized institutions for the pursuit of specific studies and often dedicated to a narrowly defined programme.

We find historical logic in the fact that the earliest academy of art worthy of the name was founded in Florence and that its initiator and organizer was no other than Vasari, that versatile man of the world, to whom professional status and academic propriety had always been objectives of primary importance. Vasari knew exactly how to handle this affair and give it the right cachet: in 1563 he launched the *Accademia del Disegno* under the combined auspices of Duke Cosimo de'Medici and Michelangelo.[21]

In certain respects the old guilds were similar to our Trade Unions. Like the latter, they looked after the economic interests of their members and protected them against foreign competition. The new foundation, on the other hand, welcomed artists 'of any nationality' into its fold provided they were 'distinguished by their genius and judgment'.[22]

74. Roman Bust of Faustina, formerly in Mantegna's Collection, now Palazzo Ducale, Mantua.
This mediocre antique was highly treasured by Mantegna. When the aged painter believed himself to be penurious he made determined efforts to sell the piece at an excessively high price to his patroness, Isabella d'Este.

75. Giambologna's Tomb behind the Altar in the Memorial Chapel erected for himself, 1599. SS. Annunziata, Florence.
Bologna's business methods were peculiar and in his later years he complained of his great poverty. Yet he always lived in style and was able to defray the costs of a grand memorial chapel.

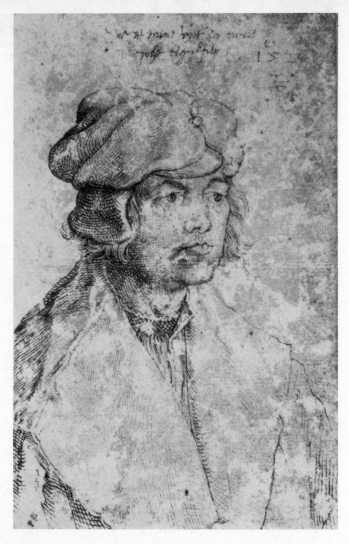

76. Albrecht Dürer (1471–1528),
Portrait, 1520. Drawing.
Städelsches Kunstinstitut, Frankfurt.
In order to finance his journey through the Netherlands
Dürer sold or bartered drawings, etchings and
woodcuts *en route*. The illustration, inscribed:
'This is my host at Antwerp Jobst Plankfelt 1520',
shows the innkeeper who presented him with a chunk of
white corals in return for this portrait.

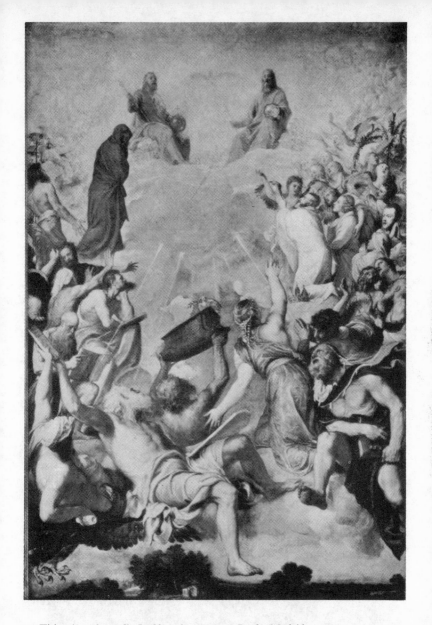

77. Titian (1477?–1576), *La Gloria*, begun 1551. Prado, Madrid.
No one doubts Titian's integrity as an artist. Yet he was an unsentimental
realist where his interests were concerned. In the *Gloria* he painted the portrait of
Vargas, Spanish envoy in Venice, but suggested to Philip II of Spain to have it
changed into whatever he pleased. The portrait was turned into the figure of Job,
the bearded man with upraised hands at the right.

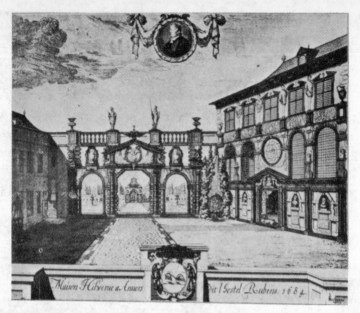

78. Rubens' Town House in Antwerp. Engraving of 1684 by Jacob Harrewyn after J. van Croes. Little of this mansion has survived, but engravings show it in its pristine condition. The grandeur of this italianate palace gives an idea of Rubens' princely style of living.

79. Peter Paul Rubens (1577–1640), Landscape with Castle Steen.
Detail. National Gallery, London. Five years before his death Rubens bought this large estate which also carried a title of nobility. Although not a social climber, the artist had thus joined the landed gentry.

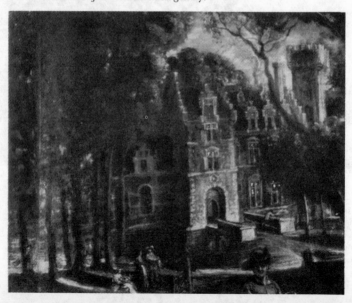

Artistic competence rather than corporate protection opened the doors to the Academy. Titian, Tintoretto, Palladio and other famous masters applied for membership. As we have mentioned elsewhere, a grand ducal decree of 1571 exempted all Florentine academicians from membership of the guilds. This was the thin end of the wedge driven officially between arts and crafts.

But whether Vasari was disappointed with the development of the Academy and lost interest, or the academicians quibbled too much over trivial points, or Florence ceded her primacy in matters of art slowly and inexorably to the papal city, it was in Rome that the next important step was taken with the foundation of the *Accademia di San Luca*.

Not that the aspirations of the Roman founder-members were entirely fulfilled; on the contrary, very little of the original programme survived for more than a few years. But just as the Italian academies of literature, music, science, law, sport, dance, and so on inspired other European countries to found similar establishments, so the *Accademia di San Luca* in Rome became the prototype of all European academies of art. France followed first with the *Académie Royale*, founded in 1648; Germany opened five academies between 1650 and 1750; while it was not until 1768 that England's Royal Academy was inaugurated. Nowhere did the academies entirely supplant the old system of workshop training, but they supplemented it to an ever-increasing degree. In Paris, for instance, no life classes were permitted outside the *Académie Royale*; in Germany, on the other hand, the guilds could, as late as 1756, prevent Anton Graf from Augsburg from painting because he had not served the prescribed term of apprenticeship.[23]

The Roman academy owed its foundation chiefly to the ambition and drive of Federigo Zuccari (1542/3–1609), who was elected its first president.[24] A prolific painter and draughtsman, versatile, much travelled, and an eloquent, not to say verbose, theorist, Zuccari immediately set the pace for a certain pomposity which distinguished many later academicians both in their work and in their manner of living. In his inaugural address on November 14, 1593, he urged artists to show 'goodness of heart, to have upright and civil manners and to be, above all, prudent in your actions and undertakings, reverential and obedient to your superiors, affable and courteous to your equals, benevolent and amiable to your inferiors.' And he exhorted them not to give way to 'extravagant, frenzied caprices and a dissolute, eccentric life'. The statutes proposed by Zuccari repeated *ad nauseam* that the academicians shall behave 'peacefully and quietly. They shall not complain or grumble, not sow discord or give rise to dissensions.'

To regulate conduct by statute may strike us as hypocritical. And, indeed, how different was reality in Rome in those years! But it still

remains a fact that these provisions set the official seal on the drive towards conformity advocated from many quarters since the mid-sixteenth century (see Chapter IV). For Zuccari the Academy was the legitimate body to vouch for the high mission of the artist and his calling.

Zuccari himself had made up his mind to further the prestige of the profession by a public-spirited personal contribution. On his journeys through Italy, France, Belgium, England and Spain he had amassed a considerable fortune, a large part of which he spent in buying extensive grounds on the Pincian Hill. In 1590, during one of his intermittent stays in Rome, he began building a house which seems to have been the talk of the town. The ambassador of Urbino wrote to his master, Duke Francesco Maria II:

Federigo Zuccari, as your Highness may perhaps have heard from others, has embarked on the realization of a poetical caprice which may well prove the ruin of his children. He has started building a small palace without rhyme or reason on a most extravagant site, which might have made a beautiful painting but will easily engulf whatever capital he has accumulated up to now, besides diverting him almost completely from his profession, as he does no work now except for some small things at home for the sake of earning some money.[25]

The ambassador was right: the enterprise far exceeded the painter's means. He did not see the top floors and roofs finished, though he moved with his family into the habitable parts of the dwelling-house, and in the studio or *casa grande* he entertained the members of the new academy under frescoed ceilings which illustrated his creed as an artist (Fig. 71). He had planned to turn the gracefully decorated ground floor into a home for poor artists and to make the Academy heir to his entire estate. Yet his sons inherited nothing but debts and had first to lease and later to sell the property.[26]

4 *Salvator Rosa's Academy*

In the seventeenth century private and public academies entered to an ever larger degree into the lives of artists and naturally exerted a growing influence on their art, their mode of thought and their behaviour. Even a marked individualist like Salvator Rosa (1615–73) did not eschew the prestige lent by the academies, but his life shows that room was left for the assertion of personal idiosyncrasies.

Born into a poor Neapolitan family, Rosa went to Rome at the age of twenty, a penniless youth, dressed in a *bizzarro* Spanish garb with the inevitable sword at his side. Quick-eyed and sharp-witted, he had begun to attract some attention when illness compelled him to return to Naples. In 1639 he was once again in Rome, this time resolved 'to satisfy a wish which he had always cherished: to have his name on everybody's lips. He

found a way of fulfilling this desire far beyond his expectation, while at the same time remaining more occupied with his art than ever.'[27] Rosa had formed an amateur theatrical group and his popular burlesque improvisations were an enormous success. But his lampoons against the mighty Bernini made it expedient for him to leave Rome in a hurry and to accept an invitation to Florence where he stayed for nine years, perhaps the happiest of his life. There he founded the 'Accademia dei Percossi', a meeting place for literati, artists and virtuosi, where those

... magnificent dinners, which were attended by the academicians and the cream of the nobility, were held at the expense of the academicians, helped by large contributions from Salvator himself. And I say advisedly, the effects were obvious; for we know from an account which he made at the time and from what he himself confessed ... that during the nine years which he spent in Florence he had earned with his brush up to the sum of nine thousand scudi, not counting the revenues received from the palace. When he left Florence he took only three hundred to Rome. The remainder, apart from what little he had needed for his own private use, had all been spent for the benefit of the Academy in those very gay and spirited meetings ... and also for the pleasure and entertainment of his friends whom at all times and in all places he held in such esteem and loved so well that he seemed unable to be parted from them, even if only for a short time.[28]

It was at the meetings of his Academy that Rosa and others read their poetry and delighted a select audience with the spirited performance of comedies.[29]

5 Titles and Honours

Titles and honours have always been status symbols. They were not readily accessible to artists while they belonged to the artisan class. When they became eligible for public awards their ascent from their old class was implicitly acknowledged. In the Quattrocento such distinctions were still rare, but in the sixteenth and seventeenth centuries artists expected these signs of recognition: they were the means of satisfying social aspirations. Needless to say, the craving for a handle to one's name had an adverse influence on many characters. Endless feuds ensued and the following story may show that no holds were barred in the struggle for advancement.

The protagonists were two friends, Orazio Borgianni (c. 1578–1616) and Gaspare Celio (1571–1640), lesser known but not unimportant contemporaries of the many famous painters active in Rome in the early seventeenth century. Borgianni was a headstrong and aggressive man. Educated in Sicily, he came to Rome in about 1604. There he met the Procurator of the Spanish Friars; a friendship sprang up between them and the Father ordered some paintings from the artist. These he liked so

much that he offered to approach the Spanish ambassador in Rome in order to try to obtain the title of *Cavaliere di Cristo di Portogallo* for his friend. Whereupon the grateful Borgianni sent his benefactor a few more pictures as a present. 'This came to the ears of Gaspare Celio, his companion, who did not want him to get this advancement; he began to discredit Borgianni with the Father Procurator by inferring that those pictures were not originals and not even good copies and that therefore he had been cheated by Orazio.' The Father allowed himself to be convinced by Celio, who now, in his turn, presented him with some pictures. 'In the meantime word had come to invest Borgianni with the insignia of his title as the Father had asked. But the latter having changed his mind as he had changed his affections, gave the title to Celio instead of to Borgianni.' Baglione reports that when Borgianni heard of this, his grief was such that his health became greatly impaired.[30]

Obviously, a title could boost an artist's renown to a degree not always consistent with his achievements. The blessings of an English knighthood are described by Houbraken in his *Life* of Sir Peter Lely (1618–80), the German-born successor to Sir Anthony van Dyck at the English Court.

Several people [Houbraken writes] who had visited Lely in England told me how nobly he lived; that he rose late in the morning and did not start work before 9 o'cl.; that he kept several servants and footmen, one of whom wrote down whose turn it was for a sitting, so that if a lady or whoever it may be did not turn up at the appointed hour, this person had to wait until the whole round had run its course before it was his or her turn again. He painted from 9 o'cl. in the morning until 4 in the afternoon at which hour he dined, rarely without guests. He always had the table laid for twelve, and his friends as well as foreigners who had dealings with him were invited to partake. Meanwhile there was music and singing in another room.[31]

The title held a brief not only for a gentlemanly way of life but also for lordly behaviour which 'the quality' would normally only take from a man of their own rank.

But court appointments accompanied by appropriate honours were available to relatively few. Election to membership of an academy, on the other hand, was open to many. After the foundation of the Royal Academy in London artists regarded the rank of R.A.—as Reynolds' pupil, Northcote, put it—as 'equal to a patent of nobility'. Academies also boasted of a whole hierarchy of impressive-sounding offices. The level-headed Hogarth was suspicious of presidents, directors, professors, *et cetera* and warned against the 'ridiculous imitation' in England 'of the foolish parade of the French Academy'.[32]

Indeed, in the battle of wits, endurance and cunning it was not always the most deserving artists who reached the top. While his hated rival

Lebrun directed the *Académie Royale* in Paris, Pierre Mignard (1612–95), a successful painter of society portraits, kept aloof and professed to be an opponent of academic tenets. This did not prevent him, however, from painting in a thoroughly academic manner, nor from becoming in 1664 a director of the *Accademia di S. Luca* in Rome. Moreover, when Colbert died in 1683 and was succeeded by Louvois, the latter 'strongly supported Mignard's plans' against his predecessor's favourite Lebrun. 'In the end the intrigues of Mignard and his partisans caused Lebrun's death from chagrin' and the road was open for Mignard to step into all the offices and revenues of his deceased antagonist.[33] A later sympathizer of Lebrun informs us that Mignard was 'devoured by his insatiable desire for wealth'. He only liked his art 'because he hoped that through it he would arrive at the highest ranks and gain the favours of Fortuna'.[34] As all-powerful Director of the Academy he had reached the summit of his ambition.

So long as British artists had no academy of their own they gladly took advantage of the liberality of the Italians and sought to gain admission to their famous institutions. When the young Scottish architect Robert Adam (1728–92) went to Italy in 1754 he was determined to make his way in the world by every conceivable means. He admitted that he was set on meeting 'the right people' and on 'piling up a stock of good acquaintance that may be of use to me hereafter'.[35] To this end he fitted himself out in Paris. He bought 'a compleat suit of Cut Velvet of two colours', silk stockings, red-heeled shoes, laces and stone buckles, a gold-handled sword, ribbons, a white beaver cap 'with gold lace round the edge of it & a gold Button atop'. Thus in the guise of a gentleman of means and leisure he proceeded in slow stages on his journey south-wards. In Genoa he bought some velvet suits for informal wear, 'quite plain' but 'very genteel'. Having spent carnival-time in Florence he finally arrived in Rome where he rented 'the very best apartment' and kept a carriage, a couple of servants and a cook. After a round of sight-seeing and social activities he settled down to do some serious work. Before leaving Rome in the spring of 1757 he decided to pull all available strings in order

. . . to be made Professor of Architecture, Painting & Sculpture in the Academy of St Luke in Rome, the Ceremony of which and the getting out of my Diploma will cost me twenty-five guineas at least. But it is extreamly honourable & showy in all books and things you may publish. I shall obtain this easily and grandly as I will sollicit my good friend the Cardinal Albani to ask it in person.

For good measure, he had himself, on his way north, elected a member of the Florentine Academy as well.

6 *Stylish Dress and Decorous Manners*

Robert Adam's studied attitude as a man of the world, his *distingué* manner of dressing, his grand style of living, his social contacts, his pose of infinite leisure—all these are the characteristic marks of a special type of artist which we may label as the *artifex academicus*. Conformity with the upper strata of society was the guiding-star of these artists' lives. Seventeenth and eighteenth century sources abound in descriptions of the modish garb and the affability of artists, and even a brief listing would be tediously repetitive. We shall only give a very few examples.

The Cavaliere d'Arpino (1568–1640), founder member of the *Accademia di S. Luca*, who 'liked to appear bizarre', was seen right up to the day of his last illness on horseback, always carrying a sword.[36] To own a good horse and to carry a sword were at the time important appurtenances of a gentleman. A rogue like Agostino Tassi always used to ride splendidly attired with his sword at his side and a golden chain across his chest.[37] Guido Reni dressed on all occasions like a nobleman.[38] The blind sculptor Giovanni Gonnelli (1603–64) 'was of handsome and jovial aspect, his manners being charming and his conversation both amusing and pleasant. He dressed nobly, and when going about in town always leant on the arm of a very polite servant.'[39] In contrast to his son-in-law Philip Roos, the Roman painter Giacinto Brandi (1623–91) lived 'with decorum and even in splendour, keeping servants and a carriage, always enjoying with his whole family the life of a *grand seigneur*'. He was possessed by a 'desire for money . . . not for the pleasure of keeping it locked in chests, but in order to spend it generously so as to hold a place in society perhaps grander than it behoves a painter to do'.[40]

Wherever we turn, we meet the type again and again with only slight variations. Letters describe Inigo Jones as a sprightly courtier, vain and conceited, acting before the King the rôle of the accomplished virtuoso with complete assurance.[41] A minor master like John Riley (1646–91) had the reputation of being a perfect gentleman, 'extremely courteous in his Behaviour, obliging in his Conversation, and prudent in all his Actions. He was a dutiful son, an affectionate Brother, a kind Master, and a faithful Friend.'[42]

All these traits we find epitomized in the greatest masters of this period and some character-sketches in the next chapter will round off the image of the accomplished gentleman-artist—the ideal to which these masters aspired and to which many of the public and all the biographers wholeheartedly responded. We have also seen (in Chapter IX) that the biographers regarded extravagant spending and a grand style of living as signs of social accomplishment. But where artists overstepped the bounds of reason, they were harshly dealt with. Roger de Piles tells us

of Francis Mieris that 'he lived without a care, without rule and without forethought, and he spent prodigiously. His bad conduct landed him in debts for which he was several times put into prison . . . This disorderly life brought about his death in the flower of his years in 1683.'[43]

7 *The Reverse of the Medal*

Taking a summary view, the effort of the artists to gain social recognition—a steady uphill struggle since Alberti's day—seemed to have been crowned by success. The academies provided a social and professional organization on a level with other learned institutions and the *artifex academicus* had travelled a long way on the road to social equality. But all was not yet well despite the artists' frantic efforts to conform. In fact, the artists themselves never ceased to be acutely aware of a resistance they were unable to break. Federigo Zuccari's almost hysterical admonitions were an expression not only of his doubt in the reliability of his colleagues but also symptomatic of deep-rooted insecurity. Some artists faced the situation without sentimentality. When Ferdinand I, Grand Duke of Tuscany, asked the Florentine painter Bernardino Poccetti (1548–1642) why he spent so much time with disreputable companions instead of leading a life in accordance with his circumstances and merits, Poccetti answered:

Serenissimo, the reason is that by keeping company with this kind of people it is I who am the *signore*; but were I to associate with some of the nobles, I wonder whether all that *virtù* which Your Highness so kindly concedes to me would suffice to make them regard me as more than a servant because not every nobleman values *virtù* as high as nobility.[44]

Whether or not this conversation took place as reported by Baldinucci, it does reflect an attitude of which even a man like Rubens took note although in his own case he may have been over-sensitive (Chapter IV, p. 97). Many members of the nobility were obviously willing to accept individual artists on equal terms even if they hesitated to extend this privilege to the profession as a whole.

In points of etiquette women have always been inveterate sticklers for convention, and they could snub the wives of artists cruelly. The wife of the Bolognese painter Alessandro Tiarini (1577–1668, member of and teacher at the famous *Accademia Clementina*), herself 'a good and rich citizen', believed she had the right of being considered a 'gentlewoman': 'that was the reason why, like the other ladies of that time, she always wanted to wear a mantle to the annoyance of those who ill suffered that the wife of a mere painter should be so forward'.[45] A hundred years or so later the architect Robert Adam wrote of Allan Ramsay's wife, then

living in Rome with her famous and successful husband: 'though she is of so good a family her being the wife to an Artist prevents her being admitted into any Company'.[46]

The stigma attached to artists in antiquity had never entirely disappeared; neither high society nor the middle classes (Chapter I, p. 11f.) could forgive the artist for working with his hands.

Carlo Dolci's self-portrait (Fig. 72) is a revealing pictorial document of the dichotomy in the life of the gentleman-artist. His three-quarter-length figure is wrapped in the large folds of a ceremonious garment. A modish white collar sets off the noble face which looks at the beholder, slightly inclined as if weighed down by deep reflection. The fine bone-structure of the head is framed by carefully disarrayed locks. A dandyish moustache adorns the upper lip. The wistfully smiling mouth, large sad eyes, and deep furrows combine to evoke the countenance of a man who had experienced all the woes of life, but whose breeding has taught him to carry his load with proper detachment. This image of a stylish *melancholicus* holds in his right hand another version of himself: the toiling artist at work. An awkward *pince-nez* sits on the tip of a nose by no means aristocratic but merely long. The mouth is now narrow, half-opened and weak. The eye, small and piercing, stares at the work in hand. The emaciated, well-clad philosopher-artist can see himself also as a drably dressed, unshaven, anaemic little craftsman.

8 Jealousies in Academic Circles

Without exception the history of the academies makes strange reading. It invariably presents what the historian of the Royal Academy in London calls 'a painful record of strife and dissension'.[47] It would be futile to try to discuss the extent of the jealous quarrels which agitated academicians everywhere. We can only sketch very briefly a few typical incidents.

We have mentioned that the Florentine *Accademia del Disegno* was founded in 1563 under Vasari's leadership. In 1564 Michelangelo died in Rome, but the Florentines could not bear the idea of their greatest native artist being buried elsewhere. They arranged for the transfer of his body to Florence and decided to entomb it with the utmost solemnity. The members of the academy asked Duke Cosimo for permission to plan the funeral ceremonies and to execute the appropriate decorations in the church of S. Lorenzo. Their request was granted and financial support promised. A committee of four, under the chairmanship of Don Vincenzo Borghini, was appointed to work out the programme: Bronzino and Vasari represented the painters, Ammanati and Cellini the sculptors. At the very first meeting violent dissensions broke out. Vasaris' self-appointed authority over the group was bitterly contested by Cellini.

This aroused the wrath of Don Vincenzo who, moreover, bore a grudge against most of the older members of the academy because he was made to feel that they considered him incompetent in matters of art. He therefore suggested to Vasari to employ only younger artists in the execution of the elaborate catafalque planned for the obsequies and to get rid of the hated Cellini, whom he called a hopeless lunatic. He did succeed in ousting Cellini from the committee, but to Vasari's credit it must be said that he resisted Don Vincenzo's wish to have Cellini excluded from the second edition of the *Lives*. The offended Cellini stayed away from the ceremony in S. Lorenzo. Vasari diplomatically explained the sculptor's absence as due to 'a slight indisposition'.[48]

The writer-painter Giovanni Baglione (1571–1644) was himself involved in many of the quarrels which raged between the Roman artists of his time and we can be sure that few of the current intrigues escaped him. His eye-witness account of a scandal which rocked the *Accademia di S. Luca* to its very foundations shows how little the academicians heeded Federigo Zuccari's advice. Our particular case resulted from the enmity between Tommaso Salini (*c.* 1575-1625), a painter chiefly of flower- and fruit-pieces known for his 'very free and often biting tongue', and Antiveduto Gramatica (1571–1626), the then President of the Academy.

It so happened [Baglione reports] that Antiveduto Gramatica and the Cavaliere Guidotti had been elected to settle a few differences among the academicians. Antiveduto, who was ill-disposed towards Salini, had the statutes of the Academy revoked and established a committee of only twenty-five members, the most distinguished of this illustrious body, who were elected by lot, and he so managed it that Salini remained outside that number. This offended the latter so gravely that he began to intrigue hard against Antiveduto. Having discovered with the help of the Cavaliere Padovano [the portrait-painter Ottavio Leoni] that Antiveduto wanted to give Raphael's picture of S. Luca to a great nobleman and leave in its stead a copy, painted by himself, in the Academy's church, he appealed to the superiors and so wrangled it that Antiveduto was deprived of the presidency and Simon Vouet, a Frenchman, elected president in his place. The affair disturbed and excited everybody; many sessions were held and with the help of Cardinal Francesco Maria del Monte the committee was dissolved, the Academy returned to its former state and, above all, a confirmatory brief was obtained from His Holiness Pope Urban VIII. All this greatly discomfited Gramatica and partly caused his death, for after these events he was never well again.[49]

The incident had occurred in 1624. Salini survived his act of revenge by a year, Gramatica died in 1626. Vouet returned to France in 1627, there to become the teacher of a whole generation of successful painters. But in his own country he was never honoured with an official position, as he

had been in Italy. When the French Academy was founded in 1648 Lebrun, Vouet's most outstanding pupil, took good care to keep his master—and any other possible rival for that matter—out of the way.

The beginnings of the French Academy were not propitious; for years it had a hard struggle to survive. Only after Colbert's energetic intervention in 1661 and a complete reorganization in 1663 was it firmly established. Thereafter, under the virtual dictatorship of Colbert and Lebrun, the academy exercised a strong and unbroken influence on French art and artists.

Into this atmosphere Bernini entered in the early summer of 1665. His triumphal journey to France will be described in the next chapter. Here we have to comment on the less fortunate events of his visit. The grand old man, whose every word was law at home, could hardly conceal his contempt for the things he disliked abroad—and they were many. His anecdotes and sallies which delighted the papal court fell flat in the stilted atmosphere of the French court. He spoke only Italian and the French nobility were bored by his endless stories, shocked by his lack of formality and his occasional outbursts of temper, and offended by his ill-concealed·dislike of their national heritage. The French artists, so divided among themselves, were immediately united by their consuming jealousy of the foreigner and started a successful whispering campaign against the mighty rival.

Bernini, himself as generous in praise as he was outspoken in blame, could not bear the niggling thrusts levelled against him by those whom he considered his inferiors as artists. The constant sly attacks and malicious murmurings against his Louvre plans and his portrait bust of Louis XIV irritated him beyond words. Chantelou describes a typical scene during a meeting with Perrault, Colbert's favourite architect. One day, towards the end of Bernini's stay, Perrault appeared in the Cavaliere's studio, producing a notebook wherein he had written down 'all the objections he wanted to put forward'. He spoke not only for himself and Colbert, he declared, 'but for a dozen others', and he proceeded to criticize Bernini's Louvre design. Then, pencil in hand, his plans on the table before him, Bernini burst. He shouted

... that it was not for him—Perrault—to make difficulties; he was willing to listen to criticism in what concerned matters of expediency, but only one cleverer than himself could be permitted to criticize the design; in this respect Perrault was not fit to wipe his boots ... his designs had been passed by the King; he would complain to the King himself, and was going now to M. Colbert to tell him how insulted he was. M. Perrault, seeing what effect his words had had, was very much alarmed.

Chantelou, Bernini's son Paolo, and his assistant

. . . tried to calm him [Bernini], but without success. He went into the next room, saying one moment that he was going to M. Colbert, the next, that he would go to the *Nunzio*. 'To a man like me,' the Cavaliere was saying, 'whom the Pope treats with attention and to whom even he defers, such usage is a gross insult, and I shall complain of it to the King. If it costs me my life, I intend to leave tomorrow.'[50]

But Bernini was nothing if not magnanimous. The next day he accepted Perrault's apologies and 'agreed that it had all been a misunderstanding, that no more should be said about it, and that he wished to forget it altogether'. In all likelihood, he was truly prepared to forget and forgive, but he did not reckon with the implacable resistance of the French artists to his plans.

Bernini returned to Rome in the autumn of 1665. Two years later his Louvre designs were abandoned in favour of a French project which his shrewd enemies had successfully manoeuvred through interminable crises.

9 *Suspicious Masters*

On September 30, 1664, before Bernini set out on his Paris journey, the *abbate* Benedetti, the representative of the French court in matters of art in Rome, had written to Colbert in Paris:

Your Excellency will now have seen the [Louvre] design by Signor Pietro da Cortona which he sent via Florence for fear that I might let the Cavaliere Bernini see it. I understand that he has much changed his original idea. These artists (*questi virtuosi*) are jealous of each other and eccentric, and one can do nothing but bear with their defects.[51]

The phrasing of the last sentence does not make it clear whether '*questi virtuosi*' refers only to Cortona and Bernini or to artists in general, but few observers would have hesitated, we believe, to extend Benedetti's verdict to the profession as a whole. Individual, regional or national jealousies were described by biographers long before the academies gave new scope for feelings of envy. Some of the old rivalries have never been forgotten. Anyone even slightly acquainted with the history of artists knows that Torrigiano broke Michelangelo's nose in a fit of jealous rage. Michelangelo's angry suspicion that it was the envy of Raphael and Bramante which caused 'all the dissensions' between himself and Pope Julius II is still remembered after more than four hundred years, and the question whether Michelangelo's envious antagonism towards Leonardo is fact or fiction is still discussed. There is scarcely a single artist of whom it was not said either that he was the victim of the jealousies of others or that he himself was a jealous man. Even Rubens, who was in fact one of

the most generous supporters of younger artists, was nevertheless suspected by Bellori of subtle scheming to keep his pupil van Dyck out of his own field:

Being very wise, he took the opportunity of Anthony's having painted a few portraits to give him the highest praise and to propose him in his stead to whoever came for a portrait, so as to get him away from painting figures. For the same reasons, but more brusquely, did Titian rid his house of Tintoretto.[52]

Similar aspersions were cast on the much-admired Carlo Maratti in a letter written by Tommaso Redi (1665–1726), a Sienese painter studying in Rome. 'Maratti', he informed his Florentine colleague Anton Domenico Gabbiani (1652–1726),

. . . took me to his house and showed me fine things. He has a house fit to receive any prince. Afterwards he took me for a walk to St Peter's and talked to me on beautiful subjects. But one must be careful about what he says, for he makes subtle insinuations, and covertly jibes at modern painters, particularly at [Luca] Giordano.[53]

Even Reynolds, who had attained more fame and favours than any other English painter either before or during his time, was supposedly possessed by

. . . fear and jealousy which he certainly felt towards all those whose merits he thought put his own superiority in danger. This fear he artfully endeavoured to hide by lavishingly bestowing patronage and assistance on those whom he was sure could never interfere with himself, that he might by this means appear to the world as a patron of the arts without the risk of hurt to himself.[54]

10 Warfare within Local Schools

Bologna

Bologna is as good an example as any to illustrate the internecine warfare that raged between the artists within local groups. As soon as the Bolognese school of painters emerged from relative provincial obscurity into European eminence the mutual jealous dislikes of its members became a source of great fascination to the partisans of the various factions. They kept each other well-informed about current studio gossip, and for once left posterity with little to guess.

After the Fleming Denys Calvaert had settled in Bologna and opened his workshop, Albani and Reni were among his first pupils, soon followed by the slightly younger Domenichino. Calvaert's success as a teacher inspired the Carracci to open a rival studio, and the Fleming had to suffer the humiliation of seeing his best pupils desert him. After Albani and Reni had gone over to the opposite camp, Domenichino decided

. . . to imitate them in this resolution. Through these friends he had got hold of a drawing, I do not know whether by Lodovico or Agostino [Carracci], and finding it much to his taste, he began copying it, but very secretly, so that he should not be found out by the master. Calvaert had felt hurt by the other two leaving him, fearing that his reputation might suffer. When, therefore, he discovered what Domenichino was drawing, he attacked him in such a rage that he wounded him in the head with an unfortunate blow.[55]

Then Domenichino's father took matters in hand and at his son's 'request introduced him to Agostino Carracci . . . who received him with every courtesy'.

But the atmosphere in the Carracci school was far from harmonious. The famous collaboration between the two brothers at times suffered not only from their incompatibility of character but also from professional jealousies. In a letter to his cousin Lodovico, written from Rome, Annibale complained about the

. . . unbearable pedantry of Agostino who, never satisfied with what I did and always looking for something to find fault with, spoiled and destroyed all I had done, and his continuously taking poets, writers, and courtiers on to the scaffolding hindered and disturbed me and was the reason why neither he nor anybody else ever did a thing.[56]

The Carracci pupils, especially in their later years, were constantly at loggerheads. When Guido Reni and Francesco Albani followed their master to Rome shortly after 1600 they set out 'in good comradeship'. Domenichino joined them a little later. At first the three shared, amiably enough, a room in the convent of S. Prassede. But though Albani and Reni

. . . looked after all Domenichino's needs he would have little to do with them, going away on his own to draw and to satisfy his genius with such studies as he considered most necessary. He returned in the evening to S. Prassede, and after having supped with his room-mates, he went to bed so as to rise early in the morning while Albani and Guido stayed up to play cards together, which they often did throughout the night. And Domenichino told me that they did not let him sleep much, as he would frequently hear them calling out: *passo, passo*.

He told me once that the strict rule which he always kept not to be seen when working had been taught him by his most intimate friends whom he had once allowed to watch him while painting. As soon as they had left his room they declared him to be so painstaking a painter, who worked with such difficulties, that it was a bore to watch him. After this he had vowed never to admit anyone again.[57]

The close friendship between Reni and Albani did not last very long either.

Since Guido, as the older of the two, had already won greater renown with his work, and was treated with more respect, deference, and courtesy than Albani, the latter felt rather jealous, the more so as Reni himself knew that he had become important and treated him, or so it seemed to Albani, with some arrogance and contempt. He grew all the more embittered when he saw that he had occasionally to subordinate himself to Reni and of necessity work under his command on those paintings for which Guido received more orders than he did himself. The pretensions [of peace] gave way at last to open quarrels, detractions, and mutual insults. And indeed, the two parted, never to have dealings with one another again.[58]

Jealousy of Reni became an obsession with Albani who was known and feared for his 'satirical and sharp tongue'. Malvasia tells us that

. . . there was not a painter alive who escaped being touched and lightly pricked by his [Albani's] double-tongued metaphors and the nicknames which he readily bestowed on everyone. Guido Reni he always called the *smorza zolfanello*.* His envy of this rival was such, that whenever he heard him being mentioned he would explode with anger.

One morning Albani went shopping; he wanted to buy some *Piacentino* cheese. The grocer recommended a kind which Signor Guido also had bought, upon which Albani flew into a rage and left without buying anything; to the young man [in his company] who advised him to go to another shop, he said that there was no place left unpolluted by the *smorza zolfanello*.[59]

We may also let Baldinucci speak:

With the passing of years this rivalry became so open and so strong that in the city of Bologna two large factions arose, consisting not only of the students, but also of the admirers of the two schools, the one calling themselves the Albanesi, the other the Guidisti, and their time was mainly passed in gossip, slander, and stories to extol their own idol and abase his rival.[60]

Jealousy also poisoned the relations between Reni and his powerful younger rival Guercino, as well as between Domenichino and Lanfranco who competed for the commission to paint the dome of S. Andrea della Valle in Rome. Domenichino lost and never got over his defeat.

Rome

When Albani and Reni first arrived in Rome their presence was welcomed by some of the Roman painters as a means of fighting their own rivals. If Malvasia is right, the Cavaliere d'Arpino used his influence to oust the hated Caravaggio and have him replaced by Reni, suggesting that the Bolognese could work quite as well in *'quella maniera cacciata e scura'*—in that dashing and dark manner.[61] In fact, the commission for the *Crucifixion of St Peter* (now in the Vatican) went to Reni and not to

* Literally: 'match quencher'. Guido was reputed to have been so stingy that he saved old matches.

Caravaggio. It was one of his earliest Roman works (1604–5) and shows how well he could handle the manner of his competitor.

Towards the end of the sixteenth and throughout the seventeenth century Rome surpassed all other European capitals in building activities. The vast programmes for new, and the redecoration of old, churches and palaces held out great promise of work for architects, painters and sculptors. But the extremely large number of artists who flocked to Rome unsettled the delicate balance between supply and demand. Competition, of necessity, was fierce and the fight for work ruthless. Artists blessed with good commissions rarely escaped the machinations of their envious rivals. Every imaginable means was used to discredit and harass the lucky ones.

Domenico Fontana (1543–1607), the favourite architect of Pope Sixtus V, was accused by his competitors of having used inferior materials in order to increase his earnings, whereas the shoddy execution of some of his works was undoubtedly due to the impatience of the Pope who could not wait to see the buildings finished.[62]

Two young Florentine artists, Giovanni da San Giovanni (1592–1636) and Francesco Furini (c. 1600–46), were almost put out of work by the plot of two spiteful fellow-painters. The friends had come to Rome and, after a period of living mostly on bread and water '*alla disperata*', Giovanni obtained, after much pleading, the commission for the fresco of the *Night* in Cardinal Bentivoglio's palace (later Palazzo Pallavicini) on Monte Cavallo. Furini was to be his assistant.

Having produced a carefully thought-out cartoon, Giovanni began to paint. At the end of the first day he had succeeded in finishing a figure representing the moon. He went home with his companion, but when they came back to work next morning, they found the painting soiled and covered in a dirty mould.

Giovanni had to scrape it off and begin the figure all over again. The second, third, fourth, and even the fifth day passed with the same thing happening each time, and so the rumour spread that the Florentine painter did nothing but make and unmake his own work. This news was quickly brought to the Cardinal who summoned the artist and asked him what he was up to.

The desperate Giovanni explained that the Roman plaster must be at fault and that now he knew what to do. He procured some Florentine plaster and tried again but with the same lamentable result.

The Cardinal, being informed that the painter's new remedy had not served either, called for him, and told him that he appreciated his efforts and that that would do for the moment. Whereupon Giovanni beseeched the prelate for permission to work once more, for the last time. On parting from the Cardinal he said to Furini: '*Cecco mio*, it is certainly something other than the plaster or cement which is playing these tricks on me.' So he had a mattress

carried up on to the scaffolding and there they stayed together. They were both up there in the dark, quiet as mice, when, at midnight, the door of the room gently opens and in creep two persons carrying a small light and a pot containing a certain liquid. Climbing deftly up the ladder to the scaffolding, they had almost reached the top when Giovanni, a hand on his sword, shouted in a loud voice: 'Here are those rascals' and together with Furini he took the ladder and upset it backwards, so that owing to the heavy fall one of the aggressors broke a thigh and the other an arm.

Next day at crack of dawn the bricklayer arrived with a labourer to begin work and found that the two ill-doers were two French painters whom the Cardinal kept at the palace to paint grotesques.[63]

It is impossible to say how much of this story is studio gossip; we are inclined to believe that Baldinucci was well-informed.

Not only competing rivals but also antagonists in matters of artistic principle watched each other warily and lost no occasion to vent their animosity. Out of opposition to Bernini and the florid Baroque style Andrea Sacchi (1599–1661) did what he could to support Duquesnoy, the embodiment of pure classical taste. When Duquesnoy had finished his statue of S. Susanna for the church of S. Maria di Loreto, Sacchi

. . . loudly acclaimed it, and in order to demonstrate still further the high opinion he had of it, he included it in the oil painting which he was executing for the church of the *Padri Capuccini* in Rome. [*Miracle of S. Anthony* in S. Maria della Concezione in via Capo le Case].

It is certainly true that Andrea's enthusiasm was not simply prompted by his feelings of charity towards the Fleming, but was used as a stone to throw at the head of someone whom he hated at that time [i.e. Bernini]. And this often happens: one does a favour to one in order to annoy somebody else, since hatred is more practised than love.[64]

11 *Regional Feuds*

Some of the bitterest quarrels arose from regional jealousies. Italians have always been fiercely loyal to their *paese*, the region of their birth. Also, centuries of wars between the scores of principalities and city states had made them more resentful against 'foreigners' from nearby provinces than from far-away countries. Dante's verse

> or fu giammai
> gente si vana come la Sanese?
> Certo non la Francesca si d'assai!

> Were people ever as vain as the Sienese?
> Surely not even Frenchmen are as bad as they!
> (*Inferno* XXIX, 121–3)

lived on in every Florentine's heart and is symptomatic of that constantly smouldering *campanilismo* which needed only the incentive of

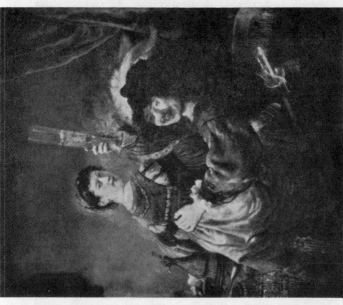

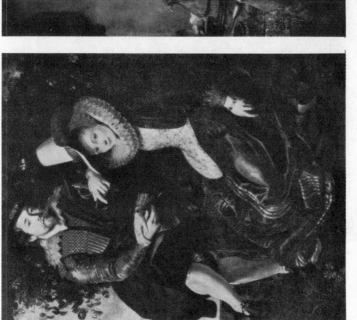

80. Rubens, Self-Portrait with Isabella Brant, c. 1609. Alte Pinakothek, Munich. Rubens' self-portraits always show a handsome man of impeccable breeding and taste, restrained even in moments of intense *joie de vivre*.

81. Rembrandt (1606–69), Self-Portrait with Saskia, c. 1634. Gemäldegalerie, Dresden. Rembrandt depicts himself as a boisterous, young plebeian, proud of his bride and his wealth.

82. Rubens, Self-Portrait. A Version of the Self-Portrait of 1623–4 in the Royal Collection at Windsor Castle. Uffizi, Florence.

At the height of his career Rubens embodied the fulfilment of the gentleman-artist's wishdream: in his art superior to most, in life inferior to none.

83. Rembrandt, Self-Portrait, c. 1664. Uffizi, Florence. Rembrandt's greatest achievement as an artist coincides with his failure as a citizen. But the ravaged features of his late self-portraits proclaim wisdom and humility rather than humiliation.

personal rivalry to send the sparks flying. The pitch to which tempers could then rise may be illustrated by two major clashes, the one raging between the Bolognese artists and a Roman painter, the other showing the fury of the Neapolitans against all comers.

Federigo Zuccari's 'Porta della Virtù'

In the spring of 1580 Pope Gregory XIII had asked Federigo Zuccari to continue the decoration of the Cappella Paolina in the Vatican begun by Michelangelo. At the same time Paolo Ghiselli, the Pope's chamberlain, commissioned him with a large altar-piece for the church of the Madonna del Baraccano in Bologna.[65] But when this painting (now lost) arrived at its destination towards the end of the year, Ghiselli was disappointed and the Bolognese painters were outraged. Slighted as they felt by the preference given to a Roman artist, they immediately started to criticize the work loudly and cruelly. Zuccari, they maintained, had left most of the execution to studio hands. Moreover, they believed the three main figures in the painting to be caricature-like portraits of the Pope—a native of their city—and two members of his entourage.

Zuccari was not long in retaliating. In the summer of 1581 he publicly exhibited a large cartoon entitled *Porta della Virtù*, composed of many abstruse allegorical figures which were meant to satirize his detractors, and in case anybody should miss his point, he had it explained to all and sundry. This caused a resounding scandal. The Bolognese painters—who saw themselves represented as figures with asses' ears, accompanying the allegory of Ignorance—and the offended papal courtiers took legal action. The cartoon is lost, but three preparatory drawings for it are still extant (Fig. 73) and so are the minutes of the proceedings.

Zuccari defended himself against the prosecuting party as best he could and at great length. Asked what he knew about the criticism levelled against his altarpiece he stated he had heard it said that it was

... lacking in several respects as if it had been executed by the hand of the lowest of painters—a man who had never handled a brush, which left me surprised and bewildered although I realise that I am not as perfect as I should be.

The defects objected to were, so they said, that the colours which should have been light were dark, and those which should have been dark were in some places light; and that the figures which should have been large were small and the small ones should have been large, and in the perspective the figures were not properly foreshortened.

Asked about the meaning of the figures and the various mottoes in his satirical cartoon he declared:

The mottoes are appropriate to explain those figures, and the purpose of this cartoon was no other but that I, having been persecuted by slander and envy

wherever I have been, wanted to make those who are not of the profession understand that they could not so easily blame other people's labours; they who have no experience at all are the ones who have injured me everywhere.

Zuccari further declared that the invention and original idea was his though Domenico Passignano, his studio help, did most of the execution because he himself had been busy with other work. Asked whether he had explained the meaning of his composition to anyone, he tried to tone down his freely given comments:

To tell the truth, I have talked about its interpretation and meaning to some people like painters and others who approached me, this having been a new thing and they having wanted to know the subject; and I told them that the subject represented the difficulties which artists have to endure in acquiring competence [*virtù*].

He also tried to minimize the effect which the public exhibition had had and insinuated that perhaps Domenico Passignano might have said something about the satire being directed against the Bolognese artists.

The next day Passignano was called as a witness. He denied Zuccari's suggestion violently:

Never have I discussed nor talked about the faults that have been found in Bologna with Messer Federigo's picture, nor has Messer Federigo talked to me about this, because if you knew him his nature is such that he never talks to anybody about his own affairs, least of all to his servants.

He protested that the '*invenzione*' of the satire was entirely Federigo's, he himself had worked on it for only three days and merely done what he was told. Nor had he said that the allegories or mottoes were directed against the Bolognese painters: 'I shall never believe that anybody can testify to what I have not said . . . Messer Federigo was the inventor of this work; whosoever had wanted to know the interpretation would have been informed by him alone.'

Things looked bad for Zuccari, but he still tried to extricate himself. He asked for a second hearing and stated:

. . . though it is true that the painted cartoon entitled *Porta Virtutis* has been executed this summer, the idea came to me some four years ago in Florence where occasions for such subjects were not lacking. Sonnets, songs, and madrigals, blaming my work, were made when I painted the cupola of S. Maria del Fiore, and these aroused similar ideas in me, but because of my being constantly occupied I never had time to carry them out.

He went on to explain that only this summer had he been able to give a sketch of those old ideas to Passignano as an exercise for the young man 'and the truth is that said Domenico did not know the meaning of said cartoon'.

Zuccari's defence rambles on and on, but all his sophistry was of little avail. He was banned from Rome and forbidden to work within the papal State under penalty of being sent to the galleys.[66] He was given four days in which to leave. The much-travelled painter once again took to the road and turned first to Florence, then to Venice where he was immediately commissioned to paint frescoes in the large hall of the Doge's palace. Meanwhile his patrons and well-wishers set to work and tried to effect a reconciliation with the Pope. Within twelve months Zuccari was allowed to work in the papal State, and after another year he was granted a full pardon so that he could return to Rome and continue with the frescoes in the Cappella Paolina.

The Bolognese in Naples

Our second case is connected with Naples' holiest shrine, the chapel of S. Gennaro, known as the *Cappella del Tesoro*, where the Saint's skull and blood are preserved. In 1616 it was resolved to have this chapel decorated with frescoes,[67] and despite the opposition of the local artists a commission suggested that the Cavaliere d'Arpino should be summoned from Rome for the work. When, however, he failed to fulfil his contract, the commissioners approached Guido Reni. He accepted and arrived in Naples in 1621, accompanied by one of his pupils and a servant. His stay was of the shortest: one day his servant was found gravely wounded, and Reni returned promptly to Rome.

Suspicion of having instigated the mean act fell on the Neapolitan painter Belisario Corenzio (c. 1560–c. 1640) who had a bad reputation. He was arrested but had to be released for lack of evidence. After a delay of two years the commission chose a Neapolitan artist. Their choice was Fabrizio Santafede, who turned out to be a great disappointment. He was dismissed in 1625 and the decoration of the chapel was suspended until 1628 when Belisario Corenzio succeeded in receiving permission to paint one corner 'on approval'. He took a year over this task. The commissioners were not sure whether they liked what they saw, but allowed him to paint a second corner. This time they did not hesitate to declare themselves dissatisfied; the frescoes were erased, and Domenichino was called from Rome to take over.

A shy and withdrawn man under the best of circumstances, given to 'meditating all day in silent and almost monk-like solitude' (Passeri), Domenichino wavered. Even before he had signed the contract he received a threatening letter from Naples. When he had finally made up his mind to accept, and arrived in Naples in the early summer of 1631,

. . . he began to taste the bitter fruits of rivalry and envy. When leaving his room on the second morning of his stay he found a note in the keyhole threatening his life if he did not hasten his return to Rome.

Alarmed, Domenichino went without delay to the Viceroy and showed him the message. The latter heartened him and gave him assurances for his safety, exhorting him to continue his stay in good spirits and without fear. Encouraged by these words, he carried on, but hardly dared to leave the house, going nowhere else except from his room to his work, which came to the same thing as not going out at all.[68]

Domenichino worked with great zeal and a year later the first of his frescoes could be shown to the public. But he was no match for the combined forces of his Neapolitan rivals, foremost among them the Spanish-born Ribera. The situation became so unbearable that in 1634, leaving behind his wife and daughter, Domenichino fled post-haste to Frascati where he found asylum in Cardinal Aldobrandini's Villa Belvedere. From there he wrote to the Cardinal's secretary:

I sincerely thank His Eminence and his mother for granting me the favour of a room and the wine necessary for my sustenance.

I must tell you how, having lately taken this decision, I rode day and night, almost without rest, with only my disgust and my suspicions for company. I arrived here after three days, and so early that I might as well have gone on to Rome, but I was so exhausted that I did not believe I would survive. With the help of God, and the good air of Belvedere, together with the bounties of the Aldobrandini who graciously remembered me, I am restored so much that I now feel safe and sound.[69]

Domenichino needed a year to recuperate and summon up enough courage to return to Naples where he

. . . dedicated himself assiduously to the finishing of his work. He was never looked upon favourably again by the Neapolitan *Signori*, and was most bitterly maligned by the painters because he had come back. He was extraordinarily pained by this and felt greatly afflicted.[70]

The careful balance of Domenichino's compositions and the poise of his figures, so greatly admired by many of his contemporaries and later generations, did not result from a harmonious nature. Domenichino was a solitary man, oppressed by morbid fears, incapable of good relations with his family, ill-at-ease with his friends. No wonder the atmosphere of hostility in Naples

. . . reduced him to such a state that mealtimes became the greatest torture. He began to harbour the suspicion that the food which he took to sustain life might prove to be the morsel of death, and the hour in which he should have found repose was the one in which he suffered the greatest torments from suspicions and fear.[71]

When he died in Naples at the age of sixty his wife was convinced that he had, in fact, been poisoned by his enemies.

CHAPTER XI

BETWEEN FAMINE AND FAME

1 *The Economic Position of Artists in the Renaissance*

IN THE second chapter we gave a general outline of the manner in which artists earned their living. We are now concerned with the more difficult question of the actual or relative amount of their incomes. Interesting comparisons have been made between the salaries of artists and those of other professional men. In one such study,[1] for instance, we find that at the time when Ghiberti and Fra Angelico had a yearly salary of two hundred florins, a chancellor of the Signoria of Florence drew six hundred florins annually, though out of this he had to pay the wages of four scribes. Salaries of distinguished professors of medicine or law ranged between five hundred and two thousand florins. An efficient copyist who had full board and lodging was paid thirty florins a year— less than a good, and more than a mediocre, studio hand. This analysis throws some light on the economic position of artists during the fifteenth century; even in Florence, the most advanced centre, their place was obviously in the lower ranks of the petty bourgeoisie. But though such figures give us some idea of the artist's status in general, they do not disclose the financial position of individuals, for they fail to mention customary fringe benefits such as rent-free workrooms and living quarters; the supply of food, fuel, tools and part, or all, of the necessary materials as well as wages paid by patrons directly to assistants and workmen. They do not account for revenues from sources other than salaries such as extra earnings; interest from capital investments, income from real estate, speculations or inheritance. Tax declarations and wills, so far as they exist, show the great importance of these items for the artist's overall income.

Thus even the most careful calculation will always leave a margin of doubt. Only this much can be said with certainty: there never was a time when an artist's career was regarded as a sinecure. The misery of ill-paid, fitfully employed men was constantly before everybody's eyes. Again and and again do we find fathers warning their sons against entering such a hazardous profession. Yet more than enough hopeful young men persisted in following their inclination. The result was an appallingly

large proletariat of artists. To mention just two figures: Antwerp around 1560 had three hundred registered masters of painting and the graphic arts as against one hundred and sixty-nine bakers and seventy-eight butchers;[2] and of the one hundred and eleven artists who lived in the borough of Campo Marzio in Rome in the middle of the seventeenth century, almost fifty per cent were listed as poor.[3] Eclipsed by their luckier, more dynamic or more fashionable contemporaries, many gifted men were doomed to a life of want and frustration. Then as now, those disappointed artists would blame their failure on the indifference of an uncomprehending public and dream of a golden past when art had been more appreciated. In 1431 the German painter Lukas Moser wrote on one of his works, the altarpiece in the church at Tiefenbronn:

Schri. Kunst. schri und klag dich ser	Cry art cry, lament ye sore,
Din begert jecz nemen mer.	You aren't wanted any more.
So. o. we.[4]	Woe is me.

Vasari, who had seen a great deal of misery among his friends, both 'freelance' and court painters, was appalled by the discrepancy between 'the extraordinary rewards' bestowed on the 'most famous masters' and the plight of 'those rare intellects who, not only without reward, but in miserable poverty, bring forth their works'. He firmly believed that

. . . if there were just remuneration in this our age they would, without doubt, produce greater and better works than the ancients; but since they have to face famine rather than fame, these hapless artists remain ignored and unrecognized to the shame and disgrace of those who could raise them from obscurity yet do not lift a finger.[5]

This reproach was not entirely unfounded. Many patrons spent considerably more money on collecting antiques than on commissioning contemporary works of art. Others, after bursts of enthusiastic patronage, might lose interest and become stingy once their whim had passed. Still others lacked the discrimination and courage to back an unknown artist. The notion that genius thrives best in penury was also a convenient excuse used by tight-fisted patrons long before the Romantics had thought of poverty-in-a-garret as the most fertile atmosphere for generating master-pieces. Cellini, in answer to the Pope's suggestion that a regular salary might make him 'entirely forget his admirable art', contended that

. . . good cats mouse better to fatten themselves than merely through hunger, and men of genius exert their abilities always to most purpose when they are in affluent circumstances; insomuch that those princes who are most munificent to such men may be considered as encouraging and, as it were, watering

the plants of genius; left to themselves they wither and die away—it is encouragement alone that makes them spring up and flourish.[6]

2 Andrea Schiavone—A Neglected Master

Facts about the lives of those ill-favoured artists who had 'withered away' in their own time were not likely to be handed down to posterity, but we can gain an impression of their fate from such a borderline case as the Venetian painter Andrea Schiavone (1522–63), whose importance was not so entirely lost on his contemporaries as to deprive him of a place in biographical literature. Yet, if one can trust tradition, he was largely disregarded by potential patrons. Driven by poverty,

. . . he often worked for painters of chests who, by an ancient privilege of the Senate, had their dwellings under the porticoes of the Piazza San Marco. He painted little stories, leaves, grotesques, and other caprices on the chests which were customarily sold there, some of which are now kept as rare objects by their owners while many have been dispersed. But such commissions were not always available, nor the possibility of painting pictures for the shops, so that poor Andrea was often reduced to begging his friend, master Rocco della Carità, a painter of chests, to employ him by the day, as the wretch had nothing else to live on. His works were not much appreciated in his time, since people only valued those of Giovanni Bellini, the citizens still holding to the old views which favoured his sort of pious and carefully painted figures. Moreover, Giorgione, Palma Vecchio, and Titian had aimed at and reached such utter refinement that their works not only embellished public places but also private houses, whilst the paintings of Andrea, though skilfully and cleverly executed, were more appreciated by painters than by the general public.[7]

That Schiavone may indeed have been a painter's painter is supported by Titian's interest in him. It was on Titian's recomendation that Schiavone was chosen to be among a team of seven artists commissioned to execute the ceiling frescoes in the Libreria Vecchia of S. Marco, one of Schiavone's few large public works.

3 Artists' Professions of Poverty

Perhaps the least reliable basis for assessing their earnings are the artists' own declarations. Overstatements were probably as frequent as understatements. In 1755 the Swiss miniature painter and enameller Rouquet published a little book, *The Present State of the Arts in England*, in which he summarized thirty years of experience among English painters. A portrait painter, he says,

. . . makes his fortune in a very extraordinary manner. As soon as he has attained a certain degree of reputation, he hires a house fit for a person of distinction.

His aim is then not so much to paint well, as to paint a great deal; his design is to be in vogue.

Rouquet goes on to describe how the gentleman painter handles his clientèle. He shows his pictures in a room separate from that in which he works. People are received by a footman who knows by heart all the names, real and imaginary, of the persons whose portraits decorate the picture room. If the master himself emerges from the studio he pretends to have a great deal of business which is, as Rouquet remarks, 'oftentimes a good way of getting it'.

Surely, to dazzle the public by alleged success is as timeless a device as its opposite, the pretence of financial distress in order to collect outstanding money, plead tax relief or avoid the repayment of debts. In reading what artists themselves have said about their financial affairs one is struck by the number of masters who professed the most pitiful needs though they are known to have been fully employed. Their letters have often been taken as evidence for the callous attitude of their patrons and have done much to strengthen the popular notion of the unrewarded genius. Yet failure to fulfil his part of the contract does not necessarily show bad faith on the side of a patron. Personal setbacks or general economic upheavals may have made the fulfilment of his obligations genuinely difficult, even impossible. On the other hand, it can scarcely be doubted that many a petitionary letter was written with the sole purpose of moving the recipient's heart and opening his purse.

Fra Filippo Lippi
Such a letter is the clumsily phrased and ill-spelled but eloquent missive by Fra Filippo Lippi, addressed to Cosimo the Elder's son, Piero de' Medici. When still in his twenties Fra Filippo, the friar from the slums of the S. Frediano district, had emerged as one of Florence's promising young painters. Barely thirty, he had painted some important altarpieces, among them that for the Barbadori chapel in S. Spirito which was so large that his competitor Domenico Veneziano thought that 'even though he worked day and night, it could not be done in less than five years'. Yet in 1439 he complained bitterly about his empty purse:

After having waited for thirteen days I have at last received your letter in reply to mine. This delay has caused me much damage. You finally answer that you cannot take any decision about the panel which I should keep for you. By God, this is an ill-mannered way to tell me that even were I to die you could not give me a farthing. This has caused me much grief for various reasons, one of them being that I am, as is well known, one of the poorest monks in Florence, that's me. God has left me with six nieces to marry off who are sickly and useless and for whom I am the only, if meagre, support. If you could let me have on account from your house a little corn and wine it would

be a great comfort to me. I beseech you with tears in my eyes that were I to die you will give it to these poor children. I inform you that I have been to Ser Antonio del Marchese so as to know what he wanted from me. He said that were I to go and serve him he would lend us five florins each and with us being twelve people at home I see that I would not be able to have a pair of stockings made for me.[8]

Mantegna

How difficult it is to distinguish between true, pretended, or imagined needs is shown by the correspondence between Mantegna and Isabella d'Este of Mantua. After years of negotiations, during which he had worked on and off for Marquess Lodovico Gonzaga, Isabella's husband, Mantegna (1431–1506) finally accepted the quite liberal terms offered him, and in 1459 settled in Mantua as court painter with a good monthly salary, free living quarters, and a generous allowance of wood and corn. Over and above this regular income he received presents of money and valuables and was allowed to accept commissions elsewhere. His salary, it is true, was not always paid punctually, but Isabella was often short of funds and even had to pawn her jewels in order to pay her most urgent debts. It may have been annoying for Mantegna to have to ask for his dues, but he cannot have been too badly off. Apart from his professional earnings he had some income from houses and estates. He was able to marry off two daughters and a niece with quite respectable dowries and he seems to have spent rather large sums on collecting antiques. A house which he began to build in 1468, or soon after, but in which he probably never lived, was apparently planned to hold his collection.

In 1506, shortly before his death, Mantegna bought another house, as we learn from one of his letters. He was then in his seventy-fifth year. By all accounts his old age was far from calm and happy. Never a patient man, his irascibility had involved him in more than one legal feud with neighbours. Family worries beset him and, when an outbreak of the plague disrupted the economic life of the principality, he was doubtless hit by financial difficulties. But even amidst all his troubles and in spite of his advanced years he remained a shrewd negotiator who knew how to flatter his patrons as his letter to Isabella d'Este of January 13, 1506, shows. He wrote:

Illustrissima Madonna mia. I commend myself to you. As I have not been able to obtain a farthing anywhere in months, I am now more than ever in great need. I am much embarrassed because, hoping that things would take a different turn and not wanting to remain an unsettled vagabond, I bought a house for the price of three hundred and forty ducats, payable in three instalments. The first term is ended, I am harassed by creditors and, as your Excellency knows, one cannot at present either sell or pawn anything, and I have many other debts as well. So it has come to my mind to help myself as best I can by

means of my dearest possession: having often been asked, and by many people, to sell my dear Faustina of antique marble, and being driven by necessity which makes us do many things, I thought of writing to Your Excellency because if I have to part with her I would much rather that you have her than anybody else in the world. Her price is one hundred ducats which I could have had many times from great masters. And may it please you to let me know the intention of your Excellency to whom I recommend myself infinitely.[9]

Who can tell how great his need really was, how sincere his grief about the proposed sale of his antique marble head or how much he played on Isabella's well-known mania for collecting? In July 1506 he still stuck tenaciously to his terms. Isabella's agent had seen him and reported:

This morning I visited Mantegna on your Ladyship's behalf. I found him very querulous about his needs and necessities; he informed me that, in order to meet them, he had to pawn things to the value of sixty ducats, and, in addition, he told me about other debts. Nevertheless, he does not want to go lower with the price of his Faustina, for he hopes to get it. I objected that this is not a time when anyone wants or can afford to go to such expense. To this he answered that rather than let her go for less than a hundred ducats, he would keep her for himself.[10]

Isabella asked for the bust to be sent on approval and, having seen it, agreed to pay the price. Six weeks later death put an end to Mantegna's troubles. His laboriously amassed lifetime savings did not last long under the hands of his three sons and heirs. The house he built for his collection still exists, though much altered and repaired. But the collection itself was soon dispersed and can no longer be traced with the exception of the Faustina which is now in the Museum of the Palazzo Ducale in Mantua (Fig. 74). It is a disappointing work and one wonders whether the painter realized its mediocrity and tried to profit from his patroness's lack of discrimination or whether his love for antiquity had dulled his own eye for quality.

None of Mantegna's obduracy and testiness could tarnish his reputation. Writers and poets of his time—Ariosto in his *Orlando Furioso*, Castiglione in his *Cortegiano*, Cesariano in his *Commentaries* to Vitruvius—ranked him with the greatest of the period, Leonardo, Michelangelo, Raphael, Titian; a judgment with which few have disagreed in more than four hundred and fifty years.

Giambologna

Towards the end of the sixteenth century a hard tug-of-war about money was fought between Grand Dukes Francesco and Ferdinando de' Medici and two of their court artists, Giovanni Bologna and Bernardo Buontalento. Bologna, born in Douai in 1529, went to Florence in 1556;

Buontalenti, his junior by seven years, was a native of Florence; both worked extensively for the Medici Court, and both died in the year 1608.

Bologna was not only one of the most influential sculptors in the latter part of the sixteenth century, he was also one of the busiest. The large workshop which he maintained and the great number of works he poured out would have required a good organizer in addition to a fertile mind. But his business methods seem to have been peculiar. Archdeacon Simone Fortuna, charged to negotiate the commission for a marble statue for the Duke of Urbino, visited the sculptor in 1581. Greatly impressed by Bologna's stamina he wrote to the Duke on October 27:

He never wastes an hour's time, neither by day or night, and I am surprised at how he endures such great fatigue without ever taking a rest.

He is the best man one could ever find, not at all miserly, as his great poverty proves. His only interest is glory, and his extreme ambition to reach the excellence of Michelangelo, an object which, in the judgment of many, it would seem he has already reached.

But when it came to the financial side of his mission, the Archdeacon was nonplussed:

I tried my very best to learn the approximate cost, though with dexterity and tact. I did not succeed, as he answered that he does not value money and never arranged prices beforehand, taking what is given to him, and it must be added that everybody says that he has never been paid half the price his works are worth and would be valued by others. In the end I insisted so much that I found out that for a centaur he made for Cavaliere Gaddi, and a similar one for Sgr. Jacomo Salviati, one sent him cloth worth fifty *scudi*, the other a necklace worth sixty *scudi* because he professed not to want anything. I reckoned that one might give him a hundred *scudi* for one statue and in my opinion they would be well spent, since being by his hand I believe one need not entertain any fear regarding their excellence. Those things which he did in his youth and which he does not judge to be good he bought, and still buys, at a higher price than he sold them for in order to destroy them.[11]

Whether Bologna was really financially disinterested or whether he used a well-tried stratagem to put the Duke under a moral obligation is a matter of opinion, but he certainly knew how to press for money if he wanted to. From 1583 on he began to remind Grand Duke Francesco of old promises, at the same time appealing to the Grand Duchess to put in a good word on his behalf.[12] When his vague promptings proved unsuccessful he composed, in June 1585, a memorandum which he sent, together with a covering letter, to Antonio Serguidi, the Grand Duke's secretary, and in which he explained:

The need in which I find myself, my advanced age and the many firm

promises received from His Serene Highness make me so bold as to send you the enclosed supplication, the contents of which, unless I have been blinded by my own interests, appear justified to me. The works which I made for his Highness with the understanding that they should be paid for—at the time I only got thirteen *scudi* a month for my upkeep—were many more than are mentioned here, and were estimated at a much higher figure than what I ask for now. Yet I request nothing as my due, on the contrary, anything will be a gift.

The arrears he claimed were considerable—fifteen hundred *scudi*; but the payment, he hastened to explain, would really be no drain on the ducal coffers:

I shall at once return in taxes two hundred and fifty of the fifteen hundred *scudi* which he gives me, besides spending His Highness's gift within his State. Neither will I molest His Highness any more, nor shall I feel ashamed at not having known how to put some money aside after so much work for so many years, when I see many servants and pupils of mine who have become wealthy and honoured, after they left me, with what they learnt from me and with my models. And it seems to me that they laugh at me for, in order to stay in the service of His Serene Highness, I have refused most favourable offers both from the King of Spain and the Emperor of Germany. I do not regret this now and hope that, thanks to His Highness's goodness, I shall not have to repent, wherefore I beg of you to say a few words in my favour as I have no practice in that sort of thing, having given more of my efforts to deeds than to words.[13]

At first reading this sounds reasonable enough, but on second thoughts one begins to wonder. Though certainly no youth—Bologna was in his middle fifties when he wrote his petition—he clearly emphasized his 'advanced age' with a purpose. The 'firm promises' which he suddenly remembered must have been given to him many years before. Bologna had entered Grand Duke Cosimo's services in about 1560 when he himself was in his early thirties and at that time thirteen *scudi* a month, which he makes sound like a paltry sum, was not a bad basic salary by any standards. In 1564 Cosimo retired. His son Francesco became Regent and, after his father's death in 1574, Grand Duke. Whatever his failings may have been, he was a true art-lover who spent enormous sums on his villas, his palaces, and art collections. It was during his reign that Bologna's salary was increased to forty-five *scudi* a month[14]—a generous stipend if one bears in mind that the annual rent of his workshop amounted to only forty *scudi*. Prematurely exhausted by a feverishly active and dissipated life, Francesco lost interest in the arts. He died in 1587, aged forty-six, having spent the last few years, 'much withdrawn and in great melancholy',[15] devoting himself almost entirely to the study of alchemy. Bologna must have been acutely disturbed by the difference between the Grand Duke's former munificence and his later retrench-

ment. The sculptor's letter sounds like a desperate attempt to get what he could out of his ailing patron.

Francesco was succeeded by his brother Ferdinando who was a much better and steadier ruler. Intelligent, a good politician and skilled financier, he was 'economical and frugal' in his personal needs, but 'marvellously magnificent' as far as official court life was concerned. Altogether Bologna cannot have fared too badly under his several patrons. He owned landed property and a house in Florence. According to Baldinucci his style of living was *molto decoroso e civile* as befitted a twice-knighted man. If his financial assets were in some disorder, perhaps even depleted in his later years, he was still able to defray the costs of transforming the central chapel behind the main altar of SS. Annunziata into a lavishly decorated memorial chapel for himself and other Flemish artists who would die after him in Florence (Fig. 75). In his will he left an endowment for the maintenance of the chapel and for a weekly Mass to be celebrated *in perpetuo* for his soul.

Buontalenti

Bernardo Buontalenti's affairs are similarly puzzling. His first datable architectural commission in Florence was the alteration of a palace in 1567. It belonged to Bianca Cappello, the notorious mistress, later second wife, of Duke Francesco. Apart from some works in Pisa, Siena and Livorno, Buontalenti was mainly active in Florence and more particularly for the Medici Court. His range was extraordinarily wide. He was equally successful as an architect, painter, sculptor, engineer, as well as a designer for festival and stage decorations, costumes, and china ware. His lighting effects and fireworks were the delight of the spectacle-loving Florentines. Apart from his pay for all these commissions he drew a yearly salary of two hundred and forty *scudi* as engineer for the river works[16] and seems to have made an occasional extra penny with inventions such as a new system to preserve snow for keeping food cool in the summer. He was granted a licence to sell the snow, but the terms of the concession did not satisfy him. He also ran a thriving school in his own house in the fashionable via Maggio, where he taught his many crafts, and instructed the sons of noblemen in the rudiments of drawing, perspective, and architecture. But it is as one of the foremost Mannerist architects of such buildings as the Palazzo Nonfinito that he is best known nowadays.

Commissions for public and private buildings were never lacking until after the turn of the century. From about 1602, however, they dwindled noticeably. With all his immense activities for the better part of thirty-five years Buontalenti's earnings should have been more than adequate to provide for a comfortable old age. Yet at the threshold of the biblical

three score and ten his situation was such that the threatened lack of a few *scudi* spelled despair for the old master. In 1588 Grand Duke Ferdinand had granted him a monthly pension of ten *scudi* and a weekly allowance of four loaves, one and a half *fiaschi* of wine, firewood, and other provisions. For eighteen years he seems to have received his due, but in 1606 he wrote to his patron, begging him to remember the ten *scudi*, because

. . . now they tell me that these have been taken away from me. My poor family! Here I find myself old and weak, crippled by that fall which I had in the gallery, so that I cannot stand upright. I have fifteen mouths to feed, for there are seven relatives, four females and three men, and I lack two measures of corn in order to be able to live this year.[17]

In his *Life* of Buontalenti, the master's devoted pupil, the architect Gherardo Silvano, blamed the straitened circumstances of those last years on Buontalenti's 'having been burdened with many nephews and nieces' and on his 'having spent all he earned and possessed for models made in the service of His Highness' as well as on the extraordinary solicitude he showed for his pupils whom he helped in their every need to such an extent 'that it often did damage to himself, so that at his death he did not leave much behind'.[18]

4 *Some Wealthy Masters in the Fourteenth and Fifteenth Centuries*

Biographers took great pride in describing the riches of outstandingly prosperous artists. Vasari, in particular, was pleased to perpetuate in print the stories he collected about his wealthy Florentine forerunners. In many cases the local tradition has been proved right. We know now that Giotto earned a great deal more than most of his contemporaries. Apart from being highly paid for his paintings he was a salaried city architect of Florence and had a substantial income from other sources: he owned land, hired out looms, and lent money at interest.[19] Compared with the average earnings of a fifteenth century artisan, Ghiberti was a rich man, in fact one of the richest artists of his time. A shrewd manager, he invested his money wisely. He owned a house and his workshop in Florence as well as some land and a vineyard in the country; he had bank and savings accounts, and had acquired a valuable collection of antiques. Professor Krautheimer[20] has compared his annual income at the height of his career to that of a branch manager of the Medici bank, which would raise him decidedly above most of his fellow-artists, but would rank him below the wealthy merchant class. Brunelleschi was one of the few artists whose assets surpassed Ghiberti's, while Donatello, though he too had a more than average income, was never interested in accumulating wealth He does not seem to have owned landed property

nor to have had any savings so that, according to Vasari, he had to be assisted in his old age by the Medici and other friends.[21]

But the great gulf between artists 'facing famine' and those enjoying 'the extraordinary rewards' bestowed on fame, opened up only when the great masters of the late fifteenth and the early sixteenth century appeared on the scene. Bramante, Raphael, Titian were rich men and lived like princes; Michelangelo was rich though he lived like a pauper; Leonardo was offered extremely liberal salaries in Florence, Milan, and especially later in France. Never before in Western Europe had such a high premium been placed on genius, and nowhere else but in Italy did it happen so early. The disparity between north and south may be gauged by contrasting Dürer's financial position with that of his Italian fellow-artists.

5 *The Financial Aspect of Dürer's Netherlandish Journey*

In 1515 Dürer had been granted a yearly sum of one hundred florins by the Emperor Maximilian. This sum meant a great deal to the Nuremberg master—how much we shall discuss presently. In Rome at that time Raphael, twelve years his junior, had amassed a sizeable fortune. According to Condivi, Bramante, who had died the year before, had 'spent enormously and, though the pension granted him by the Pope was large, he found it insufficient for his needs'.[22] In July 1520, Dürer set out on his journey to the Netherlands. His main reason was to present himself at the Imperial Court—not because the fame of this great German painter had moved anyone to call him there, but merely in order to plead humbly with Charles V for the reinstatement of the annual allowance which the Councillors of Nuremberg had seen fit to suspend after the Emperor Maximilian's death.[23]

Dürer, then a man of nearly fifty, accompanied by his wife and a serving woman, travelled at his 'own cost and expense', painfully counting every farthing on this journey which lasted twelve months. In his diary he left a minute description of everything he saw, did, and spent. The Bishop of Bamberg, whom he presented with two paintings, a woodcut, and an engraving, entertained him, paid his bill at the inn, and gave him a customs pass as well as three letters of recommendation. Between Bamberg and Cologne Dürer crossed thirty-two customs frontiers without paying duties; only four times did the Bishop's pass fail him and to his great annoyance he had to leave a deposit. So he went on to Antwerp, earning his living along the way. He sold drawings, etchings, and wood-cuts either by his own or by his pupils' hand: '*Item* Sebald Fischer bought from me at Antwerp 16 of the Little Passion at 4 fl. Also 32 large books at 8 fl. Also 6 engraved Passions at 3 fl.'[24] He is meticulous in returning favours: 'I gave Master Joachim [Patinir]

art [i.e. one or some of his works] value 1 fl. because he had lent me his apprentice and some paint.'[25] He bartered his 'art' for wine, food, curios, and other things, under the polite guise of presents exchanged; he drew the likeness of innumerable persons, among them Tommaso Bombelli, a rich Genoese silk merchant, and his two brothers; in return he was asked twelve times to dine with Signor Tommaso. A little later he noted: 'Also, the brother of Tommaso gave me a pair of gloves in return for 3 fl. worth of etchings.'[26] The portrait drawings of one of his hosts who presented him with a chunk of white corals is now one of the prize possessions of the Museum in Frankfurt (Fig. 76).[27] He moved on to Brussels where the new Emperor's aunt, Margaret, Regent of the Netherlands, promised her good offices on his behalf.[28] The grateful Dürer gave her an etching of his *Passion*. In a long list of presents and counter-presents exchanged with many people in Brussels he did not forget to note: '*Item*, 6 persons whom I protrayed in Brussels have given me nothing.'

But Dürer had to return to Aix-la-Chapelle to submit his petition to the Emperor. At last, in November, he received his '*Confirmacio*' from Charles 'with great trouble and toil', and from the pages of his diary one gains the impression that only then could he really enjoy his journey. He is a little easier with money. He had always been a bit vain, to the amusement of his friends. His beard gave away his weakness. '*Commenda me multiphariam nostro Alberto Duerer*. Let me know whether he still trims and curls his beard' wrote Dr Lorenz Behaim to Willibald Pirckheimer.[29] Now he spends more than during the first part of his journey on clothes, shoes, gloves and buys an odd assortment of curios. He even gambles a little! From now on also, his peregrinations turn into a veritable sight-seeing tour, and wherever he arrives he is received with great ceremony by the artists' guilds.

In the middle of the preparations for his return journey Dürer is honoured by a request to draw the portrait of King Christian II of Denmark, the Emperor's brother-in-law. The charcoal sketch pleases: 'I had to eat with the King, and he was very gracious to me.'[30] The next day 'at the King of Denmark's command' he goes once more to Brussels. There he is not only a spectator at the banquet given by the Emperor for King Christian, but he also receives an invitation to attend the banquet which the Danish King gives in return: '*Item* the Sunday before St Margaret the King gave a great banquet for the Emperor, Mistress Margaret, and the Queen of Spain and invited me, and I also ate there.' Practically in the same breath he adds: 'I have been invited by Master Jobst, the tailor, with whom I supped.'[31]

In July 1521 Dürer was home again. Financially the journey had not been rewarding: 'With all my doings and spendings, sellings and other

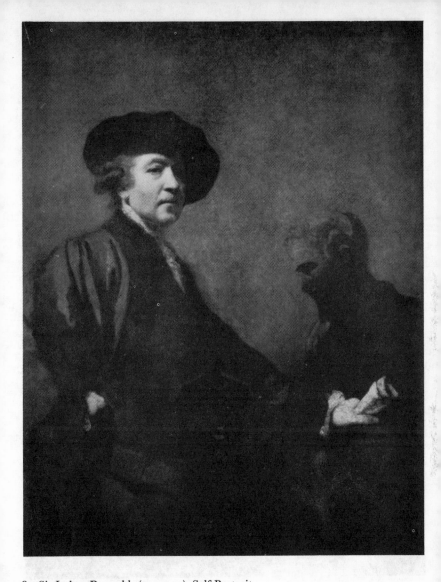

84. Sir Joshua Reynolds (1723–92), Self-Portrait,
1773. Royal Academy, London.
Reynolds' self-portrait shows the dignity, equipoise and grandeur
of an eighteenth century academician.
Michelangelo, the *divino artista*, whose bust appears in
the background, was Reynolds' guiding star.

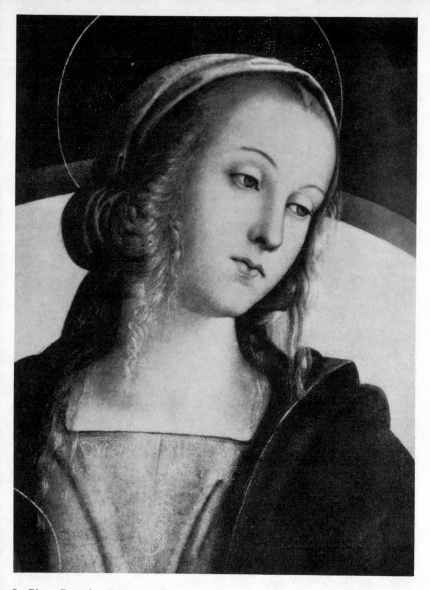

85. Pietro Perugino (1445–1523),
Detail from the Virgin and Child with two Saints, 1493. Uffizi, Florence.
Do Perugino's paintings reflect the mind of a sincerely devout man or of an
irreligious hypocrite? Visual images are ambiguous and the interpretation of the
personality behind the work depends on the beholder's subjective response to the work.

deals I have had poor luck in the Netherlands in all my affairs with people high and low, and particularly Mistress Margaret has given me nothing in return for all the things I gave her and made for her.'[32] Still, with his careful habits, 'over long years of great exertion and toil and with the help of God',[33] he had saved the sum of one thousand florins which he thought to invest in 1524. Four years later he died in his fifty-seventh year.

During his stay in the Netherlands Dürer had learned of Raphael's death in Rome in the spring of 1520. At the age of thirty-seven this favourite of popes and intimate of cardinals and princes left a fortune estimated at sixteen thousand florins comprising a house at Urbino, a house, a palace, vineyards and land in and near Rome—all acquired during a working life of barely two decades, a life, moreover, spent in great luxury and splendour.[34]

6 *Titian's Opulence and Financial Astuteness*

The epitome of a grand Renaissance artist's life was that of Titian. After a somewhat slow beginning he had fought his way to the fore against fierce competition. By the time he had reached his late forties he had won the admiration of all Italy and most of Europe with his portraits, mythological paintings and large altarpieces. The Emperor Charles V had nominated him court painter and invested him with the title of a Count Palatine and the Knighthood of the Golden Spur. He also had become a very rich man. Titian looked after his financial interests with skill, patience and tenacity. Never, as far as one can judge from his correspondence, did he give up a financial claim. The image of the 'typical' artist unconcerned with the value of money most certainly did not fit him. He has been blamed more than once for having been covetous and avaricious, but he had to deal with patrons to whom the same epithets might be applied: they coveted his paintings but were strongly disinclined to part with their money when it came to paying. Titian just kept urging. Neither his work nor the stream of visitors whom he wined and dined in his resplendent house in Venice prevented him from writing long letters. Year after year, in almost monotonous repetition, they followed the same pattern: profuse protestations of faithful service; skilful hints at pictures nearly ready—very soon to be dispatched; and blunt reminders of money due. Judiciuosly turned phrases which may sound servile to modern ears, are no more than the usual formulae of polite society at his time. They alternate with straighforward demands and, occasionally, with rather threadbare allusions to his 'straitened means', his 'embarrassments' or his 'ill-health'. Titian was never in want, and he enjoyed an unusually robust constitution. Extracts from his correspondence with the Spanish Court, one instance among many less

important exchanges of letters with patrons, will give an impression of his stubbornness in handling his affairs.

There is an additional interest attached to this correspondence. The fact that a great painter thought he had the right to request the greatest monarchs on earth to take a permanent interest in the *minutiae* of his finances is without parallel and shows that now an artist of Titian's standing felt himself to be in a special category, superior to the rest of men.

In 1535 or 1536 Charles V had promised Titian a 'corn privilege' on the treasury of Naples; in 1541 he was granted a pension of one hundred ducats a year payable by the Milanese treasury. This sum was doubled in 1548. Nothing, however, was paid him for years in spite of his persistent appeals to the offices concerned. At last, in 1554, Titian turned to the Emperor himself, using the opportunity to complain about yet another unfulfilled promise.

Titian to Charles V.

Venice, September 10, 1554.

By order of your Majesty a yearly pension of two hundred *scudi* was assigned to me at Milan, and a privilege for the carriage of corn was granted me at Naples. The latter has cost me hundreds of *scudi* to pay an agent there. Lastly, I received a *naturalezza* in Spain for one of my sons, to which a yearly pension of five hundred *scudi* was attached. It has been my ill fortune to fail in obtaining anything from these grants, and I now beg leave to say a word about them to your Majesty, hoping that the liberal mind of the greatest Christian Emperor that ever lived will not suffer his orders to be neglected by his ministers. I should consider such a benefit as an act of charity, inasmuch as I am straitened for means, having been in ill health, and having married off a daughter. My supplication to the Virgin Mary to intercede for me with your Majesty is shown in her image, which now comes before your Majesty with an expression of grief which reflects the intensity of my troubles. I also send the picture of the 'Trinity' [*La Gloria*, Fig. 77] and, had it not been for the tribulation I have undergone, I should have finished and sent it much earlier, but in my wish to satisfy your Majesty I have not spared myself the pains of wiping out, two or three times, the labour of many days to bring it to perfection and satisfy myself, thereby spending more time than I usually do on such work. But I shall hold myself fortunate if I give satisfaction, and beg your Majesty will accept my eager wish to be of service, my greatest ambition being to please your Majesty.[35]

The letter arrived at an unpropitious moment. Weary of his imperial duties Charles was preparing to retire to a life of contemplation and religious devotion. In the following year he entered the monastery of S. Juste where he died in 1558. His son Philip succeeded him as King of

Spain in 1556. Titian not only retained his position as favourite court painter to the new ruler, he even seemed successful in drawing the King's attention to his outstanding claims. In 1557 he sent his son Orazio to Milan expecting to receive at least part of the overdue pensions as well as some money for pictures delivered to Spain which the treasury of Genoa was supposed to remit. His hopes were disappointed. It was only after Charles V's death that Philip II gave definite orders to settle all accounts with Titian who once again sent his son to collect the money from the Milanese and the Genoese treasuries. But Orazio nearly lost his life as well as the preliminary payment of two thousand ducats in Milan and never got as far as Genoa (see p. 191f.).

Titian, though furious, was undaunted. Assuring Philip in 1559 that he 'will ever be dedicated to his service', he dangled the bait of five almost completed paintings before his eyes. Another year passed and nothing happened. At least four of the five promised pictures had been dispatched when Titian sent such a daringly sarcastic letter that one suspects the helping hand of his friend Aretino in the background. He wrote on April 22, 1560:

Seven months have elapsed since I sent the pictures which your Majesty ordered of me, and as I have received no notice of their arrival, I should be grateful to hear whether they gave pleasure, because if they should not have done so, according to the perfect judgment of your Majesty, I would take steps to paint them afresh so as to correct past errors.

The letters with which I was favoured by your Majesty in respect of the money assigned to me at Genoa have not had any effect; from which it appears that he who can conquer the most powerful and proud of his enemies is not able to secure the obedience of his ministers, and I do not see how I can hope ever to obtain the sums granted to me by your Majesty's grace. I therefore humbly beg that the obstinate insolence of these subordinates may be chastised, either by ordering that my claims should be instantly satisfied, or by transferring the order of payment to Venice or elsewhere, so that your humble servant shall be enabled to obtain the fruits of your Majesty's liberality.[36]

There followed the familiar promises of more and grander paintings to come. Not before another year had gone by and another letter been sent were the old master's claims met—or so Philip thought. But the cunning Genoese agents had paid Titian in ducats, whereas his claims had been in gold, a difference of two hundred ducats to the painter's disadvantage. He was not slow in pointing this out:

Thanks to your Majesty's kindness I have at last received the money from Genoa, and I now most humbly bow and give thanks for the favour which, since it frees me from some embarrassment, will, I hope, enable me to spend the rest of my life in peace in the service of your Majesty. True indeed,

I have received two hundred ducats less than your Majesty's first schedule ordered, because the last did not specify that I should be paid in gold; but your Majesty will doubtless have the matter rectified and I shall get the difference, which will be of the greatest use to me.[37]

The King wrote in the margin of this letter: 'Send the money (two hundred *scudi*) from here, which will be least inconvenient.' There still remained the balance of the Milanese pension to be settled as well as the Neapolitan 'privilege' granted in 1536, and also the old promise of a pension for Titian's son Pomponio. In July 1563[38] he tried his old technique again: two pictures are nearly completed and can be dispatched quite soon, the one a *Last Supper*, the other the *Twelve Apostles*— a work, he adds, 'which is perhaps one of the most laborious and important that I ever did for your Majesty'. When nothing at all happened for several months Titian sent another reminder in December, promising that he could now send the *Last Supper*, and ending: 'And, as till now, I have not had the slightest payment for the numerous works which I have furnished, I ask for no more from the singular benignity and clemency of your Majesty than my ordinary dues on the Camera of Milan.'[39]

But the *Last Supper* was by no means finished, nor did Titian intend to finish it before he had seen his money. The correspondence between King and painter went to and fro, the one wanting the picture, the other the money. At last, in March 1564, Philip gave the long expected order to Milan and Naples and by the same mail wrote to his envoy Hernandez at Venice that he now hoped to receive the *Last Supper*. Seven months later the envoy could report that the painting would only take another week or so and repeated the artist's insistence on being paid.[40] Again the King sent orders to Milan, again the treasurers balked.

In December 1567 Titian complained:

I also humbly beg your Majesty to deign to assist me in my wants in my old age if in no other way than in commanding the officials to pay my pension without delay, as I do not receive a *quatrino* but the half of it goes in commission and interest, or in fees for agency and other expenses, or in bills and presents.[41]

He then went on to reiterate all outstanding payments due to him. But more time passed, more letters had to be written until on February 27, 1576,[42] the master, almost ninety years old, took up his pen for the last time. In well-turned phrases he reminded the Emperor of his 'devoted service', of his 'great old age' reached 'not without privations', and the fact that 'twenty years have elapsed and I have never had any recompense for the many pictures sent on divers occasions to your Majesty'.

Six months later, on August 27, 1576, Titian died during the plague which wiped out almost a quarter of the population of Venice.

In 1566 Titian had lost the privilege of exemption from income tax which he had enjoyed for fifty years. For the first time in his life he had to declare his possessions.[43] He could not hide the fact that he owned lands and fields, cottages, houses, sawmills and other properties, but he deliberately understated their value and he misrepresented his financial assets. He never so much as mentioned the receipts from his dealings in art and antiquities, his pensions, and income from the sale of his pictures. His wealth was great in spite of the defaulting Spanish Court. Vasari, who visited him in that year, wrote:

Titian has enjoyed health and happiness unequalled, and has never received from Heaven anything but favour and felicity. His house has been visited by all the princes, men of letters and gentlemen who ever came to Venice, since apart from being excellent in his art he is pleasant company, of fine deportment and agreeable manners. He has had rivals in Venice, but none of any great talent. His earnings have been large, because his works were always well paid.[44]

This is how Titian's memory has lived on through the ages: a happy man who had fulfilled his ambition as an artist and a man of the world. His contemporaries took it for granted but posterity has often forgotten that he hardly ever used his brush except on commission. Works which bear the stamp of incontestably sincere emotional experience and unrivalled technical mastery were to him so many objects of trade, barter and bribe once they were ready to leave his studio.

The *Trinity*, a painting so dear to the Emperor Charles' heart that it accompanied him to his retreat at Juste, contains the portrait of Charles and his family. It also displayed the portrait of Vargas, the Spanish envoy, who had expressed a desire to have his likeness recorded together with that of his royal master. Vargas handled the Emperor's financial affairs in Venice and was therefore an important man for Titian. Prudence demanded that he be humoured and he was duly portrayed in the figure at the Emperor's feet. What did Titian feel about this work whose 'celestial Queen' was to express in her features 'the intensity of [his] troubles'? In a postscript to the letter of September 10, 1554 (p. 266), he wrote: 'The portrait of Signor Vargas, introduced into the work, was done on his request. If it should not please your Majesty, any painter can, with a couple of strokes, convert it into any other person.'[45]

Time and again we find Titian painting a portrait for no other reason than that the sitter's influence might be advantageous to him. This is immaterial so long as the beholder is concerned with contemplating Titian's paintings purely as works of art. It is a different matter if he uses them as a basis for psychological conjecture; in that case disregard

of biographical data is apt to distort his conclusions. This, we believe, has happened to the author of *Prolegomena to a Psychology of Art*[46] who divides all artistic activities into two main classes: the 'play class' in which 'the artist seeks the pleasure of artistic creation' and the 'work class' in which he pursues an 'ulterior motive such as making a living, gaining social prestige, or propagating a cause'. Obviously guided by his own pleasure in Titian's portraits, in which he finds 'the impress of the pure joy of artistic creation', the author puts him at the 'play class' end of his scale, undeterred by the fact that Titian hardly undertook anything without 'ulterior motives'. It is precisely because of the unsentimental and determined manner in which he used his genius to serve his self-interest that Titian became a man of substance who had the world at his feet. His work shows that 'ulterior motives' and the 'joy of artistic creation' are not mutually exclusive.

Titian's cupidity is not at all exceptional. It only arouses special interest because of his greatness as an artist. The Scottish portrait painter Allan Ramsay (1713–84)—to give one example—said that 'he never painted but two pictures that were not for money';[47] he was animated by mercenary motives similar to Titian's—but there the comparison ends.

7 *Two Grand Seigneurs of the Baroque*

Bernini

Great and prosperous artists had existed before the Renaissance. Many who were distinguished both in their work and in their wordly position were to follow. But the degree to which Raphael and Titian combined genius with social grace; success with artistic integrity; wealth, fame and popularity with sustained devotion to their art was unprecedented and remained unique until, in the Baroque era, Bernini and Rubens arose as their peers.

Bernini, celebrated as the foremost sculptor and architect, famous for his technical as well as literary work for the theatre, and known as a good painter, was accepted as *par inter pares* by the highest society of his time. The son of a sculptor, he neither felt, nor was he ever made to feel that the carver's craft, which he liked best among his many accomplishments, was in the least beneath his dignity. On the contrary, when Queen Christina of Sweden, soon after her arrival in Rome,

... desired to honour him by going to see him at work in his house, he received her in the same rough and soiled dress he usually wore when working the marble and which, being an artist's dress, he held to be the most appropriate in which to receive that great lady. Her Majesty who, with sublime understanding instantly perceived this beautiful finesse, enlarged on his *concetto* not

only in thought but in actually touching his dress with her own hand as a sign of her admiration for his art.[48]

This story may well be true although it sounds like a variation of the familiar *topos* invented in praise of the dignity of the artistic profession, best illustrated by the famous anecdote according to which Charles V picked up Titian's brush.[49] Queen and artist, both conversant with the humanist idea of a *concetto*, the fitting expression given to a situation, could relish and respect each other's quick grasp of intention.

Whether or not Bernini's own memory and the hero-worship of his biographers exaggerated the early date of his first exploits as an artist, he was without doubt a prodigy. When still a boy he won the patronage of Cardinal Maffeo Barberini, one of the great connoisseurs in Rome; in his early twenties he became President of the *Accademia di San Luca* and was raised to the rank of cavaliere. From 1618 to 1680, with the sole exception of a brief period of disgrace in the reign of Pope Innocent X, he was the declared favourite of eight successive popes. 'It is your great good luck, Cavaliere, to see Maffeo Barberini Pope', his first patron was said to have exclaimed when he ascended the papal throne as Urban VIII in 1623, 'but we are even luckier in that the Cavaliere Bernini lives at the time of our pontificate'.[50]

For the privilege of owning a work by Bernini's hand his admirers were prepared to pay phenomenal fees. Duke Francis I d'Este sent him the unheard-of sum of three thousand *scudi* for his marble portrait; Cardinal Richelieu presented him with a jewel studded with thirty-three diamonds, seven of them large ones, in return for his bust. Charles I, King of England, considered it an honour to be portrayed by Bernini. His marble bust, commissioned by Pope Urban VIII as an act of high diplomacy in his endeavours to convert the King to Catholicism, was shipped to England with unusual precautions. It was accompanied by special guards who had strict orders to report daily about the progress of the journey and the safety of the treasure.

In addition to the large income from his sculptural work—for almost sixty years he maintained the largest studio in Italy and perhaps in Europe—Bernini earned considerable fees as the holder of several official appointments and as an architect. It was in this latter capacity that Louis XIV called him to Paris in 1664. The King, who desired to rival the building activities of the popes, thought it fitting that the ancient Louvre, the residence of the greatest living monarch, should be enlarged, modernized, and completed by the greatest living architect.

A year later, at the age of sixty-seven, Bernini, who had hardly ever left Rome, set out on his first journey abroad—'not without the apprehensions and trepidations of the whole town'. It was feared that he might suffer 'from the perils of the voyage' or that 'the royal magnifi-

cence of that monarch' might offer 'such conditions to keep him there that he would find it difficult to resist'.[51] As it turned out Rome need not have trembled. Never for one moment was Bernini tempted to stay in Paris which he detested, nor was the French court (not to speak of the Parisian school of artists) in the least inclined to dissuade him from returning home. The spirited Italian individualist and the etiquette-ridden French courtiers were heartily glad when they saw the last of each other. But in the beginning everybody was full of great expectations.

The immensely famous and immensely dignified old artist travelled like a *grand seigneur*. His retinue consisted of his son Paolo, the second born of his eleven children; his chief draughtsman; an assistant sculptor, a cook, three servants, a courier, and Sieur Mancini—all paid by King Louis. Wherever the party stopped on its way north Bernini was received with great honours and was the guest of the princes through whose realm he passed. In Florence 'the whole town was depopulated, as it were, because all wished to see with their own eyes that man of whose works they had heard so much'.[52] When he crossed the Italian border into France the traveller was received with public addresses by order of the King; when he approached Lyons he was met 'by all the painters, sculptors, and architects of the town, some on horseback, others in carriages'.[53] 'The Aldermen were to give him lodging; this was quite an extraordinary honour, usually accorded by the city of Lyons only to the Princes of the Blood.'[54] The King detailed M. de Chantelou, his Master of the Household, to meet Bernini outside Paris. The Prime Minister, M. Colbert, sent his brother's coach-and-six to convey the Italian party in state to the palace in Paris which had been prepared for them.

The day after his arrival Bernini was taken to be presented to the King. M. de Chantelou, who was to be his companion and interpreter, and who kept a diary of his every move, noted 'the perfect assurance' with which the proud old master met the sovereign. Everything was done, according to the lights of the French court, to make the papal architect's stay in Paris agreeable. A coach-and-six was put at his disposal. He was taken to see all the sights and shown every attention. The Queen Mother received him graciously; every courtier, every nobleman in town called on him. 'The Royal Academy of painters and sculptors came in a body to pay him their respects.' His opinions on matters of art were constantly sought and he was beleaguered with requests for designs.

Bernini stayed in Paris from June 2 to October 20, 1665. When he left he was, at least in intention, generously rewarded: apart from the promise of a life pension of six thousand ducats a year and a present of three thousand three hundred *pistolae* for himself, well-filled purses were given to his son and his assistants; his servants were liberally tipped.[55]

His journey home was as elaborately organized as his arrival had been. Two six-horse carriages were to take him, 'his suite, and the baggage to Lyons, where he would find litters for himself, and other conveyances for his family'. One courier was to accompany him to Lyons, another all the way back to Rome; the cook and other household staff who had served him in Paris were to look after his needs on the journey.

Bernini's leave-taking at Court was ceremonious, but it was not cordial. Only the parting from Chantelou evoked some sincere regrets in both men. The Roman artist could not and did not hide the fact that, in spite of all the attention lavished on him, he was glad to return to the more congenial atmosphere of the papal city.

Never before or after had an artist travelled in such style. Others have been more successful in their missions; none has ever been so royally honoured. A comparison between Dürer's journey to the Netherlands and Bernini's triumphal procession from Rome to Paris shows what had happened to the artist's professional standing in less than one hundred and fifty years. It has never reached that peak again. Now paid publicity agents may whip up mass enthusiasm for film stars, but no government would take so much trouble to look after a travelling architect, no Prime Minister would go out of his way to make his stay agreeable.

Rubens

Peter Paul Rubens (1577–1640) was the northern counterpart of the outstandingly wealthy Italian artists; his genius was as great, his fame as universal, his earnings as fabulous as theirs. But whereas Raphael, Titian and Bernini owed their social position solely to their artistic achievements, Rubens added to his reputation as a painter the prestige of a diplomatic envoy. His training for both careers had started almost simultaneously: as a boy of not quite fifteen he became a page to Margaret of Ligne; about a year later he left her service and turned to painting. During his first appointment as court painter he was chosen by Duke Vincenzo of Mantua to be one of his envoys sent in 1603 to take a cargo of presents to the Spanish Court in Madrid. Such acts of courtesy always had political implications. Although Rubens' rôle on that occasion was a minor one, it undoubtedly gave him some insight into diplomatic procedure and must have stood him in good stead in his later political career. From 1623 onwards he was employed by the Infanta Isabella, Governess of the Spanish Netherlands, as a special agent in the peace negotiations between Spain, England, France, and the Netherlands. For ten years Rubens travelled about, entrusted with confidential missions, yet painting all the time wherever his duties took him.

These were strenuous years, and only a man of Rubens' fortunate disposition, methodical mind, and infinite capacity for work could carry out simultaneously two absorbing professions while rushing from one European court to the next, keeping up a large correspondence, and also maintaining a studio in Antwerp. There his assistants worked on the numerous commissions, for which he would usually supply the sketches and to which he gave the finishing touches whenever he was able to spend some time at home. It was a rich and fruitful period, but it was not an untroubled one. In 1623 he had lost his eldest child, Clara Serena; three years later his wife, the beautiful Isabella Brant died; serious setbacks thwarted his political work. But Rubens had that admirable fortitude in the face of adversity which stems from an innate harmony, a balance between emotional engagement and intellectual detachment. Misfortune did not sap his strength, nor did success spoil his clear judgment. He had, moreover, the enviable gift of being able to formulate his thoughts and express his feelings. In 1634, after he had resigned his political career and found new happiness in his second marriage, he wrote to his friend Peiresc:

Now, for three years, by divine grace, I have found peace of mind, having renounced every sort of employment outside my beloved profession. *Experti sumus invicem·fortuna et ego* [Fortune and I have come to know each other; Tacitus, *Historiae* 2.47]. To Fortune I owe great obligation, for I can say without conceit that my missions and journeys in Spain and England succeeded most favourably. I carried out negotiations of the gravest importance, to the complete satisfaction of those who sent me and also of the other parties. And in order that you may know all, they then entrusted to me, and to me alone, all the secret affairs of France regarding the flight of the Queen Mother and the Duke of Orleans from the kingdom of France as well as the permission granted them to seek asylum with us. Thus I could provide an historian with much material, and the pure truth of the case, very different from that which is generally believed.

When I found myself in that labyrinth, beset night and day by a succession of urgent duties; away from my home for nine months, and obliged to be present continually at Court, having reached the height of favour with the Most Serene Infanta (may she rest in glory) and with the first ministers of the King; and having given every satisfaction to the parties abroad, I made the decision to force myself to cut this golden knot of ambition, in order to recover my liberty. Realizing that a retirement of this sort must be made while one is rising and not falling, that one must leave Fortune while she is still favourable, and not wait until she has turned her back, I seized the occasion of a short, secret journey to throw myself at Her Highness's feet and beg, as the sole reward for so many efforts, exemption from such assignments and permission to serve her in my own home. This favour I obtained with more difficulty than any other she ever granted. . . . Since that time I have no longer taken any part in the affairs of France, and I have never regretted this decision. Now,

by God's grace, as you have learned from M. Picquery, I am leading a quiet life with my wife and children, and have no pretension in the world other than to live in peace.[56]

This letter was written from his town house in Antwerp, one of the earliest Italianate buildings and a show-place in that Gothic town. Rubens had bought a plot of land in 1610 and subsequently enlarged the property by acquiring adjoining houses. Very little of his mansion has survived, but engravings show it in its pristine condition (Fig. 78). It consisted of three wings surrounding a large courtyard, the fourth side of which was flanked by a tripartite monumental arch opening into the garden. In accordance with his Italian models, Rubens kept the street fronts unadorned and reserved all decorations for the garden façade of the main wing and for the arch. That main wing also contained a grand staircase after the model of Genoese palaces and, above all, it contained a room especially built for his collections.

I have never failed, in my travels [he wrote in the same letter] to observe and study antiquities, both in public and private collections, or missed a chance to acquire certain objects of curiosity by purchase. Moreover, I have kept for myself some of the rarest gems and most exquisite medals from the sale which I made to the Duke of Buckingham. Thus I still have a collection of beautiful and curious things in my possession.[57]

A more detailed description was given by Bellori. Rubens, he wrote,

. . . had collected marbles and statues which he brought and had sent from Rome, together with all sorts of antiquities such as medals, cameos, *intaglios*, gems and metal work. He had a circular room built in his house in Antwerp with only a round skylight in the ceiling, similar to the Pantheon in Rome, so as to achieve the same perfectly even light. There he installed his valuable museum. He had also collected many books, and he adorned the rooms partly with his original pictures, partly with copies which he had painted in Venice and Madrid after Titian, Paolo Veronese and other excellent painters.[58]

For many years Rubens had owned a modest piece of property in the country where his family spent the summer months. Now, in 1635, anticipating 'a quiet life', he bought a large country seat, Castle Steen, roughly halfway between Antwerp and Brussels (Fig. 79). The purchase price was high—about ninety-three thousand guilders—but it was a manor which carried certain legal, ecclesiastical, and military privileges and also a title of nobility. The estate included woodland, an orchard, ponds, a hill with a large square tower, a farmstead, barns, stables and other buildings.[59] But Rubens was already a sick man when he acquired this retreat. He had been plagued for several years by what was generically called 'the gout'. During the summer of 1639, which he spent at Castle Steen, he was so ill that two doctors from Malines were in

constant attendance. He recovered sufficiently to return to Antwerp for the winter, but with the spring of the next year his attacks of paralysis and fever returned and he died on May 30, 1640. He had been a careful manager, a shrewd business man, and a tough negotiator who could hardly ever be moved to reduce the high fees he stipulated for his paintings.[60] The fortune he left to his heirs amounted altogether to about four hundred thousand guilders,[61] which is probably equal to the same sum in pounds at present-day rates.

8 *Rubens and Rembrandt Contrasted*

Even his most devoted admirers will admit that it was not his genius alone which carried Rubens to the height of his profession. The contrast between his and Rembrandt's career shows perhaps most clearly that an inscrutable something—luck, fate, Providence, whatever one may call it —is needed to crown greatness with success. At the age of twenty-five, Rubens, the son of upper-class Catholic parents, had been travelling for two years in Italy. At the same age Rembrandt, the son of a Protestant miller and a baker's daughter, moved from Leyden to Amsterdam which he never left again. Rubens, well-read and speaking five languages with ease, found his patrons among the royalty, the Church dignitaries, and the nobility of Europe. Rembrandt, who reputedly 'read only Dutch and even that badly' (Sandrart), worked for the Dutch burghers. Both were thirty-three years old when they bought their town houses and both paid roughly the same sum for their purchases. The two houses were famed for their art treasures, but while Rubens was a conservative, judicious collector of first-rate works, Rembrandt bought avidly and indiscriminately anything that roused his imagination.

He often visited public auctions where he bought used and old-fashioned clothes which appeared to him bizarre and picturesque. And these, in spite of their sometimes being filthy, he would hang along the walls of his studio among the beautiful things which he also delighted in possessing, such as every kind of antique and modern weapon—arrows, halberds, daggers, sabres, knives, and such like; also innumerable quantities of exquisite drawings, prints, medals and similar things. Furthermore he deserves great praise for a certain extravagant prodigality of his, that is, because of the great esteem in which he held his art, whenever objects pertaining to it were auctioned, especially paintings and drawings by great men, he would, with his first bid, offer a price so high that there never was a second bidder.[62]

In 1656, when Rembrandt was fifty years old, he was declared bankrupt. His collections, which had been valued at over seventeen thousand florins, had to be sold. They fetched five thousand florins. Two years later he was forced to sell his stately house at a considerable loss and move into a poor neighbourhood. The downward trend in his circum-

stances had begun soon after 1642 when his wife Saskia had died. Her place in the household was taken by a trumpeter's widow, tactfully referred to by the artist's biographers as his son's nurse. Then, in 1645, Hendrickje Stoffels entered the painter's life. She had been taken on as a servant-girl but soon became his mistress, whereupon the trumpeter's widow sued Rembrandt for breach of promise. The long-drawn-out suit was resolved in 1650 when the plaintiff was declared insane and committed to an asylum. [63] Despite the strong representations of the Church, Rembrandt never legalized his relations with Hendrickje because under the terms of Saskia's will he would have forfeited the income from her estate had he married again.

At the age of fifty Rubens, too, was a widower, but during his frequent absences his household and his children were well looked after by responsible trustees until he brought home his second wife.

Both masters were sixty-three years old when they died—Rubens rich, honoured, at the pinnacle of his fame; Rembrandt poor and, though not quite so forgotten by his contemporaries as some writers would have it, long past the zenith of his renown. Rubens had all his life been in perfect tune with the society in which he moved; Rembrandt, with his 'extravagant manners' and his 'capricous way of living', was 'very different in his person from other men'. [64] His 'ugly, plebeian face' looks at us from innumerable self-portraits—boisterous in his early double-portrait with Saskia, tense in his middle years, battered and ravaged in his later ones, always proclaiming almost audibly the core of his thought and feelings at each stage of his life (Figs. 81, 83).

Rubens' self-portraits, much fewer in number, show from the first to the last a handsome man of impeccable breeding and taste, sure of himself and imperturbable; an artist, neither deceived by illusions nor spoiled by success, to whom wealth came as the fitting corollary of a well-spent life (Figs. 80, 82).

9 Van Dyck and Velasquez

Of course there were others whose gifts and good fortune carried them to social success, to titles, honour and wealth. Rubens' pupil and collaborator van Dyck (1599 1641) comes to mind; his meteoric and brief career recalls that of Raphael. Van Dyck's early and outstanding achievements in his art, and his good education, broadened by extensive travel, secured him an unprecedented position at the Court of Charles I of England, far superior to that of any native English painter. Like Rubens he was raised to a knighthood by King Charles.

Or one might think of van Dyck's exact contemporary Velasquez (1599–1660) who, at the age of twenty-four, joined the retinue of Philip IV of Spain under much better conditions than his predecessors. He was

given a studio in the palace, living quarters in town valued at two hundred ducats a year, as well as free medical and apothecary services. His initial yearly salary of two hundred and forty ducats was soon increased to three hundred and in addition he received a special pension, also of three hundred ducats per annum.[65] In subsequent years the King raised Velasquez' official standing at Court by appointing him to an increasing number of remunerative offices and even investing him with the Order of St Jago, usually only bestowed on persons of noble descent —a point which had to be stretched rather far in his case. But in the eyes of his contemporaries Velasquez was supremely fitted for this unusual honour. They praised his 'deportment and dignity' and, though a commoner, he was said to possess 'the ease and poise of a nobleman'.[66] Philip was a strange man and not given to emotion, yet he had grown so attached to Velasquez that when the painter died in 1660, after almost forty years in his employment, the King was deeply moved. With a trembling hand he wrote two words on the margin of a memorandum dealing with the vacancy created by the death: *Quedo adbatido*—I am utterly crushed.[67]

10 *The Acme of Dignity and Wealth: Sir Joshua Reynolds*

It is, perhaps, not until the late eighteenth century that an artist approached most closely the grandeur of Raphael, Titian, Bernini, and Rubens. This time the setting is England, the artist Sir Joshua Reynolds (1723–92). The son of a Devonshire family of modest means but on both sides 'rich in clergymen and unusually given to sound learning',[68] the boy received a careful education. When it became apparent that he had a talent for painting he was apprenticed to the best portrait painter in London—portraiture being the surest way for an artist to make his living. From 1749 to 1752 Reynolds studied in Italy, methodically preparing himself to become what was still a rarity in England—a learned artist. In 1753 he returned to London which he never again left except for brief visits to France and the Low Countries. His success in the capital was immediate and rewarding. Whereas he had charged three guineas for a portrait head before going abroad, he could now ask five guineas which he raised to twelve in 1755. From then on he stepped up his charges periodically until he was paid fifty guineas for a head; at the same time his prices for half-lengths rose from twenty-four to a hundred guineas, those for full-length from forty-eight to two hundred.[69]

In 1760 Reynolds bought the leasehold of a house in fashionable Leicester Square—an investment which swallowed nearly all his savings, but since he earned about six thousand pounds a year, this did not prevent him from leading a life befitting the most eminent English painter of the time. His pupil Northcote recorded:

The carriage which he set up on removing to that house was particularly splendid, the wheels were partly carved and gilt; and on the panels were painted the four seasons of the year, very well executed by Charles Catton, R.A., the most eminent coach-painter of his day. The coachman frequently got money by admitting the curious to a sight of it; and when Miss Reynolds [his sister] complained that it was too showy, Mr Reynolds replied, 'What, would you have one like an apothecary's carriage?'[70]

Reynolds lived to see the beginnings of an important change—the gradual shift of patronage from the upper to the rising industrial and mercantile middle classes and once, though reluctantly, he bowed before the new force.

When Alderman Boydell projected the scheme of his magnificent edition of the plays of Shakespeare, accompanied with large prints from pictures to be executed by English painters, it was deemed to be absolutely necessary that something of Sir Joshua's painting should be procured to grace the collection; but, unexpectedly, Sir Joshua appeared to be rather shy in the business, as if he thought it degrading to himself to paint for a print-seller, and he would not at first consent to be employed in the work.[71]

However, money had a persuasive power. A bank bill of five hundred pounds adroitly tendered by one of Boydell's negotiators was said to have induced Reynolds to think again, and in the end he executed three pictures for the gallery for fees ranging from five hundred to a thousand pounds each. But this was his only concession to the new era. He remained entirely a man of the eighteenth century. His patrons comprised the English Court, the aristocracy and the most eminent 'wits'; literary men such as Goldsmith, Dr Johnson and David Garrick, among many others, were his friends. Neither lavish praise nor public honours, neither his knighthood nor his presidency of the Royal Academy could change his essentially middle-class, staunch bearing. He was at the farthest remove from the Bohemian type of artist. Northcote described him in terms of a perfectly balanced man—for the eighteenth century the true measure of genius (see p. 94):

He had none of those eccentric bursts of action, those fiery impetuosities which are supposed by the vulgar to characterize genius, and which frequently are found to accompany a secondary rank of talent, but are never conjoined with the first. His incessant industry was never wearied into despondency by miscarriage, nor elated into negligence by success.[72]

There was a polish even in his exterior, illustrative of the gentleman and the scholar. His general manner, deportment, and behaviour were amiable and prepossessing; his disposition was naturally courtly. He always evinced a desire to pay due respect to persons in superior stations, and certainly contrived to move in a higher sphere of society than any other English artist had

done before. Thus he procured for Professors of the Arts a consequence, dignity, and reception, which they had never before possessed in this country.[73]

Sir Joshua himself was fully aware of this new dignity (Fig. 84). When he died in 1792, after years of failing health, his funeral cortège was an impressive symbol of the service he had rendered to British artists. Three dukes, two marquesses, three earls and two lords were his pall-bearers. Ninety-one carriages, conveying all the members of the Royal Academy and close to sixty well-known and distinguished men, followed the body to its final resting place in St Paul's Cathedral.

Reynolds had never married. In his last will he left substantial sums of money and works of art from his collection to many of his friends. The bulk of his estate went to his niece. It amounted to close on one hundred thousand pounds.

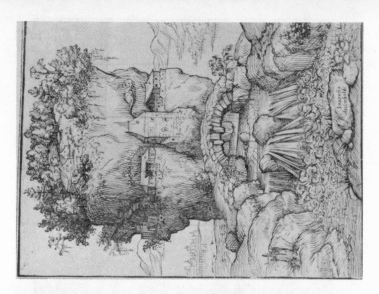

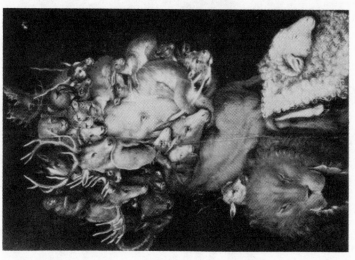

86. Giuseppe Arcimboldo
(1527–93), Double Image:
A Face composed of Animals.
Formerly Joanneum, Graz.
The concept underlying this
trick picture is allegorical
and moralizing. Such works
should not be interpreted in
terms of surrealist art.

87. Arcimboldo, A Double
Image: Landscape and Face.
Engraving after a Picture (in a
Venetian private collection)
with the inscription:
Homo Omnis Creatura.
In his own time Arcimboldo's
imaginative transformations of
closely observed and faithfully
rendered nature elicited mirth
as well as admiration. Even
with a knowledge of the artist's
background and intention it is
impossible to draw conclusions
as to his personality on the
pictorial evidence alone.

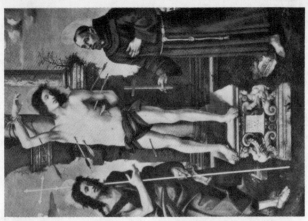

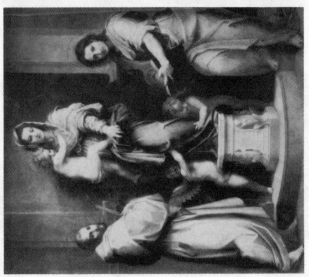

88. Andrea del Sarto (1486–1531). *Madonna dell'Arpie*, 1517. Uffizi, Florence.
The psycho-analyst Ernest Jones believed that the harpies at the pedestal are suggestive of the artist's subconscious attitude towards his domineering wife—a historically untenable explanation.

89. Filippino Lippi (1457–1504). S. Sebastian, 1503. Detail. Palazzo Bianco, Genoa.
A symbol of the triumphant Church, the Christian martyr stands on a pagan altar, characterized as such by the flanking sirens.

CHAPTER XII

PERSONALITY, CHARACTER, AND WORK

1 *Works as Keys to the Character of Artists*

THROUGHOUT the pages of this book we have repeatedly touched upon the relation between works of art and the personality of their makers. The conviction that a man's character and the character of his works are interdependent had already taken deep roots in antiquity. At the beginning of the Christian era, Philo, probably repeating much older Stoic ideas, wrote: 'Unfailingly, works of art make known their creator, for who, as he looks at statues and pictures, does not immediately form an idea about the sculptor and the painter?'[1] Mankind has always been tempted to believe in unitary concepts, and the simple reciprocity of an artist's character and work is surely an attractive thought. It is so attractive that most people implicitly accept it as incontestable; like Philo, they do not doubt that works of art 'reveal their creator'. We have seen in the fourth chapter[2] that Marsilio Ficino formulated this theory anew, and that, in his wake, it gained wide acceptance in the age of the Renaissance and retained a pervading influence in the following centuries. But do the facts confirm the theory?

Every work of art bears, of course, the personal stamp of its maker. In support of this obvious statement we will only say that we can recognize an artist's style as we do a person's handwriting, and the style tells us something about the man; even if we are uncertain about the artist's biography and name, his work bespeaks a distinct personality. But it remains an open question whether a work can be regarded as a mirror-image of its creator.

There are certainly cases in history where the nature of an artist and of his work would seem to harmonize. One might argue that the characters of Raphael and Rubens, of Frans Hals, Brouwer and Caravaggio speak consistently and unmistakeably from their works. But having made this statement, we must pause and reflect for a moment. We are not equipped to enter into a philosophical discussion of the difference between personality and character. In everyday parlance, the terms are almost interchangeable, though personality has, perhaps, the wider connotations.[3] If conduct and behaviour are outward manifestations of

character, it will at once be clear how cautious we should be in our interpretations: there is no way of divining, for instance, Caravaggio's unruly conduct from the fierce quality of his paintings. Assuming such a deduction were possible, the patently absurd generalization could be made that all painters working with a fierce brush lead an unruly life. Equally absurd would be the opposite assertion that 'tame' painters have gentle characters and are therefore law-abiding, conforming and pleasant to deal with. Among others, the Pre-Raphaelites demonstrate the fallacy of such a statement. Even a man like Jacob Burckhardt did not altogether avoid the temptation of trying to ascertain the conduct of artists from their paintings. Talking about Signorelli, Leonardo and Raphael, he says that judging only from their works one instinctively imagines these men to have been princes.[4] In reality Burckhardt projected into the works of these artists what he knew about their lives. We have to admit that, if their works were the sole keys, the majority of artists would defy any guess at their character and conduct.[5] Who could say from the visual evidence alone that sensuality was one of Filippo Lippi's most pronounced character traits or lewdness one of Sodoma's; that Elsheimer, Duquesnoy and Annibale Carracci were sick men for years and behaved accordingly? And when attempts have been made to see signs of Borromini's 'hypochondria' (or approaching schizophrenia) in the specific forms of his architecture, they were based on foreknowledge and not on an unbiased analysis of his designs.

In the Preface to this book we expressed the realistic view that everyone accepts or rejects not only literary but also visual documentation exactly as it suits his purpose. We must add now that ambiguity is one of the characteristics of the visual image: what looks chaste to one beholder may appear obscene to the next; and the personality imagined behind the work will obviously change according to the varying visual reactions. Character studies derived from a beholder's subjective response to works of art are therefore of necessity highly suspect. But art historians have given this matter little thought. Sometimes naïvely, sometimes arbitrarily, they have created a pantheon peopled by an imaginary race of artists. The two major offences may be labelled as the 'whitewashing' and the 'modernizing' of characters.

In cases such as Sodoma's and Holbein's we have noted how the visual evidence was adduced as telling proof against unfavourable literary traditions. The same principle of 'whitewashing' by means of visual evidence has been applied to a great many artists. Thus some art historians find in Perugino's works the reflection of a pure and devout mind. The admirers of his art refute as defamatory Vasari's characterization of the painter as 'a man of very little religion, whom no one could ever get to believe in the immortality of the soul; on the contrary, with

words befitting his hardheadedness, he rejected most obstinately every right course.'

We may add that those who dislike Perugino's sweet saints and Virgins with their rosebud mouths and dreamy eyes (Fig. 85) regard Vasari as a reliable source and declare that they always sensed the hypocrite who knew what he could sell and who merely turned out endless repetitions of a well-tested formula, 'for with the terror of poverty constantly preying upon his mind he undertook, in order to earn money, such work as he would probably not have looked at, had he had means to live'.[6]

Misinterpretation is one of the great stimuli for keeping the past alive. Only that which strikes a congenial note will be taken up from an immensely rich tradition and revitalized in the present. To use works of art of past ages for their own purposes is the prerogative of artists. Historians generally believe themselves to be more objective but in fact they too cannot escape from looking at the past with the eyes of their time. Just as medieval and Renaissance artists were endowed with typically Victorian characteristics by the historians of the nineteenth century, so they are now often invested with unmistakably twentieth century qualities. While such distortions may be unavoidable, misinterpretations owing to arbitrary analogies are not. We will single out here for a detailed discussion the case of Arcimboldo, a minor Italian painter of the sixteenth century who has caused a considerable stir in recent years, especially among surrealist painters. Understandably, they traced their ancestry back to him;[7] they could do so because they misunderstood his intentions and remained unaware of the meaning of his work. But historians should pause before they invest him with the cloak of modernity.

2 *Giuseppe Arcimboldo—A Surrealist 'avant la lettre'?*

Born in Florence in 1527, the son of a painter, Arcimboldo settled in Prague in 1562 where he remained as court artist to three successive German emperors until 1587. He died in Florence in 1593, still in the service of the imperial court. His duties included the buying of antiquities, *objets d'art*, and curios, as well as exotic animals and birds for his patrons' collections. He must have been something of an inventor—his *gravicembalo a colori*, a kind of 'colour-piano', was played by the court musicians. His versatile talents were handsomely rewarded and his fame was international. Almost forgotten for centuries, he has now been rediscovered mainly because of his strange 'double-images', landscapes which are also figures or faces, portraits composed of flowers and animals —mysterious-looking fantasies which, according to one art historian, are

'a triumph of abstract art in the sixteenth century—veritable paragons of surrealist painting'.[8] Such an interpretation evokes a world of dark emotions, of a personality shaped by the experience of Freudian traumas. Do Arcimboldo's paintings warrant the reconstruction of a modern, complex character?

Not one word written by Arcimboldo's own hand has yet come to light. Beyond mere biographical data, we know nothing about the man —'his physique, his passions, his virtues or vices',[9] but we have a vivid description of the impact his paintings made on his contemporaries; two years before his death there appeared at Mantua a treatise in which his work figures large. Though the learned author, Gregorio Comanini, is mainly concerned with expounding the comparative merits of painting and poetry and the moral versus the delectable mission of art, he finds occasion to extol the *ingegnosissimo* Arcimboldo. From Comanini we know what people saw and liked in the painter's work. Describing one of Arcimboldo's portraits the commentator explains:

On the command of the Emperor Maximilian he painted a most ridiculous likeness of a certain doctor whose entire face was ravaged by the pox with the exception of a bit of beard on his chin. He composed the whole of animals and divers grilled fish, and with this ruse he succeeded so well that everybody admired and immediately recognized it as a true likeness of the great jurist. Of the amusement this caused to the Emperor and the laughter it raised at court I need not talk; you can imagine it yourself.[10]

On another occasion Comanini explains the significance of the various component parts of a head entirely built up of animals for the study of which the Emperor had granted Arcimboldo special facilities. A fox, for instance, was chosen for the forehead, because a fox, being the most crafty of all animals, serves well to form a human forehead which is the seat of cunning. It is here that man, 'though he be cheerful sometimes feigns sadness, and though he hates, often shows love'. Or the cheek, which is the seat of modesty, is shaped by the head of an elephant 'of whom Pliny writes in the eighth book of his Natural History that his modesty is most marvellous, for when defeated, he shuns the sight of the victor, nor does he ever mate with his female in public but only in places where he cannot be seen by others' (Fig. 86).[11]

This extraordinary zoological physiognomy was much in vogue at the time. Its ancestry leads straight back to Aristotle and it found a fashionable revival in Giovan Battista Porta's *De humana physiognomia* of 1586.[12] The allegorical meaning of Arcimboldo's painting is, of course, entirely lost on anyone who is not conversant with this tradition and the contemporary obsession with such magical analogies.[13]

The piquancy of Arcimboldo's work was its great attraction. Comanini

was so entranced with the painter's involved representations that he actually attempted to translate one of the paintings, the *Flora* (now lost), into words. His madrigal, as typical of Mannerist literature as was the pictorial rendering of the Spring goddess of Mannerist painting, expresses not only the author's admiration for the painter but also, implicitly, his belief in the unity of painting and poetry:

> What am I? Flora or rather flowers?
> If flowers—how is it
> That I wear the very smile of Flora? But if Flora,
> Why then is Flora nought but flowers?
> Ah, neither flowers am I, nor am I Flora,
> But I am Flora and flowers all in one—
> A thousand flowers and a single Flora.
> Knowest thou why Flora flowers is and flowers' are Flora?
> Because an inspired painter changed
> Flowers into Flora and Flora into flowers.[14]

Arcimboldo's paintings were regarded as imaginative metamorphoses of nature, renderings of 'the natural formations' which he discovered 'in a man, a wild beast, a mountain; the sea, the plains, and similar things'[15] (Fig. 87). Their mystique does not spring from dream-images thrown up by the subconscious. They embody the mystique of science, the abstruse science of his day—intelligible to all who shared his knowledge. We share it no longer, but when we have learned to decipher his riddles and when the first shock of those weird configurations has worn off, they emerge as what they are: the sometimes pedantic or didactic, sometimes jesting and satirical illustrations of involved sixteenth century para-scientific notions. The place of these artifices was quite rightly among the curios and rarities in the cabinets of European courts.

It is evident that Arcimboldo's paintings tell us little about the artist himself; but this statement requires a qualification. Let us assume that we mistake an Arcimboldo for a twentieth century work. We would then look at it as we do at a surrealist 'paranoic picture' and see through it a complex modern personality, the artist with the intuitive or reasoned awareness of his typically post-Freudian mind. The moment we realize our chronological error, these associations vanish. Recognizing the picture as one painted by a 'pre-psychological' man, we automatically revise our judgment. Our changed attitude is governed by the fact that our knowledge of historical situations enables us to establish a generic type of personality. In spite of all their individual differences of character and conduct, painters of surrealist pictures have certain ideas, convictions, traditions, reactions, and idiosyncrasies in common, features which contribute to a recognizable type of personality. And the same is

true of sixteenth century court painters, of the grand masters of the Baroque, or the academic painters of the nineteenth century. One must be on one's guard, however, not to take the 'generic personality' for a timeless type of artist nor to mix it up with individual character.

3 Typological Theories of Psychologists: Lombroso and Kretschmer

We believe we have reasons for warning against the tendency to stereotype the artistic personality, for we cannot help feeling that psychologists were apt to confuse the individual with the type. In so far as nineteenth century psychologists were at all interested in art, their attention was focused on the psychology of the creative process, and this, for them, was tantamount to an enquiry into the old problem of genius. Lombroso, by far the most important and most influential of the older psychologists, was convinced from the outset—as we have seen in an earlier chapter— that 'genius is one of the many forms of insanity'.[16] His statistical enquiries seemed to promise objective results: he compared the reactions of creative and of insane people to the influence of sudden stimuli such as alcohol or to meteorological and climatic conditions ('thus we see that the barometer has a similar influence on the insane and the great intellects') and dicussed hereditary, racial and geographical factors. Though always admitting exceptions, he arrived at the conclusion that 'there are more than a few points where the physiology of men of genius meets with the pathology of the insane'. A welter of anecdotes and legends were to him scientific proofs of his theories. Stories—such as that told of the painter Francesco Francia, who was said to have died of joy at the sight of a painting by Raphael—confirmed his belief in the pathological excitability of great artists. He never doubted the tales about ordinary men who reputedly became outstanding in their profession after having suffered, and recovered from, accidental brain damage. They were to him further evidence of the connection between genius and mental disease.

Lombroso's encyclopedic medley aimed at a timeless definition of the artistic personality and neither works of art nor specific problems of individual artists had a place in his deliberations. His examples, it must be admitted, had devastating consequences. Far into the twentieth century other psychologists tried to beat him at his own game. Among these, the brothers Pannenborg may be mentioned. They sought to establish a typology of creative personalities (painters, sculptors, and musicians) by a statistical method—an ambitious enterprise doomed to failure.[17] They found that painters are 'unreliable' and 'unpunctual, schwärmerisch, discontented with their environment, impatient, obsessed with the notion of liberty (freiheitssüchtig), and untidy'. Sculptors, according to them, are predominantly 'men of duty, constant in their

habits, more serious, more punctual, less communicative, more reserved'; in addition, 'visionaries are lacking among them'. It is curious how similar these findings are to those of Cardanus, the famous sixteenth century philosopher, mathematician and physician, who described painters as 'fickle, of unsettled mind, melancholic, and changeable in their manners', while sculptors are generally 'more industrious and less ingenious' than painters.[18] Cardanus arrived at this distinction by a speculative rather than an analytical method as part of a typology of a great number of professional men.

Even Ernst Kretschmer followed in Lombroso's footsteps. Like the latter, he focused his attention on the physiological conditions of psychological phenomena. Chiefly concerned with demonstrating 'the fundamental biological laws of personality' he uses 'great works of art or the labours of scientists' in support of broad typological and racial theories. These lead him to pretentious generalizations of which the following gives a fair impression: 'The realistic, joyful mood of the Renaissance, with its entirely worldly, earth-loving, pleasure-seeking, constructive, artistic nature, had, in comparison with the Gothic spirit, a more cyclothymic infusion.'[19]

Whether Kretschmer's differentiation between pycnic, leptosomatic and athletic physical types and between cyclothymic and schizothymic temperaments[20] is helpful to the experimental psychologist we cannot judge. His historical conclusions, however, are deceptive, as his misrepresentation of the Renaissance shows. His influence on art historians was understandably slight. Attempts such as Pinder's,[21] Sedlmayr's,[22] Hartlaub's and Weissenfeld's[23] to apply his typology to individual artists are really begging the question. They resulted, in fact, in little more than an amplification in modern terms of the old statement that each painter paints himself.[24]

While these authors, and in particular the last two, concerned themselves with the problem of the reciprocity between the artist's character and his work, such a thought was far from Lombroso and his successors. Yet they made a considerable impact in other respects. They had shifted the inquiry into art and artists from philosophical speculations to medical research and, though misapprehending the Aristotelian concept of the 'mad' and 'melancholic' genius, had given the old tradition of the link between genius and abnormal psychological conditions a pseudo-scientific basis. In perfect accord with the prevailing scientific and moralistic tenets of their time, their seemingly watertight testimony offered an acceptable explanation for the eccentric behaviour of many artists of the waning romantic era and the anti-bourgeois, anti-social attitude of the younger generation. To many it appeared a proven fact that 'degenerates are not always criminals, prostitutes, anarchists and

pronounced lunatics; they are often authors and artists'.[25] Psychology made a travesty of the artistic personality and fostered the alienation of the artist.

4 Psycho-analytical Dialectics: The Interaction between Personality and Work

Even psycho-analysis, the offspring of nineteenth century psychology, so revolutionary in many respects, did not break with the old tradition. The time-honoured 'mad' or 'melancholic' artist became the 'neurotic' artist. When psycho-analysts turn to discussing works of art they ask what neurotic features these works reveal rather than what kind of character speaks from them. Yet within the area of our special interest psycho-analysts have made an important contribution by using the case-histories of artists to interpret their work and, conversely, by drawing conclusions from the work about the less accessible aspects of the personality. In contrast to most pre-Freudian psychologists, who neglected both the artist's individuality and his work in their search for the typical character traits of the group, and in contrast also to the old mirror-image relationship between character and work, psycho-analysts regard personality problems as the incentive behind artistic creation and the works as a new dimension added to the personality, since they result from the resolution and sublimation of repressions.[26] It is only thus that we can understand why a retiring character may be a bold painter or an outgoing personality timid in his work. It remains to consider how successful the method has been in practice.

Freud's Study of Leonardo da Vinci

When Freud prepared his study on Leonardo[27] he had to fall back on the documentary and literary material well-known to art historians. He found that Leonardo was an illegitimate child and that he had homosexual inclinations. The sources are quite explicit on these points, though other students of Leonardo have not paid much attention to them. It did not occur to them to connect Leonardo's art with his illegitimate birth, nor did their moral taboos allow them to discuss matters which, in Freud's view, were of prime importance for the understanding of the artist's character and work. Starting from some passages in Leonardo's own writings, Freud proceeded to analyse the artist's childhood memories. These, he suggested, explain Leonardo's homosexuality and solve some of the enigmas in his paintings, especially in his *Virgin and Child with St Anne*. Since Freud's study has become a classic, we need not give his arguments and interpretation here. Neither his Leonardo study nor his later psycho-analytical explorations of art and artists attracted much comment from art historians. Although Freud's influence and especially his breaking down of the barriers of moral convention is apparent in

almost every biography written since, a scholarly investigation of his analysis of Leonardo was not undertaken until forty-six years after its publication. In 1956, Professor Meyer Schapiro wrote two papers in which he showed that Freud's assumptions were based on factual errors and, in addition, pointed out some methodological shortcomings of psycho-analytical procedure when used in investigating historical personalities and works of art.[28] Schapiro's studies have recently called forth a spirited but, it seems to us, ill-tempered attack by a doctrinaire psycho-analyst.[29] Rather than enter the arena as combatants, we prefer to confine ourselves to discussing some points not sufficiently touched upon by either author.

In the biography of his great teacher, Ernest Jones says that, in writing his essay on Leonardo, 'Freud was expressing conclusions which in all probability had been derived from his self-analysis and are therefore of great importance for the study of his personality.'[30] Later Jones expresses 'the feelings that much of what Freud said when he penetrated into Leonardo's personality was at the same time a self-description; there was surely an extensive identification between Leonardo and himself'.[31] These are illuminating observations. If they are correct—and there is no reason to doubt that they are—they would lend a professional's authority to our contention[32] that psycho-analytical explications are as dependent on the personal bias of the interpreter as are other methods.

If 'much of what Freud said' about Leonardo was 'at the same time a self-description', it was surely also descriptive of the emotional responses to family relations and illegitimacy pertaining to Freud's generation and environment, but not necessarily to Leonardo's. There is no evidence that Leonardo suffered from his illegitimate birth or his separation from his mother other than Freud's own controversial analysis of Leonardo's childhood dream and of the 'slips of his pen' when he recorded his father's death.[33] Freud's interpretation was obviously based on the assumption that children born out of wedlock and separated from their mothers at an early age show the same psychological reactions everywhere and at all times. But the attitude of Italian Renaissance people towards illegitimacy differed so much from that of Victorian society that Freud's conclusions cannot be accepted. 'Natural' children of all classes usually enjoyed the same care and often also the same rights as legitimate ones.[34] That Leonardo felt entitled to be treated on equal terms with his half-brothers is proved by the fact that, his father having died intestate, he fought for his inheritance through legal action. In Leonardo's own day Giulio de'Medici's illegitimate birth did not prevent his ascension to the papal throne as Clement VII. It is hardly believable that such general indulgence should produce the same emotional

response as the intolerance of the nineteenth century. Moreover, Leonardo was adopted by his father in early childhood and this fact alone militates against any stigma attached to his illegitimate birth. No direct or secondary source tells us anything about Leonardo's relationship with his mother, a simple peasant woman who married soon after the child's birth. Nor is there anything left to indicate what kind of people she and his stepmother were. For all we know the boy may have thoroughly enjoyed the move from the maternal home into the presumably much more comfortable house of his father, a prosperous young notary.

What remains of Freud's study of Leonardo is, in Professor Schapiro's words, 'at once homage to a great master and an unforgettable rendering of the conflicts within two men of genius'.

Andrea del Sarto's Harpies: A Psycho-analytical Mystification

Three years after Freud's essay appeared, Ernest Jones published an enquiry into *The Influence of Andrea del Sarto's Wife on his Art*.[35] A pupil of Piero di Cosimo and a habitué of the eccentric gatherings in the house of Giovan Francesco Rustici,[36] the highly gifted Andrea del Sarto (1486–1531) belonged to that unruly Florentine coterie which we have discussed in previous chapters. At the age of about thirty-one he married a beautiful but low-born widow. Vasari described her in the first edition of his *Lives* as a most unpleasant woman, though in the second edition he dropped many of the unfriendly things he had said about her eighteen years before.[37] This revision has given rise to much speculation, but so far it has not yet been possible to establish the reason for his change of mind or to ascertain which of the two character-sketches was nearer the truth.[38] Jones believed in the first version and suggested that the painter's failure to attain the highest mastery in his art, despite his great gifts, resulted from his suppressed homosexuality and his feminine character which suffered from the unresolved hate-love relation to his domineering wife. He found a confirmation for this belief in one of the painter's best-known works: he noticed that on the pedestal of the *Madonna delle Arpie* (Fig. 88) there were

> ... several harpies, which are, of course, entirely out of place in a subject of this character; so far as I know it is the only instance of a pagan motif occurring in any of Andrea's works ... Critics have been completely mystified by this, but, if my suggestion concerning Andrea's unconscious attitude towards his wife is correct, it should not be difficult of explanation.[39]

Unfortunately for Jones' thesis, harpies, prominently displayed under the feet of the Virgin, are far from being 'out of place in a subject of this character'. Harpies as well as sirens and sphinxes in similar positions are

rather common in religious imagery of the period. From among many examples it will suffice to mention Filippino Lippi's *Virgin with Saints* at Prato (1498) and his *St Sebastian* at Genoa (1503) showing the same kind of motif (Fig. 89).[40] Within the context in which the ancient monsters appear they can only symbolize paganism superseded by Christianity and more specifically: the Virgin enthroned above them signifies the triumph of purity over sin.[41]

We may add that if it were true that Andrea never represented similar pagan motifs in any of his paintings, it would mean that neither his subject-matter nor the wishes of his patrons called for such representations. Like most artists of his time, he was hardly in a position to choose from a number of existing symbols the one which satisfied his subconscious urges. The *Virgin with the Harpies* was commissioned by a monk of the Minorite Order of S. Croce for the convent of the nuns of S. Francesco in the via Pentolini,[42] and in such cases the patron usually prescribed minutely what he wanted to have represented.

As an illustration of his curious disregard for national customs, we may quote an aside by Ernest Jones. In a footnote he refers to Vasari who reported that 'every morning Andrea went himself to market to select the best bits for his favourite dishes'. For Jones this is an additional proof of the artist's homosexuality; he ignores the fact that shopping for food, especially delicacies, is a male prerogative in many Italian households even to this day.

The Psycho-analytical Sesame

Our two examples of psycho-analytical studies in art, one a classic by the master himself, the other by a distinguished disciple, point to some basic weaknesses of the method: the wishful reading and interpretation of biographical and artistic data and the neglect of historical information at the authors' disposal. But, like all great scholars, Freud himself was careful in his statements and well aware of the limitations of the psycho-analytical approach to art and artists. Not all who took up and enlarged upon his theories were equally circumspect. Freud's qualified suggestions were subsequently propagated as irrefutable truths and have by now become established conventions as rigid as those which he himself set out to break. Ever since his ideas and terminology have captivated the imagination of the literary public, it has become unfashionable to cast doubt on the applicability of psycho-analytical methods to historical research. The magic words neurosis, repression, sublimation, *inter alia*, have been accepted as the open sesame to the hidden springs of the artist's creative power, although Freud himself was infinitely more modest in his claims. Ernest Jones describes 'the immense respect' which Freud 'always had for artists . . . He seemed to take the romantic

view of them as mysterious beings with a superhuman, almost divine afflatus.'[43] Even on the highest level and with such careful investigators as Ernst Kris the pattern tends to kill individuality.[44] Less perceptive psycho-analysts turn the victims of their attention into mere textbook illustrations of all the known complexes.

Take Leonardo's anatomical drawings. It has always been noted that some of them are incorrect. This was hitherto explained by the general lack of precise anatomical knowledge and the difficulties of obtaining corpses for dissection. But recently Miss Sigrid Esche has shown that his inaccurate drawings were preceded by anatomically exact ones—an indication that accuracy in detail was for him a stepping-stone towards simplification for the purpose of demonstrating and interpreting the structure and function of the human body. His anatomical drawings also served more than one purpose. Some were obviously clarifications of verbal descriptions in ancient textbooks, others would have gone into the projected anatomical atlas.[45]

The author of a psycho-analytical study of Leonardo's drawing of the anatomy of procreation (Windsor 19097) displays an almost unbelievable ignorance and naïvety in approaching material of this kind.[46] He neither concerns himself with Leonardo's working procedure nor with the methodical purpose of the drawing in question. In fact, the writer's 'observations' and remarks are so ludicrous that they defy discussion. But the worst is that Leonardo's anatomical 'slip' ('*Fehlleistung*'), the author's premise, is in reality an addition by the 'artist' who retouched the drawing for the purpose of publication. Indeed an excellent starting point from which to penetrate into Leonardo's psyche!

Convinced of having the master-key that opens all the secrets of the soul, these facile manipulators of historical material can reach a degree of purblindness and distorted judgment that has few parallels in the works of historians. As a further example we may quote the following passage about the Sistine ceiling. We are told that

Michelangelo, notably lacking a father figure, could not do justice to God in the Sistine Chapel; he succeeded only in painting an old man with a beard. This weakness of the God figure he recognized himself, as shown by his attempts to glorify it by the immediate background.[47]

Such misapprehensions discredit Freud's new mythology of the artist's personality and work and make havoc of historical situations and the entire meaning of Western art.

5 *Does a Constitutional Type of Artist Exist?*
If psycho-analysis has taught us anything, it is the infinite complexity of man's personality and the many levels of self-realization, conscious-

ness, and responses elicited. This recognition strengthens our conviction in the arbitrariness of the older typology worked out by psychologists who tended to confirm the traditional image of the alienated artist.[48] In previous chapters we have endeavoured to follow up the varying fortunes of this particular image which sprang, we found, from changing conceptions rather than from an innate, specifically artistic temper. But under certain conditions and in certain periods the artists lived up to expectation.

Throughout the pages of this book we have implied, without labouring the point, that cultural trends have a determining impact on the formation and development of character. If this statement finds acceptance, even without a lengthy exposition, it militates most strongly against the existence of a timeless constitutional type of artist. The history of the last five hundred years may be discussed in terms of the controversy about the supremacy of reason over the emotions and *vice versa*. If we want to use Freudian terminology, at times the 'id', 'the obscure inaccessible part of our personality', the pre-logical, instinctual cauldron which is controlled by the 'ego',[49] makes stronger claims than at other times when the 'super-ego', the conscious self-discipline and devotion to ideologies, takes charge. The part artists played in these changing manifestations of personality can easily be traced. It can be traced in the attitude of the public, for there are times when intellect and rationality were believed to be the sources of creative power and people looked for the cogitative faculties expressed in the artist's works. On the other hand, when feeling and sensibility reigned supreme, these were the qualities looked for and found. Progressive artists were not only aware of the prevalent trend but often led it. Their works show it and their words prove it. For the Renaissance, learning enjoyed an unrivalled prestige and the intellectual responsibilities artists took upon themselves had no mean influence on disciplining their minds. With Michelangelo, they believed that 'a man paints with his brain' and with Leonardo they agreed that 'painting has to do with natural philosophy', that it is 'truly a science' and that a painter had 'first to study science and follow with practice based on science'.

For the better part of three hundred years this ideology, which was surely character-forming, held sway despite occasional incursions against it. The first signs of a rebellion are noticeable in the sixteenth century and found expression even in Federigo Zuccari's scholastic treatise.[50] He advocated the artist's freedom to represent 'whatever the human mind, fancy or whim may invent'. But it was not until the second half of the eighteenth century that the emphasis slowly shifted. Sir Joshua Reynolds still tried to balance the two conflicting approaches to life and art. 'There may perhaps be too great an indulgence as well as

too great a restraint of imagination' he wrote in *The Idler* of October 20, 1759 (No 79). Half a generation later Blake vented his scorn against the reign of Reason in a poem of which we quote two famous lines:

All Pictures that's Painted with Sense & with Thought
Are Painted by Madmen as sure as a Groat.

The revolt of the 'naïve' and 'intuitive' against the intellectual artist had begun in earnest. Romanticism brought about the most serious change in the personality of artists and in the approach of the public to the profession. When the psychologists entered the arena, artists, backed by an 'authoritative' analysis of the psyche and armed with an up-to-date vocabulary, could state with confidence the case for a free imagination, untrammelled by book-learning. 'Self-expression' and the 'subconscious' became the infinitely complex equivalents to Zuccari's 'fancy' and 'whim'.

The Freudian and post-Freudian artist arrogates to himself a degree of subjective and moral freedom which would bewilder even his romantic precursors. When Picasso says that 'the artist is a receptacle of emotions come from no matter where',[51] or Chagall answers to a question about his pictures 'I do not understand them at all. They are not literature. They are only pictorial arrangements that obsess me';[52] when William Baziotes begins his paintings 'intuitively' and allows each work to find its 'own way of evolving',[53] or Mark Rothko strives to eliminate all obstacles 'among others, memory, history, or geometry'[54] —they may emphasize and cultivate the emotional element in artistic creation, but it requires a highly sophisticated mind to do so. Theirs is a very conscious surrender to the subconscious. Psycho-analysis has produced a new type of artistic personality with distinct characteristics of its own.

While for better or for worse psychology thus helped to shape the generic personality and character of modern artists, it can never solve the historical problem on which we have concentrated in this book. We wanted to communicate what the sources tell us about the character and conduct of artists. In order to judge and assess this material, a knowledge of the *ambiance* of the artists, of beliefs and convictions current at a given time, of philosophical thought and literary conventions is necessary.

What we see emerging is a pattern valid for all human relations: it is a composite of myth and reality, of conjectures and observations, of make-believe and experience, that determined and still determines the image of the artist. There never has been and never will be a final answer to the enigma of the creative personality for, to end with a quotation from that very great and very 'mad' painter Turner, 'Art is a rum business.'

NOTES

CHAPTER 1

1 Pliny, xxxiv, 83; Sellers, 1896, 69.

2 Archaeologists are, however, not in agreement as to whether the sculptor and architect Theodoros was one or two persons; see Thieme-Becker, *Künstler-Lexikon* XXXII, 1938, 598.

3 Vitruvius, VII, Preface, 12ff.

4 From among the abundant archaeological literature we mention for further guidance Overbeck, 1868; Sellers, 1896; Kalkmann, 1898.

5 See also Dresdner, 1915, 22ff.

6 Pliny, xxxv, 76; Sellers, 119.

7 *Ibid.*

8 Athen. xii, 543f, quoted after Sellers, p. lv. Pliny, xxxv, 71, is less explicit than Athenaios. It has been shown likely that both authors' source was ultimately Duris of Samos (see below). There seems to be no reason to regard Parrhasios' inscriptions as apocryphal; see Sellers, p. lviif.

9 Pliny, xxxv, 62; Sellers, 107.

10 Birt, 1902, 10ff.

11 Sellers, p. xlviff.; Kalkmann, 1898, 144f. For a defence of Duris, see Schweitzer, 1925, 103.

12 For the following: Birt, 1902; Dresdner, 1915, 20ff.; Poeschel, 1925; Schweitzer, 1925, 36ff.; Zilse, 1926, 22ff.

13 See, especially, Schweitzer, 68ff.

14 Pliny, xxxv, 59; Sellers, 105.

15 Pliny, xxxv, 62; Sellers, 109.

16 Xenophon, *Memorabilia* III, X, 1–8 (ed. Marchant, 1923, 231ff.).

17 Pliny, xxxv, 85.

18 *Ibid.*, 86f.

19 Sellers, lixf.; Schweitzer, 1925, 58.

20 Schweitzer, 80, 81.

21 The first passage quoted by Lactantius, *Instit.*, II, 2 (*Patr. Lat.*, vi, 258f.); the second in Seneca, *Epist. mor.* 88, 13 (1920, II, 359); see also Zilsel, 1926, 27.

22 Plutarch, ed. Perrin, III, 1916: Pericles, i, 4, 5; ii, 1; Dresdner, 1915, 33.

23 Lucian, ed. Harmon, III, 1947, Somn. 9; Dresdner, *ibid.*

24 Pliny, xxxiv, 5; Sellers, 7.

25 Petronius, ed. Mitchell, 1923, chap. 88.

26 Pliny, xxxiv, 92; Sellers, 79.

27 Pliny, xxxiv, 81; Sellers, 67.

28 Xenophon, 1947, 504 (28).

29 Pliny, xxxv, 102; Sellers, 139.

30 Pliny, xxxv, 120; Sellers, 149.

31 Jucker, 1950, 85.

32 Quoted after Coulton, 1953, 82.

33 We know inscriptions by artists from the eighth century on, see Jahn, 1960, 153. For the assessment of such inscriptions, Schapiro, 1947, 148.

34 Booz, 1956, 10.

35 Doren, 1908, 1.

36 A list of early references to the painters' guilds in eighteen northern cities in Huth, 1923, 88.

37 Knoop, 1933, 225.

38 Coulton, 1953, 370.

39 F. Sacchi, *Notizie pittoriche Cremonesi*, 1872, 324; Janitschek, 1879,78. From the statutes of August 11, 1470.

40 Huth, 1923, 10.

41 Coulton, 1953, 218, 370.

42 Doren, 1908, 769.

43 Wittkower, 1961, 297.

44 Fabriczy, 1892, 97.

45 Thieme-Becker, *Künstler-Lexikon*, *sub voce*.

46 Schlosser, 1956, 397.

47 Bottari, VI, 56–97, contains Paggi's correspondence; see particularly 83f., 89; also 189ff., 195. In addition, Soprani, 1768, I, 112ff., particularly 124–30, 136–8. Guhl, 1880, II, 37–46.

48 Soprani, 126f.

49 For this and the following Pevsner, 1940, 112ff., 32ff.

50 Condivi, 1927, 11, 16.

51 Müntz, 1878, I, 259.

52 Laborde, 1850, I, 38ff.

53 R. de Piles, 1699, 498.

54 Doppelmayr, 1730; Stetten, 1779–88; Nicolai, 1785; Schlosser, 1924, 428, 439.

55 Zils, 1913.

56 Oppenheimer, 1960, 108.

57 A list in Wackernagel, 1938, 336. For the lower middle-class parentage of medieval artists as well as for the craft running in families, see Coulton, 1953, 199.

58 Schlosser, 1924, 167f.

59 Zilsel, 1926, 159f.

60 Landucci, ed. Jervis, 1927, 2f. The artists' names mentioned are: Donatello, Desiderio, Antonio Rossellino, Castagno, Domenico Veneziano and the two Pollaiuolo.

61 Novella 84, see Sacchetti, 1946, 191; Floerke, 1913, 257. Floerke's work contains all the important material extracted from a number of authors.

62 For a somewhat different viewpoint, see Schapiro, 1947.

63 Cennini, ed. Thompson, 1932, 16.

64 Schlosser, 1912, 51; Krautheimer, 1956, 306ff.

65 For the following Janitschek, 1877, and Alberti, ed. Spencer, 1956, 40, 63, 66, 67, 79, 91.

66 Pevsner, 1940, 306; Wittkower, 1952, 4ff.

67 For the following, Zilsel, 146f.

68 Condivi, 1927, 102.

69 Clark, 1944, 20.

CHAPTER 2

1 Pevsner, 1940, 83.

2 Krautheimer, 1956, 108, 369f.

3 Jansen, 1957, 163–69. The contract of April 29, 1447, for the high altar in S. Antonio mentions four 'sculptors and disciples'. In later documents five '*garzoni*' and '*lavoranti*' appear. In addition, there were bronze casters, goldsmiths, stonecutters, masons and painters who probably did not belong to Donatello's workshop.

4 Huth, 1923, 18.

5 Wittkower, 1958, 210; also *id.*, 1955, 39f.

6 Davidsohn, 1925, IV, ii, 29; also Piattoli, 1929, 235.

7 Sacchetti, ed. Pernicone, 1946, 187; Floerke, 1913, 252.

8 Huth, 1923, 19f.

9 See chap. IX, 211, 221.

10 Coulton, 1953, 79.

11 Knoop and Jones, 1933, 105.

12 Salzmann, 1952, 123f.

13 Huth, 1923, 20.

14 Origo, 1957, 41f.

15 *Ibid.*, 42, also Piattoli, 1929, 1930.
16 Wackernagel, 1938, 289f.
17 For the following, mainly Floerke, 1905; Thieme, 1959.
18 Roger de Piles, 1699, 455.
19 Floerke, 1905, 87; Thieme, 1959, 16f.; also Pevsner, 1940, 135; Hauser 1951, 465ff.; Thieme-Becker, *Künstler-Lexikon, s.v.*
20 Huth, 1923, 77ff.
21 See chap. VIII, 205.
22 Wittkower, 1955, 179.
23 Bridenbaugh, 1942, 164.
24 See above, p. 4.
25 Coulton, 1953, 76; *ibid.*, for further details; Salzmann, 1952, 68ff.
26 Coulton, 1953, 78; Harvey, 1944, 22. Yevele also secured contracts of a more modern type.
27 Beissel, 1884, 149ff.
28 Lerner-Lehmkuhl, 1936, 54; also Wackernagel, 1938, 346ff. (chapter on regulation of prices).
29 Thieme, 1959, 18. The purchasing power of 5 escalins was sufficient for a livelihood, see Floerke, 1905, 178.
30 Antal, 1947, 282; also Wackernagel, 1938, 352.
31 Zucchini, 1942, 66ff.
32 Cennini, ed. Thompson, 1932, 3.
33 This is Zilsel's opinion, 1926, 145.
34 Villani, 1847. 47; Antal, 1947, 376.
35 Antal, *ibid.*—For the development of the *gloria* ideal, Zilsel, 1926, 117ff.
36 Janitschek, 1877, 99.
37 Ludwig, 1888, I, 120, no. 65.
38 The passage is in the section: '*De statu mercatorum et artificiorum*' of St Antonio's *Summa Theologica*, quoted by Gilbert, 1959, 76.

39 See the last note. Somewhere else he categorized architecture as a 'mechanical art'; see Coulton, 1953, 83f.
40 See chap. III, 61.
41 Campori, 1881, 138f.
42 Rooses and Ruelens, 1898, II, 261. We have modernized the old spelling.
43 Guhl, 1880, II, 356.
44 A good survey of the problem in Coulton, 1953, 371ff.
45 Lange-Fuhse, 1893, 181.
46 Zucker, 1886; Panofsky, 1943, I, 233; Rupprich, 1956, 92, 85ff., 106ff., 113, 166f., and *passim*; Saxl, 1957, 267–76. Weixlgärtner, 1949, 120ff., with some reservations.
47 Zucker, 1886, 2.
48 Panofsky, 1943, I, 233.
49 On Luther's relation to art, see Lehrfeldt, 1892, particularly 51ff.; Preuss, 1931, 51ff.; Weixlgärtner, 1949, 124ff.
50 Roth, 1906, 76ff.
51 Bier, 1925, 4f.
52 Zülch, 1943, 165ff.
53 Baader, 1862, II, 53f., 74; Seibt, 1882, 4ff.
54 E. His in Carl Brun's *Schweizerisches Künstler-Lexikon*, 1908, II; H. Koegler in Thieme-Becker, *Künstler-Lexikon, s.v.*
55 Zwinger, 1604, vol. xx, bk. iii, 3701.
56 For the following Zülch, 1938; Weixlgärtner, 1949.
57 Franz, 1933, 318.
58 Sandrart, 81ff.
59 Burckhardt, 1929, VII, 314, 328f., 344. Artists' tax declarations reveal their changing circumstances, for instance: in 1523 Christoph Bockstorfer, a reputable painter at Constance, paid taxes on property valued at 300 pounds; in 1524 at 150 and in 1525 at 45 pounds; between 1530 and 1543 he was never

assessed at more than 30 pounds. See Rott, 1933, 89.

60 Meyer, 1873, 60.

61 *Ibid.*, 61.

62 *Ibid.*, 62.

63 Wittkower, 1948, 50f.

64 Bredius, 1909; Dülberg, 1925; Rehorst 1939.

65 Gombrich, 1960, 279ff.; Wackernagel, 1938, 241.

66 In Lorenzo de' Medici's words; see Gombrich, 1960, 285.

67 Busse, 1930, 110ff.

68 See chap. VIII, 186.

69 Perosa, 1960, 23f.

70 Gaye, I, 175.

71 *Ibid.*, 192.

72 For instance, Nicolò Niccoli's friendship with Brunelleschi, Donatello and others.

73 Landucci, 1883, 59.

74 Chastel, 1959, 11ff.

75 *Ibid.*, 19.

76 Vasari, II, 630; Wackernagel, 1938, 268.

77 Frey, 1907, 77.

78 See above, p. 28.

79 Castiglione, 1948, Bk. I, L.

80 Gaye, I, 136.

81 Canuti, 1931, I, 176ff., II, 212f.

82 Beltrami, 1919, 65; translation Cartwright, 1932, I, 318.

83 Gaye, II, 71; a survey of the negotiations in Cartwright, 1932, I, 341–61; see also Walker, 1956, 17f.

84 Rupprich, 1956, I, 59: letter of October 13, 1506.

85 Golzio, 1936, 95.

86 *Ibid.*, 96.

87 *Ibid.*, 97.

88 *Ibid.*, 105.

89 *Ibid.*, 106.

90 *Ibid.*, 144.

91 Campori, 1874, 590; translation Crowe and Cavalcaselle, 1877, I, 236; Walker, 1956, 45.

92 Condivi, 1926, 67f.; Symonds, 1893, I, 441f.

93 Condivi, *loc. cit.*

94 Milanesi, 1875, cccxliii; translation Symonds, 1893, I, 155.

95 Bottari, III, 472; translation Symonds, I, 180, with alterations.

96 Letter to Giovanfrancesco Fattucci. Milanesi, ccclxxxiii; translation Symonds, I, 156.

97 Letter to Monsignor Aliotti, October 1542. Milanesi, cdxxxv; translation Symonds, I, 157f., with alterations.

98 Gaye, II, 163.

99 Letter to her court poet, Paride de' Ceresari, November 10, 1504; Canuti, 1931, II, 223, doc. 346.

100 Both letters addressed to the Florentine representatives in France, in Gaye, II, 59, 60.

101 Condivi, 1926, 53.

102 Piattoli, 1930, 101; Wackernagel, 1938, 370.

103 Lerner-Lehmkuhl, 1936, 27f.; Huth, 1923, 28.

104 Biagi, 1946, 63ff., 70ff.

CHAPTER 3

1 For full information, see W. K. Ferguson, 1948, and Erwin Panofsky, 1960.

2 For the following, see John Harvey, 1950, 40ff., 50ff.

3 Schlosser, 1891, 176.

4 Murray, 1953, 64f. Paatz, 1950, 85ff., believed that the use of terms such as '*doctus*', '*expertus*', and '*famosus*' allows us to conclude that as early as 1334 the Florentine government, when entrusting Giotto with public works, made a clear distinction between manual and spiritual values in art.

5 See note 2.

6 The documents only mention that in 1317 King Robert endorsed the payment of an annual pension to a cavaliere Simone Martini, who may or

may not have been the famous painter, but scholars are now inclined to refer the document to him; see Paccagnini, 1955, 93.

7 Panofsky, 1948, 57, 61.

8 Hahnloser, 1935, 49f.

9 For the following, see especially Vaes 1919, 181, 183.

10 Vasari, II, 337.

11 *Id.*, 338.

12 *Id.*, 339f.

13 Manetti, 1927. No unaminity exists among scholars as to whether the journey took place at some time between 1403 and 1405 or much later. For the pros and cons in modern art historical literature, see Janson, 1957, II, 99f.

14 Petrarch, ed. Fracassetti, 1859, II, 14; see Tatham, 1925, I, 338.

15 *Id.*, 1581, III, 191. *Epistolae metricae*, II, 5.

16 Alberti, 1550, Bk. VI, ch. 1. Translation adapted from Leoni's edition of 1715–20.

17 Gaye, I, 345. This letter, purportedly written in Cremona, on January 29, 1499, has often been published (e.g. Venturi, 1929, 280; Gardner, 1911, 170, English translation), but for reasons of chronology it has sometimes been assumed that either the date is wrong or even the whole letter apocryphal; see Puerari, 1957, 203, note 114.

18 Passeri, 322f. Bellori's report differs only in minor details.

19 *Ibid.*, 324. We now know that Poussin arrived in Rome early in March; see Costello, 1955, 298.

20 Holt, 1947, 373f.

21 Félibien, III, 1725, 362ff., tells Callot's early exploits in great detail.

22 Baldinucci, IV, 372.

23 Montaiglon, 1889ff.

24 Vasari, VII, 654.

25 Sandrart, 202.

26 Shaftesbury, 1732, I, 338.

27 Part of the translation after Pevsner, 1940, 197. The entire correspondence first published by Carstens' friend Fernow, 1806. See also E. Cassirer, 1919, 97–105, and Heine, 1928, 108ff.

28 Webster's *International Dictionary*.

29 Vasari, II, 289.

30 *Id.*, II, 168.

31 *Id.*, II, 204, 205, 217.

32 *Id.*, VI, 16.

33 *Id.*, VI, 241.

34 Baldinucci, III, 235f.

35 *Id.*, III, 183f.

36 Ridolfi, II, 203.

37 Bellori, II, 139f.

38 Soprani, II, 16.

39 Mengs, 1796, 23, 30.

40 Bottari, II, 38f. Ricciardi was professor of moral philosophy at Pisa.

41 Passeri, 396.

42 Neudörfer, 1875, 78f.

43 The report is by the writer Matteo Bandello (1485–1561); it introduces one of his famous *novelle*. He was educated by his uncle, the Prior of the monastery of S. Maria delle Grazie, and had therefore ample occasion to see Leonardo at work. Although at that time Matteo was only twelve years old and the *novella* was probably written about forty years later, there is no reason to doubt the essential correctness of the writer's recollection; see F. Flora, 1952, I, 646 (Part I, *Novella* 58); also Vasari, IV, 30.

44 Vasari, IV, 30f.

45 *Id.*, VI, 289.

46 *Id.*, VI, 600.

47 Richter, 1939, I, 35, no. 8.

48 Zilsel, 1926, 237ff.
49 Letter of September 1547; see Aretino, ed. 1957, II, 180.
50 Dolce, ed. Barocchi, 1960, 146, 161, 187, 201.
51 Lomazzo, 34.
52 Hollanda, 1899, 98f.; English translation, Holt, 1947, 212.
53 Sandrart, 188.
54 Vasari, V, 581.
55 Id., 583f.
56 Passeri, 296, 302f.
57 Pascoli, I, 19.
58 Wilkins, 1958, 34.
59 Petrarch, 1955, 106. On 'acidia' see below, ch. 5.
60 Letter of December 28, 1556; Milanesi, 1875, no. cdlxxix.
61 Huizinga, 1957, 123, 125.
62 Ludwig, 1888, 114, no. 58a.
63 Vasari, VI, 600.
64 Id., V, 192f.
65 Id., III, 145.
66 Ridolfi, 64f.
67 Bottari, I, 296.
68 Fernow, 1806, 102f.

CHAPTER 4

1 Kris and Kurz, 1934.
2 Piattoli, 1930, 131.
3 G. Borselli, Cronica gestorum ac factorum memorabilium civitatis Bononlae, in Muratori, XXIII, ii, 113.
4 Vasari, IV, 137.
5 Ibid., IV, 142f.
6 Ibid., pp. 279, 288, 289.
7 Cecchi, 1956, 34f.
8 Vasari, II, 598.
9 Ibid., VI, 451.
10 Gotti, 1875, I, 23; translation after Symonds, 1893, I, 80.
11 Gotti, I, 136; translation after Symonds, I, 315f.
12 Letter of December 7, 1547; Bottari, I, 71.
13 Gaye, II, 489.
14 Frey, 1897, LXXX, 2.
15 Letter of August 19, 1497; Milanesi, 1875, no. ii; Symonds, 1893, I, 79.

16 Letter of October 17 (November 17?), 1509; Milanesi, 1875, no. lxxx; Symonds, 1893, I, 221. See also Frey, 1961, no. 35.
17 Letter of October 1512; Milanesi, 1875, no. xxxvii; Symonds, 1893, I, 233.
18 Letter of January 26, 1524; Milanesi, 1875, no. ccclxxxvii; Symonds, 1893, I, 374.
19 Letter of May 1525; Milanesi, 1875, no. cccxcvii; Symonds, 1893, I, 396.
20 Letter of January 20, 1542; Milanesi, 1875, no. cdxxii; Symonds, 1893, II, 68.
21 Letter of October 1542; Milanesi, 1875, no. cdxxxiv; Symonds, 1893, II, 74.
22 Letter of October 1549; Milanesi, 1875, no. cdlxv. Frey, 1961, 151, dates this letter in 1547.
23 Frey, 1897, LXXXI.
24 Vasari, IV, 17, 21, 44, 50.
25 Kenneth Clark, 1958, 159.
26 Heydenreich, 1954, 20.
27 Ibid., 19.
28 MacCurdy, 1952, 134.
29 Id., 1945, I, 72, 86, 96, 97; 1952, 172, 207.
30 MacCurdy, 1945, II, 538.
31 Id., 1952, 209.
32 Ibid., 207.
33 Vasari, IV, 18.
34 Letter by the Carmelite Vicar-General, Fra Pietro da Novellara, to Isabella d'Este, April 3, 1501; Beltrami, 1919, 65; Cartwright, 1932, I, 319.
35 Vasari, IV, 34.
36 Ibid., 46f.
37 Bavetta, 1953, nos. 9–10.
38 MacCurdy, 1952, 117f.
39 Finished by Pompeo Ferrucci, now in SS. Trinità de' Pellegrini; Hess, 1951, 186ff.
40 Baglione, 95.
41 Bellori, I, 197f. Further on Barocci's illness, Olsen, 1955, 22.

42 Letter to Simonetto Anastagi, Urbino, October 2, 1573; Bottari, III, 84. The picture mentioned in the letter is the *Rest on the Flight into Egypt*, now in the Vatican Gallery; see Olsen, 1955, 121.

43 Gronau, 1935, 200.

44 Pollak, 1913, 4; Gronau, 1935, 208.

45 Van Mander, 1906, I, 127.

46 Malvasia, II, 49.

47 Baglione, 264f.

48 Farington, 1924, IV, 192.

49 Stillman, 1961.

50 Soprani, I, 180ff.

51 Sandrart, 195f.

52 *Ibid.*, 158. For the following Seligmann, 1948; Holmyard, 1957; Hartlaub, 1959.

53 Vasari, III, 190.

54 Vasari, V, 231ff. Vasari's account derived from Girolamo Bedoli, who had married Parmigianino's cousin; cf. Popham, 1953, 19.

55 Gualandi, 1845, II, 10, no. 153.

56 Freedberg, 1950, 87.

57 *Ibid.*, 256; Popham, 1953, 20.

58 Vasari, IV, 483f.

59 Vasari, VI, 608f.

60 Soprani, II, 120f.

61 Baglione, 126.

62 Baldinucci, III, 637f.

63 Sandrart, 199.

64 Vasari, IV, 315f.

65 Hollanda, 21.

66 Armenini, 231, 236.

67 Lomazzo, 33.

68 Pini, 1548; see Barocchi, 1960, 136f. Cennini had already voiced similar demands, see chap. I, 14f.

69 Ficino, *Opera omnia*, Bâle, 1576, 229; quoted after Gombrich, 1945, 59.

70 Gutkind, 1938, 234.

71 Richardson, 1715, 34, 199, 201.

72 Du Bos, 1746, II, 19f., 54, 96, 366. For the concept of the 'balanced genius' see also below, chap. XI, 279.

73 De Piles, 1715, 518.

74 See below, p. 237.

75 Sandrart, 156, 157.

76 Magurn, 1955, 393.

77 *Ibid.*, 288.

78 *Ibid.*, 77.

79 *Ibid.*, 102.

80 Rooses-Ruelens, 1898, II, 156.

CHAPTER 5

1 Janitschek, 1877, 90f.

2 Ficino, 1561, II, 1365. See also Chastel, 1954, 129ff.

3 See, among others, the excellent treatment in Yates, 1947, 80ff. and *passim*.

4 *De tranquillitate animi*, XVII, 10–12; see Seneca, 1932, II, 285. According to Seneca the sentence is Aristotle's. As such it had already been quoted by Petrarch in *De secreto conflictu* (1955, 174).

5 Pilgrim, 1893, 368.

6 Zilboorg, 1941, 462ff.; Lange-Eichbaum, 1956, *passim*. See also below, chap. XII.

7 Courbon, 1906, 44f.

8 Lange-Eichbaum, 1942, 244. See also the recent statement by J. Portnoy: 'Artists tend to be neurotic personalitities' (*Journal of Aesthetics and Art Criticism*, XIX, 1960, 193).

9 Lowenfeld, 'Psychic Trauma and Productive Experience in the Artist', in *Art and Psychoanalysis*, 1957, 298.

10 Dracoulidès, 1952, 16.

11 *The Maxims of Marcel Proust*, edited and translated by Justin O'Brien (New York, 1961).

12 Trilling, 'Art and Neurosis', in *Art and Psychoanalysis*, 1957, 503.

13 Lamb, 1859, 434.

14 Pelman, 1912, 218.

15 Frankl, 1958, 291

16 See the work by Adele Juda, 1953, and the paper read by Eliot Slater and Alfred Meyer at the meeting of the Osler Society, 1959; report London *Times*, July 10, 1959.

17 Schneider, 1950, 9.

18 See above, pp. 53, 61f., 63, 90.

19 Pasto and Kivisto, 1953, 81f.

20 See above, p. 92.

21 Phillips, 'Introduction: Art and Neurosis', in *Art and Psychoanalysis*, 1957, p. xiv.

22 See Taylor, 1928, 588.

23 Aristotle, *Problemata*, XXX, 1. (English, 1927, VII, 953²ff.) Text in Panofsky-Saxl, 1923, 93ff. We want to acknowledge our indebtedness to this remarkable work for the following pages.

24 Panofsky-Saxl, 1923, 20ff.

25 *Ibid.*, 32ff., 104ff. (Ficino's text.) Others took up this idea from Ficino; for instance, the physician Girolamo Fracastoro (1483–1553) in his *Turrius sive de intellectione*; see Zilsel, 1926, 277.

26 Boll, 1926, 48.

27 Babb, 1951.

28 *Ibid.*, 75f.

29 Vasari, II, 285.

30 *Ibid.*, III, 78.

31 Warburg, 1932, 529.

32 For a detailed analysis of the engraving, see Panofsky-Saxl, 1923.

33 Letter by the Ferrarese ambassador Paulucci, December 17, 1519; *ibid.*, 31. References to melancholy are less common in the seventeenth century, but see, for instance, Reni's 'natura malinconica', mentioned by Malvasia, 1678, II, 59, in addition to the cases referred to in chap. IV and the present chapter.

34 This was convincingly demon-strated by Redig de Campos, 1946, 83ff.

35 See above, p. 74.

36 Romano Alberti, *Trattato della nobilità della pittura*, Rome, 1585, quoted in Panzacchi, 1902, 303; see also Panofsky-Saxl, 1923, 31.

37 Bright, 1586, chap. XX.

38 J. L. Vives, *De anima ed vita*, Bâle, 1538, iii; quoted after Zilboorg, 1941, 191.

39 S. Teresa, edited Burke, 1911, chap. vii.

40 Walker, 1958, 5.

41 *Ibid.*, 6.

42 Bandmann, 1960, 11ff.

43 Pini, 1548; ed. Barocchi, 1960.

44 *Ibid.*, 97.

45 *Ibid.*, 132.

46 *Ibid.*, 135. The therapy was of course traditional. The word *virtù* in the sense of quality or efficacy of performance is common in the sixteenth century, see, for instance, Daniele Barbaro, in his Vitruvius commentary of 1556 (I,i,): '*La virtù consiste nell' applicazione*', i.e., *virtù* is the care with which theory is translated into practice or idea into form.

47 For this and the following, see chap. IV, p. 92ff.

48 Hartlaub, *Caspar David Friedrichs Melancholie*, 1951, 217.

49 Burton, edited Dell and Jordan-Smith, 1955. For Seneca, see above, p. 99.

50 A good introduction to Burton is Babb, 1959. Evans, 1944, stresses Burton's modernity.

51 Forty-one editions appeared in the course of the nineteenth century.

52 Grube, 1881; Kettlewell, 1882.

53 For Thomas à Kempis (1380–1471), see Kettlewell, 1882.

54 For the Latin text and German translation of the Chronicle,

see Sander, 1912, 519ff., 543ff. French translation in Destrée, 1914, 12ff., 219 (Latin, 215ff.). The chronicle was written between 1509 and 1513.

55 See above, p. 106.

56 According to medieval terminology *frenesis* comprised also melancholy.

57 Sander, *op. cit.*, has shown that Ofhuys had carefully studied Galen.

58 Dupré and Devaux, 1910; Destrée, 1914, 16ff., 67.

59 Thomas à Kempis, *De imitatione Christi*. A convenient modern English edition in the Penguin Classics, 1952.

60 Grube, 1881 and 1886.

61 Kettlewell, 1882, II, 120ff.

62 Heiler, 1923, 261ff.

63 As a rule the *Death of the Virgin* is dated before Hugo's illness; see Panofsky, 1953, 337.

64 Bottari, II, 486f.

65 Baglione, 102.

66 Tietze, 1906–7, 147, n. 1.

67 Mancini, 1956, I, 218.

68 Chantelou, 1885, under July 22, 1665.

69 Bellori, I, 86.

70 Sandrart, 275.

71 Malvasia, I, 327.

72 Mancini, I, 219.

73 For an able interpretation of the work of Annibale's latest period, see Posner, 1960, 1ff.

74 See chap. XII, p. 287.

75 Malvasia, II, 96ff.

76 *Ibid.*

77 Sandrart, 162.

78 Weizsäcker, 1936, note 174.

79 Magurn, 1955, 53f.

80 But Rubens' use of the word *acedia* may mean that he regarded his friend as melancholic; on *acedia* see above p. 102; also Saxl, 1957, 296.

81 Passeri, 112.

82 Bellori, II, 14.

83 Passeri, 114f.

84 Bellori, II, 11.

85 Passeri, 114.

86 Evelyn, ed. de Beer, 1955, V, 38.

87 Baldinucci, V, 341f., 349f.

88 *Id.*, V, 354.

89 *Id.*, V, 355.

90 *Id.*, V, 358f.

91 Kris, 1932, 169ff. A summary of this long study, incorporating new aspects, appeared in *Psychoanalytic Explorations*, 1953, 128ff., as chapter 4 of Part II which is entitled: *The Art of the Insane*. For most of the facts about Messerschmidt's life we are indebted to Dr Kris's studies.

92 For the full German text, see Kris, 1932, 174. We translated the German: '*der alle übrigen Professores und Directores für seine Feinde hat*', as 'towards whom all the other professors and directors are hostile', while, Kris, 1953, 130, translates: 'he believes all other professors and directors to be his enemies' and regards this belief as 'among the first symptoms of his illness' (p. 149). The interpretation of this passage is important, since Kris bases his proof of Messerschmidt's persecution mania on it. If our translation is correct, Messerschmidt was not wrong in considering himself 'a victim of the academic gang'.

93 The visitor was Johann Georg Meusel; see Kris, 1932, 228. Appendix.

94 Friedel, *Briefe aus Wien*, 1784; see Kris, *ibid*.

95 Nicolai, 1785, VI, 401ff., also for all following quotations from Nicolai.

96 Nicolai had heard this from people who had known Messerschmidt in Rome.

They also told him that the young German lived very simply, more like a labourer than like other foreign art students who usually had grants or scholarships.

97 Kris, 1953, 131.

98 Ilg, 1885.

99 Feulner, 1929, 44.

100 Tietze-Conrat, 1920, 29.

101 Fuelner, *ibid.*

102 Tietze-Conrat, *ibid.*

103 Kris, 1953, 132.

104 *Id.*, 138.

105 Fessler (1756–1839), the most interesting among Messerschmidt's sitters, began his career as a Capuchin monk in Vienna, was released from the Order and became professor of oriental languages at the University of Lemberg (1784), organized the Berlin Freemason's Lodge (1797), and finally was made Bishop of the Evangelical Church in Russia (1819). See Wurzbach, *Biographisches Lexikon des Kaisertums Oesterreich*, Vienna, 1891.

106 Panofsky, 1939, 213ff.

107 The titles of the individual busts are to a certain extent misleading. They were added after Messerschmidt's death.

108 Kris, 1953, 136: 'In the majority of busts a comprehensible expressionhasnotbeenachieved'; p. 144: 'Messerschmidt's busts frequently convey an impression of disunity of expression; certain separate mimic elements appear to be in distinct opposition to others.'

109 *Ibid.*, 144.

110 *Ibid.*, 134f., for a fuller statement.

111 It goes back to Vitruvius' introduction to his third book.

112 For Ficino's and later philosophers' belief in demonology, see Walker, 1958.

113 A. Marx, 1929.

114 Kris, 1953, 142.

115 *Ibid.*, 145f., 150.

116 *Ibid.*, 141. Other authors, essentially in sympathy with him, are referred to by Kris.

117 Kris, 1953, 129.

CHAPTER 6

1 Zilboorg, 1936, 271.

2 We are grateful for valuable information to Colin Eisler, S. J. Gudlaugsson, and J. B. Trapp.

3 Vasari, V, 208, 210.

4 Pelman, 1912, 69f.

5 The pitfalls of statistics have been clearly recognized by modern scholars; see, e.g., George Simpson's Introduction to Durkheim, 1951, 18ff.

6 Morselli, 1882, 244.

7 Fedden, 1938, 145.

8 But according to Durkheim, 1951, 368, 'suicide increased only slightly up to the eighteenth century'.

9 Motta, 1890.

10 Bartel, 1960, 145, also for the following quotation. It should be noted that in the nineteenth century England seems to have had fewer suicides than any other European country; Durkheim, 1951, 160.

11 Bartel, 1960, 149.

12 Fedden, 1938, 155.

13 Piker, 1938, 97ff.

14 Fedden's is an exception.

15 Zils, 1913, 192. The passage comes from Albert von Keller's autobiography.

16 Letter by Annibale Caro, February 16, 1538; Bottari, III, 199.

17 Vasari, V, 167.

18 *Ibid.*, 170.

19 *Ibid.*, 169.

20 *Ibid.*, 172f.

21 Kusenberg, 1931, 1.

22 Roy, 1920, 82–93.

23 *Ibid.*, 92.

24 Durkheim, 1951, 327.

25 Roy, 1920, 88.

26 Venturi, 1929, IX, iv, 1261.

27 Baglione, 61.

28 Ridolfi, I, 399.

29 Verci, 1775, 156f.

30 Hempel, 1924, 47.

31 Pascoli, I, 302.

32 Portoghesi, 1958, 17: from Bellori's marginal notes to Baglione.

33 Chantelou, 1885, entry of October 20, 1665.

34 Passeri, 365f.

35 Bertolotti, 1881, II, 32ff.

36 Pascoli, I, 302.

37 Passeri, 365.

38 Pascoli, I, 303f.

39 Bertolotti, 1881, II, 37ff.

40 Marabottini, 1954, 116.

41 Passeri, 184.

42 Baldinucci, V, 314f.

43 Sandrart, 289.

44 Fogolari, 1913, 365. The notebook (*Zibaldon*) by an anonymous author is now in the library of the Seminario patriarcale, Venice.

45 Houbraken, 1880, 156, writes that Pieter van Laer committed suicide by drowning. He may have derived this information from Roger de Piles, 1699, 427. But Sandrart, Pieter van Laer's close friend does not mention suicide and the well-informed Passeri (see p. 160) writes that he died of syphilis. About de Wolfe, Houbraken, 406f.

46 *Ibid.*, 124ff.

47 Woodward, 1949, 35.

48 Edwards, 1808, 285.

49 Lépicié, 1752, II, 114.

50 Dezallier d'Argenville, 1762, IV, 423f.

51 Lépicié, 1752, II, 115f.

52 *Nouvelles archives de l'art français*, 2ᵉ serie, VI, 1885, 206.

53 Hannover, 1907.

54 Justi, 1898, II, 75ff.

55 Tesdorpf, 1933, 78.

56 Sedlmayr, 1930, 117ff. For a criticism of Sedlmayr's hypothesis, see also Kris, 1932, 172.

CHAPTER 7

1 For Perini and Febo di Poggio, see Frey, 1961, 78, 105, 365f.; *id.*, 1897, 504f. For Luigi del Riccio and Cecchino Bracci, see Steinmann, 1930 and 1932; Frey, 1897, no. lxxiii, 355ff.

2 Frey, 1961, 166; Michelangelo's letter of March 7, 1551; Symonds, 1893, II, 97. On Michelangelo and Vittoria Colonna, Tolnay, 1960, V, 51ff.

3 Eissler. 1961, 131.

4 Panofsky, 1939, 180.

5 Steinmann-Wittkower, 1927, 56, no. 307.

6 E.g. Gotti, 1875, I, 231.

7 C. Frey, 1892, 104; *Facezie*, 1622, edited Floerke, 1913, 78.

8 Bode, 1921, 197.

9 Manetti, edited Toesca, 1927, 21.

10 Malvasia, 1678, II, 72.

11 The Italian *torre* stands for *togliere:* 'take a woman', i.e. marry.

12 Golzio, 1936, 31.

13 Vasari, IV, 366f.

14 Passavant, 1860, II, 281.

15 Portigliotti, 1920, 23ff.

16 Golzio, 1936, 181ff. The following is a free translation of a poem on the back of a sheet in the Ashmolean Museum, Oxford. All the drawings with love-poems are illustrated and discussed in Fischel, 1925, *Abteilung* 6, 306ff.

17 Vasari, IV, 355.

18 *Ibid.*, 382.

19 Golzio, 1936, 30. Internal evidence allows us to date this letter in 1514. The autograph is lost and problems presented by the letter are discussed by Golzio.

20 See above, p. 91ff.

21 Vasari, II, 620f.

22 Documents published by Milanesi, in Vasari, III, 490.

23 *Ibid.*, II, 628.

24 Milanesi, in Vasari, II, 633ff.

25 Lucrezia's father had died in 1450 when she was 15; Vasari's remark about the father's grief is therefore incorrect.

26 Villari and Casanova, 1898, 43.

27 Vasari, II, 520; Maritain, 1946, 55.

28 *Ibid.*, 163.

29 Schapiro, 1947, 131.

30 Milanesi, 1856, III, 281; Bacci, 1929, 130ff.

31 Drey, 1927, 16, 113f.

32 *Ibid.*, 22, 116.

33 Vasari, IV, 467.

34 *Ibid.*, IV, 222.

35 Vasari uses the word *giostra*, i.e. tournament. The use of such words for erotic matters was common in the Middle Ages; see Huizinga, 1924, 151.

36 Vasari, IV, 225.

37 *Ibid.*, V, 630. The translation is de Vere's, VI, 223f.

38 Baglione, 60.

39 Passeri, 74. According to Passeri, van Laer died of the disease. For another tradition, see chap. VI, note 45.

40 Sandrart, 183.

41 Baldinucci, III, 725f.

42 *Ibid.*, V, 431.

43 Letter of March 18, 1647; Pollak, 1913, 54.

44 Baglione, 75.

45 Prota-Giurleo, 1953, 68ff.

46 This and the following documents in Bertolotti, 1876,

193–220; Orbaan, 1927, 158; Passeri, 122.

47 Sexual relations with a sister-in-law, while the wife was alive, were regarded as incestuous.

48 Passeri, 118.

49 Hess, 1935, 34.

50 Sandrart, 209.

51 Mancini, 1956, I, 252.

52 Passeri, 117 and *passim*.

53 *Ibid.*, 128.

54 Morpurgo, 1921, lxii, no. 85.

55 Letter of September 8, 1506. Heidrich, 1918, 143.

56 Conway, 1958, 55.

57 Heidrich, 1918, 139.

58 For the following, among other writings, Huizinga, 1924, 146ff., Burckhardt, 1944, 261 (chapter: Morality and Religion); Robb, 1935, 176ff.

59 Symonds, 1877, II, 254ff.; Vittorio Rosso, *Storia letteraria d' Italia. Il Quattrocento* (Milan 1938), 127ff.

60 A. della Torre, 1902, 297.

61 Castiglione (1528), adapted from Sir Thomas Hoby's translation (1561), 1948, 315, 317.

62 Landucci, 1883, 346. The English translation by Alice de Rosen Jervis, 1927, 274, is doctored so as to make the passage more palatable for modern readers.

63 *Ibid.* Again, this passage was suppressed in the English translation.

64 Sandulli, 1934, 305.

65 Davidsohn, 1927, IV, iii, 320.

66 Villari and Casanova, 1898, 61, 63.

67 *Ibid.*, 507.

68 Landucci, 1883, 251. English translation, 201.

69 *Ibid.*, 273f., and (English translation) 218.

70 Davidsohn, 1927, IV, iii, 321.

71 Burckhardt, 1908, II, 362, 363.

72 Beltrami, 1919, 4f.

73 The entire material for the following was well assembled by Möller, 1928, 139ff.

74 Eissler, 1961, 111. The original text and translation in Richter, 1939, I, 385, no. 676.

75 Eissler, *loc. cit.*

76 Vasari, VI, 379.

77 *Ibid.*, 380.

78 *Ibid*, 386f.

79 G. della Valle, 1786, III, 244. We have to thank Professor Mario Praz for his generous help in translating this difficult document. The puns and obscene allusions of the original cannot be rendered in English.

80 Kupffer, 1908, 80, 162.

81 Eekhoud, 1900, 277ff.

82 Sandrart, 234.

83 Vasari, III, 277, n. 2.

84 *Ibid.*, V, 71.

85 Baldinucci, IV, 634.

86 *Ibid.*, V, 213ff.

87 Soprani, II, 205.

88 *Rep.* 401b. In F. M. Cornford's translation, 1941, 87f.

89 Janitschek, 1879, 78.

90 Wackernagel, 1938, 300; Schnitzer, 1923, I, 392ff., II, 807f.

91 Blunt, 1940, 118, in an illuminating chapter on 'The Council of Trent and Religious Art'.

92 The entire letter translated in Symonds, II, 51ff.

93 Rosa, 1892, I, 237f.

94 Bottari, III, 532ff.; the entire letter translated in Holt, 1947, 252.

95 For Ammanati's relation to the Jesuits, Pirri, 1943, 6ff.

96 Vasari, IV, 188.

97 Brosses, 1931.

CHAPTER 8

1 Walpole, 1937, V, 221f.

2 For this and the following, Baader, 1860, I, 14ff.; Lochner, in Neudörfer, 1875, 86ff.;

Lossnitzer, 1912, 94ff., and xxvff.—Stoss had invested the sum with a merchant, Jacob Baner. The latter repaid the money and on his advice Stoss reinvested it with another merchant who embezzled it. Stoss argued that his misfortune was due to Baner's ill advice. The faked promissory letter, Stoss believed, would convince the court that Baner had not yet returned the money.

3 Zülch, 1938, 50.

4 Bredius, 1916, 47ff.

5 Pascoli, I, 177ff.

6 Landucci, 1883, 93; English translation by A. de Rosen Jervis, 1927, 77.

7 *Ibid.*, 305, 308; English translation 243, 245.

8 Burckhardt, 1944, 275.

9 Landucci, 1883, 258f.; English translation 206.

10 Butzbach, 1869 and 1933.

11 Davidsohn, 1900, II, 184; 1922, IV, i, 327ff.; 1927, IV, iii, 221f.

12 Landucci, 16. The document appears in a note by the editor I. del Badia. English translation, 14.

13 Schlosser, 1912, I, 44 (Comm. II, 18); Schlosser, II, 89, has shown that the passage derives from Vitruvius, bk. VI, preface, 2. Our translation is Middlemore's (in Burckhardt, *The Civilization of the Renaissance*, 1878, republished 1944, 84).

14 Salzman, 1927, 215.

15 Burckhardt, 1944, 274.

16 Cellini (Roscoe's translation) 1847, 338.

17 Price, 1914, 727. For other psychiatric studies, see Lange-Eichbaum, 1956, 507.

18 Goethe, 1910, vol. IX, 471 (in the Appendix to Cellini's *Life*).

19 Mabellini, 1885, 119.
20 For the following particularly Greci, 1930, 10ff. A synopsis of Cellini's affairs is impressive. He was involved in serious brawls in 1516, 1523, 1524, c. 1541, 1556; theft (unproven): 1538, 1545; sodomy: 1523, 1543, 1548, 1557; homicides: 1529, 1534, 1540.
21 Cellini, edited Roscoe, 1847, 486.
22 Bottari, V, 247ff., also for the quotations below.
23 Venturi, 1937, X, iii, 400.
24 Bottari, III, 156. The letter is dated April 1546.
25 Letter addressed to Philip II, July 12, 1559. Crowe and Cavalcaselle, 1877, II, 513ff.
26 Proske, 1956, 10.
27 Documentation for the following in Bertolotti, 1881, II, 19, 49–76. Italian text and English translation of all the relevant documents (supplementing Bertolotti) in Friedlaender, 1955, 269–93.
28 Friedlaender, 1955, 289.
29 Id., 1948, 27ff.
30 Rott, 1933, 8ff. Like Caravaggio, Witz seems to have enjoyed street brawls which brought him into conflict with the police.
31 Imprisoned; later accused of having killed his wife. But the documents are not conclusive, see Puerari, 1957, 76ff.
32 Venturi, 1932, IX, iv, 319; Borghesi and Banchi, 1898, 444f.
33 Baglione, 241, talks about him as 'the swashbuckler and the furious and crazy killer'.
34 Prota-Giurleo, 1953, 85f.
35 Palomino, 1947, 989ff.; Wethey, 1955, 12ff., believes that the stories regarding Cano's violence can be disproved.
36 Bertolotti, 1881, I, 70.
37 Ibid., 71.
38 Ibid., II, 65f.
39 Ibid., 65f.
40 Baglione, 147.
41 Passeri, 226ff.
42 Ibid., 233.
43 Crinò and Nicolson, 1961, 144.
44 Bertolotti, 1881, II, 61ff.
45 Baglione read the letter in court on September 13, 1603.
46 From Gentileschi's deposition in court, September 14, 1603. Bertolotti 1881, II, 63. See also Friedlaender, 1955, 278f.; Martinelli, 1959, 82ff.; Salerno, 1960, 103.
47 The text says: 'avrebbe fatto assai buon profitto nella virtu'. For the interpretation of virtù as 'quality of work', see above, chap. 5, note 46.
48 Baglione, 245.
49 Bertolotti, 1881, II, 84.
50 Cellini, 1906, I, 278 (Bk. I, lxxiv).
51 Carré, 1891, 499f.
52 Max J. Friedländer's phrase in On Art and Connoisseurship.
53 See the pertinent remarks by Mitchell, 1960, 455ff.
54 Vasari, VII, 550.
55 Translation by Symonds, 1893, I, 50, from Condivi. There is no reason to regard this story as apocryphal, as has been suggested; see Tolnay, 1943, 202.
56 Neudörfer, 1875, 198.
57 Hogarth himself reminisced: '. . . after having had my plates pirated in almost all sizes, I, in 1735, applied to Parliament for redress, and obtained it in so liberal a manner as hath not only answered my own purpose, but made prints a considerable article in the commerce of this country.' Ireland, 1798, III, 35; Dobson, 1891, 50f.

58 Baldinucci, V, 95. According to Kitson and Röthlisberger, 1959, 14ff., 328ff., Claude started the *Liber Veritatis c.* 1635, mainly to protect his reputation.

59 Guillet de Saint-Georges, 1854, I, 88f.

60 *Ibid.*

61 Félibien, 1725, IV, 265.

62 Jentsch, 1925, 228ff.

63 The literature on faking is vast; see Robert G. Reisner, *Fakes and Forgeries in the Fine Arts. A Bibliography*, New York, 1950, with 859 references. The best book on the subject: Kurz, 1948.

64 Baglione, 149f.; Kurz, 1948, 32.

65 Smith, 1949, 5f.

66 *Ibid.*, 122.

67 *Ibid.*, 175. The landscapist Robert Crone died in 1779.

68 Bertolotti, 1880.

69 *Id.*, 1881, I, 147.

70 *Ibid.*, I, 128f.

71 Gotti, 1875, I, 203; Symonds, 1893, I, 440.

72 For this and the following full documentation in Bertolotti, 1881, I, 143f., II, 126–61.

CHAPTER 9

1 Wickram, 1555; modern edition, 90.

2 Vasari, IV, 118f.

3 Malvasia, 1678, I, 366. For the modern point of view, see Gnudi, 1956, 71, with further literature.

4 Van Mander, 1936, 216.

5 Baldinucci, III, 373.

6 Passeri, 287ff.

7 Smith, 1949, 59.

8 *Ibid.*, 1.

9 *Ibid.*, 182.

10 *Ibid.*, 180f.

11 *Ibid.*, 108f.

12 *Ibid.*, 227.

13 *Ibid.*, 193f—Sir William Beechey, R.A., painter, 1753–1839.

14 Woltmann, 1874–6, II, 43.

15 *Ibid.*, II, 42.

16 Gantner, 1960, 202, 205, and *passim*, with further references.

17 Woltmann, 1872, 195.

18 Trivas, 1941, 9.

19 Houbraken, 48.

20 Sandrart, 170.

21 Collins, 1953.

22 Houbraken, 218.

23 *Ibid.*, 136.

24 Sandrart, 174.

25 Bredius, 1915ff., I, 203, 212f.; VII, 141.

26 *Ibid.*, I, 9ff., 25.

27 De Vries, 1948, 17. For the following, 19f.

28 Bredius, 1910, 62ff.

29 *Ibid.*

30 Schultze, 1867.

31 Pelman, 1912, 130.

32 Burton (first edition, 1621), 1927, 198, 199. The passion for liquor persisted. In 1750 Fielding (*An Enquiry into the Causes of the Late Increase of Robbers*) estimated that in twenty years there would be few of the common people left to drink gin if drinking were 'continued in its present Height'. A year later Hogarth published his plate *Gin Lane*—the most cynical indictment of this vice.

33 Cudell, 1927.

34 Dézallier D'Argenville, 1762, III, 219. (First edition 1745–52.)

35 *Reizen van Cornelis de Bruyn door de vermaardste delen van Klein Azie*, Delft, 1698; quoted by Hoogewerff, 1952, 109f.

36 Passeri, 73.

37 Dézallier D'Argenville, 1762, III, 219.

38 Houbraken, 270f.

39 Vasari, VI, 609ff.

40 Cellini, 1847, 59ff.

41 Gronau, 1932, 503f.
42 Vasari, II, 681.
43 *Ibid.*, IV, 164. See also below, chap. XI, p. 263.
44 Passeri, 357f.
45 *Ibid.*, 352f.
46 *Ibid.*, 95.
47 *Ibid.*, 95f.
48 Malvasia, 1678, 45, 47, 57, *passim.*
49 Baldinucci, IV, 21f. Compare also Sandrart, 280f.
50 Soprani, I, 141f.
51 *Ibid.*, I, 277.
52 *Ibid.*, I, 314f.
53 *Ibid.*, II, 171.
54 Martínez, *Discursos practicables*, quoted after Aznar, 1950, 175.
55 Pacheco, 1956; see Cossio, 1908, 477.
56 Translation in Byron and Rice, 1931, 181.
57 Aznar, 1950, 169ff., Marañón, 1956, 291ff.
58 Meyer, 1873, 10; Hieber, 1923, 10.
59 Sandrart, 154.
60 Baldinucci, V, 303f.
61 Seznec and Adhémar, 1960, 115; Hautecœur, 1950, III, 269, also for further information about the artist.
62 Wackernagel, 1938, 353, for instance, thinks that Donatello is an early example of 'the outspoken indifference of artists towards money and other property'.

CHAPTER 10

1 Pliny, ed. Sellers, 1896.
2 Politian, ed. Wesselski, 1929, 27.
3 Castiglione, 1960, 178 (bk. II, lxxvi).
4 Gougenot, 1854, 217f.
5 Colasanti, 1905.
6 Vasari, VI, 182.
7 Colasanti, 1905, 413ff., 423; also Vasari, VI, 195.

8 Colasanti, 423.
9 *Ibid.*, 438.
10 *Ibid.*
11 Gaye, II, 278f.
12 Colasanti, 1905, 439.
13 *Ibid.*, 434.
14 *Ibid.*, 428.
15 *Ibid.*, 430.
16 Vasari, VII, 42.
17 Pevsner, 1940, 39ff.
18 One by Agostino Veneziano with date 1531; the other, undated, by Enea Vico. Bandinelli referred proudly to '*mia accademia*' (Colasanti, 1905, 429) and the earlier engraving; the later was probably published after he had dictated his memoirs. See also Pevsner, *loc. cit.*
19 Best survey, Chastel, 1954, 7ff.
20 About this process, Yates, 1947. Also Pevsner, 1940, 8ff.
21 Pevsner, 42ff.
22 *Ibid.*, 298.
23 Drey, 1910, 51 note.
24 For the following Missirini, 1823, 23ff., 27ff., 36.
25 Letter of July 21, 1593; Gronau, 1935, 226.
26 Missirini, 1823, 65; Körte, 1935, 9 and *passim*; Heikamp, 1959, 176.
27 Baldinucci, V, 439.
28 *Ibid.*, V, 454.
29 Ozzola, 1908, 57ff.
30 Baglione, 134.
31 Houbraken, 1880, 182.
32 Hogarth, 1833, 25.
33 Dézallier d'Argenville, 1762, IV, 81.
34 Lépicié, 1752, I, 113.
35 For the following, Fleming, 1955, 118ff.
36 Baglione, 255.
37 Passeri-Hess, 122.
38 Malvasia, 1678, II, 59.
39 Baldinucci, IV, 620ff.
40 Pascoli, I, 131f.
41 Wittkower, 1948, 50f.
42 Dufresnoy, 1695, 348.

43 Roger de Piles, 1699, 441.
44 Baldinucci, III, 149.
45 Malvasia, II, 188.
46 Fleming, 1955, 118ff.
47 Sandby, 1862, 42.
48 Frey, 1930, II, 31–48: for full documentation of these events see also A. del Vita, 1958, 15ff.
49 Baglione, 183; also 177.
50 Chantelou, 1885: the events took place on October 6, 1665.
51 Depping, 1855, IV, 538.
52 Bellori, I, 258.
53 Letter of June 10, 1690. Bottari, II, 85.
54 Northcote, 1898, 223.
55 Passeri-Hess, 22.
56 Malvasia, I, 295.
57 *Ibid.*, 23, 68.
58 Passeri-Hess, 264.
59 Malvasia, II, 177f.
60 Baldinucci, IV, 54.
61 Malvasia, II, 13.
62 Pastor, 1927, XI, 648.
63 Baldinucci, IV, 230–33. Giovanni da San Giovanni's fresco of the *Night* is in the ballroom of the palace.
64 Passeri-Hess, 108.
65 For the following, Bertolotti, 1876, 129ff.; Lanciarini, 1893, 107ff., 117ff.; Heikamp, 1959, 185ff.; *id.*, 1960, 45ff.
66 See also Körte, 1935, 75f.
67 For the following, Bellucci, 1915; Costantini, 45ff.
68 Passeri-Hess, 56.
69 Bottari, V, 88f.
70 Passeri-Hess, 64f.
71 *Ibid.*

CHAPTER 11

1 Lerner Lehmkuhl, 1936, 36ff., 50, and *passim*.
2 Hauser, 1951, 466.
3 Wittkower, 1958, 211.
4 Waldburg-Wolfegg, 1939, 13.
5 Vasari, IV, 15.
6 Cellini, 1847, 126.
7 Ridolfi, I, 249.
8 Gaye, I, 141f. For other examples, see Wackernagel, 1938, 354.
9 Bottari, VIII, 28f.
10 *Ibid.*, VIII, 31. See also Kristeller, 1901, 496ff., for further letters; and Levi, 1931, 63f., for the bust of Faustina.
11 Gaye, III, 440–43.
12 Dhanens, 1956, 350, 354.
13 Gaye, III, 468ff.
14 We owe this information to Professor James Holderbaum's kindness.
15 Pieraccini, 1925, II, 144.
16 Giovannozzi, 1932, 505ff., also for the following.
17 Gaye, III, 536.
18 Giovannozzi, 1932, 522.
19 Antal, 1947, 282.
20 Krautheimer, 1956, 7ff., 365, and *passim*.
21 Wackernagel, 1938, 353ff., supplies more material for the financial position of Florentine artists.
22 Symonds, 1893, I, 149.
23 Weixlgärtner, 1914, 19.
24 Heidrich, 1918, 37f.
25 *Ibid.*, 38.
26 *Ibid.*, 39.
27 *Ibid.*, 37.
28 *Ibid.*, 48.
29 Reicke, 1940, IV, 500.
30 Heidrich, 1918, 114.
31 *Ibid.*, 116.
32 *Ibid.*, 112.
33 *Ibid.*, 176.
34 Golzio, 1936, 56, 60, 102, 108, 116f., and *passim*.
35 Crowe and Cavalcaselle, 1877, II, 507f. (text); translation based on II, 231f.
36 *Ibid.*, 518f. and 305f. (translation).
37 Letter of August 17, 1561. *Ibid.*, 520f. and 310 (translation).
38 *Ibid.*, 326.
39 *Ibid.*, 527 and 327 (translation).

40 *Ibid.*, 344.

41 *Ibid.*, 536 and 381 (translation).

42 *Ibid.*, 541 and 408 (translation).

43 *Ibid.*, 364ff.

44 Vasari, VII, 459.

45 According to Tietze, 1936, I, 210f., Vargas' portrait was replaced by the figure of Hiob.

46 Fairbairn, 1938.

47 Farrington, 1924, I, 100.

48 Baldinucci, 1948, 143.

49 For other examples, Kris and Kurz, 1934, 51f.

50 Baldinucci, 1948, 80.

51 *Ibid.*, 117.

52 Domenico Bernini, 1713, 125.

53 Baldinucci, 1948, 118.

54 Chantelou, 1885, and *passim* for some of the following.

55 Wittkower, 1961, 517: computation of Bernini's entire income connected with the Paris journey.

56 Magurn, 1955, 391.

57 *Ibid.*, 394.

58 Bellori, I, 252.

59 Evers, 1942, 385.

60 Thieme, 1959, 38ff., with a useful survey of the prices of Rubens' pictures. See also above, chap. II, p. 24.

61 Evers, 1942, 474, 477.

62 Baldinucci, V, 307. Baldinucci was well informed about Rembrandt through the latter's pupil, B. Keil, who stayed in Italy from 1656 to 1687.

63 Rosenberg, 1948, 13ff.

64 Baldinucci, V, 306.

65 Justi, 1933, 168, 171.

66 *Ibid.*, 733ff., a detailed report of the long-drawn-out investigation leading to Velasquez's investiture.

67 *Ibid.*, 746.

68 Waterhouse, 1941, 3.

69 Cotton, 1856, 73, 149; Leslie and Taylor, 1865, I, 101; Waterhouse, 1941, 13.

70 Northcote, 1818, I, 103.

71 *Ibid.*, II, 226.

72 *Ibid.*, II, 321.

73 *Ibid.*, II, 322.

CHAPTER 12

1 Philo, *De monarchia*, I, 216M (II *fr.* 1010), quoted after Schweitzer, 1925, 102.

2 Above, chap. IV, 93; also chap. VII, 175.

3 Following Kretschmer, 1936, 258, we may say that the term 'character' stresses the affective side of the total personality and includes exogenous factors such as education and environment.

4 Burchkardt, 1934, XIII, 179.

5 But see the contrary point of view of Hartlaub and Weissenfeld, 1958. Lange-Eichbaum, 1956, 106, asks 'can one from the work alone reconstruct the personality of the creator without knowing anything about him?' but he never answers the question. Collingwood, 1938, 316, refutes strongly the 'nonsense about self-expression'.

6 Vasari, III, 566, 589.

7 Wescher, 1950, 3ff.; Hocke, 1957, 150ff.

8 Geiger, 1954, 45.

9 Legrand and Sluys, 1955, 106.

10 Comanini, 1591, 50f.

11 *Ibid.*, 46.

12 Further to this problem, Kris, 1932, 199f.

13 Hocke, 1957, 73.

14 Comanini, 32. We offer this tentative translation of the madrigal which Legrand and Sluys, 1955, 113, thought to be untranslatable.

15 *Ibid.*, 29.

16 Lombroso, 1882. About Lombroso and his influence, Lange-Eichbaum, 1956, 171ff.

17 Pannenborg, 1917 and 1920.

See also the *critique* by Plaut, 1929, 238ff.

18 Cardanus, 1561, 504.

19 Kretschmer, 1931, 51ff., 87, 193.

20 *Id.*, 1921.

21 Pinder, 1926, 142ff.

22 See chap. VI, 149.

23 Hartlaub and Weissenfeld, 1958.

24 See above, chap. IV, 394.

25 Max Nordau (1849–1923); quoted in the *Times Literary Supplement*, May 4, 1956.

26 Kris, 1952, 25ff., 60, and *passim*.

27 Freud, 1910, and 1943, VIII, 127–211.

28 Schapiro, 1956, 147ff., 1955–56, 3ff.

29 Eissler, 1961.

30 Jones, 1955, II, 86; also quoted by Schapiro, 1955–6, 8.

31 Jones, II, 480.

32 See above, chap. V, 131.

33 Schapiro, 1955–6, 3ff.

34 Davidsohn, 1927, IV, iii, 366. See also chap. VIII, 206f.

35 Jones, 1913; reprinted, 1923, 226–44.

36 Vasari, V, 609.

37 Vasari, V, 19, and *ibid.*, note 1 (text of edition of 1550).

38 See Gombrich's analysis of Vasari, 1954, 6.

39 Jones, 1913 (edition of 1923, 240).

40 Scharf, 1935, Catalogue, nos. 4, 51.

41 See also Fraenckel, 1935, 216.

42 Vasari, V, 20.

43 Jones, 1955, II, 386.

44 Above, chap. V, 132.

45 Esche, 1954, 26, 29 and *passim*.

46 Reitler, 1916–7, 205ff.

47 Pasto and Kivisto, 1953, 76.

48 See above, p. 286.

49 Read, 1937, 198.

50 Zuccaro, 1607; Goldwater and Treves, 1947, 115.

51 Ghiselin, 1958, 58.

52 Sweeney, 1946, 7.

53 *The New American Painting As Shown in Eight European Countries 1958–9*, New York, Museum of Modern Art, 1959, 20. (Quoted from *Possibilities* I, Winter 1947–48.)

54 *Ibid.*

BIBLIOGRAPHY

ALBERTI, Leon Battista: *L'Architettura. Tradotta in lingua Fiorentina da Cosimo Bartoli* (Florence, 1550)
On Painting. Translated with Introduction and Notes by John R. Spencer (London, 1956)
See JANITSCHEK

ANTAL, Frederick: *Florentine Painting and its Social Background* (London, 1947)

ARETINO, Pietro: *Lettere sull'arte*. Commentario di Fidenzio Pertile. A cura di Ettore Camesasca (Milan, 1957)

ARISTOTLE: *The Works*, edited by W. D. Ross. Volume VII: *Problemata*, translated by E. S. Forster (Oxford, 1927)

ARMENINI, Giovan Battista: *Dei veri precetti della pittura* (Ravenna, 1587). Quotations from the Pisa edition of 1823

Art and Psychoanalysis (New York, 1957). With contributions, among others, by W. Phillips, E. Kris, H. Lowenfeld, L. Trilling

AZNAR, José Canón: *Domenico Greco* (Madrid, 1950)

BAADER, J.: *Beiträge zur Kunstgeschichte Nürnbergs* (Nördlingen, 1860–62)

BABB, Lawrence: *The Elizabethan Malady. A Study of Melancholia in English Literature from 1580 to 1642* (Michigan State College Press, 1951)
Sanity in Bedlam. A Study of Robert Burton's Anatomy of Melancholy (Michigan State University Press, 1959)

BACCI, Peleo: *Jacopo della Quercia. Nuovi documenti e commenti* (Siena, 1929)

BAGLIONE, Giovanni: *Le vite de'pittori, scultori, architetti, ed intagliatori* (Rome, 1642). Quotations from the third edition (Naples, 1733)

BALDINUCCI, Filippo: *Notizie de'professori del disegno da Cimabue in qua* (Florence, 1681–1728). Quotations from the fifth edition, 5 volumes (Florence, 1845–47)
Vita di Gian Lorenzo Bernini (Florence, 1682). Quotations from the edition by S. Samek Ludovici (Milan, 1948)

BANDELLO—*See* FLORA

BANDMANN, Günter: *Melancholie und Musik* (Cologne, 1960)

BAROCCHI, Paola: *Trattati d'arte del Cinquecento* (Bari, 1960)

BARTEL, Roland: 'Suicide in 18th Century England: The Myth of a Reputation', *Huntington Library Quarterly*, XXIII (1960), pp. 145–158

BAVETTA, Lucian, and TRAUMAN STEINITZ, Kate: 'Nutritional Concepts of Leonardo da Vinci', *The Bulletin of the National Institute of Nutrition*, III, nos. 9–10 (Los Angeles, 1953)

BEISSEL, Stephan: *Geldwerth und Arbeitslohn im Mittelalter* (Ergänzungshefte zu den 'Stimmen aus Maria-Laach' 27), (Freiburg i. B., 1884)

BELLORI, Giovanni Pietro: *Le vite de'pittori, scultori, ed architetti moderni* (Rome, 1672). Quotations from the third edition, 3 volumes (Pisa, 1821)

BELLUCCI, P. Antonio: *Memorie storiche e artistiche del Tesoro nella cattedrale dal sec.* XVI al XVIII (Naples, 1915)

BELTRAMI, Luca: *Documenti e memorie riguardanti la vita e le opere di Leonardo da Vinci* (Milan, 1919)

BERNINI, Domenico: *Vita del Cavalier Gio. Lorenzo Bernini* (Rome, 1713)

BERTOLOTTI, A.: 'Agostino Tassi, suoi scolari e compagni pittori a Roma,' *Giornale di Erudizione Artistica*, V (1876), pp. 193–220
'Federigo Zuccari, il suo processo ed esilio nel 1581', *ibid.*, 129ff.
Artisti Belgi ed Olandesi a Roma nei secoli XVI e XVII (Florence, 1880)
Artisti Lombardi a Roma nei secoli XV, XVI e XVII, 2 volumes (Milan, 1881)

BIAGI, Luigi: *Jacopo della Quercia* (Florence, 1946)

BIER, Justus: *Tilman Riemenschneider* (Würzburg-Augsburg, 1925, 1930)

BIRT, Theodor: *Laienurtheil über bildende Kunst bei den Alten* (Marburg, 1902)

BLUNT, Anthony: *Artistic Theory in Italy 1450–1600* (Oxford, 1940)

BODE, Wilhelm von: *Botticelli* (Berlin, 1921)

BOLL, Franz: *Sternglaube und Sterndeutung* (Leipzig-Berlin, 1926)

BOOZ, Paul: *Der Baumeister der Gotik* (Munich-Berlin, 1956)

BORGHESI, S., and BANCHI, L.: *Nuovi documenti per la storia dell'arte senese* (Siena, 1898)

BOTTARI, Giovanni: *Raccolta di lettere sulla pittura, scultura ed architettura*, 8 volumes (Milan, 1822–25)

BREDIUS, Abraham: *Johannes Torrentius Schilder, 1589–1644* (The Hague, 1909)
'Nieuwe Bijdragen over Johannes Vermeer', *Oud Holland*, XXVIII, pp. 61–64 (1910)
Künstler Inventare. (Quellenstudien zur holländischen Kunstgeschichte) (The Hague, 1915–22)
'Waarom Jacob van Loo in 1660 Amsterdam verliet', *Oud Holland*, XXXIV, pp. 47–52 (1916)

BRIDENBAUGH, Carl and Jessica: *Rebels and Gentlemen* (New York, 1942)

BRIGHT, Timothy: *A Treatise of Melancholy* (London, 1586)

BROSSES, Charles de: *Lettres familières sur l'Italie*, edited by Y. Bézard (Paris, 1931)

BURCKHARDT, Jacob: *Die Kultur der Renaissance* (first edition 1860). Tenth edition by Ludwig Geiger (Leipzig, 1908). English edition *The Civilization of the Renaissance* (London, 1944)
Gesamtausgabe, volumes VII and XIII (Berlin-Leipzig, 1929, 1934)

BURTON, Robert: *The Anatomy of Melancholy*, edited by Floyd Dell and Paul Jordan-Smith (New York, 1955)

BUSSE, Kurt H.: 'Der Pitti-Palast', *Jahrbuch der Preuss. Kunstsammlungen*, LI, pp. 110–32 (1930)

BUTZBACH, Johannes: *Chronica eines fahrenden Schülers, oder Wanderbüchlein* (German translation from the Latin by D. J. Becker) (Regensburg, 1869). English translation by R. F. Seybolt and Paul Monroe (Ann Arbor, Michigan, 1933)

BYRON, R., and RICE, D. Talbot: *The Birth of Western Painting* (New York, 1931)

CAMPORI, Giuseppe: 'Tiziano e gli Estensi', *Nuova Antologia*, XXVII, pp. 581–620 (1874)
'Michelangelo Buonarroti e Alfonso I d'Este', *Atti e memorie della R. Deputazione di storia patria dell'Emilia*, N. S. VI, pp. 127–140 (1881)

CANUTI, Fiorenzo: *Il Perugino* (Siena, 1931)

CARDANUS: *De utilitate ex adversis capienda, libri iiii* (Basel, 1561)

CARRÉ, A.: *Crime et suicide* (Paris, 1891)

CARTWRIGHT, Julia: *Isabella d'Este Marchioness of Mantua 1474–1539* (London, 1932)

CASANOVA, E.—*See* VILLARI

CASSIRER, Else: *Künstlerbriefe aus dem neunzehnten Jahrhundert* (Berlin, 1919)

CASTIGLIONE, Baldassare: *Libro del Cortegiano* (Venice, 1528). Quotations from the edition by Carlo Cordiè (Milan-Naples, 1960), and from the first English translation by Sir Thomas Hoby (1621), republished as *The Book of the Courtier* (London, 1948)

CECCHI, Emilio: *Jacopo da Pontormo. Diario* (Florence, 1956)

CELLINI, Benvenuto: *Memoirs written by Himself*. Translated by Thomas Roscoe (London, 1847); and by John A. Symonds (New York, 1906)

CENNINO D'ANDREA CENNINI: *Il libro dell'arte*. Edited by Daniel V. Thompson Jr (Yale University Press, 1932)

CHANTELOU, M. de: *Journal du voyage du Cav. Bernin en France*. Edited by L. Lalanne (Paris, 1885)

CHASTEL, André: *Marsile Ficin et l'art* (Genève-Lille, 1954)
Art et humanisme à Florence au temps de Laurent le Magnifique (Paris, 1959)

CLARK, Kenneth: *Leon Battista Alberti on Painting* (British Academy, 1944)
Leonardo da Vinci (Penguin Books, 1958)

COLASANTI, Arduino: 'Il memoriale di Baccio Bandinelli', *Repertorium für Kunstwissenschaft*, XXVIII, pp. 406–43 (1905)

COLLINGWOOD, Robin George: *The Principles of Art* (Oxford, 1938)

COLLINS, Leo C.: *Hercules Seghers* (University of Chicago Press, 1953)

COMANINI, Gregorio: *Il Figino* (Mantua, 1591)

CONDIVI, Ascanio: *Vita di Michelangiolo* (Florence, 1926) (first edition 1553)

CONWAY, William Martin: *The Writings of Albrecht Dürer* (New York, 1958) (first edition 1889)

CORNFORD, Francis Macdonald: *The Republic of Plato* (Oxford, 1941)

COSSIO, Manuel B.: *El Greco* (Madrid, 1908)

COSTANTINI, Vincenzo: *Vite avventurose dei pittori del Seicento* (Milan, 1946)

COSTELLO, Jane: 'Poussin's Drawings for Marino', *Journal of the Warburg and Courtauld Institutes*, XVIII, 296ff. (1955)

COTTON, William: *Sir Joshua Reynolds and his Works* (London, 1856)

COULTON, G. G.: *Art and the Reformation* (Cambridge, 1953) (first edition Oxford, 1928)

COURBON, P.: *Étude psychiatrique sur Benvenuto Cellini* (Lyons, 1906)

CRINÒ, Anna Maria and NICOLSON, Benedict: 'Further documents relating to Orazio Gentileschi', *Burlington Magazine*, CIII, 144 (1961)

CROWE, J. A., and CAVALCASELLE, G. B.: *Titian: His Life and Times*, 2 volumes (London, 1877)

CUDELL, Robert: *Das Buch vom Tabak* (Cologne, 1927)

DAVIDSOHN, Robert: *Forschungen zur Geschichte von Florenz*, volume II (Berlin, 1900)
Geschichte von Florenz, volumes IV,1, IV,2, IV,3, (Berlin,1922, 1925, 1927)

DE PILES, Roger: *Abrégé de la vie des peintres* (Paris, 1699). (Quotations also from the edition Paris, 1715)

DEPPING, G. B.: *Correspondance administrative sous le règne de Louis XIV* (Paris, 1855)

DESTRÉE, Joseph: *Hugo van der Goes* (Brussels, 1914)

DE VRIES, A. B.: *Jan Vermeer van Delft* (London, 1948)

DÉZALLIER D'ARGENVILLE: *Abrégé de la vie des plus fameux peintres*, 4 volumes (Paris, 1762) (first edition 1745–52)

DHANENS, Elisabeth: *Jean Boulogne* ('Verhandelingen Koninklijke Vlaamse Academie voor Wetenschappen . . . Klasse der Schone Kunsten Nr. 11') (Brussels, 1956)

DOBSON, Austin: *William Hogarth* (London, 1891)

DOLCE, Lodovico: *Dialogo della Pittura intitolato l'Aretino*. (First edition Venice, 1557). *See* BAROCCHI

DOPPELMAYR, Joh. Gabr.: *Historische Nachrichten von den Nürnbergischen Mathematicis und Künstlern* (Nürnberg, 1730)

DOREN, Alfred: *Das Florentiner Zunftwesen* (Stuttgart-Berlin, 1908)

DRACOULIDÈS: *Psychoanalyse de l'artiste et de son œuvre* (Geneva, 1952)

DRESDNER, Albert: *Die Entstehung der Kunstkritik* (Munich, 1915)

DREY, F.: *Carlo Crivelli und seine Schule* (Munich, 1927)

DREY, P.: *Die wirtschaftlichen Grundlagen der Malkunst. Versuch einer Kunstökonomie* (Stuttgart-Berlin, 1910)

DU BOS, Abbé J. B.: *Reflexions critiques sur la poesie et sur la peinture* (Paris, 1719). (Quotations from the Paris edition of 1746)

DUFRESNOY, C. A.: *The Art of Painting*. English translation by Dryden (London, 1695)

DÜLBERG; Franz, and BREDIUS, Abraham: 'Der gottlose Maler Johannes Torrentius', *Deutsche Rundschau*, CCIII, pp. 35–52 (1925)

DUPRÉ, E., and DEVAUX: 'La melancholie du peintre Hugo van der Goes', Congrès des médecins aliénistes et neurologistes de France, *L'Encéphale*, V, ii (1910)

DURKHEIM, Emile: *Suicide. A Study in Sociology*. Translated by J. A. Spaulding and George Simpson (Glencoe, Illinois, 1951) (first French edition 1897)

EDWARDS, Edward: *Anecdotes of Painters* (London, 1808)

EEKHOUD, Georges: 'Un illustre uraniste du XVIIe siècle, Jerôme Duquesnoy', *Jahrbuch für sexuelle Zwischenstufen*, II, 277ff. (1900)

EISSLER, K. R.: *Leonardo da Vinci's Psychoanalytic Notes on the Enigma* (New York, 1961)

ESCHE, Sigrid: *Leonardo da Vinci: Das anatomische Werk* (Basel, 1954)

EVANS, Bergen: *The Psychiatry of Robert Burton* (New York, 1944)

EVELYN, John: *The Diary*. Edited by E. S. de Beer (Oxford, 1955)

EVERS, H. G.: *Peter Paul Rubens* (Munich, 1942)

FABRICZY, Cornel von: *Filippo Brunelleschi* (Stuttgart, 1892)

Facezie, buffonerie del Gonella e del Barlacchia e di diversi (Florence, 1622)

FAIRBAIRN, W. R. D.: 'Prolegomena to a Psychology of Art', *British Journal of Psychology*, XXVIII (1938)

FARINGTON, Joseph: *The Diary*. Edited by James Greig (London, 1924)

FEDDEN, Henry R.: *Suicide. A Social and Historical Study* (London, 1938)

FÉLIBIEN, André: *Entretiens sur les vies et les ouvrages des plus excellens peintres, anciens et modernes* (Paris, 1666–88). (Quotations from the edition, Trevoux, 1725)

FERGUSON, W. K.: *The Renaissance in Historical Thought. Five Centuries of Interpretation* (Cambridge, Mass., 1948)

FERNOW, C. L.: *Über den Bildhauer Canova und dessen Werke* (Zurich, 1806)
Leben des Künstlers Asmus Jacob Carstens (Leipzig, 1806)

FEULNER, A.: *Skulptur und Malerei des 18. Jahrhunderts in Deutschland* (Handbuch der Kunstwissenschaft) (Wildpark-Potsdam, 1929)

FICINO, Marsilio: *Opera omnia* (Basel, 1561)

FISCHEL, Oskar: *Raphaels Zeichnungen.* Abteilung 6 (Berlin, 1925)

FLEMING, John: 'Robert Adam the Grand Tourist', *The Cornhill*, no. 1004, 118ff. (1955)

FLOERKE, Hanns: *Studien zur niederländischen Kunst- und Kulturgeschichte.* Die Formen des Kunsthandels, das Atelier und der Sammler (Munich and Leipzig, 1905)
Die fünfundsiebenzig italienischen Künstlernovellen der Renaissance (Munich and Leipzig, 1913)

FLORA, Francesco: *Tutte le opere di Matteo Bandello* (Milan, 1952)

FOGOLARI, Gino: 'L'Accademia Veneziana di Pittura e Scoltura del Seicento', *L'Arte*, XVI (1913)

FRAENCKEL, Ingeborg: *Andrea del Sarto* (Strassburg, 1935)

FRANKL, V. E.: 'Kunst und Geisteskrankheit', *Universitas*, Heft 3 (1958)

FRANZ, Guenther: *Der deutsche Bauernkrieg* (Munich-Berlin, 1933)

FREEDBERG, Sydney J.: *Parmigianino. His Work in Painting* (Cambridge, Mass., 1950)

FREUD, Sigmund: 'Eine Kindheitserinnerung des Leonardo da Vinci', *Schriften zur angewandten Seelenkunde*, Heft VII (Leipzig-Vienna, 1910). Reprint with additional notes: *Gesammelte Werke*, VIII, pp. 127–211 (London, 1943). English translation by A. A. Brill (New York, 1916)

FREY, Carl: *Il codice Magliabechiano cl. XVII. 17* (Berlin, 1892)
Die Dichtungen des Michelangiolo Buonarroti (Berlin, 1897)
Michelagniolo Buonarroti. Quellen und Forschungen (Berlin, 1907)
Der literarische Nachlass Giorgio Vasaris. Edited by Herman-Walther Frey, volume II (Munich, 1930)
Die Briefe des Michelagniolo Buonarroti (Berlin, 1961)

FRIEDLAENDER, Walter: 'The Academician and the Bohemian: Zuccari and Caravaggio', *Gazette des Beaux Arts*, XXXIII, 27ff. (1948)
Caravaggio Studies (Princeton University Press, 1955)

GANTNER, Joseph (and others): *Die Malerfamilie Holbein in Basel* (Catalogue) (Basel, 1960)

GARDNER, E. G.: *The Painters of the School of Ferrara* (London, 1911)

GAYE, Giovanni: *Carteggio inedito d'artisti dei secoli XIV, XV, XVI*, 3 volumes (Florence, 1839–40)

GEIGER, Benno: *I dipinti ghiribizzosi di Giuseppe Arcimboldo* (Florence, 1954)

GHISELIN, Brewster: *The Creative Process*. Mentor Books (New York, 1958)

GILBERT, Creighton: 'The Archbishop on the Painters of Florence', *The Art Bulletin*, XLI, 75ff. (1959)

GIOVANNOZZI, Vera: 'La vita di Bernardo Buontalenti scritta da Gherardo Silvani', *Rivista d'Arte*, XIV, 505ff. (1932)

GNUDI, Cesare (and others): *Mostra dei Carracci* (Catalogue) (Bologna, 1956)

GOETHE, J. W. von: *Grossherzog Wilhelm Ernst Ausgabe*. Insel Verlag (Leipzig, 1910). Goethe's translation of Cellini's Memoirs first published 1796

GOLDWATER, Robert, and TREVES, Marco: *Artists on Art* (London, 1947)

GOLZIO, Vincenzo: *Raffaello nei documenti* (Rome, 1936)

GOMBRICH, Ernst H.: 'Botticelli's Mythologies', *Journal of the Warburg and Courtauld Institutes*, VIII, 7ff. (1945)
'Psycho-Analysis and the History of Art', *The International Journal of Psycho-Analysis*, XXXV, iv (1954)
'The Early Medici as Patrons of Art: A Survey of primary Sources', *Italian Renaissance Studies*, edited by E. F. Jacob, pp. 279–311 (London, 1960)

GOTTI, Aurelio: *Vita di Michelangelo Buonarroti* (Florence, 1875)

GOUGENOT, Louis: 'Vie de Robert le Lorrain', in *Mémoirs inédits sur la vie et les ouvrages des membres de l'académie royale* (Paris, 1854)

GRECI, Luigi: 'Benvenuto Cellini nei delitti e nei processi fiorentini ricostruiti attraverso le leggi del tempo', *Quaderni dell'Archivio di antropologia criminale e medicina legale* (Turin, 1930)

GRONAU, Georg: 'Andrea del Castagno debitore', *Rivista d'Arte*, XIV, 503f. (1932)
Documenti artistici urbinati (Florence, 1935)

GRUBE, Karl: *Johannes Busch, Augustinerpropst zu Hildesheim* (Freiburg i. B., 1881)
Des Augustinerpropstes Johannes Busch Chronicon Windeshemense (Halle, 1886)

GUALANDI, Michelangelo: *Nuova raccolta di lettere sulla pittura, scultura ed architettura*, volume II (Bologna, 1845)

GUHL, Ernst: *Künstlerbriefe* (Berlin, 1880)

GUILLET DE SAINT-GEORGES: 'Mémoirs inédits sur les artistes français', *Mémoirs inédits sur la vie des membres de l'académie* (Paris, 1854)

GUTKIND, Curt S.: *Cosimo de' Medici* (Oxford, 1938)

HAHNLOSER, Hans R.: *Villard de Honnecourt* (Vienna, 1935)

HANNOVER, E.: *Dänische Kunst des 19. Jahrhunderts* (Leipzig, 1907)

HARTLAUB, G. F.: *Fragen an die Kunst* (Stuttgart, 1951)
Der Stein der Weisen. Wesen und Bildwelt der Alchemie (Munich, 1959)
and WEISSENFELD, Felix: *Gestalt und Gestaltung. Das Kunstwerk als Selbstdarstellung des Künstlers* (Krefeld, 1958)

HARVEY, John: *Henry Yevele c. 1320 to 1400* (London, 1944)
The Gothic World 1100–1600 (London, 1950)

HAUSER, A.: *The Social History of Art* (London, 1951)

HAUTECOEUR, Louis: *Histoire de l'architecture classique en France*, volume III (Paris, 1950)

HEIDRICH, Ernst: *Albrecht Dürers schriftlicher Nachlass* (Berlin, 1918)

HEIKAMP, D.: 'Vicende di Federigo Zuccari', *Rivista d'Arte*, annuario 1957, VII, pp. 175–232 (1959)
'Ancora su Federigo Zuccari', *Rivista d'Arte*, annuario 1958, VIII, 45ff. (1960)

HEILER, Friedrich: *Der Katholizismus* (Munich, 1923)

HEINE, A. F.: *Asmus Jakob Carstens und die Entwicklung des Figurenbildes* (Strassburg, 1928)

HEMPEL, Eberhard: *Francesco Borromini* (Vienna, 1924)

HESS, Jacob: *Agostino Tassi, der Lehrer des Claude Lorrain* (Munich, 1935)
'The Chronology of the Contarelli Chapel', *Burlington Magazine*, XCIII, 186ff. (1951)

HEYDENREICH, Ludwig H.: *Leonardo da Vinci* (London, 1954)

HIEBER, Hermann: *Elias Holl* (Munich, 1923)

HOCKE, Gustav René: *Die Welt als Labyrinth* (Rowohlt, 1957)

HOGARTH, William: *Anecdotes of William Hogarth written by Himself* (London, 1833)

HOLLANDA, Francisco de: *Vier Gespräche über die Malerei*. Original text mit Übersetzung. Edited by J. de Vasconcellos (Vienna, 1899)

HOLMYARD, E. J.: *Alchemy* (Penguin Books, 1957)

HOLT, Elizabeth G.: *Literary Sources of Art History* (Princeton, 1947)

HOOGEWERFF, G. J.: *De Bentvueghels* (The Hague, 1952)

HOUBRAKEN, Arnold: *De Groote Schouburgh* (Amsterdam, 1718–20). Quotations from the German edition by Wurzbach (Vienna, 1880)

HUIZINGA, Johan: *Herbst des Mittelalters* (Munich, 1924). Modern American edition: *The Waning of the Middle Ages*, Anchor Books (New York, n.d.)
Erasmus and the Age of Reformation. Harper Torchbooks (New York, 1957)

HUTH, Hans: *Künstler und Werkstatt der Spätgotik* (Augsburg 1923)

ILG, Albert: *F. X. Messerschmidt, Leben und Werke* (Leipzig, 1885)

IRELAND, John: *Hogarth Illustrated* (London, 1791; third volume 1798)

JAHN, Johannes: 'Die Stellung des Künstlers im Mittelalter', *Festgabe für Friedrich Bülow*. Herausgegeben von Otto Stammer und Karl C. Thalheim, pp. 151–168 (Berlin, 1960)

JANITSCHECK, Hubert: *Leone Battista Albertis kleinere kunsttheoretische Schriften* (Vienna, 1877)
Die Gesellschaft der italienischen Renaissance und die Kunst (Stuttgart, 1879)

JANSON, H. W.: *The Sculpture of Donatello* (Princeton, 1957)

JENTSCH, E.: 'Die Schreckensneurose Claude Lorrains', *Psychiatrisch-neurologische Wochenschrift*, XVII (1925) (*Allgemeine Zeitschrift für Psychiatrie*, LXXIII)

JONES, Ernest: 'The Influence of Andrea del Sarto's Wife on his Art', *Imago*, II (1913). Reprinted in *Essays in Applied Psycho-Analysis*, pp. 226–44 (London-Vienna, 1923) (New edition London, 1951)
Sigmund Freud, Life and Work (London, 1955)

JONES, G. P.—*See* KNOOP

JUCKER, Hans: *Vom Verhältnis der Römer zur bildenden Kunst der Griechen* (Frankfurt, 1950)

JUSTI, Karl: *Winckelmann und seine Zeitgenossen* (Leipzig, 1898)
Diego Velasquez und sein Jahrhundert (Zurich, 1933) (Reprint of edition of 1903)

KALKMANN, A.: *Die Quellen der Kunstgeschichte des Plinius* (Berlin, 1898)

KEMPIS—*See* Thomas À KEMPIS

KETTLEWELL, S.: *Thomas à Kempis* (London, 1882)

KITSON, Michael, and RÖTHLISBERGER, Marcel: 'Claude Lorrain and the *Liber Veritatis*', *Burlington Magazine*, CI, 14ff., 328ff., 381ff. (1959)

KNOOP, Douglas, and JONES, G. P.: *The Mediaeval Mason* (Manchester University Press, 1933)

KÖRTE, Werner: *Der Palazzo Zuccari in Rom. Sein Freskenschmuck und seine Geschichte* (Leipzig, 1935)

KRAUTHEIMER, Richard. In collaboration with Trude Krautheimer-Hess: *Lorenzo Ghiberti* (Princeton, 1956)

KRETSCHMER, Ernst: *Körperbau und Charakter* (Berlin, 1921). English edition: *Physique and Character* (London, 1936)
Geniale Menschen (Berlin, 1929). English edition: *The Psychology of Genius* (London, 1931)

KRIS, E.: 'Die Charakterköpfe des Franz Xaver Messerschmidt', *Jahrbuch der kunsthistorischen Sammlungen in Wien*, VI, 169ff. (1932) *Psychoanalytical Explorations in Art* (London, 1952) and KURZ, Otto: *Die Legende vom Künstler* (Vienna, 1934)

KRISTELLER, Paul: *Andrea Mantegna* (London, 1901)

KUPFFER, E. v.: 'Giovan Antonio—il Sodoma. Der Maler der Schönheit', *Jahrbuch für sexuelle Zwischenstufen*, IX (1908)

KURZ, Otto: *Fakes. A Handbook for Collectors and Students* (London, 1948)
—See KRIS, E.

KUSENBERG, K.: *Rosso Fiorentino* (Strasbourg, 1931)

LABORDE, Le Conte de: *La Renaissance des arts à la cour de France. Étude sur le seizième siècle* (Paris, 1850)

LAMB, Charles: 'The last Essays of Elia: Sanity of True Genius', in *The Works* (London, 1859)

LANCIARINI, V.: 'Dei pittori Taddeo e Federigo Zuccari' ('Atti del processo contro Federigo Zuccari'), *Nuova Riv. Misena*, VI, 104ff., 117ff. (1893)

LANDUCCI, Luca: *Diario Fiorentino*, edited by I. del Badia (Florence, 1883). *A Florentine Diary from 1450 to 1516*. English translation by Alice de Rosen Jervis (London—New York, 1927)

LANGE, K., and FUHSE, F.: *Dürers schriftlicher Nachlass* (Halle, 1893)

LANGE-EICHBAUM, Wilhelm: *Genie, Irrsinn und Ruhm* (Munich, 1942). Fourth edition (Munich-Basel, 1956)

LEGRAND, Francine-Claire, and SLUYS, Felix: *Arcimboldo et les arcimboldesques* (Aalter, Belgium, 1955)

LEHRFELDT, P.: *Luthers Verhältnis zu Kunst und Künstlern* (Berlin, 1892)

LÉPICIÉ, François-Bernard: *Vies des premiers peintres du Roi depuis M. Le Brun, jusqu' à présent* (Paris, 1752)

LERNER-LEHMKUHL, Hanna: *Zur Struktur und Geschichte des florentinischen Kunstmarktes im 15. Jahrhundert* (Lebensräume der Kunst, Heft 3) (Wattenscheid, 1936)

LESLIE, Charles Robert, and TAYLOR, Tom: *Life and Times of Sir Joshua Reynolds* (London, 1865)

LEVI, Alda: *Sculture Greche e Romane del Palazzo Ducale di Mantova* (Rome, 1931)

LOMAZZO, Paolo: *Idea del Tempio della Pittura* (Milan, 1590). Quotations from the Bologna edition of 1785

LOMBROSO, Cesare: *Genio e follia* (Pavia, 1863). Fourth edition (Turin, 1882)

LOSSNITZER, Max: *Veit Stoss* (Leipzig, 1912)

LUCIAN: *Works*. With an English translation by A. M. Harmon, Loeb Classical Library, Volume III (1947)

LUDWIG, Heinrich: *Leonardo da Vinci. Das Buch von der Malerei* (Vienna, 1888)

MABELLINI, A.: *Delle rime di Benvenuto Cellini* (Rome, 1885)

MACCURDY, Edward: *The Notebooks of Leonardo da Vinci* (London, 1945)
The Mind of Leonardo da Vinci (London, 1952)

MAGURN, Ruth Saunders: *The Letters of Peter Paul Rubens* (Harvard University Press, 1955)

MALVASIA, Carlo Cesare: *Felsina Pittrice, Vite de'Pittori Bolognesi* (Bologna, 1678). If not otherwise stated, the quotations are from the edition Bologna, 1841, two volumes (with notes by Giampietro Zanotti).

MANCINI, Giulio: *Considerazioni sulla Pittura.* Edited by Adriana Marucchi and Luigi Salerno (Rome, 1956)

MANDER, Carel van: *Dutch and Flemish Painters,* translated from the *Schilderboek* by C. van de Wall (New York, 1936). Dutch and German edition by H. Floerke (Munich, 1906) (First edition Alkmaar, 1604)

MANETTI, Antonio: *Vita di Filippo di Ser Brunellesco.* Edited by Elena Toesca (Florence, 1927)

MARABOTTINI, A.: 'Novità sul Lucchesino', *Commentari,* V (1954)

MARAÑÓN, G.: *El Greco y Toledo* (Madrid, 1956)

MARITAIN, Jacques: *Art and Scholasticism.* Translated by J. F. Scanlan (London, 1946)

MARTIN, W.: 'The Life of a Dutch Artist,' *Burlington Magazine,* XI, 357ff. (1907)

MARTINELLI, Valentino: 'L'amor divino "tutto ignudo" di Giovanni Baglione e la cronologia dell'intermezzo caravaggesco', *Arte Antica e Moderna,* V, pp. 82–96 (1959)

MARX, Arnold: *Die Gold und Rosenkreutzer. Ein Mysterienbund des ausgehenden 18. Jahrhunderts in Deutschland* (Berlin, 1929)

MENGS, Anton Raphael: *The Works of Anthony Raphael Mengs.* Translated from the Italian. Published by Joseph Nicholas D'Azara, two volumes (London, 1796)

MEYER, Christian: *Die Selbstbiographie des Elias Holl, Baumeister der Stadt Augsburg* (Augsburg, 1873)

MILANESI, Gaetano: *Documenti per la storia dell'arte Senese* (Siena, 1854 –1856)
Le lettere di Michelangelo Buonarroti (Florence, 1875)

MISSIRINI, Melchior: *Memorie per servire alla storia della Romana Accademia di S. Luca* (Rome, 1823)

MITCHELL, Charles: 'Archaeology and Romance in Renaissance Italy', *Italian Renaissance Studies,* edited by E. F. Jacob (London, 1960)

MÖLLER, E.: 'Salai und Leonardo da Vinci', *Jahrbuch der kunsthistorischen Sammlungen*, Vienna, N.F. II, 139ff. (1928)

MONTAIGLON, A. de: *Correspondance des directeurs de l'Académie de France à Rome*, Paris, 1889ff.

MORPURGO, S.: *Il Libro di buoni costumi di Paolo Messer Pace da Certaldo*. Documenti di vita trecentesca fiorentina (Florence, 1921)

MORSELLI, Henry: *Suicide: An Essay on Comparative Moral Statistics* (New York, 1882)

MOTTA, E. : *Bibliografia del suicidio* (Bellinzona, 1890)

MÜNTZ, Eugène: *Les arts à la cour des Papes pendant le XV* *et le XVI* *siècle* (Paris, 1878–82)

MURATORI, Antonio: *Rerum italicarum scriptores*, edited by A. Sorbelli, volume XXIII

MURRAY, Peter: 'Notes on some early Giotto Sources', *Journal of the Warburg and Courtauld Institutes*, XVI, 58ff. (1953)

NEUDÖRFER, Johann: *Des Johann Neudörfer Schreib- und Rechenmeisters zu Nürnberg Nachrichten von Künstlern und Werkleuten daselbst aus dem Jahre 1547*. Edited by G. W. K. Lochner (Quellenschriften für Kunstgeschichte X) (Vienna, 1875)

NICOLAI, Friedrich: *Beschreibung einer Reise durch Deutschland und die Schweiz im Jahre 1781*, Volume VI (Berlin-Stettin, 1785)

NICOLSON—*See* CRINÒ

NORTHCOTE, James: *The Life of Sir Joshua Reynolds* (second edition, London, 1818)
Memorials of an Eighteenth Century Painter. Edited by Stephen Gwynn (London, 1898)

OLSEN, Harold: *Federico Barocci* (*Figura*, VI) (Stockholm, 1955)

OPPENHEIMER, Sir Francis: *Stranger Within. Autobiographical Pages* (London, 1960)

ORBAAN, J. A. F.: 'Notes on Art in Italy', *Apollo*, VI, p. 158 (1927)

ORIGO, Iris: *The Merchant of Prato, Francesco di Marco Datini* (London, 1957)

OVERBECK, J.: *Die antiken Schriftquellen zur Geschichte der bildenden Künste bei den Griechen* (Leipzig, 1868)

OZZOLA, Leandro: *Vita e opere di Salvator Rosa* (Strasbourg, 1908)

PAATZ, W.: 'Die Gestalt Giottos im Spiegel einer zeitgenössischen Urkunde', in *Eine Gabe der Freunde für Carl Georg Heise* (Berlin, 1950)

PACCAGNINI, Giovanni: *Simone Martini* (Milan, 1955)

PACHECO, Francisco: *Arte de la pintura*. Edited by F. J. Sanchez Canton (Madrid, 1956) (First edition, 1649)

PALOMINO, Antonio: *El Museo pictórico y escala óptica* (Madrid, 1947) (First edition, 1715–24)

PANNENBORG, H. J. and W. A.: 'Die Psychologie des Zeichners und Malers', *Zeitschrift für angewandte Psychologie*, XII, pp. 230–75 (1917) 'Die Psychologie der Künstler. Beitrag zur Psychologie des Bildhauers', *ibid.*, XVI, pp. 25–39 (1920)

PANOFSKY, Erwin: *Studies in Iconology. Humanistic Themes in the Art of the Renaissance* (New York, 1939)
Albrecht Dürer (Princeton, 1943)
Abbot Suger (Princeton, 1948)
Early Netherlandish Painting, its Origin and Character (Cambridge, Mass., 1953)
Renaissance and Renascences in Western Art (Stockholm, 1960)
and SAXL, Fritz: *Dürers 'Melencolia' I* (Leipzig-Berlin, 1923)

PANZACCHI, E.: *Il libro degli artisti* (Milan, 1902)

PASCOLI, Lione: *Vite de' pittori, scultori ed architetti moderni*, two volumes (Rome, 1730–36)

PASSAVANT, J. D.: *Raphael d'Urbin.* Edition française par M. Paul Lacroix (Paris, 1860)

PASSERI, Giambattista: *Vite de' Pittori Scultori ed Architetti che anno lavorato in Roma, Morti dal 1641 fino al 1673* (Rome, 1772). Modern edition: *Die Künstlerbiographien von Giovanni Battista Passeri.* Edited by Jacob Hess (Leipzig and Vienna, 1934). Quotations from the 1934 edition

PASTO, T. A., and KIVISTO, P.: 'Art and the Clinical Psychologist', *Journal of Aesthetics and Art Criticism*, XII (1953)

PASTOR, L. v.: *Geschichte der Päpste*, Volume XI (Freiburg i.B., 1927)

PELMAN, C.: *Psychische Grenzzustände* (Bonn, 1912)

PEROSA, Alessandro, *Giovanni Rucellai ed il suo Zibaldone* (London, 1960)

PETRARCA, Francesco: *Opera* (Basel, 1581)
Epistolae de rebus familiaribus et variae. Edited by J. Fracassetti (Florence, 1859)
'Secretum', a cura di Enrico Carrara, in *Prose* (Milan-Naples, 1955)

PETRONIUS: *The Satyricon.* Translated by J. M. Mitchell (London, 1923)

PEVSNER, Nikolaus: *Academies of Art Past and Present* (Cambridge University Press, 1940)

PIATTOLI, Renato: 'Un mercante del Trecento e gli artisti del tempo suo', *Rivista d'Arte*, XI (1929); XII (1930)

PIERACCINI, Gaetano: *La stirpe de' Medici di Cafaggiolo* (Florence, 1925)

PIKER, Philip: '1817 Cases of Suicidal Attempts', *American Journal of Psychiatry*, p. 97 (July 1938)

PILES, R. de—*See* DE PILES

PILGRIM, Charles W.: 'Genius and Suicide', *Popular Science Monthly*, XLII (1893)

PINDER, Wilhelm: *Das Problem der Generationen in der Kunstgeschichte Europas* (Berlin, 1926)

PINI, Paolo: *Dialogo di Pittura* (Venice, 1548)

PIRRI, Pietro: 'L'architetto Ammanati e i Gesuiti', *Archivium Historicum Societatis Jesu*, XII (1943)

PLAUT, Paul: *Die Psychologie der produktiven Persönlichkeit* (Stuttgart, 1929)

PLINY: *The Elder Pliny's Chapters on the History of Art*. Translated by K. Jex-Blake. Commentary and introduction by ·E. Sellers (London, 1896)

PLUTARCH: *Lives*. With an English translation by Bernadotte Perrin, volume III, Loeb Classical Library (1916)

POESCHEL, Hans: *Kunst und Künstler im antiken Urteil* (Munich, 1925)

POLITIAN: *Angelo Polizianos Tagebuch*. Edited by A. Wesselski (Jena, 1929)

POLLAK, Oskar: 'Italienische Künstlerbriefe aus der Barockzeit', *Jahrbuch der Preussischen Kunstsammlungen*, XXXIV, Beiheft (1913)

POPHAM, A. E.: *The Drawings of Parmigianino* (New York, 1953)

PORTIGLIOTTI, G.: 'La morte di Raffaello', *L'Illustrazione Medica Italiana*, II, pp. 23–26 (1920)

PORTOGHESI, Paolo: 'Saggi sul Borromini', *Quaderni dell' Istituto di Storia dell' Architettura*, nos. 25, 26 (1958)

POSNER, Donald: 'Annibale Carracci and his School: The Paintings of the Herrera Chapel', *Arte Antica e Moderna* (1960)

PREUSS, Hans: *Martin Luther. Der Künstler* (Gütersloh, 1931)

PRICE, G. E.: 'A Sixteenth Century Paranoiac (Benvenuto Cellini)', *New York Medical Journal*, IC, p. 727 (1914)

PROSKE, Beatrice Gilman: *Pompeo Leoni* (New York Hispanic Society, 1956)

PROTA-GIURLEO, Ulisse: *Pittori napolitani del Seicento* (Naples, 1953)

PUERARI, Alfredo: *Boccaccino* (Milan, 1957)

RAMAZZINI, Bernardino: *De morbis artificum* (Padua, 1713). Translation and notes by Wilmer Cave Wright (University of Chicago Press, 1940)

READ, Herbert: *Art and Society* (London and Toronto, 1937)

REDIG DE CAMPOS, Deoclecio: *Raffaello e Michelangelo* (Rome, 1946)

REHORST, A. J.: *Torrentiùs* (Rotterdam, 1939)

REICKE, E.: *Willibald Pirckheimers Briefwechsel I*, 'Veröffentlichungen zur Erforschung der Geschichte der Reformation und Gegenreformation, Humanistenbriefe, IV' (Munich, 1940)

REITLER, Rudolf: 'Eine anatomisch-künstlerische Fehlleistung Leonardos da Vinci', *Internationale Zeitschrift für Psychoanalyse*, IV, pp. 205–207 (1916-17)

RICE, D. Talbot—*See* BYRON, R.

RICHARDSON, Jonathan: *An Essay on the Theory of Painting* (London, 1715)

RICHTER, Jean Paul: *The literary Works of Leonardo da Vinci* (London, 1939)

RIDOLFI, Carlo: *Le maraviglie dell'arte, overo Le vite de gl'illustri pittori veneti, e dello stato* (Venice, 1648). Quotations from the edition by Detlev von Hadeln, 2 volumes (Berlin, 1914–24)

ROBB, Nesca A.: *Neoplatonism of the Italian Renaissance* (London, 1935)

ROOSES, Max and RUELENS, Charles: *Correspondance de Rubens*, Volume II (Antwerp, 1898)

ROSA, Salvator: *Poesie e lettere edite e inedite.* Edited by G. A. Cesareo (Naples, 1892) (First edition 1695)

ROSENBERG, Jakob: *Rembrandt* (Cambridge, Mass., 1948)

ROTH, Friedrich: 'Die Chronik des Augsburger Malers Georg Preu des Älteren 1512–1537', *Die Chroniken der schwäbischen Städte. Augsburg* (Leipzig, 1906)

RÖTHLISBERGER—*See* KITSON

ROTT, Hans: *Quellen und Forschungen zur südwestdeutschen und schweizerischen Kunstgeschichte im XV. und XVI. Jahrhundert. I. Bodenseegebiet* (Stuttgart, 1933)

ROY, Maurice: 'La mort du Rosso', *Bulletin de la Société de l'Histoire Française* (1920), 82ff. Reprinted in *Artistes et monuments de la Renaissance en France*, 148ff. (Paris, 1929)

RUPPRICH, Hans: *Albrecht Dürer. Schriftlicher Nachlass* (Berlin, 1956)

SACCHETTI, Franco: *Il Trecentonovelle.* Edited by Vincenzo Pernicone (Florence, 1947)

SALERNO, Luigi, 'The Picture Gallery of Vincenzo Giustiniani', *Burlington Magazine*, CII, 93ff. (1960)

SALZMAN, L. F.: *English Life in the Middle Ages* (Oxford, 1927)
Building in England down to 1540 (Oxford, 1952)

SANDBY, W.: *The History of the Royal Academy of Arts* (London, 1862)

SANDER, H. G.: 'Beiträge zur Biographie Hugos van der Goes und zur Chronologie seiner Werke', *Repertorium für Kunstwissenschaft*, XXXV, 512ff. (1912)

SANDRART, Joachim v.: *Teutsche Academie der Edlen Bau-Bild- und Mahlerey-Künste* (Nürnberg, 1675). Quotations from the edition by Peltzer (Munich, 1925)

SANDULLI, Alfredo: *Arte delittuosa* (Naples, 1934)

S. TERESA OF JESUS: *Works:* Edited by John J. Burke (New York, 1911)

SAXL, Fritz: *Lectures* (London, 1957)
—*See* PANOFSKY

SCHAPIRO, Meyer: 'On the Aesthetic Attitude in Romanesque Art', in *Art and Thought.* Issued in Honor of Dr. Ananda K. Coomaraswamy. Edited by K. Bharatha Iyer (London, 1947)
'Two Slips of Leonardo and a Slip of Freud', *Psychoanalysis. Journal of Psychoanalytic Psychology*, IV, ii, pp. 3–8 (1955-56)
'Leonardo and Freud: An Art-Historical Study', *Journal of the History of Ideas*, XVII, pp. 147–178 (1956)

SCHARF, Alfred: *Filippino Lippi* (Vienna, 1935)

SCHLOSSER, J. von: *Beiträge zur Kunstgeschichte aus den Schriftquellen des frühen Mittelalters* (Vienna, 1891)
Lorenzo Ghibertis Denkwürdigkeiten. I commentarii (Berlin 1912)
La Letteratura artistica. Translation of *Die Kunstliteratur* (Vienna, 1924) with bibliographical additions by O. Kurz (Florence, 1956)

SCHNEIDER, Daniel: *The Psychoanalyst and the Artist* (New York, 1950)

SCHNITZER, Josef: *Savonarola* (Munich, 1923)

SCHULTZE, Rudolf: *Geschichte des Weins und der Trinkgelage* (Berlin, 1867)

SCHWEITZER, Bernhard: 'Der bildende Künstler und der Begriff des Künstlerischen in der Antike', *Neue Heidelberger Jahrbücher* (1925)

SEDLMAYR, Hans: *Die Architektur Borrominis* (Berlin, 1930)

SEIBT, G. K. W.: *Hans Sebald Beham* (Frankfurt, 1882)

SELIGMANN, Kurt: *The History of Magic* (New York, 1948)

SELLERS, E.—*See* PLINY

SENECA: *Epistolae morales.* Edited by Richard M. Gummere, Volume II (Loeb Classical Library, London, 1920)
Moral Essays. Edited by John W. Basore (Loeb Classical Library, London, 1932)

SEZNEC, Jean and ADHÉMAR, Jean: *Diderot. Salons* (Vol. II: 1765) (Oxford, 1960)

SHAFTESBURY, Anthony, Earl of: *Characteristicks*, volume I. Treatise III. 'Soliloquy: or, Advice to an Author'. (London, 1732) (first edition 1710)

SLUYS—*See* LEGRAND

SMITH, J. T.: *Nollekens and his Times* (London, 1949) (first edition 1828)

SOPRANI, Raffaele: *Le vite de' pittori, scultori, et architetti genovesi* (Genoa, 1674). Quotations from the expanded edition by Giuseppe Ratti, 2 volumes (Genoa, 1768–69)

STEINMANN, E., and WITTKOWER, R.: *Michelangelo-Bibliographie 1510–26* (Leipzig, 1927)
Michelangelo im Spiegel seiner Zeit (Leipzig, 1930)
Michelangelo e Luigi del Riccio (Florence, 1932)

STETTEN, Paul von: *Kunst-, Gewerb- und Handwerksgeschichte der Reichs-Stadt Augsburg* (Augsburg, 1779–88)

STILLMAN, Damie: *The Genesis of the Adam Style*. Dissertation, Columbia University. Unpublished (New York, 1961)

SWEENEY, James Johnson: *Marc Chagall* (New York, 1946)

SYMONDS, John A.: *The Renaissance*, volume II (London, 1877)
The Life of Michelangelo Buonarroti (London, 1893)

TATHAM, E. H. R.: *Francesco Petrarca* (London, 1925)

TAYLOR, A. E.: *A Commentary on Plato's Timaeus* (Oxford, 1928)

TESDORPF, Karl Wilhelm: *Johannes Wiedewelt, Dänemarks erster klassizistischer Bildhauer* (Hamburg, 1933)

THIEME, Gisela: *Kunsthandel in den Niederlanden im 17. Jahrhundert* (Cologne, 1959)

THOMAS À KEMPIS: *The Imitation of Christ*. English by Leo Sherley-Price (Penguin Classics, 1952)

TIETZE, H.: 'Annibale Carraccis Galerie im Palazzo Farnese und seine römische Werkstätte', *Jahrbuch des A. H. Kaiserhauses*, Vienna, XXVI (1906-7)
Tizian. Leben und Werk (Vienna, 1936)

TIETZE-CONRAT, E.: *Österreichische Barockplastik* (Vienna, 1920)

TOLNAY, Charles de: *Michelangelo*. Volume I. *The Youth of Michelangelo* (Princeton, 1943); volume V. *The Final Period* (1960)

TORRE, A. della: *Storia dell' Accademia Platonica* (Florence, 1902)

TRAUMAN-STEINITZ—*See* BAVETTA

TRIVAS, N. S.: *Frans Hals* (London, 1941)

VAES, M.: 'La colonie flamande de Rome au XVᵉ et XVIᵉ siècle', *Bulletin de l'Institut Belge de Rome*, 163ff. (1919)

VALLE, Guglielmo della: *Lettere Sanesi* (Rome, 1786)

VASARI, Giorgio: *Le vite de'più eccellenti pittori scultori ed architetti*. Edited by Gaetano Milanesi, 9 volumes (Florence, 1878–85). Quotations from this edition. Vasari's first edition 1550; enlarged second edition 1568. English edition by Gaston de Vere, 10 volumes (London, 1911–15)

VENTURI, A.: *Storia dell'Arte Italiana*, IX, iv (Milan, 1929); IX, v (1932); X, iii (1937)

VERCI: *Notizie intorno alla vita e alle opere di Pittori, Scultori e Intagliatori della città di Bassano* (Venice, 1775)

VILLANI, Filippo: *Le vite d'uomini illustri fiorentini* (Collezione di storici e cronisti italiani, volume VII) (Florence, 1847)

VILLARI, P. and CASANOVA, E.: *Scelte di prediche e scritti di Fra Girolamo Savonarola* (Florence, 1898)

VITA, Alessandro del: *Rapporti e contrasti fra artisti nel Rinascimento* (Arezzo, 1958)

VITRUVIUS: *De architectura libri X.* Edited by Frank Granger (Loeb Classical Library, London, 1931–34)

WACKERNAGEL, Martin: *Der Lebensraum des Künstlers in der florentinischen Renaissance* (Leipzig, 1938)

WALDBURG-WOLFEGG, Graf Johannes von: *Lukas Moser* (Berlin, 1939)

WALKER, D. P.: *Spiritual and Demonic Magic from Ficino to Campanella* (London, 1958)

WALKER, John: *Bellini and Titian at Ferrara* (London, 1956)

WALPOLE, Horace: *Anecdotes of Painting in England*, volume V, edited by F. W. Hilles and P. B. Daghlian (Yale University Press, 1937)

WARBURG, A.: *Gesammelte Schriften* (Leipzig-Berlin, 1932)

WATERHOUSE, Ellis: *Reynolds* (London, 1941)

WEISSENFELD, F.—*See* HARTLAUB

WEIXLGÄRTNER, Arpad: 'Eine Nürnberger Steuerrechnung mit Eintragungen, die Albrecht Dürer betreffen', *Mitteilungen der Gesellschaft für vervielfältigende Kunst* (Beilage der *Graphischen Künste*), no. 2 (Vienna, 1914)

'Dürer und Grünewald', *Göteborgs Kungl. Vetenskapsoch Vitterhets-Samhällers Handlingar.* Ser. A, Bd. IV, no. 1 (Göteborg, 1949)

WEIZSÄCKER, H.: *Adam Elsheimer* (Berlin, 1936)

WESCHER, Paul: 'The "Idea" in Giuseppe Arcimboldo's Art', *Magazine of Art*, XXXXIII, pp. 3–8 (1950)

WETHEY, Harold E.: *Alonso Cano, Painter, Sculptor, Architect* (Princeton, 1955)

WICKRAM, Joerg: *Das Rollwagenbüchlein* (1555). Edited by Insel Verlag (Leipzig, n.d.)

WILKINS, Ernest H.: *Petrarch at Vaucluse* (Chicago, 1958)

WITTKOWER, Rudolf: 'Inigo Jones, "Puritanissimo Fiero"', *Burlington Magazine*, XC, 50f. (1948)

The Artist and the Liberal Arts (University College, London, 1952)

Gianlorenzo Bernini (London, 1955)

Art and Architecture in Italy 1600–1750 (Pelican History of Art, 1958)

'Individualism in Art and Artists: A Renaissance Problem', *Journal of the History of Ideas*, XXII, pp. 291–302 (1961)

'The Vicissitudes of a Dynastic Monument: Bernini's Equestrian Statue of Louis XIV', in *De Artibus Opuscula XL. Essays in Honor of Erwin Panofsky* (New York, 1961)

WOLTMANN, Alfred: *Holbein and his Time*. Translated by F. E. Bunnett (London, 1872)

Holbein und seine Zeit. Second edition (Leipzig, 1874-6)

WOODWARD, John: *Tudor and Stuart Drawings* (London, 1949)

XENOPHON: *Memorabilia and Oeconomicus*. Edited by E. C. Marchant (Loeb Classical Library, London, 1923)

Apologia Socratis. Edited by O. J. Todd (Loeb Classical Library, London, 1947)

YATES, Frances: *The French Academies of the Sixteenth Century* (London, 1947)

ZILBOORG, Gregory: 'Differential Diagnostic Types of Suicide', *Archives of Neurology and Psychiatry*, XXXV (1936)

in collaboration with George W. Henry: *A History of Medical Psychology* (New York, 1941)

ZILS, W.: *Geistiges und künstlerisches München in Selbstbiographien* (Munich, 1913)

ZILSEL, E.: *Die Entstehung des Geniebegriffes* (Tübingen, 1926)

ZUCCARI, F.: *L'idea de' pittori, scultori et architetti* (Turin, 1607)

ZUCCHINI, Guido: 'Un libro-cassa del pittore Marcantonio Franceschini', *L'Archiginasio*, pp. 66–71 (1942)

ZUCKER, M.: *Dürers Stellung zur Reformation* (Erlangen, 1886)

ZÜLCH, Walter Karl: *Der historische Grünewald* (Munich, 1938)

'Jerg Ratgeb, Maler', *Wallraf-Richartz-Jahrbuch*, XII-XIII, pp. 165–197 (1943)

ZWINGER, Jacob: *Theatrum humanae vitae* (Basel, 1604)

INDEX

333